DUTCH PAINTING
in Soviet Museums

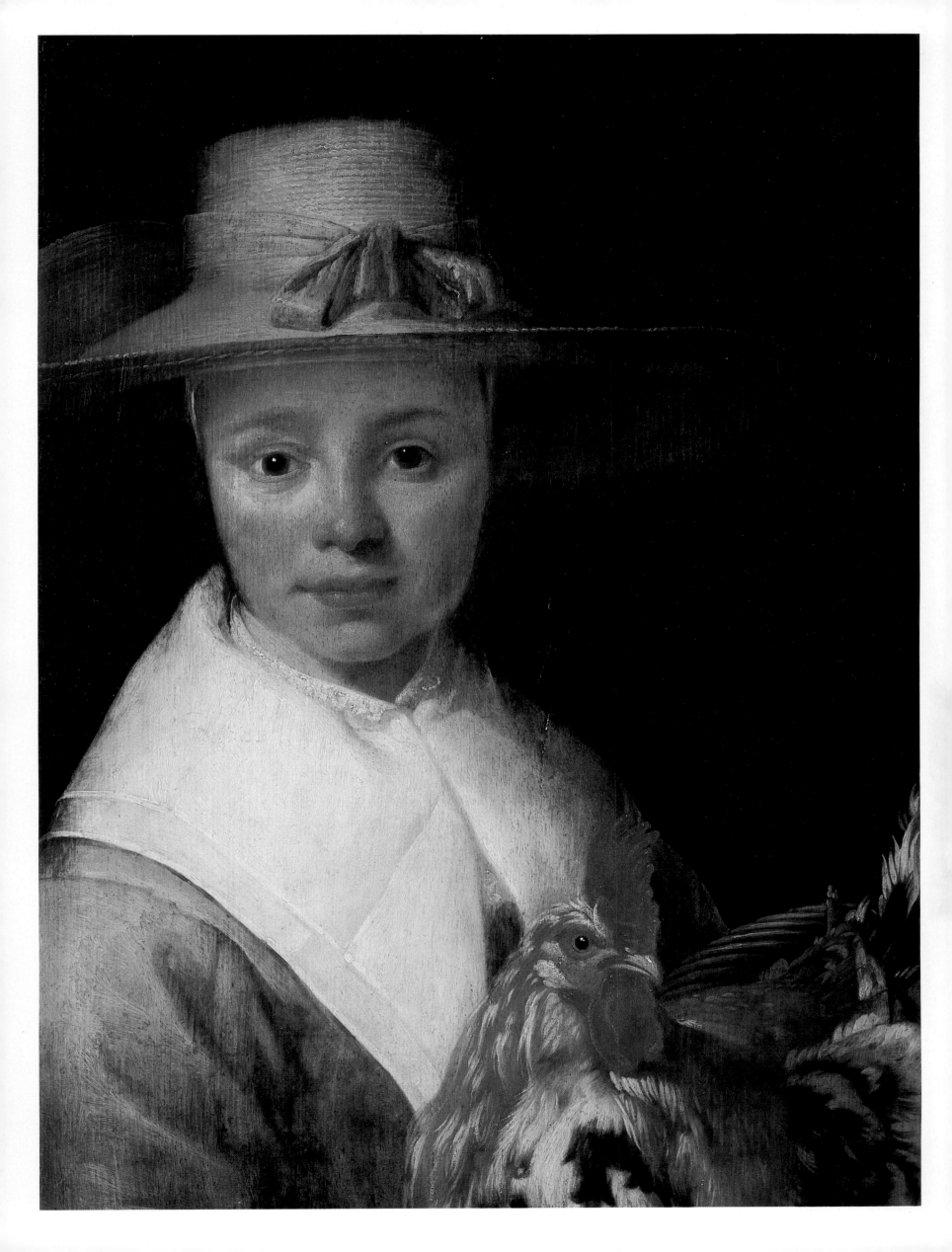

DUTCH PAINTING

in Soviet Museums

By Yury Kuznetsov and Irene Linnik

HARRY N. ABRAMS, INC., PUBLISHERS, NEW YORK
AURORA ART PUBLISHERS, LENINGRAD

Designed by MARINA SOROKINA

Library of Congress Catalog Card Number: 80-66702
International Standard Book Number: 0-8109-0803-4

Created by Aurora Art Publishers, Leningrad, for joint publication
of Aurora and Harry N. Abrams, Inc., New York

Printed and bound in Yugoslavia

The Hermitage, Leningrad
The Pushkin Museum of Fine Arts, Moscow
Museum of Western European and Oriental Art, Riga
Art Museum, Kharkov
Art Museum of the Estonian SSR, Tallinn
Museum of Western European and Oriental Art, Odessa
The Radishchev Art Museum, Saratov
Museum of Western European and Oriental Art, Kiev
Palace Museum, Pavlovsk
The Hermitage Pavilion, Petrodvorets
The Monplaisir Palace, Petrodvorets
Picture Gallery, Kalinin
The Lunacharsky Art Museum, Krasnodar
Museum of Art and Local Lore, Zhitomir
Art Museum, Kaluga
Art Museum of the Tatar ASSR, Kazan
Picture Gallery, Tambov
Art Museum, Irkutsk
Art Museum, Kuibyshev
The Deineka Art Gallery, Kursk
Art Museum, Riazan
Museum of Fine Arts, Voronezh
Art Gallery of Armenia, Yerevan
Art Museum, Ulyanovsk
Art Gallery, Lvov
Art Museum, Sevastopol

The creative genius of the Dutch manifested itself most vividly in the field of pictorial art. One need only recall the names of Lucas van Leyden, Rembrandt van Rijn, Jan Vermeer of Delft, Vincent van Gogh to appreciate the contribution of this small country to the treasure chest of world art. Dutch painters stood at the fountainhead of the realist tradition, and the major achievements of realism in the past are linked with many a Dutch name. A profound admiration for life in all its manifestations, an ability to perceive beauty even in the most inconspicuous corner of nature or in the everyday world that surrounds us—these qualities place Dutch painting in the forefront of world culture. Because they are living proof of the heights to which human genius can rise, works by Dutch artists are treasured by museums throughout the world.

The Soviet Union possesses one of the richest collections of Dutch painting. The Hermitage stocks are world-famous, but there are a number of valuable canvases in the museums of Moscow, Riga and Kiev, and some unique pieces in many regional and city museums. It can safely be said that there is not a single art gallery in the country where the Dutch school is not represented by at least a few works.

The first Dutch paintings came to Russia in the early eighteenth century. In the St. Petersburg and Peterhof galleries of Peter the Great and in the Kunstkammer he founded, works by Dutch artists were for a long time, and with good reason, the nucleus of the collections.

Russian artistic culture of that time was undergoing a period of rapid secularization, with the influence of the church in decline. It was only natural, therefore, that Russian art should turn to the achievements of Western European painting, absorbing the lessons of the great masters. The experience of the Dutch school, in which realism had come to play the dominant role, was in these circumstances especially valuable for Russian artists. They learned from it both abroad, where Peter had sent them to study, and at home in St. Petersburg, where noteworthy collections had already been amassed.

In 1715–16 Osip Solovyov and Yury Kologrivov, diplomatic and commercial agents of Peter the Great, bought 43 pictures in The Hague, 121 in Amsterdam and 117 in Brussels and Antwerp. Shortly afterwards another 119 canvases were acquired through the British merchants Evan and Elsen. These pictures, most by Dutch and Flemish masters, formed the basis of Peter's collections. According to Jakob Stœhlin von Storcksburg, Peter's biographer, the Russian tsar's favorite artists were Peter Paul Rubens, Jan van Eyck, Rembrandt, Jan Steen, Philips Wouwerman, Pieter Brueghel, van der Werff—evidently Pieter van der Werff (1665–1722), who painted Peter's portrait in 1697 or 1698—and Adriaen van Ostade. This suggests that Peter showed a sincere interest in democratic art, in scenes from the life of "Dutch mouzhiks and babas," as Jakob Stœhlin von Storcksburg puts it in *Original Anecdotes of Peter the Great*. However, one should not interpret this fondness for all things Dutch, including Dutch painting, simply as

a reflection of "skipper Pieter's" personal taste, although it undoubtedly played a part. The burgher democracy of the Dutch, which their painting so vividly expressed, was very similar in character to Peter's reforms in the culture and everyday life of Russia, reforms that were, in the final analysis, determined by the historical development of the country. The educative functions of Dutch art had never perhaps come so actively to the fore as in Russia. The works of the marine painter Adam Silo, for example, were highly esteemed for the artist's knowledge of the arts of shipbuilding and sailing.

The artistic merits of the Dutch canvases in the St. Petersburg collections of the time were, generally speaking, not very high. Nevertheless, they included several masterpieces that were later to become the pride of the Hermitage collection, in particular Rembrandt's *David's Farewell to Jonathan* (purchased in Amsterdam in 1716). This was the first work of the great Dutchman to come into Russian ownership. Interesting, too, are Adriaen van Ostade's *The Scuffle*, Jan Steen's *Marriage Contract* and *Scene in a Tavern*, and Johannes Oudenrogge's *The Weaver*. Originally housed in the Monplaisir Palace of Peterhof (now Petrodvorets), they were transferred to the Hermitage in 1882.

In the mid-eighteenth century, interest in painting in Russia took a somewhat different turn. With the consolidation of Russian absolutism and the pursuit of pleasure and ostentatious magnificence that ensued, the picture as such was transformed from a source of knowledge into an element in the ornamental furnishings of state rooms. Paintings now came to be particularly prized for their large dimensions and decorativeness, qualities not usually characteristic of Dutch painting. Even so, of the 115 works purchased for Elizabeth Petrovna by the German painter Georg Christoph Groot and destined for the picture gallery of the Palace in Tsarskoye Selo, Dutch paintings still constituted a significant part. True, along with the more usual small-size pictures by Adriaen van Ostade, Johannes Lingelbach, Dominicus van Tol, and others, the group also included some large, imposing canvases by their compatriots Jan Both and Emanuel de Witte. The latter's *Church Interior*, for example, is the largest of the artist's known pictures, measuring 64 $^5/_8 \times$ 54 $^1/_8$″ (164 by 137.5 cm.).

With the founding of the Hermitage in 1764 and the purchase of works in the possession of Johann Ernest Gotzkowsky, Heinrich Brühl, Pierre Crozat, Baudouin, and others, the collection of Dutch painting in St. Petersburg had by the second half of the eighteenth century become one of the richest in the world. It was now characterized by fullness, diversity, and very high quality. Almost all the leading masters of the seventeenth century, the heyday of Dutch painting, were represented by major works. The Rembrandts acquired by then included *Abraham's Sacrifice, Flora, Danaë, The Holy Family, Portrait of an Old Man in Red, Ahasuerus, Haman and Esther* (now in the Pushkin Museum of Fine Arts, Moscow), and *The Return of the Prodigal Son*. From these canvases the viewer could trace the great master's creative development through all the main stages of his career and in almost every genre. Another great Dutchman, Frans Hals, was represented by magnificent portrait pieces as well as by some of his rare evangelical and genre compositions. The Hermitage also possessed more than ten works by Holland's foremost landscapist, Jacob van Ruisdael, among them his celebrated *The Marsh*. Pictures by Jan van Goyen, Aelbert Cuyp, Aert van der Neer, Nicolaes (Claes) Pietersz Berchem, Adam Pynacker, and Jan van der Heyden helped to provide a more comprehensive survey of landscape works. The flowering of genre painting could be

appreciated in some of the best works of Anthonie Palamedesz, Jacob Duck, Gerrit Dou, Adriaen van Ostade, Jan Steen, Gerard Ter Borch, Gabriel Metsu, Frans van Mieris, and many other celebrated masters.

But whereas the Golden Age of Dutch painting was represented to a degree that, it seemed, could hardly be improved, the same could not be said of the fifteenth and sixteenth centuries. There were few pictures from this period of birth and maturation of Dutch art, a period underestimated and little studied at the time. Yet even then the Hermitage could take pride in Lucas van Leyden's large altarpiece *The Healing of the Blind Man of Jericho*—considered a special rarity by the painter and historian of Dutch art Karel van Mander in his *Het Schilderboek* (*Book of Artists*) as far back as 1604—as well as two group portraits of Amsterdam musketeers (a genre that hardly exists outside Holland) by Dirck Jacobsz, and Pieter Aertsen's superb picture *The Apostles Peter and John Healing the Sick*, at the time ascribed to Hans Holbein.

The quality and scope of the Hermitage collection directly influenced the character of private collecting. It was precisely the late eighteenth and early nineteenth centuries that saw the formation of the Golitsyn, Yusupov, Sheremetev, Stroganov, and other galleries, and if some collectors favored the Italian or French schools, they almost always gave the Dutch second place in their collections. These private galleries were of course less famous than the Hermitage, but they did own some quite valuable pictures.

The picture gallery of A. M. and D. M. Golitsyn in Moscow was very well known. It had in its possession many pieces by minor Dutchmen popular in the second half of the eighteenth century—Adriaen van der Werff, Philips and Jan Wouwerman, Herman Saftleven the Younger, Cornelis Pietersz Bega, Jan van der Heyden, and others. We should note here that works presumed to have been executed by the then fashionable artists Adriaen van Ostade, Cornelis van Poelenburgh, Caspar Netscher, and Pieter Neeffs were in fact painted by their pupils or followers: Pieter Jansz Quast, Dirck van der Lisse, Constantin Netscher, and Gerard Jorisz Houckgeest. True, such attributions were not so misguided then as they might now appear.

In the nineteenth and twentieth centuries a new category of collector from the more democratic circles of society appeared in St. Petersburg and especially in Moscow, Riga, and some other provincial centers. Because of their small dimensions, reasonable prices, and captivating subject matter, paintings of the Dutch school made up the bulk of these collections. The artistic merits of the canvases, largely the work of minor masters, were for the most part not of a very high order, but it is on the basis of these private collections that many city galleries and museums came into being. Thus, the Museum of Western European and Oriental Art in Riga began with the collections of V. Brederlo, a city councillor, D. de Robiani, a merchant, E. Hollander, the mayor, and several other townsmen. Riga today has the third largest collection of Dutch art in the Soviet Union, in which such little-known artists as Jacobus Sibrandi Mancadan, Wybrand de Geest the Elder, Hendrick Heerschop, Michiel Sweerts, and Ludolf de Jongh are represented. The Dutch section of the Kharkov Art Museum is based on a collection that once belonged to a local engraver, A. Alfiorov. In addition to Adriaen Pietersz van de Venne, Ferdinand Bol, Bartholomeus van der Helst, and other masters of the "Golden Age," this museum also has on display works by Dutch painters of the sixteenth (Jan van Scorel) and eighteenth to nineteenth centuries (Pieter Gerardus van Os and Jozef Israëls).

In Moscow in the nineteenth century, Dutch painting could be seen not only in the Golitsyn Museum and the palace collections of the Sheremetevs and Yusupovs, but also in the private galleries of A. Vlasov, F. Mosolov, A. Tuchkov, and E. Tiurina, and, finally, in the Rumiantsev Museum, which was transferred to Moscow from St. Petersburg. In 1862 this museum's collection was enlarged with the entry of two hundred works from the Hermitage, more than half by Dutch and Flemish painters. Well represented in the Moscow collections of the time were Rembrandt and his pupils Gerrit Dou, Ferdinand Bol, Gerbrand van den Eeckhout, Govaert Flinck, Philips de Koninck, Aert de Gelder; the genre painters Adriaen van Ostade, Cornelis Dusart, Pieter Codde, Gerard Ter Borch; the landscapists Salomon van Ruysdael, Jan Both, Nicolaes Pietersz Berchem, Aert van der Neer, Jan van der Heyden; the still-life painters Willem van Aelst, Abraham van Beyeren, Jan Davidsz de Heem, Martinus Nellius, Juriaen van Streeck, and other minor Dutchmen. The works of all these masters were handed over to the Museum of Fine Arts (since 1937 the Pushkin Museum of Fine Arts) in 1924.

In the Volga region the best collection of Dutch painting is in the Radishchev Art Museum, Saratov, founded in 1885 by the Russian landscapist Alexei Bogoliubov. The museum's evident preference for landscape painting is a reflection of its founder's tastes. The landscape genre in Dutch art is shown here in works by Adam Willaerts, Karel Dujardin, Frédéric de Moucheron, Johannes Lingelbach, and by the nineteenth-century artists Barend Cornelis Koekkoek, Andreas Schelfhout, L. J. H. Meier, Remigius Adrianus van Haanen, and others.

This same Bogoliubov was entrusted by Alexander III to purchase pictures for the Anichkov Palace, through which St. Petersburg became acquainted with the new Dutch painting. But the main popularizer of Western European art in the nineteenth century was the public gallery of Count Nikolai Kushelev-Bezborodko, which he bequeathed to the Academy of Arts in 1862. The works of Johannes Bosboom, Jan Weissenbruch, Herman Frederick Carel ten Kate, Willem Roelofs, Petrus van Schendel, and other Dutchmen that have graced the Hermitage exhibition since 1922 come from that outstanding collection.

The Hermitage of the prerevolutionary period, however, continued to devote all its attention to the old masters. In the nineteenth century it acquired such masterpieces of Dutch painting as *The Crucifixion* by Maerten van Heemskerk, *The Descent from the Cross* and *Portrait of a Young Man in a Lace Collar* by Rembrandt, *A Glass of Lemonade* by Gerard Ter Borch, *Breakfast* by Gabriel Metsu, *A Woman and Her Maid* by Pieter de Hooch, *The Farm* by Paulus Potter, *Family Group* by Abraham van den Tempel, *Introducing the Bride* by Bartholomeus van der Helst, and *Self-portrait* by Aert de Gelder. Most of these canvases were from the Malmaison Palace, purchased by the Hermitage in 1814 from Napoleon's first wife Joséphine de Beauharnais and in 1829 from her daughter the Countess of Saint-Leu, ex-queen of Holland; the rest came from the collections of William II, Stadholder of the Netherlands, and King Stanislaw II August Poniatowski of Poland, or were bought at Paris auctions.

The most important addition to the Hermitage's Dutch section, however, was the Semionov-Tien-Shansky Collection which entered the museum in 1915. A famous Russian scholar and explorer, Piotr Semionov-Tien-Shansky began collecting pictures by Dutch masters in 1861. Aided by his extensive knowledge of painting, he set out with an

amazing perseverance to gather works by minor Dutch and Flemish masters largely or totally unrepresented in the Hermitage. By 1910 he had acquired 719 works by 340 artists of whom 190 had not formerly been exhibited there. Consequently, the museum's Dutch section, which had previously outshone all others for the masterpieces in its possession, now became one of the richest in the world for the number of works by different artists, some of them quite unique, that it included.

After the October Revolution the museum's holdings provided the basis for a special art fund to facilitate the study of Dutch art. This fund was successfully used, among other things, to train Soviet art historians.

Lenin's decrees of 1918 on the nationalization and preservation of art treasures and on the democratization of all art institutions were conducive to a more systematic acquisition of pictures (and other works of art) and their redistribution among the country's museums. The popularization of outstanding art works among the broadest possible masses of the population now became government policy. It is during this period that existing state collections were consolidated and new ones were created. In this respect, special mention should be made of the Moscow Museum of Fine Arts which received several famous works from the Hermitage and various Leningrad museums. Among the canvases that thus entered the Moscow collection were Rembrandt's *The Incredulity of the Apostle Thomas*, *Portrait of an Elderly Woman*, *Portrait of an Old Woman*, and *Portrait of Adriaen van Rijn, the Artist's Brother*, Jacob van Ruisdael's *Landscape* and *View of Egmond aan Zee*, Jan Steen's *Merry Party*, *Peasant Wedding*, and *A Sick Old Man*, Gerard Ter Borch's *Scene in a Tavern* and *Lady Washing Her Hands*, Adriaen van Ostade's *Village Feast*, *At School*, and *Peasant Revel*, as well as works by Aelbert Cuyp, Paulus Potter, Pieter de Hooch, Nicolaes Maes, and a number of other masters. Works from private Moscow collections were handed over to the Museum of Fine Arts. These included *The Mocking of Christ* by Jan Mostaert, *Skating* by Hendrick Avercamp, Emanuel de Witte's *Market in the Port* and *Church Interior*, Adriaen van de Velde's *Allegory*, and Willem Kalf's *Still Life with Cup*. As a result the Pushkin Museum's Dutch collection is today the second largest in the country, surpassed only by that of the Hermitage.

Foremost among the new museums organized after the October Revolution was the Kiev Museum of Western European and Oriental Art, inaugurated in 1919. Its exposition was built around the private collection of B. and V. Khanenko, which boasted some superb Dutch canvases. In 1925–26, another rich private collection, that of V. Shchavinsky, entered the museum. Like Semionov-Tien-Shansky, Shchavinsky had striven to gather as complete a selection of Dutch and Flemish masters as possible and from the very beginning intended it for the city of Kiev.

The same period saw the inauguration of museums in Ulyanovsk, Gorky, Tambov, and Perm. The Soviet government's prime achievement in the museum field, though, was the organization of art galleries in the outlying areas of the former Russian Empire—the cities of Central Asia and Transcaucasia, Siberia, and the Far East. Today their holdings of Dutch art include works of high and in some cases outstanding artistic merit. Such canvases as Hendrick Terbrugghen's *Christ Crowned with Thorns* (Art Museum, Irkutsk), Mathias van Stomer's *The Annunciation* (Museum of Art and Local Lore, Zhitomir), and a sketch by Jan Steen (Art Museum, Khabarovsk) indicate well the quality and importance of these collections.

11

The works housed and displayed in Soviet museums allow the viewer to follow the evolution of the Dutch school over a period of almost five centuries, from its origins in the fifteenth century. The seventeenth century, the Golden Age of Dutch painting, is represented by works of a high standard with hardly any lacunae.

Two great masters stood at the fountainhead of Dutch art—Geertgen tot Sint Jans and his teacher Aelbert van Ouwater. The Netherlands of that period consisted of a number of separate princedoms, both secular and ecclesiastical, which the dukes of Burgundy had begun to unite under their dominion in the late fourteenth century. The wealthy cities of Flanders, Brabant, Zealand, and Holland with their long-standing and well-developed cloth manufacture were established centers of secular culture whose role gained even more importance during the age of discovery and the shifting of the main trade routes from the Mediterranean to the Atlantic.

Major schools of art had existed from medieval times in the Netherlands, both in the South (Brugge, Ghent, Antwerp, and Brussels) and in the North (Utrecht and Haarlem). It was, however, only in the fifteenth century, at first through Jan van Eyck, then Geertgen tot Sint Jans, that those artistic devices that were later to be the hallmark of Flemish and Dutch painting first came into use.

One of the earliest works in which the qualities peculiar to the early Dutch school are apparent is *Saint Bavo* (the Hermitage, Leningrad), although its attribution to Geertgen is uncertain. Looking at the homely but inspired face of the saint, at the hilly landscape with a Gothic chapel surrounded by houses and a wall, or at the chain mail and armor that softly reflect the light, one cannot help admiring the naive and rapt narrative manner, the masterly portrayal of human feelings, and the sensitive treatment of light.

But whereas Geertgen tot Sint Jans expressed the reverent awe of medieval man before the great world around him, his contemporary Hieronymus Bosch saw its negative side—deep social contradictions, violence, and deceit. To reflect all this he drew on the imagery of popular fantasy and Dutch folklore. Bosch's works are strongly tinged with a morbid imagination, with melancholy and pessimism. He was the last of the medieval artists. He saw before him the breakdown of the old outlooks and beliefs, the disintegration of outdated social relations, the decline of feudal ethics and morals. To his mind this signified the collapse of all the social and spiritual mainstays of life, and his criticism of the sins of Dutch society was an attempt to save it from what he saw as perdition.

At the end of the fifteenth century the Netherlands was incorporated into the vast empire of the Habsburgs. Trading with Germany, Austria, Spain, and the colonies strengthened the bourgeoisie and bourgeois relations. New trade and industrial centers came to the forefront, and many old towns slipped into obscurity. The fame of Brugge, based on strictly regulated shop production, declined, while Antwerp, with a commercial port and a more advanced system of manufacture, began to prosper. Further north Amsterdam, Antwerp's future rival, continued its rapid growth.

In a very short time there developed a collision of interests between the Netherlands, which had embarked on the capitalist path, and Spain, still a feudal country. The flames of impending conflict were fanned by the quick spread of Calvinism in the country. As a result the whole second half of the sixteenth century in the Netherlands was marked by an unceasing, fierce struggle against Catholic Spain for national independence and freedom of religion.

This was a period in which the secular and urban elements and the humanistic tendencies of Dutch culture grew ever stronger. The progress achieved in book printing promoted the spread of education and a rising interest in antique literature and the culture of the Italian Renaissance. As a result, the orientation of Dutch art toward the more advanced art of Italy was a natural and inevitable phenomenon. This engendered the powerful "Romanist" trend which lasted throughout the sixteenth century. But along with those painters (later given the name of Romanists), whose art was mainly influenced by the Italian Renaissance, the same century produced such profoundly national and inimitable masters as Lucas van Leyden and Pieter Brueghel, called "Peasant Brueghel."

Lucas van Leyden's teacher Cornelis Engelbrechtsen, who lived in Leyden, and his Amsterdam contemporary Jacob Cornelisz van Oostsanen were in many respects faithful to the Gothic tradition in their work. This was especially evident in the more archaic-minded Engelbrechtsen—the figures in his pictures retained their elongated proportions and their movements were marked by a pronounced artificiality. An oil ascribed to the artist, *Calvary* (the Hermitage, Leningrad), may well serve as an example of late-Gothic Mannerism in the art of the Northern Netherlands. In his portrait pieces, Cornelisz van Oostsanen drew upon the techniques and decor of Renaissance art, but here again the borrowings are of an outward, purely superficial kind. The same can be said about the art of Jan Mostaert, who worked in Amsterdam during those same years.

A profound innovatory role in the evolution of Dutch art was exercised by Lucas van Leyden. The artist's thematic repertoire was still closely linked with the Bible, but it was interspersed with antique motifs and, what was particularly significant and new for the time, with genre compositions and portraits.

There is an abundance of genre motifs in Van Leyden's famous triptych *The Healing of the Blind Man of Jericho* (the Hermitage, Leningrad). The triptych is presumed to have been painted for a Leyden hospital. For that reason the artist felt free to produce not a traditional altarpiece but a work of art that would induce the viewer to participate in the event and force him to take an attitude toward it.

The first artist to make a final choice between the medieval tradition and the Renaissance was Jan van Scorel. Scorel was a typical product of the new age. A man of great versatility, he was at the same time painter, rhetorician, musician, and engineer, knew the technical sciences to perfection, was custodian of the Belvedere art collections in Rome, and the canon of the chapter of St. Mary in Utrecht. His was a significant contribution to altar painting, the landscape, and the portrait alike.

Soviet collections allow for a quite comprehensive assessment of Scorel's artistic achievements. In Lvov there is an early work of his, *The Meeting of Mary and Elizabeth*, and in Kharkov an excellent landscape ascribed to the master with a scene depicting the baptism of the eunuch; finally, the Tambov Picture Gallery has on display one of his masterpieces: the left leaf of the diptych *The Virgin and Child*. Both Mary and the Infant Christ, as well as the landscape in the background, are rendered in a bold, sweeping and generalized manner. This is a work in which Scorel's painterly skill achieves perfection.

Another member of the Romanist group was Maerten van Heemskerk, a pupil of Scorel's. But if the calm and composed Scorel took for his model the art of Raphael, his temperamental pupil was an admirer of Michelangelo. Heemskerk's triptych *Calvary* (the Hermitage, Leningrad) stands out for the emphatic treatment of the musculature,

its complicated foreshortenings, and its dynamism. The triptych repeats, with slight alterations, the central panel of his famous altarpiece for the Church of St. Lawrence in Alkmaar. The portraits of the donors on the side panels of the triptych prove that Heemskerk not only inherited his teacher's skills as a portraitist, but even surpassed them. The lifelike quality we see here is not perhaps to be found in Scorel's oeuvre.

However, the purely Dutch type of portrait—the group or corporate portrait—came into being not in Catholic Utrecht nor in patrician Haarlem, but in the more democratic city of Amsterdam. The Hermitage has in its possession two rare examples of this type of portrait, almost unknown outside Holland. Executed by the Amsterdam painter Dirck Jacobsz, the son and pupil of Cornelisz van Oostsanen, these works manage to convey, through the images of the Amsterdam musketeers, the cohesion and resolve, the sense of common interest and the readiness to defend that interest in armed combat that the artist's compatriots displayed in the revolution of 1566 and in the struggle for national liberation against the Spanish oppressors.

The growing self-awareness of the Dutch people also shaped the art of Jacobsz's junior contemporary, the Amsterdamer Pieter Aertsen, whose art was inspired by the democratic theme. An important stage in the evolution of Dutch realism resulted from the urge to present the peasant and the common people in general in a heroic vein (for example, *Vendor of Fowl*, in the Hermitage, Leningrad). Even in the religious picture *The Apostles Peter and John Healing the Sick* (the Hermitage, Leningrad) the artist's interest is focused on the life of the crowd in a Dutch street, whereas the scene of the miracle itself is moved into the background.

As a result of Holland's bourgeois revolution and her victory in the war for national liberation (1566–1609), the seven northern provinces gained their independence and formed the first bourgeois republic in the history of Western Europe. However, the art of republican Holland could not immediately reflect all the major changes the country had undergone. The traditions of late Romanism (Karel van Mander), Mannerism (Abraham Bloemaert, Joachim Wtewael), and of the Haarlem Academy (Hendrick Goltzius, Cornelis Cornelisz van Haarlem) outlived the sixteenth century; it was only in the first quarter of the seventeenth century that realism finally gained the upper hand.

In the history of Holland the seventeenth century was a period that saw a powerful upswing in the economy, politics, and culture of the country. The principles that came to underlie the economic and political structure of the republic were the most progressive of their time; the natural sciences and the humanities, literature, and book printing flourished. This was the heyday of Holland's spiritual culture, and here lived and worked the greatest thinkers of the century, Spinoza and René Descartes (Holland was the latter's second motherland), the brilliant astronomers and physicists Willebrord Snellius, Christian Huygens, and Anton van Leeuwenhoek, the creators of the national literature Pieter Cornelisz Hooft, Joost van den Vondel, Gerbrandt Bredero, Jacob Cats, the composer and organist Jan Pieters Sweelinck. But the most significant achievement of the Golden Age of Dutch history was the establishment of the national school of realist painting.

The bourgeois revolution reoriented the public mind toward the real world, and life as the one source of creative inspiration asserted itself definitively in art. So new, so manifold, and so unusual was the beauty of the living world that no one artist even attempted to encompass it in all its manifestations. On the contrary, it seemed as though

the artists had divided the visible world among themselves: some painted only still lifes, others portraits or landscapes. This specialization penetrated so deeply into the fabric of art that even within a particular genre the artist would choose a strictly limited field. Thus, some still-life artists painted flowers, others depicted fish, still others specialized in "breakfasts" or "trophies of the chase." The landscape group consisted of marinists, animalists and townscapists. In genre painting there were artists who took the peasantry as their theme and others who studied the urban scene. Portraiture was subdivided into the individual, the family, and the increasingly popular group or corporate portrait.

In Dutch art of the seventeenth century, therefore, all those forms of painting that we recognize today had taken shape. These subdivisions allowed for a more comprehensive exploration of the reality of life, but at the same time such strict specialization, prompted in part by competition in the art market (in the bourgeois society pictures became a commodity), limited the painter's outlook and prevented Dutch art from achieving a wider measure of universality.

The artist could no longer look to the church and the feudal lord for commissions, but painted for the open market. This, though, by no means signified that he was a free agent in his creative endeavor. The art market which catered to the needs and tastes of the new customer for works of art, the bourgeoisie, made its own claims on the painter. The tastes of the young and rising class, though sober and democratic, especially in the early stages, were nevertheless limited. Yesterday a member of the oppressed third estate, and today the owner of all material wealth and the bearer of all spiritual values, the bourgeois wanted above all to see a true and accurate depiction of himself.

Such a portraiture came into being in the first third of the seventeenth century. A typical example is *Portrait of a Man* by Thomas de Keyser (the Hermitage, Leningrad), which depicts an Amsterdam merchant. The uncomely, somewhat puffy and windblown face, the awkward, stout figure on which the flaps of the coat do not meet, and the shortish arms show that the artist had no wish to prettify his model. But apart from the outward likeness, De Keyser observed something else—the inner dignity of an independent man pleased with his affairs and with himself.

Such masterly skill in reflecting the human character did not appear in Dutch portraiture overnight. De Keyser's predecessors—Cornelis van der Voort, Nicolaes Elias, Michiel van Mierevelt, Jan Anthonisz van Ravesteyn, Paulus Moreelse—often limited themselves to attaining the desired likeness, were sometimes overzealous in conveying every detail of dress, and tended towards an idealization of their sitters. Nevertheless, their works possessed qualities that paved the way for the triumph of realist portraiture.

The supreme achievement of the early phase of Dutch realism was the oeuvre of one of the seventeenth century's major portraitists, Frans Hals. Hals's works stand out for their penetrating insight into the human character and bold innovation in painterly technique. He shattered the prevailing view of the portrait as an impassive cast of nature, and had no use for traditional devices—a conventional pose and meticulous rendering of accessories. His characters live the hale and hearty lives of a victorious generation.

Hals's magnificent group portraits were the first to be dedicated to men who had come to feel themselves rightful citizens. He captured and recorded in his works the revolutionary spirit of the struggle for national independence, and for this reason his was a truly democratic art.

The master's painterly technique was aimed, as it were, at arresting on canvas the transitory movements of his sitters. His quick, sweeping, and resolute manner, the variety in his application of the brush to the picture surface—now in short, well-defined strokes, now laying on large, spreading areas of paint—signified a breach of existing tradition. Hals brought to painting the artistry and expressiveness of a master to cast off the uninspired monotony of the artisan. His favorite color scheme was silvery-black, and that too was a reaction against the florid and variegated colors of his predecessors. The tonal uniformity of Hals's color scale serves to underline the integrity of his artistic judgment.

Other artists, such as Jan Verspronck, Jan de Bray, Jacob van der Merck, and Thomas de Keyser (mentioned above), embraced these traditions too, partly under the influence of Hals himself. A new and important step forward in the portrait genre would be made in the middle of the century by Rembrandt.

Parallel to the evolution in portraiture there were developments in genre painting, which was strongly influenced in the early seventeenth century by the realistic and democratic art of the Italian painter Michelangelo da Caravaggio. The Dutch followers of Caravaggio—Gerrit van Honthorst, Hendrick Terbrugghen, Dirck van Baburen, Jan van Bijlert, and Jan Gerritsz van Bronckhorst—were active mainly in Utrecht. These masters are well represented in the museums of Leningrad, Moscow, Irkutsk (where Terbrugghen's recently discovered *Christ Crowned with Thorns* is on display), Zhitomir, Saratov, and Lvov. The Caravaggists created a new, distinct type of picture, with large half-figures in the near foreground, a vigorous plasticity in the modeling of forms, light-and-shade effects that heighten the dramatic expressiveness of the action and, above all, with a new, democratic protagonist.

The role of the Utrecht Caravaggists in shaping the realist art of Holland was undoubtedly significant, but the future of the national school did not lie with them. There appeared in Dutch painting a distinctive type of work, characterized by a painstaking execution: the small, "cabinet-size" picture with a narrative subject. It is interesting to note that this type of picture first appeared in genre painting. And though these works hardly ever reflected public affairs, limiting themselves to the depiction of the family, they did give a panoramic view of the customs, morals and ethics of the new bourgeois society. The genre composition was the most democratic form of expression in painting both for its content and the lucidity of its artistic idiom, and was thus available to the broadest strata of the society.

This new type of work originated in Haarlem in the studio of Frans Hals. The actual founder of the trend was Hals's younger brother, Dirck, who depicted jolly, carefree groups in interiors or in parks. Through the works of Willem Duyster, Jacob Duck, Pieter Codde, Jacob van Velsen, and Anthonie Palamedesz the "merry party" genre spread to other art centers—Amsterdam, Delft, and Utrecht.

The workshop of Frans Hals gave birth to yet another trend in genre painting—the portrayal of the life of the peasants and the lower classes in the urban centers. And though the treatment of plain folk in the works of Hals's pupils Adriaen Brouwer and Adriaen van Ostade at first bordered on the grotesque, by the 1640s Van Ostade, his younger brother Isack, Jan Miense Molenaer, and others were depicting peasants with a great degree of affection. The soft, warm chiaroscuro of their works creates an atmosphere of coziness and intimacy.

The Leyden genre painters Gerrit Dou and his pupil Quiringh van Brekelenkam dedicated their endeavor to the life and mores of the minor townsman. Artisans, vendors, students, physicians, housewives—these were the protagonists of their small, meticulously wrought pieces. (Thanks to his brilliant mastery of miniature painting, a favorite art form in the eighteenth century, Dou was even then well represented in the Hermitage.) Their works were held in great regard also for the profundity of their imagery. Dou's canvases (for example, *The Scholar*, *The Astronomer*, *The Fiddler*, all in the Hermitage, Leningrad) and those of Brekelenkam (*The Doctor's Visit*, the Museum of Western European and Oriental Art, Riga) were extremely popular in the city of Leyden.

To develop genre painting the Dutch masters had to solve a number of technical problems, such as rendering sunlight in open-air scenes and in interiors, reproducing all the coloristic wealth of their environment, and conveying the textural properties of objects. They had also to learn how to fathom the thoughts and emotions of their subjects. Only with the solution of these problems did genre painting enter into its prime, and only then did it produce a number of major talents—Gerard Ter Borch, Jan Steen, Jan Vermeer of Delft, Pieter de Hooch, and others. These artists, with the exception of Vermeer, are very well represented in Soviet museums.

Ter Borch was a painter of intimate scenes from the life of Dutch high society. The consummate craftsmanship of this artist, a fine draughtsman and a subtle colorist, lies not only in his virtuoso handling of silk and velvet, glass and metal, fur and wood (in which respect he had no equal), but also in the inimitable way he reveals the inner world of his subjects. *A Glass of Lemonade* (the Hermitage, Leningrad), the master's finest work, has a stock theme—a gentleman entertaining a lady. But has any artist more sensitively rendered the meaningful glances and tender touching of hands, the eloquent ring of unspoken words, and the smoldering desire that we see in this picture? It was Ter Borch who introduced all this into genre painting.

Another artist to enrich the genre was the witty storyteller Jan Steen, who used widely and to good effect a new artistic weapon—laughter. *The Revelers* (the Hermitage, Leningrad), a bubbling, joyful picture with an opulent color scheme in which Steen portrayed himself and his wife Margrit, is permeated with lusty folk humor. In *Marriage Contract* (the Hermitage, Leningrad)—"Urgent Marriage" would have been a more appropriate title—and *The Sick Old Man* (the Pushkin Museum of Fine Arts, Moscow), which caustically ridicules the pretensions of old age, the artist's humor acquires moralizing overtones. Steen's moral reflections, based as they are on plain common sense, are, however, far removed from the ostentatious praise of virtue that we see in, for example, Adriaen van de Velde's *Allegory* (the Pushkin Museum of Fine Arts, Moscow), where Innocence is depicted at the crossroads of life choosing between the virtues (Faith, Hope, and Charity) and the deadly sins (Gluttony, Covetousness, Pride, and Lust).

In the oeuvre of Pieter de Hooch, one of genre painting's outstanding masters, new accents appear. Celebrating the unhurried life-style of the well-to-do and practical bourgeois, the artist gradually encased himself in the narrow world of the home, the yard, and the garden, into which the worries and anxieties of the life outside do not penetrate. Yet the irresistible sincerity and the glowing intimacy of his narrative style and, above all, his masterly skill in expressing the mood and characteristics of the light-and-air medium lend his work an inimitable charm. De Hooch's masterpiece is *A Woman and Her Maid*

17

(the Hermitage, Leningrad). The light of the sun falls gently, like golden pollen, on the serene faces and neat clothes of the women, on the furniture, utensils, flowers, grass, and trees. Both nature and the women are afraid to stir lest they shake off the sweet languor they abide in or dispel the mood of tranquil repose that pervades the scene. These tendencies grow even more pronounced in the works of Gabriel Metsu, Ludolf de Jongh, Frans van Mieris, and, especially, the masters of the end of the century, resulting finally in an outright idealization of the luxury and indolence of high society.

Though Dutch history painting also developed apace, in the seventeenth century it lost its leading position in the hierarchy of genres. At that time the term "history painting" applied to pictures on biblical and mythological subjects, events of ancient and contemporary history, and allegorical themes. The doyen of the Dutch school of history painting was Rembrandt's teacher, Pieter Lastman of Amsterdam. In 1614 he produced his finest work, *Abraham on the Way to Canaan* (the Hermitage, Leningrad). It illustrates the biblical story of Abraham leading his people to the fertile country of Canaan. The long journey is at an end, before them is the promised land, and in the rays of a divine light the travelers stand transfixed in wonder and gratitude. Such is the subject of the picture, but it also has a deeper meaning. The Bible story is here read anew, as it were, and applied to the events of Holland's recent history. The long war of the Dutch for their independence ended in 1609 and victory was achieved at a heavy price. The people longed for rest, and the peace that had come seemed everlasting. These sentiments were voiced by contemporary politicians, poets, and preachers. Holland was likened to the "promised land" and the Dutch were the "chosen people." It was natural, therefore, that Lastman should express his thoughts and feelings in a biblical imagery easily understood.

The artistic idiom of these history pictures also underwent a change. Lastman did away with the pompous manner of his predecessors, insisting that the composition must be forthright and lucid and the portrayal as true to life as possible. He carefully studied nature, attempting to merge the landscape and the figures into an integral whole, took note of expressive gestures, and introduced into the composition an abundance of everyday phenomena and meticulously wrought details. The artist felt that all this would induce the viewer to believe in the reality of the event depicted and project it on the country's recent past. Lastman's works enjoyed great success among his contemporaries.

Lastman is well represented in Soviet museums. Five pictures are in the Hermitage, including the famous *Bathsheba at Her Toilet* copied by Rembrandt; one is in the Pushkin Museum of Fine Arts, Moscow (*The Reconciliation of David and Absalom*); and one canvas from the master's workshop is in Petrodvorets (*Adam and Eve Weeping over Abel*, a copy; the original is in the Rembrandt House in Amsterdam).

Another picture that possibly reminded contemporaries of recent events in their history is *Clelia's Escape from the Camp of Porsenna* (the Hermitage, Leningrad) by Nicolaes (Claes) Moeyaert. This is the story of the legendary Roman women who were taken hostage by Porsenna, King of Etruria, during his siege of Rome but, led by Clelia, succeeded in escaping. The images of the women and their heroic exploit are used by the artist to extol the courage and fortitude of his own countrywomen.

No less successful in the history genre were Jan Pynas of Amsterdam, Léonard Bramer of Delft, Nicolaus Knüpfer of Utrecht, and Pieter de Grebber of Haarlem, as well as such little known masters as Jakob Wabbe, Rombout van Troyen, and Pieter van Bie.

In their best works, history painters roused the patriotic sentiments of the Dutch. However, they all too often limited themselves to the moralizing illustration of biblical stories. But the man who breathed real life into the history genre was Rembrandt. The art of this great genius is the supreme achievement of seventeenth-century Dutch painting. Democratic and humane, permeated with an impassioned faith in the triumph of truth, it embodied the life-asserting ideals of the age. Rembrandt developed a painterly idiom characterized by a subtle chiaroscuro technique, a saturated and emotion-charged color scheme, and an expressive brushstroke. The spiritual life of man now became an object of study not only for the scholar and the writer but for the painter too, and what the painter achieved far surpassed what had been accomplished by his contemporaries in related arts and in science. Rembrandt the portraitist founded the singular genre of the "biography portrait" in which the life and inner world of man were revealed in all their complexity and contradictions. In his history pictures he converted the legends of antiquity and the Bible into tales of real earthly feelings and relationships that were inspired by a deeply humanistic approach.

Rembrandt's oeuvre marks the culmination of his predecessors' searchings and at the same time reaches beyond the temporal and national boundaries of art. The artist's ability to fathom the very core of things and events and the innermost recesses of the human psyche impresses the modern viewer as forcefully as it did his contemporaries: thus, Rembrandt's art is relevant to us even today.

The Hermitage collection of Rembrandts, unrivaled for its quality and scope (as many as twenty-five pictures), and complemented by six works in Moscow museums, is brilliantly representative of his entire creative biography, from the artist's first works—the small painting *Christ Driving the Money Changers from the Temple* (1626)—to the monumental canvas *The Return of the Prodigal Son* (1660s).

About ten works date from the 1630s, a period of prodigious success and renown for the artist. These include costume portraits; scenes from the Old and New Testaments; *Portrait of a Scholar*, probably his first commissioned portrait; *Flora*, one of the young master's most enchanting canvases, where in the guise of the Roman goddess of spring and flowers he depicted his dearly beloved wife Saskia; *Abraham's Sacrifice* (1635), the most theatrical and baroque of his works; *The Parable of the Laborers in the Vineyard* (1637), modest but charged with deep social overtones. These works alone are sufficient to indicate the scope and variety of Rembrandt's interests.

The Hermitage has six canvases from the master's output of the next decade, two of which deserve special mention—*David's Farewell to Jonathan*, which ranks among the finest achievements of Rembrandt the colorist, and *The Holy Family*, the very embodiment of the happiness of family life.

A landmark in the artist's creative evolution is *Danaë*. Executed in 1636 and repainted a decade later (as recent research has revealed), this picture shows the emergence of the psychological insight for which Rembrandt is famous. In the first version of the picture he merely illustrated the ancient myth, whereas in the second, final version it is the woman's inner being that is his prime concern.

The 1650s are represented by several portraits that mark a deepening of the psychological principle in Rembrandt's art, and by two other compositions, one genre (*Young Woman with Earrings*) and one religious (*Christ and the Woman of Samaria*).

Works in Soviet collections dating from the last decade of Rembrandt's life begin with the poetic *Ahasuerus, Haman, and Esther*, a canvas of fairy-tale beauty which in many respects is indicative of his other works of this type. There is no action here, just as there is none in *The Return of the Prodigal Son* and *David and Uriah*. What we see is a dramatic collision, or reconciliation, of men's inner worlds, of human destinies.

In the years of his renown Rembrandt was surrounded by pupils. There were real talents among them, drawn to the master by his innovatory genius, but pursuers of cheap success were there too, because it was the fashion. The creative biographies of both groups closely followed the overall development of Dutch art in the seventeenth century, which, with the degeneration of bourgeois society, tended toward a greater degree of idealization. Such a path was taken by Jacob Adriaensz Backer, Ferdinand Bol, Gerbrand van den Eeckhout, and Jan Victors. Even so talented a master as Nicolaes Maes underwent the same metamorphosis. His early work, *The Mocking of Christ* (the Hermitage, Leningrad), continued in the tradition of Rembrandt, but in his late period Maes changed beyond recognition. His *Portrait of a Young Lady* (the Hermitage, Leningrad), for all the brilliance of execution and sharpness of character study, clearly leans toward showy aristocratic portraiture.

Only Aert de Gelder remained loyal to the principles of Rembrandt's art, which he upheld to the end of his creative career in the middle of the eighteenth century. Gelder's *Lot and His Daughters* (the Pushkin Museum of Fine Arts, Moscow), which conveys subtle nuances of mood and is noteworthy for the depth of its psychological characterizations, and his inspired *Self-portrait* (the Hermitage, Leningrad), where the artist showed himself holding an etching by his great teacher, are perhaps the finest works of Rembrandt's school.

The landscape genre underwent the same striking evolution as the history picture. The natural scenery of their native land had long attracted the attention of Dutch painters. The Dutch landscape is to a large extent the result of deliberate human effort which in the course of many generations transformed the seabed into fertile polders. An alien eye would hardly appreciate its unassuming beauty; one has to be a Dutchman and love the country like a Dutchman to find a lyrical charm in the low horizons, the monotonous sand dunes with their sparse vegetation, and the enormous cupola of the sky overhead.

Hendrick Avercamp and Adriaen van de Velde were the first artists to discover the aesthetic merits of their native countryside. Showing simple views of dunes or the broad mirror of a frozen river enlivened by a crowd of carefree skaters, their canvases delight the eye with their fresh perception of nature and sincerity of feeling. But it is Jan van Goyen and Salomon van Ruysdael who must be accredited with the creation of a truly Dutch landscape genre in which nature is used to express the moods and feelings of the people who were bending it to their will.

The enormous interest in the sea and in fishermen, inherent in the brave seafarers that are the Dutch, gave birth to a new form of landscape painting—the marine. The pictures of Jan Porcellis, a prominent marine painter of the first half of the seventeenth century, and his pupil Simon de Vlieger demonstrate the level of perfection achieved by marinists in their handling of the humid, sun-pervaded sea air, the wind-driven clouds, the wavy surface of the water, and the shores and villages dissolving in the silvery distance. Concurrently with Goyen and Ruysdael, the marine painters of Holland evolved new

techniques of tonal coloring and aerial perspective, and these helped them to create the impression of a unified light-and-air environment.

In the 1640s one can see a deepening in the emotional content of the landscape genre. Mere recording of the states of nature led at first to the creation of pictures that were somewhat superficial, though not without a certain lyrical charm. One thinks here of the landscapes of Aert van der Neer, with their magnificent sunsets, melancholic moonlit nights, and gentle, silvery winter days. However, Isack van Ostade, a gifted landscape and genre painter who died at an early age, was the first to use chiaroscuro to convey a more delicate and subtle mood. *Winter Scene* (the Hermitage, Leningrad), his masterpiece, portrays with striking finesse the illumination of a short winter day as twilight falls. The atmosphere of dying day imbues the landscape with an especially sad mood. Nature as seen through the eyes of common folk seems to echo their emotions.

The realist trend in the Dutch landscape reached maturity in the works of Jacob van Ruisdael. No artist before him achieved so majestic and at the same time so compassionate a portrayal of nature. Even his admirable early pieces, *The House in the Grove* (1646, the Hermitage, Leningrad) and *Peasant Houses in the Dunes* (1647, the Hermitage, Leningrad) are marked by a deep insight into the soul of nature that his predecessors did not possess. In *The Marsh* (c. 1660), one of the gems of the Hermitage collection, Ruisdael builds a synthetic image of nature that is at once a powerful artistic generalization and a profound philosophical study. The struggle of light and darkness, the contrast between the clear blue of the sky and the faded ocherous tones of the autumn foliage, the counterposing of the young, vulnerable shoots to the rotting or storm-felled trees and the tranquility of the mirror-smooth waters to the jerky swaying of the branches—all reveal the very essence of nature's being: its perennial transformation, dying, and renewal.

In contrast to Ruisdael's philosophical and at times melancholy-tinged pictures, the works of Paulus Potter are filled with a sense of immediacy and exuberance. In the best of these, *The Farm* (the Hermitage, Leningrad), the artist displays a sincere, almost childlike admiration for nature and animal life. In the depiction of animals he had no rival; in fact, it was Potter who established animal painting as an independent genre. In the work of another animalist and landscapist, Philips Wouwerman, appear new tendencies that are more characteristic of the art of Holland in the second half of the seventeenth century. His canvas *The Outskirts of Haarlem* (the Hermitage, Leningrad), with its blue vistas and silvery sand dunes, demonstrates his striving for a more picturesque composition and a richer palette. This brings Wouwerman closer to the so-called Italianate movement in Dutch painting.

This movement played a complex and contradictory role in Dutch art, which to this day is not fully appreciated. The fact that it often stood opposed, in its creative aspirations, to the national school of realist painting should not, in our view, overshadow its undeniable merits. The Dutchmen who worked in Italy created an image of the Italian landscape that was more realistic and alive than that of their Italian or French contemporaries. Widely circulated outside Holland, the works of the Italianists brought the progressive aesthetic principles of Dutch realism to Western European art. Furthermore, there is no denying their achievements in working out the problem of sunlight in the landscape. All in all, the Italianists introduced a buoyant, optimistic note into the Dutch genre and landscape painting of the time.

21

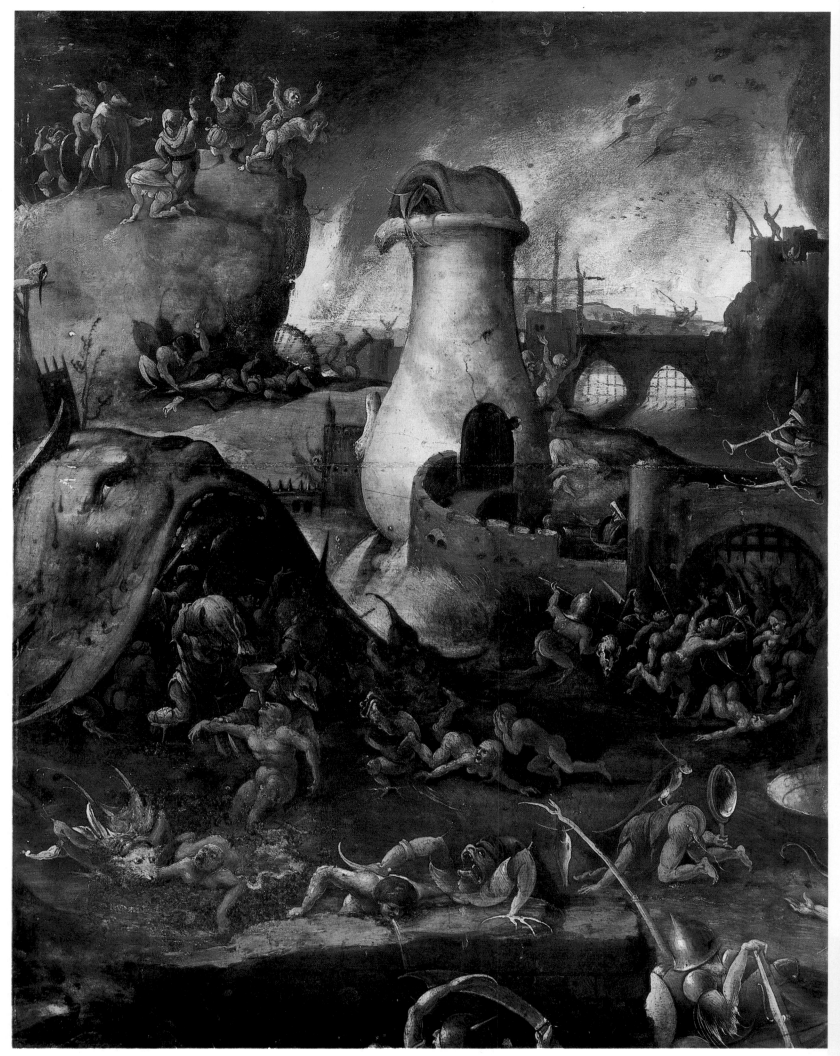

HIERONYMUS BOSCH (SCHOOL OF)

Properly Hieronymus van Acken who sometimes
signed his works "Bosch" because he was a native of
's-Hertogenbosch. Born between 1450 and 1460, he
died in 1516 in the town of his birth. Worked mainly in
's-Hertogenbosch as a painter and draughtsman.
Painted pictures on biblical themes in which genre and
landscape motifs and folklore personages play
a prominent role. Had many followers, among them
Pieter Brueghel the Elder, and exercised a significant
influence on the evolution of Netherlandish art in the
sixteenth century.

2

Hell

Oil on panel, 13 5/8×15 1/4" (34.7×38.5 cm.)
The Hermitage, Leningrad. Inv. No. 8491

Depictions of hell often occur in the works of Bosch and his
followers. The Hermitage picture is a fragment, or rather the top
left part, of a composition which must have been the right leaf,
where Bosch usually placed his hell, of a diptych. The picture was
executed by one of the painter's followers in the first decades
of the sixteenth century.
The paint layer in the lower left of the picture is badly damaged.

PROVENANCE

December 18, 1948 — The Hermitage, Leningrad (purchased from T. Ivanov)

REFERENCES

* *Catalogue. The Hermitage* 1958, 2, p. 10; * Nikulin 1972, No. 9.

7

LUCAS VAN LEYDEN

Lucas (Lucas Hughensz Jacobsz) was born in 1489 or 1494
in Leyden and died there in 1533. He was a pupil of Hughe
Jacobsz (his father) and Cornelis Engelbrechtsen (about 1508).
In 1521 he settled in Antwerp. Around 1527 he visited
Middelburg and the South Netherlands. He was influenced by
Albrecht Dürer, Jan Gossaert, Jan van Scorel, Bernard van
Orley, and Marcantonio Raimondi. He was a painter, engraver,
draughtsman, and glass painter. Most of his works are religious
pictures and portraits.

← 6–9

The Healing of the Blind Man of Jericho
(triptych)

Oil on canvas (transferred from a panel). Central panel, 45 ⅝×59 ⅜"
(115.5×150.5 cm.); the wings with depictions of heralds,
35×12 ⅞" (89×32.5 cm.)
Signed with monogram, bottom, along the middle of the triptych's central panel
The Hermitage, Leningrad. Inv. No. 407

The subject is taken from the Bible (St. Luke XVIII: 35–43).
Originally the scene of the Healing of the Blind Man was painted on the
central panel and the obverse of the wings. The heralds with the
coats-of-arms of the artist's clients were depicted on the reverse of the wings.
These particulars are from a 1604 description of the triptych by Karel
van Mander. In the Crozat Collection in 1755, judging from a drawing made
by Gabriel de Saint-Aubin on a copy of the collection's catalogue, the
triptych already had its present-day look: the wings were sawn apart to
separate the painted surfaces of the obverse and the reverse. The parts which
referred to the main subject were joined to the central panel. The pictures of
the heralds constitute independent paintings, though they are now shown in
conjunction with the scene of the healing. The tops of the wings are missing,
the central part has quadrilateral extensions affixed to its top.
The man in the red hat depicted in the background to the left of Christ is, in
the opinion of Nikulin, a self-portrait.
Portrayed in the composition are the coats-of-arms of the persons who
commissioned the altarpiece—Jacob Florisz van Monfort of Leyden and his
wife Dirkgen van Lindenburch, the daughter of Amsterdam burgher Dirck
Boelens. Beets believes the triptych was intended for the Leyden hospital.
According to Karel van Mander's description of the triptych the date 1531
was inscribed on the reverse of its wings.
There is a free version of the Hermitage triptych by Jan van Scorel or one of
his followers in the Suermondt Museum, Aachen. The wings of that triptych
are not joined to the central part.

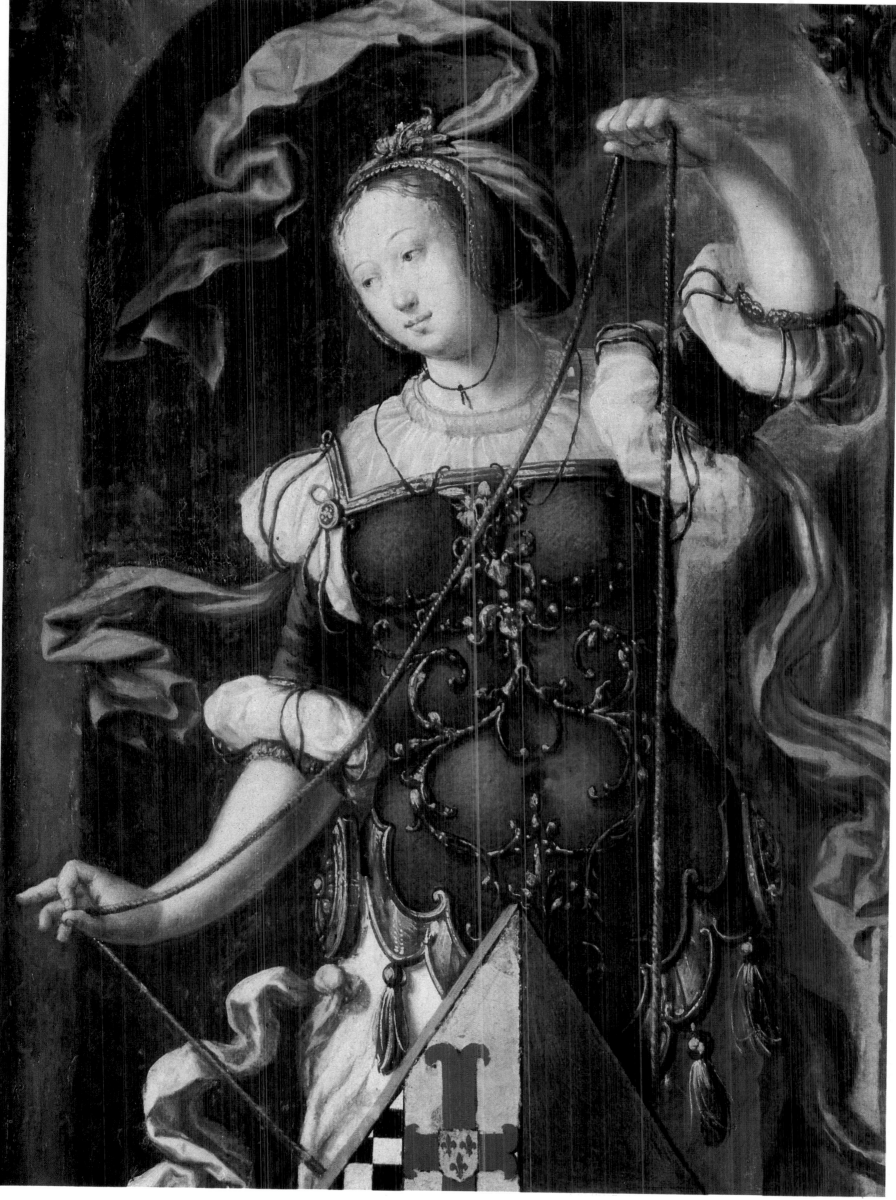

9

11

11

The Virgin and Child

Oil on canvas, 26×17 ¼" (66×44 cm.), top corners rounded
Picture Gallery, Tambov. Inv. No. 13

Painted around 1530. Attributed to Jan van Scorel by Yury Kuznetsov.
At one time was ascribed to an unknown Italian artist of the
sixteenth century.
The picture is the left wing of a diptych whose right wing is possibly
Jan van Scorel's *Portrait of a Man* (Gemäldegalerie, Berlin-Dahlem).
The model for the Virgin was the artist's mistress Agatha van Schconhoven.
An old copy of the Hermitage picture was put up for sale in London
(March 20, 1959, No. 61).

PROVENANCE

1846	The Saltmarshe Gallery, England
Until 1919	The Stroganov Collection, Znamenka estate near Tambov
1919	Museum of Local Lore, Tambov
Early 1960s	Picture Gallery, Tambov

REFERENCES

* Kuznetsov 1958, pp. 65–73; * Kuznetsov. *Van Scorel* 1959, pp. 26–30; Irene Geismeier, "Selbstbildnisse Jan van Scorels?," *Kunstmuseen der Deutschen Demokratischen Republik. Mitteilungen und Berichte*, III, 1961, pp. 64–65; * Kuznetsov 1967, No. 14; Juri Kuznetsov, *Capolaviri fiamminghi e olandesi. I disegni dei maestri a cura di Walter Viztum*, Milan, 1970, pl. 5.

18

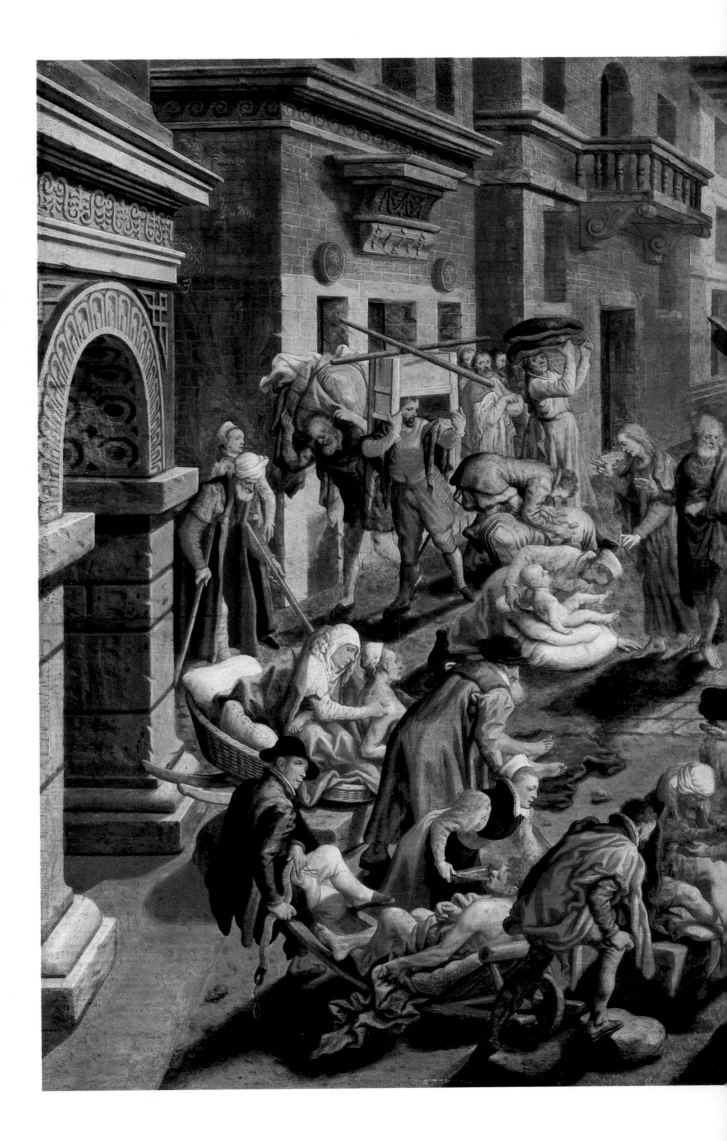

19

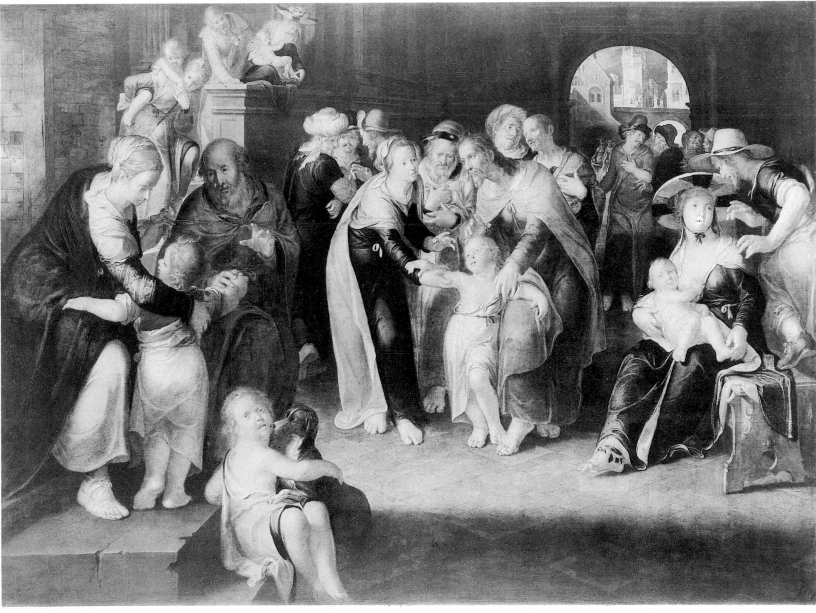

25

JOACHIM ANTONISZ WTEWAEL (UTEWAEL)

Born 1566 in Utrecht, died there in 1638. Studied under Antonis Wtewael (his father) and Joos de Beer. Spent four years in France and Italy. Worked in Utrecht (from 1592). Painted biblical, mythological, and genre subjects, also portraits.

25

Christ Blessing Children

Oil on panel, 33 3/4×45 1/8" (86×114.5 cm.)
Signed and dated, bottom: Jo. Wtewael fecit 1621
The Hermitage, Leningrad. Inv. No. 709

This composition is a typical example of Wtewael's painterly manner in his late period, characterized by sharp light-and-shade contrasts. A sketch for the picture is in the Detroit Institute of Arts (inv. No. 59.4).

PROVENANCE

Until 1891 The A. Kaufmann Collection, St. Petersburg
1891 The Imperial Hermitage, St. Petersburg

REFERENCES

* *Catalogues. The Hermitage* 1893–1916, No. 1796; C. M. A. A. Lindeman, *Joachim Antonisz Wtewael*, Utrecht, 1929, pp. 64, 12, 243, No. 14; * *Catalogue. The Hermitage* 1958, 2, p. 286; *Dutch Mannerism. Apogee and Epilogue. Vassar College Art Gallery*, New York, 1970, No. 105, pl. 60.

HENDRICK GOLTZIUS

Born 1558 in Mühlbrecht (Flanders), died 1617 in Haarlem. Pupil of the engraver Dirck Volkertsz Cornhert. Worked in Antwerp and Haarlem (from 1579). Lived in Rome (1590–92). Best known as an engraver and draughtsman. Painted pictures on biblical themes.

26 →

Adam and Eve

Oil on panel, 90 1/4×52 3/4" (203.5×134 cm.)
Signed with monogram and dated, bottom left: H. G. 1608
The Hermitage, Leningrad. Inv. No. 702

Companion picture to *The Baptism* (*see* plate 27).

PROVENANCE		REFERENCES
Until 1764	The Johann Ernest Gotzkow-sky Collection, Berlin	* *Catalogues. The Hermitage* 1863–1916, No. 495; D. Hirschmann, *Hendrick Goltzius als Maler*, The Hague, 1916, p. 15; * *Catalogue. The Hermitage* 1958, 2, p. 184.
1764	The Imperial Hermitage, St. Petersburg	

27 →

The Baptism

Oil on panel, 90 1/4×52 1/4" (203.5×132.5 cm.)
Signed with monogram and dated on stone, bottom left: HGL 1608
The Hermitage, Leningrad. Inv. No. 701

Companion picture to *Adam and Eve* (*see* plate 26).

PROVENANCE		REFERENCES
Until 1764	The Johann Ernest Gotzkow-sky Collection, Berlin	* *Catalogues. The Hermitage* 1863–1916, No. 496; D. Hirschmann, *Hendrick Goltzius als Maler*, The Hague, 1916, p. 15; * *Catalogue. The Hermitage* 1958, 2, p. 184.
1764	The Imperial Hermitage, St. Petersburg	

CORNELIS CORNELISZ VAN HAARLEM

Born 1562 in Haarlem, died there in 1638. Studied under Pieter Pietersz in Haarlem and Gillis Congnet in Antwerp. Was in France (1579). Worked in Haarlem. Painted biblical, mythological, and genre subjects, also portraits.

28 →

Bacchus

Oil on canvas, 43 3/8×34 7/8" (110×88.5 cm.)
Signed with monogram and dated on stone, bottom left: CH 1618
The Hermitage, Leningrad. Inv. No. 5589

PROVENANCE		REFERENCES
Until 1925	The P. Stepanov Collection, Leningrad	* *Catalogue. The Hermitage* 1958, 2, p. 209.
1925	The Hermitage, Leningrad	

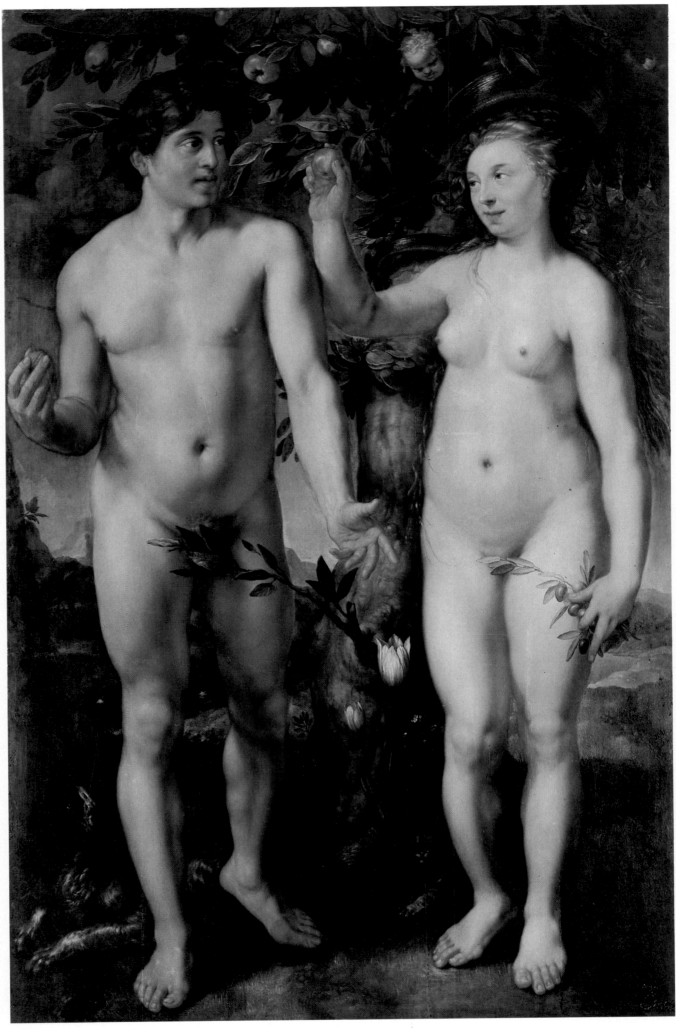

26

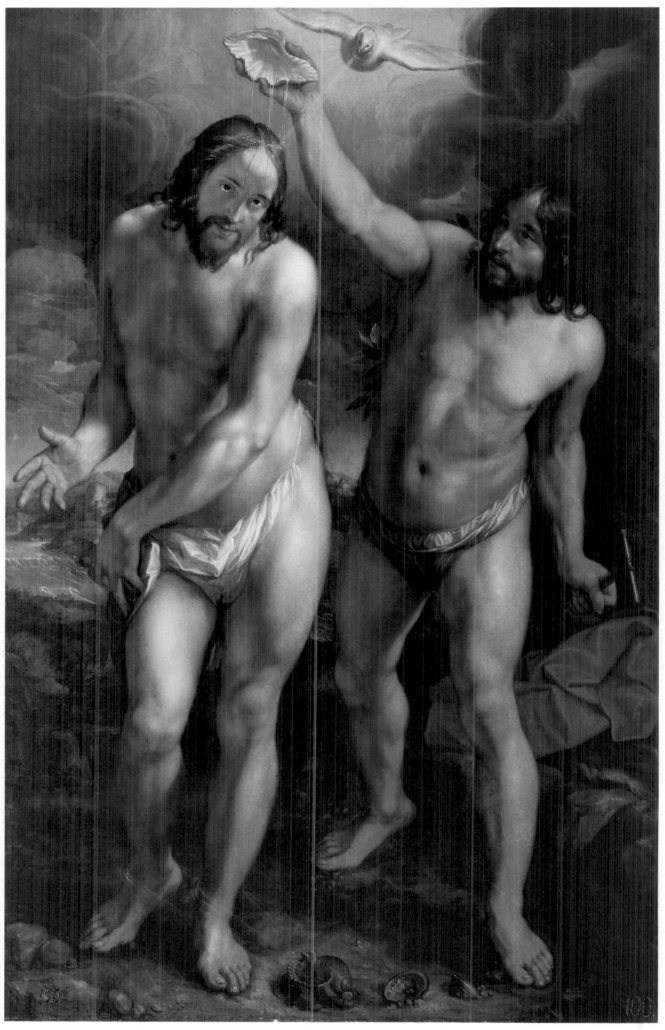

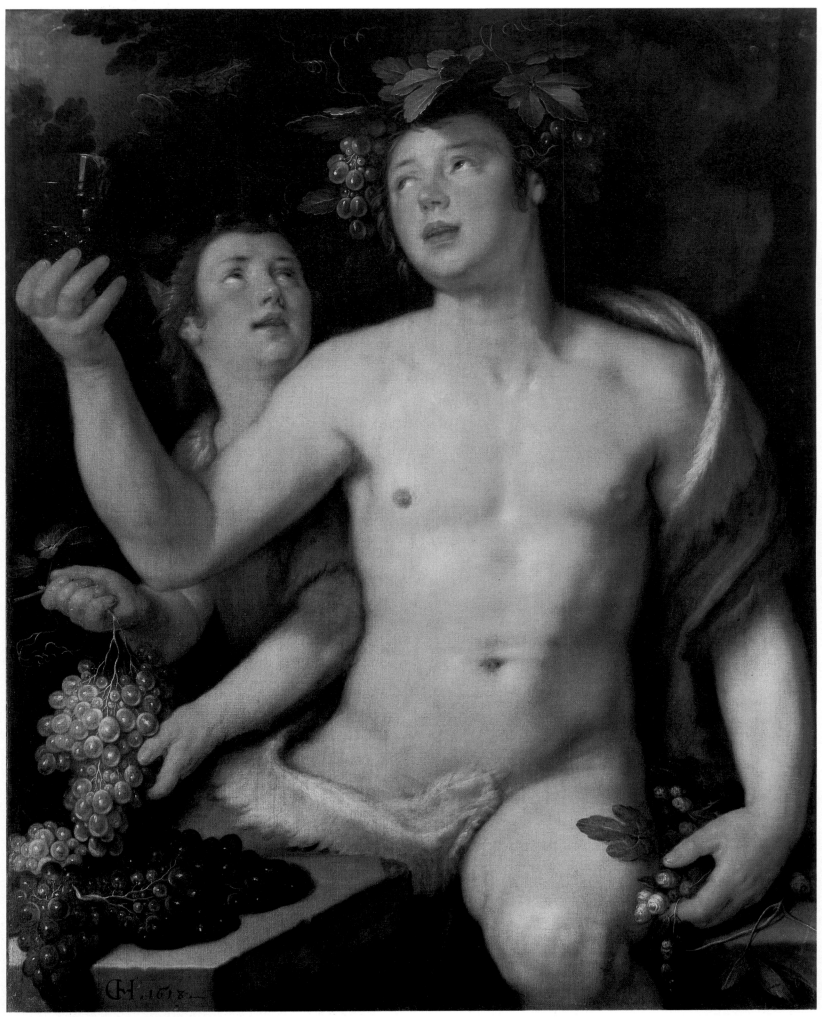

28

17th Century

PAULUS MOREELSE

Born 1571 in Utrecht, died there in 1638. Studied under
Michiel van Mierevelt in Delft. Visited Italy (before 1604).
Worked in Utrecht. Painted portraits as well as pictures on
mythological subjects.

29

Portrait of a Young Woman and a Child (as Venus and Cupid)

Oil on panel, 28 1/4×23" (71.5×58.5 cm.)
Signed and dated, top right: P. Moreelse fe. 1630
The Hermitage, Leningrad. Inv. No. 870

The woman depicted was formerly identified as Marie
de Rohan-Montbazon, Duchess of Chevreuse (1600–1679), on the basis of
the portrait's comparison with an engraving by James Stow produced in 1798.
However, the subjects of the Hermitage portrait and the engraving do not in
the least resemble Marie de Rohan-Montbazon.
A replica of the picture was in the Helbing sale, Munich, as a work of the
Rubens school (November, 1911, No. 58, oil on panel, 29 1/2×24 3/4"
or 75×63 cm.)

PROVENANCE

Until 1769 The Heinrich Brühl Collection,
Dresden
1769 The Imperial Hermitage,
St. Petersburg

REFERENCES

* *Catalogues. The Hermitage* 1863–1916, No.
744; C. H. de Jonge, *Paulus Moreelse. Portret-
en genreschilder te Utrecht 1571–1638*, Assen,
1938, pp. 39–40, 121, No. 278; * *Catalogue.
The Hermitage* 1958, 2, p. 224.

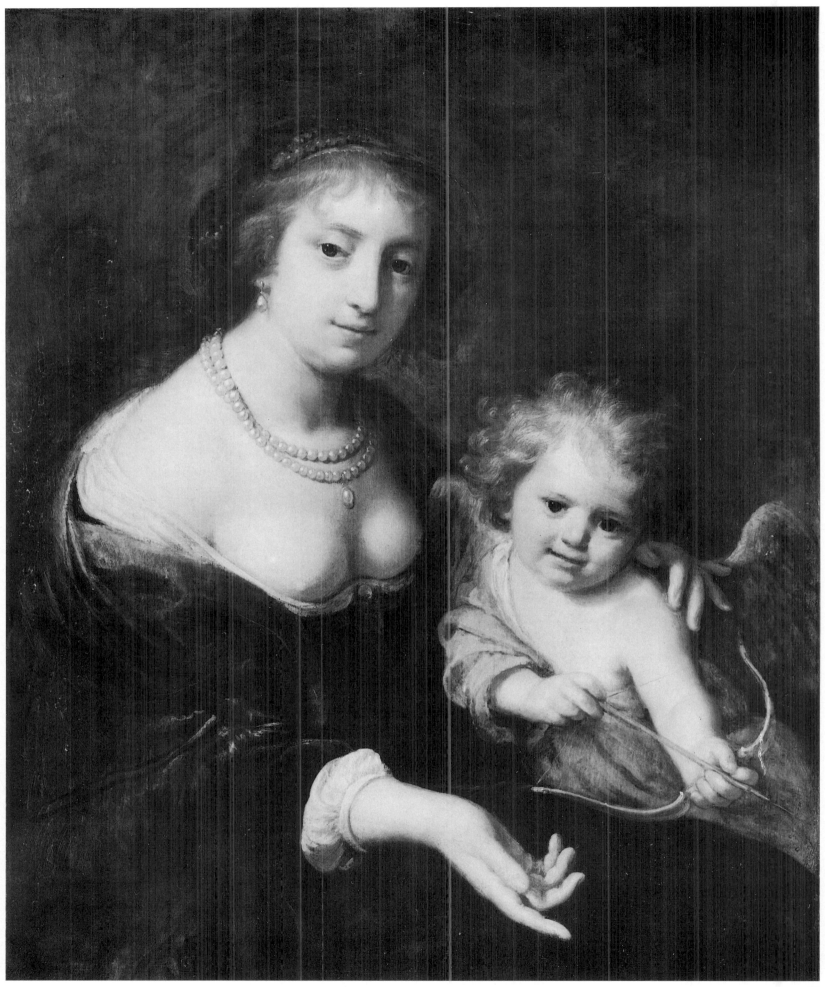

29

CORNELIS VAN DER VOORT

Born about 1576 in Antwerp, died 1624 in Amsterdam. Probably
studied under Cornelis Ketel. Worked in Amsterdam
as a portraitist.

30

Portrait of Johannes van Geel

Oil on canvas, 45 5/8×34 5/8" (116×88 cm.)
Art Museum, Ulyanovsk. Inv. No. 81

The identity of the person portrayed—Johannes van Geel de
Spaendreck—was established from an old inscription on the obverse of the
canvas. Companion picture to *Portrait of Daniel van Geel*, also housed in the
Ulyanovsk Art Museum (inv. No. 80).

PROVENANCE

The S. Abamelek-Lazarev Collection,
St. Petersburg Institute of Russian Lit-
erature of the USSR Academy of Sci-
ences (the Pushkin House), Leningrad
1929 Art Museum, Ulyanovsk

REFERENCES

* *Catalogue. Ulyanovsk* 1957, p. 91; * Kuzne-
tsov 1959, No. 15; * Kuznetsov 1967, No. 29.

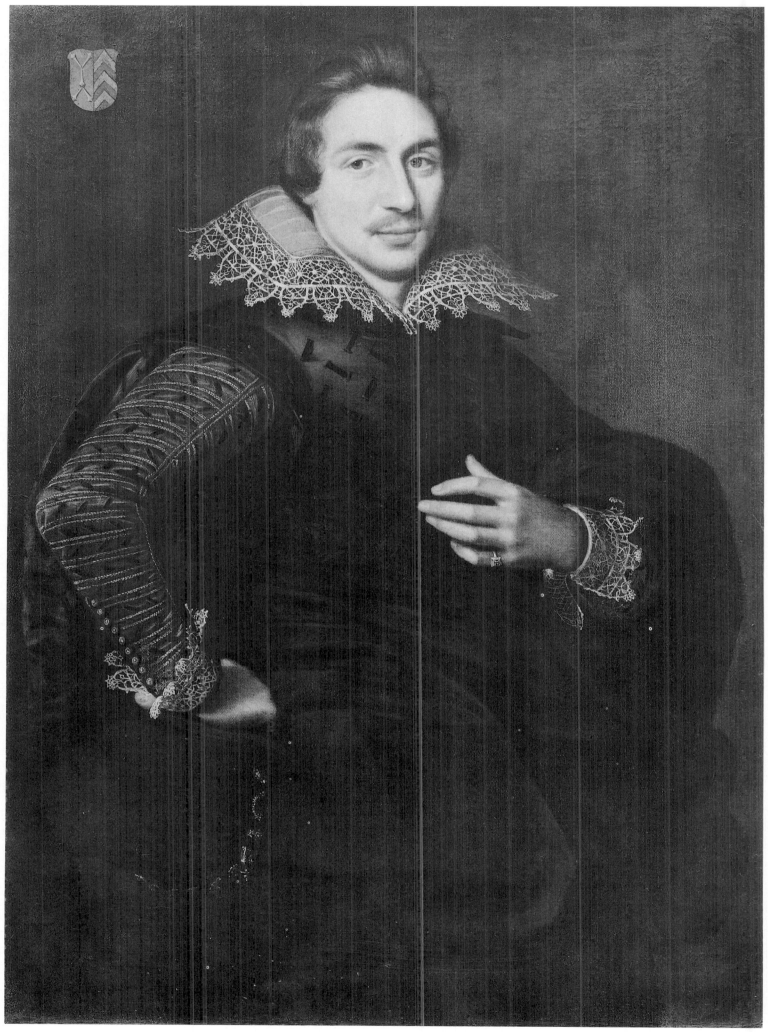

30

HENDRICK BLOEMAERT

Born about 1601 in Utrecht, died there in 1672. Pupil
of Abraham Bloemaert (his father). Was in Italy (beginning of
1627). Worked in Utrecht (from 1630). Was a poet and painter.
Painted mostly portraits and pictures on biblical, mythological,
and genre themes.

31

Portrait of a Man

Oil on panel, 22×18 $^{1}/_{8}$" (56×46 cm.)
Signed, dated, and inscribed, top left: Hen. Bloemaert Aetatis 50 A 1643
The Hermitage, Leningrad. Inv. No. 1815

PROVENANCE		REFERENCES
Until 1769	The Heinrich Brühl Collection, Dresden	*Catalogues. The Hermitage* 1863–1916, No. 790; *Catalogue. The Hermitage* 1958, 2, p. 140.
1769	The Imperial Hermitage, St. Petersburg	

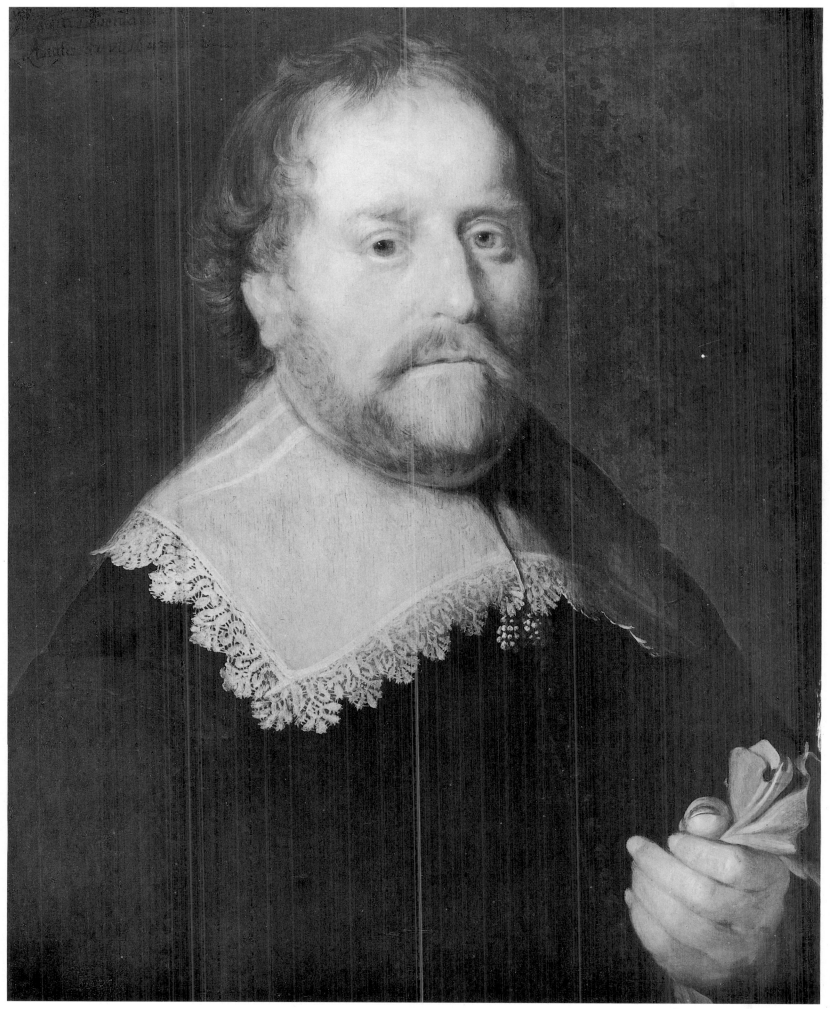

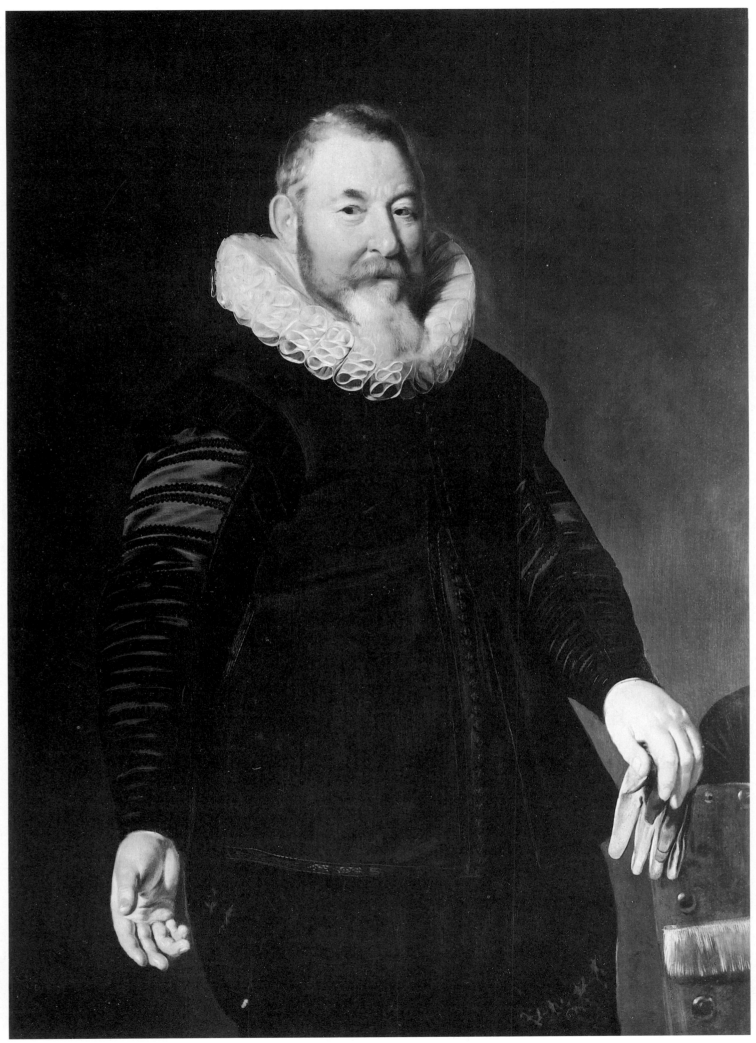

32

THOMAS DE KEYSER

Born 1596/97 in Amsterdam, died there in 1667. Pupil of the architect Hendrik de Keyser (his father). His art matured under the influence of the Amsterdam portraitists Cornelis van der Voort and Nicolaes Eliasz Pickenoy. Was a portraitist and architect. Painted a few pictures on biblical themes.

32

Portrait of a Man

Oil on panel, 48×35 3/8" (122×90 cm.)
Signed with monogram, dated and inscribed, top left.
TDK anno 1632 aetatis suae 66
The Hermitage, Leningrad. Inv. No. 868

The identity of the man depicted (sixty-six years old according to the inscription) is unknown. Most likely he is an Amsterdam trader.

PROVENANCE		REFERENCES
Between 1763 and 1774	The Imperial Hermitage, St. Petersburg	* *Catalogues. The Hermitage* 1863–1916, No. 788; R. Oldenbourg, *Thomas de Keysers Tätigkeit als Maler*, Leipzig, 1911, No. 133; * *Catalogue. The Hermitage* 1958, 2, p. 201.

JACOB FRANSZ VAN DER MERCK

Born around 1610 in 's Gravendeal, died 1664 in Leyden. Worked in Delft, Dordrecht, The Hague, and Leyden (from 1658). Painted portraits and still lifes.

33 →

Portrait of a Young Man

Oil on panel, 29 3/8×19 3/4" (74.5×50 cm.)
Signed and dated, top right corner: Ae 25 J. V. Merck f. 1648
The Hermitage, Leningrad. Inv. No. 3317

PROVENANCE		REFERENCES
Until 1915	The P. Semionov-Tien-Shansky Collection, Petrograd	Semenov. *Etudes* 1906, No. 329 bis; * *Catalogue. The Hermitage* 1958, 2, p. 218.
1915	The Imperial Hermitage, Petrograd	

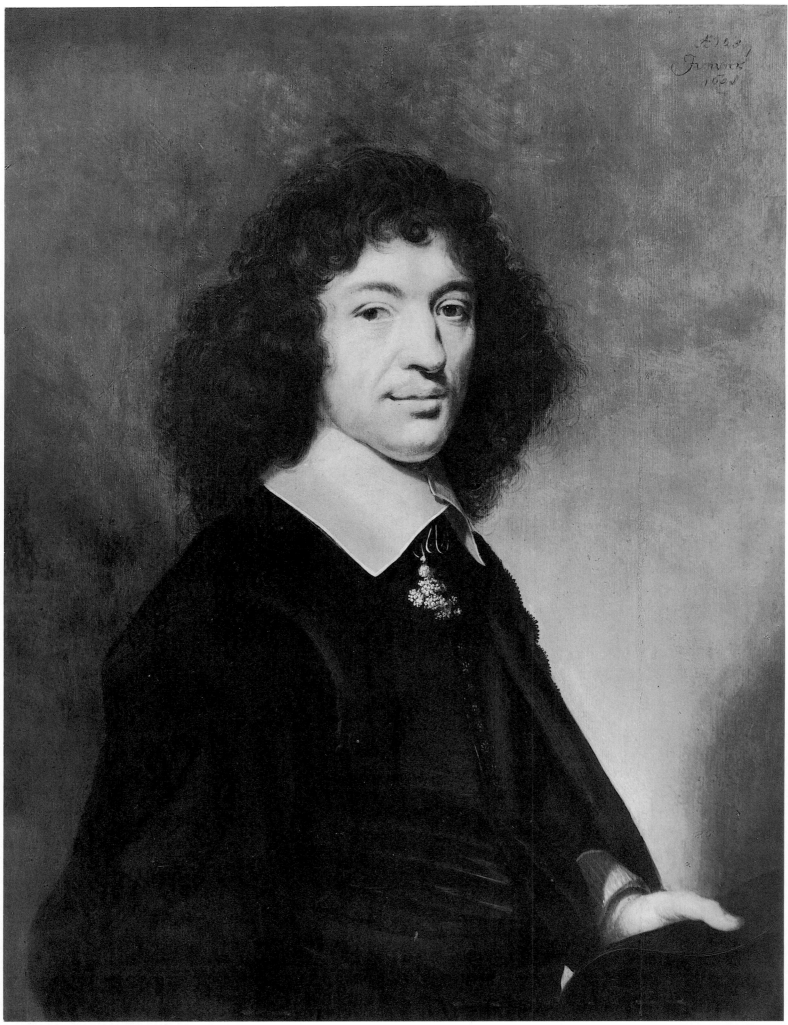

33

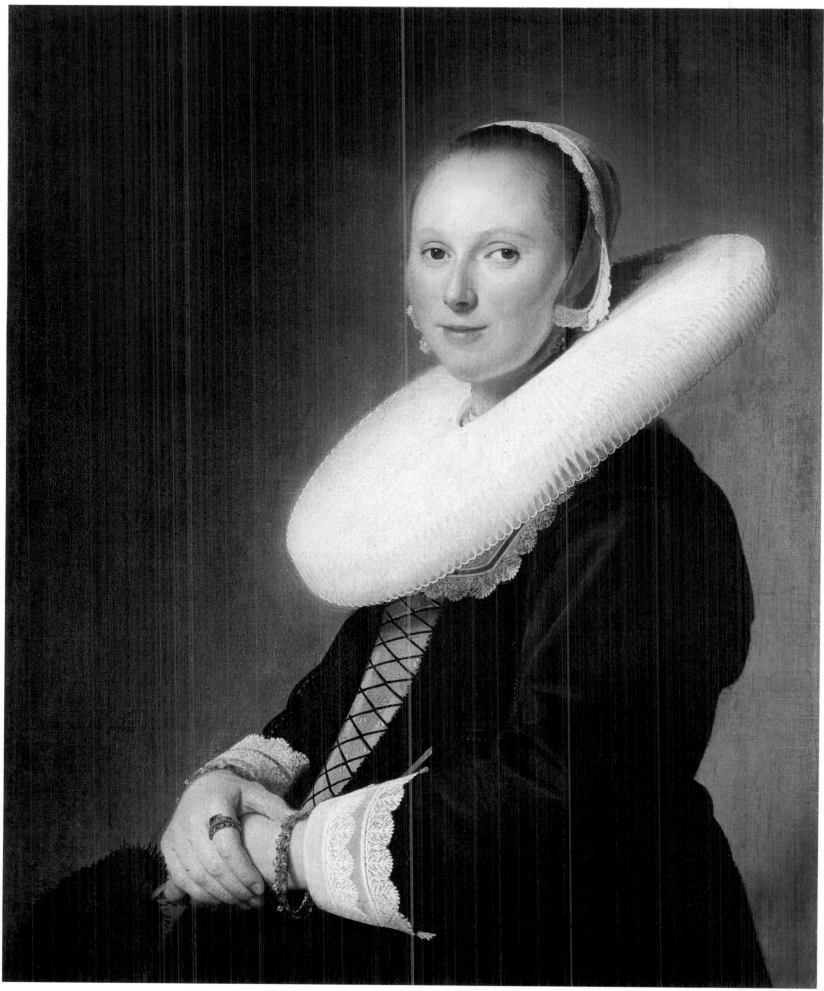

JAN VERSPRONCK

Born 1597 in Haarlem, died there in 1662. Studied under
Cornelis Verspronck (his father) and Frans Hals. Worked
in Haarlem. Painted portraits.

← 34

Portrait of a Young Woman

Oil on canvas, 31 1/2×26" (80×65.9 cm.)
Signed and dated, left: J. Verspronck 1644
The Hermitage, Leningrad. Inv. No. 1002

Companion picture to *Portrait of a Man*, also housed in the Hermitage
(inv. No. 2759).

PROVENANCE		REFERENCES
Until 1859	The Imperial Hermitage, St. Petersburg	*Catalogue. The Old Years* 1908, No. 247; *Wrangel 1908, p. 677; * Shchavinsky 1916, p. 90; * Catalogue. The Hermitage* 1958, 2, p. 155.
Until 1920	Palace, Gatchina	
1920	The Hermitage, Petrograd	

GOVAERT TENNISZ FLINCK

Born 1615 in Cleves, died 1660 in Amsterdam. Studied under
Lambert Jacobsz and Rembrandt (1631–35). Worked
in Amsterdam. Painted pictures on biblical, mythological,
and historical themes, also portraits.

35

Portrait of Cornelia Haring

Oil on canvas, 27 1/8×23 5/8" (69×60 cm.)
Signed and dated, bottom right: G. Flinck f. 1645
The Hermitage, Leningrad. Inv. No. 6835

The identification of the sitter was made by J. W. von Moltke by comparing
the picture with an eighteenth-century copy known from the album of de
Moor (the Rijksbureau voor Kunsthistorische Documentatie at The Hague,
No. 21). Another copy exists that is ascribed to Jan Jansz de Stomme
(a photograph of which is in the archives of the Netherlands Institute of Art
History in The Hague).

PROVENANCE		REFERENCES
Until 1933	The Stroganov Palace Museum, Leningrad	*Catalogue. Rembrandt* 1956, p. 105; * Catalogue. The Hermitage* 1958, 2, p. 285; J. W. von Moltke, *Govaert Flinck*, Amsterdam, 1965, No. 423.
1933	The Hermitage, Leningrad	

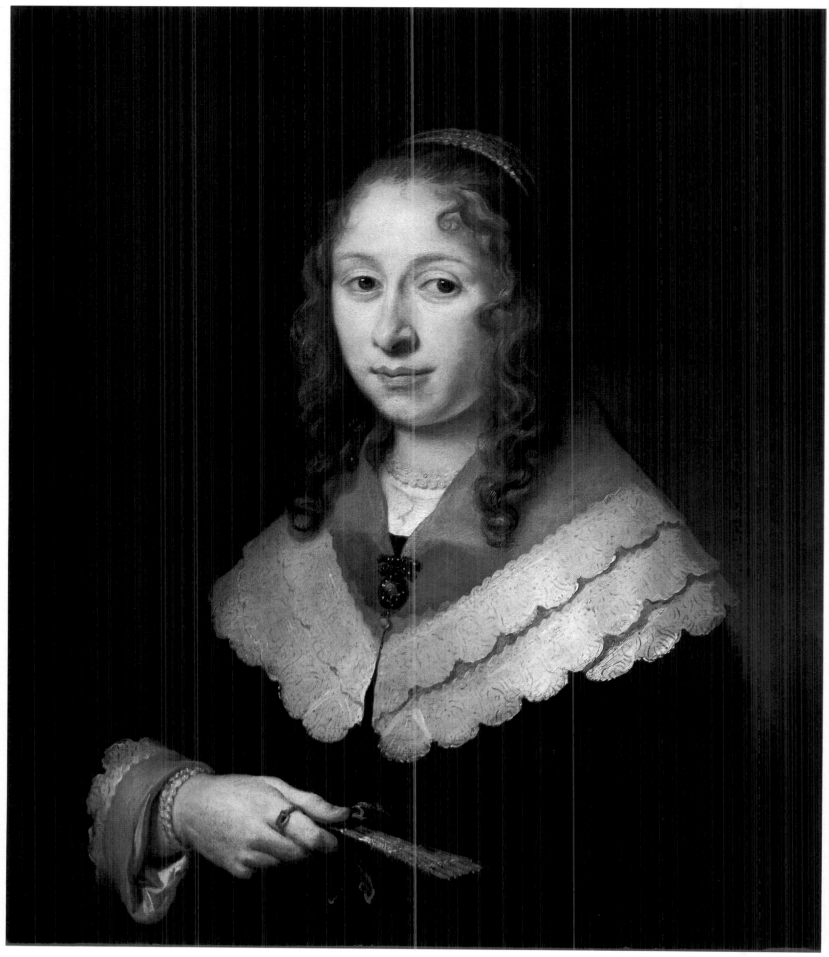

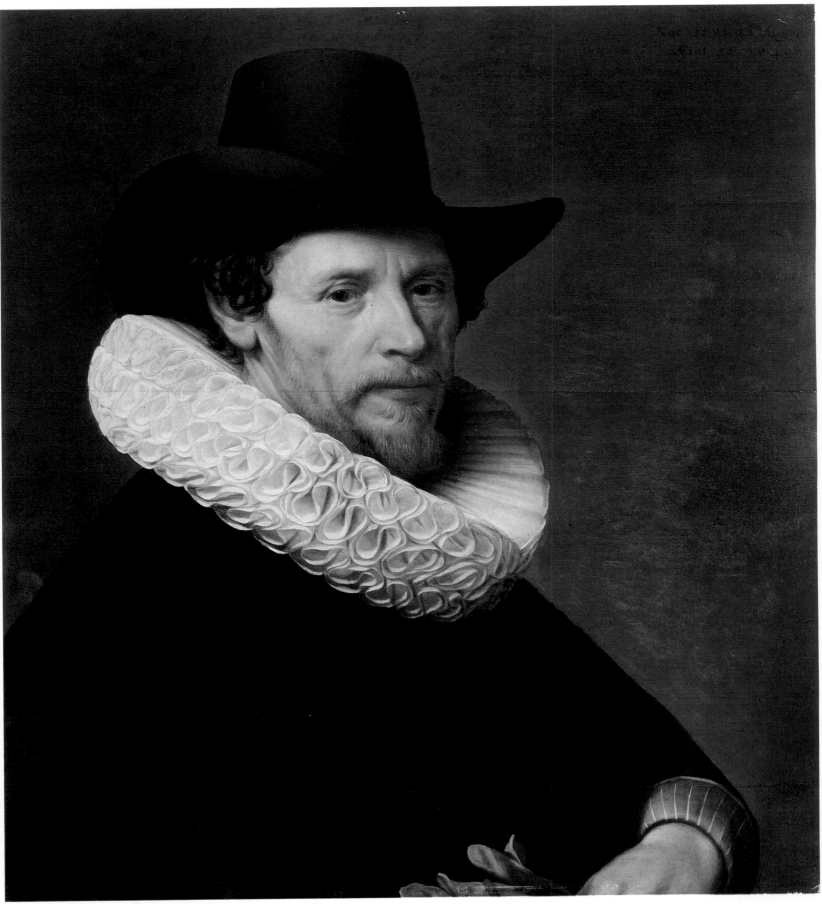

36

NICOLAES ELIASZ PICKENOY

Born 1590/91 in Amsterdam, died there between 1654 and 1656.
Pupil to Cornelis van der Voort. Worked in Amsterdam.
Painted portraits.

36

Portrait of a Man

Oil on panel, 26×24 ¹/₄" (66×61.5 cm.)
Inscribed, top right: Nat 1591. 23 August Aetat 58. 1649
Art Museum, Sevastopol. Inv. No. 511

A similar picture (old replica) of the portrait is in the Museum of Western
European and Oriental Art, Kiev (cat. of 1961, No. 138). The Sevastopol
piece is cut down at the bottom.

PROVENANCE

Until 1949	Museum of Local Lore, Simferopol
1949	Art Museum, Sevastopol

FRANS HALS

Born between 1581 and 1585, apparently in Antwerp, died in Haarlem in 1666. Moved to Haarlem together with his parents and there studied under Karel van Mander (1600–1603). Entered the Haarlem guild (1610) and was its officer (1644). His principal activity was as portrait painter, but he also painted pictures on biblical and genre themes.

37

Portrait of a Man

Oil on canvas, 33 1/4×26 1/4" (84.5×67 cm.)
Signed with monogram on background, right: FH
The Hermitage, Leningrad. Inv. No. 816

The British Museum, London, has a drawing in black chalk (inv. No. 1891. 7. 3. 16) which J. Q. Regteren-Altena believes is a preliminary study for the Hermitage portrait. It is more likely, though, that the drawing is a copy from the Hermitage picture and was made at the time the man depicted still had on his hat, subsequently overpainted. The contours of the hat are easily discernible even now. J. Q. Regteren-Altena was the first to draw attention to the fact.

The Hermitage portrait or the British Museum drawing served as the model for an engraving by Jacobus Houbraken, the illustrator of a book of artists' biographies written by his father Arnold Jacobus Houbraken. The engraving is purported in the book to be a portrait of Frans Hals himself. There are, however, no grounds for such an identification.

PROVENANCE

Between 1763 and 1774 The Imperial Hermitage, St. Petersburg

REFERENCES

A. Houbraken, *De Groote Schouburgh der Nederlantsch Konstschilders en Schilderessen*, Amsterdam, 1718–21; * *Catalogues. The Hermitage* 1863–1916, No. 772; Hofstede de Groot, III, No. 309; J. Q. Regteren-Altena, "Frans Hals Teekenaar," *Oud-Holland*, 1929, pl. 149–152; * Fechner 1960, pp. 14–16; *Frans Hals. Exhibition on the Occasion of the Centenary of the Municipal Museum at Haarlem. Catalogue*, Haarlem, 1962, No. 79; Seymour Slive, *Frans Hals*, vol. 1, London, 1970, pp. 191–193.

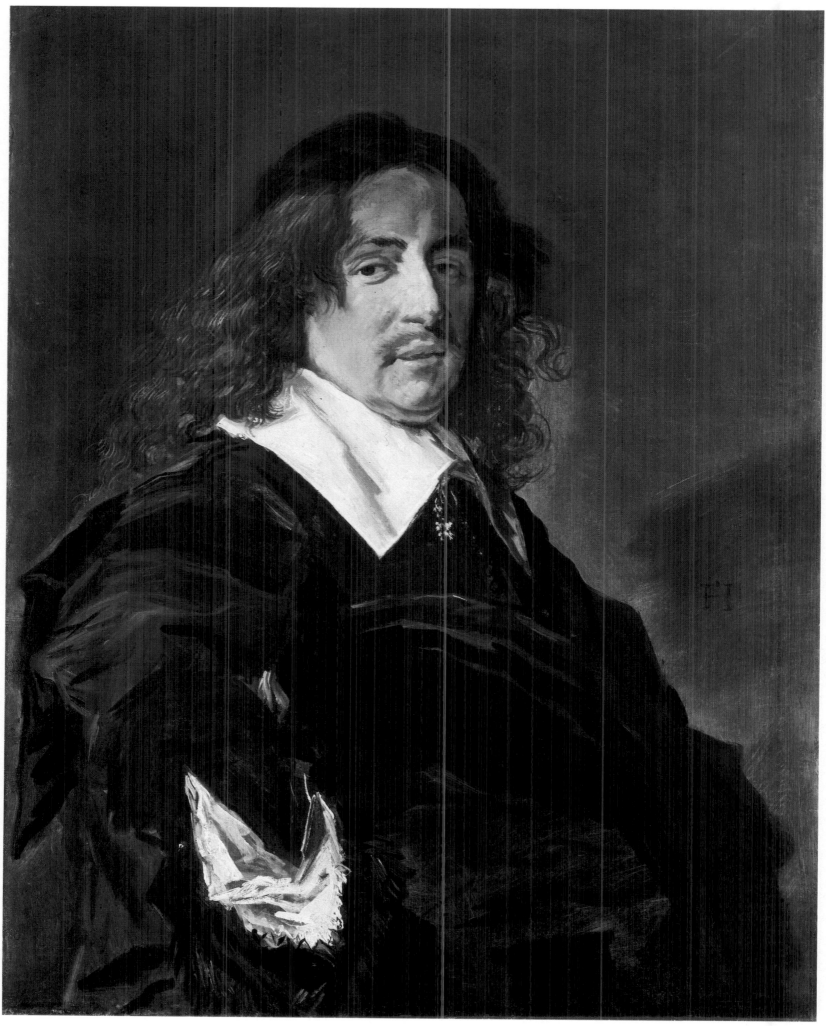

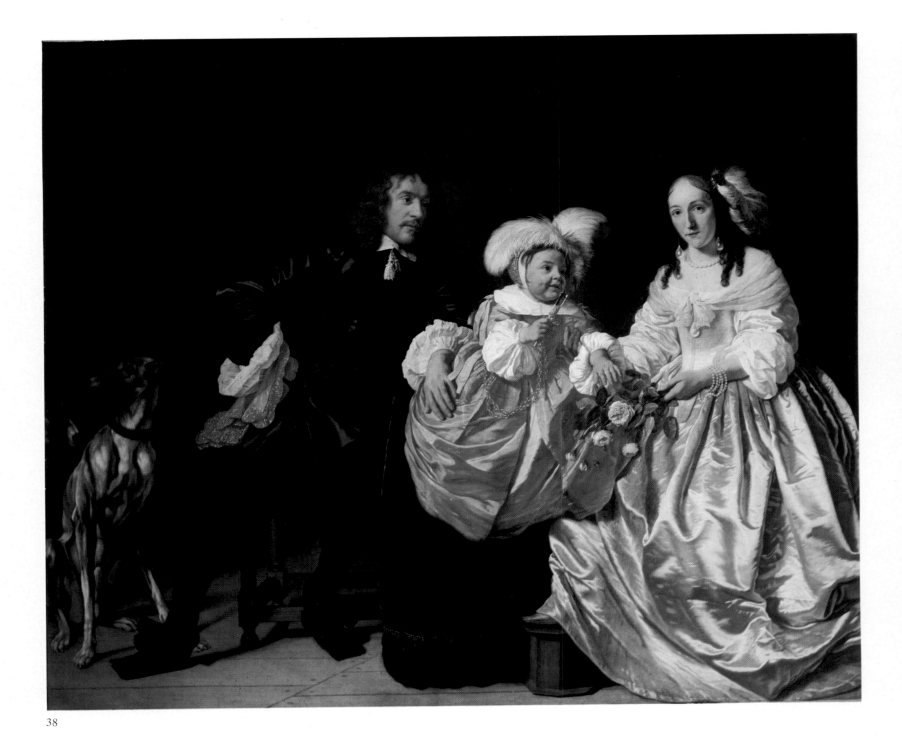

38

BARTHOLOMEUS VAN DER HELST

Born 1613 in Haarlem, died 1670 in Amsterdam.
Probably studied under Nicolaes Eliasz Pickenoy. Worked in
Amsterdam. Painted portraits as well as biblical, mythological,
and genre scenes.

38, 39

Family Group

Oil on canvas, 73 7/8×89 1/4" (187.5×226.5 cm.)
Signed and dated, bottom left: Bartholomeus van der Helst f. 1652
The Hermitage, Leningrad. Inv. No. 860

PROVENANCE

Before 1774 The Imperial Hermitage,
St. Petersburg

REFERENCES

* *Catalogues. The Hermitage* 1863–1916, No.
779; Waagen 1870, p. 174; A. Lavice, *Revue des
Musées de Belgique, de Hollande et de Russie*,
Paris, 1872, p. 253; J. J. van Gelder, *Bartho-
lomeus van der Helst*, Rotterdam, 1921, p. 107,
No. 871.

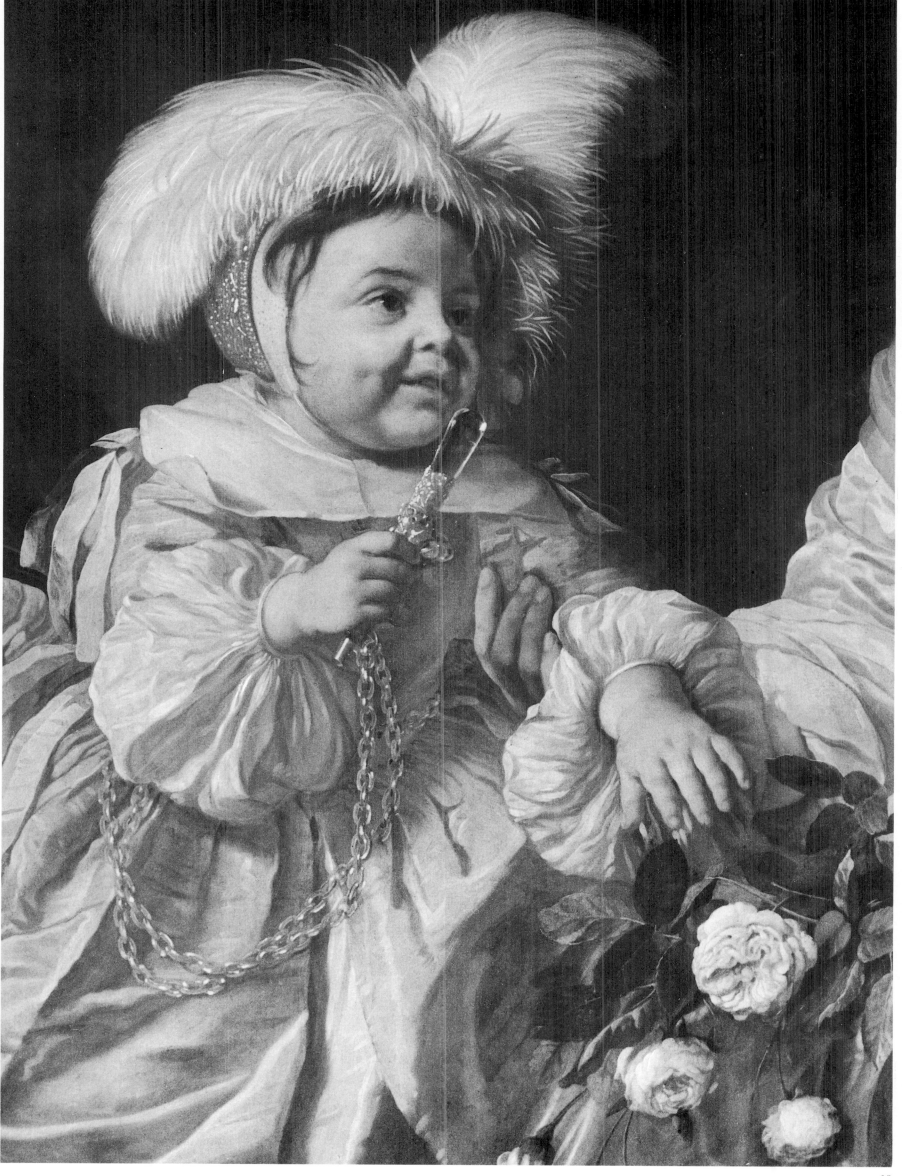

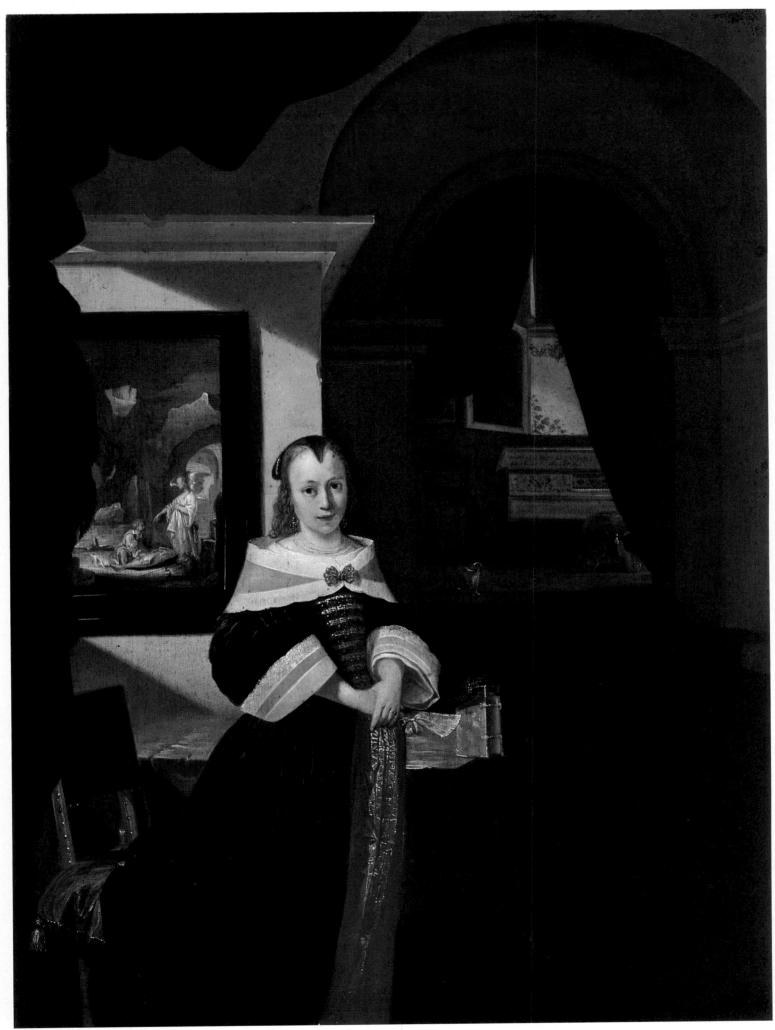

40

KAREL SLABBAERT

Born around 1619 in Zierikzee, died 1654 in Middelburg.
Probably studied in Leyden. Lived mostly in Middelburg, also
for some time in Amsterdam. Member of the Middelburg guild
(from 1645). Painted portraits and genre compositions.

40

Portrait of a Young Woman

Oil on panel, 22 3/4×17 1/4" (58×43.5 cm.)
Signed, bottom right: K. Slabbaert. The inscription on the lid of the clavecin
reads: musica letitiae comes medicina dolorum (music is concomitant with joy,
a medicine for grief)
Museum of Art and Local Lore, Zhitomir. Inv. No. 41

Judging from the woman's dress the portrait was painted in the 1640s.

PROVENANCE

Until 1919 The Baron de Chaudoir Collec- 1919 Museum of Art and Local Lore, Zhitomir
 tion, Zhitomir

PIETER NASON

Born about 1612 in Amsterdam, died between 1688 and 1690
in The Hague. Probably studied under Jan Anthonisz van
Ravesteyn. Worked in The Hague and for a while in Amsterdam.
Painted portraits and still lifes.

41 →

Portrait of a Man

Oil on canvas, 35 3/8×27 1/2" (90×70 cm.)
Signed and dated, bottom right: P. Nason f 1664
Picture Gallery, Tambov. Inv. No. 70

The style of this portrait of a young naval officer illustrates a blend of
Amsterdam and The Hague artistic traditions, typical of Nason's oeuvre as
a whole.

PROVENANCE

1864 The Antiquariaat, The Hague
 The B. Chicherin Collection, Karaul es-
 tate near Tambov
1927 Museum of Local Lore, Tambov
1960 Picture Gallery, Tambov

REFERENCES

* Kuznetsov 1959, No. 83; * Kuznetsov 1967,
No. 66.

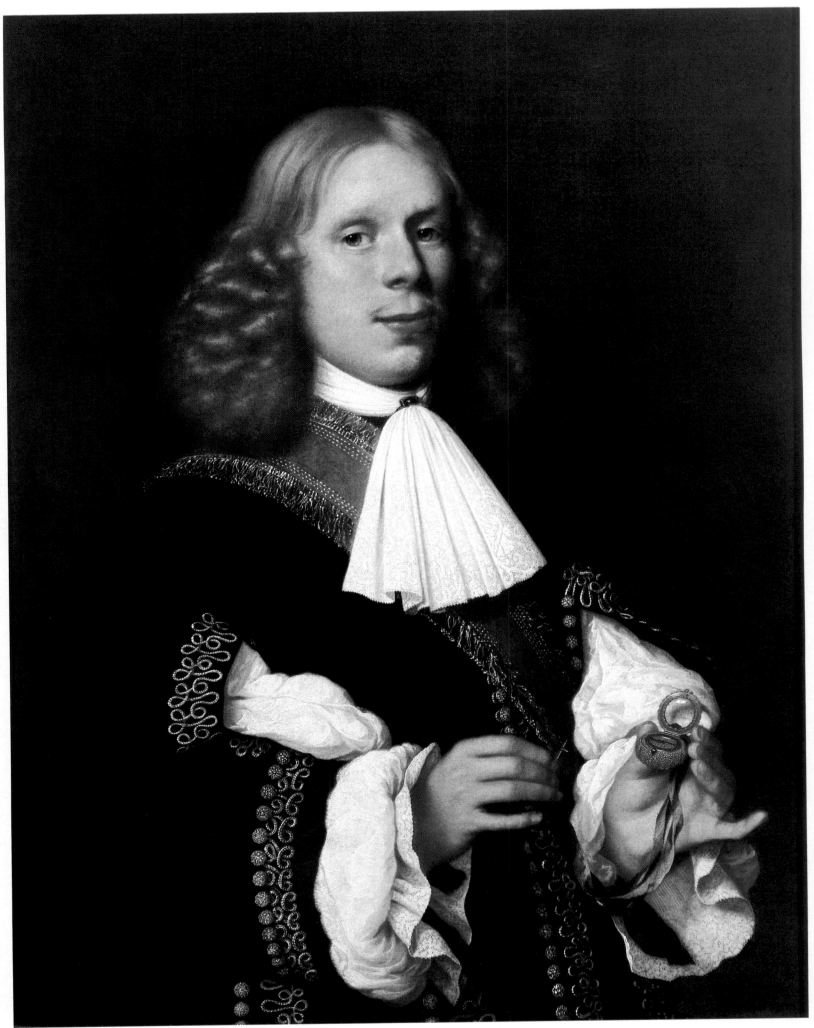

41

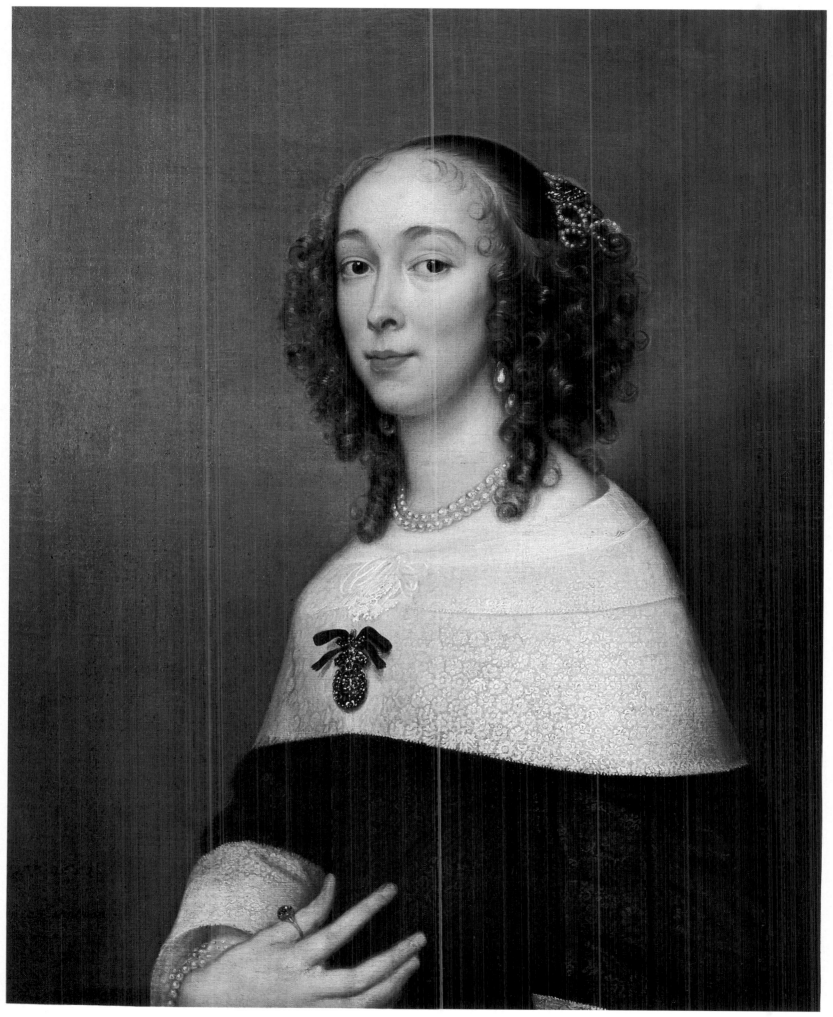

ADRIAEN HANNEMAN

Born around 1601 in The Hague, died there in 1671.
Studied under Jan Antonisz van Ravesteyn and Daniel Mytens
the Elder. Worked in London and The Hague (from 1640).
Painted portraits.

← 42

Portrait of a Woman

Oil on canvas, 30 3/4×24 3/8" (78×62 cm.)
Signed and dated, bottom left: 1653 Adr Hanneman Fe
The Pushkin Museum of Fine Arts, Moscow. Inv. No. 2738

This is one of the artist's most refined and charming female images.

	PROVENANCE	REFERENCES
1915	The K. Klochkova Collection, Moscow	*Catalogue. Private Collections* 1915, No. 137; * Shchavinsky 1915, p. 111; * Kuznetsov 1959, No. 82; * Catalogue. The Pushkin Museum of Fine Arts 1961, p. 48.
Until 1937	The Grachova Collection, Moscow	
1937	The Pushkin Museum of Fine Arts, Moscow	

ANTHONIE PALAMEDESZ

Born 1601 in Delft, died 1673 in Amsterdam. Probably studied
under Michiel van Mierevelt and Hendrick Gerritsz Pot.
Worked in Delft, Haarlem, and Amsterdam. Painted portraits
and genre scenes.

43

Portrait of a Lady with a Carnation

Oil on canvas, 31 3/4×26 1/4" (80.5×67 cm.)
Signed and dated, bottom left: AET: 36 A° 1600 A Palamedes pinxit
Museum of Western European and Oriental Art, Kiev. Inv. No. 32

	PROVENANCE	REFERENCES
	The Naryshkina Collection, St. Petersburg	*Catalogue. Khanenko* 1899. No. 259; * Collection Khanenko 1911–13, p. 57; * Art in Southern Russia 1913, repr.; * Catalogue. Kiev 1931, No. 298; Thieme-Becker, 26, p. 155; * Catalogue. Kiev 1961, No. 131.
	The B. and V. Khanenko Collection, Kiev	
1919	Museum of Western European and Oriental Art, Kiev	

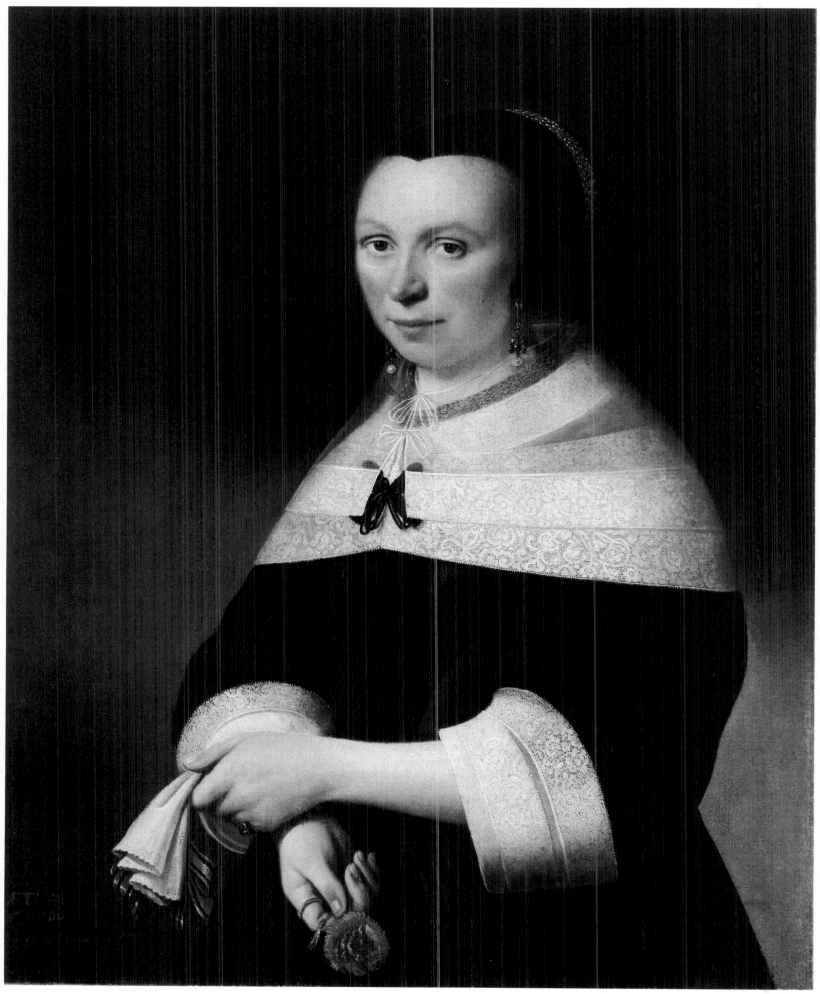

43

MICHIEL SWEERTS

Born 1624 in Brussels, died in India in 1664. Worked in Rome
(1646–56), Brussels (1656), Amsterdam (1661), and Paris, and
from 1662 in India. Was a painter and etcher. Painted
portraits and pictures on genre and biblical subjects.

← 44, 45

Portrait of a Young Man

Oil on canvas, 44 ⁷/₈×36 ¹/₄" (114×92 cm.)
Inscribed and dated on sheet of paper attached to tablecloth: A. D. 1656. Ratio
Quique Reddenda (All bills must be paid); signed, bottom:
Michiel Sweerts F.
The Hermitage, Leningrad. Inv. No. 3654

PROVENANCE

Until 1922 Museum of the Academy of Arts, Petrograd
1922 The Hermitage, Leningrad

REFERENCES

* *Catalogue. Academy of Arts* 1874, No. 537; W. Martin, "Michiel Sweerts als Schilder," *Oud-Holland*,1907, pp. 133–156; * *Catalogue. The Hermitage* 1958, 2, p. 268; Vitale Bloch, "Michael Sweerts und Italien," *Jahrbuch der Staatlichen Kunstsammlungen in Baden-Württemberg*, vol. 2, 1965, pp. 168, 169, 171; Vitale Bloch, *Michael Sweerts*, The Hague, 1968, p. 23, pl. 19.

JAN DE BRAY

Born around 1627 in Haarlem, died there in 1697.
Pupil of Salomon de Bray (his father). Worked in Haarlem.
Painted pictures on biblical and mythological themes,
also portraits.

46

Portrait of a Woman

Oil on panel, 28 ³/₄×21 ⁵/₈" (73×55 cm.)
Signed and dated, bottom left: 1658 J. Bray
The Hermitage, Leningrad. Inv. No. 5613

PROVENANCE

The A. Fabergé Collection, Petrograd
1922 The Hermitage, Petrograd

REFERENCES

* *Catalogue. The Hermitage* 1958, 2, p. 114.

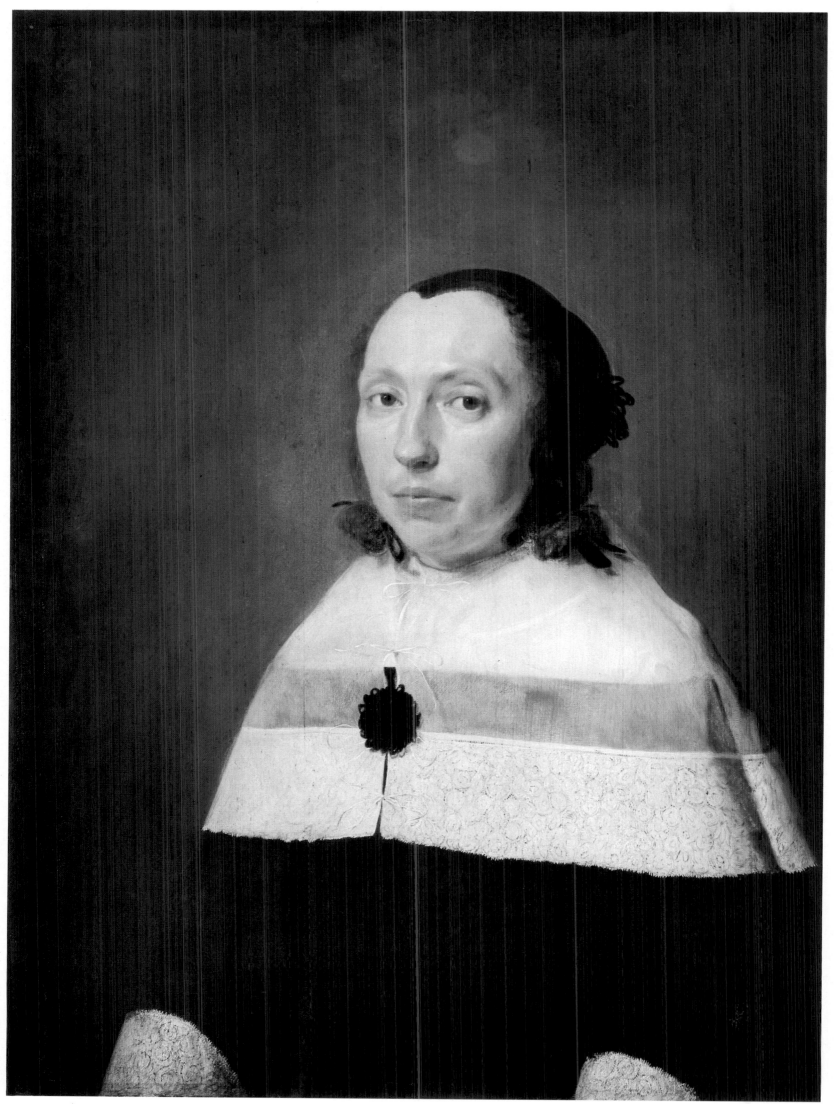

ISAACK LUTTICHUIJS

Born in London in 1616, died 1673 in Amsterdam.
Worked in Amsterdam (from 1638). Was a portraitist.

47

Portrait of a Man

Oil on panel, 25 7/8×19 3/4" (65.5×50 cm.)
Signed and dated, top right (date is partly worn): I. Luttichuis Anno 165…
Art Museum of the Tatar ASSR, Kazan. Inv. No. 955

Painted in the first half of the 1650s.

PROVENANCE		REFERENCES
Until 1895	The A. Likhachov Collection	* Dulsky 1923, p. 129; * *Catalogue. Kazan* 1927, No. 36; * *Catalogue. Kazan* 1934, No. 20; * *Catalogue. Kazan* 1958, p. 9.
1895	Art Museum, Kazan	

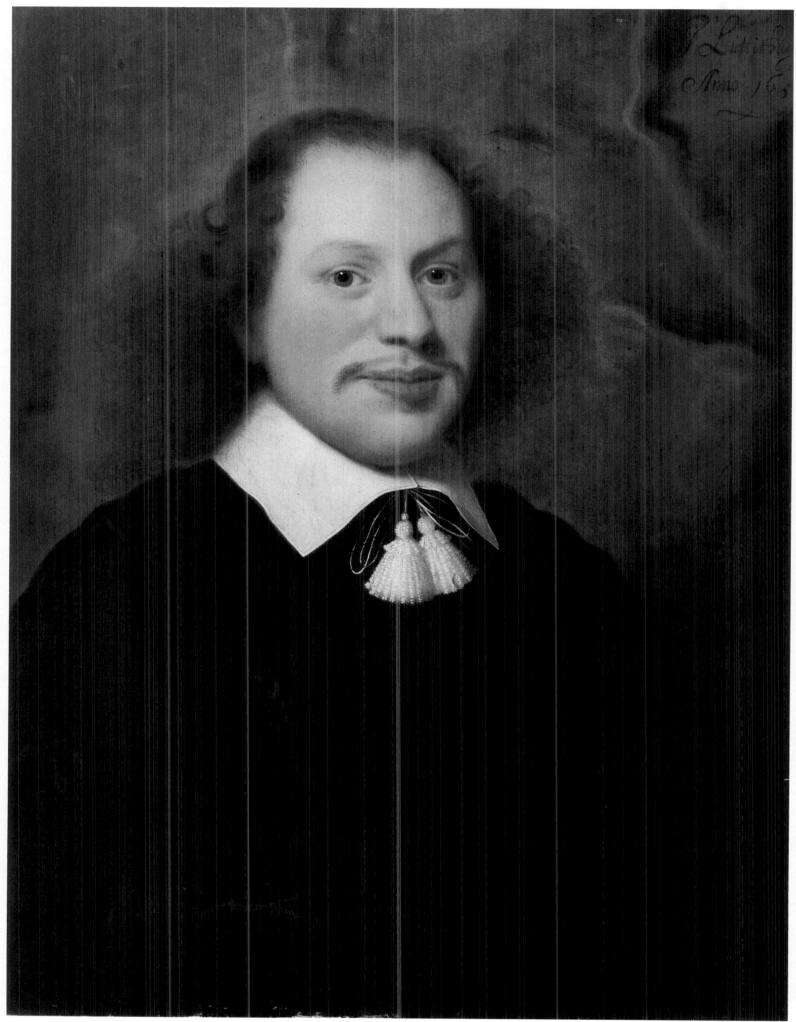

47

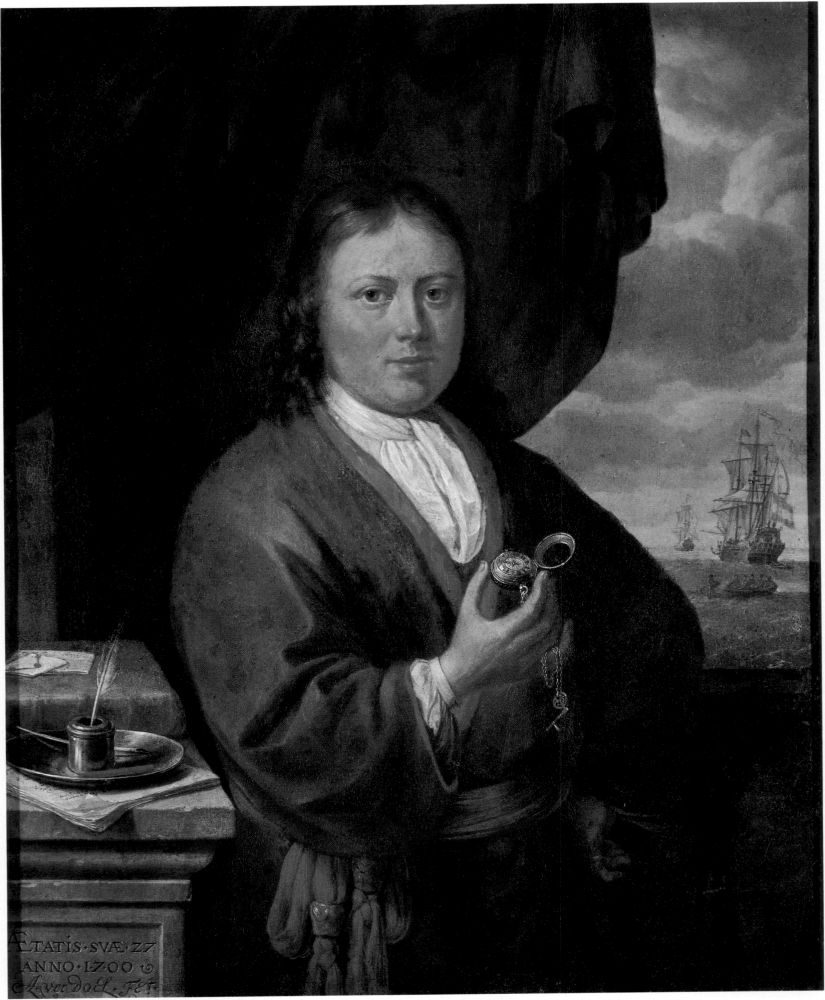

ÆTATIS·SVÆ·27
ANNO·1700
A.verdoel·Fec

48

ADRIAEN VERDOEL THE YOUNGER

Active in the late seventeenth and early eighteenth centuries.
Probably studied under his father, who bore the same name.
Member of the Middelburg guild (1695–96). Painted portraits.

48

Portrait of a Man

Oil on copper, 18 ³/₈×15" (46.5×38.2 cm.)
Signed and dated, bottom left: Aetatis suae 27 Anno 1700 A. ver Doel Fec. The
barely visible writing on the letter reads: ... Hoog........Batavia
Art Museum, Kharkov. Inv. No. 32

Judging by the date, 1700, the picture is probably the work of Adriaen
Verdoel the Younger (the name of Verdoel the Elder does not occur in
documents after 1675). If this surmise is correct, then the Hermitage portrait
is the master's only work that we know of.

REFERENCES

Provenance unknown. * *Catalogue. Kharkov* 1959, p. 42.

HENDRICK HEERSCHOP

Born around 1620 in Haarlem, died there (?) after 1672. Studied
under Willem Claesz Heda and Rembrandt. Worked in
Haarlem. Painted genre scenes and portraits.

49

Portrait of Seijger van Rechteren

Oil on panel, 18 1/8×14 1/2" (46×37 cm.)
Inscribed, signed, and dated on title page of book: Journael van Oostindien
door Seyger van Re... H. Heerschop 1661
Museum of Western European and Oriental Art, Riga. Inv. No. 217

Seijger van Rechteren was a Dutch physician who went to India in 1628 and
on his return in 1635 began publishing a journal. The identity of the sitter was
established by E. W. Moes by comparing the picture with an engraved
portrait. A variant of the portrait, signed with monogram and dated 1660,
is in the Yale University collection (New Haven, Connecticut).

PROVENANCE	REFERENCES
1904 Museum of Western European and Oriental Art, Riga (bequeathed by L. Kerkovius)	Neumann 1906, No. 81; Thieme-Becker, 16, p. 235; * *Catalogue. Riga* 1955, p. 90; * *Catalogue. Riga* 1973, p. 39.

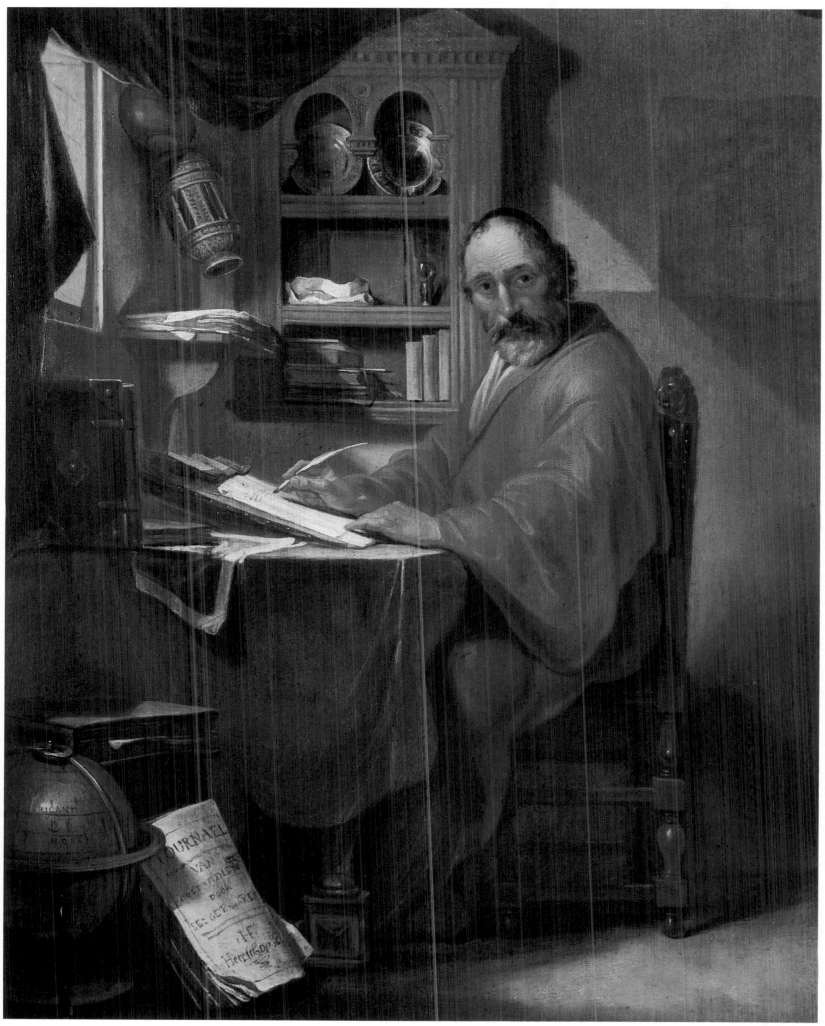

REMBRANDT HARMENSZ VAN RIJN

Born 1606 in Leyden, died 1669 in Amsterdam. Studied under
Jacob Swanenburgh in Leyden (1624–27) and Pieter Lastman in
Amsterdam. Worked in Leyden and Amsterdam (from 1631).
An outstanding painter, draughtsman, and etcher, he painted
biblical, historical, and mythological scenes, portraits,
landscapes, and still lifes. Had many pupils, among them: in
Leyden, Gerrit Dou; in Amsterdam in the 1630s, Jacob Backer,
Govaert Flinck, Ferdinand Bol, Gerbrand van den Eeckhout; in
the 1640s, Philips de Koninck, Carel Fabritius, Samuel van
Hoogstraaten, Jan Victors; from the late 1640s to the late 1660s,
Nicolaes Maes, Barent Fabritius, and Aert de Gelder.

50

Portrait of Baertjen Martens Doomer

Oil on panel, 30×22" (76×56 cm.)
Signed, bottom left: Rbrandt f (sic!)
The Hermitage, Leningrad. Inv. No. 729

As determined by W. Martin (1909), the woman depicted is Baertjen
Martens Doomer (about 1604–78), the wife of the cabinetmaker who
supplied Rembrandt with frames for his pictures, and the mother of Lambert
Doomer (1622–1700), a landscape painter and a pupil of Rembrandt. In 1640
Rembrandt painted a portrait of her husband Herman Doomer (Metropolitan
Museum of Art, New York). It would seem very likely that the companion
portrait of his wife Baertjen was painted the same year.
On May 23, 1662, Baertjen, by then a widow, drew up a will stipulating that
"…her son Lambert Doomer inherit and preserve her, the testatrix's, and
her husband's portraits painted by Rembrandt, but subject to the condition
that all Lambert's brothers and sisters receive copies of those portraits to be
made at this expense." These conditions were apparently met, i.e., five pairs
of copies were produced, some of which have come down to our day.
However, the portraits of his parents signed by Lambert and now housed in
the Duke of Devonshire's collection cannot really be considered copies
inasmuch as they differ significantly from the portraits produced by
Rembrandt.

PROVENANCE

1640 The Herman Doomer Collection, Amsterdam
1654 The Baertjen Doomer Collection, Amsterdam
1678 The Lambert Doomer Collection, Amsterdam
1700 The collection of Herman Voster Jr.; the portrait was bequeathed to him by his uncle Lambert Doomer, Amsterdam
1797 The Imperial Hermitage, St. Petersburg

REFERENCES

* *Catalogues. The Hermitage* 1863–1916, No. 829; Bode 1873, p. 9; Hofstede de Groot, suppl. No. 251a; Valentiner 1909, p. 255; W. Martin, "Rembrandt's portret van Herman Doomer en Baertjen Martens," *Bulletin van de Nederlands oudheidkondigen Bond*, 2, 1909, pp. 126–129; A. Bredius, "Rembrandtiana," *Oud-Holland*, 1910, pp. 2–18; Hofstede de Groot, VI, No. 643; Knuttel 1956, p. 118; * Loewinson-Lessing 1956, p. IX; I. N. van Edghen, "Baertjen Martens en Herman Doomer", *Maandblad Amstelodamum*, 43, 1956, p. 133; * *Catalogue. The Hermitage* 1958, 2, p. 252; * Vipper 1962, p. 350; * Fechner 1965, No. 14; Bauch 1966, No. 499; Gerson 1968, No. 231; Haak 1968, p. 166; Bredius 1969, No. 357.

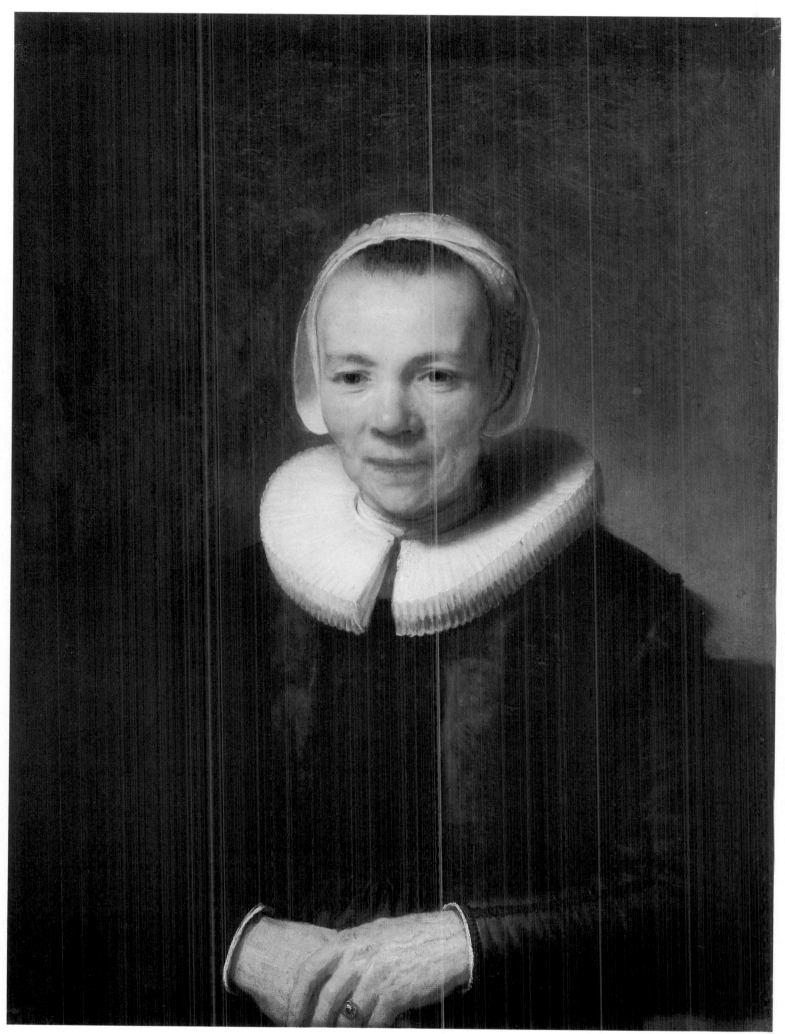

51

Portrait of a Man

Oil on canvas, 28×24" (71×61 cm.)
Signed and dated near shoulder, left: Rembrandt f. 1661
The Hermitage, Leningrad. Inv. No. 781

This man appears in many of Rembrandt's works. In the opinion of specialists, one of the most expressive pictures of him is the *Portrait of a Man* housed in the National Gallery in London. The same model served the artist for the famous canvas *Aristotle Contemplating the Bust of Homer* (Metropolitan Museum of Art, New York). The dates of execution of *Aristotle Contemplating the Bust of Homer* and the Hermitage portrait, 1653 and 1661 respectively, are such as to warrant the conclusion that the man in question belonged to Rembrandt's circle or knew him for quite some time. The same man is apparently depicted in *Count Floris V of Holland* (Kunstmuseum, Göteborg), and *Man with a Gold Chain* (1657, California Palace of the Legion of Honor, San Francisco). Hence there are good reasons for believing that the Hermitage canvas also portrays a historical figure, what with his rich apparel and stern nobility of bearing.

PROVENANCE

Until 1829 The Duchess of Saint-Leu
 Collection, Paris
1829 The Imperial Hermitage,
 St. Petersburg

REFERENCES

* *Catalogues. The Hermitage* 1863–1916, No. 821; Bode 1873, p. 10; Bode 1883, pp. 503, 602; Valentiner 1909, p. 496; Hofstede de Groot, VI, No. 441; W. R. Valentiner, *Wiedergefundene Gemälde*, Berlin–Leipzig, 1923, pp. 89, 104, 105; Benesch 1935, p. 66; * Loewinson-Lessing 1956, p. XVII; * *Catalogue. The Hermitage* 1958, 2, p. 259; * Fechner 1965, No. 27; Bauch 1966, No. 239; Gerson 1968, No. 402; Bredius 1969, No. 309.

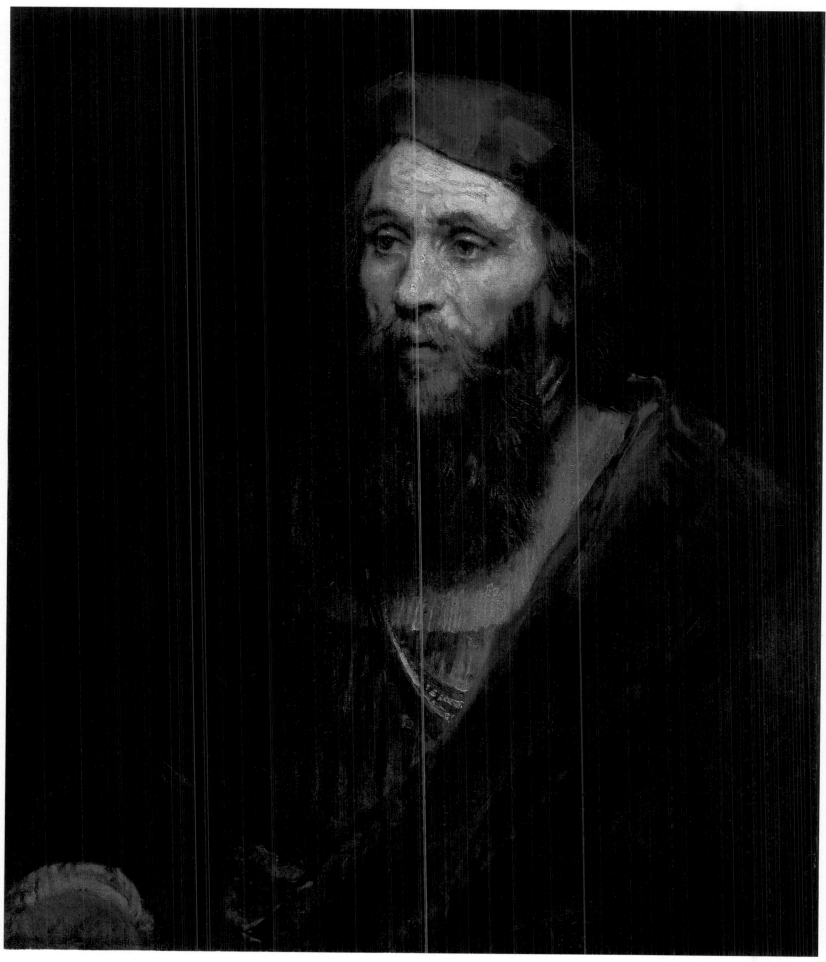

GERARD TER BORCH

Born 1617 in Zwolle, died 1681 in Deventer. Studied under his father, who bore the same name, and Pieter Molijn in Haarlem. Was in England, Germany, Italy, Spain, and France. Worked mainly in Deventer, also in Zwolle (1650–54). Painted portraits and genre scenes.

52

Portrait of Catharina van Leunink

Oil on canvas, 31 1/2×23 1/4" (80×59 cm.)
The Hermitage, Leningrad. Inv. No. 3783

Painted not earlier than 1662–63. Catharina van Leunink (1635–1680) was the wife of the Deventer burgomaster J. van Suchtelen. The whereabouts of a companion picture that undoubtedly existed (a portrait of J. van Suchtelen) are not known.

PROVENANCE

Belonged to the Suchtelen family, St. Petersburg, then entered the collection of F. Kushelev-Bezborodko
1886 The Kushelev Gallery, St. Petersburg Museum of the Academy of Arts, Petrograd
1922 The Hermitage, Petrograd

REFERENCES

* *Catalogue. The Kushelev Gallery* 1886, No. 74; * *Catalogue. The Hermitage* 1958, 2, p. 279; S. J. Gudlaugsson, *Gerard Ter Borch*, The Hague, 1960, No. 184.

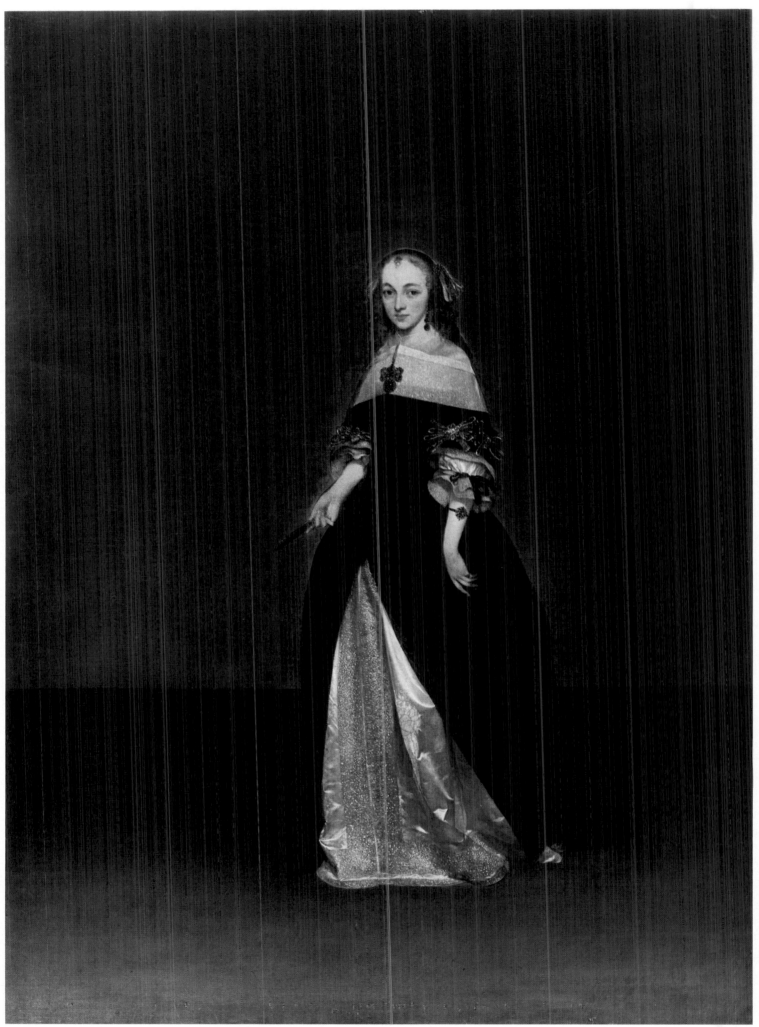

ABRAHAM VAN DEN TEMPEL

Born 1622 or 1623 in Leeuwarden, died 1672 in Amsterdam.
Pupil of Lambert Jacobsz (his father) and Jacob Backer. Was
influenced by the art of Bartholomeus van der Helst. Worked in
Leyden (from 1648) and Amsterdam (from 1660). Painted
mainly portraits.

53

Portrait of a Young Widow

Oil on canvas, 48 3/8×40 7/8" (123×103.5 cm.)
Signed and dated, bottom right: A. van Tempel Ao 1670
The Hermitage, Leningrad. Inv. No. 2825

This work was formerly considered a portrait of the widow of Admiral van
Balen by reason of a supposed similarity with *Portrait of the Wife of Admiral
van Balen* painted by the same Abraham van den Tempel and housed in the
Gemäldegalerie (Alte Meister und Antikenabteilung), Kassel (cat. of 1819,
No. 397). In our opinion, though, the Kassel portrait was done from another
model. Besides, the authors of the Kassel gallery's most recent catalogue no
longer identify the woman depicted in their galerry's canvas with the wife of
Admiral van Balen (cat. of 1958, No. 272).

PROVENANCE

The Montferrand Collection, St. Petersburg
The P. Semionov-Tien-Shansky Collection, St. Petersburg
1951 The Imperial Hermitage, Petrograd

REFERENCES

* *Art Treasures in Russia*, I, 1901, No. 8 (repr.);
Semenov. *Etudes* 1906, p. XCIX, No. 509;
* Shchavinsky 1909, pp. 252–253; * *In Memory
of Semionov* 1915, No. 58; * *Catalogue. The
Hermitage* 1958, 2, p. 279; * Kuznetsov 1959,
No. 86.

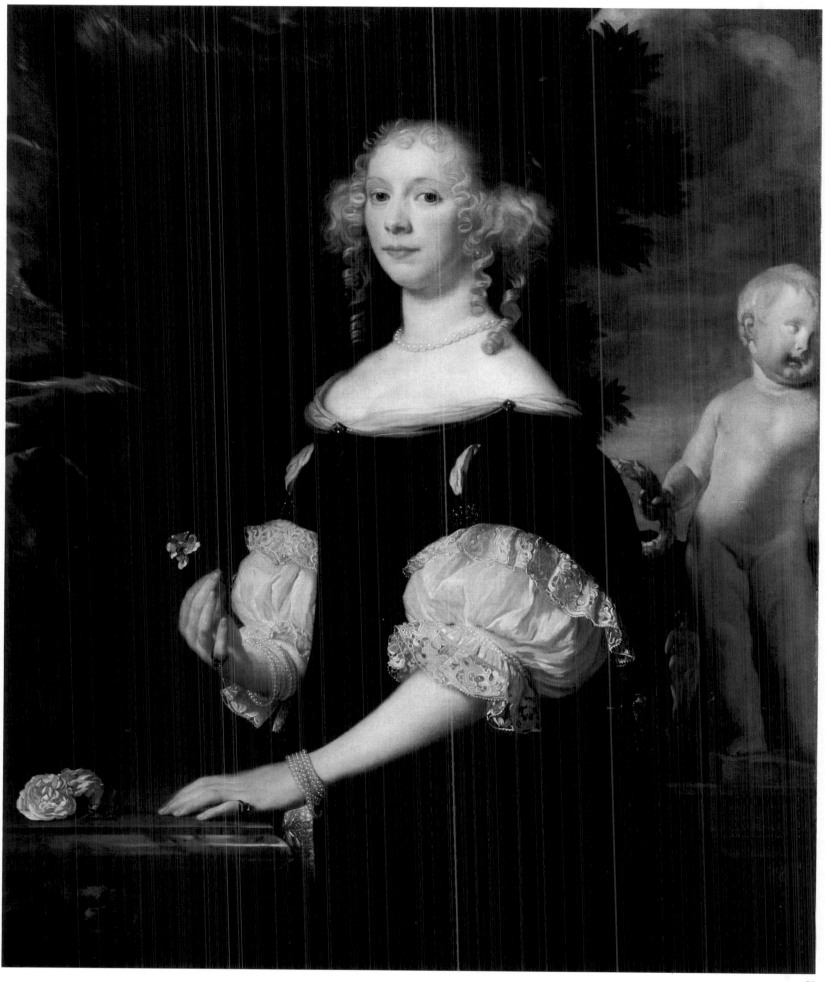

53

NICOLAES MAES

Born 1634 in Dordrecht, died 1693 in Amsterdam. Pupil
of Rembrandt (1648–52). Worked in Dordrecht, Antwerp
(1660–65), and Amsterdam (1673–93). Lived in the Southern
Netherlands (1665–67). Painted genre scenes and portraits,
occasionally biblical subjects.

54

Portrait of a Young Lady

Oil on canvas, 37×30" (94×76 cm.)
Signed and dated on column: Maes 1678
The Hermitage, Leningrad. Inv. No. 3640

PROVENANCE

Until 1922 Museum of the Academy of
 Arts, Petrograd
1922 The Hermitage, Petrograd

REFERENCES

Catalogue. Academy of Arts 1874, No. 521;
Catalogue. Rembrandt 1956, p. 103; *Catalogue. The Hermitage* 1958, 2, p. 216; *Catalogue. Rembrandt* 1969, No. 61.

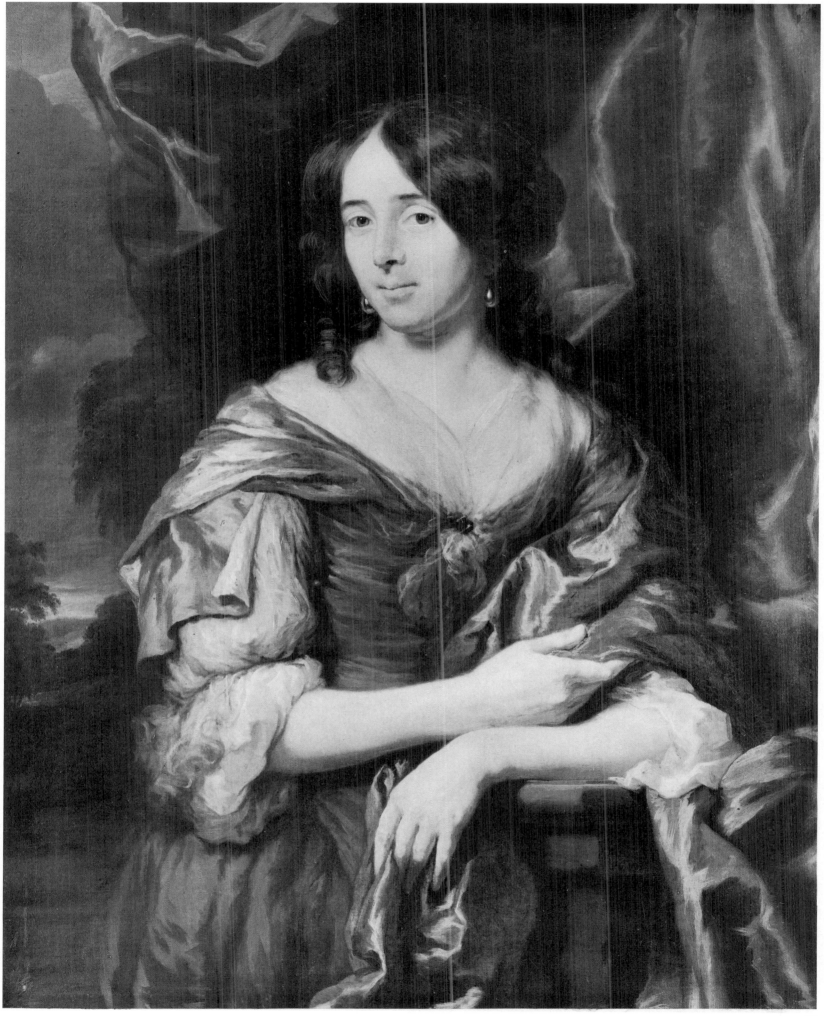

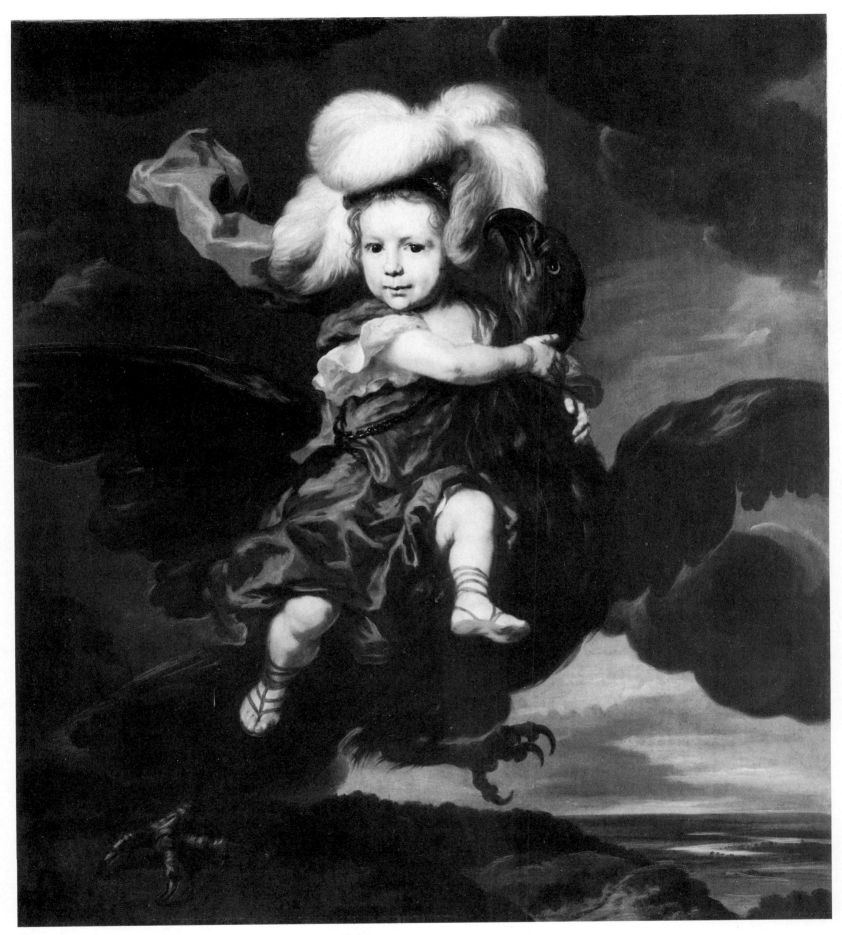

55

55

Ganymede

Oil on canvas, 44 1/2×40 7/8" (113×104 cm.)
Signed and dated, bottom left: Maes 1678
The Pushkin Museum of Fine Arts, Moscow. Inv. No. 2549

This type of allegorical portrait was very popular in Western European art in the sixteenth and seventeenth centuries. Portrayed as Ganymede, a beautiful Trojan youth whom Zeus (Jupiter), in the form of an eagle, carried off to Olympus, is apparently a child who had died shortly before. Nicolaes Maes is known as the author of numerous other allegorical portraits. One such, for example, was put up for sale March 24, 1972, at Christie's in London (No. 35). It depicts a boy flying off astride an eagle and a girl trying to hold him back by the hem of his clothes.

	PROVENANCE	REFERENCES
1908	The Duke of Leuchtenberg's Collection, St. Petersburg	Hofstede de Groot, VI, No. 359; * Catalogue. The Old Years 1908, p. 682; Les anciennes ecoles des peintures dans les palais et collections privée russes, Brussels, 1910, pp. 86–87; The Burlington Magazine, 1929, May, p. 269; * Catalogue. Rembrandt 1956, p. 84; Catalogue. The Pushkin Museum of Fine Arts 1961, p. 118.
Until 1928	State Museum Reserve, Leningrad	
1928	Museum of Fine Arts, Moscow	
1937	The Pushkin Museum of Fine Arts, Moscow	

ZACHARIAS BLIJHOOFT

Date and place of birth unknown. Died in 1681/82 in Middelburg. Worked in Middelburg. Was a portraitist.

56 →

Portrait of a Scholar

Oil and grisaille on panel, 15 3/8×12 5/8" (39×32 cm.)
Dated and signed on book: An 1661. Z. Blijhooft fecit. Aet 54
The Hermitage, Leningrad. Inv. No. 3114

In his *Etudes*, P. Semionov-Tien-Shansky mentions a picture by Blijhooft entitled *Lovers Conversing* (the M. Glybov Collection, St. Petersburg), from which we may conclude that in addition to portraits the artist painted genre scenes too. Some elements of the Hermitage portrait are likewise reminiscent of genre painting.

	PROVENANCE	REFERENCES
Until 1915	The P. Semionov-Tien-Shansky Collection, Petrograd	Semenov. Etudes 1906, p. CI, No. 41; * Catalogue. The Hermitage 1958, 2, p. 138.
1915	The Imperial Hermitage, Petrograd	

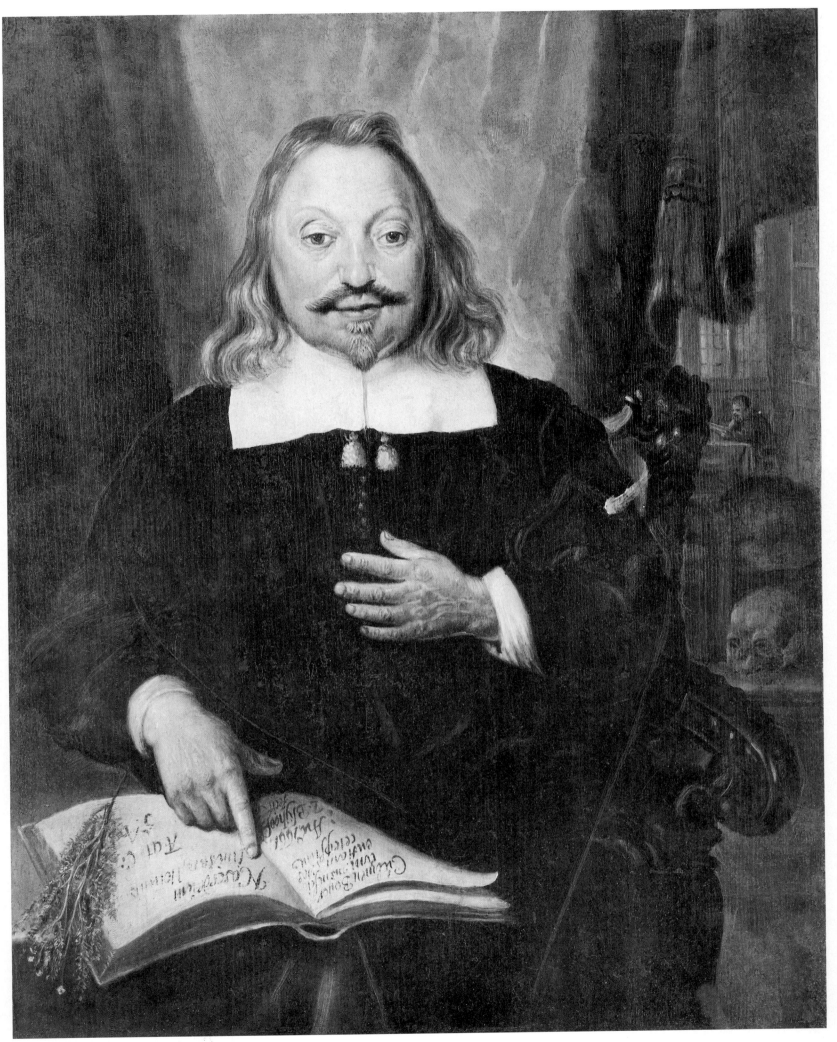

56

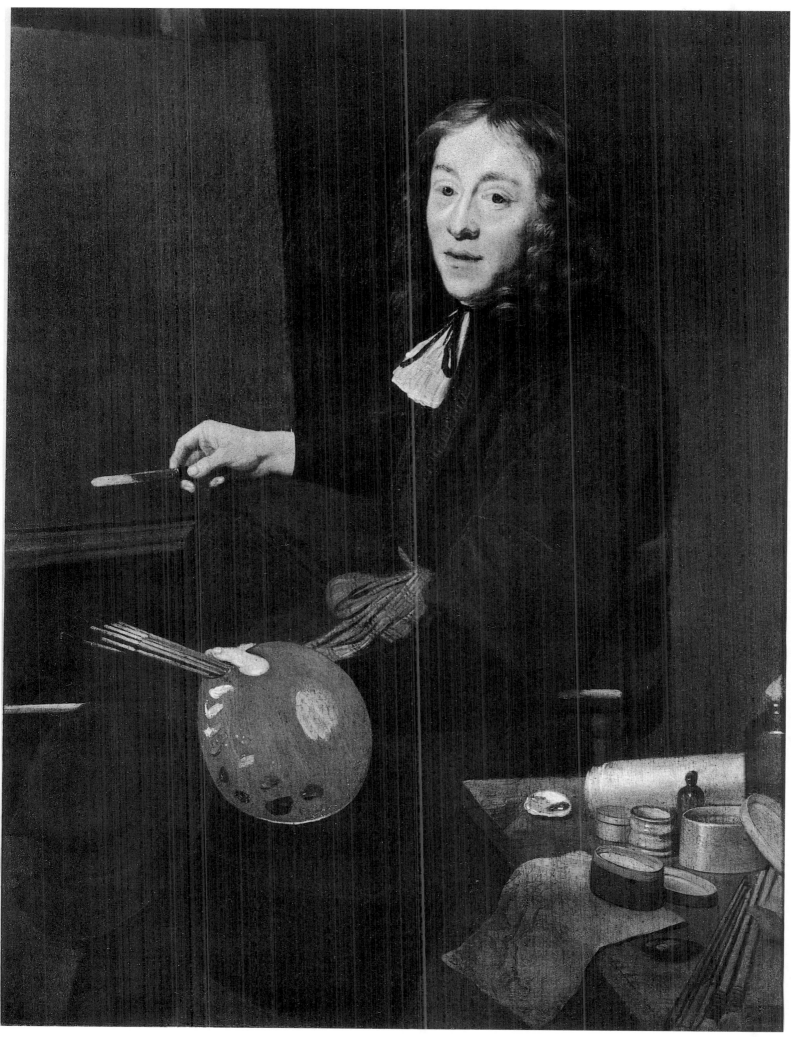

MICHIEL VAN MUSSCHER

Born 1645 in Rotterdam, died 1705 in Amsterdam.
Studied under Martinus Saagmoolen (1661), Abraham van
den Tempel (1665), Gabriel Metsu, and Adriaen van Ostade
(1665–67). Worked in Rotterdam. Painted genre scenes
and portraits.

← 57

Self-portrait

Oil on panel, 13 3/8×10 1/4" (34×26 cm.)
Signed and dated, bottom left: M. v. Musscher pin. A. 1669
The Pushkin Museum of Fine Arts, Moscow. Inv. No. 2007

The picture was attributed to Michiel van Musscher by M. Fabrikant.
The full signature of the master notwithstanding, this portrait, prior to its
entry into the Pushkin Museum of Fine Arts, was considered a work by
Nicolaes de Vree.

	PROVENANCE	REFERENCES
	Private Collection, Volokolamsk	* Fabrikant 1927, pp. 21–22; * *Catalogue. The*
Until 1927	Museum of History, Moscow	*Pushkin Museum of Fine Arts* 1961, p. 135.
1927	Museum of Fine Arts, Moscow	
1937	The Pushkin Museum of Fine Arts, Moscow	

FERDINAND BOL

Born 1616 in Dordrecht, died 1680 in Amsterdam. Studied
under Rembrandt in Amsterdam (around 1635). Worked in
Amsterdam. Was a painter and etcher. Painted biblical,
historical, and mythological subjects, also portraits.

58

Portrait of a Man

Oil on canvas, 42 1/2×36 1/4" (108×92 cm.)
Signed and dated, bottom right: Bol 1658
Art Museum, Kharkov. Inv. No. 31

	PROVENANCE	REFERENCES
Until 1928	The Zubalov Collection, Moscow	* *Catalogue. Kharkov* 1959, p. 46.
1928	Art Museum, Kharkov	

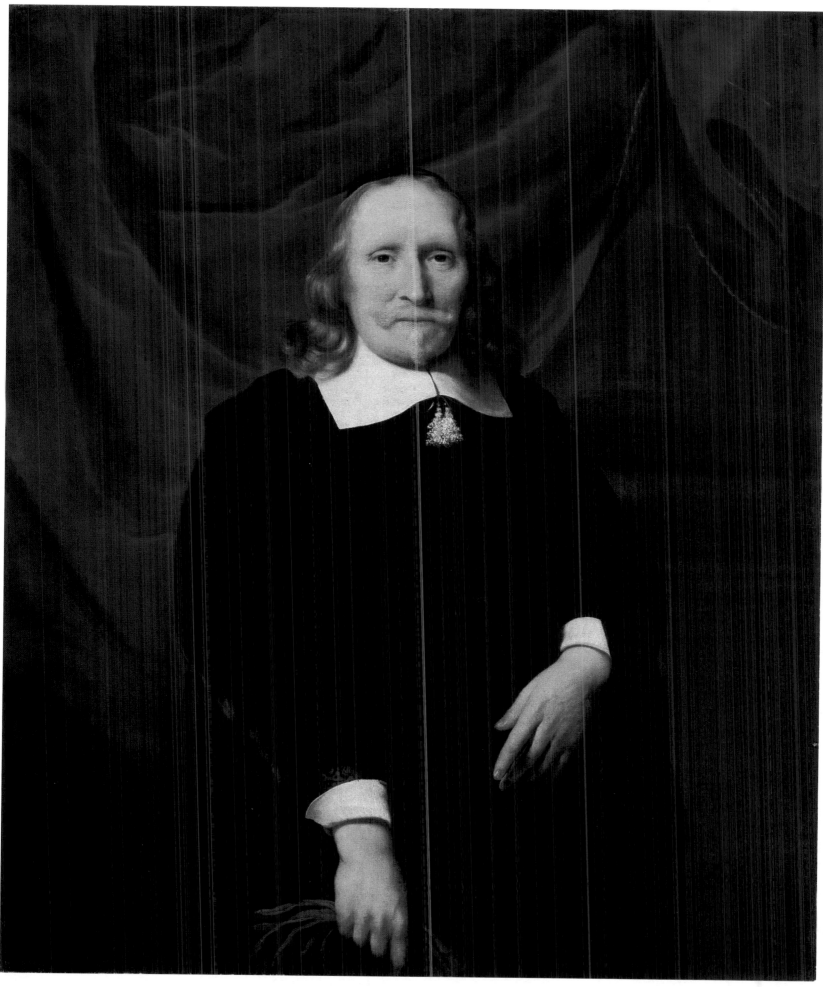

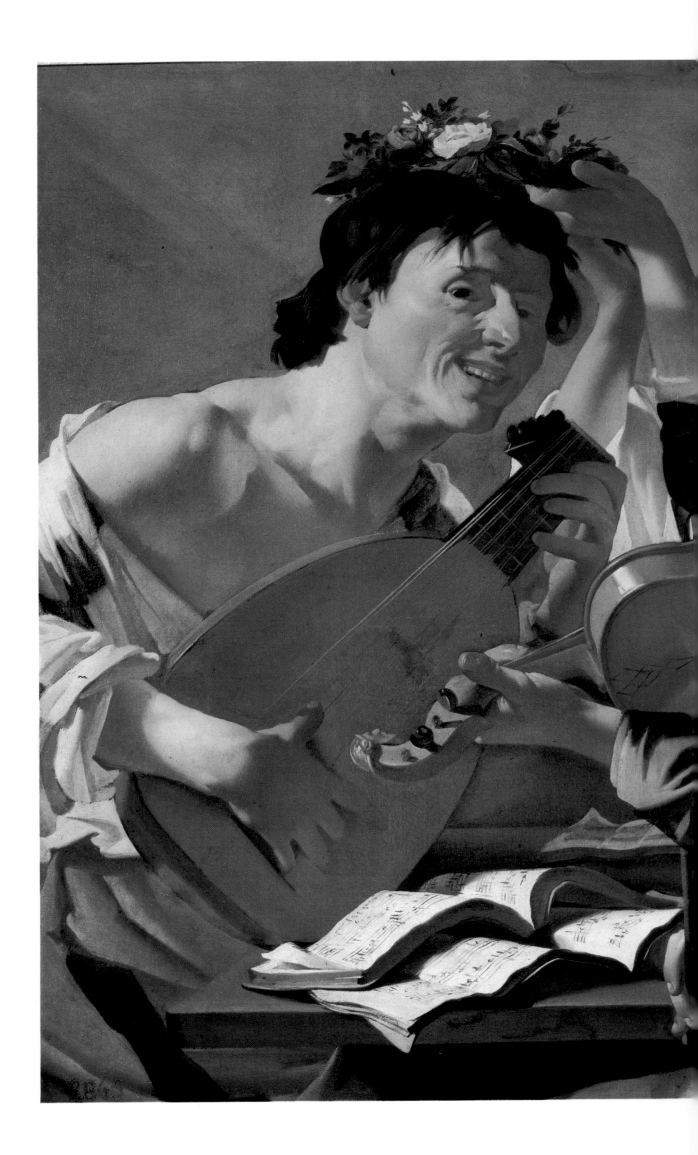

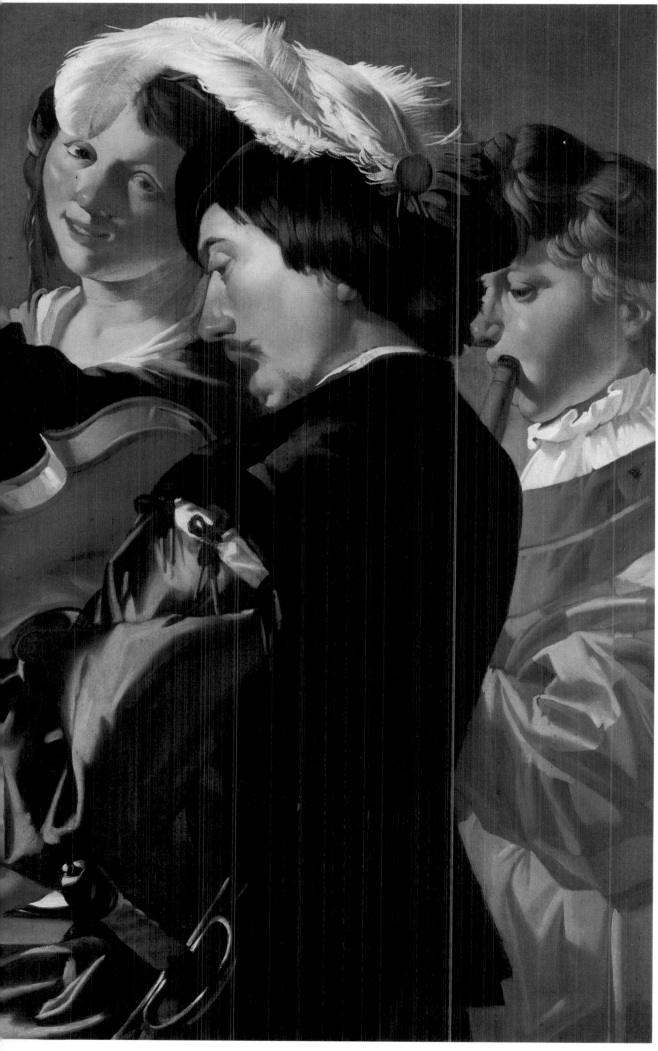

THEODOR (DIRCK) VAN BABUREN

Born around 1595 in Utrecht (?), died there in 1624. Is listed
(1611) in the roster of the Utrecht guild as a pupil of Paulus
Moreelse. Was in Italy (1612). Worked in Rome together with
the Dutch artist David de Haen. On his return to Utrecht (about
1620) worked with Hendrick Terbrugghen, probably sharing
a studio with him. Painted genre and biblical scenes.

← 60

Musical Party

Oil on canvas, 39×51 ¹/₈" (99×130 cm.)
The Hermitage, Leningrad. Inv. No. 772

The work was formerly ascribed to Gerrit van Honthorst. Attributed to
Theodor van Baburen by R. H. Wilenski. B. Nicolson is absolutely correct in
asserting that the compositional arrangement of the picture betrays the strong
influence of Bartolommeo Manfredi, and the handling of the light and shade
shows an affinity with Hendrick Terbrugghen's works of 1623–24.
Among Van Baburen's other works the one stylistically closest to the *Musical
Party* is *The Prodigal Son* of 1623 (Mittelrheinisches Landesmuseum, Mainz).
The Hermitage piece should evidently be referred to the same date.

PROVENANCE

Until 1764	The Johann Ernest Gotzkowsky Collection, Berlin
1764	The Imperial Hermitage, St. Petersburg

REFERENCES

* *Catalogues. The Hermitage* 1863–1916, No.
747; R. H. Wilenski, *An Introduction to Dutch
Art*, London, 1928, p. 45; A. van Schneider, *Ca-
ravaggio und die Niederländer*, Marburg–Lahn,
1933, p. 130; G. Isarlo, *Le Caravage et le Cara-
vagisme européen*, Aix-en-Provence, 1951, p.
71; * *Catalogue. The Hermitage* 1958, 2, p. 130;
B. Nicolson, *Hendrick Terbrugghen*, The Ha-
gue, 1958, p. 45; Leonard J. Slatkes, *Dirck van
Baburen*, Utrecht, 1962, pp. 85–86, No. A 26;
* *Catalogue. Caravaggio and His Followers*
1973, No. 2; *Caravaggio and His Followers*
1975, Nos. 113–116.

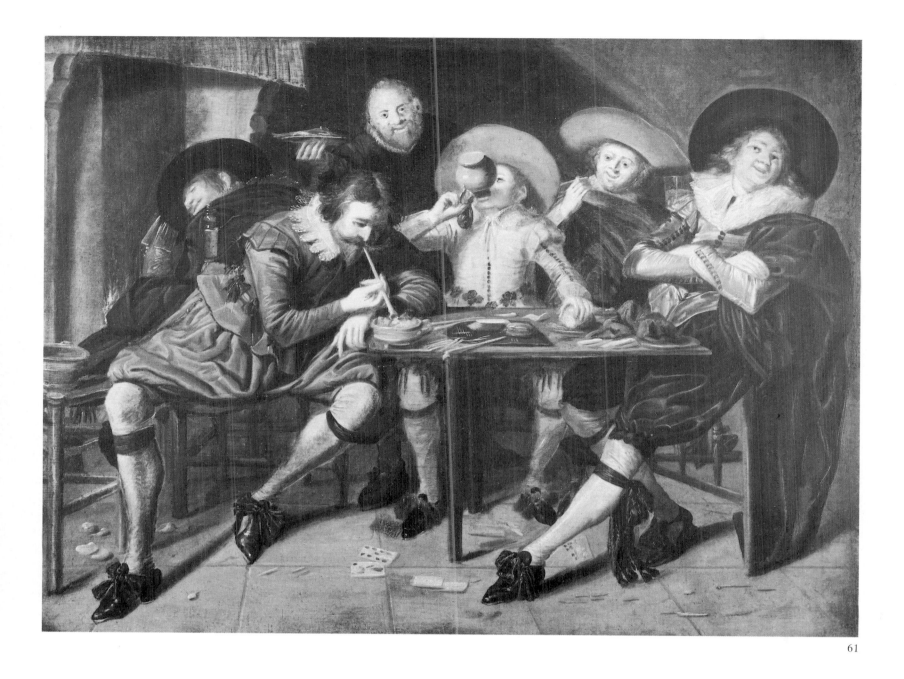

DIRCK HALS

Born 1591 in Haarlem, died there in 1656. Pupil of his elder
brother, Frans Hals. Worked in Haarlem. Painted genre scenes.

61

Merry Party in a Tavern

Oil on panel, 10 ⁷/₈×14 ¹/₈" (27.5×36 cm.)
Signed and dated, top right: D Hals 1626
The Hermitage, Leningrad. Inv. No. 3070

The picture was painted under the strong influence of Frans Hals's art.
For example, the merry old servant (in the background) first appeared in the
works of Frans Hals. A similar type features as a jester in several pictures by
Willem Buytewech.

PROVENANCE		REFERENCES
Until 1915	The P. Semionov-Tien-Shansky Collection, Petrograd	* Semionov 1885–90, p. 266; Semenov. *Etudes* 1906, p. XLIV, No. 189; * Shchavinsky 1909, p.
1915	The Imperial Hermitage, Petrograd	242; * *In Memory of Semionov* 1915, No. 18; * *Catalogue. The Hermitage* 1958, 2, p. 169; * Kuznetsov 1959, No. 39.

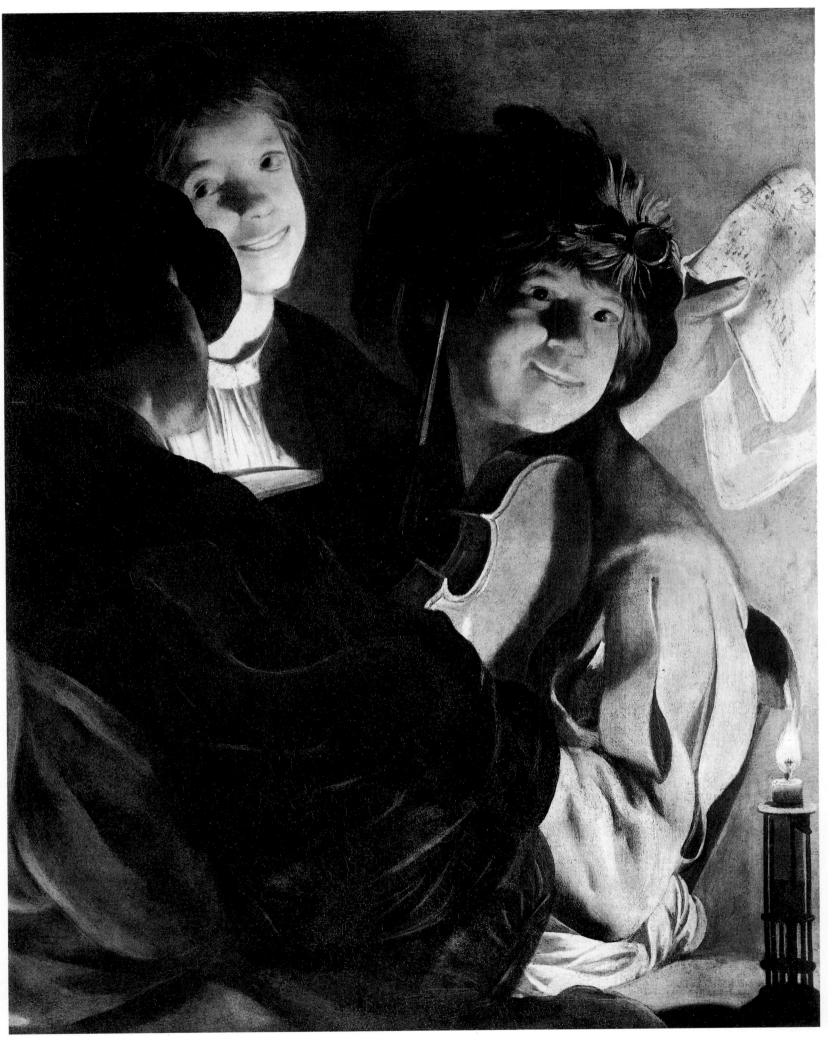

HENDRICK TERBRUGGHEN

Born 1588 in Deventer, died 1629 in Utrecht. Studied under
Abraham Bloemaert in Utrecht. Lived in Rome and Naples.
After ten years in Italy (according to documents) returned to
Utrecht (1614). Member of the Utrecht guild. Painted biblical
and genre scenes.

62

Musical Party

Oil on canvas, 40 1/4×32 5/8" (102×83 cm.)
Signed with monogram and dated on music sheet, right: HTB 1626
The Hermitage, Leningrad. Inv. No. 5599

Nicolson sees a stylistic affinity between the Hermitage canvas and Gerrit
van Honthorst's *Concert* (1623, Nationalmuseet, Copenhagen), *Merry Party*
(Alte Pinakothek, Munich) and *The Matchmaker* (Centraal Museum,
Utrecht).

PROVENANCE		REFERENCES
Until 1921	The V. Argutinsky-Dolgoruky Collection, Petrograd	* *Catalogue. The Hermitage* 1956, pp. 87–88;
1921	The Hermitage, Petrograd	* *Catalogue. The Hermitage* 1958, 2, p. 281; B. Nicolson, *Hendrick Terbrugghen*, The Hague, 1958, pp. 87–88; * *Catalogue. Caravaggio and His Followers* 1973, No. 60; *Caravaggio and His Followers* 1975, No. 112.

GERRIT VAN HONTHORST

Born 1590 in Utrecht, died there in 1656. Pupil of Abraham
Bloemaert. Visited Italy (late 1610s). Lived mostly in Rome,
fulfilling numerous commissions for churches and palaces;
among his patrons were the Marquis Vincenzo Giustiniani and
the Grand Duke of Tuscany. Member of the Utrecht guild
(1620–22). Was invited to England by Charles I. In the same
year fulfilled a major commission for the Stadtholder of The
Hague, decorating his castles. Lived the last four years of his life
in Utrecht. Painted portraits, genre scenes, historical
and allegorical pictures.

63 →

The Guitar Player

Oil on canvas, 33×26 1/2" (84×67.5 cm.)
Signed and dated, top right: G. Honthorst 1631
Art Gallery, Lvov. Inv. No. 788

Companion picture to *The Cellist* (*see* plate 64).

PROVENANCE		REFERENCES
Until 1939	The Stazerski Collection, Lvov The Bowarski Collection, Lvov	* *Catalogue. Lvov* 1955, p. 96; * Kuznetsov 1959, No. 26.
1939	Art Gallery, Lvov	

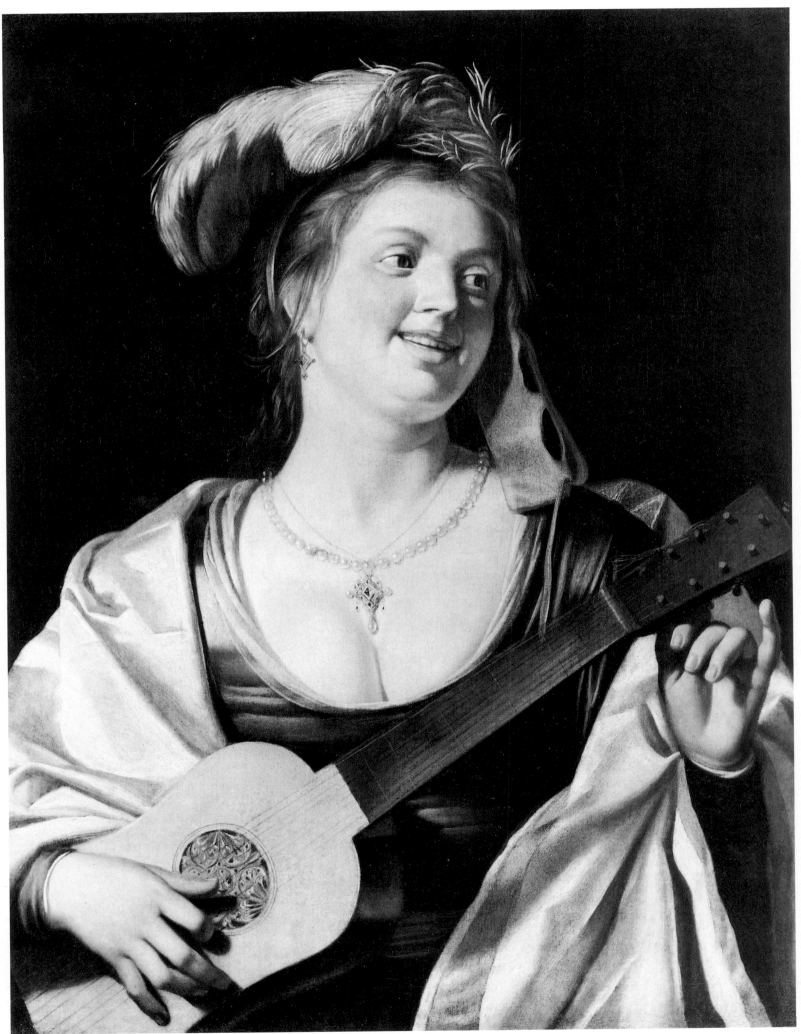

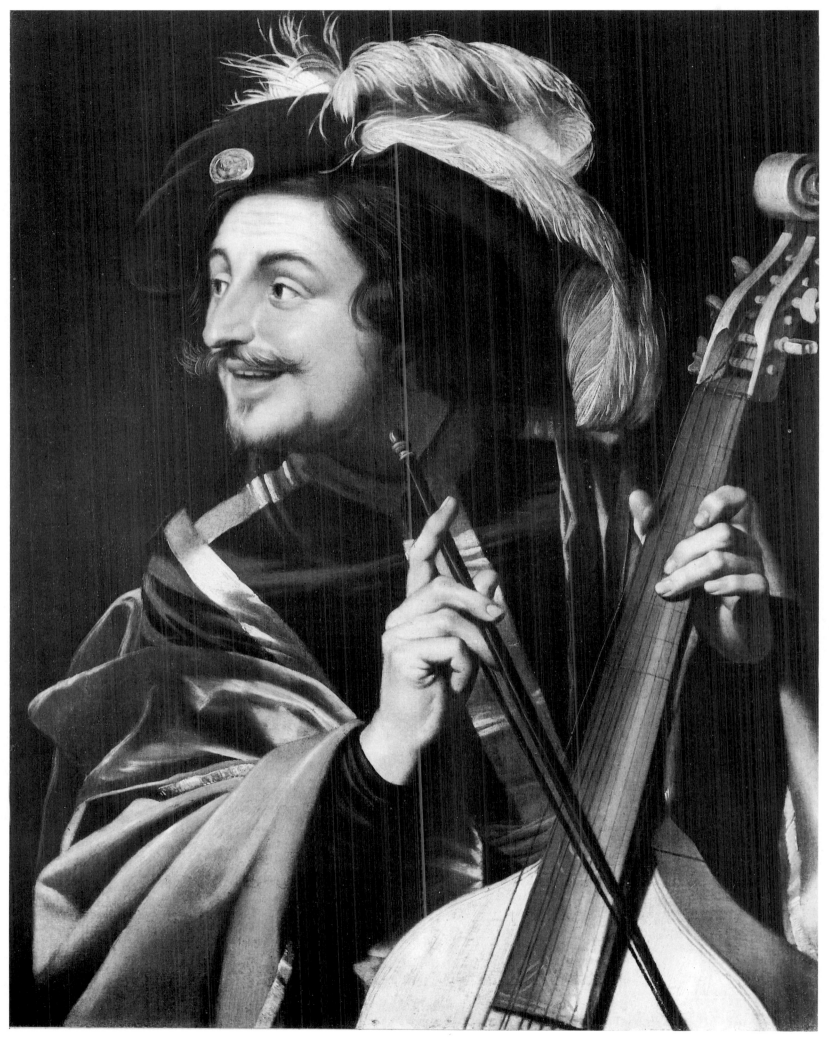

← 64

The Cellist

Oil on canvas, 33×26 ¹/₂" (84×67.5 cm.)
Signed and dated, top left: G. Honthorst 1631
Art Gallery, Lvov. Inv. No. 789

Companion picture to *The Guitar Player* (*see* plate 63).

Provenance and References: *see under* plate 63.

HERMAN VAN ALDEWERELT

Born 1628 or 1629 in Amsterdam, died there in 1669.
A self-taught artist, he imitated the Utrecht Caravaggists.
Painted genre and allegorical compositions.

65

Musical Party

Oil on canvas, 40 ⁷/₈×37" (104×94 cm.)
Signed and dated, top left corner: H. v. Alde (the ending of the signature is
*given in an ideogram in the shape of a sphere with a cross—*werelt *means*
'world' in Dutch) 1652
The Hermitage, Leningrad. Inv. No. 3334

	PROVENANCE	REFERENCES
Until 1915	The P. Semionov-Tien-Shansky Collection, Petrograd	* Semionov 1885–90, pp. 247–249; *Catalogue Semenov* 1906, No. 2; Semenov. *Etudes* 1906, p.
1915	The Imperial Hermitage, Petrograd	XXXV; * *Catalogue. The Hermitage* 1958, 2, p. 127; * *Catalogue. Caravaggio and His Followers* 1973, No. 1; *Caravaggio and His Followers* 1975, Nos. 133–135.

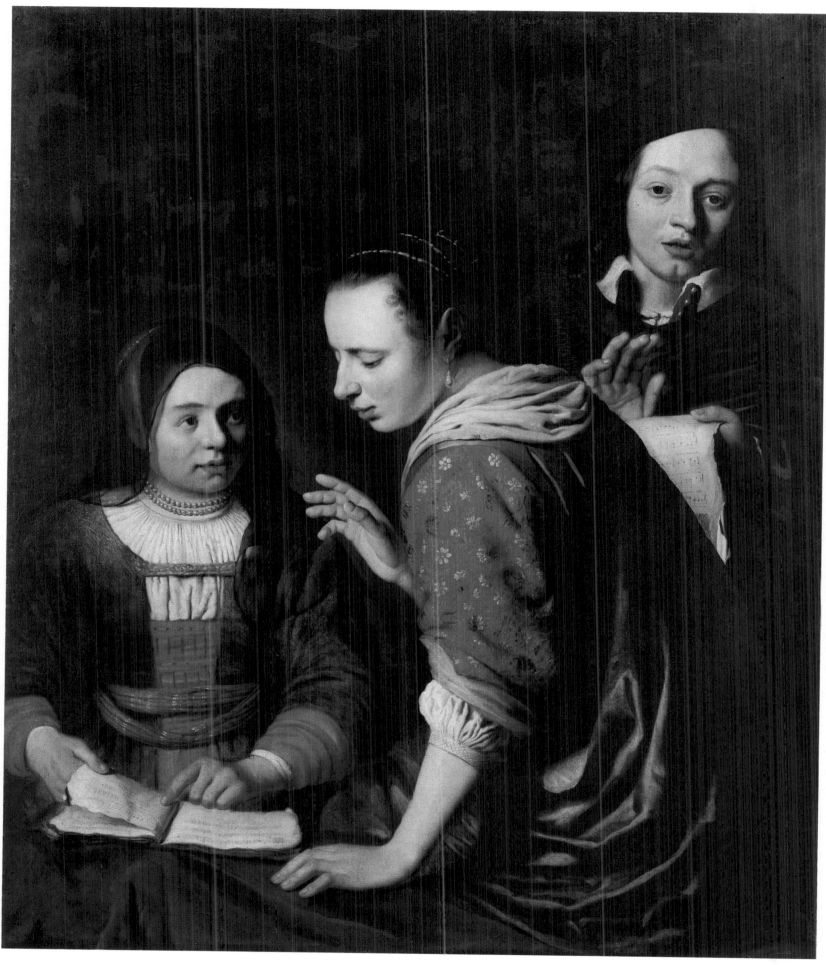

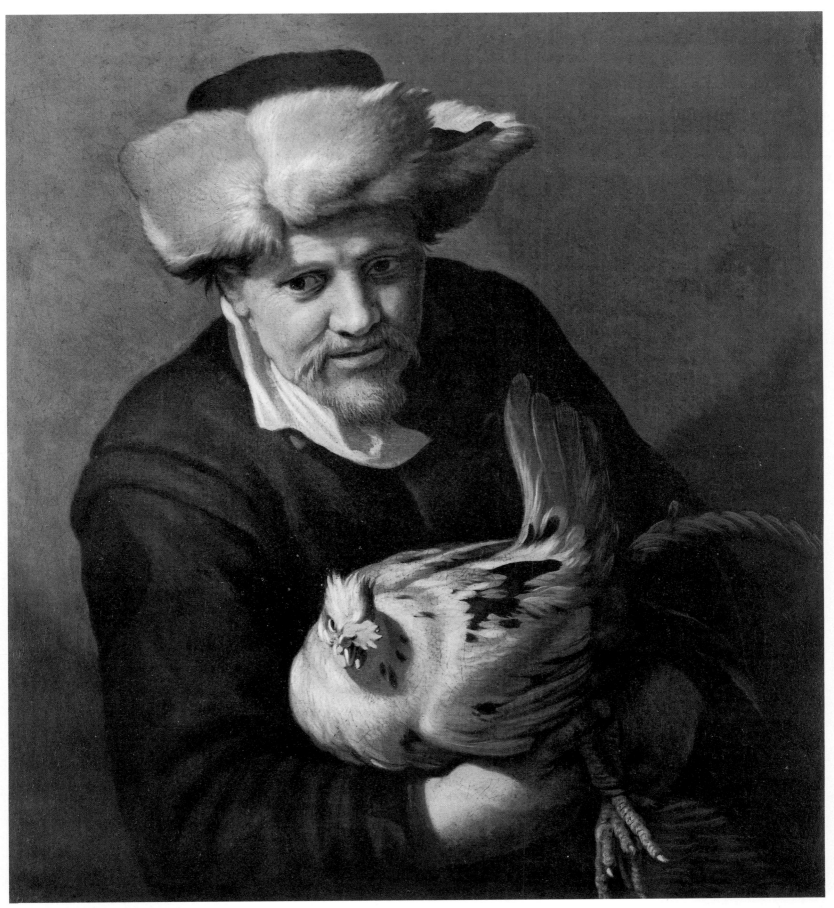

66

ABRAHAM BLOEMAERT

Born 1564 in Gorinchem, died 1651 in Utrecht. Studied under
Cornelis Bloemaert (his father), Joos de Beer, and Geryt
Splinter in Utrecht. Worked in Utrecht and Amsterdam
(1591–93). Painted biblical, mythological, and allegorical scenes,
also landscapes and portraits.

66

Old Man with a Rooster

Oil on canvas, 28 ¼×25 ⅝" (72×65 cm.)
Signed on background, right: A. Bloemaert fec.
The Hermitage, Leningrad. Inv. No. 9807

PROVENANCE		REFERENCES
Until 1959	State Museum Reserve, Leningrad	J. Fechner, "Die Bilder von Abraham Bloemaert in der staatlichen Eremitage zu Leningrad,"
1959	The Hermitage, Leningrad	*Kunsthistorisches Jahrbuch der Universität Graz*, VI, 1971, pp. 111–117.

JACOB GERRITSZ CUYP

Born 1594 in Dordrecht, died there about 1651. Pupil
of Abraham Bloemaert in Utrecht. Worked in Dordrecht.
Painted portraits, biblical and genre scenes.

67 →

Girl with a Rooster

Oil on panel, 21 ¾×17 ¾" (55.4×45.2 cm.)
Art Museum of the Estonian SSR, Tallinn. Inv. No. M-438

Companion picture to *Boy with a Goose* (see plate 68). Variants of this
work and its companion piece were in 1910 in the Flory Collection, Paris
(the Kleitberger sale, 1911, Nos. 17, 18).

PROVENANCE		REFERENCES
Until 1940	Collection of the antique dealer Cangro, Tartu	*Catalogue. Tallinn* 1953, p. 12; * *Catalogue. The Hermitage* 1964, p. 20; * Kuznetsov 1967, p. 11,
1940	Art Museum of the Estonian SSR, Tallinn	No. 32; *Catalogue. Tallinn* 1970, p. 19.

68 →

Boy with a Goose

Oil on panel, 21 ⅝×17 ⅞" (55×45.4 cm.)
Inscribed, bottom left: Mon-oÿo faict toût (My goose does everything, which
means 'Money does everything');
J. G. Cuyp fecit.
Art Museum of the Estonian SSR, Tallinn. Inv. No. M-439

Companion picture to *Girl with a Rooster* (see plate 67).

	REFERENCES
Provenance: *see under* plate 67.	*Catalogue. Tallinn* 1953, p. 12; * *Catalogue. The Hermitage* 1964, p. 20; * Kuznetsov 1959, No. 9; *Catalogue. Tallinn* 1970, p. 21.

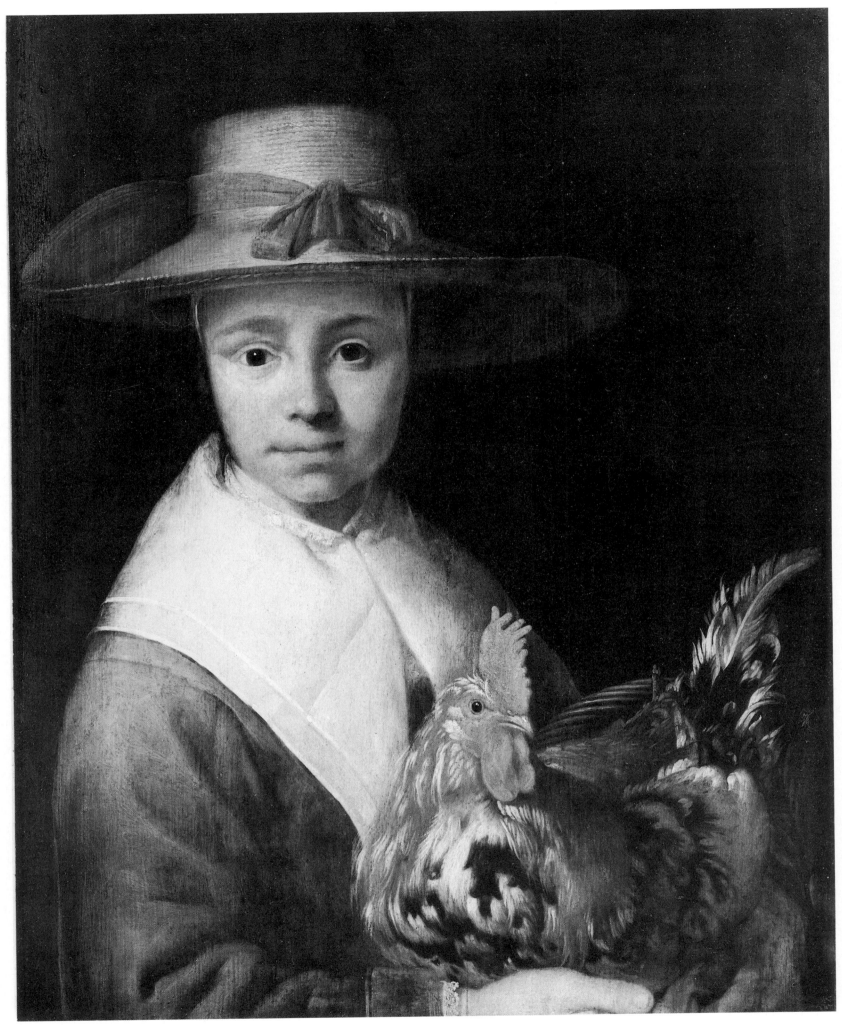

67

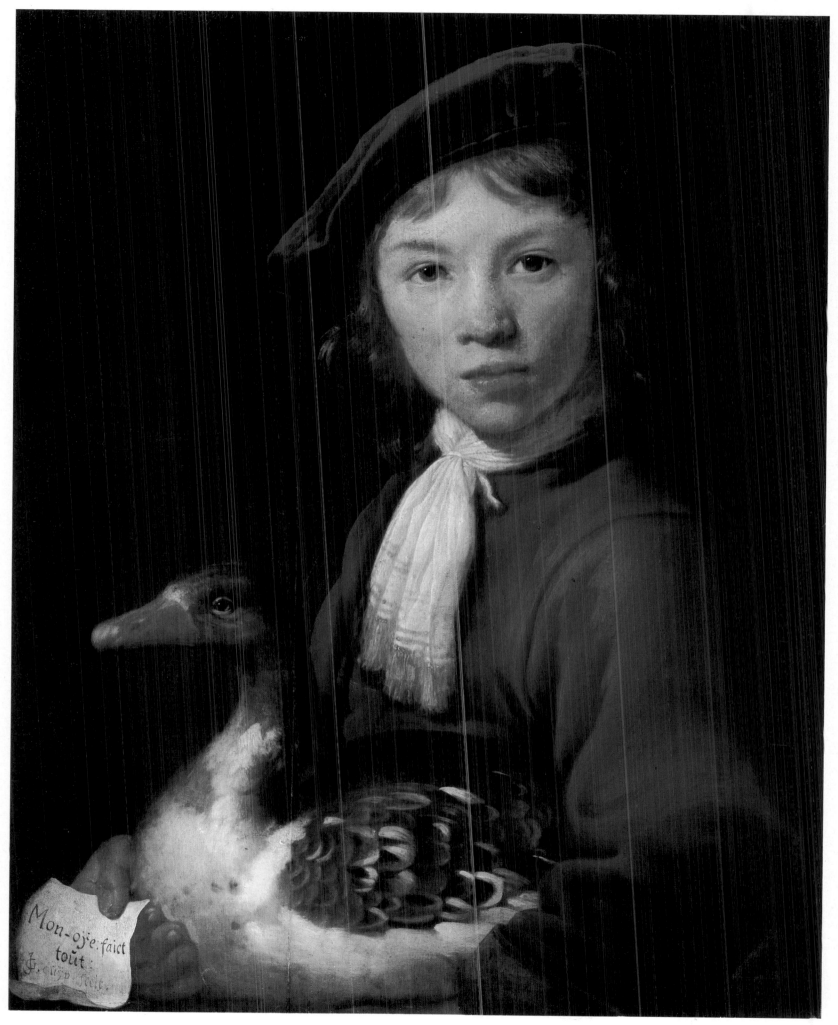

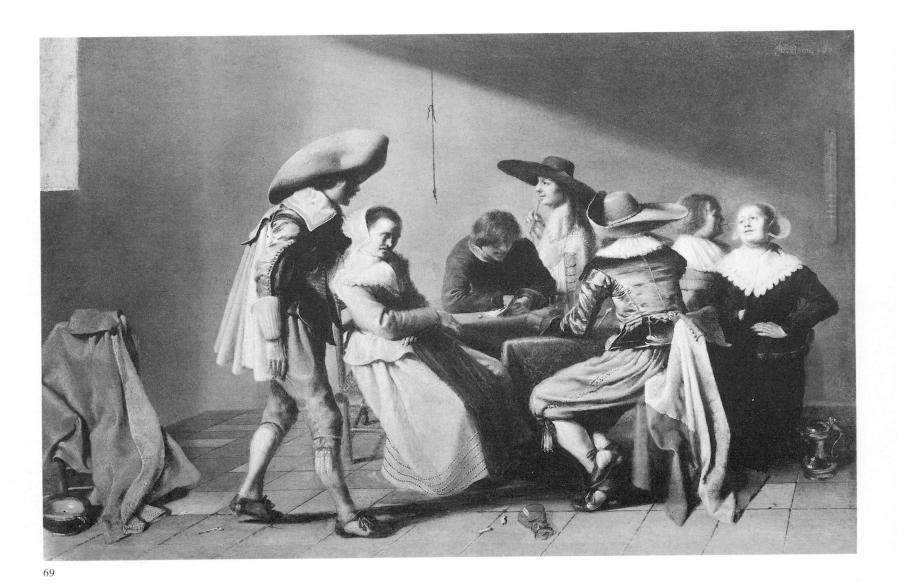

69

JACOB VAN VELSEN

Date and place of birth unknown, died in 1656 in Amsterdam.
Worked in Delft (from 1625) and Amsterdam.
Painted genre scenes.

69

Reading a Letter

Oil on panel, 14 ³/₄×22″ (37.5×56 cm.)
Signed and dated, top right: J v Velsen 1633
The Hermitage, Leningrad. Inv. No. 813

This is one of the few pictures by the artist to have come down to our day.

PROVENANCE	REFERENCES
Before 1797 The Imperial Hermitage, St. Petersburg	* *Catalogues. The Hermitage* 1863–1916, No. 1695; * *Catalogue. The Hermitage* 1958, 2, p. 151; Plietzsch 1960, p. 34.

ANTHONIE PALAMEDESZ

Biography: *see under* plate 43.

70

Musical Party

Oil on panel, 17 1/2×25" (44.5×63.5 cm.)
The Hermitage, Leningrad. Inv. No. 897

PROVENANCE

Before 1797 The Imperial Hermitage.
St. Petersburg

REFERENCES

* *Catalogues. The Hermitage* 1863–1916, No.
932; * *Catalogue. The Hermitage* 1958, 2, p. 236.

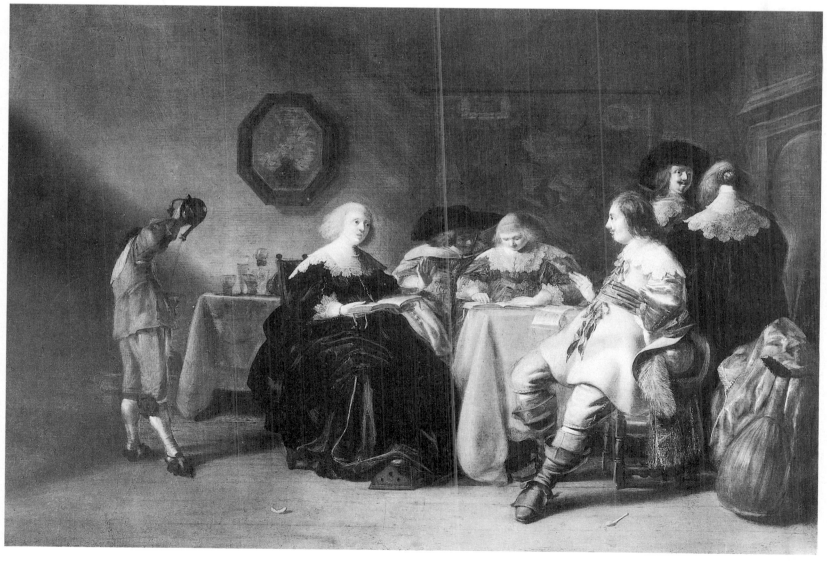

JAN MIENSE MOLENAER

Born around 1610 in Haarlem, died there in 1668.
Probably studied under Frans Hals, was influenced by
the art of Adriaen Brouwer. Worked in Haarlem
(1636), Amsterdam (1637–48, 1655), Heemstede
(from 1648), and again in Haarlem. Apart from
portraits and religious pictures, his work consists
entirely of genre subjects.

71

The Lacemaker

Oil on panel, 12 1/4×14 1/8" (31×36 cm.)
Signed with monogram, bottom right: MR
The Hermitage, Leningrad. Inv. No. 3500

The picture has certain qualities that pertain to the workshop of
Frans Hals; it should therefore be dated not later than the 1630s.

PROVENANCE		REFERENCES
Until 1915	The V. Zurov Collection, Tsarskoye Selo	* Schmidt 1916, No. 14; * *Catalogue. The Hermitage* 1958, 2, p. 293.
1915	The Imperial Hermitage, Petrograd (gift of V. Zurov)	

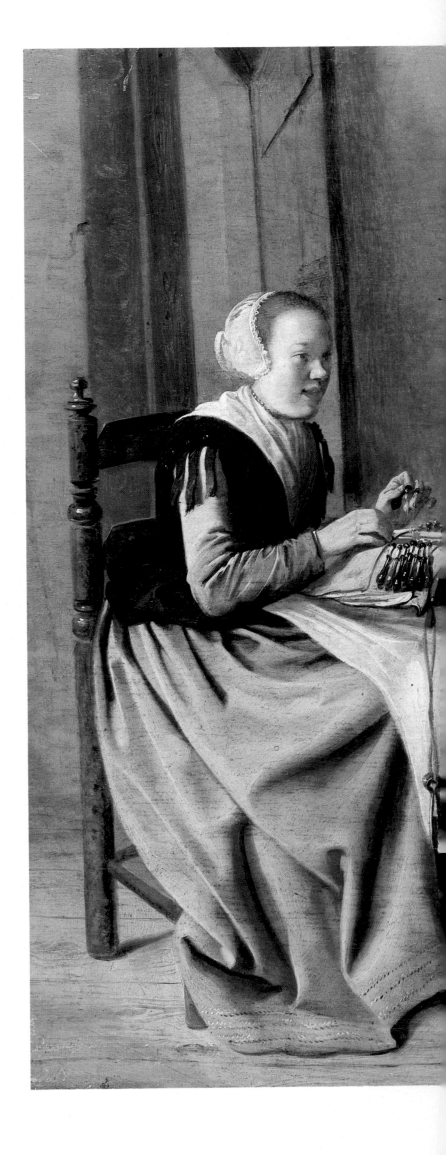

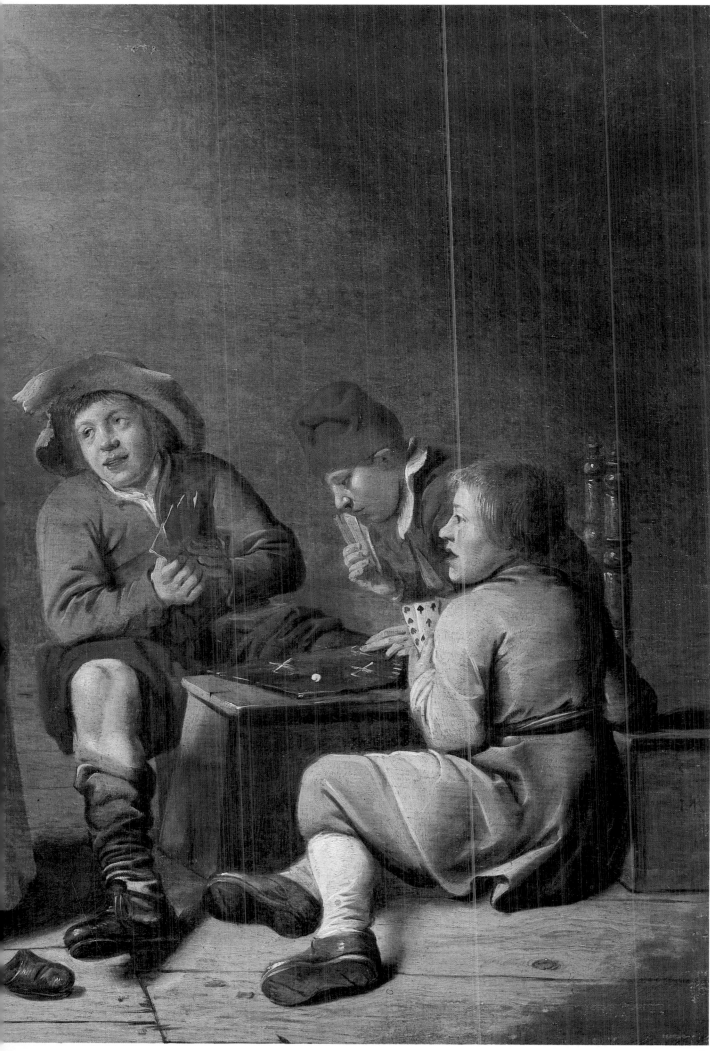

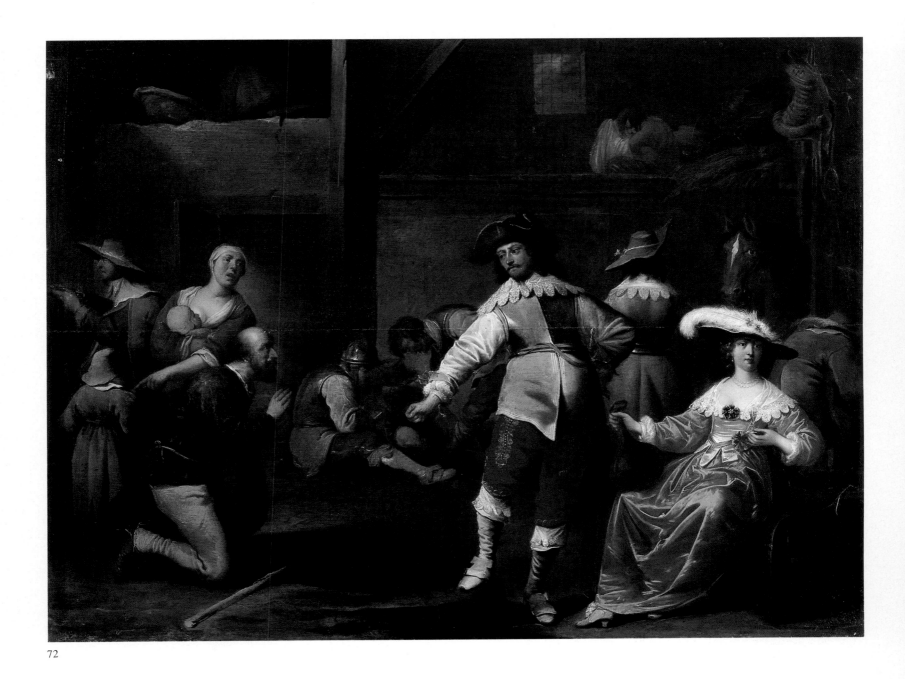

72

PIETER QUAST

Born 1605 or 1606 in Amsterdam, died there in 1647.
Was influenced by the art of Adriaén Pietersz van de Venne
and Adriaén Brouwer. Worked in Amsterdam and The Hague.
Painted genre scenes, occasionally biblical
and mythological subjects.

72

Scene in a Guardhouse

Oil on panel, 18 1/2 × 24 5/8" (47×62.5 cm.)
Signed with monogram, bottom center: PQ
The Lunacharsky Art Museum, Krasnodar. Inv. No. 241

PROVENANCE		REFERENCES
Until 1925	State Museum Reserve, Leningrad	* *Catalogue. Krasnodar* 1953, No. 483.
1925	The Lunacharsky Art Museum, Krasnodar	

JACOB DUCK

Born around 1600 in Utrecht, died there after 1660.
Pupil of Joost Cornelisz Droochsloot. Worked in Utrecht
and The Hague. Painted genre scenes.

73

The Card Game

Oil on panel, 16 1/8×20 3/8" (41×52 cm.)
The Radishchev Art Museum, Saratov. Inv. No. 35

Attributed to Jacob Duck by Irene Linnik (verbally). Formerly ascribed to an
unknown Dutch painter of the seventeenth century.

PROVENANCE		REFERENCES
Until 1920	Department of Fine Arts, Saratov	* Kuznetsov 1959, No. 40; * *Catalogue. The*
1920	The Radishchev Art Museum, Saratov	*Hermitage* 1964, p. 17; * *Catalogue. Saratov* 1969, p. 8.

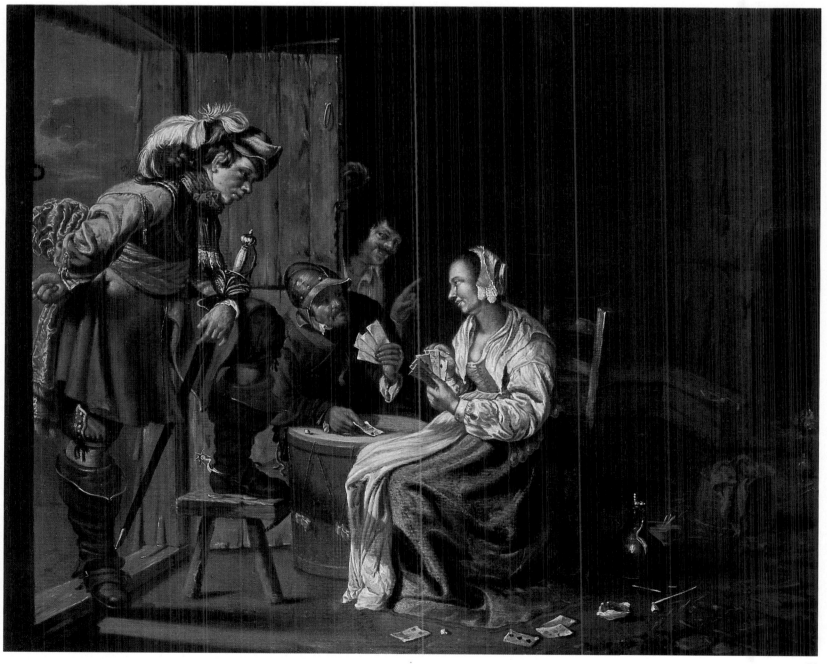

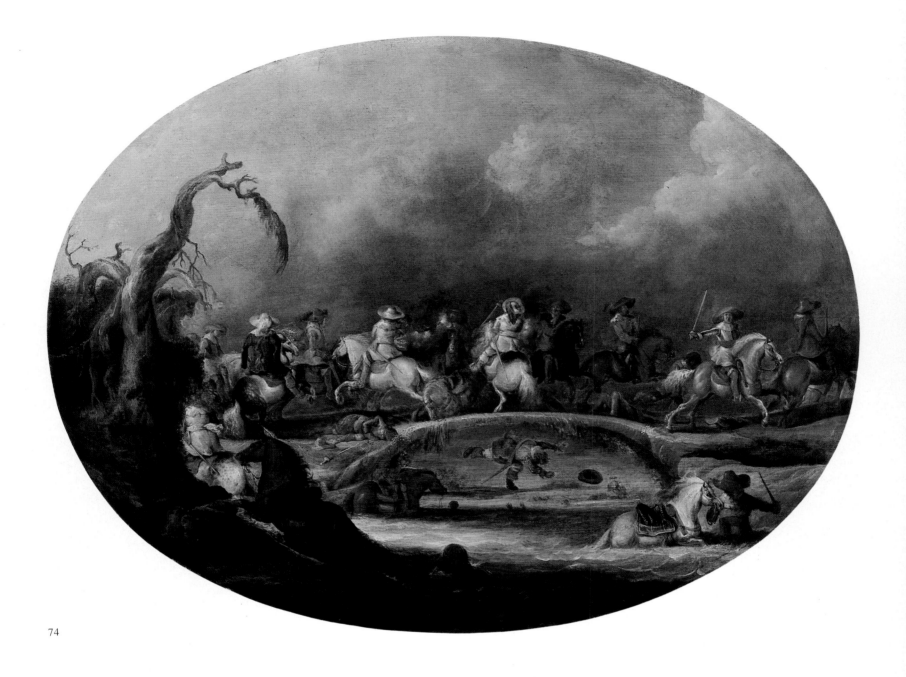

74

JAN MARTSZEN THE YOUNGER

Born around 1609 in Haarlem, died after 1647.
Was influenced by the art of Esaias van de Velde (his uncle).
Worked in Amsterdam (1629–45) and Delft.
Painted landscapes and battle scenes.

74

The Battle on the Bridge

Oil on panel, 24 ³/₄× 33 ³/₈″ (63×85 cm.), oval
Signed, bottom left: J Marts. fec.
The Lunacharsky Art Museum, Krasnodar. Inv. No. 481

PROVENANCE

Until 1938 State Museum Reserve, Lenin-
grad
1938 The Lunacharsky Art Museum,
Krasnodar

REFERENCES

* *Catalogue. Krasnodar* 1953, No. 502;
* Kuznetsov 1959, No. 6.

ABRAHAM VAN HOEF

Born 1611 or 1612 in Delft, died 1666 in Haarlem.
Worked in Delft and Haarlem. Painted battle scenes.

75

A Battle

Oil on panel, 18 ³/4×32 ¹/2" (48×82.5 cm.)
Signed and dated, bottom right: AVHoef 1641
Art Museum of the Estonian SSR, Tallinn. Inv. No. 1720

This picture was definitely influenced by the art of Jan Martszen the Younger
and Anthonie Palamedesz.

PROVENANCE	REFERENCES
The R. von Liphart Collection, Tartu	*Eesti Rahva Muuseumi Kunsti ja Kultuurilooliste kogude juht.*, Tartu, 1934, No. 35; *Catalogue.*
Until 1947 Ethnographical Museum, Tartu	*Tallinn* 1953, p. 18; *Catalogue. Tallinn* 1970,
1947 Art Museum of the Estonian SSR, Tallinn	p. 27.

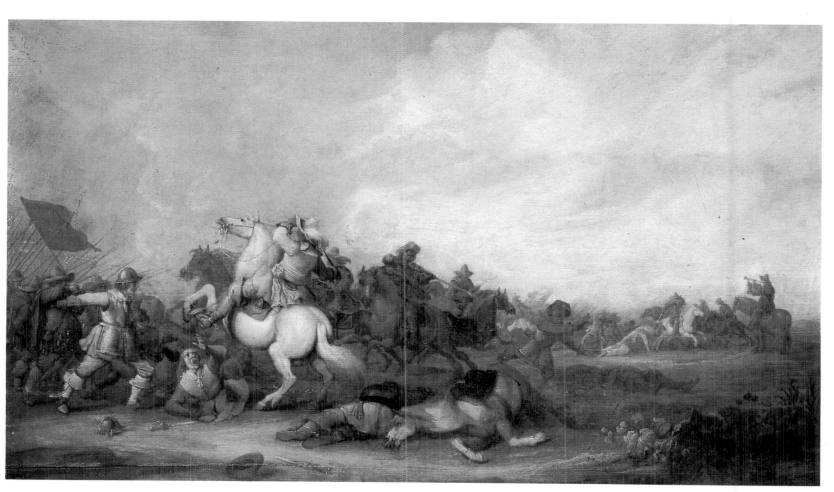

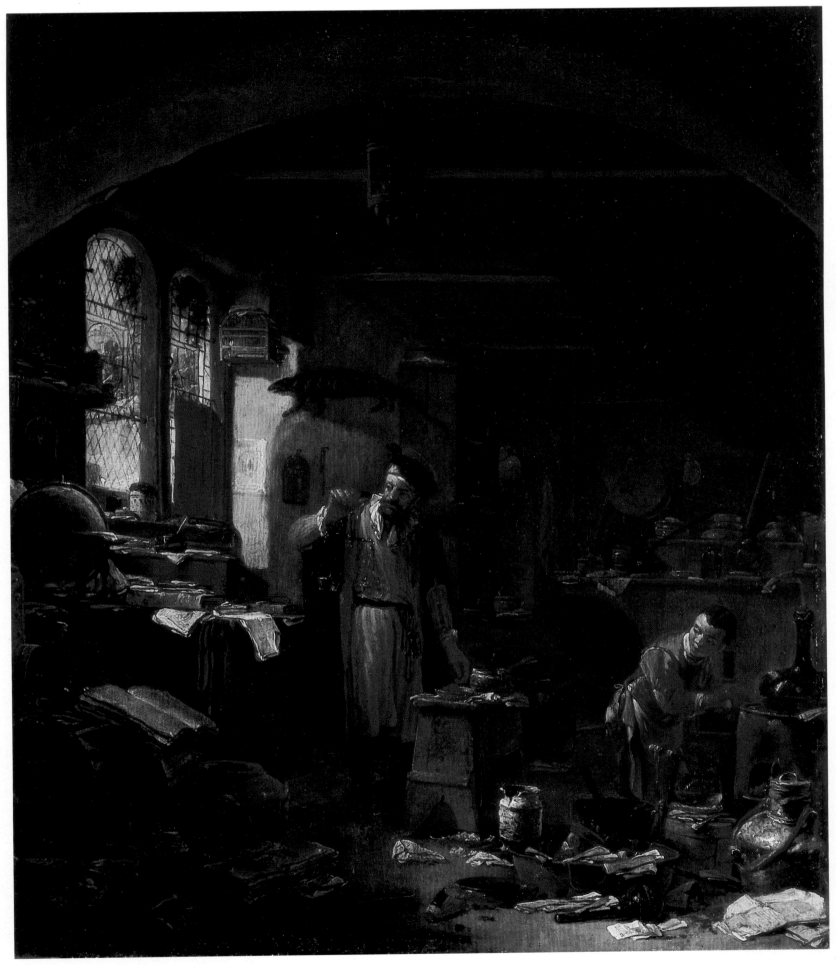

76

THOMAS WIJK

Born about 1616 in Beverwyck, died 1677 in Haarlem.
Visited Italy and London (about 1660). Worked in Haarlem.
Painted landscapes and genre scenes.

76

The Alchemist

Oil on panel, 16 ¹/₈ × 14' (41×35.5 cm.)
Signed, bottom left: T. Wijk
The Hermitage, Leningrad. Inv. No. 1942

This is a companion picture to *Scientist in His Study*, also in the Hermitage
(inv. No. 1943).

	PROVENANCE	REFERENCES
Until 1772	The Pierre Crozat Collection, Paris	* *Catalogues. The Hermitage* 1863–1916, No. 1100; * *Catalogue. The Hermitage* 1958, 2, p. 148.
1772	The Imperial Hermitage, St. Petersburg	

JAN AERTSEN (?) MARIENHOF

Worked in Utrecht in the mid-seventeenth century.
Was influenced by the art of Nicolaus Knüpfer and Rembrandt.
Painted biblical and genre scenes.

77 →

The Artist's Workshop

Oil on panel, 14 ³/₄ × 12 ⁷/₈" (37.5×32.5 cm.)
Signed with monogram and dated, bottom right: JAMhof 1648
The Hermitage, Leningrad. Inv. No. 974

	PROVENANCE	REFERENCES
Until 1768	The Karl Cobenzl Collection, Brussels	* *Catalogues. The Hermitage* 1863–1916, No. 1256; * *Catalogue. The Hermitage* 1958, 2, p. 215.
1768	The Imperial Hermitage, St. Petersburg	

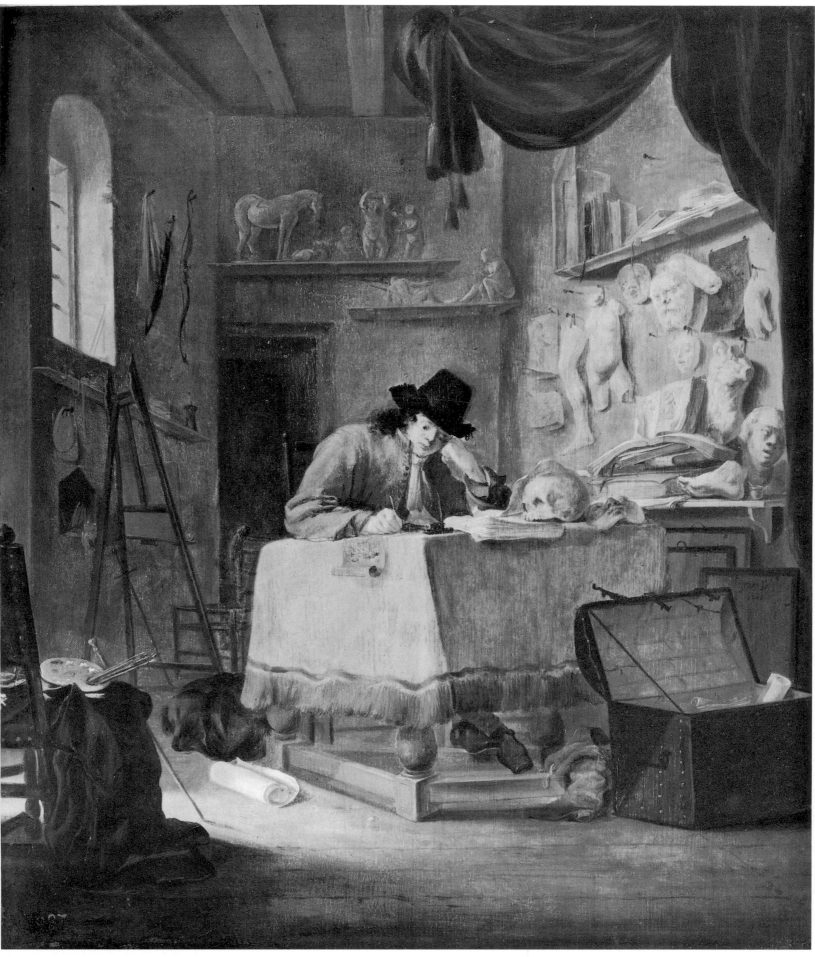

77

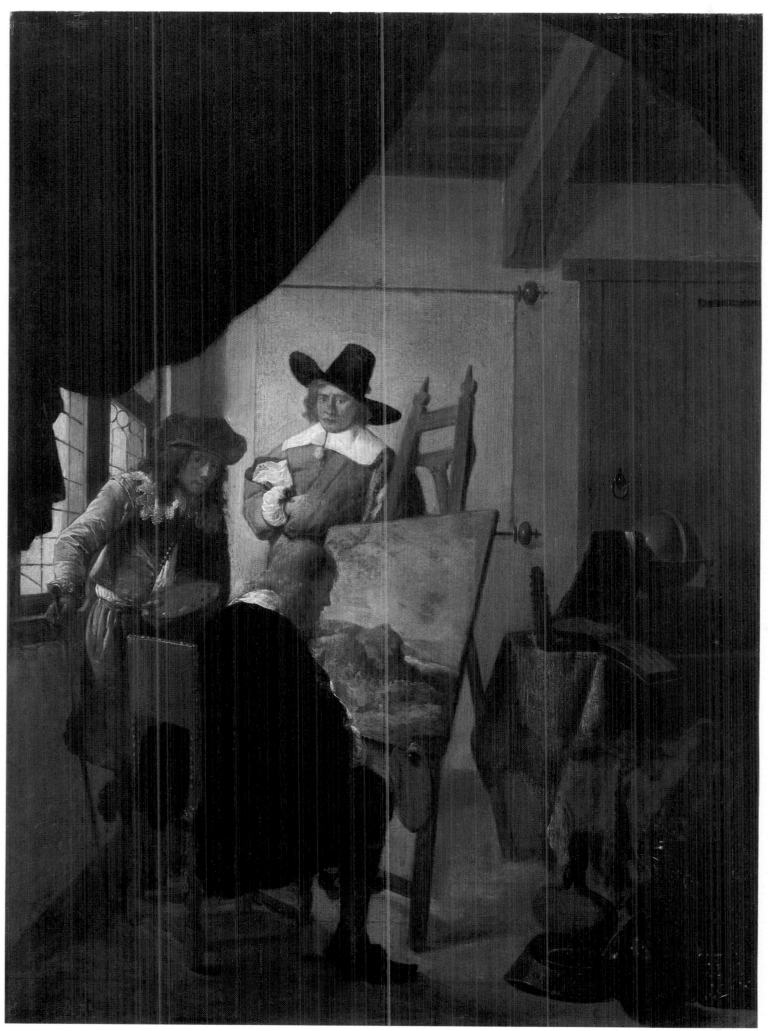

JOB ADRIANSZ BERCKHEYDE

Born 1630 in Haarlem, died there in 1693. Pupil of Jacob
Willemsz de Wet. Traveled to Germany. Worked in Haarlem.
Painted townscapes, genre and biblical scenes, and landscapes.

← 78

The Artist's Workshop

Oil on panel, 19 1/4 × 14 3/8" (49×36.5 cm.)
Signed with monogram and dated on backrest of chair (worn and faint): B 1659
The Hermitage, Leningrad. Inv. No. 965

The man with the palette standing by the window and facing the viewer is
Job Adriansz Berckheyde himself. This can be corroborated by comparing
this likeness with a Berckheyde self-portrait housed in the Uffizi Gallery in
Florence (cat. No. 434). The Uffizi work also depicts, hanging on a wall, the
artist's third known self-portrait (Frans Hals Museum, Haarlem, cat. No. 389).
The resemblance between all three persons is undeniable.

PROVENANCE

Until 1769 The Heinrich Brühl Collection,
Dresden

1769 The Imperial Hermitage,
St. Petersburg

REFERENCES

* *Catalogues. The Hermitage* 1863–1916, No.
921; L. Goldschneider, *Fünfhundert Selbstpor-
träts von der Antike bis zur Gegenwart*, Vienna,
1936, No. 250; * *Catalogue. The Hermitage*
1958, 2, p. 136; G. Eckardt, *Selbstbildnisse nie-
derländischer Maler des 17. Jahrhunderts*, Ber-
lin, 1971, p. 169.

→

JAN VAN BIJLERT

Born 1598 in Utrecht, died there in 1671. Pupil of Herman van
Bijlert (his father), a glass painter, and Abraham Bloemaert.
Together with Jan Gerritsz van Bronckhorst and Cornelis van
Poelenburgh went to Italy, where he lived in Rome (1621–24).
Member of the Utrecht guild (1630), later its dean (1633–35).
Painted portraits, historical, and allegorical subjects.

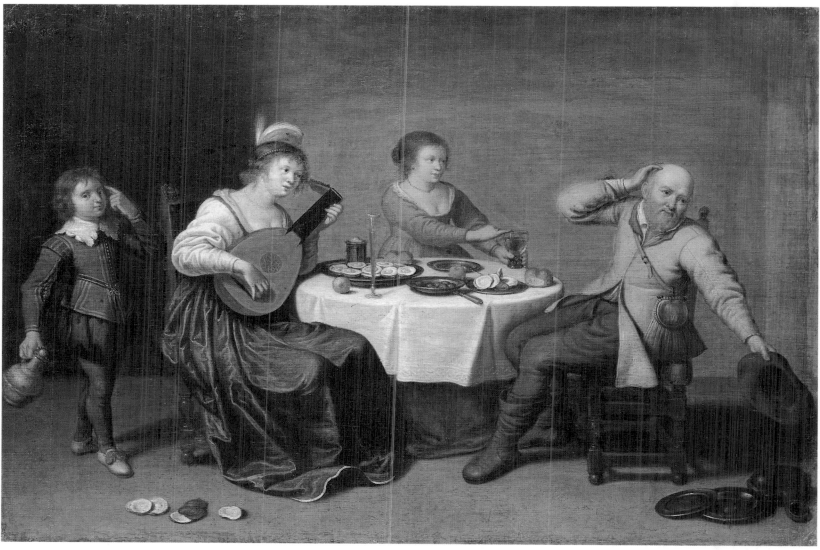

79

The Revel

Oil on panel, 14 ½×21 ⅞" (37×55.5 cm.)
The Hermitage, Leningrad. Inv. No. 2247

This picture remained long unattributed. It was produced by Jan Bijlert at
a time (the second half of the 1630s) when, in contrast to his earlier, purely
Caravaggesque works, he turned, in imitation of Dutch genre painters, to the
small-figure genre scene. Very few such pictures by Jan van Bijlert were
known earlier. *The Revel* entered the Hermitage as a work by an unknown
seventeenth-century Dutch artist of the school of Anthonie Palamedesz (who
worked in Delft and Amsterdam), then was ascribed to the Rotterdam
painter Pieter de Bloot. Finally, it was attributed to an unknown Dutch artist
of the seventeenth century. The picture was assigned to Jan van Bijlert by
Irene Linnik on the basis of its comparison with that painter's other works:
Musical Party (Gemeentemuseum, The Hague), the so-called *Feast of
Cleopatra* (Gemäldegalerie, Berlin), and *Satyr and Nymph* (the Sabatello
Collection, Rome).

PROVENANCE

From 1859 The Imperial Hermitage,
St. Petersburg

REFERENCES

* Linnik 1973, pp. 8–12; * *Catalogue. Caravaggio and His Followers* 1973, No. 3.

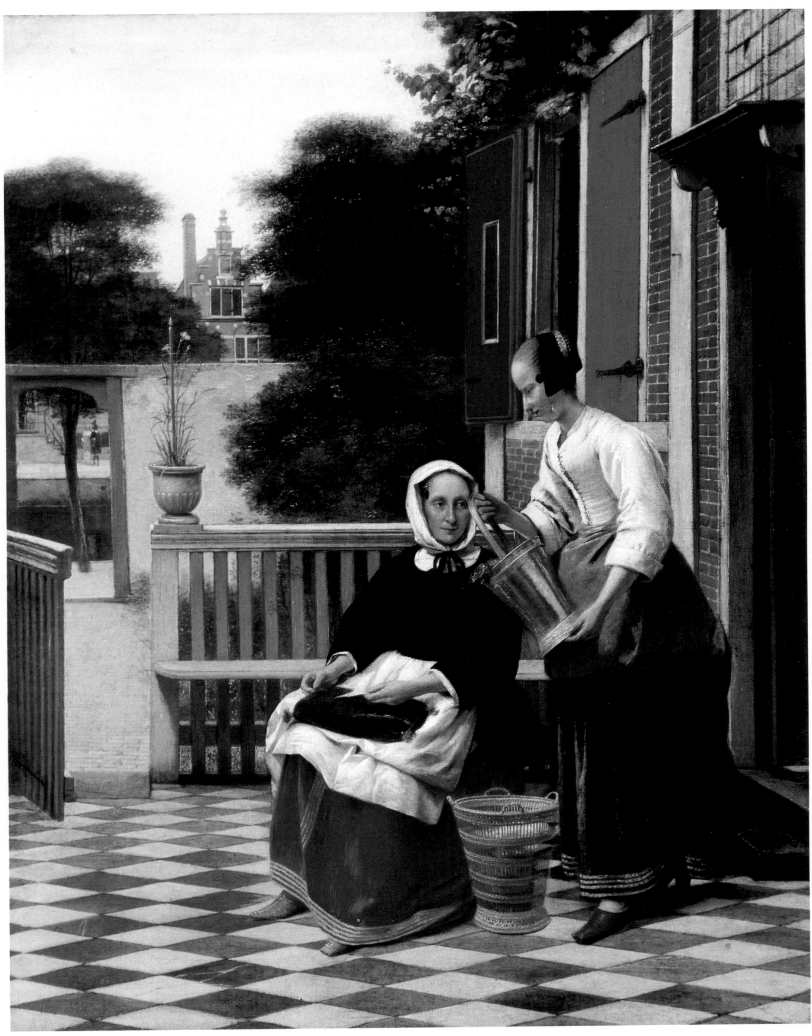

PIETER DE HOOCH

Born 1629 in Rotterdam, died in Amsterdam in 1684. Pupil of
Nicolaes Berchem. Was influenced by the art of Jacob Duck
and Anthonie Palamedesz, later of Carel Fabritius and Jan
Vermeer of Delft. Worked in Amsterdam (1653), The Hague
and Leyden (between 1653 and 1657), again in Amsterdam,
and Delft (1667). Painted genre scenes.

80

A Woman and Her Maid

Oil on canvas, 20 3/4×16 1/2" (53×42 cm.)
The Hermitage, Leningrad. Inv. No. 943

Painted around 1660, this is one of the artist's finest works.

PROVENANCE		REFERENCES
1808	Sale at Mont de Piété, Paris	* *Catalogues. The Hermitage* 1863–1916, No.
Until 1810	The Lafontaine Collection, Paris	860; Hofstede de Groot, I, No. 41; W. R. Va-
1810	The Imperial Hermitage,	lentiner, *Pieter de Hooch* (*Klassiker der Kunst*),
	St. Petersburg	1929, p. 47; * *Catalogue. The Hermitage* 1958,
		2, p. 187.

81 →

The Soldier and the Servant-girl

Oil on panel, 28×23 1/4" (71×59 cm.)
The Hermitage, Leningrad. Inv. No. 6316

Painted about 1653. Some scholars, including W. R. Valentiner and
E. R. Vipper, ascribe the picture to Gabriel Metsu. In spite of a certain
affinity (mainly in the type of the persons portrayed) with Metsu's *Almsgiving*
(Gemäldegalerie: Alte Meister und Antikenabteilung, Kassel) and *The
Hunter's Gift* (Rijksmuseum, Amsterdam), the Hermitage picture is
definitely a work by de Hooch painted at the end of his first Delft period.

PROVENANCE		REFERENCES
	The Pieter Calckoen Collection,	Hofstede de Groot, I, No. 271; W. R. Valenti-
	Amsterdam	ner, *Pieter de Hooch* (*Klassiker der Kunst*),
1781	Sale in Amsterdam, 10 Sep-	1929, p. 289; W. von Bode, *Die Meister der hol-*
	tember (No. 65); the Duke of	*ländischen und flämischen Malerschulen* (8th
	Leuchtenberg's collection,	edition), Leipzig, 1956, p. 102; * *Catalogue.*
	St. Petersburg	*The Hermitage* 1958, 2, p. 187; * Vipper 1960,
Until 1930	Museum of Fine Arts, Moscow	p. 318.
1930	The Hermitage, Leningrad	

81

PIETER CORNELISZ VAN SLINGELANDT

Born 1640 in Leyden, died there in 1691. Pupil of Gerrit Dou.
Worked in Leyden. Painted genre scenes and portraits.

82 →

The Kitchen

Oil on panel, 10×8″ (25.5×20.5 cm.)
Signed with monogram and dated on seat of bench,
left (worn and faint): P 1648
The Hermitage, Leningrad. Inv. No. 895

In the Brühl Collection and for a long time in the Hermitage this piece was
considered a work by Gerrit Dou. J. Smith attributed it to Pieter van
Slingelandt. Waagen believes the head of the woman to have been done by
Cornelis van Poelenburgh and not by Egbert van der Poel to whom the
picture was ascribed in all Hermitage catalogues from 1863 to 1916.

PROVENANCE		REFERENCES
Until 1769	The Heinrich Brühl collection, Dresden	J. Smith, *A Catalogue Raisonné of the Works of the Most Eminent Dutch, Flemish and French Painters*, vol. IX, London, 1842, p. 25, No. 3; * *Catalogues. The Hermitage* 1863–1916, No. 980; * *Catalogue. The Hermitage* 1958, 2, p. 269.
1769	The Hermitage, St. Petersburg	

JACOBUS VREL

Worked in the mid-seventeenth century in Amsterdam and Delft.
Painted townscapes and genre scenes.

83 →

Old Woman by the Fireplace

Oil on panel, 14 1/8×12 1/4″ (36×31 cm.)
Signed with monogram on backrest of chair: JV
The Hermitage, Leningrad. Inv. No. 987

Painted after 1654. Attributed to Jacobus Vrel by W. Bode. The picture was
formerly thought to have been done by an unknown seventeenth-century
Dutch artist.

PROVENANCE	REFERENCES
1797 The Imperial Hermitage, St. Petersburg	* *Catalogues. The Hermitage* 1863–1916, No. 1760; * *Catalogue. The Hermitage* 1958, 2, p. 168; Plietzsch 1960, p. 83.

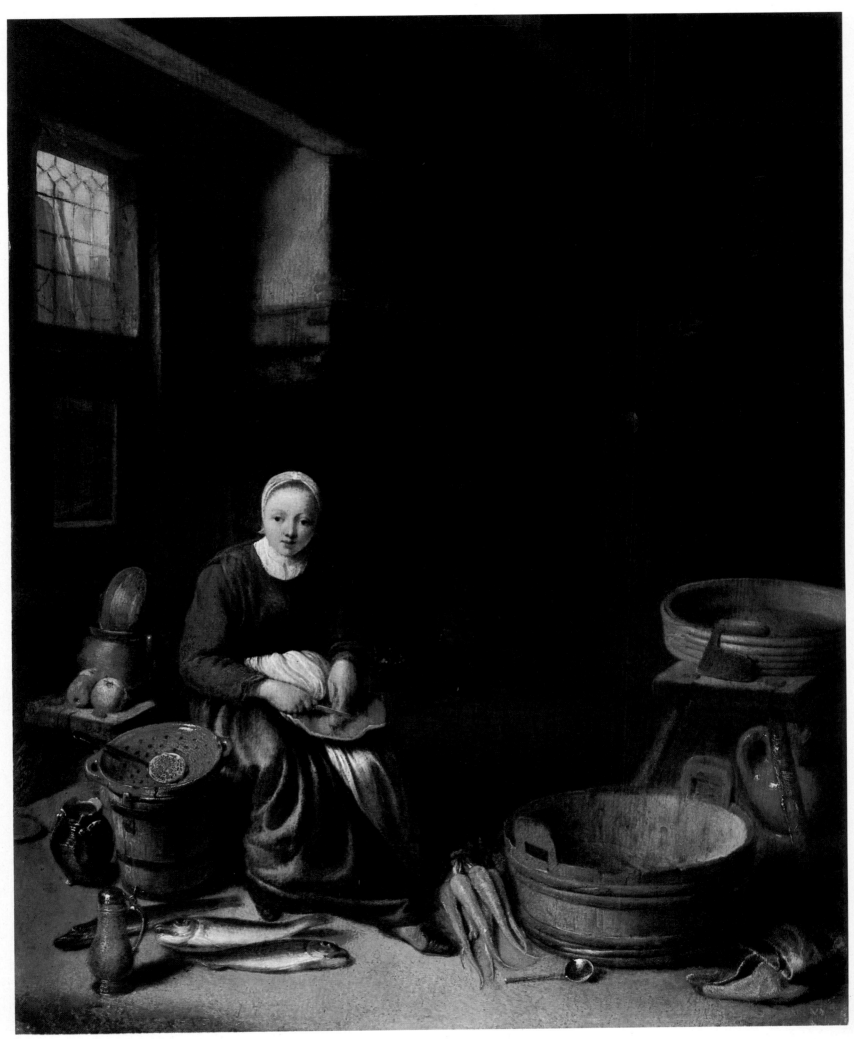

82

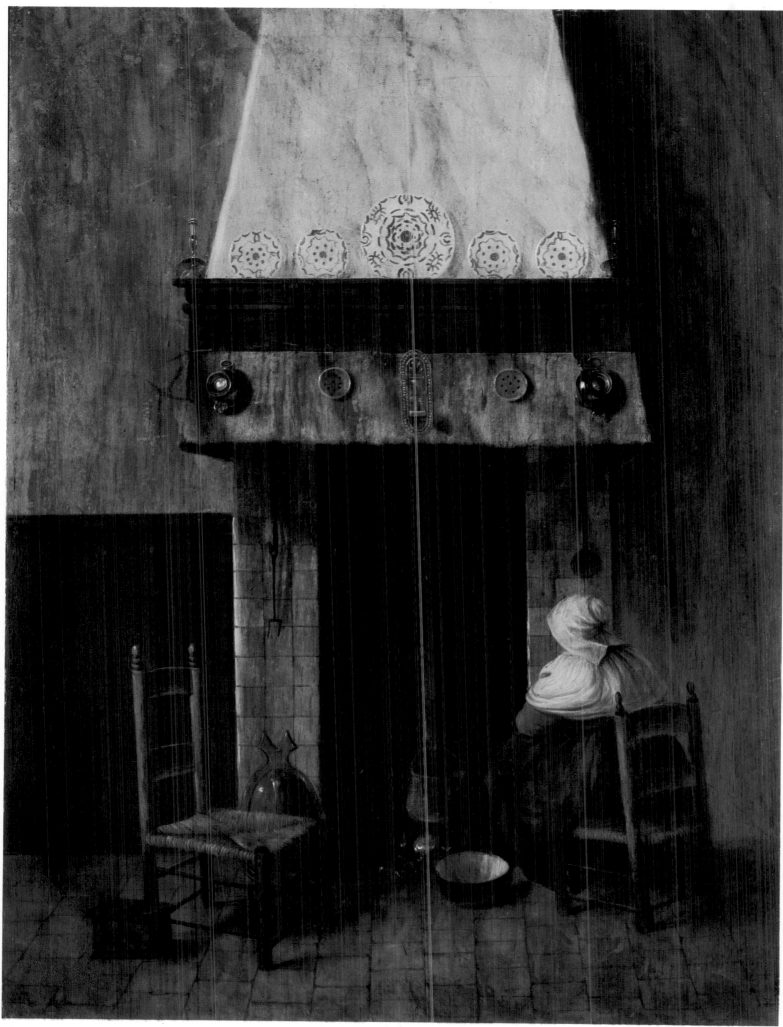

ADRIAEN PIETERSZ VAN DE VENNE

Born 1589 in Delft, died 1662 in The Hague. Studied under
Simon Valck in Leyden and Jan van Diest in The Hague.
Worked in Antwerp (about 1607), Middelburg, and The Hague
(1625). Painted genre, mythological and allegorical
compositions, also portraits.

84

Beggars Fighting

Oil on panel, 11 1/4×15 3/4″ (28.5×40 cm.)
Signed, bottom right: A. v. Venne; dated, bottom center: 1633
Art Museum, Kharkov. Inv. No. 34

PROVENANCE

Until 1928 Private collection, Kharkov
1928 Art Museum, Kharkov

REFERENCES

* *Catalogue. Kharkov* 1959, p. 42.

PHILIPS DE KONINCK

Born 1619 in Amsterdam, died there in 1688. Pupil of Jacob de
Koninck (his brother) and Rembrandt (around 1641). Worked
in Amsterdam. Painted portraits, genre scenes, and landscapes.

85

In a Tavern

Oil on canvas, 14 3/4×17 3/4" (37.5×45 cm.)
Signed, bottom left: P. Korinck
Art Museum, Ulyanovsk. Inv No. 3

This work was unknown to Gerson, who therefore did not include
it in his monograph on the artist.

PROVENANCE		REFERENCES
Until 1919	Department of Railroads, Simbirsk (now Ulyanovsk)	H. Gerson, *Philips Koninck*, Berlin, 1936;
1919	Art Museum, Ulyanovsk	* *Catalogue.* Ulyanovsk 1957, p. 92.

ADRIAEN VAN OSTADE

Born 1610 in Haarlem, died there in 1685. Pupil of Frans Hals;
was influenced by the art of Adriaen Brouwer. Worked in
Haarlem. Painted genre scenes and portraits,
occasionally landscapes.

86

In a Barn

Oil on panel, 15 ³/₄×10 ¹/₄" (40×26 cm.)
Signed and dated, bottom center: AV. Ostade 1639
Art Museum, Riazan. Inv. No. 544

This early Ostade work betrays the artist's attempt to master the
Rembrandtesque treatment of light and shade in depicting an interior.

	PROVENANCE	REFERENCES
Until 1918	The Bariatinsky Collection, Pe- sochnia estate, Riazan district	Hofstede de Groot, III (the Riazan picture is probably listed here under No. 669—*Interior of a Barn*; No. 669 was in a sale in Amsterdam,
1918	Art Museum, Riazan	May 4, 1706); * *Art Museum, Riazan* 1927, p. 9; * *Catalogue. Riazan* 1957, p. 58; * Kuznetsov 1960, No. 10.

87 →

Village Musicians

Oil on panel, 15 ³/₈×12" (39×30.5 cm.)
Traces of signature and date, bottom right: Av. Os..de 16.5
The Hermitage, Leningrad. Inv. No. 904

Painted in 1645 (previously the date was erroneously read as 1665 or 1655).

	PROVENANCE	REFERENCES
Until 1772	The Pierre Crozat Collection, Paris	* *Catalogues. The Hermitage* 1863–1916, No. 951; Hofstede de Groot, III, No. 356; * Kuzne-
1772	The Imperial Hermitage, St. Petersburg	tsov 1948; * *Catalogue. The Hermitage* 1958, 2, p. 234; * Kuznetsov 1960, No. 16.

88–90 →

Peasant Company

Oil on panel, 16 ¹/₈×13 ³/₄" (41×35 cm.)
Signed and dated on table support: Av. Ostade. 1671
The Hermitage, Leningrad. Inv. No. 9990

	PROVENANCE	REFERENCES
1966	The Hermitage, Leningrad (acquired from a private collection)	* Kuznetsov 1972, No. 48.

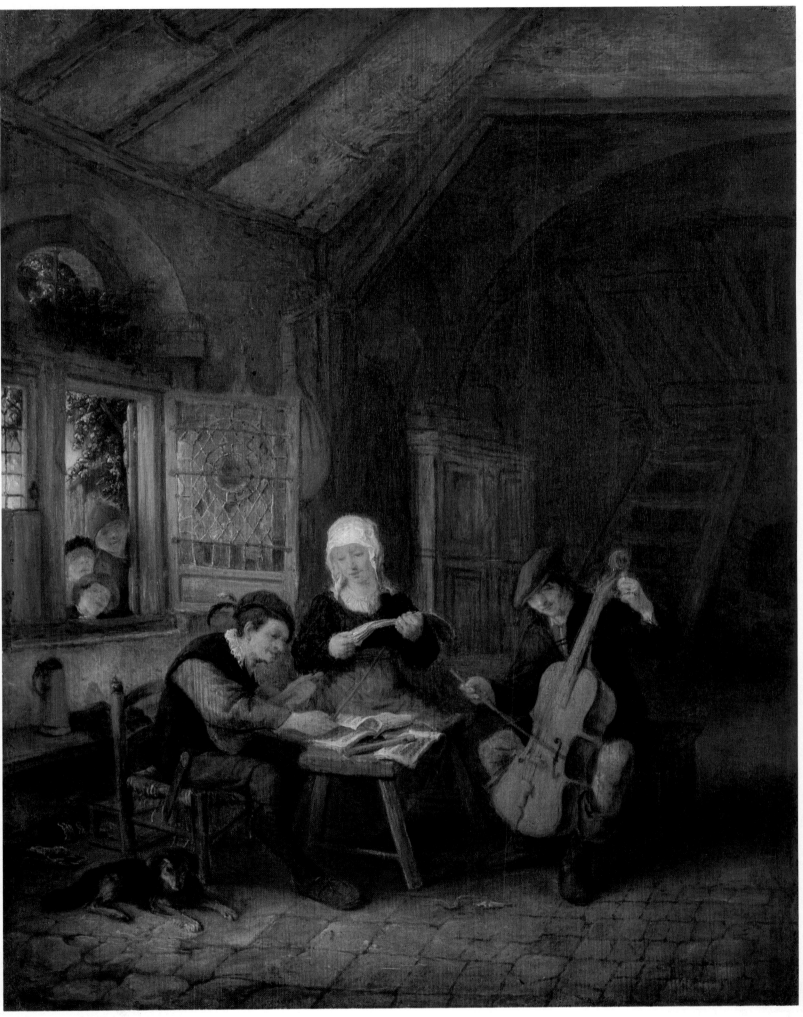

87

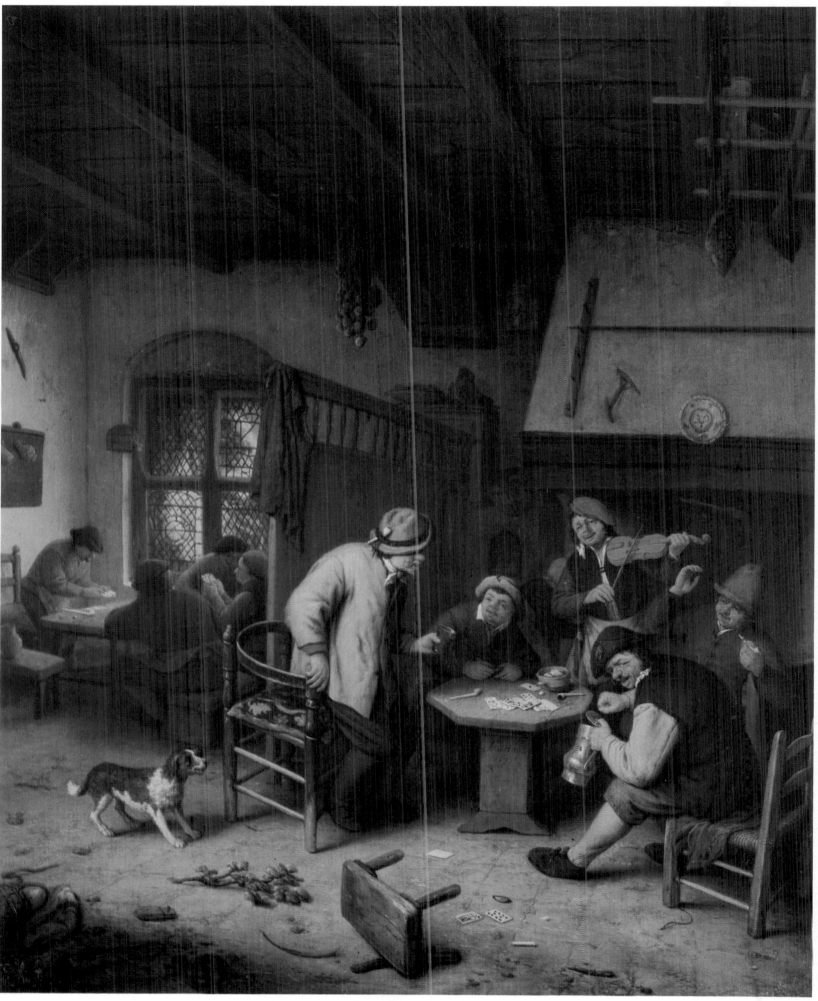

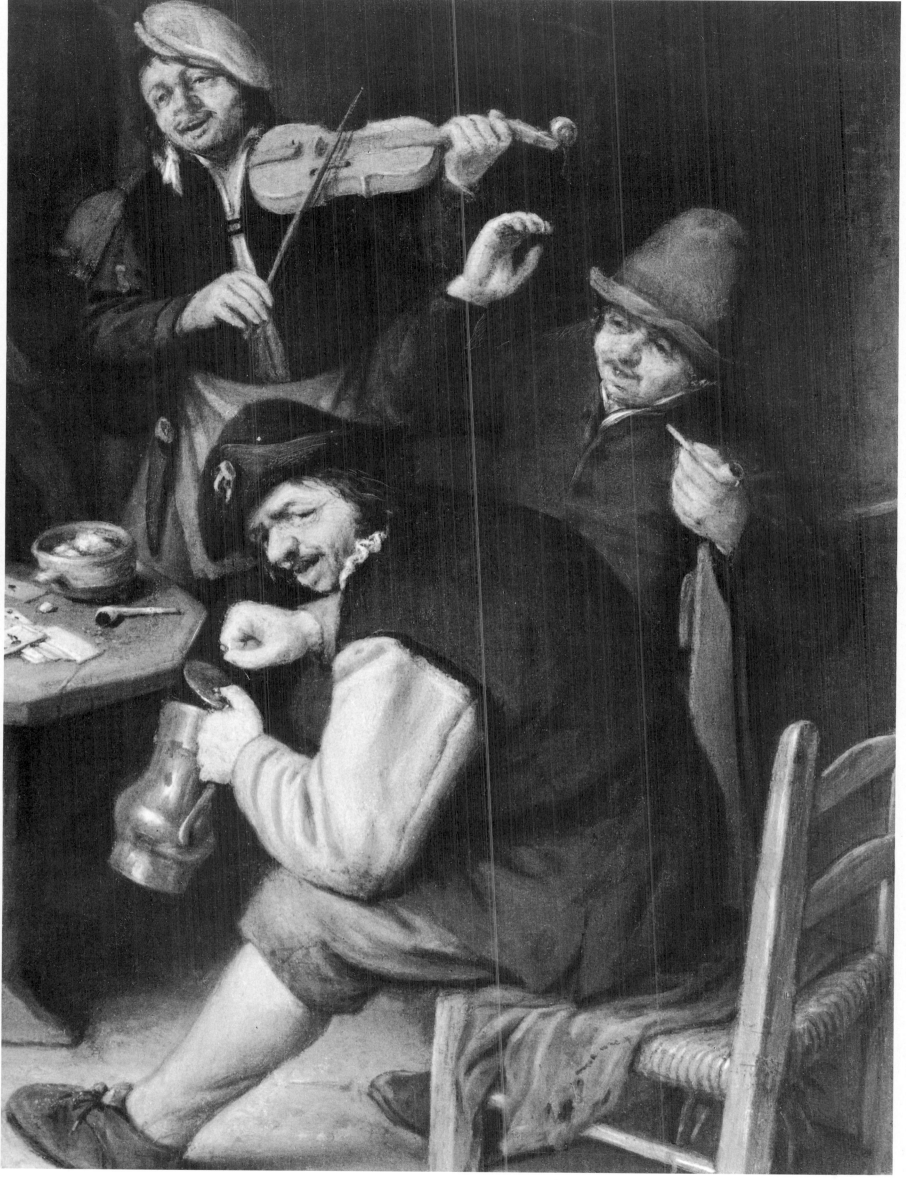

PIETER PIETERSZ VAN NOORT

Born 1602 in Leyden, died there after 1648. Worked in
Leyden (1626–48), later probably in Zwolle.
Painted still lifes and genre scenes.

91

Woman Stitching

Oil on panel, 11 ³/₈×15" (29×38 cm.)
Signed (?), bottom center: P. v. Noort
The Radishchev Art Museum, Saratov. Inv. No. 23

PROVENANCE		REFERENCES
Until 1922	Archaeological Society, Saratov	* Catalogue. Saratov 1969, p. 11.
1922	The Radishchev Art Museum, Saratov	

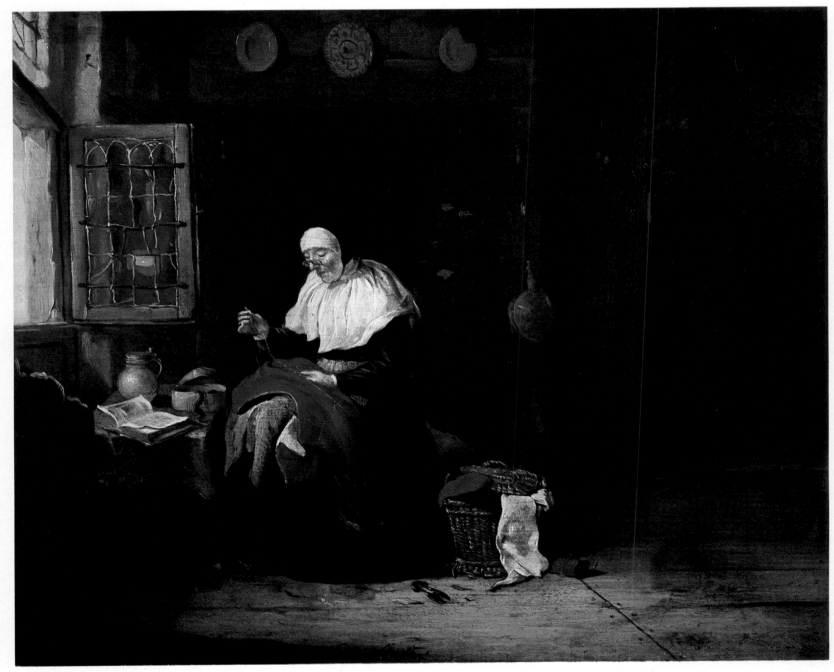

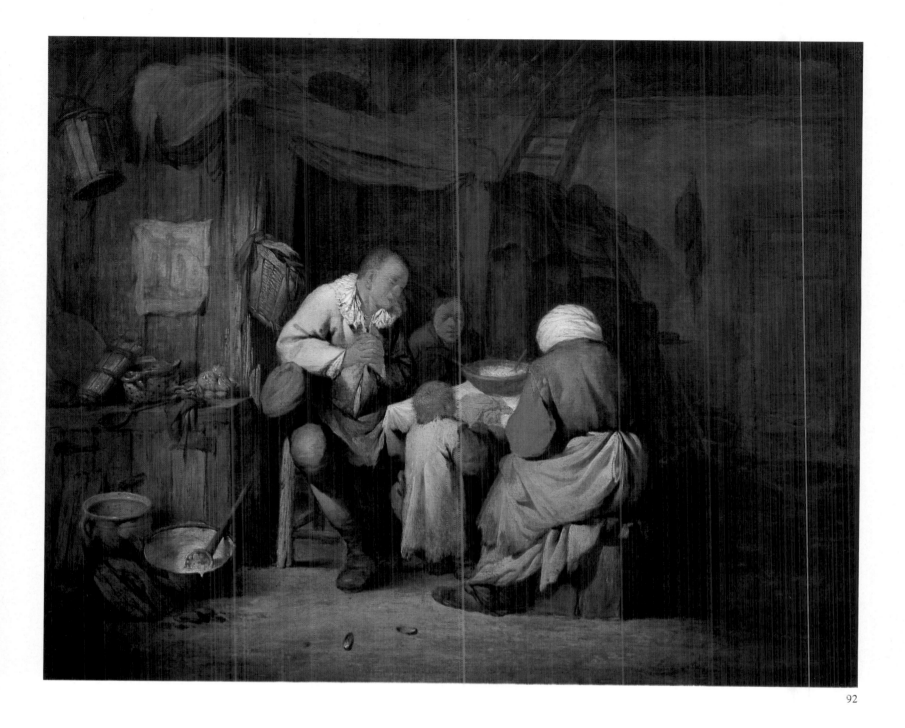

CORNELIS PIETERSZ BEGA

Born 1620 in Haarlem, died there in 1664. Pupil of Adriaen van
Ostade. Traveled in Germany and France. Worked in Haarlem.
Painted genre scenes.

92

Peasant Supper

Oil on panel, 14 1/2×19 1/2" (37×49.5 cm.)
The Hermitage, Leningrad. Inv. No. 3501

Painted about 1655, probably under the influence of Adriaen van Ostade's
etching *Grace before Dinner* (B. 34). The picture is attributed to Cornelis
Pietersz Bega by Yury Kuznetsov. It was previously ascribed to an unknown
Dutch artist of the seventeenth century.

PROVENANCE	REFERENCES
Until 1915 The V. Zurov Collection, Tsarskoye Selo	* Kuznetsov 1955, pp. 21–22; * *Catalogue. The Hermitage* 1958, 2, p. 133; * Kuznetsov 1960, No. 47.
1915 The Imperial Hermitage, Petrograd (gift of V. Zurov)	

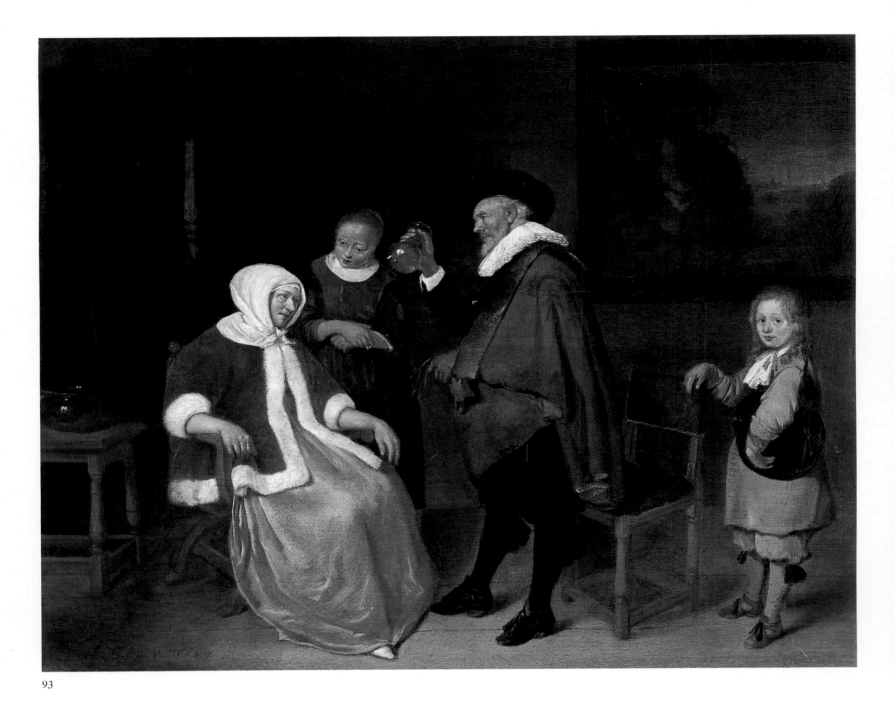

93

QUIRINGH GERRITSZ VAN BREKELENKAM

Born about 1620 in Zwammerdam, died 1668 in Leyden.
Probably studied under Gerrit Dou. Worked in Leyden.
Painted genre scenes.

93

The Doctor's Visit

Oil on panel, 16×20 3/8" (40.8×52 cm.)
Signed and dated, bottom left: Brekelenkam 1667
Museum of Western European and Oriental Art, Riga. Inv. No. 3

This is one of the artist's last works. The signature and date notwithstanding,
it was formerly ascribed to Gillis van Tillborch. Attributed to Brekelenkam
by Hofstede de Groot.

PROVENANCE

1862 The V. Brederlo Collection, Riga
1868 The Brederlo Picture Gallery, Riga
1905 Museum of Western European and
 Oriental Art, Riga

REFERENCES

Neumann 1906, No. 19; * *Catalogue. Riga* 1955,
p. 14; * Kuznetsov 1959, No. 41; * *Catalogue.
The Hermitage* 1964, p. 9; * Kuznetsov 1967,
No. 54; * *Catalogue. Riga* 1973, p. 15.

ESAIAS BOURSSE

Born 1631 in Amsterdam, died 1672 on his way to India.
Visited Italy. Worked in Amsterdam. Painted genre scenes.

94

Repairing a Drum

Oil on panel, 11 ⅜×13 ⅜" (29×34 cm.)
Signed, bottom left: Js (intertwined) Boers
The Hermitage, Leningrad. Inv. No. 3069

PROVENANCE

Until 1915 The Thieme Collection, Leipzig
The P. Semionov-Tien-Shansky
Collection, Petrograd
1915 The Imperial Hermitage, Petrograd

REFERENCES

Semenov. *Etudes* 1906, pp. XCII–XCIII, No.
53; * Shchavinsky 1909, pp. 250–251; * *In Memory of Semionov* 1915, No. 9; * *Catalogue.
The Hermitage* 1958, 2, p. 147.

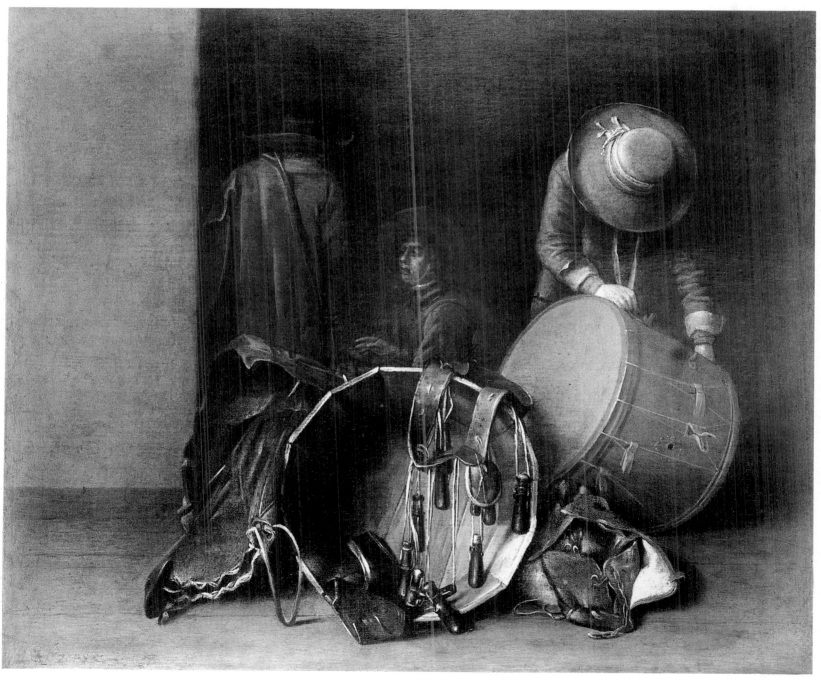

JURIAEN VAN STREECK

Born 1632 in Amsterdam, died there in 1687. Worked
in Amsterdam. Painted still lifes, genre scenes, and portraits.

95

The Smoker

Oil on canvas, 26×24" (66×61 cm.)
Signed, bottom right: J. v. Streek
The Pushkin Museum of Fine Arts, Moscow. Inv. No. 465

PROVENANCE

Until 1924 The Rumiantsev Museum, Moscow

1924 Museum of Fine Arts, Moscow
1937 The Pushkin Museum of Fine Arts, Moscow

REFERENCES

** Catalogue. The Pushkin Museum of Fine Arts 1961, p. 175; * The Pushkin Museum of Fine Arts 1966, No. 39.*

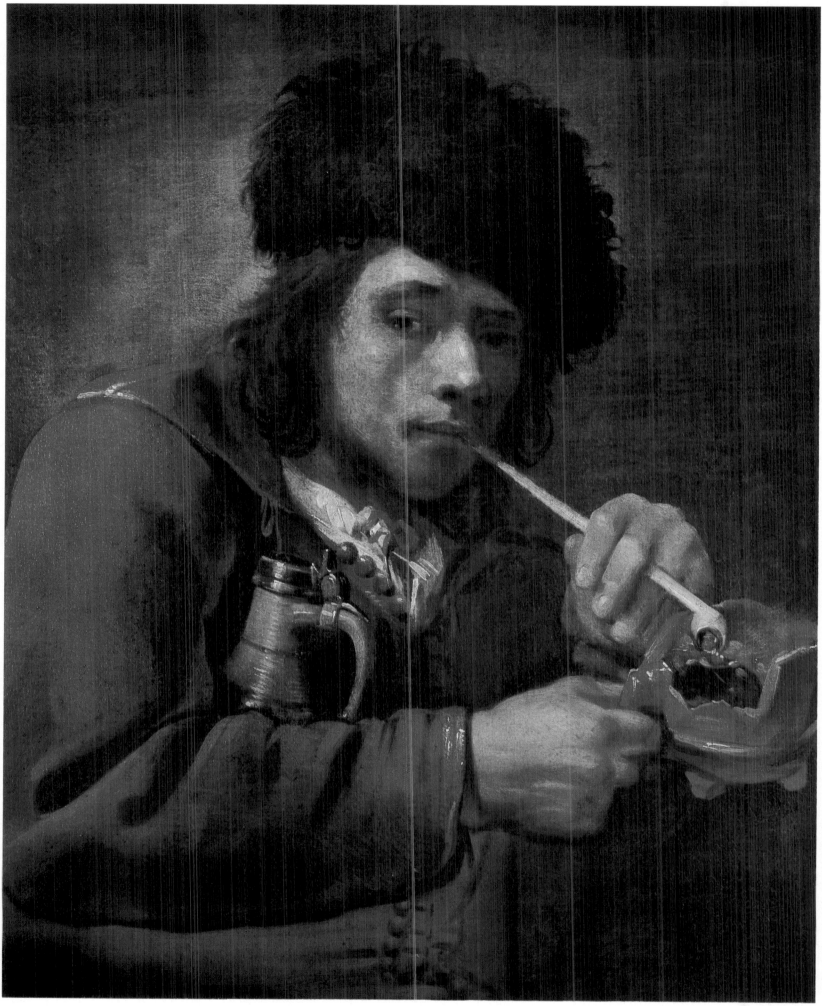

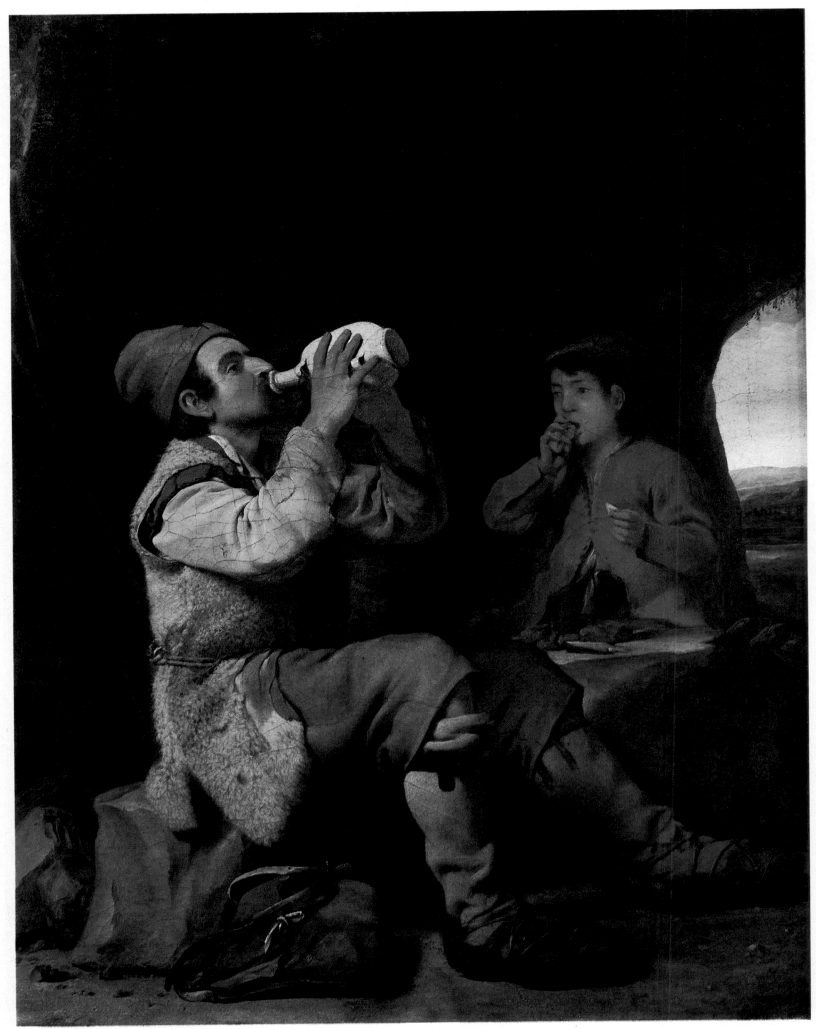

96

MICHIEL SWEERTS

Biography: *see under* plates 44, 45.

96

Shepherds in a Cave

Oil on canvas, 18×14" (45.5×35.5 cm.)
Signed on rock, right: C. S.
Museum of Western European and Oriental Art, Riga. Inv. No. 26

The picture is attributed to Michiel Sweerts by C. Hofstede de Groot. The initials C. S. stand for Cavalier Suars, the name under which Sweerts was known in Italy.

	PROVENANCE	REFERENCES
Until 1868	The V. Brederlo Collection, Riga	Neumann 1906, No. 167; W. Martin, "Michiel
1868	The Brederlo Picture Gallery, Riga	Sweerts als schilder," *Oud-Holland*, 1907, p. 152, No. 18; * *Catalogue. Riga* 1955, p. 76;
1905	Museum of Western European and Oriental Art. Riga	* Kuznetsov 1959, No. 53; * *Catalogue. The Hermitage* 1964, p. 39; * Kuznetsov 1967, No. 53; * *Catalogue. Riga* 1973, p. 35.

ISAAC KOEDYCK

Born 1616 or 1617 in Leyden, died 1668 apparently in Amsterdam. Worked in Amsterdam, Leyden, Haarlem, and Batavia (1651–59), where he was in the employ of the East India Company. Painted genre scenes.

97 →

The Reveler

Oil on panel, 29 1/2×22 3/8" (75×57 cm.)
Signed and dated, bottom left: Koedyck Fe. 1650
The Hermitage, Leningrad. Inv. No. 1862

	PROVENANCE	REFERENCES
Before 1797	The Imperial Hermitage, St. Petersburg	* *Catalogues. The Hermitage* 1863–1916, No. 1257; * *Catalogue. The Hermitage* 1958, 2, p. 210.

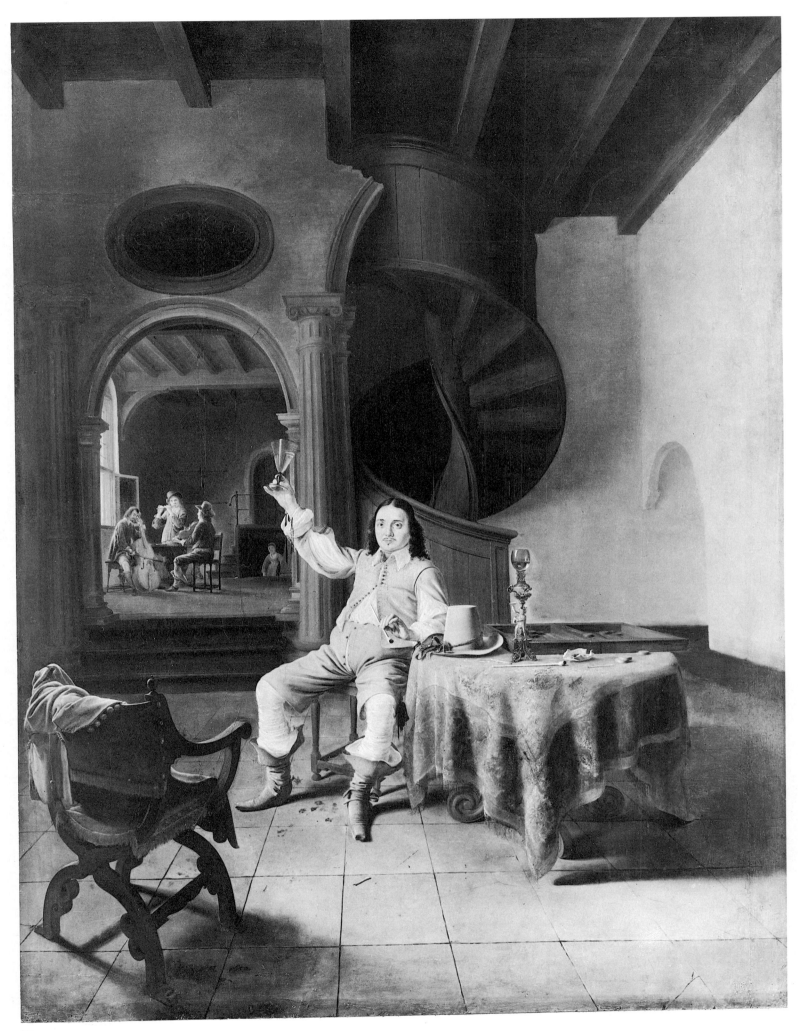

97

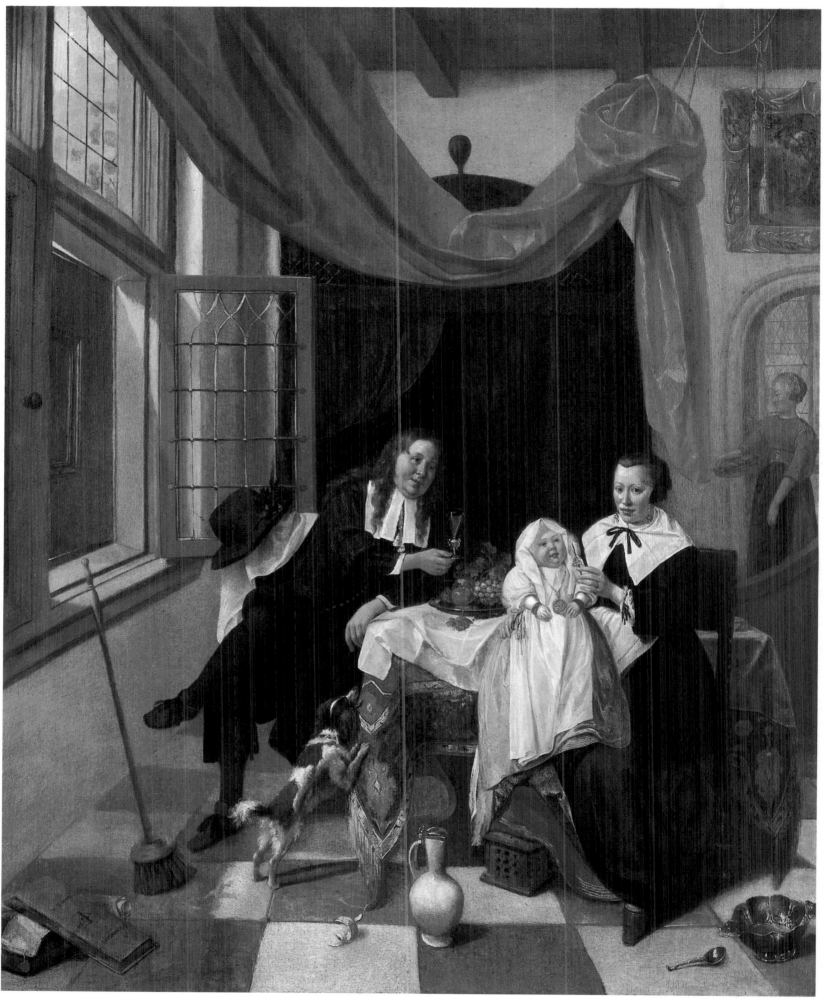

LUDOLF (LOUVEN) DE JONGH

Born 1616 in Overschie, died 1679 in Hilversum. Studied under
Cornelis Saftleven in Rotterdam, Anthonie Palamedesz in Delft,
and Jan van Bijlert in Utrecht. Worked in France (1635–42),
Rotterdam (1643–65), and Hilversum (1665–79).
Painted portraits and genre scenes.

← 98

The Family

Oil on panel, 28×23 ⁵/₈" (71×60 cm.)
On the book at left are an illegible monogram, inscription and date:
Memoriael Anno 1670
Museum of Western European and Oriental Art, Riga. Inv. No. 80

In spite of a certain retreat from his customary handling of interior scenes this
is an authentic Ludolf de Jongh work.

PROVENANCE	REFERENCES
1862 The V. Brederlo Collection, Riga	Neumann 1906, No. 69; Thieme-Becker, 19, p.
1868 The Brederlo Picture Gallery, Riga	132; * *Catalogue. Riga* 1955, p. 35; * Kuznetsov
1905 Museum of Western European and Oriental Art, Riga	1959, No. 52; Plietzsch 1960, p. 58; * *Catalogue. The Hermitage* 1964, p. 18; * Kuznetsov 1967, No. 55, * *Catalogue. Riga* 1973, p. 25.

CORNELIS DUSART

Born 1660 in Haarlem, died there in 1704. Pupil of Adriaen van
Ostade. Worked in Haarlem. Painted genre scenes.

99

Mother and Child

Oil on panel, 18 ³/₄×15 ³/₄" (48×40 cm.)
Signed and dated, bottom right: Cor. Dusart 1681
The Pushkin Museum of Fine Arts, Moscow. Inv. No. 517

PROVENANCE	REFERENCES
Until 1924 The Rumiantsev Museum, Moscow	* Shchavinsky 1915, repr.; * Bloch 1922, p. 12; * *Catalogue. The Pushkin Museum of Fine Arts* 1961, p. 81.
1924 Museum of Fine Arts, Moscow	
1937 The Pushkin Museum of Fine Arts, Moscow	

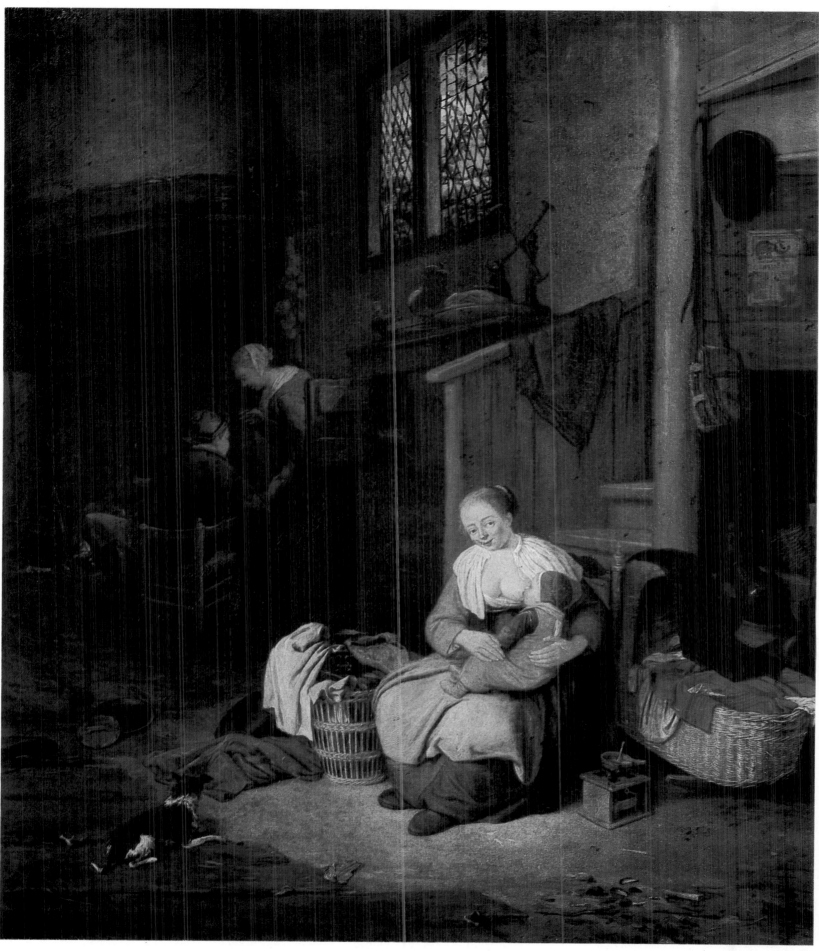

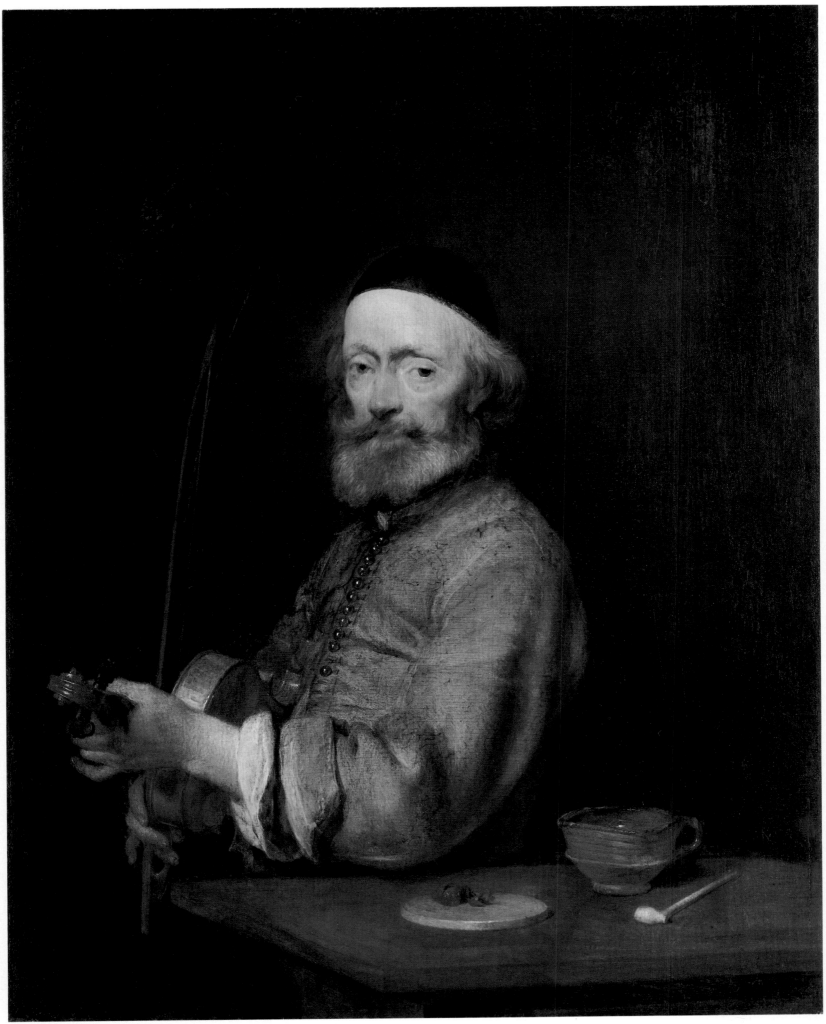

100

GERARD TER BORCH

Biography: *see under* plate 52.

100

The Violin Player

Oil on canvas, 11 ³/₈×9 ³/₈″ (29×24 cm.)
Signed with monogram on tabletop: GTB
The Hermitage, Leningrad. Inv. No. 882

Painted in the late 1640s. The Staatliches Museum in Schwerin has a copy
of somewhat larger dimensions (13×10 ¼″ or 33×26 cm.) and with
a different color scheme. It was painted after 1670. Hofstede de Groot listed
it in the museum's catalogue as the original.

PROVENANCE

September 3, 1737	The S. van Huls sale in The Hague, No. 90
November 10, 1762	The N. Tjark sale in Amsterdam, No. 29 (purchased by Van Loon)
Between 1763 and 1774	The Imperial Hermitage, St. Petersburg

REFERENCES

* *Catalogues. The Hermitage* 1863–1916, No. 871; Hofstede de Groot, V, No. 138; * *Catalogue. The Hermitage* 1958, 2, p. 279; S. J. Gudlaugsson, *Gerard Ter Borch*, The Hague, 1960, No. 75.

101, 102 →

A Glass of Lemonade

Oil on canvas (transferred from a panel), 26 ¹/₄×21 ¹/₄″ (67×54 cm.)
The Hermitage, Leningrad. Inv. No. 881

Painted about 1663–64. While in the Duke of Choiseul's collection the
picture was engraved by Antoine Romanet. It is evident from the engraving
that, compared with its present form, the picture had significant extensions
attached to the sides and the top. It is precisely this fact that led to the
assertion (*see* Hermitage catalogues prior to 1958) that the picture had
initially been larger in size and was subsequently cut down on three sides.
This, however, is not so, as Gudlaugsson established and proved—at one
time the picture did have those extensions, and Romanet's engraving could
not but show them. They were removed in the eighteenth century. The
one-time presence of the extensions is today confirmed only by the fact that
in the lower right-hand corner of the picture is a ball and chain, whereas the
engraving has here a monkey with a ball chained to its foot. It is interesting to
note that the artist who "improved" Ter Borch did not even try to make
newly painted parts conform to the original picture—the shadow of the ball is
opposite in direction to the shadow in Ter Borch's composition.

PROVENANCE

April 24, 1742	The N. G. Hasselaar sale, Amsterdam (No. 11, 670 florins)	Until 1814	Empress Josephine's collection, the Malmaison Castle near Paris
1754	The L. J. Gaignat Collection, Paris	1814	The Imperial Hermitage, St. Petersburg
February 14–22, 1769	The L. J. Gaignat sale, Paris (No. 21, 5,100 francs)		
April 6, 1772	Duc de Choiseul sale, Paris (No. 25, 4,000 francs)		
February 18, 1793	The Choiseul-Praslin sale, Paris (No. 104, 15,501 francs)		
February 19–20, 1808	The Choiseul-Praslin sale, Paris (No. 18, 13,001 francs)		
January 22, 1812	The Séréville sale, Paris (No. 23, 15,000 francs)		

REFERENCES

* *Catalogues. The Hermitage* 1863–1916, No. 870; Hofstede de Groot, V, No. 87; * *Catalogue. The Hermitage* 1958, 2, p. 281; S. J. Gudlaugsson, *Gerard Ter Borch*, The Hague, 1960, No. 192; *Gerard Ter Borch* (exhibition catalogue), The Hague, 1974, No. 52.

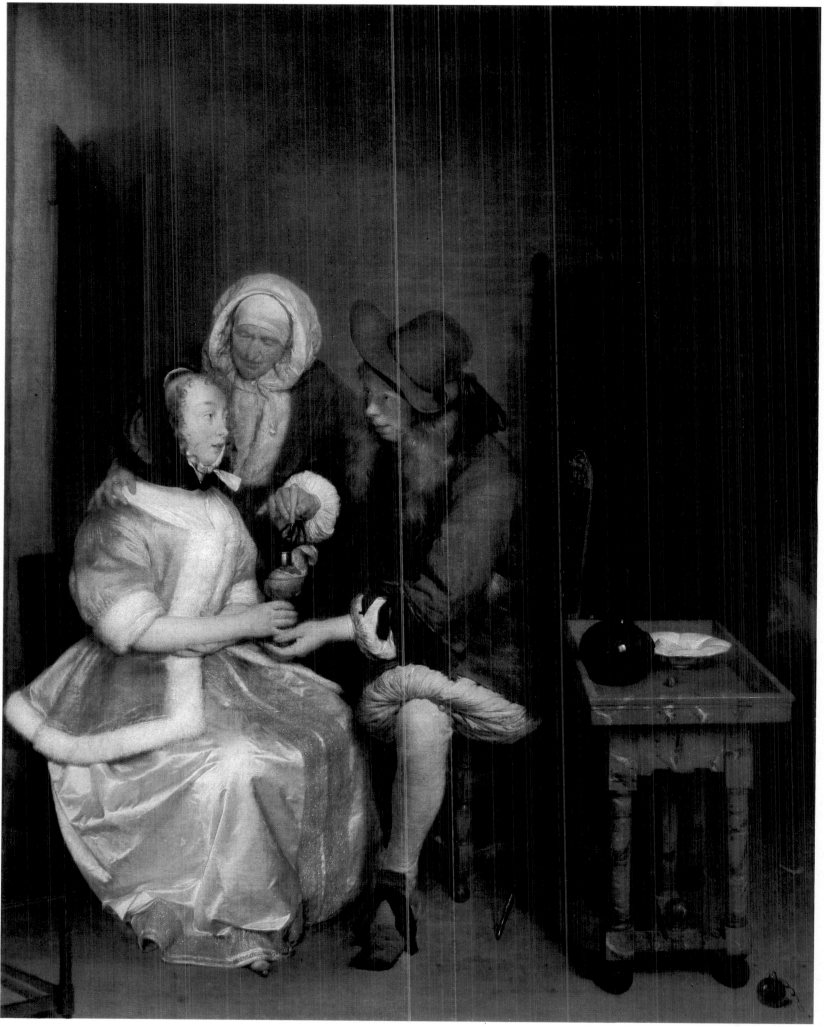

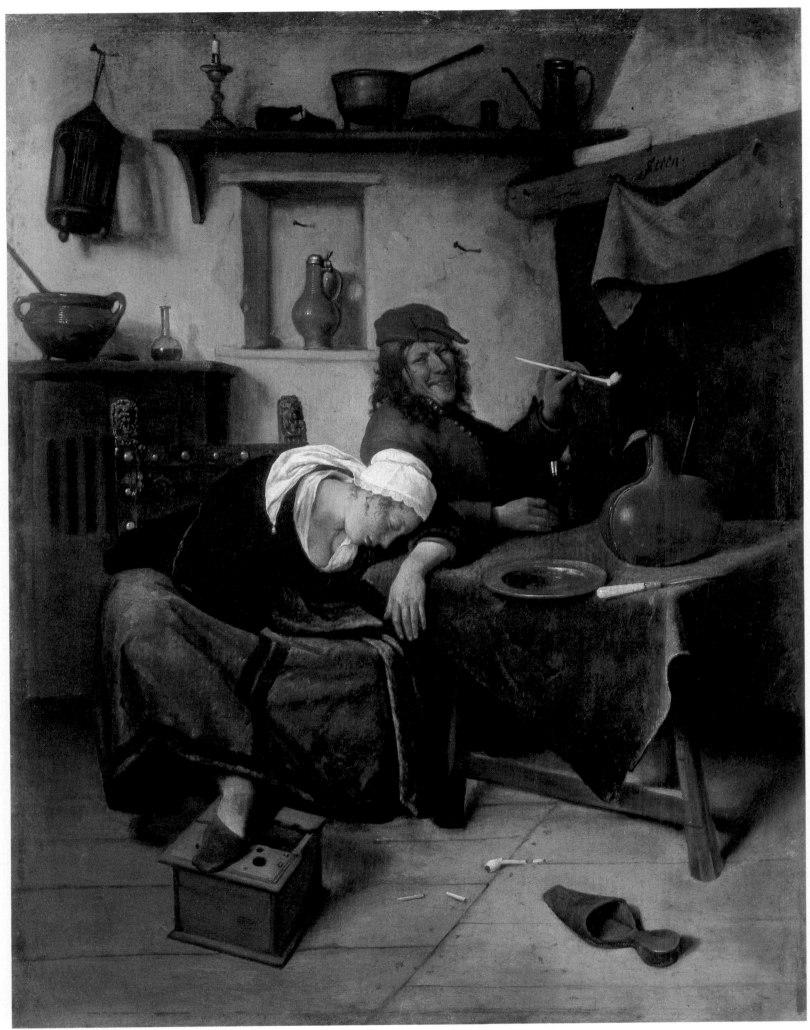

103

JAN STEEN

Born 1626 in Leyden, died there in 1679. Studied under Nicolaus Knüpfer and Jan van Goyen. Worked in Leyden (before 1649 and from 1669), The Hague (until 1654), Delft (1654–56), Warmond (until 1661), and Haarlem (1661–69). Painted genre scenes, landscapes, and portraits.

103

The Revelers

Oil on panel, 15 3/8×11 3/4" (39×30 cm.)
Signed, top right: J Steen
The Hermitage, Leningrad. Inv. No. 875

Painted in the early 1660s. Depicted are the artist and his wife Margaretha, daughter of Jan van Goyen. Yury Kuznetsov identifies the Hermitage piece with the picture *Jan Steen and His Sleeping Wife* (Hofstede de Groot, I, No. 866a), which was bought at a sale in Amsterdam in 1708 for 101 florins (Hoet 1752, I, 27, No. 40). The high price argues in favor of such a hypothesis because the Hermitage picture is an excellent work and really worth it. Hofstede de Groot reports that two replicas of the Hermitage picture were sold in Amsterdam on November 26, 1851, and in Ghent on August 4, 1856, and points out that it is incorrect to identify the Hermitage piece with a work that figured in the Kretschmar sale of 1757 (Amsterdam) and in another Amsterdam sale (June 5, 1765).

PROVENANCE

September 12, 1738	Bought at a sale in Amsterdam (101 florins)
Before 1773	The Imperial Hermitage, St. Petersburg

REFERENCES

* *Catalogues. The Hermitage* 1863–1916, No. 898; * Somov 1899, pp. 891–913; Hofstede de Groot, I, No. 758; * Kuznetsov. *Jan Steen* 1958, pp. 396–398, 414; * *Catalogue. The Hermitage* 1958, 2, p. 272; * Kuznetsov 1959, No. 48; Kuznetsov. *Jan Steen* 1964, No. 16.

FRANS VAN MIERIS THE ELDER

Born 1635 in Leyden, died there in 1681. Studied under
Abraham Toorenvliet, a painter on glass, Gerrit Dou, and
Abraham van den Tempel. Worked in Leyden. Painted genre
and biblical scenes, also portraits.

104, 105

The Morning of a Young Lady

Oil on panel, 20 1/4×15 3/4" (51.5×40 cm.)
The Hermitage, Leningrad. Inv. No. 915

E. de Jongh describes an allegorical meaning in the picture. In his opinion,
the lady and the dog standing on its hind legs illustrate the proverb, "As the
mistress is, so is her dog" (Gelijk de Juffer is, soo is haar hondeke) or,
"As the mistress dances, so dances her dog" (Gelijk de Juffer danst, soo
danst haar hondeke). On the surface such a conclusion may sound somewhat
farfetched, but it is well to remember that until quite recently scholars paid
little heed to the symbolic message of so many Dutch pictures—genre scenes,
still lifes, even portraits, all so unassuming, so simple. A closer scrutiny
reveals in them a polysemy, a hidden allegorical meaning over and above the
self-evident narrative. The idiom of allegory was widespread in
seventeenth-century art. It should be pointed out that more illustrated books
on the meaning of emblems were published in Holland than anywhere else,
and these books were written by the most eminent and the most popular
poets of the time—Jacob Cats and Joost van den Vondel. De Jongh's surmise
is made the more plausible by the presence of a servant-girl in the picture.
Cats's book on emblems carries an engraving that depicts a lady and a dog
dancing, with verses under it to explain that the dog imitating her mistress
symbolizes a servant-girl.

PROVENANCE

	Collection of Maximilian III Emmanuel, Elector of Bavaria
Until 1769	The Heinrich Brühl Collection, Dresden
1769	The Imperial Hermitage, St. Petersburg

REFERENCES

* *Catalogues. The Hermitage* 1863–1916, No.
915; Hofstede de Groot, X, No. 214; * *Catalogue.
The Hermitage* 1958, 2, p. 222; Plietzsch 1960, p.
51, No. 65; E. de Jongh, *Zinneen minnebeelden
in de Nederlandsche schilderkunst van de zeven-
tiende eeuw*, Amsterdam–Antwerp, 1967, pp.
38–41.

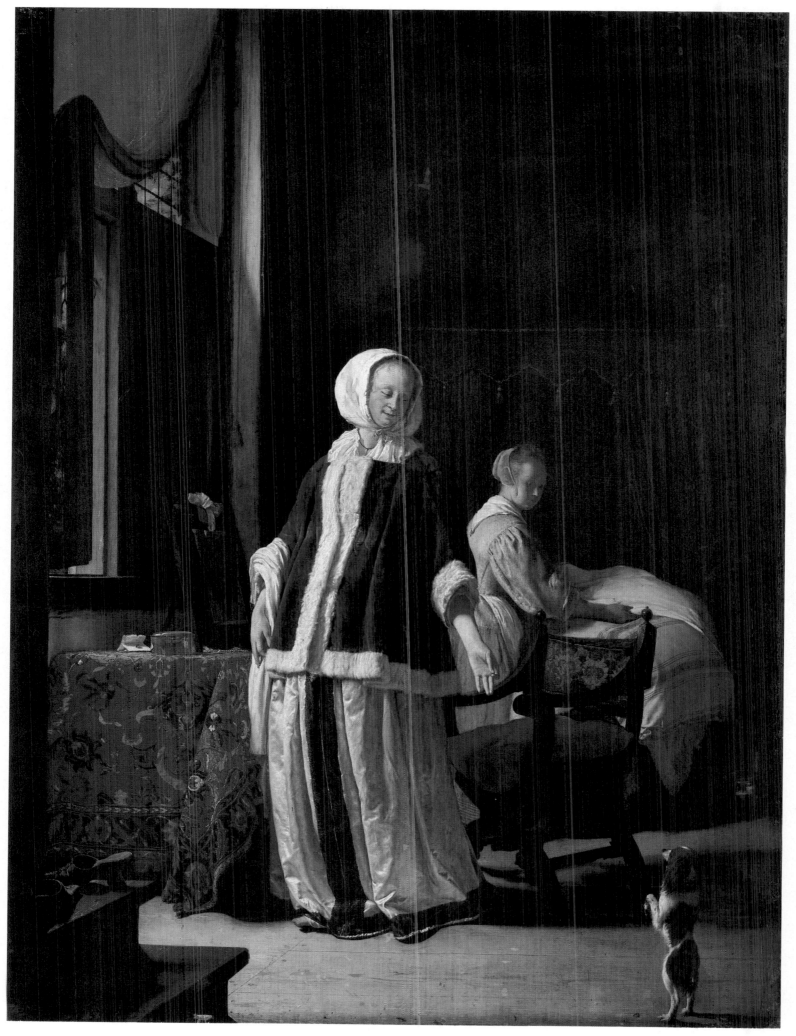

JACOB OCHTERVELT

Born 1634/35 in Rotterdam, died about 1708 in Amsterdam.
Pupil of Nicolaes Berchem. Worked in Rotterdam and from
about 1674 in Amsterdam. Painted genre scenes and portraits.

106 →

Buying Fish

Oil on canvas, 32×25" (81.5×63.5 cm.)
Signed, bottom right: Jac. Ochtervelt f.
The Hermitage, Leningrad. Inv. No. 952

Painted around 1669, this is a companion picture to *Buying Grapes*, also in
the Hermitage (inv. No. 951).

PROVENANCE		REFERENCES
Between 1763 and 1774	The Imperial Hermitage, St. Petersburg	* *Catalogues. The Hermitage* 1863–1916, No. 889; * *Catalogue. The Hermitage* 1958, 2, p. 235; Plietzsch 1960, p. 65.

GABRIEL METSU

Born 1629 in Leyden, died 1667 in Amsterdam. Possibly studied
under Gerrit Dou in Leyden. Worked in Leyden and
Amsterdam (from 1654). Painted genre scenes.

107 →

The Doctor's Visit

Oil on canvas, 24×18 3/4" (61×48 cm.)
Signed, top left, above door: G. Metsu
The Hermitage, Leningrad. Inv. No. 919

Painted about 1665.

PROVENANCE		REFERENCES
Until 1702	The Jan Agges Collection, Amsterdam	* *Catalogues. The Hermitage* 1863–1916, No. 878; Hofstede de Groot, I, No. 100; W. Bode,
Until 1767	The Julienne Collection, Paris	*Die Meister der holländischen und flämischen*
1767	The Imperial Hermitage, St. Petersburg	*Malerschulen*, Leipzig, 1956, p. 119; * *Catalogue. The Hermitage* 1958, 2, p. 219.

108, 109 →

Oyster Eaters

Oil on canvas, 21 7/8×16 1/2" (55.5×42 cm.)
Signed, center left: G. Metsu
The Hermitage, Leningrad. Inv. No. 920

Painted about 1660–65.

PROVENANCE		REFERENCES
1783	The Altstadt Collection, Kassel	* *Catalogues. The Hermitage* 1863–1916, No.
Until 1814	Empress Josephine's collection, the Malmaison Castle near Paris	880; Hofstede de Groot, I, No. 174; * *Catalogue. The Hermitage* 1958, 2, p. 218.
1814	The Imperial Hermitage, St. Petersburg	

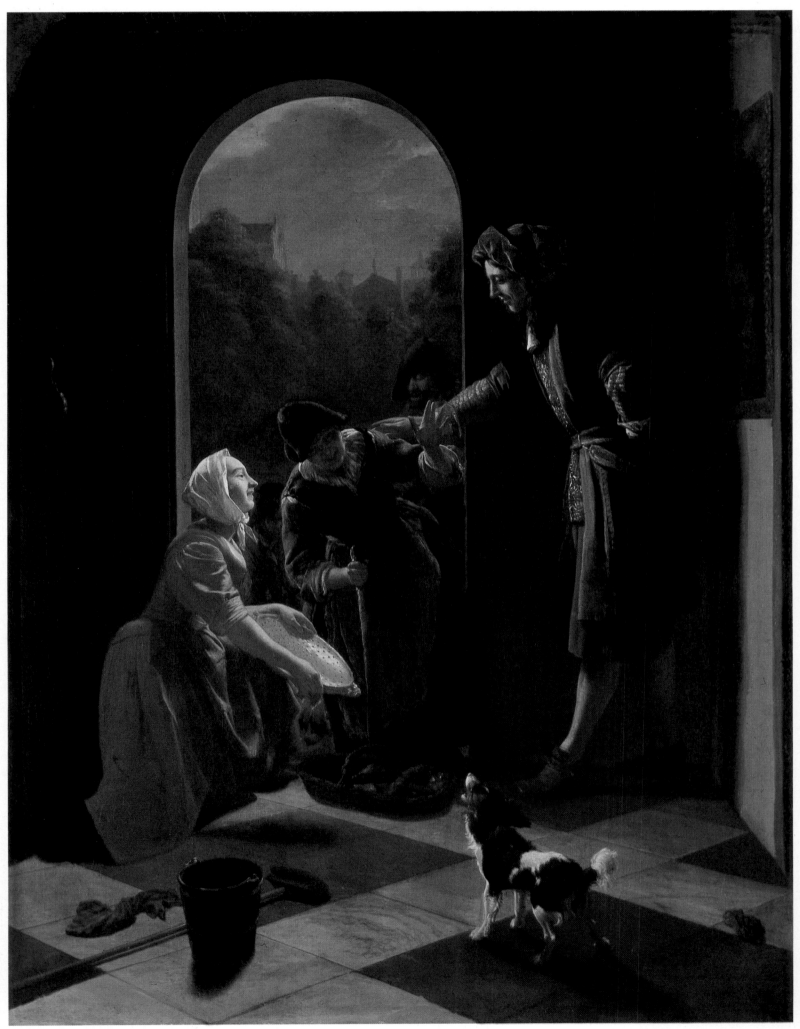

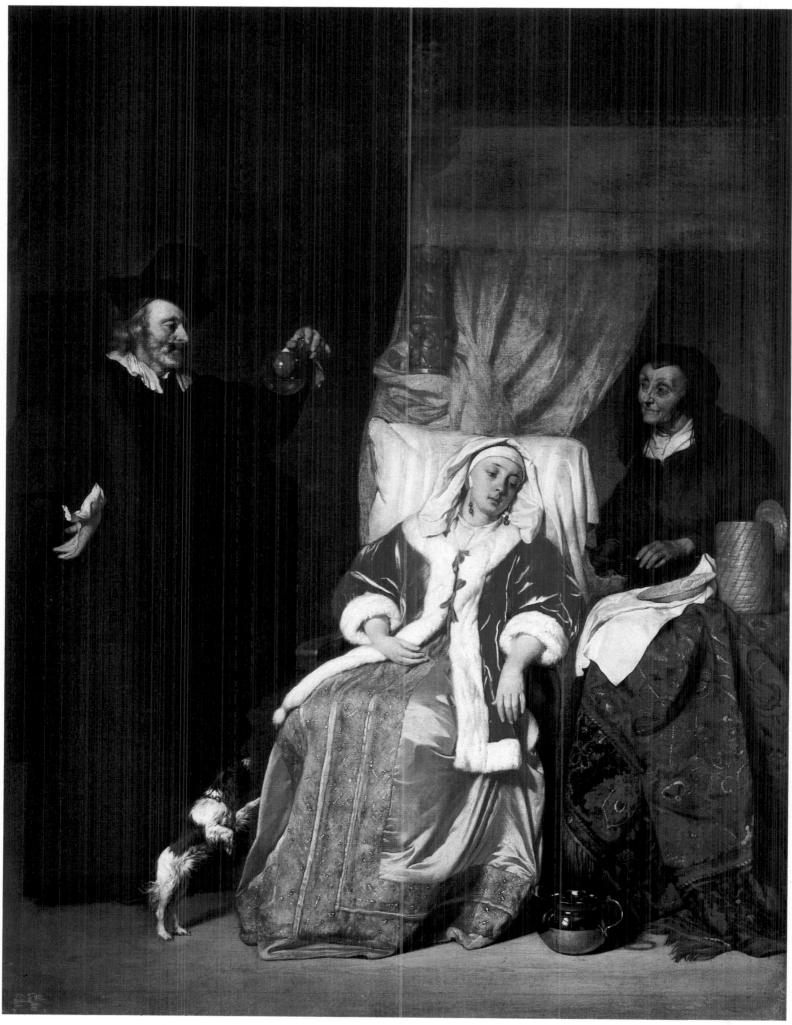

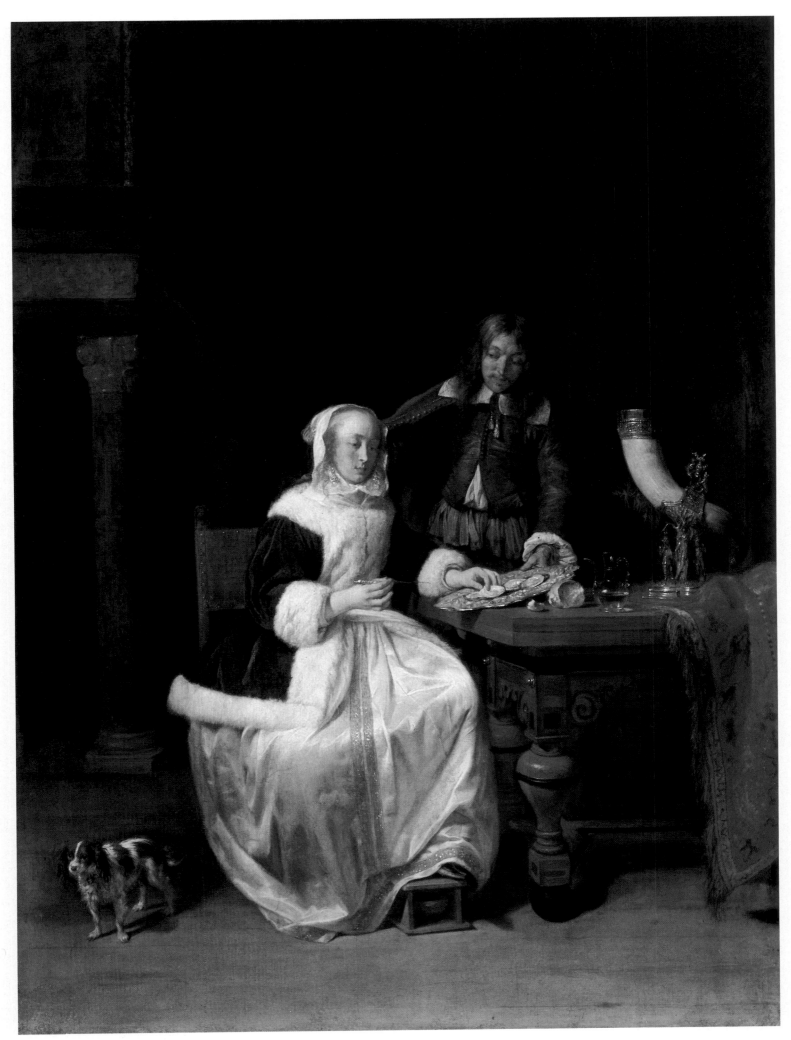

108

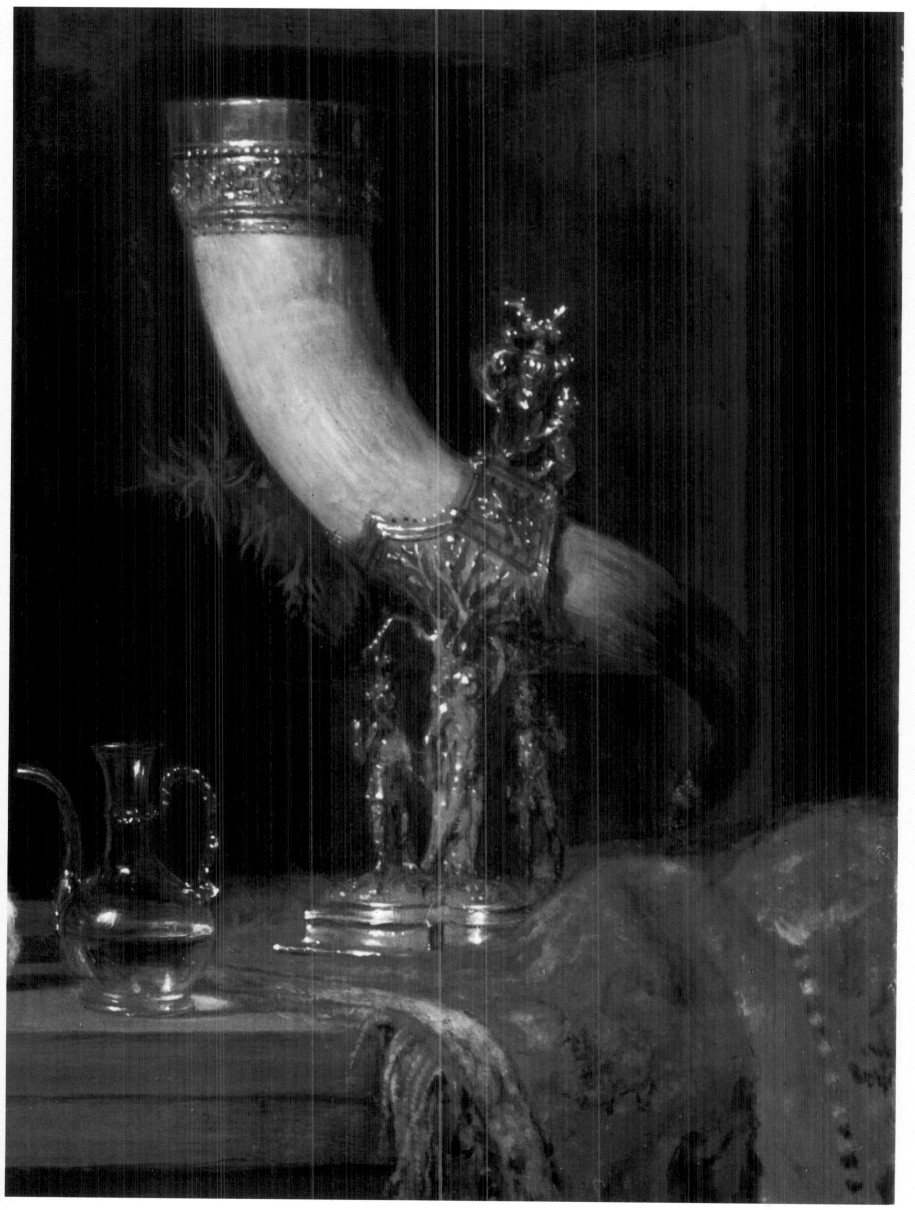

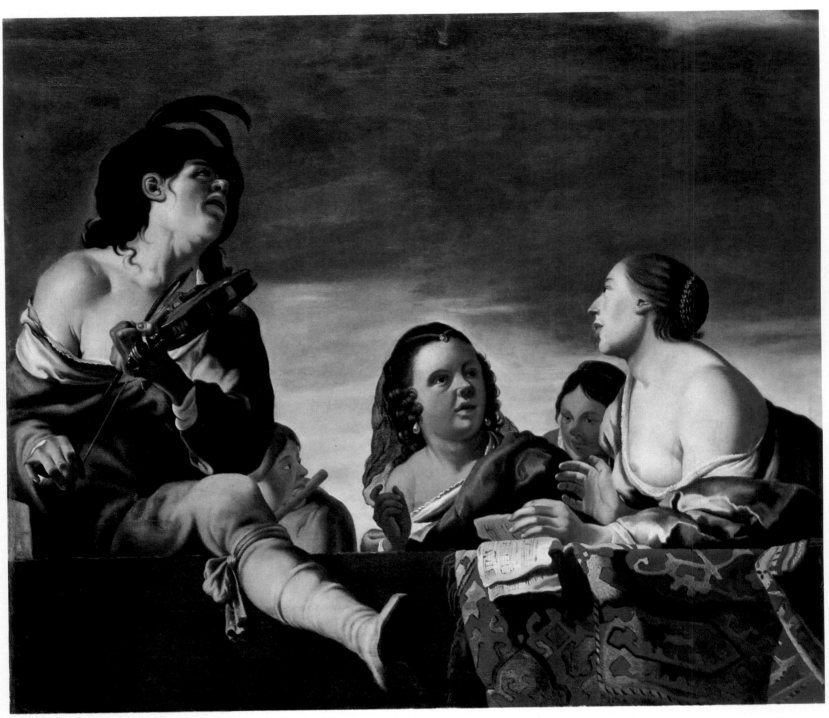

110

JAN GERRITSZ VAN BRONCKHORST

Born 1603 in Utrecht, died 1661 in Amsterdam. Studied under
Jan van der Burch, a painter on glass (1614–20). Lived in Paris.
Went to Italy together with Jan van Bijlert and Cornelis van
Poelenburgh (1621), where he lived in Rome. Returned to
Utrecht via Paris. Member of the Utrecht guild (1639–40).
Moved to Amsterdam in 1647. Painted genre scenes, historical
and religious compositions.

110

Merry Party with a Violin Player

Oil on canvas, 47 ¹/₈×58 ¹/₈″ (120×148 cm.)
Signed, bottom left corner: J. v. Bronckhorst fecit
The Hermitage, Leningrad. Inv. No. 3303

There is an unsigned variant of this canvas in the Centraal Museum of
Utrecht, though of different dimensions (45 ³/₈×60 ⁵/₈″ or 115×154 cm.).
It is held that the Utrecht piece belongs to a series of three pictures, the other
two being *Merry Party with a Mandolin Player* (private collection, London)
and *Merry Party with a Lute Player*, which is in the Herzog Anton Ulrich
Museum, Brunswick (cat. of 1932, No. 191). All three works share a thematic
and compositional affinity—the figures are placed behind a carpet-covered
parapet and depicted in a complex foreshortening (from below). Apparently
the pictures had been hung high up in a hall and were intended to be viewed
from below. The Utrecht museum's catalogue expresses the opinion that
some time after its execution, the *Merry Party with a Violin Player* in their
possession was cut down on the sides, which is why it is considerably
narrower than the two other pictures of the series. However, inasmuch as the
Hermitage canvas is signed and is almost equal in height to the other two, it,
and not the Utrecht picture, is most likely the third component of the set.
The Hermitage picture may be dated to the 1640s. In the museum's catalogue
of 1958 it was erroneously ascribed to Jan Gerritsz van Bronckhorst's son
Gerrit and entitled *The Prodigal Son*.

PROVENANCE		REFERENCES
Before 1915	The P. Semionov-Tien-Shansky Collection, Petrograd	*Catalogue Semenov* 1906, No. 88 bis; * *Catalogue. The Hermitage* 1958, 2, p. 147; * *Catalogue. Caravaggio and His Followers* 1973, No. 7; *Caravaggio and His Followers* 1975, No. 118.
1915	The Imperial Hermitage, Petrograd	

JOOST VAN GEEL

Born 1631 in Rotterdam, died there in 1698. Pupil of Gabriel
Metsu. Worked in Rotterdam. Visited France, Germany, and
England. Painted genre and biblical scenes, and also portraits.

111 →

The Duet

Oil on canvas, 22 ³/₈×20″ (57×50.5 cm.)
Signed on curtain, left: J. v. Geel
The Hermitage, Leningrad. Inv. No. 1860

PROVENANCE		REFERENCES
Before 1797	The Imperial Hermitage, St. Petersburg	* *Catalogues. The Hermitage* 1863–1916, No. 1250; * *Catalogue The Hermitage* 1958, 2, p. 175.

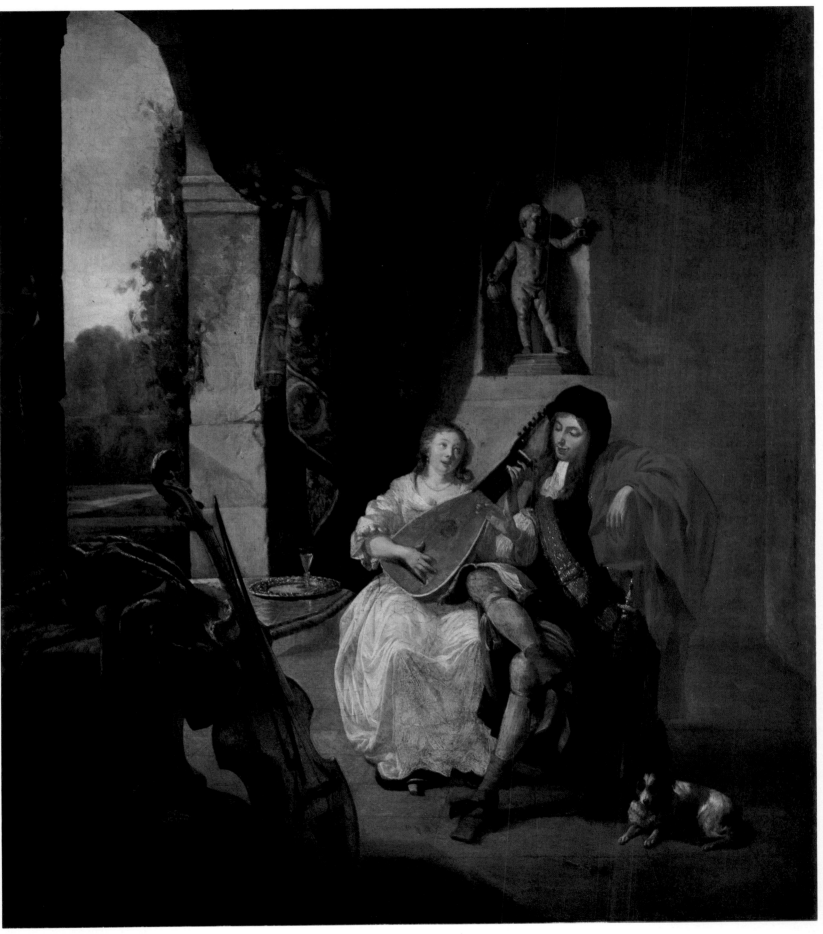

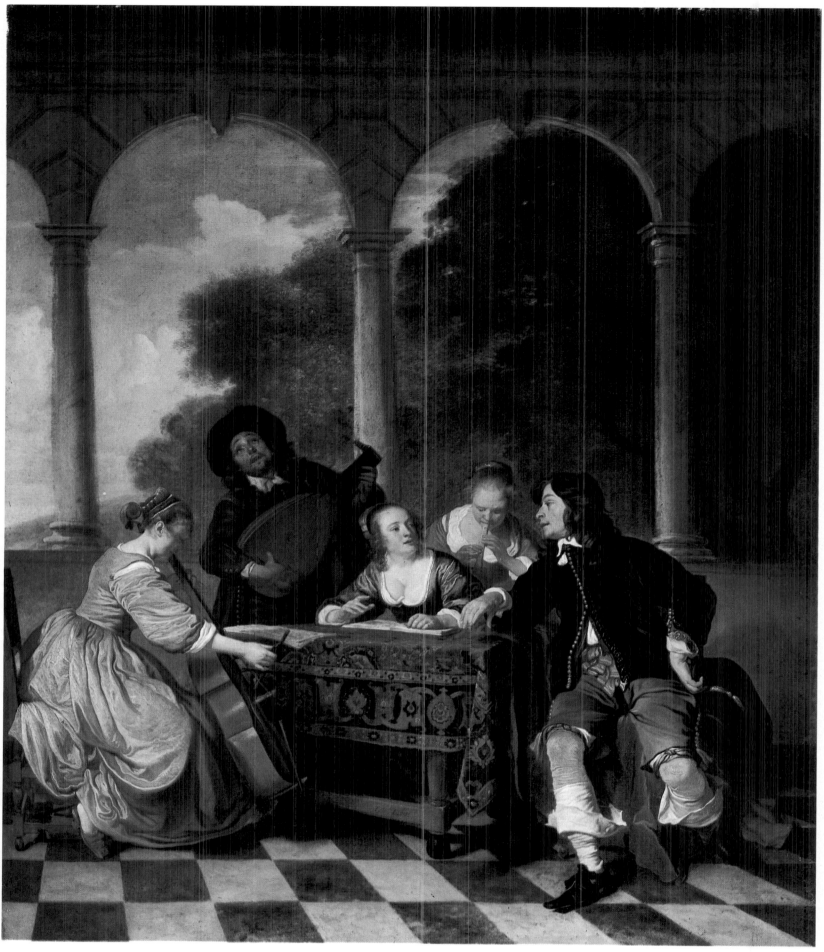

JACOB VAN LOO

Born 1614 in Sluis, died 1670 in Paris. In his early period was
influenced by the art of Jacob Backer and Bartholomeus van der
Helst, later of Gerard Ter Borch and Nicolaes Maes. Worked in
Amsterdam (from 1642) and Paris (from 1662). Member of the
Paris Academy of Arts (from 1663). Painted portraits
and genre scenes.

← 112

Musical Party

Oil on canvas, 30×25 ⁵/₈" (76×65 cm.)
Signed on crossbar adjoining table's legs: J. v. Loo
The Hermitage, Leningrad. Inv. No. 1092

This is a companion picture to *The Condescending Old Lady*, also
a Hermitage canvas (inv. No. 1091). *Musical Party*, like its companion piece
which depicts two young couples openly flirting, seems to hint with disfavor
at the rather loose morals of the day.

PROVENANCE	REFERENCES
Before 1785 The Imperial Hermitage, St. Petersburg	*Catalogues. The Hermitage* 1863–1916, No. 1252; * *Catalogue. The Hermitage* 1958, 2, p. 214; Plietzsch 1960, p. 77.

ISRAEL COVIJN

A native of Antwerp. Worked in Dordrecht (from 1647).
Painted genre scenes.

113

The Usuress

Oil on canvas, 46 ¹/₈×39 ³/₈" (117×100 cm.)
Signed, left: I. Cov.
The Hermitage, Leningrad. Inv. No. 1982

Because the signature was previously incorrectly deciphered, old Hermitage
catalogues (before 1916) ascribed this work first to Philips de Koninck, then
to Jacob de Koninck.

PROVENANCE	REFERENCES
The I. Betskoi Collection, St. Petersburg Before 1797 The Imperial Hermitage, St. Petersburg (gift of I. Betskoi)	*Catalogues. The Hermitage* 1863–1916, No. 869; * *Catalogue. The Hermitage* 1958, 2, p. 207; * *Catalogue. Rembrandt* 1969, No. 50.

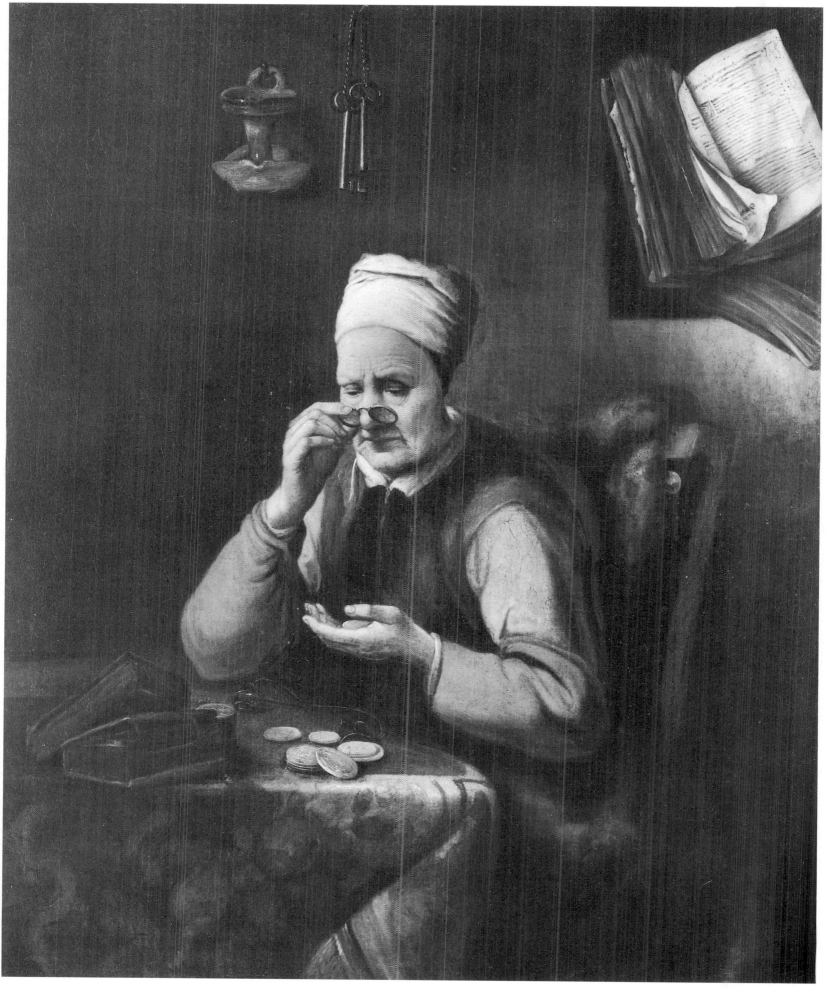

GERRIT DOU

Born 1613 in Leyden, died there in 1675. Pupil of Rembrandt (1628–31). Worked in Leyden. Had many pupils of his own and a whole group of imitators. Founded a school of miniature painting. Is best known for his genre scenes and portraits.

114

The Scholar

Oil on panel, 16 ¹/₈×15" (41×38 cm.)
Signed on background, right: G. Dov
The Hermitage, Leningrad. Inv. No. 886

Painted around 1630. The man portrayed shares a typological affinity with Rembrandt's personages: cf. the etchings *Portrait of an Old Man* and *Philo Judaeus* (B. 321 and B. 294). The illustrations in the book the scholar is perusing apparently depict Pan and Syrinx. It is, therefore, very likely that the volume is Ovid's *Metamorphoses*, then an especially popular work in the classical education center that was Leyden.

PROVENANCE		REFERENCES
Until 1781	The Baudouin Collection, Paris	* *Catalogues. The Hermitage* 1863–1916, No. 907; W. Martin, *Leven en Werken van Derrit Dou,* Leyden, 1901, No. 24; Hofstede de Groot, I, No. 52; * *Catalogue. Rembrandt* 1956, p. 76; * *Catalogue. The Hermitage* 1958, 2, p. 193; * *Catalogue. Rembrandt* 1969, No. 47.
1781	The Imperial Hermitage, St. Petersburg	

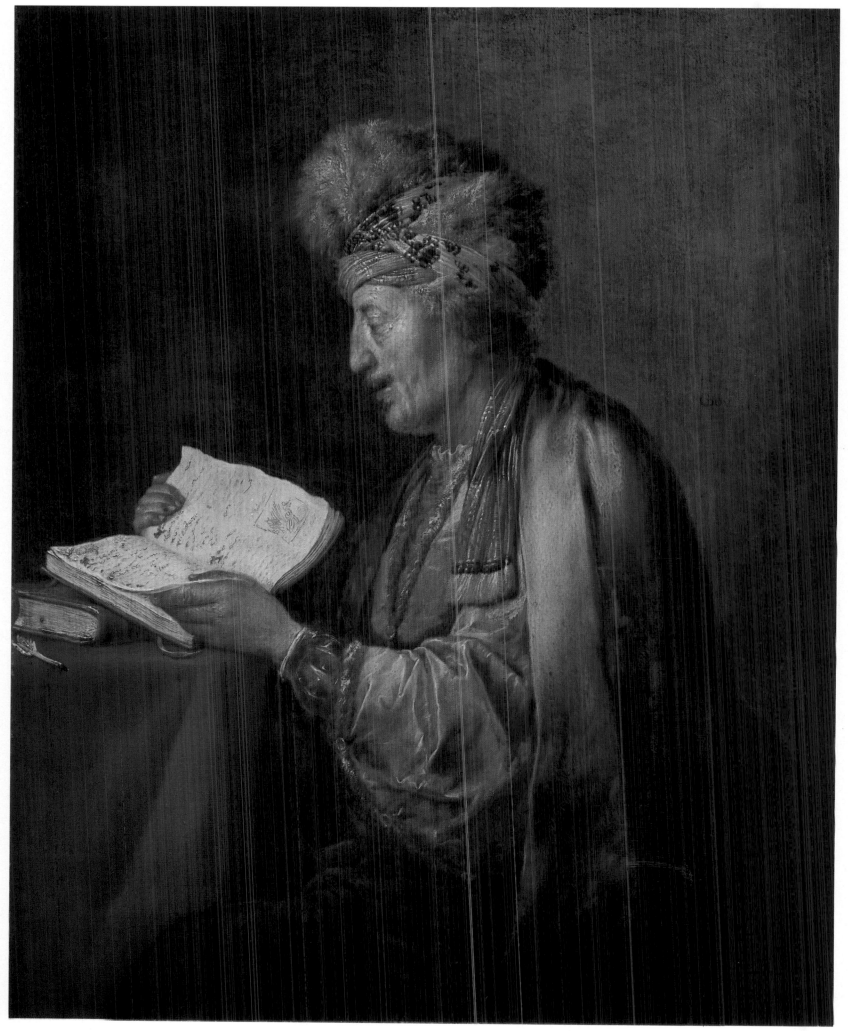

115

The Fiddler

Oil on panel, 15 3/4×11 3/8" (40×29 cm.), top corners rounded
Signed and dated on windowsill: GDov-1665
The Hermitage, Leningrad. Inv. No. 888

An inscription on the back of the canvas provides grounds for presuming that the picture once belonged to De la Vrillière, then was sold by him to Derieux-Vilé. The latter included it in his daughter's dowry, and Derieux-Vilé's son-in-law subsequently sold it to a certain M. Renou. The picture was at one time thought to be a self-portrait. However, neither the facial features nor the age of the model (Dou was fifty-two at the time, but portrayed here is a youth) warrant such an assumption. A later theory (A. Somov, W. Martin) had it that the person depicted is a nameless landscape artist, inasmuch as there is a landscape painting on the easel in the back of the room. If we take into account, however, that the foreground is taken up not by a picture but by a violin and a sword on an ornate baldric; that in the background, next to the easel, is a globe, and that all these taken together constitute the customary accessories of the allegory of vanity, then it may be safely assumed that this is an ordinary allegorical portrait so characteristic of the times. Moreover, it does not necessarily have to be a portrait of an artist—the attributes of the arts in the picture (the landscape on the easel and the violin), like the attributes of science (the globe) or of vainglory (the sword) that are always present in *Vanitas* compositions, could all symbolize the transience of the mortal existence.
A replica of the Hermitage picture is in the Gemäldegalerie (Alte Meister), Dresden (cat. No. 1707). Another known variant figured at the Piérard sale in Paris.

PROVENANCE

Until 1826 The M. Miloradovich Collection, St. Petersburg

1826 The Imperial Hermitage, St. Petersburg

REFERENCES

* *Catalogues. The Hermitage* 1863–1916, No. 906; W. Martin, *Leven en Werken van Gerrit Dou*, Leyden, 1901, No. 82; Hofstede de Groot, I, No. 153; * *Catalogue. Rembrandt* 1956, p. 100; * *Catalogue. The Hermitage* 1958, 2, p. 194.

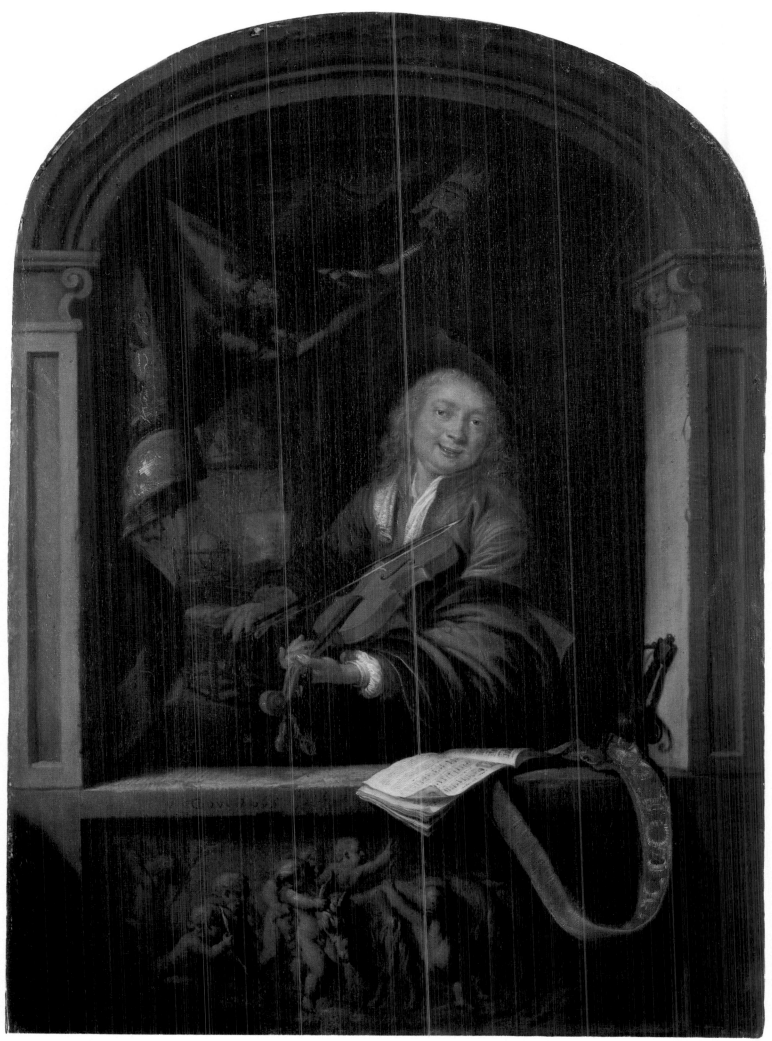

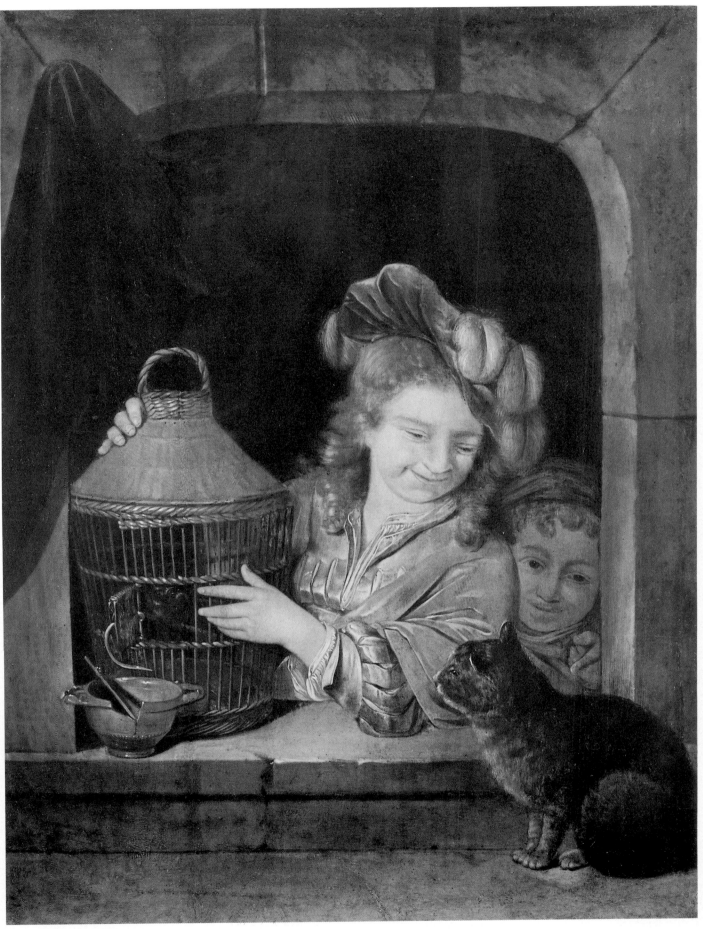

116

EGLON HENDRICK VAN DER NEER

Born 1634 in Amsterdam, died 1703 in Düsseldorf. Studied
under Aert van der Neer (his father) and Jacob van Loo.
Worked in Amsterdam, Rotterdam, The Hague, Brussels
(1681–89), and Düsseldorf (from 1690), where he was Court
Painter to the Elector of Pfalz (Palatinate). Painted genre
scenes, portraits, and landscapes.

116

Little Girl with Bird and Cat

Oil on panel, 9 3/8×7 1/2" (24×19 cm.)
The Hermitage, Leningrad. Inv. No. 1077

There are other pictures by Eglon Hendrick van der Neer devoted to the
same theme; one is in the Herzog Anton Ulrich Museum, Brunswick
(cat. of 1932, No. 320), another in the Staatliche Kunsthalle, Karlsruhe
(cat. of 1966, No. 280)

PROVENANCE	REFERENCES
Count de Vence Collection, Paris	* *Catalogues. The Hermitage* 1863–1916, No.
Duc de Choiseul Collection, Paris	993; Hofstede de Groot, V, No. 115; * *Cata-*
The Prince Conti Collection, Paris	*logue. The Hermitage* 1958, 2, p. 228.
1777 The Imperial Hermitage, St. Petersburg	

WILLEM VAN MIERIS

Born 1662 in Leyden, died there in 1747. Pupil of Frans van
Mieris the Elder (his father). Worked in Leyden. Painted genre
scenes and portraits.

117 →

In a Swoon

Oil on panel, 9 1/4×7 3/4" (23.5×20 cm.)
Signed and dated, top left: W. van Mieris 1695
The Hermitage, Leningrad. Inv. No. 1076

PROVENANCE		REFERENCES
April 6, 1695	Presumably put up for sale in Amsterdam	* *Catalogues. The Hermitage* 1863–1916, No. 1244; Hofstede de Groot, X, No. 143; * *Cata-*
August 18, 1712	The D. Grenier sale, Middelburg	*logue. The Hermitage* 1958, 2, p. 220.
Until 1772	The Pierre Crozat Collection, Paris	
1772	The Imperial Hermitage, St. Petersburg	

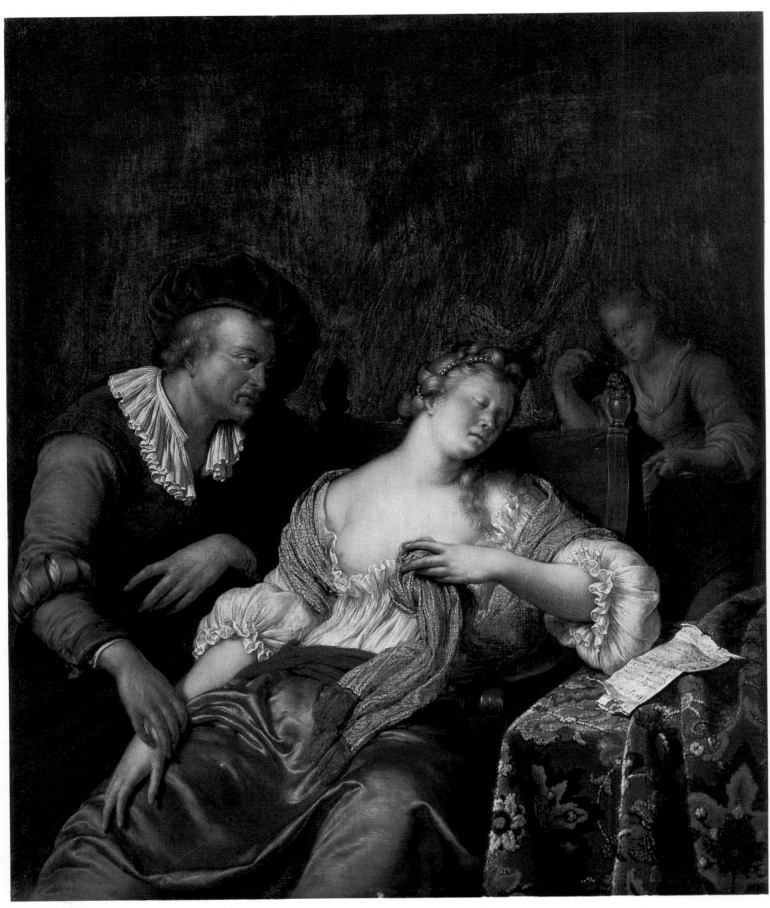

117

JAKOB WABBE

Worked in Hoorn between 1602 and 1634. Painted
biblical scenes and portraits.

118

The Meeting of Jacob and Rachel

Oil on panel, 15×24 ³⁄₈" (38×€2 cm.)
Signed and dated on stone, bottom center: J Wabens Fe 1624
The Hermitage, Leningrad. Inv. No. 3316

The subject is taken from the Bible (Genesis, XXIX: 9–12).

PROVENANCE

Until 1915 The P. Semionov-Tien-Shansky
Collection, Petrograd
1915 The Imperial Hermitage, Petro-
grad

REFERENCES

* *Catalogue Semenov* 1906, Nos. 582, 615;
* *Catalogue. The Hermitage* 1958, 2, p. 148;
* *Catalogue. Rembrandt* 1969, No. 39.

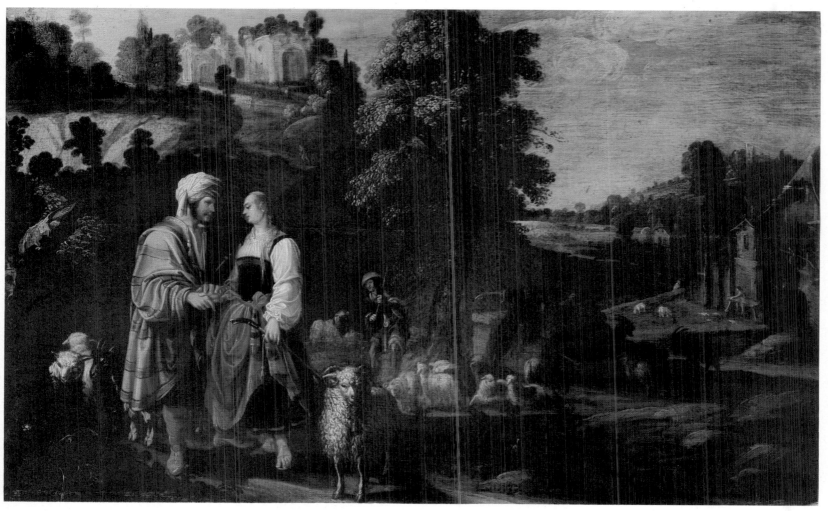

119

PIETER LASTMAN

Born 1583 in Amsterdam, died there in 1633. Pupil of Gerrit
Pietersz Sveelinck. Lived in Italy (1603–1605) where he fell
under the influence of Adam Elsheimer and the Carracci
brothers. Worked in Amsterdam (from 1605). Numbers
Rembrandt among his pupils. Painted biblical, mythological,
and historical scenes.

← 119

Abraham on the Way to Canaan

Oil on canvas (transferred from a panel), 28 1/4×48" (72×122 cm.)
Signed and dated on stone, left: Pietro Lastman fecit. A° 1614.
The Hermitage, Leningrad. Inv. No. 8306

The subject is taken from the Bible (Genesis, XII: 1–7).

PROVENANCE		REFERENCES
Until 1797	The Imperial Hermitage, St. Petersburg	Semenov, *Etudes* 1906, p. XXXI; Kurt Freise, *Pieter Lastman. Sein Leben und seine Kunst*, Leipzig, 1911, p. 32, No. 3; * *The Old Years* 1913, p. 91, No. 162 (repr.); * Shcherbachova 1940, pp. 40–41, note 8 (repr.); * *Catalogue. The Hermitage* 1956, p. 80; * *Catalogue. Rembrandt* 1969, No. 54.
1854	Bought at the Hermitage sale, passed through the Volkov, Korochentsev, Solovyov, and Feldman collections, St. Petersburg	
1938	The Hermitage, Leningrad (through the State Purchasing Commission)	

GERRIT VAN HONTHORST

Biography: *see under* plate 63.

120

The Agony in the Garden
(Christ in the Garden of Gethsemane)

Oil on canvas, 44 1/2×43 3/8" (113×110 cm.)
The Hermitage, Leningrad. Inv. No. 4612

The subject is taken from the Gospels according to St. Matthew, XXVI:
36–44; St. Mark, XIV: 32–39; St. Luke, XXII: 39–44.
Painted about 1617. On its entry into the museum the picture was ascribed
to an unknown Italian artist of the seventeenth century. The present
attribution was made by M. Shcherbachova (1956), and it rests on
a comparison of the Hermitage canvas with Honthorst's *The Virgin and Child
with Saints Francis of Assisi and Bonaventura, and Princess Colonna-Gonzaga*
(Church of the Capuchins, Albano) and *The Adoration of the Infant Christ*
(Uffizi Gallery, Florence). Several other pictures by Honthorst on the same
theme are mentioned in documents and sale catalogues.

PROVENANCE	REFERENCES
1931 The Hermitage, Leningrad (through the State Museum Reserve)	* Shcherbachova 1956, pp. 118–121; * *Catalogue. The Hermitage* 1958, 2, p. 186; J. Richard Judson, *Gerrit van Honthorst*, The Hague, 1959, pp. 151, 176, No. 39; * *Catalogue. Caravaggio and His Followers* 1973, No. 63; *Caravaggio and His Followers* 1975, Nos. 95–97.

120

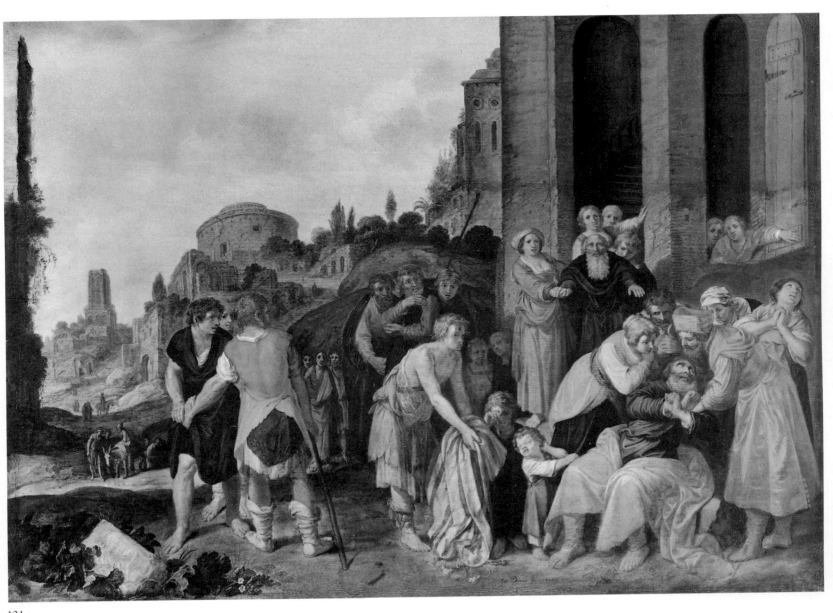

121

JAN PYNAS

Born 1583/84 in Haarlem, died 1631 in Amsterdam.
Worked in Amsterdam. Was in Rome together with Pieter
Lastman (about 1605). Influenced the young Rembrandt; was
possibly, along with Lastman, his teacher. Painted biblical
and mythological compositions.

121

The Sons of Jacob Showing Him Joseph's Bloody Coat

*Oil on panel, 35 3/8×46 7/8" (90×119 cm.). The upper part of the board
(1/3 of its height) is a later extension
Signed, bottom right of center: Jan Pynas fe 1618
The Hermitage, Leningrad. Inv. No. 5588*

←

The subject is taken from the Bible (Genesis, XXXVII: 31–35).
A preliminary sketch of this work's background landscape is in the Herzog
Anton Ulrich Museum, Brunswick. There is also a drawing from the picture
made by Rembrandt which reproduces the group of people leading a blind
old man (Schlossmuseum, Weimar). The picture was at one time very
popular. It inspired the most eminent Dutch poet of the seventeenth century,
Joost van den Vondel, to create the monologue of Reuben, the hero of his
drama *Joseph in Dothan*. A copy (?) on canvas of the Hermitage piece was in
an Amsterdam sale held June 5, 1765 (No. 223).

PROVENANCE		REFERENCES
17th century	The collection of Doctor R. van der Hoeven, Amsterdam	* Semionov 1885–90, pp. 163–164; * *Art Treasures in Russia*, II, 1902, p. 284; * *The Old Years* 1916, p. 36, note 91; K. Bauch, "Beiträge zum Werk der Vorläufer Rembrandt. 1. Die Gemälde des Jan Pynas," *Oud-Holland*, 1935, pl. 153; H. T. van Guldener, *Het Joseph-vorhaal bij Rembrandt en sijn school*, Amsterdam, 1947, pp. 93, 118; S. Slive, *Rembrandt and His Critics: 1630–1730*, The Hague, 1953, p. 69; * *Catalogue. Rembrandt* 1956, p. 85; * *Catalogue. The Hermitage* 1958, 2, p. 239; Bauch 1960, pp. 71–73; * *Catalogue. Rembrandt* 1969, No. 67.
November 3, 1779	The Iman Pauw sale, Amsterdam, No. 98	
March 17, 1783	An anonymous sale, Amsterdam, No. 188	
November 4, 1789	The Bergheon sale, The Hague, No. 84	
Until 1925	The Shuvalova Collection, St. Petersburg	
1925	The Hermitage, Leningrad	

HENDRICK TERBRUGGHEN

Biography: *see under plate 62.*

122, 123 →

Christ Crowned with Thorns

Oil on canvas, 46 7/8×45 5/8" (119×116 cm.)
Art Museum, Irkutsk. Inv. No. 670

The subject is taken from the Bible (St. John, XIX: 2–3).
Painted around 1622. The picture was previously ascribed to an unknown
Italian artist of the seventeenth century. Irene Linnik's attribution (1971) was
made through comparison with Terbrugghen's canvases *Youth Lighting
a Pipe* (Dobó István Vármuzeum, Eger, Hungary), *The Calling of Saint
Matthew* (Centraal Museum, Utrecht), *The Mocking of Christ* (Statens
Museum for Kunst, Copenhagen), and *Saint Luke the Evangelist*
(Town Hall, Deventer).
Christ Crowned with Thorns shares a compositional affinity with both the
works of the Italian Caravaggists, especially Bartolommeo Manfredi's picture
on the same subject (the Helbing sale, Munich, February 22–24, 1931), and
some canvases by Dirck van Baburen, notably *Christ Crowned with Thorns*
(Provincialaat der Minderbroeders, Weert).

PROVENANCE		REFERENCES
Until 1950	The N. Adonyev Collection, Irkutsk	* *Catalogue. Irkutsk* 1957, p. 17; * Linnik 1971, pp. 54–59; * *Catalogue. Caravaggio and His Followers* 1973, Nos. 109–111.
1950	Art Museum, Irkutsk (gift of N. Adonyev)	

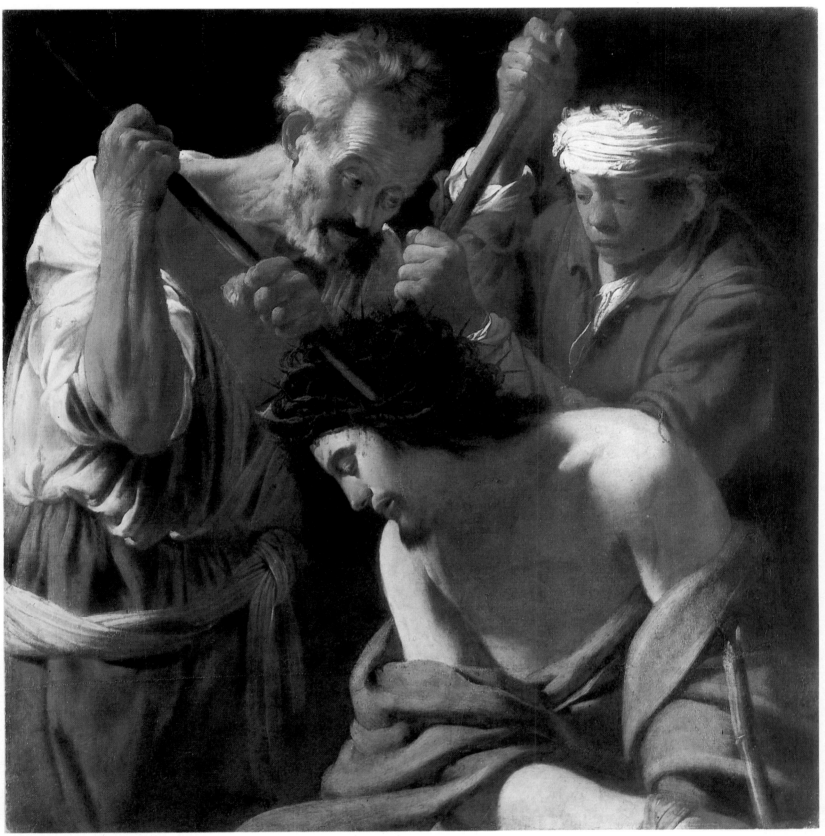

122

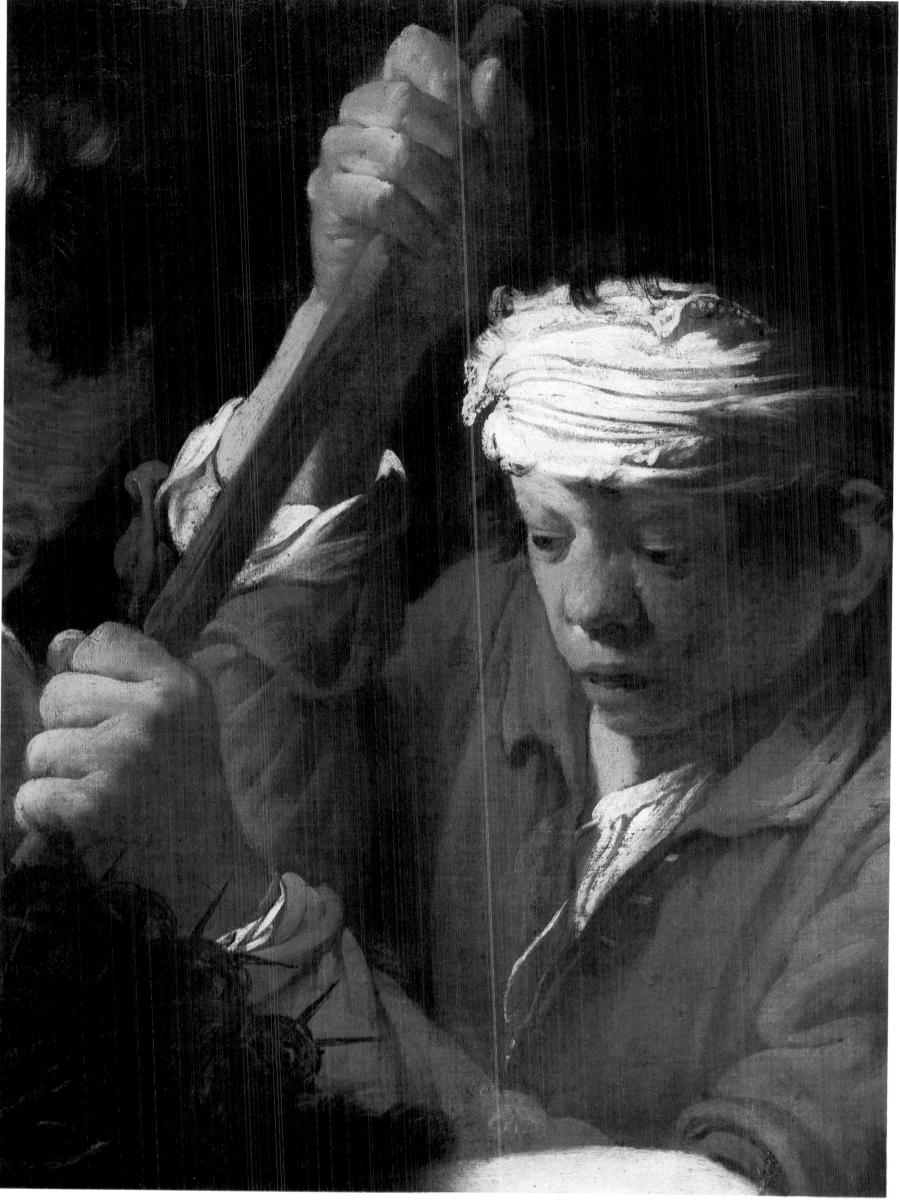

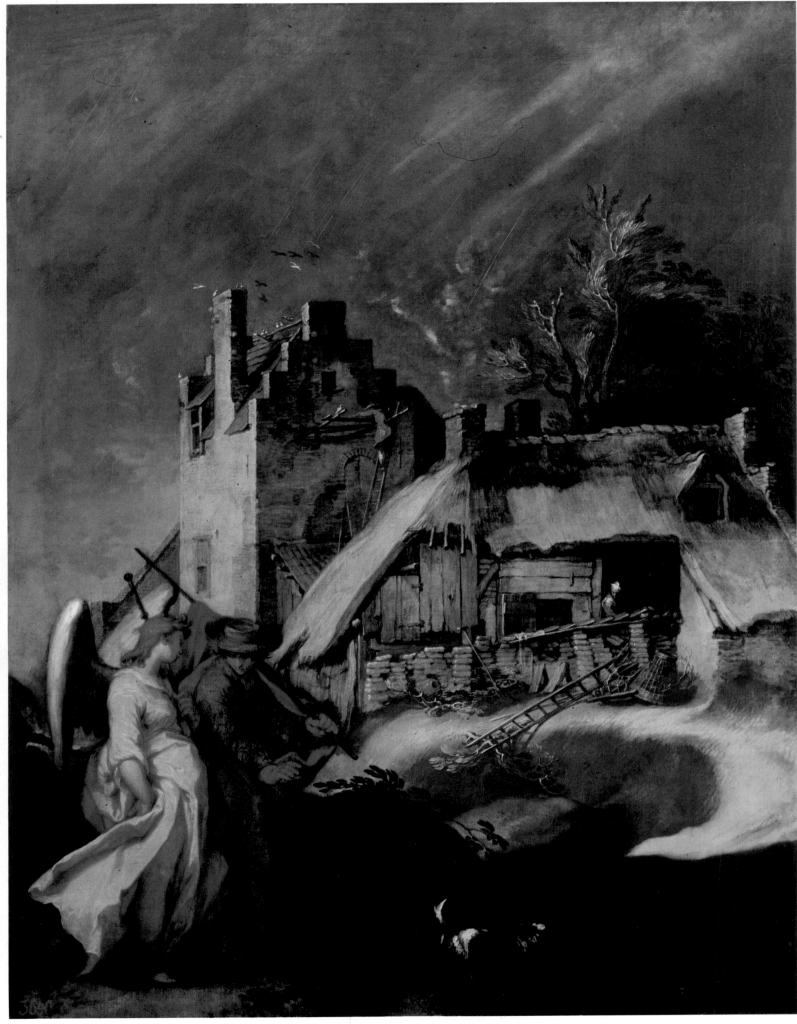

128

130

Prophet Elijah in a Landscape

Oil on canvas, 28 1/4×38 1/8" (72×97 cm.)
Signed, bottom right: Bloemaert fec.
The Hermitage, Leningrad. Inv. No. 6802

The subject is taken from the Bible (I Kings, XVII: 4–6). Elijah the Prophet hides himself by the brook Cherith and eats of the flesh and bread brought to him by the ravens.

PROVENANCE	
Until 1931	Palace Museum, Pavlovsk
1931	The Hermitage, Leningrad

REFERENCES

* Trubnikov 1912, p. 23; * Kharinova 1923, p. 89; G. Müller, "Abraham Bloemaert als Landschaftsmaler," *Oud-Holland*, 1927, p. 208; G. Delbanco, *Der Maler Abraham Bloemaert*, Strasbourg, 1928, No. 17.

131

LEONARD (LEONAERT) BRAMER

Born 1596 in Delft, died there in 1674. Worked in Delft.
Was in Italy for over ten years. Painted biblical, mythological,
historical, and literary subjects, occasionally portraits
and genre scenes.

131

David Dancing Before the Lord

Oil on copper, 16 1/2×22 3/4" (42×58 cm.)
Signed on ruins of wall, left: L. Bramer
The Pushkin Museum fo Fine Arts, Moscow. Inv. No. 436

The subject is taken from the Bible (2 Samuel, VI: 14–16; 1 Chronicles,
XV: 28). There is a well-known copy of this picture (until 1917 in the
V. Argutinsky-Dolgoruky Collection, Petrograd) which was long believed
to be the original.

PROVENANCE

Until 1916 The Rumiantsev Museum, Moscow (gift of M. Grachova)
Until 1937 Museum of Fine Arts, Moscow
1937 The Pushkin Museum of Fine Arts, Moscow

REFERENCES

* *The Old Years* 1912, p. 22 (repr.); * *The Old Years* 1915, p. 62; * *Catalogue. The Rumiantsev Museum* 1915, No. 120; H. Wichmann, *Leonaert Bramer*, Leipzig, 1923, No. 9 (copy); * *Catalogue. Rembrandt* 1956, pp. 71–72; * *Catalogue. The Pushkin Museum of Fine Arts* 1961, p. 23; * *The Pushkin Museum of Fine Arts* 1966, No. 29.

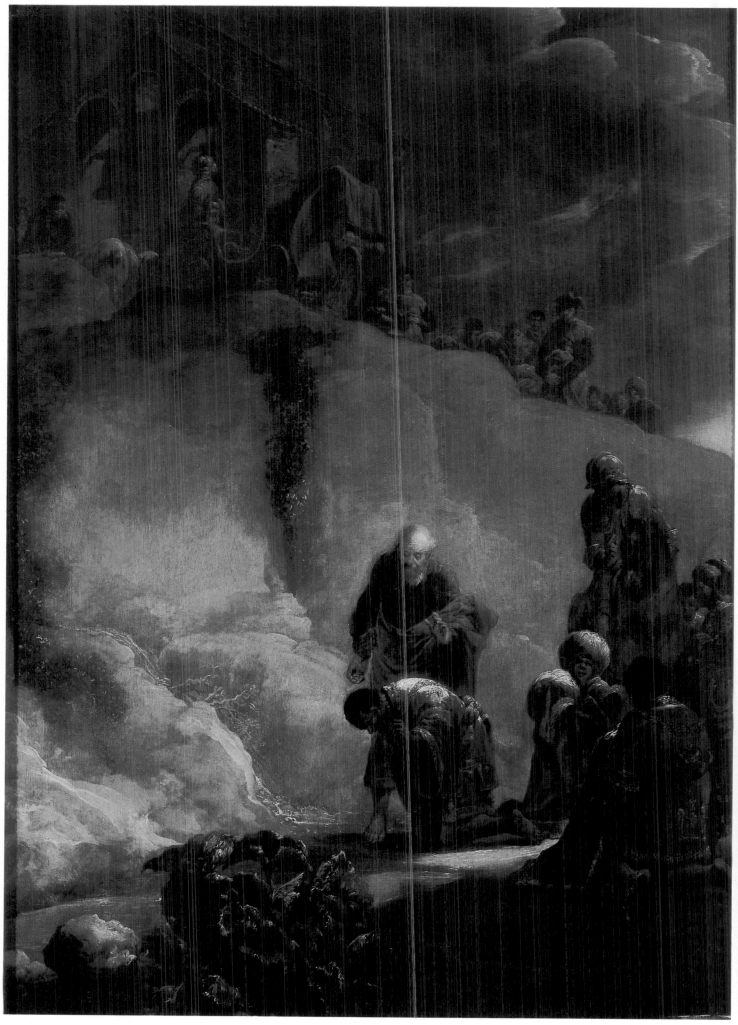

← 132

The Baptism of the Eunuch by the Apostle Philip

Oil on panel, 37 3/8×28 1/4" (95×71.5 cm.)
Signed and dated, bottom center: L. Bramer 16..
Museum of Western European and Oriental Art, Kiev. Inv. No. 214

Four other pictures by Bramer on the same subject are known. One of them (in 1907 in Count Fürstenberg's Collection, Herdringen Castle, Westphalia), judging from a description, resembles the Kiev picture but is much smaller in size (6 1/2×5 3/8" or 16.5×13.5 cm.).

PROVENANCE

1946 Museum of Western European and Oriental Art, Kiev (bought from B. Rezanov)

REFERENCES

* *Catalogue. Rembrandt* 1956, p. 72; * *Catalogue. Kiev* 1961, No. 66.

NICOLAES (CLAES) MOEYAERT

Born before 1600 in Amsterdam (?), died there in 1655. Visited Italy (before 1630). Worked in Amsterdam. Painted biblical and mythological scenes, landscapes, and portraits.

133

Hercules after His Victory over Achelous (The Allegory of Abundance)

Oil on panel, 20 5/8×26 3/4" (52.5×68 cm.)
Picture Gallery, Kalinin. Inv. No. 734

The subject is taken from Ovid's *Metamorphoses* (X, 1–100).
The attribution, by Irene Linnik, is based on the picture's iconographic and stylistic affinity with the artist's signed work *Bacchanalia* (the former Kaiser-Friedrich-Museum, Berlin, cat. of 1931, No. 699). It was previously accepted as the work of an unknown seventeenth-century artist.
The picture betrays the unmistakable influence of Jacob Jordaens's compositions on the same subject (Statens Museum for Kunst, Copenhagen, and Musée d'Art Ancien, Brussels). The Allegory of Abundance was one of Jordaens's favorite themes. In addition to the subject, Moeyaert borrowed here some individual motifs from Jordaens's canvases. Similar borrowings from Jordaens are present in other Moeyaert works as well.

REFERENCES

Provenance unknown.

* Linnik 1972, p. 7, note 6.

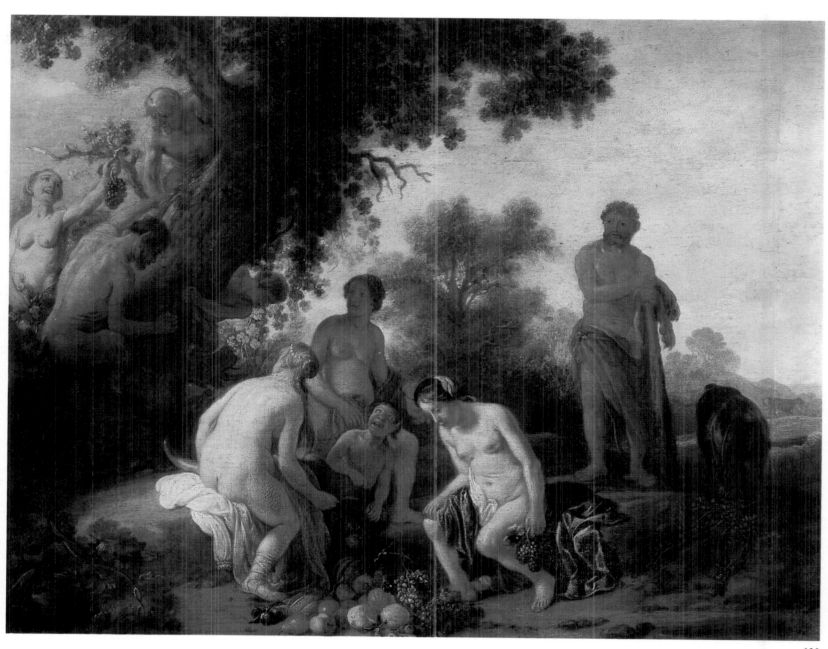

133

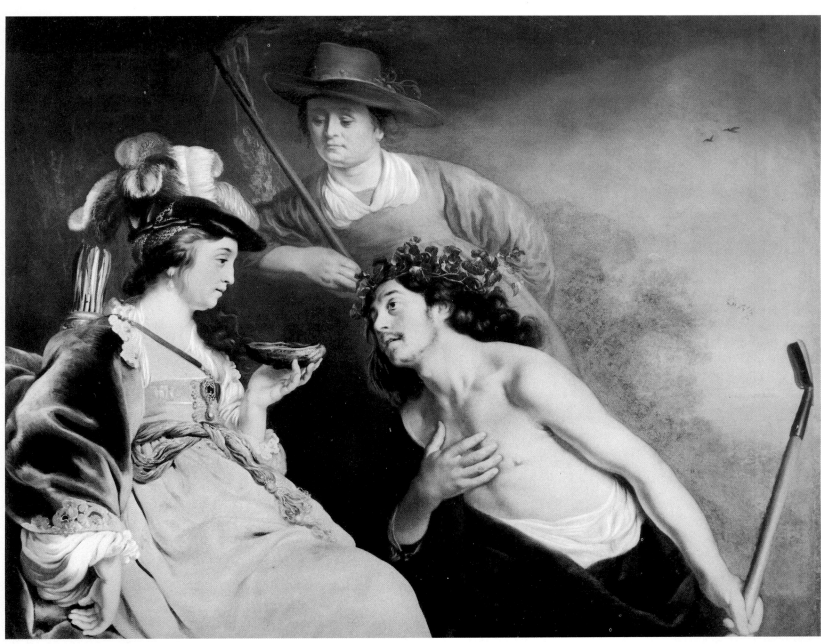

134

JACOB ADRIAENSZ BACKER

Born 1608 in Harlingen, died 1651 in Amsterdam. Studied under Lambert Jacobsz in Leeuwarden. Lived in Amsterdam (from 1632) where he was a pupil of Rembrandt. Painted mythological, allegorical, and biblical subjects, also portraits.

134

Granida and Daifilo

Oil on canvas, 49 1/8×53 3/8" (125×161.5 cm.)
The Hermitage, Leningrad. Inv. No. 787

The subject is taken from *Granida* (I, 3) by Pieter Cornelisz Hooft.
The picture was previously (before 1925) described as *Diana with Shepherds*.
The canvas entered the Hermitage as a work by Govaert Flinck, then was tentatively ascribed by V. Shchavinsky to Jan Gerritsz van Bronckhorst.
In 1925 its author was correctly identified as Backer. The Hermitage picture's closest analogues, which prove Backer's authorship beyond the shadow of a doubt, are his signed canvases on the theme of The Crowning of Mirtillo (private collection, Vienna; the Muzeul Brukenthal, Sibiu, Rumania, cat. of 1909, No. 46).

PROVENANCE		REFERENCES
Until 1797	The Imperial Hermitage, St. Petersburg	* Shchavinsky 1916. p. 84; S. J. Gudlaugsson, *Representations of Granida in Dutch Seventeenth Century Painting*; * Catalogue. Rembrandt 1956, p. 92; * Catalogue. The Hermitage 1958, 2. p. 131; * Catalogue. Rembrandt 1969, No. 27.
Until 1925	Palace, Gatchina	
1925	The Hermitage, Leningrad	

MATHIAS STOMER

Born around 1600 in Amersfoort, died 1672 in Naples.
Pupil of Joachim Antonisz Wtewael and Abraham Bloemaert
in Utrecht and, possibly, of Gerrit van Honthorst during their
joint stay in Italy. Lived in Rome (1630–37), Sicily, and Naples.
Besides biblical and historical subjects, he painted
single-figure genre scenes.

135, 136

The Adoration of the Shepherds

*Oil on canvas, 41 3/8×50 3/4" (105×129 cm.). At left and below are later
extensions. The original dimensions were 40 5/8×39"(103×99 cm.).
The Radishchev Art Museum, Saratov. Inv. No. 1033*

The subject is taken from the Bible (St. Luke, II: 16).
The attribution is made by H. Gerson (1956, verbally). In the Moscow
Museum of Fine Arts it was catalogued as a work by Honthorst, in the
Radishchev Art Museum, Saratov, it was ascribed to an unknown Italian
artist of the seventeenth century.

PROVENANCE		REFERENCES
Until 1933	The Museum of Fine Arts, Moscow	* Kuznetsov 1959, p. 6, No. 10; * *Catalogue. The Hermitage* 1964, p. 41; * Kuznetsov 1967, No. 24; * *Catalogue. Saratov* 1969, p. 12.
1933	The Radishchev Art Museum, Saratov	

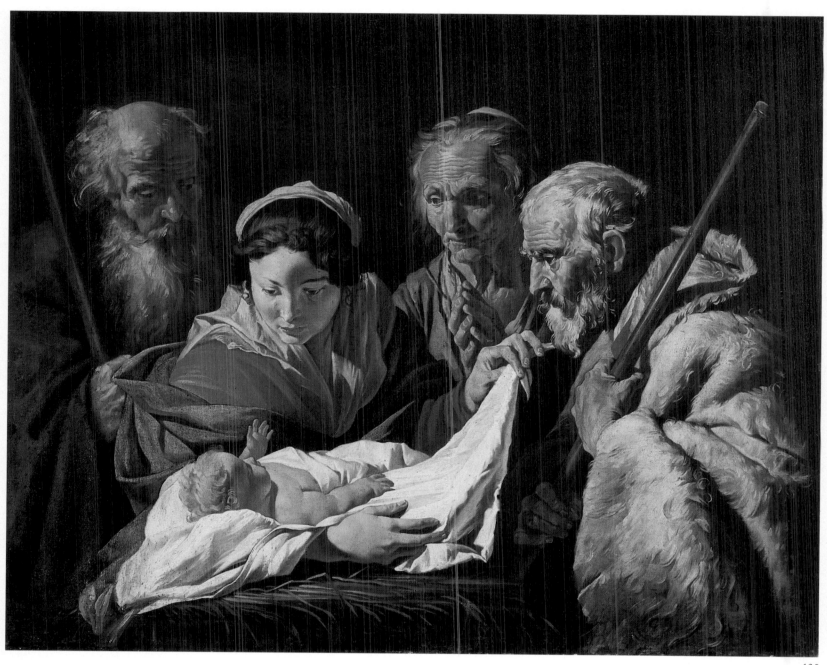

135

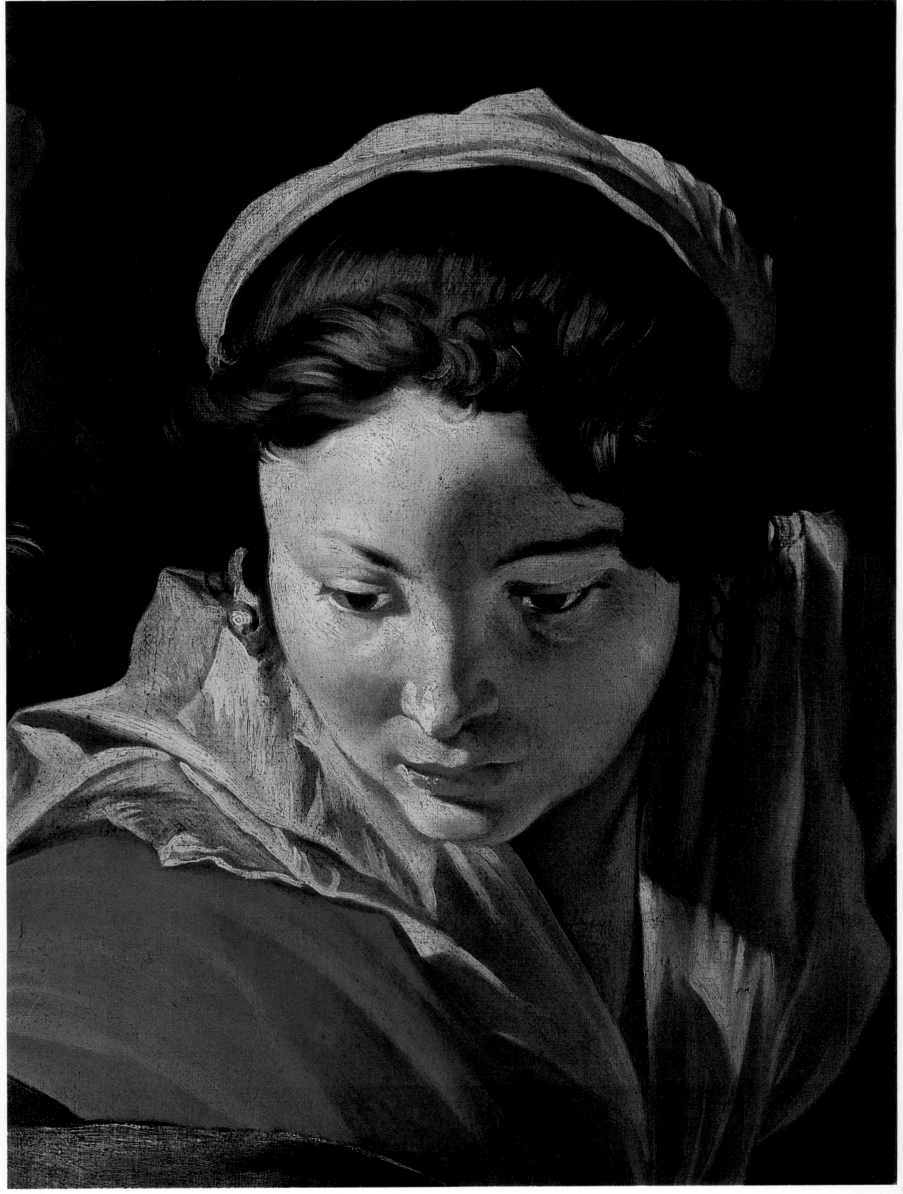

137 →

The Angel

Oil on canvas, 58 3/8 × 47 1/8" (148.5 × 119.5 cm.)
Museum of Art and Local Lore, Zhitomir. Inv. No. 34

Together with its companion picture, *The Virgin* (*see* plate 138), makes up
a single composition, *The Annunciation*.

In the Zhitomir museum this picture, like its companion piece, was
catalogued as a work by the seventeenth-century Flemish painter Gherard
Seghers. The attribution (according to archival documents in the museum's
keeping) was made through comparison with an engraving from a nonextant
Seghers picture entitled *The Annunciation* and included in M. Lebrun's
album *Galerie des peintres flamands, hollandais et allemands* (Paris, 1792).

However, what these two compositions have in common—the cast of
characters and the attributes—is conditioned by the plot. The kneeling
posture of the Virgin (*see plate* 138) is necessitated by canon. In all other
respects the pictures are dissimilar.

The attribution of the Zhitomir paintings to the brush of Stomer was made by
Irene Linnik through comparing them with the artist's pictures *Tobias
Catches a Fish as Commanded by the Archangel Raphael* (Museum Bredius,
The Hague), *The Healing of Tobias* (Museo di Castello Ursino, Catania), *The
Adoration of the Shepherds* (Kunsthistorisches Museum, the former
Liechtenstein Gallery, Vienna), *The Adoration of the Magi* (formerly in the
Dowdwells Collection, London), and *The Miracle of Saint Isidore* (Church of
Sant' Agostino, Caccano).

PROVENANCE

Until 1924	Church in the village of Denishi, Zhitomir region
1924	Museum of Art and Local Lore, Zhitomir

REFERENCES

* *Catalogue. Caravaggio and His Followers*
1973. Nos. 57, 58; *Caravaggio and His Follow-
ers* 1975. Nos. 149–153.

138 →

The Virgin

Oil on canvas, 58 3/8 × 47 1/8" (148.5 × 119.5 cm.)
Museum of Art and Local Lore, Zhitomir. Inv. No. 35

Together with its companion picture, *The Angel* (*see* plate 137), makes up
a single composition, *The Annunciation*.

Provenance and References: *see under* plate 137.

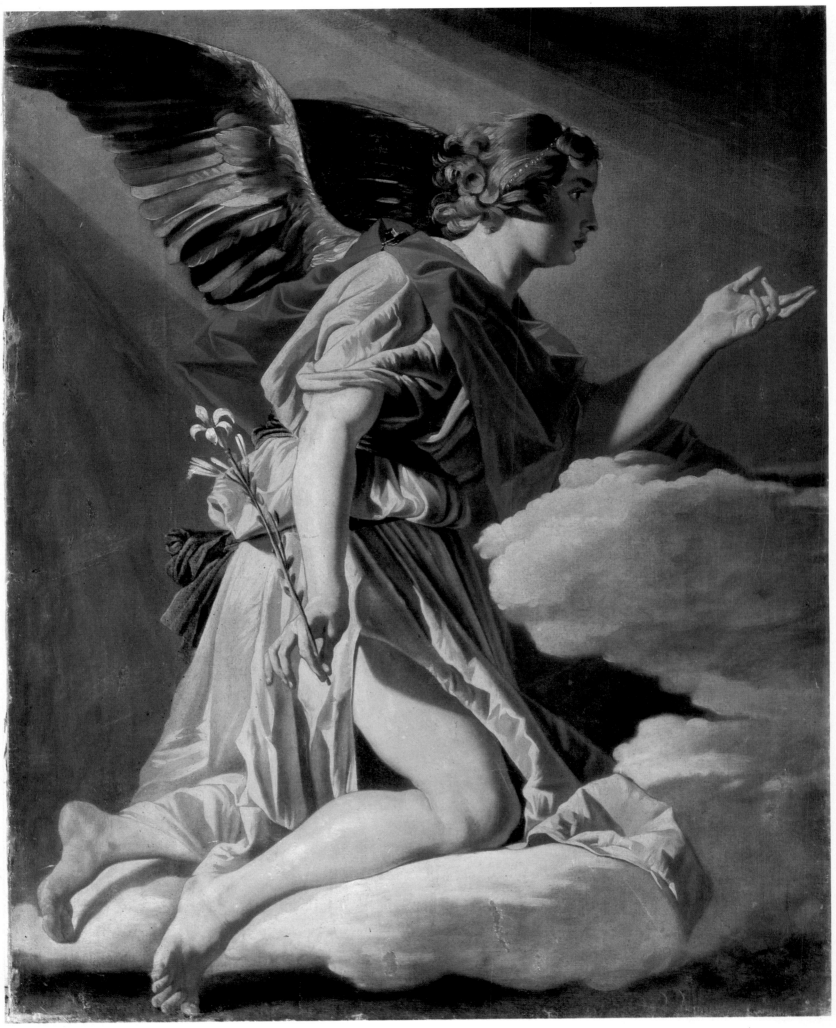

137

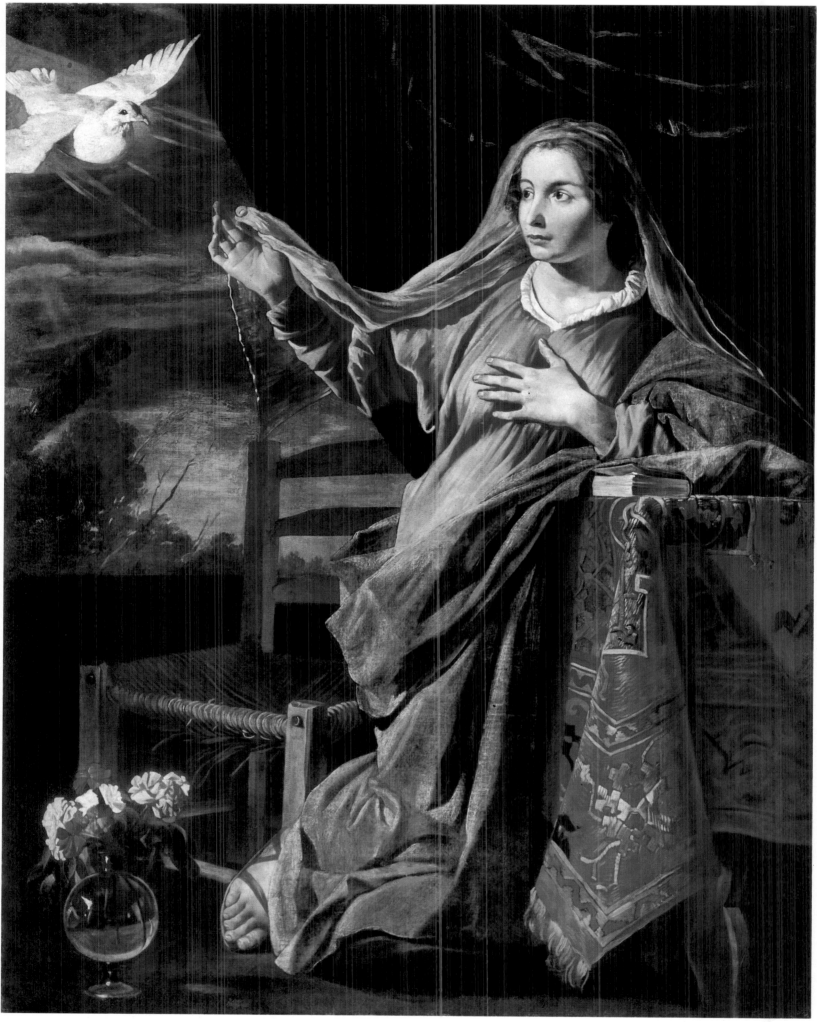

PIETER VAN BIE

Worked in the seventeenth century. Biography unknown.
Judging from the character of his works, he was influenced by
the art of Nicolaes Cornelisz Moeyaert. Painted
pictures on biblical themes.

139

The Expulsion of Hagar

Oil on panel, 20 3/4×28 1/4" (53×72 cm.)
Signed and dated, bottom left: P v Bie f A 1642
The Hermitage, Leningrad. Inv. No. 3240

The subject is taken from the Bible (Genesis, XXI: 9–14).
This is one of Bie's few known works.

PROVENANCE		REFERENCES
Until 1915	The P. Semionov-Tien-Shansky Collection, Petrograd	*Catalogue Semenov* 1906, No. 39; *Semenov, Etudes* 1906, p. XXXIV; * *Catalogue. The Hermitage* 1958, 2, p. 138; * *Catalogue. Rembrandt* 1969, No. 32.
1915	The Imperial Hermitage, Petrograd	

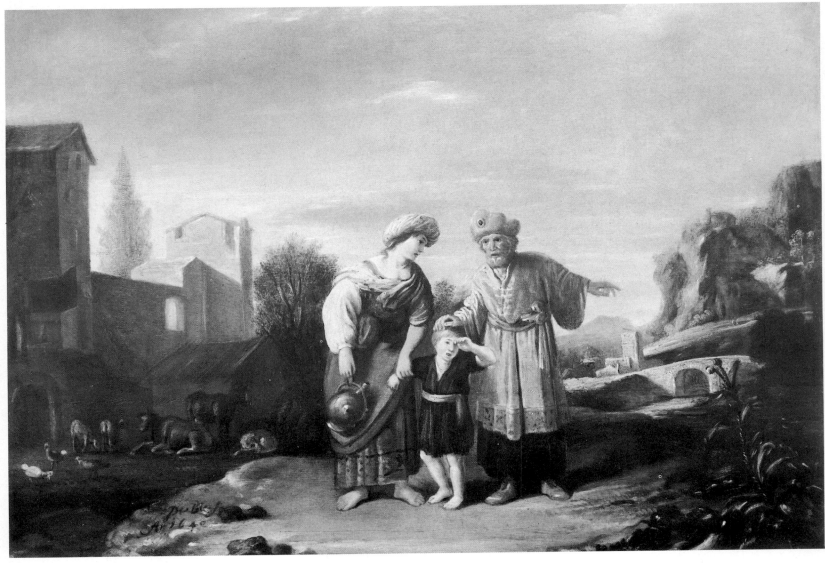

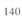

JAN MIENSE MOLENAER

Biography: *see under* plate 71.

140

Ascanio and Lucelle

Oil on panel, 21 1/4×28″ (54×71 cm.)
Signed and dated, bottom right: Molenaer 16..
Art Museum, Kharkov. Inv. No. 28

The subject is taken from *Lucelle* (Act V, final scene) by Gerbrandt
Adriaansz Bredero.
Painted around 1639. Two other Molenaer works illustrating the same subject
are known: one, dated 1636, is in the Muiden Castle, the other, from 1639, is
in a private collection in Stockholm. The latter is particularly close to the
Hermitage piece. The costumes in all three pictures reproduce those worn by
actors of the Rhetoricians' Theater where *Lucelle* was first staged between
1613 and 1615 and later revived.
This scene from *Lucelle* was depicted by other Dutch artists, including
Willem Buytewech, Jan Steen, and Hendrick Sorgh.

Provenance unknown.

PIETER DE BLOOT

Born 1601 in Rotterdam, died there in 1658. Was influenced by
the art of Adriaen Brouwer. Worked in Rotterdam. Painted
genre scenes, biblical compositions, and portraits.

141

Joseph's Brothers Lifting Him out of the Pit

Oil on panel, 20 5/8×19 1/4″ (52.5×49 cm.)
Signed and dated, bottom right: P. de Bloot f 1636
(worn and faint)
The Hermitage, Leningrad. Inv. No. 698

The subject is taken from the Bible (Genesis, XXXVII: 25–28).
In the manuscript Hermitage catalogue of 1773 this work was listed
as a Rembrandt, a companion piece to *The Incredulity of Thomas* (the
Pushkin Museum of Fine Arts, Moscow), and later as the work of an
unknown Dutch artist. B. Vipper linked the author of the picture with the
circle of Pieter Lastman. It was attributed to Pieter de Bloot by Yury
Kuznetsov in 1956. Subsequent restoration and cleaning revealed de Bloot's
signature and date, both rather indistinct, but legible.

PROVENANCE	REFERENCES
Before 1773　The Imperial Hermitage, St. Petersburg	* Kuznetsov 1956, pp. 28–30; * Vipper 1957, p. 113; * Kuznetsov 1959, No. 12; * *Catalogue. The Hermitage* 1958, 2, p. 139.

142

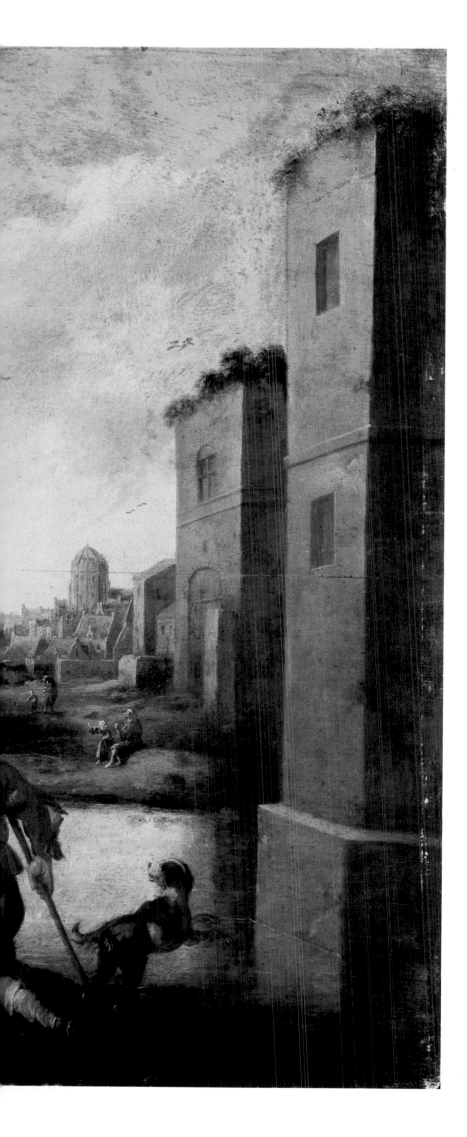

Born 1586 in Utrecht (?), died in that city in 1666. Worked in Utrecht, where he was a member of the Utrecht guild (from 1616). Painted genre and biblical scenes, and views of towns, villages, river valleys with many figures. Was also an etcher.



142

The Healing of the Sick in the Pool of Bethesda

Oil on panel, 22×28 1/4" (56×72 cm.)
Art Museum, Kaluga. Inv. No. 146



The subject is taken from the Bible (St. John, V: 1–9). Droochsloot produced several paintings on this subject which are now housed in the museums of Antwerp, Brunswick, Emden, Utrecht: moreover, one figured at the 164th Copenhagen sale under No. 1171.

PROVENANCE		REFERENCES
Until 1932	The Hermitage, Leningrad	* *Catalogue. Kaluga* 1959, p. 60.
1932	Art Museum, Kaluga	

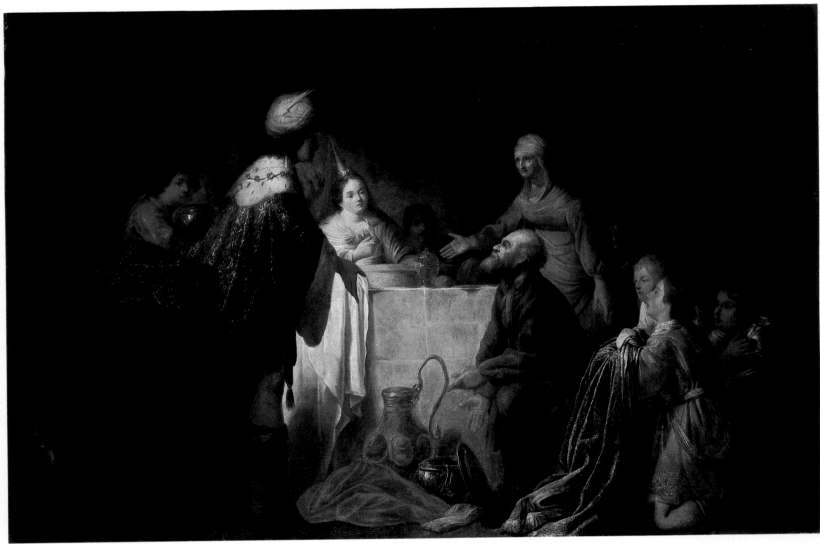

143

PIETER FRANSZ DE GREBBER

Born around 1600 in Haarlem, died there in 1653. Pupil to Frans
Grebber (his father), Hendrick Goltzius, and possibly Jan
Pynas. Worked in Haarlem. Painted biblical
and mythological subjects.

143

The Offering of a Present to the King

Oil on canvas, 38 1/8×57 1/2" (97×146 cm.)
Art Museum, Kaluga. Inv. No. 151

The subject is taken from the Bible (Isaiah, XXXIX: 1, 2).

Provenance unknown.

REFERENCES

* *Kaluga Museum* 1929, No. 174 (as a copy of
a Rembrandt painting); * *Catalogue. Kaluga*
1959, p. 60.

REMBRANDT HARMENSZ VAN RIJN

Biography: *see under* plate 50.

144, 145 →

David's Farewell to Jonathan

Oil on panel, 28 ³/₄×24 ¹/₄″ (73×61.5 cm.)
Signed and dated, bottom center: Rembrandt. f. 1642
The Hermitage, Leningrad. Inv. No. 713

The subject of the picture is taken from the Bible (I Samuel, XX: 41). It was for a long time incorrectly interpreted, and even today scholars have not arrived at a consensus. In old inventories of pictures in the Hermitage and other imperial palaces it was entered as *The Return of the Prodigal Son*, but this was later changed to *The Reconciliation of Esau and Jacob* (Genesis, XXXIII: 4). The latter title came into accepted use in the nineteenth century. It was only in 1893 that A. Somov took a critical view of the interpretation and suggested that the composition depicts the reconciliation of David with Absalom (II Samuel, XIV: 33). After considering all other more or less appropriate biblical themes Hofstede de Groot arrived at the same conclusion. However, this hypothesis soon came to be questioned too.

In 1925 K. Baudissin suggested that Rembrandt's picture depicts the scene of David's parting with Jonathan. He based his surmise on the quiver full of arrows in the right-hand corner of the composition, inasmuch as Jonathan used arrows to warn David of Saul's anger, and on the great stone of Azel where, according to the Bible, the meeting took place. But he could not explain why David was dressed in the clothing of a king, and Baudissin's version was rejected. In 1957 an article by V. Loewinson-Lessing laid aside all misgivings on that score. In the same Book I of Samuel, but in Chapter XVIII, not XX (verses 1–5), the story is told how Jonathan, who loved David "as his own soul... stripped himself of the robe that was upon him, and gave it to David, and his garments, even to his sword, and to his bow, and to his girdle." Another element that lends credence to the interpretation is the depiction, in the composition's right-hand part, of the entrance into the shelter where David hid for three days waiting for Jonathan.

V. Loewinson-Lessing went on to discover what is perhaps the final confirmation of the new interpretation's correctness—archival documents to the effect that the picture was purchased for Peter the Great in Amsterdam by Osip Solovyov on May 13, 1716, at the sale of the collection of Jan van Beuningen, where it was catalogued as *David and Jonathan*. From that time on the new interpretation has come to be accepted by most scholars.

J. van Gelder expresses one more thought that we believe deserves the closest scrutiny. In March, 1659, Rembrandt undertook to complete in one year's time and deliver to his creditor, the Amsterdam trader Lodowijk van Ludick, in partial repayment of debts outstanding, the picture *David and Jonathan*, already begun. Seeing in the picture a coloristic affinity with Rembrandt's works of the early 1660s, Van Gelder ventures to suggest that this work of 1642 was reworked two decades later, and is therefore quite probably the very piece mentioned in the promissory note of 1659. Although neither visual scrutiny nor X-raying reveals any traces of repainting, Van Gelder's supposition is in all probability correct. The upper left-hand corner of the picture is in very bad shape. The panel of the painting had been seriously cracked and now has three inserts (4 ¹/₄×5 ¹/₈″ or 11×13 cm.; ³/₄×⁷/₈″ or 1.9×2.2 cm.; and 1×1″ or 2.6×2.7 cm.); there are numerous patches

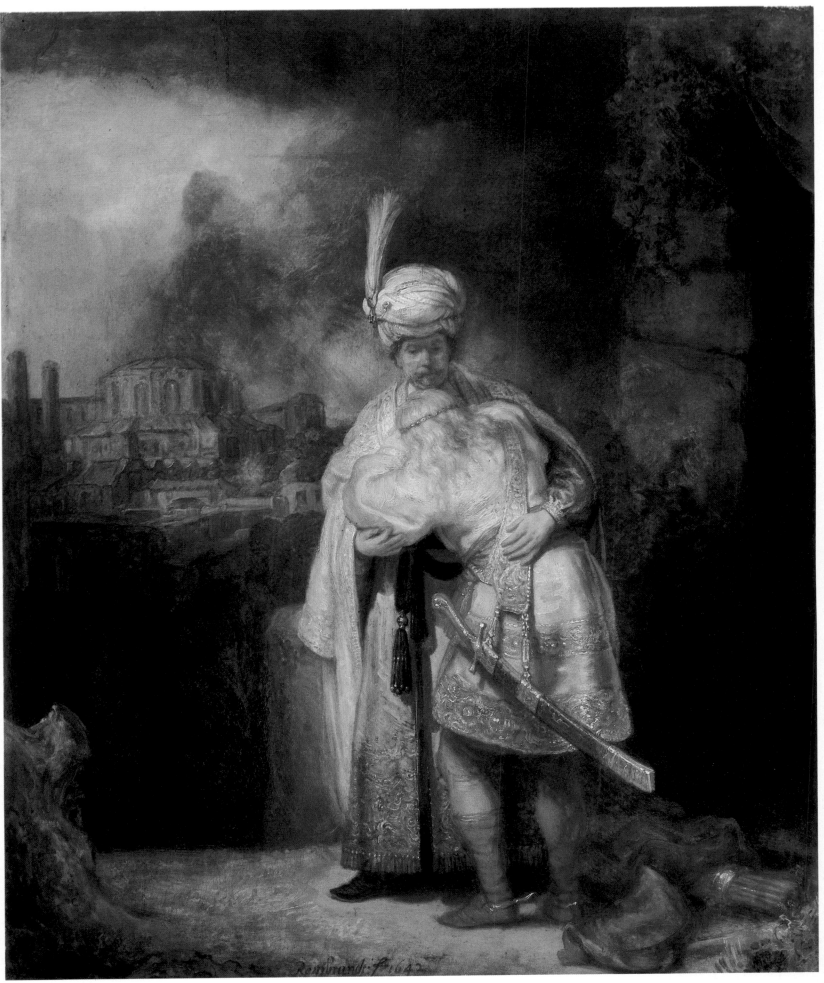

144

145

←

of overpainting along the line of fissure. That is why when Rembrandt spoke of his unfinished *David and Jonathan* in 1659, he might have had in mind the Hermitage picture, so strongly in need of repair. Another fact that argues in favor of the supposition is that up to the present time no other Rembrandt work on the subject has been discovered.

Among the several Rembrandt drawings that reproduce the scene of the Hermitage piece or of some other work very like it, the closest to our composition is *The Return of the Prodigal Son* (Teyler Museum, Haarlem; Benesch, No. 519), now also dated to 1642. J. van Gelder rightly sees in it the prototype of the Hermitage picture.

PROVENANCE

March, 1659	Probably mentioned in Rembrandt's promissory note to Lodowijk van Ludick, Amsterdam
October 19, 1678	Probably listed in the post-mortem inventory of Herman Becker, Amsterdam
April 19, 1713	The L. van der Heem sale, Amsterdam (sold for 105 florins)
May 13, 1716	The Jan van Beuningen sale; purchased for Peter the Great by Osip Solovyov, Amsterdam (for 80 florins)
Early 18th century	The Monplaisir Palace, Peterhof
1882	The Imperial Hermitage, St. Petersburg

REFERENCES

* Vasilchikov 1883, p. 25; Bode 1883, p. 44;
* *Catalogues. The Hermitage* 1863–1916, No. 1777; Valentiner 1909, p. 227; Hofstede de Groot, VI, No. 38; K. Baudissin, "Anmerkungen zu Rembrandt-Erklärung," *Repertorium für Kunstwissenschaft*, XLVI, 1925, pp. 190–192; Weisbach 1926, pp. 219, 317; Benesch 1935, p. 30; Hamann 1948, pp. 268–269; * Loewinson-Lessing 1956, pp. X–XI; Knuttel 1956, p. 144; J. Rosenberg, "Die Rembrandt-Ausstellungen in Holland," *Kunstchronik*, 1956, December, p. 346; W. R. Valentiner, *Art Quarterly*, 19, 1956, p. 395; J. Rosenberg, *Ibid.*, p. 383; J. van Gelder, H. Gerson, H. Kauffmann, J. Q. van Regteren Altena, *Kunstchronik*, 1957, May, p. 146; * *Catalogue. The Hermitage* 1958, 2, p. 256; * Chlenov 1958, pp. 60–61; Levinson-Lessing 1964, Nos. 77, 78; * Fechner 1965, No. 13; * Volskaya 1966, p. 64; * Bauch 1966, No. 24; Gerson 1968, No. 207; Bredius 1969, No. 511; Ch. Tümpel, "Studien zur Ikonographie der Historien Rembrandts," *Nederlands kunsthistorisch Jaarboek*, XX, 1969, pp. 140–146.

146

The Holy Family with Angels

Oil on canvas, 46 1/8×35 3/4" (117×91 cm.)
Signed and dated, bottom left: Rembrandt. f. 1645
The Hermitage, Leningrad. Inv. No. 741

In the 1640s Rembrandt painted a number of pictures on the theme of the Holy Family. The Hermitage canvas is the best of them all. Three drawings are extant that definitely relate to the Hermitage picture. One is a general sketch of the composition (the L. Clark Collection, Cambridge, Massachusetts; Benesch, No. 569) where the Holy Family is depicted sleeping. Perhaps this is the episode that preceded the flight into Egypt and that is known in iconography as Saint Joseph's Vision (St. Matthew, II: 13). However, the Gospel narrative speaks not of cherubim, but of the angel of the Lord who appears to Joseph in a dream warning him of the perils that await the infant Christ; he is present in another Rembrandt painting of 1645 (Gemäldegalerie, Berlin-Dahlem; Bredius 1969, No. 569). In the drawing from the Clark Collection the motifs of the cradle with the baby and of the groups of cherubims at left, which closely resemble the same motifs of the Hermitage picture, are worked out in great detail.

The general sketch that is closely related to the Hermitage canvas is in the Musée Bonnat, Bayonne (Bredius 1969, No. 567). Finally, the former H. Oppenheimer Collection had a sketch of a cradle with a sleeping baby which is wholly identical with that in the Hermitage work, but reversed.

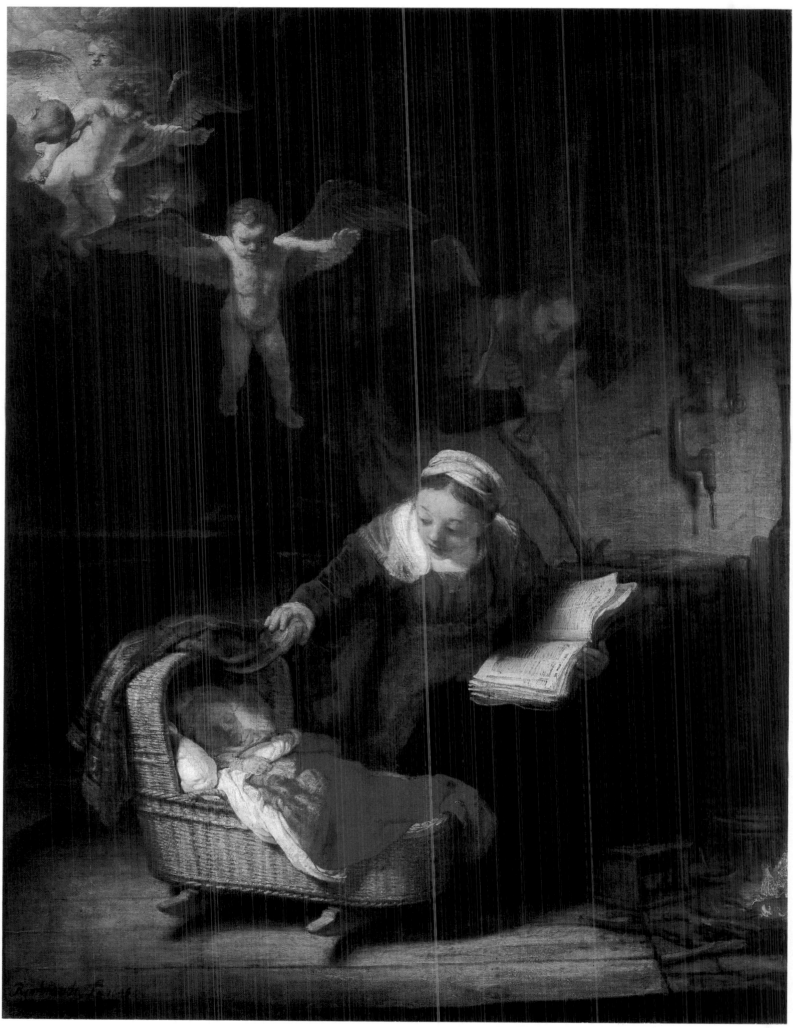

146

←

Study of a Young Girl's Head (private collection, United States; Bredius 1969, No. 375), previously considered a preliminary study for the Hermitage picture, is, as H. Gerson rightfully suggests, a partial copy made by a pupil from his master's canvas.

PROVENANCE	
1733	Possibly figured in the Adriaen Bout sale, The Hague
Until 1740	The Pierre Crozat Collection, Paris
Until 1750	The collection of François Crozat, Baron du Châtel, Paris
Until 1772	The collection of Louis-Antoine Crozat, Baron de Thiers, Paris
1772	The Imperial Hermitage, St. Petersburg

REFERENCES

* *Catalogues. The Hermitage* 1863–1916, No. 796; Bode 1873, pp. 14–15; Bode 1883, p. 476; Valentiner 1909, p. 281; Hofstede de Groot, VI, No. 94; Weisbach 1926, pp. 154, 156; Benesch 1935, pp. 36–37; Hamann 1948, pp. 287, 289; Rosenberg 1948, pp. 121–122; * Loewinson-Lessing 1956, p. XI; Knuttel 1956, pp. 145–146; Lewinson-Lessing 1964, Nos. 79, 80; * Fechner 1965, No. 17; Bauch 1966, No. 73; Gerson 1968, No. 211; Haak 1968, pp. 188–189; Bredius 1969, No. 570.

147 →

Danaë

Oil on canvas, 72 ³/₄×79" (185×203 cm.)
Signed and dated, bottom left: Rembrandt f. .6.6 (date is barely visible)
The Hermitage, Leningrad. Inv. No. 723

The absence of the golden rain traditional to the theme led to doubts as to whether the subject of the picture had been correctly identified.
The first to voice his doubts was J. Smith (1836), who called the picture *Awaiting Her Lover*. Since then eleven mutually incompatible theories have been put forward.
The traditional interpretation—Danaë giving herself to the golden rain—was strongly supported by E. Panofsky (1933) and accepted by the authors of Hermitage catalogues.
The mid-1630s was a period in Rembrandt's endeavor when he strove for monumental forms, theatrical effects, and dramatic suspense. His compositions abound in undulating lines enhanced by repetition and are dominated by deep contrasts of light-and-shade and a cold color scheme. The painterly manner is marked by a naturalistic handling of details and a decorative construction of the whole. All this is present in *Danaë*, yet over and above the features common to his works of the 1630s are others that set it distinctly apart. The pictorial idiom of *Danaë* is largely subordinated to the solution of a purely psychological problem—how best to fathom the intimate, the innermost emotions of the heroine. This concern is missing in Rembrandt's preceding works of the 1630s; also absent are the warm golden tones that highlight the center of the composition—the figures of Danaë and the old servant-woman, the illuminated parts of the bed, and the space above the bed-curtain. Beyond this central zone the color scheme again relapses into the cold, greenish-gray gamut that hallmarks Rembrandt's works of the 1630s. More than that, the picture is divided into two dissimilar parts, not only in terms of the color scheme, but in terms of the painterly manner as well. All the areas resolved in warm tones are painted in a free, bold, and generalized stroke, whereas the salient features of the patches of cold colors are a fastidious delineation and a stippled, even somewhat arid style. These visual observations were wholly confirmed by X-ray analysis. All corrections are concentrated, as might have been expected, in the warm-color zone.
The most significant alterations revealed by X-raying are the following:

1. The position of Danaë's right arm was changed. Initially the right arm was depicted somewhat below the present one with the palm facing downward instead of forward. The gesture was, therefore, much closer to the gesture of Annibale Carracci's Danaë, in whom W. Drost and E. Panofsky justly saw the prototype of Rembrandt's heroine. X-ray scrutiny also revealed a thin white drape which, like in Carracci's picture, covered her hips. The upper edge of the cloth Danaë held in her right hand. It follows, then, that the hand was doing two things simultaneously—lifting the drape from off her hip and, judging from the turn of the palm, pulling back the bed-curtain.

2. Danaë's head was painted anew; the facial features and the hairdo were altered. In the original version she was more pug-nosed and round-faced, in other words, she had resembled Rembrandt's first wife Saskia. The knot of hair on the back of the head was added later; at first the hairdo was simpler, rather like in Saskia's portrait (Gemäldegalerie Alte Meister, Dresden).

Further examination revealed that the gaze was originally more upward-directed. This is a very important discovery, indicating that in the first variant Danaë was painted in a more traditional manner. In addition, her neck and ears were adorned with a double string of pearl beads and large earrings.

3. The right leg was much more sharply bent in the knee, roughly resembling Pauline's leg in Ferdinand Bol's picture *The Priest Brings Mundus to Pauline* (Herzog Anton Ulrich Museum, Brunswick).

4. On the night table there was a pile of jewelry (the string of beads that hung down from the table is still discernible if one looks very closely).

5. The old servant-woman's position was changed. She had been placed much further to the left, was depicted in full profile, and was also looking upward. The bed-curtain which the old woman is now pulling back had correspondingly continued leftward, and the illumined zone under the canopy, which now takes up so much of the canvas and which plays such an important role in the composition, was only a narrow strip.

All the alterations that stemmed from a critical review of his creative principles were carried out by Rembrandt not in 1636, usually considered the date of the picture's execution, but later. It was only the first variant of the picture that was painted in 1636.

This first variant differs substantially from the second one both in terms of the iconography of the subject and the content of the picture. In the first version the mythological beginnings of the theme were more overtly expressed—Danaë and the old woman were both looking upward, Danaë's right hand was pulling the drape up from her hips. Moreover, in the first variant the golden rain central to the story was actually depicted—even now it is clearly visible at left against the background of the dark canopy.

Technological and stylistic analysis of the Hermitage canvas helped establish the motivations that so influenced the iconography, and provided the key to the final solution of all problems concerning the subject matter.

We know that *Danaë* was kept in Rembrandt's home up to 1656 (it is listed in an inventory of the bankrupt artist's possessions). Consequently, the painter had had enough time and pretexts at his disposal to have a second go at the picture. A study of the painterly manner and artistic style of Rembrandt's works from 1630 to 1640, X-ray and microscopic investigation of the picture's paint layer, as well as some indirect clues, all indicate the mid-1640s as the most likely period for reworking the picture. After 1642 Rembrandt subjected many of his works of the 1630s to a critical reappraisal. Certain facts of his personal life speak in favor of this date. In 1642 Saskia died. A new love and a new model entered the artist's life and creative endeavor only at the very end of the 1640s. This was Hendrickje Stoffels, the painter's

young servant-girl, later his faithful friend and the mother of his daughter Cornelia. The first documentary evidence of her stay in Rembrandt's home refers to the year 1649.

We know, too, that between 1642 and 1649 there was another woman in Rembrandt's house who was his mistress; their relationship, however, ended in a violent quarrel and separation. That woman was Geertje Dircs, a young widow and nurse to Rembrandt's little son Titus.

It has been noted by scholars too that in Rembrandt's art of the 1640s there appeared a new female model. The persistency with which the woman figures in paintings, studies, sometimes even drawings, suggests that she must have belonged to the artist's most intimate circle. No one fits the description better than Geertje Dircs.

Between 1964 and 1966, T. Weinmann and K. Bauch undertook the first serious attempts to identify Geertje Dircs with some of Rembrandt's portraits of the 1640s. The resemblance between those portraits' prototypes and *Danaë* is irrefutable. Especially noteworthy in this respect is *Girl in a Window* (Walters Art Gallery, Baltimore).

It follows, then, that if the identification of the above-mentioned portraits with Geertje Dircs is correct, then it is she who posed for Rembrandt's new *Danaë*. All things considered, it is she who inspired in Rembrandt a new approach to the composition, though, of course, the alterations were primarily triggered by the picture's no longer satisfying a Rembrandt ten years older and that much more competent and more experienced.

PROVENANCE

Until 1740	The Pierre Crozat Collection, Paris
Until 1750	The collection of François Crozat, Baron du Châtel, Paris
Until 1772	The collection of Louis-Antoine Crozat, Baron de Thiers, Paris
1773	The Imperial Hermitage, St. Petersburg

REFERENCES

J. Smith, *A Catalogue Raisonné of the Works of the Most Eminent Dutch, Flemish and French Painters*, vol. VII, London, 1836, No. 173; * *Catalogues. The Hermitage* 1863–1916, No. 802; Bode 1873, pp. 13–14; H. Riegel, *Die niederländischen Schulen im Herzoglichen Museum zu Braunschweig*, Berlin, 1882, p. 258; Bode 1883, pp. 449–451; A. Jordan, "Bemerkungen zu einigen Bildern Rembrandts," *Repertorium für Kunstwissenschaft*, 1884, p. 85; Valentiner 1909, p. 176; R. Wustmann, *Bühne und Welt*, XII, 1909–10, p. 182; * Chechulin 1912, pp. 39–42; Hofstede de Groot, VI, No. 197; Hans von Kauffmann, "Rembrandt und die Humanisten von Muidenkring," *Jahrbuch der preußischen Kunstsammlungen*, 1920, pp. 61, 65; John C. von Dycke, *Rembrandt and His School*, New York, 1923, p. 104; K. Baudissin, "Rembrandt und Cats," *Repertorium für Kunstwissenschaft*, XLV, 1925, p. 160 ff.; W. Drost, *Barockmalerei in den germanischen Ländern*, Wildpark–Potsdam, 1926, p. 159; Weisbach 1926, pp. 242–244; S. Rosenthal, "Neue Deutungen von Historienbildern aus dem Rembrandtkreis," *Jahrbuch für Kunstwissenschaft*, 1928, pp. 105–110; W. Niemeyer, "Rembrandts Danaë ist Hagar," *Repertorium für Kunstwissenschaft*, LII, 1931, pp. 61–62; E. Panofsky, "Der gefesselte Eros (Zur Genealogie von Rembrandts *Danaë*)," *Oud-Holland*, 1933, pp. 193–217; Benesch 1935, p. 18; Hamann 1948, pp. 45–46, 66, 95, 228; Rosenberg 1948, pp. 53, 161–164, 176, 198; G. Brière-Misme, "La *Danaë* de Rembrandt et son véritable sujet," *Gazette des Beaux-Arts*, 1952, May–June, pp. 305–318; 1953, January, pp. 27–36; 1953, December, pp. 291–304; 1954, February, pp. 67–76; Knuttel 1956, pl. 96; * Loewinson-Lessing 1956, pp. VIII–XI; * *Catalogue. The Hermitage* 1958, 2, p. 252; * Chlenov 1960, pp. 51–59; Levinson-Lessing 1964, Nos. 72–75; * Fechner 1965, No. 10; K. Clark, *Rembrandt and the Italian Renaissance*, London, 1966, pp. 108–110; * Volskaya 1966, pp. 59–60; * Yegorova 1966, pp. 93–94; Kuznetsov. *Danaë* 1966, pp. 26–31; Bauch 1966, No. 104; J. Kuznetsow, "Nieuws over Rembrandts *Danaë*," *Oud-Holland*, 1968, pp. 225–233; Gerson 1968, No. 270; E. Brochhagen, "Beobachtungen an den Passionsbildern Rembrandts in München," *Festschrift Kauffmann. Minuscula discipulorum*, Berlin, 1968, p. 43; Haak 1968, pp. 138–139; Ch. Tümpel, "Studien zur Ikonographie der Historien Rembrandts," *Nederlands kunsthistorisch Jaarboek*, XX, 1969, pp. 158–160; Bredius 1969, No. 474; * Kuznetsov. *Danaë* 1970; *Rembrandt* 1981, No. 17.

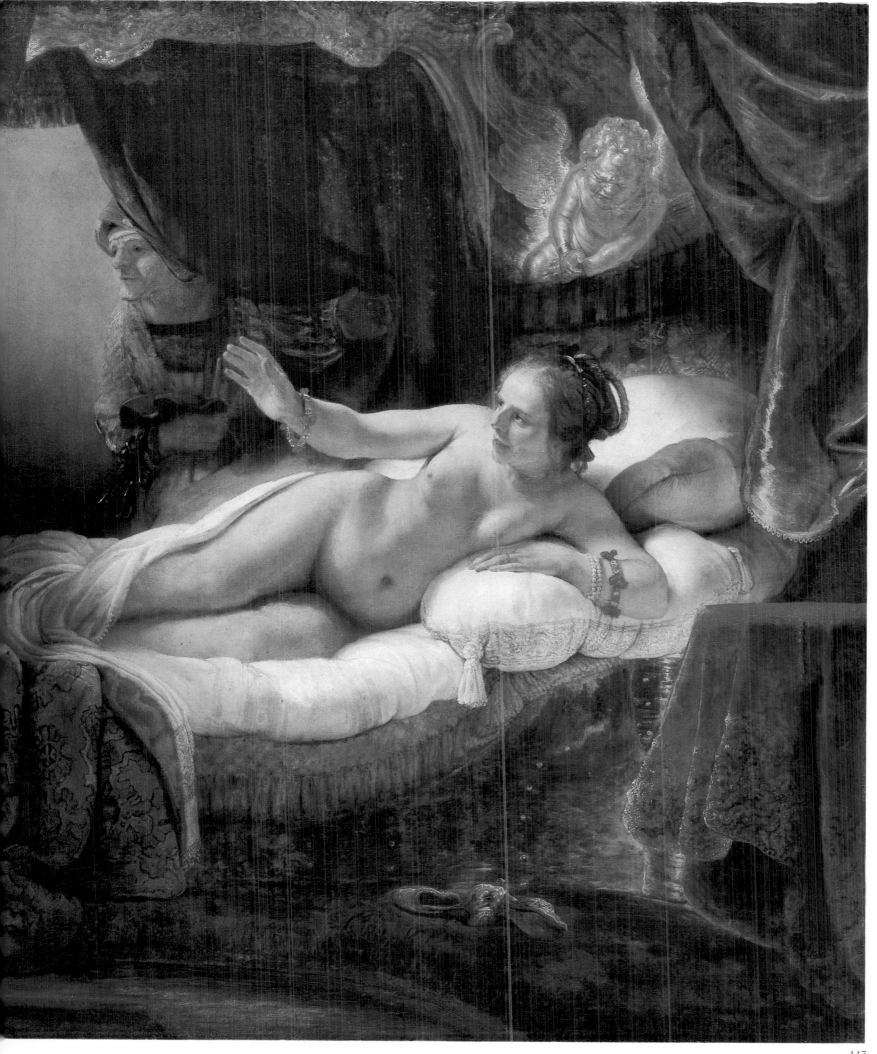

148, 149

The Return of the Prodigal Son

Oil on canvas (reinforced), 8'6 3/8×6'8 3/4" (260×205 cm.). The bottom edge of
the canvas is folded back 4" (10 cm.); at right is an extension of the same
length. Originally the picture had a rounded top; the upper corners
are affixtures.
At left near the feet of the son is the signature: Ff Rynf (the unusual character
of the signature gives reason to doubt its authenticity).
The Hermitage, Leningrad. Inv. No. 742

The subject is taken from the Bible (St. Luke, XV: 11–32).
There is no accepted opinion as to the picture's dating. H. Gerson places it among Rembrandt's works of 1661, while B. Haak subscribes to the traditional opinion of 1668–69. K. Bauch refers it to about 1668 (?).
H. Musper insists that the picture was a fairly long time in the making—begun before 1650 and completed at the end of 1650. Carefully considered, there are little grounds for such a hypothesis. To our mind the canvas ought to be dated to the early 1660s.
Rembrandt devoted a number of etchings and drawings to this theme. To juxtapose the Hermitage canvas with his first known work on the Prodigal Son theme, a 1636 etching done under the direct influence of a similarly entitled engraving by Maerten van Heemskerk, is to apprehend the gigantic leap forward in Rembrandt's creative evolution. One can judge of the way the artist's handling of the theme changed over a time span of thirty years from his drawings in the Teyler Museum, Haarlem (around 1635–36), the former Valentiner Collection (about 1640), the Print Room, Dresden (about 1658), and the Albertina Collection, Vienna (1658–59). The drawings do not, however, illustrate the consecutive development of the theme that leads from the print to the novel approach of the Hermitage canvas.
The compositional arrangement of the picture, its elongated format, and the solemn verticals of the static figures differ from all the artist's previous interpretations of the scene, as do the almost sacramental emotions of the protagonists. The traditional handling of the scene always had the father advancing toward the son and, as a sign of forgiveness, attempting to raise him from his knees, embracing and comforting him the while. This was the way all scenes of repentance and reconciliation were depicted, as in, for example, the reconciliation of Jacob with Esau. This was Rembrandt's treatment, too, before the Hermitage picture. In the latter the son rests humbly on his knees, hands joined in prayer; the father's hands are on his son's shoulders in a soothing, compassionate, and benedictory gesture.
As R. Hamann puts it, the father "lays his hands on his son's shoulders as if performing a sacred rite." This new interpretation of the emotional relations between the two protagonists, which lifts these relations to a symbolic plane, appears here for the first time in Rembrandt's work.
The art of Rembrandt brilliantly exemplifies his creative absorption of the artistic traditions of the past. In cases such as this painting he might have been inspired by sixteenth-century engravings. In the earlier phase of his career, he would utilize a fancied work, sometimes *in toto* (for example the Heemskerk engraving mentioned earlier for his etching of 1636); sometimes only its composition, if he deemed it fortunate (the compositional affinity between his *Christ Before the People* of 1654 and Lucas van Leyden's engraving on the same theme is known to all); sometimes he would borrow only individual figures. Needless to say, all these are instances not of imitation, but of a creative transformation that resulted in works far more significant than the source itself.

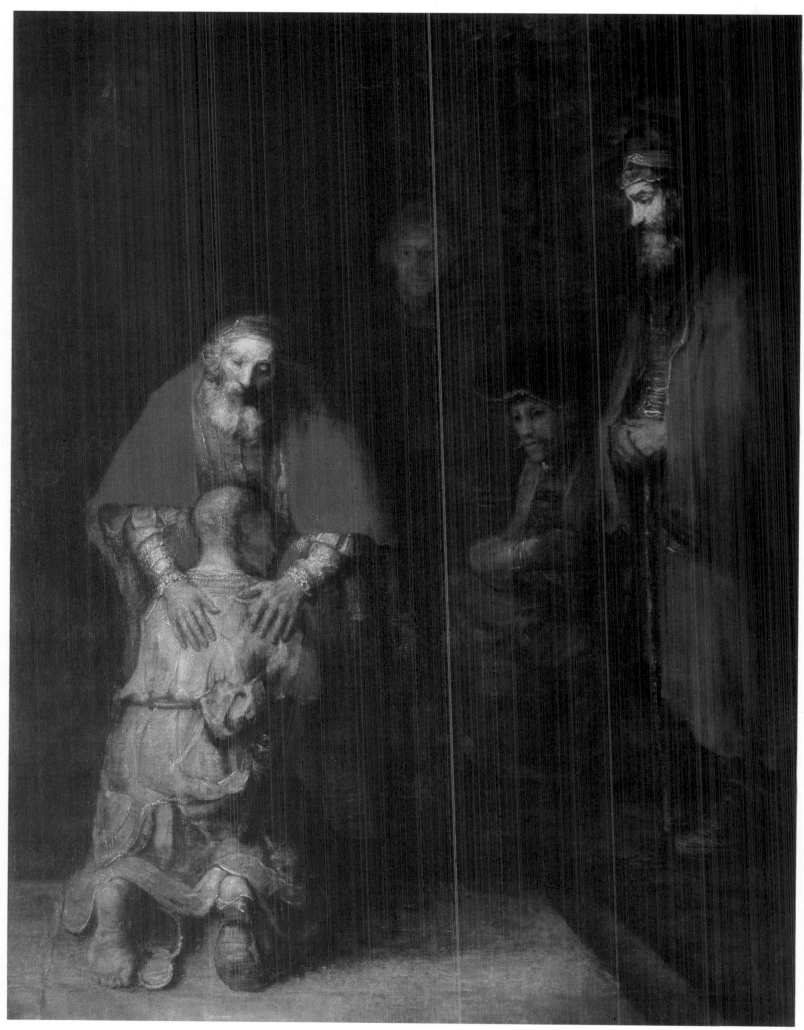

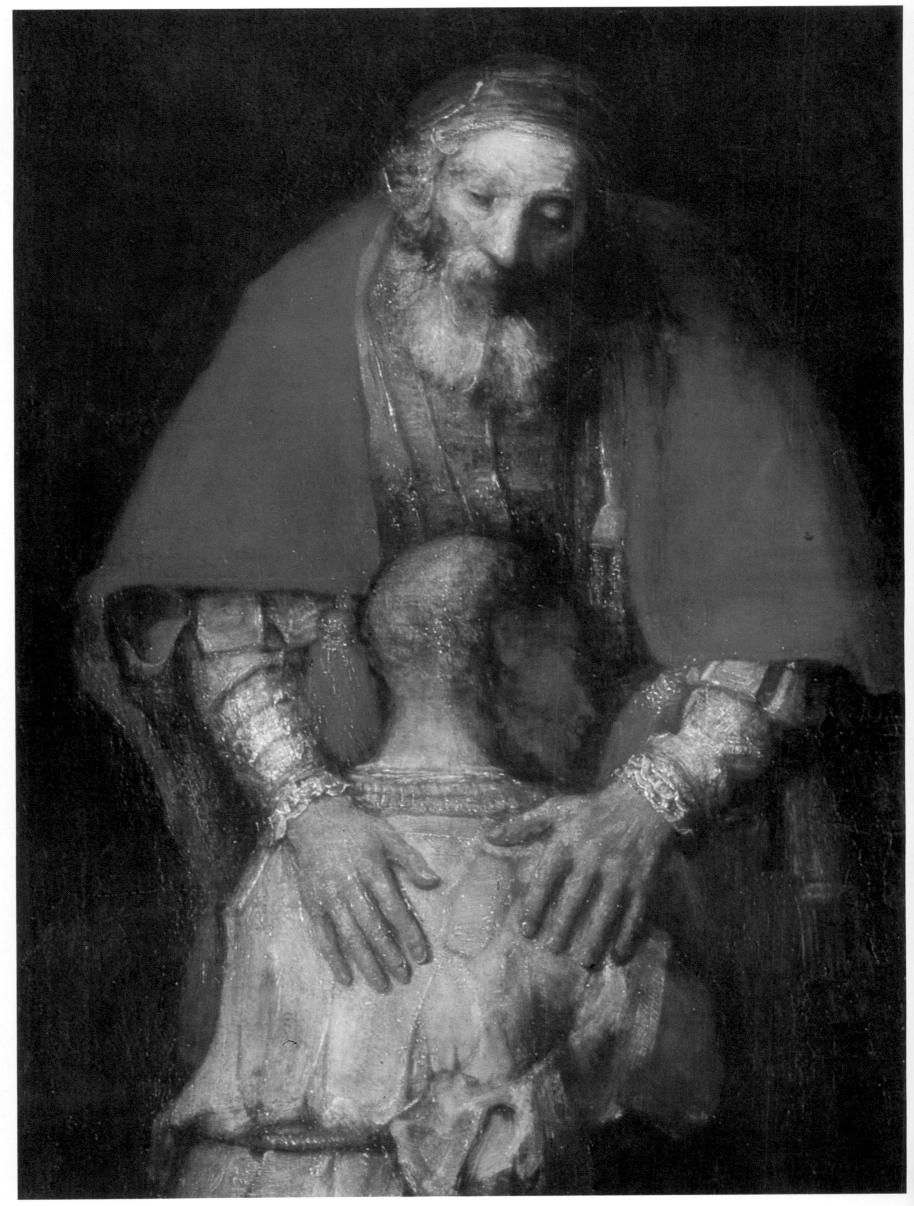

←

While it is true that *The Return of the Prodigal Son* is akin to all Rembrandt's later works in that its profound inner content is expressed through majestic, solemn, and monumental form, yet the conceptual and formal differences that set the canvas apart from earlier works cannot be explained by this general rule alone. There must have been an external impression, an external stimulus that at this particular stage fell on fertile soil, accorded with the master's creative searchings of the period, and influenced his perception of the theme. This stimulus was probably an engraving on the same subject by the Dutch engraver Cornelis Antonissen from which Rembrandt borrowed both the overall compositional arrangement and several individual motifs. We may assume that Rembrandt knew of Antonissen's engraving for quite some time. It is this very engraving that prompted the Teyler Museum drawing mentioned earlier wherein both father and son are depicted in a three-quarter turn to the right. Other details also coincide—the clothes of the father, the discarded stave at left. But in the drawing the whole group is more dynamic, more in the spirit of Rembrandt's works of the 1630s. Long after, when he was painting the Hermitage picture, his interest was drawn to the more significant aspects of the engraving—its general composition and prevailing mood.

For the old man standing at right Rembrandt used his sketches of a much earlier period. The old man's face, for instance, is present in a number of head-studies of the mid-1630s, the figure, though in a three-quarter turn instead of in profile, appears in a drawing (pupil's copy?) entitled *Beggar in a Tall Hat* (about 1636, Print Room of the Rijksmuseum, Amsterdam) and in the drawing *Walking Man* (in the same museum) which M. Henkel dates to around 1655 and O. Benesch to some years later.

PROVENANCE

1742	The Jan de Guis sale, Bonn
1764	The Archbishop Clemens Augustus of Bavaria sale (the picture was not sold because of its high price)
Until 1766	The Duke d'Amezune Collection, Paris
1766	The Imperial Hermitage, St. Petersburg

REFERENCES

* *Catalogues. The Hermitage* 1863–1916, No. 797; Bode 1883, pp. 527–528, 560; Valentiner 1909, p. 471; Hofstede de Groot, VI, No. 113; Weisbach 1926, pp. 479–480, 513, 593; Benesch 1935, p. 69; * Agafonova 1940, pp. 20–22; Hamann 1948, pp. 20, 38, 118, 196, 366, 417–418, 421, 423–424; * Loewinson-Lessing 1956, p. XIX; Knuttel 1956, pl. 44, 62, 212; * *Catalogue. The Hermitage* 1958, 2, p. 264; Levinson-Lessing 1964, No. 88 * Fechner 1965, No. 30; Bauch 1966, No. 94; Gerson 1968, p. 140, No. 335; M. Th. Musper, "Die Datierung von Rembrandts *Verlorenem Sohn* in Leningrad," *Festschrift für Werner Gross*, 1968, pp. 229–238; Haak 1968, pp. 328–329; Bredius 1969, No. 598; I. V. Linnik, "Once More on Rembrandt and Tradition," in: *Album amicorum J. G. van Gelder*, The Hague, 1973, pp. 223–226; *Rembrandt* 1981, No. 28.

150

Ahasuerus, Haman, and Esther

Oil on canvas, 28 ³/₄×37" (73×94 cm.)
Signed and dated, bottom left: Rembrandt f. 1660
The Pushkin Museum fo Fine Arts, Moscow. Inv. No. 297

The subject is taken from the Bible (Esther, VII: 6).
Queen Esther reveals to King Haman the villainous schemes
of his minister Haman.
Rembrandt apparently turned to this subject more than once. Our
picture produced a very strong impression on his contemporaries.
There is a description of it, in somewhat over-rapturous tones,
in the writings of the eminent seventeenth-century Dutch poet
and playwright Jan Vos.
In the 1650s Rembrandt sketched a number of Indian book
miniatures. Some of them, for example *Emperor Jahangir
Receiving an Address* (British Museum, London; Benesch,
No. 1190), are variations on the motifs of Haman's garb
and postures.

PROVENANCE

1662	The J. Hinlopen Collection, Amsterdam. The Geelvink, Collection, Amsterdam
1760	The G. Hoet sale, The Hague
Until 1764	The Johann Ernest Gotzkowsky Collection. Berlin
1764	The Imperial Hermitage, St. Petersburg
1862	The Rumiantsev Museum, Moscow
1924	Museum of Fine Arts, Moscow
1937	The Pushkin Museum of Fine Arts, Moscow

REFERENCES

Terwesten 1770, p. 225, No. 45; * *Catalogue. Moscow* 1862, p. 9, No. 78; Bode, Hofstede de Groot 1897–1906, No. 411; C. Hofstede de Groot, *Urkunden über Rembrandt,* The Hague, 1906, Nos. 247, 407; Valentiner 1909, p. 453; * P. V. *The Old Years* 1910, February, pp. 41–42; Hofstede de Groot, VI, pp. 30–31, No. 46; * *Catalogue. The Rumiantsev Museum* 1915, pp. 250–251, repr. (p. 202); Hamann 1948, pp. 410–411, 413; Rosenberg 1948, p. 22; * Loewinson-Lessing 1956, pp. XVIII–XIX, pl. 25; * Rotenberg 1956, pp. 33–35; * Linnik 1956, pp. 46–47; * Volskaya 1956, p. 40; Knuttel 1956, pp. 208–209; * *Catalogue. The Pushkin Museum of Fine Arts* 1961, p. 156; J. G. van Gelder e.a., *Fritz Lugt. Zijn leven en zijn verzamelingen,* The Hague, 1964, pl. 25; J. Gartner, *Rembrandt und die Verwandlung klassischer Formen,* Bern–Munich, 1964, pp. 162–164; * Fechner 1965, pp. 138–141, No. 26; Bauch 1966, No. 37; * *The Pushkin Museum of Fine Arts* 1966, No. 32; Gerson 1968, pp. 416, 502, No. 351; Bredius 1969, No. 530; *Rembrandt* 1981, No. 26.

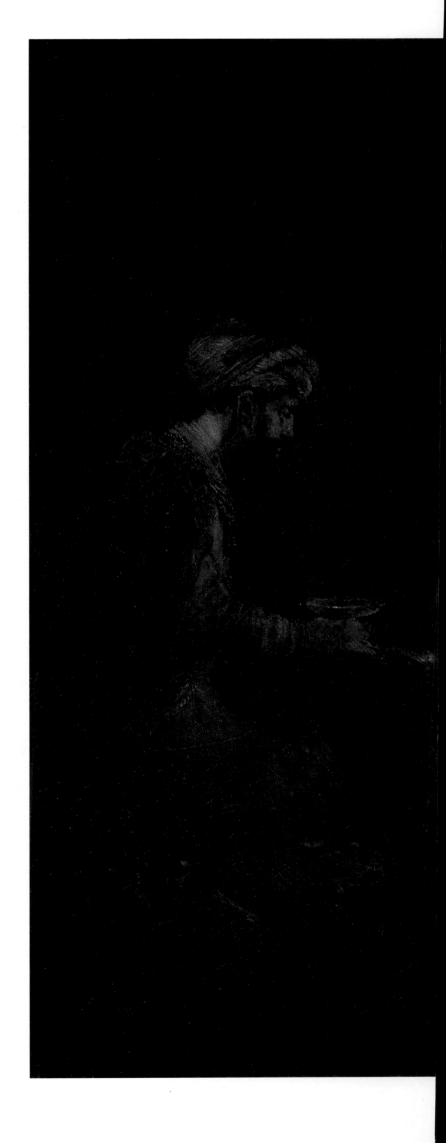

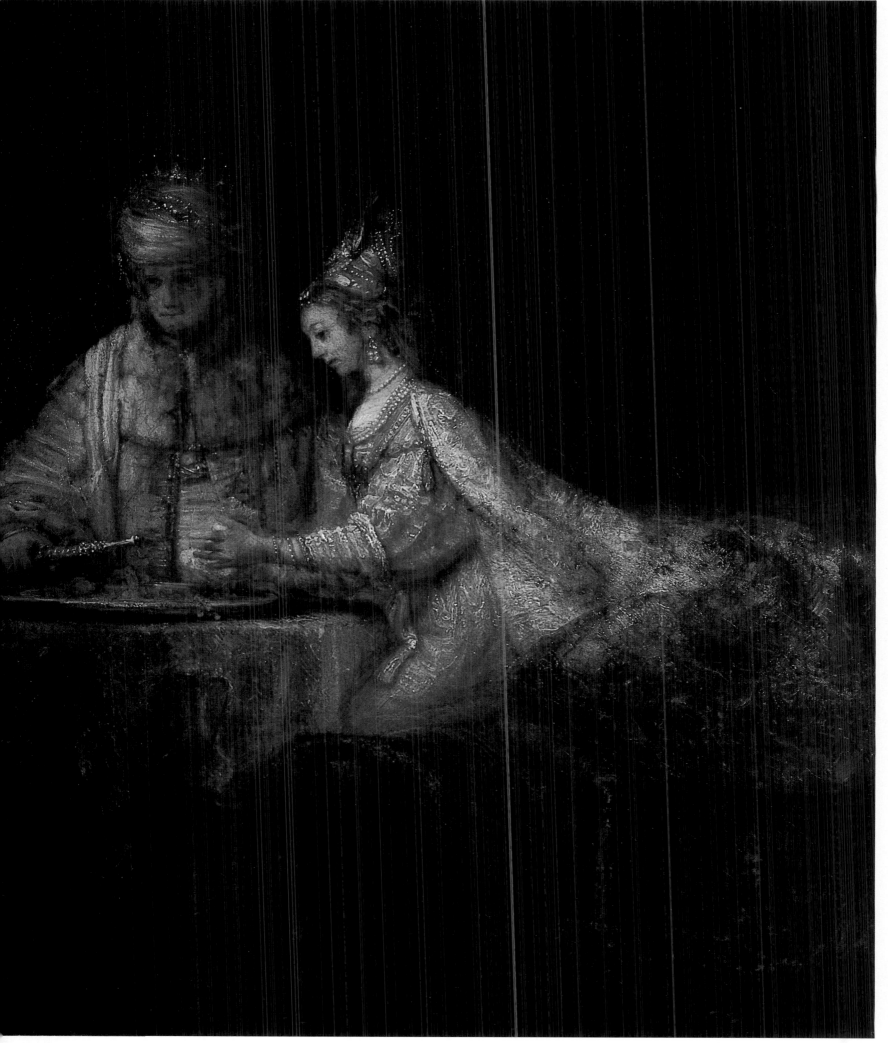

BENJAMIN GERRITSZ CUYP

Born 1612 in Dordrecht, died there in 1652. Pupil to Jacob
Gerritsz Cuyp (his brother). Was influenced by the art
of Rembrandt. Worked in Dordrecht and The Hague. Painted
biblical and genre scenes.

151

The Annunciation to the Shepherds

Oil on canvas, 42 3/8×39 3/8" (108×100 cm.)
The Hermitage, Leningrad. Inv. No. 3000

The subject is taken from the Bible (St. Luke, II: 8–14).

	PROVENANCE	REFERENCES
Until 1915	The P. Semionov-Tien-Shansky Collection, Petrograd	Semenov, *Etudes* 1906, p. LXXXVII, No. 120; * *Catalogue. The Hermitage* 1958, 2, p. 203.
1915	The Imperial Hermitage, Petrograd	

151

ABRAHAM VAN DYCK

Born 1635/36, died 1672 in Amsterdam. Possibly studied under
Rembrandt (in the early 1650s). Worked in Amsterdam. Painted
genre pictures, also biblical scenes.

152

The Praying Hermit

Oil on panel, 35×28" (89×71 cm.)
Over the edge of the book are the first letters of the artist's signature: Av
The Hermitage, Leningrad. Inv. No. 6788

In the first Hermitage manuscript catalogue (1773) the picture was ascribed
to Antonis van Dyck. Apparently the signature was at that time entirely
legible and the initial *A* was taken for the name of the painter's famous
namesake. The Hermitage inventory of 1927 ascribed it to an anonymous
Dutch artist of the Rembrandt school. The present attribution was made by
Irene Linnik by way of comparison with other pictures by Abraham van
Dyck. The closest analogue to the Hermitage piece is *The Offering in the
Temple* (the Van den Berg Collection, Amsterdam; sold in Berlin,
September 5–6, 1935).

PROVENANCE	REFERENCES
Before 1797 The Imperial Hermitage, St. Petersburg	* Linnik 1956, pp. 12–15; * *Catalogue. Rembrandt* 1956, p. 98; * *Catalogue. Rembrandt* 1969, No. 45.

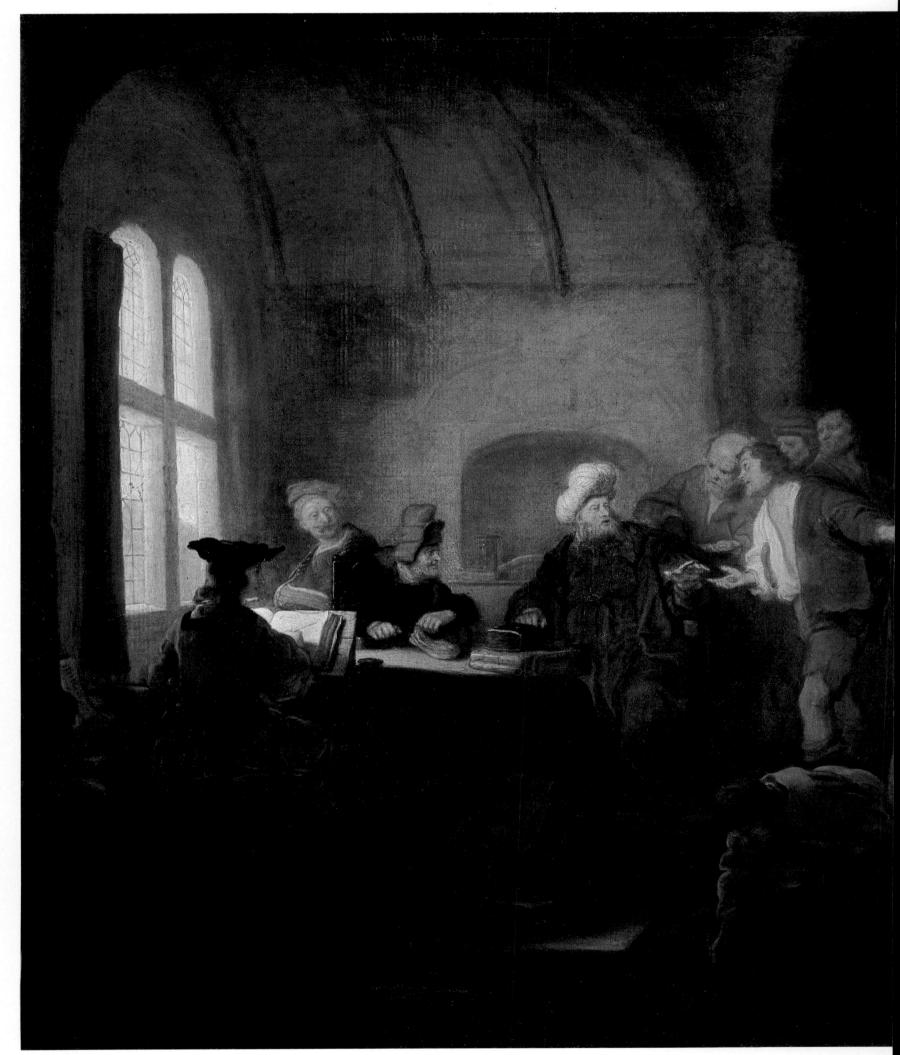

153

SALOMON KONINCK

Born 1609 in Amsterdam, died there in 1656. Worked
in Amsterdam. Pupil to David Golyns and Claes
Cornelisz Moeyaert. Was influenced by the art of
Rembrandt (in the 1630s), though did not study under
him. Painted biblical, historical, and mythological
scenes, also portraits.

153

The Parable of the Laborers
in the Vineyard

Oil on canvas, 18 3/4×22 3/8" (48×57 cm.)
The Hermitage, Leningrad. Inv. No. 2157

The subject is taken from the Bible (St. Matthew, XX: 11–16).
Painted around 1640. The handling of the theme and
the composition are borrowed from a similarly entitled picture
by Rembrandt (1637, the Hermitage, Leningrad).

PROVENANCE		REFERENCES
Until 1764	The Johann Ernest Gotz-	* *Catalogues. The Hermitage* 1863–1916,
	kowsky Collection, Berlin	No. 864; * *Catalogue. Rembrandt* 1956.
1764	The Imperial Hermitage,	No. 78; * *Catalogue. The Hermitage* 1958,
	St. Petersburg	2, p. 208; * Kuznetsov 1961, pp. 77–78;
		* *Catalogue. Rembrandt* 1969, No. 51.

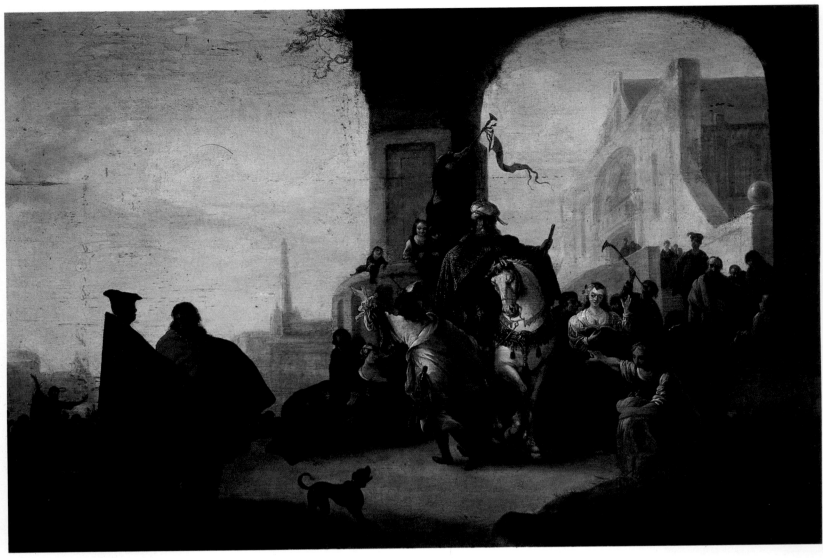

154

ADRIAEN VERDOEL

Born around 1620 in Vlissingen, died after 1675. Pupil
of Rembrandt in Amsterdam (early 1640s), then of Léonard
Bramer and Jacob de Wet. Worked in Haarlem and Vlissingen.
Painted biblical scenes.

154

The Triumph of Mordecai

Oil on panel, 29 1/2×43 3/8" (75×110 cm.)
Signed, bottom right: A v doel
The Pushkin Museum of Fine Arts, Moscow. Inv. No. 1911

The subject is taken from the Bible (Esther, VI: 11).

PROVENANCE

 The H. Brokard Collection, Moscow
Until 1924 The State Museum Reserve, Moscow
1924 Museum of Fine Arts, Moscow
1937 The Pushkin Museum of Fine Arts, Moscow

REFERENCES

Collection des tableaux anciens: H. Brokard,
No. 834; * *Catalogue. H. Brokard Collection*
1903, No. 433; *Art in America,* XII, 1929,
p. 253; * *Catalogue. Rembrandt 1956,* p. 73;
* *Catalogue. The Pushkin Museum of Fine Arts*
1961, p. 35.

JACOB WILLEMSZ DE WET

Born around 1610 in Haarlem, died there in 1671/72. Probably
studied under Rembrandt in Amsterdam (1630–32). Worked
in Haarlem and for a short while in Alkmaar. Painted biblical
and mythological scenes.

155

Eleazar and Rebecca

Oil on panel, 18 1/2×25 1/4" (47×64 cm.)
Signed and dated on step of stair, bottom right: de Wet 1646
The Hermitage, Leningrad. Inv. No. 3011

The subject is taken from the Bible (Genesis, XXIV: 15–22).

PROVENANCE		REFERENCES
Until 1915	The P. Semionov-Tien-Shansky Collection, Petrograd	*Catalogue Semenov* 1906, No. 589; Semenov. *Etudes* 1906, p. LXXVII; * *Catalogue. The Hermitage* 1958, 2, p. 158; * *Catalogue. Rembrandt* 1969, No. 40.
1915	The Imperial Hermitage, Petrograd	

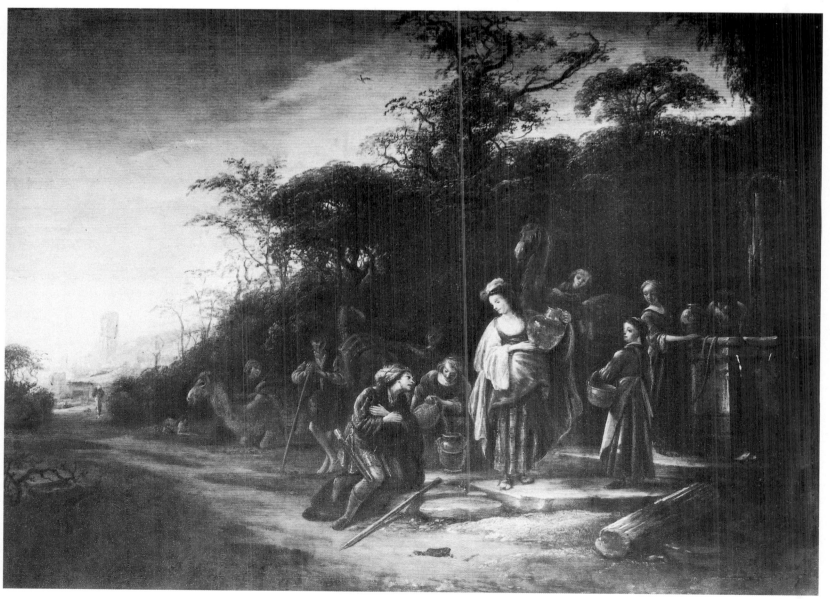

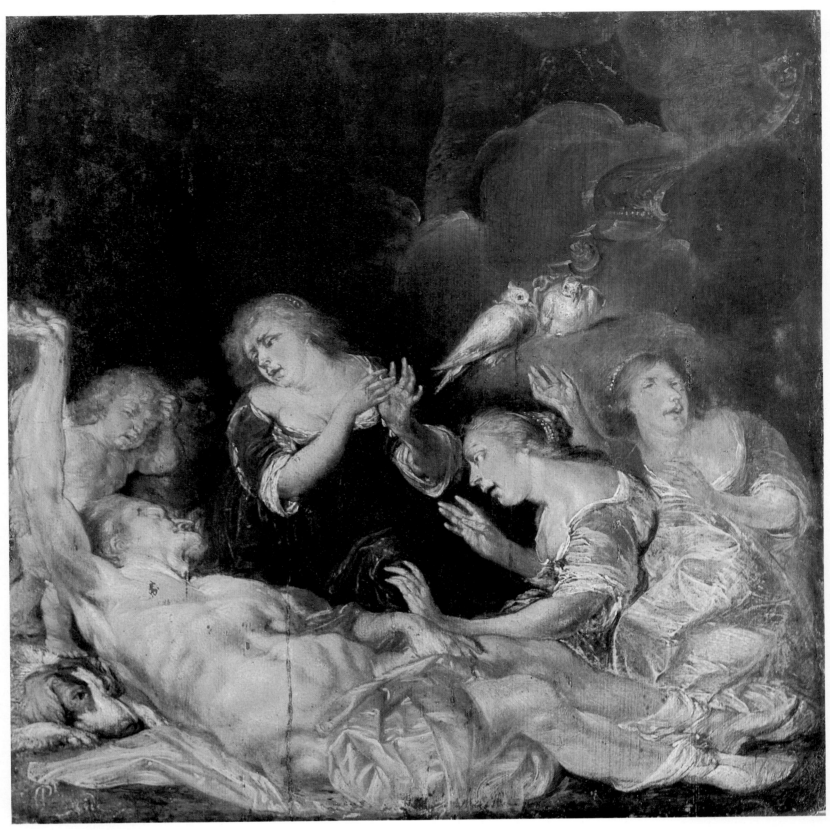

156

PIETER CODDE

Born 1599 in Amsterdam, died there in 1678. Was influenced by
the art of Frans Hals. Painted portraits and genre scenes, mostly
from the life of the military.

156

The Death of Adonis

Oil on panel, 12 1/4×12 5/8″ (31×32 cm.)
Signed, bottom left corner: P^r Codde
The Hermitage, Leningrad. Inv. No. 3150

The subject is taken from Ovid's *Metamorphoses* (X, 708–28).
Mythological compositions are few and far between in the artist's oeuvre.

PROVENANCE		REFERENCES
Until 1915	The P. Semionov-Tien-Shansky Collection, Petrograd	* Semionov 1885–90, pp. 302–303; Semenov. *Etudes* 1906, p. CI; * *Catalogue. The Hermitage* 1958. 2, p. 207.
1915	The Imperial Hermitage, Petrograd	

G. DONCK

Born 1610, died after 1640. Painted portraits, biblical
and mythological compositions. Produced many drawings for
book illustration.

157 →

Thetis in the Forge of Vulcan

Oil on panel, 24 1/8×18 3/4″ (61.3×47.5 cm.)
Signed on anvil: G. Donck
The Hermitage, Leningrad. Inv. No. 10208

The subject is taken from Homer's *Iliad* (XVIII, 368–616).

PROVENANCE			
Until 1914	The P. Delarov Collection, St. Petersburg	Until 1973	Teachers' House, Leningrad
	The Yusupov Collection, St. Petersburg	1973	The Hermitage, Leningrad

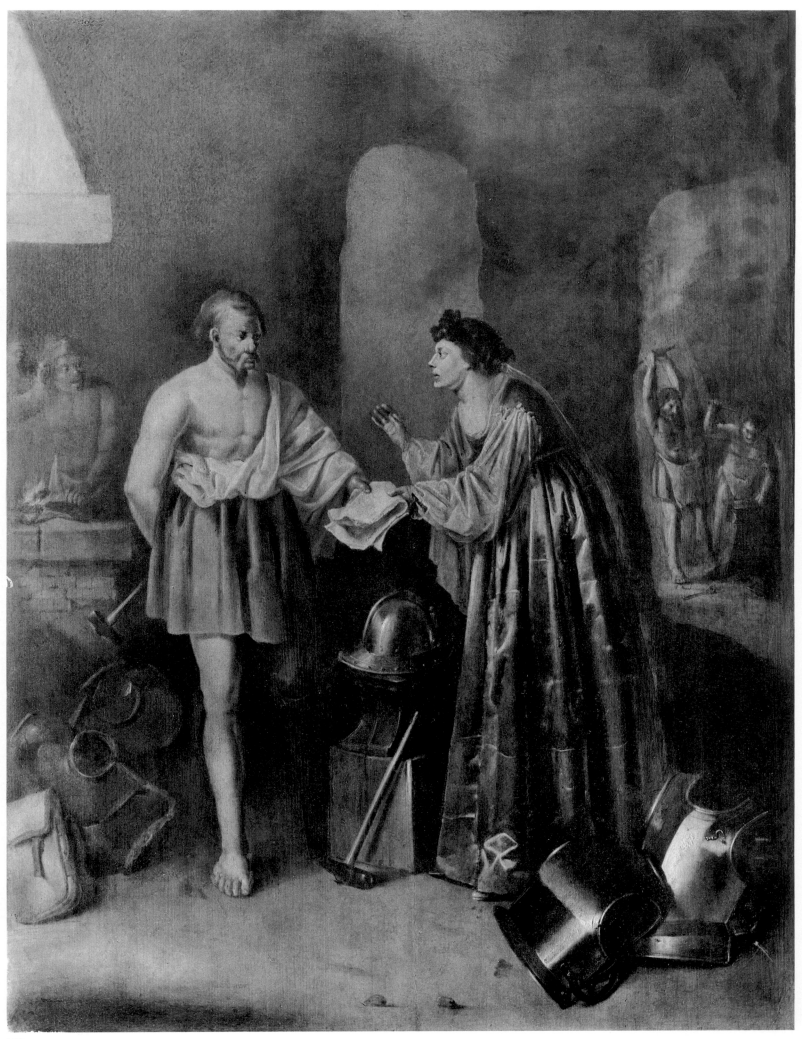

SALOMON DE BRAY

Born 1597 in Amsterdam, died 1664 in Haarlem. Worked
in Haarlem, also in Amsterdam and The Hague. Painted biblical
scenes and portraits.

← 158

The Expulsion of Hagar

Oil on panel, 25×18 ¹/₂" (63.5×47 cm.)
Signed and dated, bottom left: S. Bray 1656
Picture Gallery, Kalinin. Inv. No. 904

The subject is taken from the Bible (Genesis, XXI: 9–14).

REFERENCES

Provenance unknown. * *Catalogue. Kalinin* 1940, No. 26.

GERRIT DE WET

Died 1674 in Leyden. Worked in Haarlem and, in his last years,
in Leyden. Painted biblical subjects.

159

Christ and the Woman Taken in Adultery

Oil on panel, 20×13 ³/₈" (50.5×34 cm.) .
Signed on step of stair, bottom center: G. de Wet
The Hermitage, Leningrad. Inv. No. 3101

The subject is taken from the Bible (St. John, VIII: 3–11).

PROVENANCE	REFERENCES
Until 1915 The P. Semionov-Tien-Shansky Collection, Petrograd	*Catalogue Semenov* 1906, No. 591; * *Catalogue. The Hermitage* 1958, 2, p. 158.
1915 The Imperial Hermitage, Petrograd	

159

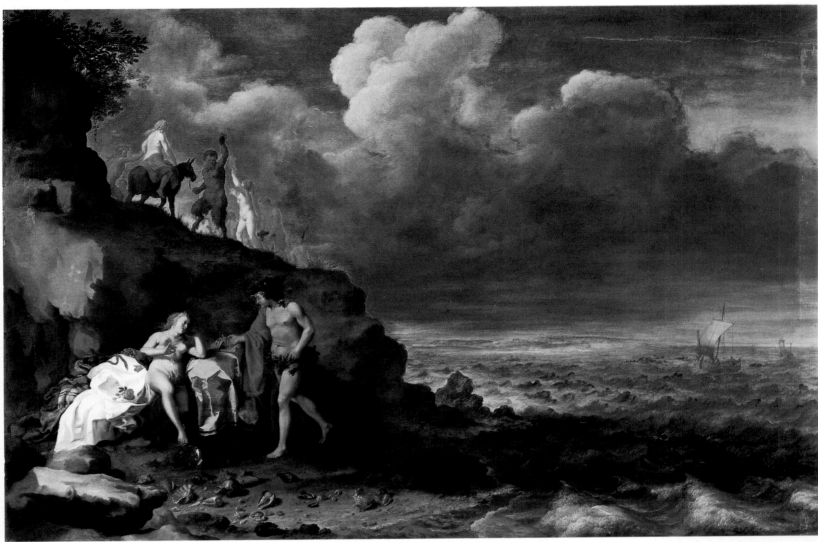

160

CORNELIS VAN POELENBURGH

Born about 1586 in Utrecht, died in that city in 1667. Pupil
of Abraham Bloemaert. Matured as an artist under the influence
of Adam Elsheimer. Worked in Utrecht, Rome (1617–23),
Florence (1624–26), and London (from 1637). Painted biblical
and mythological scenes, also portraits.

160

Bacchus and Ariadne

Oil on panel, 22×33" (56×84 cm.)
Signed on stone, bottom left: C. P. F.
Palace Museum, Pavlovsk. Inv. No. 240

The subject is taken from Philostratus's *Imagines* (I. 15).



PROVENANCE

Palace, Gatchina
Palace Museum, Pavlovsk

REFERENCES

* Shchavinsky 1916, p. 80, note 33.



JAN MYTENS

Born about 1614 in The Hague, died there in 1670. Apparently
studied under Daniel Mytens the Elder (his uncle). Worked in
The Hague. Painted mostly portraits, occasionally mythological
and biblical scenes.

161

Bacchus and Ariadne

Oil on panel, 17×22 ³/₈″ (43×57 cm.)
Signed and dated, bottom center: Jan Mytens 1646
The Hermitage, Leningrad. Inv. No. 3422

The subject is taken from Philostratus's *Imagines* (I. 15).

PROVENANCE

Until 1915 The P. Semionov-Tien-Shansky
 Collection, Petrograd
1915 The Imperial Hermitage, Petro-
 grad

REFERENCES

* Semionov 1885–90, pp. 150–151; Semenov.
Etudes 1906, pp. CI–CII, No. 378; * *Catalogue.*
The Hermitage 1958, 2, p. 217.

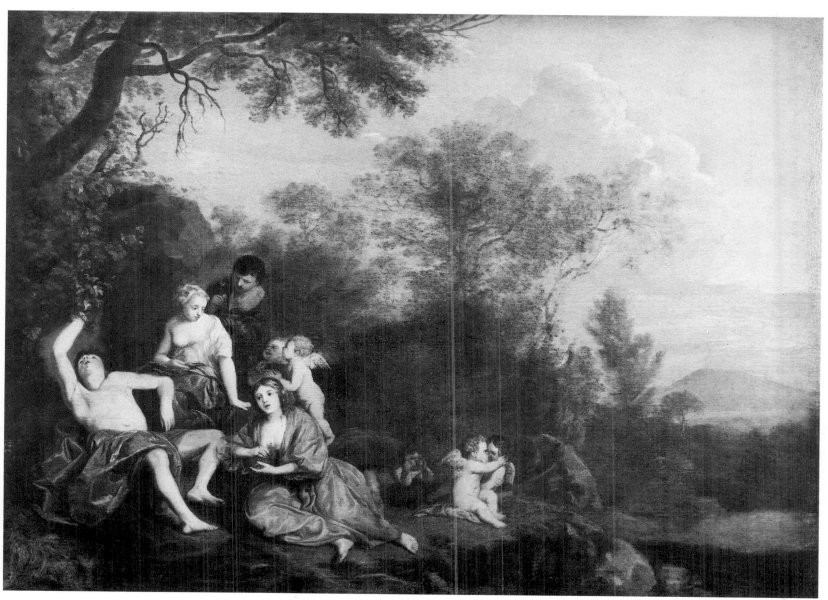

162

CORNELIS SAFTLEVEN

Born 1607 in Gorkum, died 1681 in Rotterdam. Pupil
of Herman Saftleven the Elder (his father). Worked in
Rotterdam and for a while in Antwerp. Painted genre
and biblical scenes.

162

Argus Keeping Guard over Io

Oil on panel, 14 1/2×19" (37×48.5 cm.)
Signed and dated, bottom right: C. Saftleven 1650
The Hermitage, Leningrad. Inv. No. 5449

The subject is taken from Ovid's *Metamorphoses* (I, 622–38).
This is a companion picture to *Argus and Io*, also in the Hermitage
(inv. No. 5448).

PROVENANCE

Until 1925 The Yusupov Palace Museum,
Leningrad
1925 The Hermitage, Leningrad

REFERENCES

* *Catalogue. The Yusupov Gallery* 1920, No. 306;
* *Catalogue. The Hermitage* 1958, 2, p. 268.

NICOLAUS KNÜPFER

Born 1603 in Leipzig, died 1655 in Utrecht. Pupil of Emanuel
Nysse in Leipzig and Abraham Bloemaert in Utrecht (from 1630).
Worked in Utrecht. Painted biblical, mythological, allegorical,
and genre scenes, also portraits.

163, 164 →

Semiramis

Oil on panel, 22 5/8×32 1/4" (57.5×82 cm.)
Illegible signature, bottom left
Museum of Western European and Oriental Art, Kiev. Inv. No. 45

The subject is taken from Diodorus Siculus's *The Historical Library* (II, 20)
and Claudius Aelianus's *Miscellany* (*Varia Historia*) (VII, 1).
Credit for the popularity of this story in Holland belongs to Jacob Cats. The
first variant of the picture is in the Fine Arts Museum, Budapest (No. 60.2).

PROVENANCE

Until 1770	The F. Dufresne Collection (put up for sale in Amsterdam, August 22, 1770, No. 317, as *Haman before Esther*)	Until 1928	Picture Gallery, Kiev
		1928	Museum of Western European and Oriental Art, Kiev
January 20, 1772	Put up for sale in Amsterdam (this time the subject was identified correctly as *The Death of Ninus*)		
1797	The Imperial Hermitage, St. Petersburg (inventory list of 1797, No. 2578)		REFERENCES
1854	Put up for sale in St. Petersburg, No. 36, the Rzewucki Collection, Kiev		

* *The Old Years* 1913, p. 81. No. 36; * *Catalogue. Kiev* 1931, No. 302; * *Catalogue. Rembrandt* 1956. p. 102; * *Catalogue. Kiev* 1961, No. 121; J. I. Kuznetzow, "Nikolaus Knüpfer (1603?–1665)," *Oud-Holland*, 1974, No. 121.

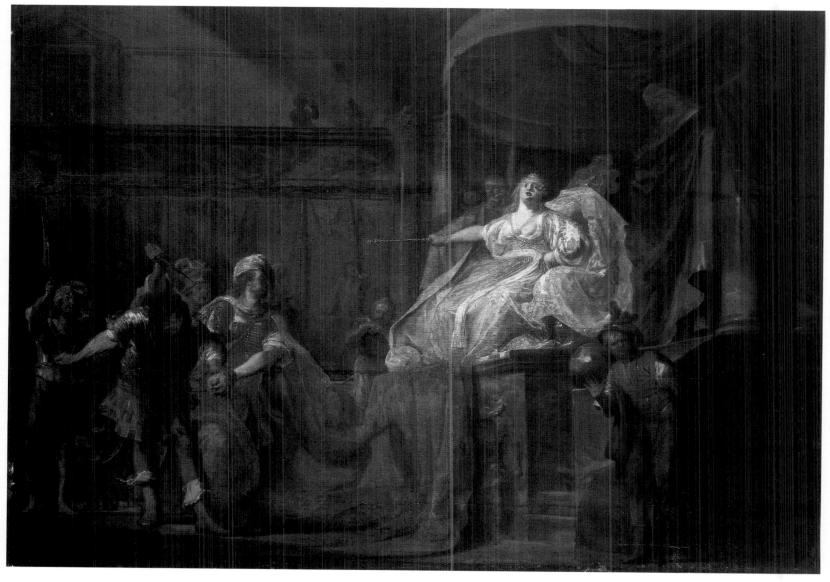

164

FERDINAND BOL

Biography: *see under* plate 58.

165

Moses and Jethro

Oil on canvas, 31 ³/₄×26" (81×66 cm.)
The Hermitage, Leningrad. Inv. No. 8866

The subject is taken from the Bible (Exodus, XVIII: 24–25).
Painted in 1655–56.
The picture entered the Hermitage as a work by an anonymous artist of the
school of Rembrandt. Its subject was also unidentified. The present
attribution is due to Irene Linnik. *Moses and Jethro* is actually a sketch for
a composition for the Town Hall of Amsterdam. It has its closest analogues in
Bol's *The Intrepid Caius Fabricius in Pyrrhus's Camp* (Town Hall,
Amsterdam; the preliminary sketch is in the Herzog Anton Ulrich Museum,
Brunswick) and *Aeneas Distributes Prizes* (Brunswick). Certain of the motifs
in the Hermitage canvas are direct borrowings from Rembrandt, a not
infrequent feature where artists of Rembrandt's school are concerned. Thus,
for example, the figure of Moses duplicates the figure of Jacob in
Rembrandt's etching *Joseph Telling His Dreams to His Parents* (B. 37), while
the figure of Jethro resembles that of the high priest in the etching *The
Offering in the Temple* (B. 50). A preparatory drawing of the Hermitage oil
sketch is in the Print Room, Munich. Several alterations were introduced into
the sketch as compared with the drawing. X-ray examination revealed that
originally some details of the drawing were repeated in the sketch (the sitting
warrior with the round shield at bottom left; the singular form of the
baldachin) but were later overpainted by the artist.
The Hermitage sketch's integral links with the entire decorative complex of
the Amsterdam Town Hall allows it to be dated fairly accurately to 1655–56.

PROVENANCE		REFERENCES
Until 1931	Museum of the Academy of Arts, Leningrad	*Catalogue. Rembrandt* 1956, p. 93; * *Catalogue. The Hermitage* 1958, 2, p. 142; * Linnik 1961, pp. 254–263; * *Catalogue. Rembrandt* 1969, No. 36.
1931	The Hermitage, Leningrad.	

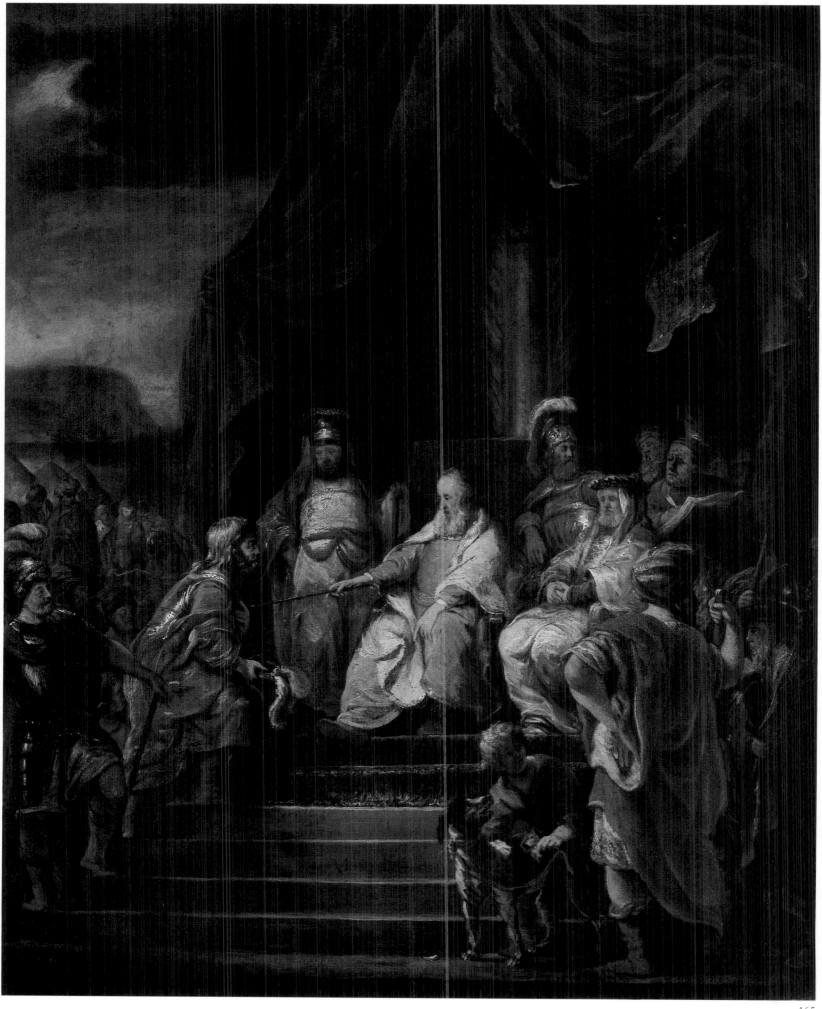

165

B. Fabritius 1660

166

BARENT FABRITIUS

Born 1624 in Midden-Beemster, died 1673 in Amsterdam.
Studied under Rembrandt in Amsterdam (in the 1650s). Worked
in Midden-Beemster (until 1657 and from 1659 to 1670), Leyden
(1657–59), Amsterdam (around 1652 and from 1670 to 1673).
Painted portraits and biblical, mythological, and genre scenes.

166

Ruth and Boaz

Oil on panel, 19 1/4×15 3/8" (49×39 cm.)
Signed and dated, bottom left: B. Fabritius. 1660
The Hermitage, Leningrad. Inv. No. 2791

The subject is taken from the Bible (Ruth, 1–3).

PROVENANCE

1906–15 The P. Semionov-Tien-Shansky Col-
lection, Petrograd
1915 The Imperial Hermitage, Petrograd

REFERENCES

* *Catalogue Semenov* 1906, No. 156; * *The Old Years* 1910, p. 206; * *In Memory of Semionov* 1915, No. 59; * *Catalogue. Rembrandt* 1956, p. 88. * *Catalogue. The Hermitage* 1958, 2, p. 284; D. Pont, *Barent Fabritius,* Utrecht, 1958, pp. 48–49, No. 11; * *Catalogue. Rembrandt* 1969, No. 76.

ADRIAEN VAN DE VELDE

Born in 1636 in Amsterdam, died in that city in 1672. Pupil of
Willem van de Velde the Elder (his father) and Jan Wijnants.
Was influenced by the art of Philips Wouwerman. Painted
landscapes in which genre motifs and domestic animals
predominated, and biblical, historical, and allegorical
compositions. Made a number of etchings.

167 →

Allegory

Oil on canvas, 29 1/8×66 7/8" (74×170 cm.)
Signed and dated, bottom right: A. Velde f. 1663
The Pushkin Museum of Fine Arts, Moscow. Inv. No. 3249

The allegory depicts the human soul at the crossroads
of life between the virtues
(Faith, Hope, and Charity) and the blessings of the world (Wealth,
Power, and Sensual Love).

PROVENANCE

Until 1949 The Kuskovo Museum, Moscow
1949 The Pushkin Museum of Fine
Arts, Moscow

REFERENCES

* *Catalogue. The Pushkin Museum of Fine Arts* 1961, p. 64; * Vipper 1962, pp. 32–33; * Kuznetsov 1959, No. 51; * Senenko 1960, p. 72.

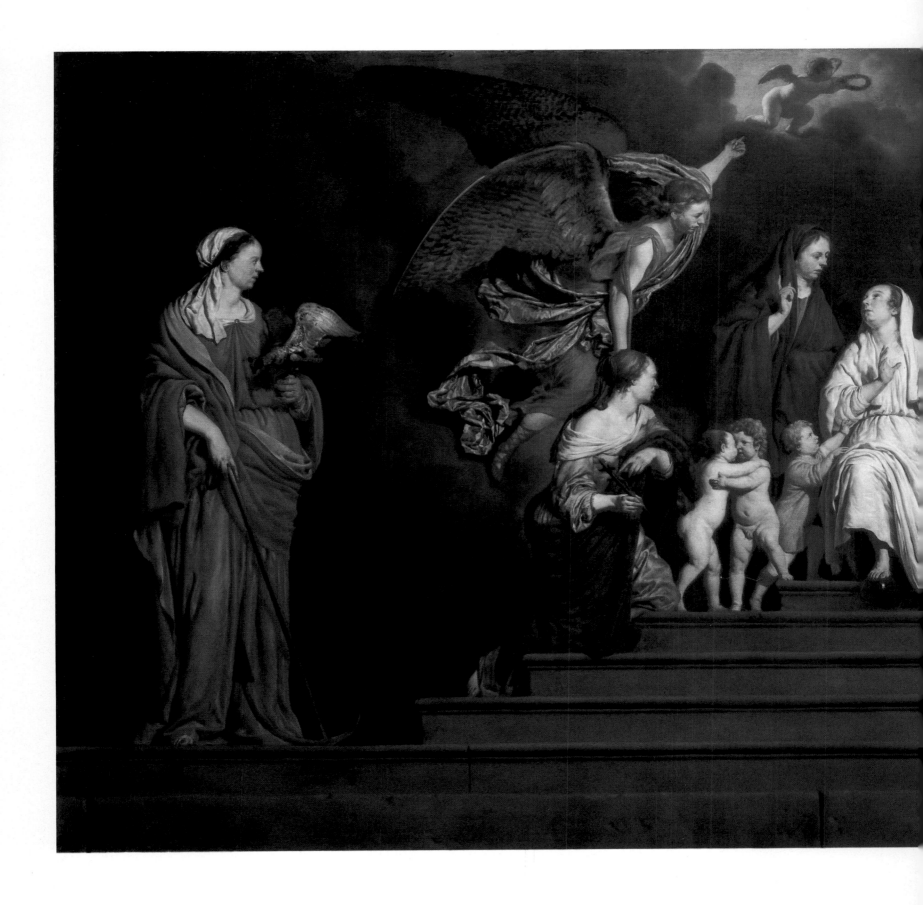

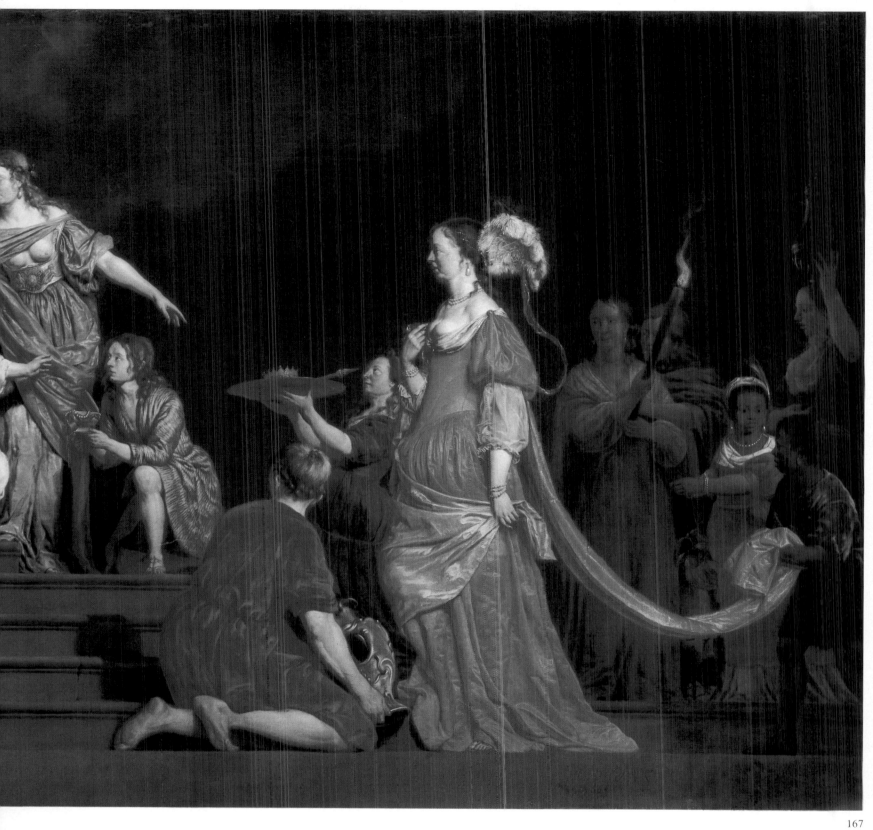

167

REYER VAN BLOMENDAEL

Information on Blomendael's life and creative endeavor is extremely scant. The only known facts are that he entered the Haarlem guild in 1662 and died in that city in 1675. None of his paintings, except for a few pictures on biblical themes, has come down to our day.

168

Moses Strikes Water from the Rock

Oil on canvas, 60 5/8×64 1/8" (154×163 cm.)
Signed, bottom right: R. v. Blom..dael
The Hermitage, Leningrad. Inv. No. 9301

The subject is taken from the Bible (Exodus, XVII: 5–6).

PROVENANCE

1949 The Hermitage, Leningrad

REFERENCES

* *Catalogue. The Hermitage* 1958, 2, p. 138;
* Fechner 1961, pp. 26–28.

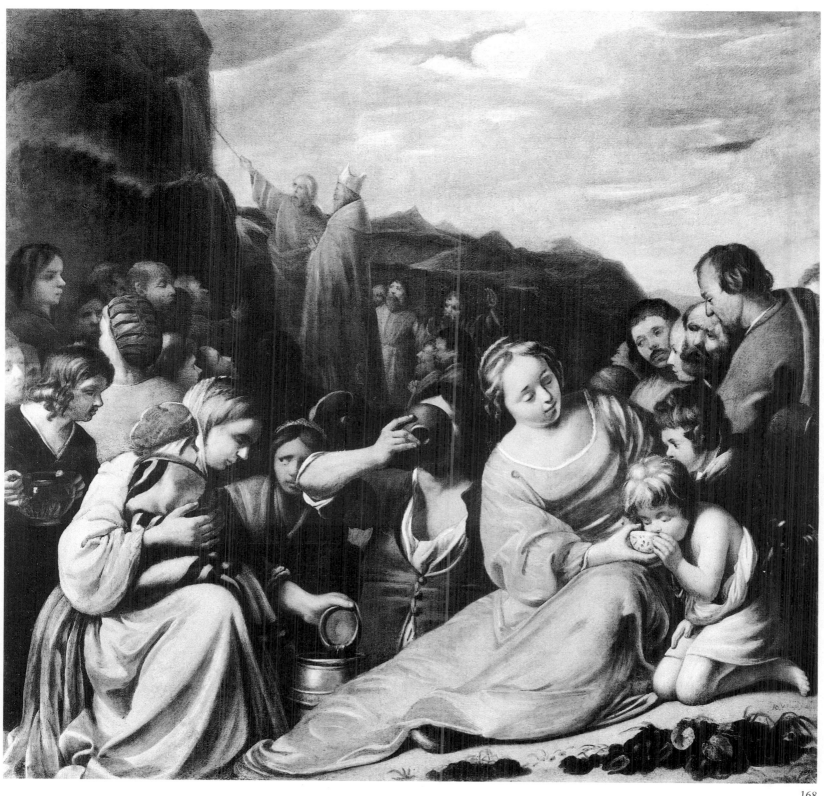

168

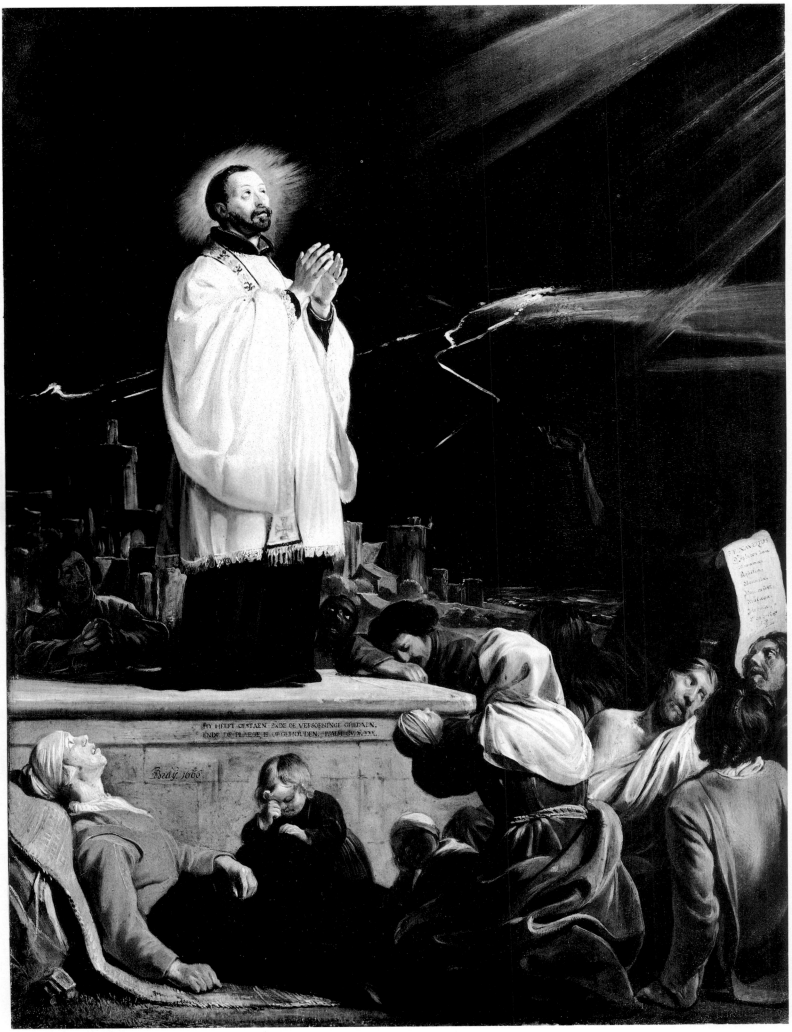

169

JAN DE BRAY

Biography: *see under* plate 46.

169

Saint Francis Xavier Healing the Sick

Oil on panel, 28 ⁷/₈×22 ⁵/₈″ (73.3×57.5 cm.)
Signed, dated, and inscribed over podium: Hy heeft gestaen ende versoeninge
gedaen en de plaege is op gehouden. (Then stood up he and executed
judgment: and so the plague was stayed.) JdBray. 1666. Inscribed on sheet
of paper, right: S.F. Xaverius Patron van Manama Azia Aquila Bonoria
Potamus Malaca Parma Neapolis.
Palace Museum, Pavlovsk. Inv. No. 872

Francis Xavier (1506–52) is a Catholic saint, a missionary in India
(1541–48) and Japan (1549–51). Listed on the sheet of paper at right in
the hand of a Negro (!) are the localities that regard Saint Francis as
their patron. The slightly modified text of a psalm of David (Psalm
CVI, 30) refers to the acts of healing performed by Saint Francis. The
picture was prompted by Rubens's canvases *The Miracle of Saint Ignatius*
and *The Miracles of Saint Francis* (Kunsthistorisches Museum, Vienna).
It is especially close to a sketch for the latter (Kunsthistorisches
Museum, Vienna).

PROVENANCE		REFERENCES
Until 1797	The Imperial Hermitage, St. Petersburg	* Trubnikov 1912, p. 28, note 25; * Schmidt 1922, pp. 186–187; W. von Moltke, "Jan de Bray," *Marburger Jahrbuch für Kuntstwissenschaft*, XI/XII, 1938–39, p. 454.
	The Prince Potiomkin Collection, St. Petersburg	
1800	Palace, Pavlovsk	

AERT (ARENT) DE GELDER

Biography: *see under* plate 59.

170

Lot and His Daughters

Oil on canvas, 55 ⁷/₈×48 ³/₈" (142×123 cm.)
False signature, right: Rembrandt
The Pushkin Museum of Fine Arts, Moscow. Inv. No. 306

The subject is taken from the Bible (Genesis, XIX: 33–35).
Painted before 1685. The picture is unsigned, but so strong is its
iconographic and stylistic affinity with the artist's authentic works that
the attribution is absolutely solid. The closest analogues are de Gelder's
pictures *Ahasuerus, Haman, and Esther* (Musée de Picardie, Amiens),
Esther and Mordecai (Gemäldegalerie Alte Meister, Dresden), *Jewish
Bride* (Alte Pinakothek, Munich), and *Lot and His Daughter* (Musée
d'Art Ancien, Brussels). There are engravings from the Hermitage
canvas by F. G. Schmidt and F. J. Leader.

PROVENANCE		REFERENCES
1752	The M. Leender de Neufville Collection, Amsterdam	Hoet 1752, 2, p. 516; J. Descamps, *La vie des peintres flamands, allemands et hollandais,* vol.
1771	The collection of Prince Heinrich of Prussia	3, Paris, 1753–64, p. 176; K. Lilienfeld, *Arent de Gelder,* The Hague, 1914, pp. 76, 80, 92, 118,
May 17, 1789	The Brian sale, London, No. 3	126, 127, 141, 189, 190, No. 4; * *Catalogue. The*
	The Rumiantsev Museum, Moscow	*Rumiantsev Museum* 1915, p. 249; * Kuznetsov 1959, No. 80; * *Catalogue. The Pushkin Mu-*
1948	The Pushkin Museum of Fine Arts, Moscow	*seum of Fine Arts* 1961, p. 51; * *The Pushkin Museum of Fine Arts* 1966, No. 38; * Kuznetsov 1967, No. 61.

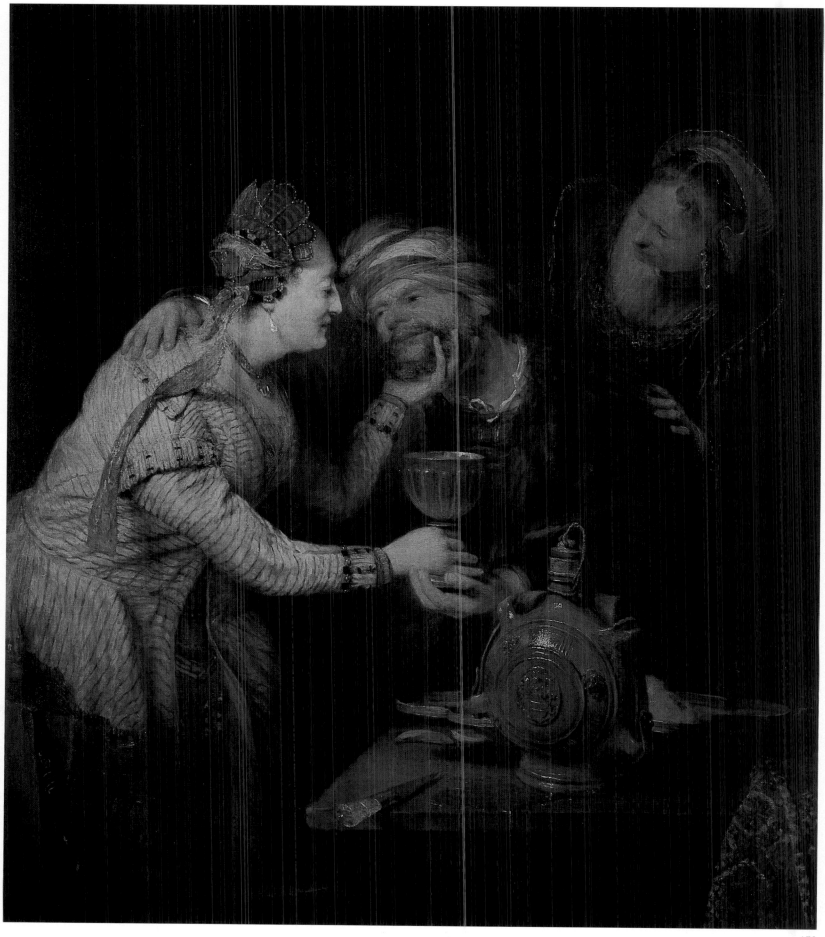

NICOLAES ROSENDAEL

Born 1636 in Hoorn, died 1686 in Amsterdam. Worked
in Amsterdam (from 1665). Was in Italy together with Jacob
Toorenvliet (1670). Painted biblical and allegorical scenes,
also portraits.

171

Melancholy

Oil on canvas, 52 ³/₈×53 ¹/₈" (133×135 cm.)
Signed and dated on set square, bottom: Ro... 1673
(signature is barely visible)
Art Museum, Ulyanovsk. Inv. No. 77

The attribution is made by Yury Kuznetsov (verbally). Because the
signature was incorrectly read, the canvas was described in the
museum's catalogue of 1957 as belonging to the brush of an imaginary
painter named Rotergoet. Also incorrectly identified was the picture's
subject (as Sibylla).

	PROVENANCE	REFERENCES
Until 1929	The S. Abamelek-Lazarev Collection, St. Petersburg Institute of Russian Literature of the USSR Academy of Sciences (the Pushkin House), Leningrad	* *Catalogue. Ulyanovsk* 1957, p. 94.
1929	Art Museum, Ulyanovsk	

171

HENDRICK MOMMERS

Born about 1623 in Haarlem (?), died 1693 in Amsterdam.
Visited Italy. Worked in Haarlem and Amsterdam (1665).
Painted genre compositions and (very rarely) biblical scenes.

172

Abraham and the Three Angels

Oil on canvas, 38 3/4×51 5/8" (98.5×131 cm.)
Signed and dated, bottom center: H. Mommers 1651
Museum of Western European and Oriental Art, Odessa. Inv. No. 260

The subject is taken from the Bible (Genesis, XVIII: 1–21).
This is one of the artist's few thematic pictures.

REFERENCES

Provenance unknown

* *Catalogue. Odessa* 1973, p. 42.

ABRAHAM HONDIUS (DE HONDT)

Born between 1625 and 1630 in Rotterdam, died 1695
in London. Worked in Rotterdam (until 1659), Amsterdam
(until 1666), and London. Painted mostly hunting scenes,
less frequently genre and historical compositions.

173

The Rape of Europa

Oil on canvas, 33×45 ⁵/₈" (84×116 cm.)
Signed and dated, bottom right: Abraham Hor.dius f 1668
The Hermitage, Leningrad. Inv. No. 2990

The subject is taken from Ovid's *Metamorphoses* (II, 835–77; VI, 103–7)
and *Fasti* (V, 605–16).

PROVENANCE		REFERENCES
Until 1915	The P. Semionov-Tien-Shansky Collection, Petrograd	* *Catalogue Semenov* 1906, No. 220; Semenov. *Etudes* 1906, p. CXXXI; * *Catalogue. The Hermitage* 1958, 2, p. 185.
1915	The Imperial Hermitage, Petrograd	

174

CASPER CASTELEYNS

Worked in Haarlem in the mid-seventeenth century. Member of
the Haarlem guild (from 1653). Painted portraits and mythological
scenes in which the landscape figured prominently.

174

Granida and Daifilo

Oil on canvas, 64 ¹/₈×78 ³/₄" (163×200 cm.)
Signed and dated, bottom left: C. Casteleyns 1653
The Hermitage, Leningrad. Inv. No. 7647

The subject is taken from *Granida* (I, 3) by Pieter Cornelisz Hooft.
This is one of the artist's few known pictures.

PROVENANCE

Until 1932 Palace Museum, Pavlovsk
1932 The Hermitage, Leningrad

REFERENCES

S. J. Gudlaugsson, "Representations of Grani-
da in Dutch Seventeenth Century Paintings,"
The Burlington Magazine, 1948, p. 351, note 8;
* Fechner 1955, pp. 9–11; * *Catalogue. The
Hermitage* 1958, 2, p. 200.

BAREND GRAAT

Born 1628 in Amsterdam, died in that city in 1709. Pupil of
Hans Bodt (his uncle). Headed the Academy of Drawing.
Painted historical and mythological scenes, also portraits.

175
Rinaldo and Armida

Oil on canvas, 55 1/8×65 5/8" (140×167 cm.)
Signed, bottom right: B. Graat
The Hermitage, Leningrad. Inv. No. 10025

The subject is taken from Torquato Tasso's *Jerusalem Delivered* (XVI, 17–25).

PROVENANCE	REFERENCES
1966 The Hermitage, Leningrad	* Nemilova 1974, pp. 22–24.

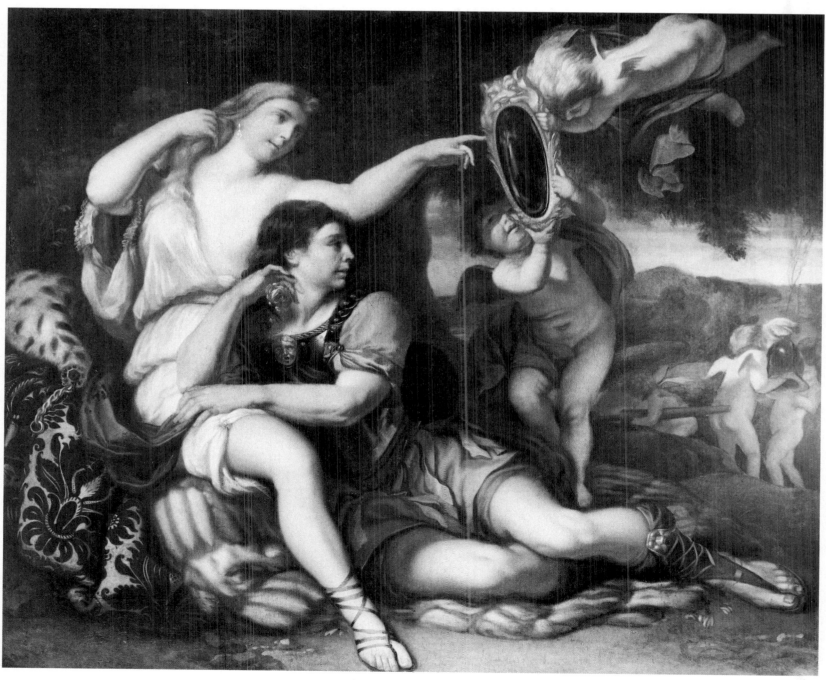

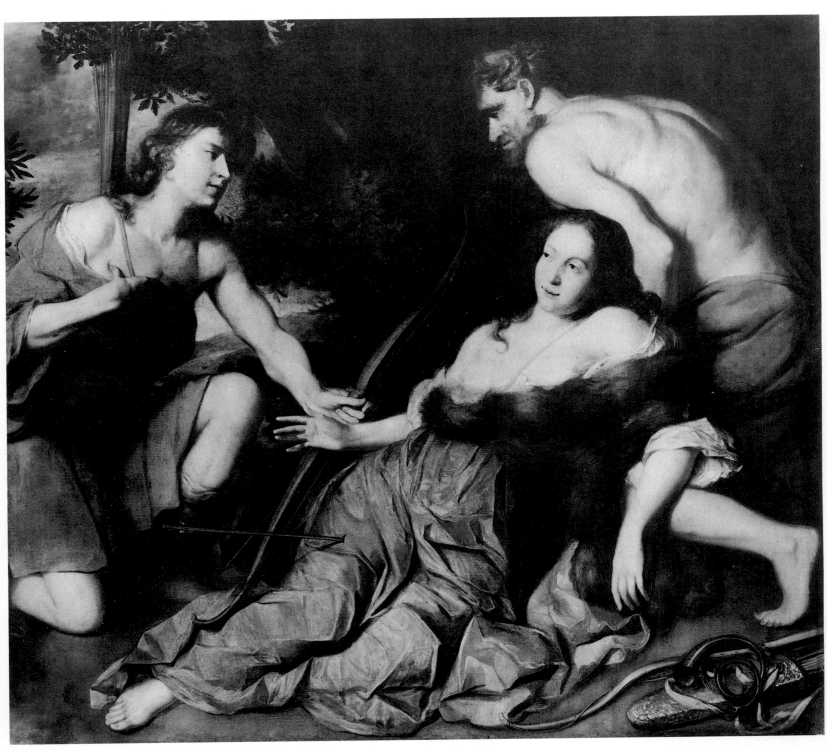

176

JAN VAN NECK

Born around 1636 in Naarden, died 1714 in Amsterdam.
Pupil of Jacob Adriaensz Backer. Worked in Amsterdam.
Painted mythological scenes, literary subjects, and portraits.
Was also an engraver.

176

Dorinda, Silvio, and Linco

Oil on canvas, 43 ⁷/8×50" (111.5×127 cm.)
Signed and dated across the quiver, right: J.v. Nek f. 1662
The Hermitage, Leningrad. Inv. No. 1118

The subject is taken from Giovanni-Battista Guarini's *Il pastor fido* (IV, 8).
In Hermitage catalogues prior to 1958 the picture was called
Cephalus and Procris.

PROVENANCE	REFERENCES
1909　The Imperial Hermitage, St. Petersburg (purchased from J. Gabicht)	* *Catalogues. The Hermitage* 1863–1916, No. 1933; * *Catalogue. The Hermitage* 1958, 2, p. 227.

HENDRICK AVERCAMP

Born 1585 in Amsterdam, died 1634 in Kampen. Worked
in Amsterdam, between 1625 and 1633 resided in Kampen.
Probably studied under Gillis van Coninxloo who lived for some
time in Amsterdam, and under Pieter Isacks. Painted winter
landscapes with many figures.

177 →

A Winter Scene with Skaters

Oil on panel, 9 ³/8×15" (24×38 cm.)
Signed on sled, bottom left: H.A.
The Pushkin Museum of Fine Arts, Moscow. Inv. No. 593

PROVENANCE	REFERENCES
Until 1924　The Dmitry Shchukin Collection, Moscow	* Bloch 1921, p. 12; * Kuznetsov 1959, No. 22; * *Catalogue. The Pushkin Museum of Fine Arts* 1961, p. 7; * Kuznetsov 1967, No. 46.
1924　Museum of Fine Arts, Moscow	
1937　The Pushkin Museum of Fine Arts, Moscow	

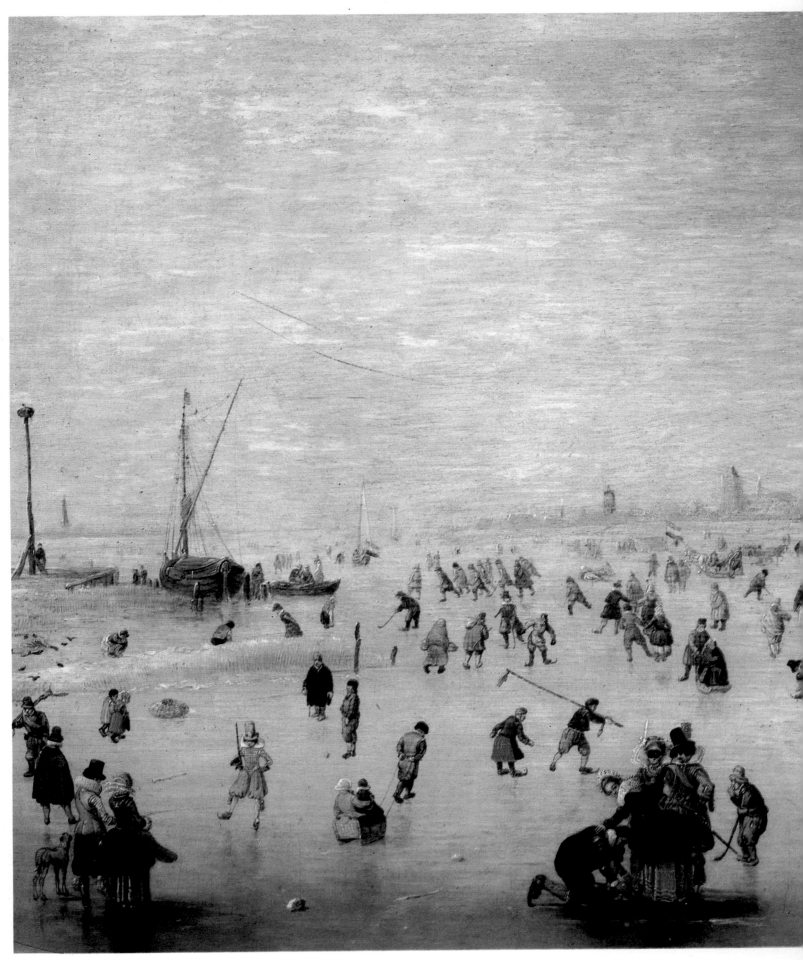

177

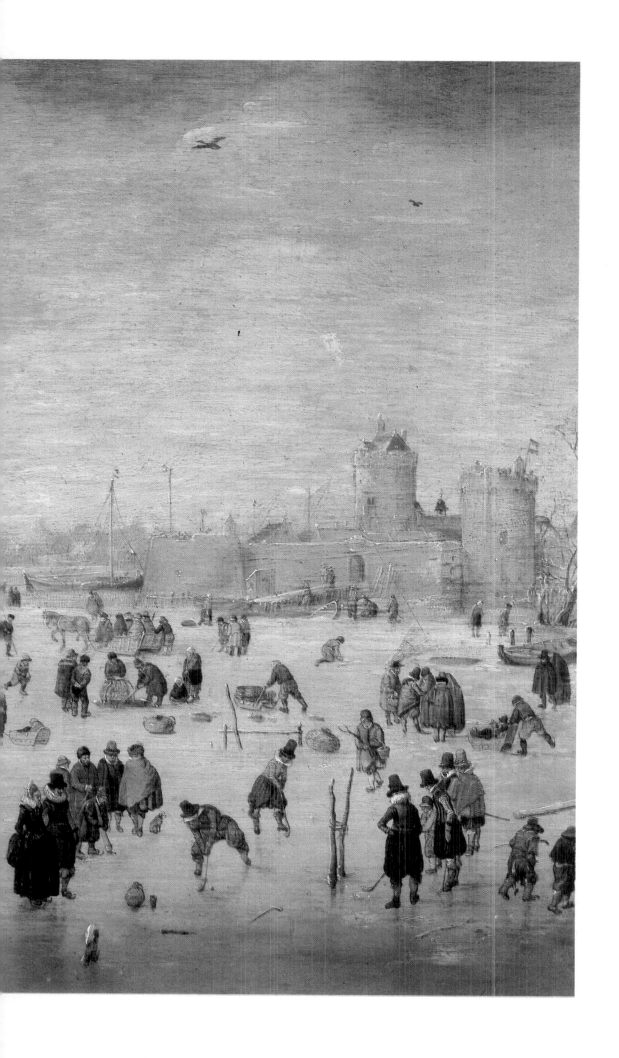

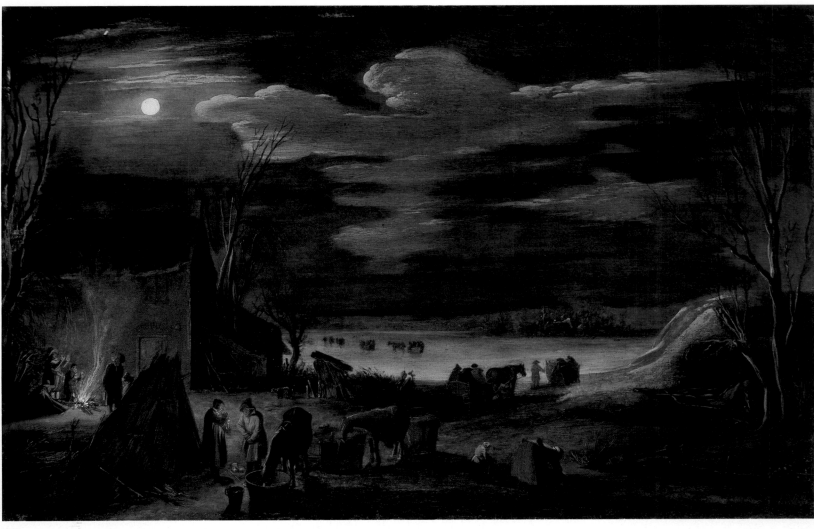

178

JAN VAN DE VELDE

Born about 1593 in Delft (?), died 1641 in Enkhuizen. Pupil of
Jacob Matham in Haarlem. Worked in Haarlem. Member of the
guild (from 1614). Possibly visited Italy, returning in 1616. Lived
in Enkhuizen (1618), Haarlem, again in Enkhuizen. Was an
engraver, draughtsman, and landscape painter.

178

Winter

Oil on panel, 11 ³/₄×17 ¹/₂" (30×44.5 cm.)
The Hermitage, Leningrad. Inv. No. 809

Painted between 1620 and 1630. Companion picture to *Summer* (*see*
plate 179). The clouds and the figures share an affinity with those depicted
in the artist's engraving *Nox*.

PROVENANCE

Late 18th century The Imperial Hermitage,
 St. Petersburg
Until 1920 Palace, Gatchina
1920 The Hermitage, Petrograd

REFERENCES

J. G. van Gelder, *Jan van de Velde*, The Hague,
1933, No. V; * *Catalogue. The Hermitage* 1958,
2, p. 151.

179

Summer

Oil on panel, 11 ³/₄×17 ¹/₂" (30×44.5 cm.)
The Hermitage, Leningrad. Inv. No. 1446

Painted between 1625 and 1630. Companion picture to *Winter* (*see* plate 178).

REFERENCES

Provenance: *See under* plate 178.

J. G. van Gelder, *Jan van de Velde*, The Hague, 1933, No. IV; *Catalogue. The Hermitage* 1958, 2, p. 151.

ADAM WILLAERTS

Born 1577 in Antwerp, died 1664 in Utrecht. Worked in Antwerp and Utrecht. Was recorded as a member of the painters' guild (from 1611). Painted marines, landscapes, and biblical scenes.

← 180

The Sermon on the Lake of Gennesaret

Oil on panel, 37 3/8×60 1/8" (95×153 cm.)
Signed, bottom left: Willaerts F.
The Radishchev Art Museum, Saratov. Inv. No. 48

The subject is taken from the Bible (Luke, V: 1).

PROVENANCE		REFERENCES
Until 1933	Museum of Fine Arts, Moscow	* *Catalogue. Saratov* 1969, p. 8.
1933	The Radishchev Art Museum, Saratov	

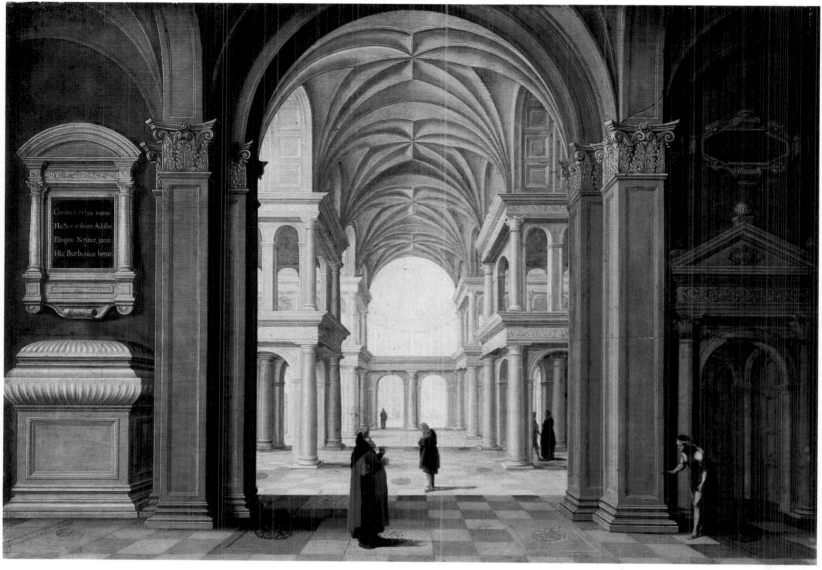

181

JAN VAN DER VUCHT

Born around 1603 in Rotterdam, died in that city in 1637.
Worked in Rotterdam and The Hague. Painted church interiors.

181

Church Interior

Oil on panel, 18 ⅛×25 ¼" (46×64 cm.)
Inscribed and dated, bottom center: Joannes van Vucht fecit 1628
The Pushkin Museum of Fine Arts, Moscow. Inv. No. 415

PROVENANCE		REFERENCES
Until 1912	The Dmitry Shchukin Collection, Moscow	* Catalogue. The Public and Rumiantsev Museums 1912, p. 113, No. 37; * Catalogue. The Pushkin Museum of Fine Arts 1961, p. 45.
Until 1924	The Rumiantsev Museum, Moscow	
1924	Museum of Fine Arts, Moscow	
1937	The Pushkin Museum of Fine Arts, Moscow	

182

ALEXANDER KEIRINCX

Born 1600 in Antwerp, died 1652 in Amsterdam. Member of the
Antwerp guild (from 1619). Lived in Amsterdam (1636).
Fulfilled commissions for Charles I in London (1625, 1630
and 1641). Painted landscapes.

182, 183

Huntsmen in the Forest

Oil on panel, 27 1/8×36 1/4" (69×92 cm.)
Signed, bottom center: A. Keirincx
The Hermitage, Leningrad. Inv. No. 455

PROVENANCE		REFERENCES
Until 1781	The Baudouin Collection, Paris	* *Catalogues. The Hermitage* 1863–1916, No.
1781	The Imperial Hermitage, St. Petersburg	533; * *Catalogue. The Hermitage* 1958, 2, p. 205.

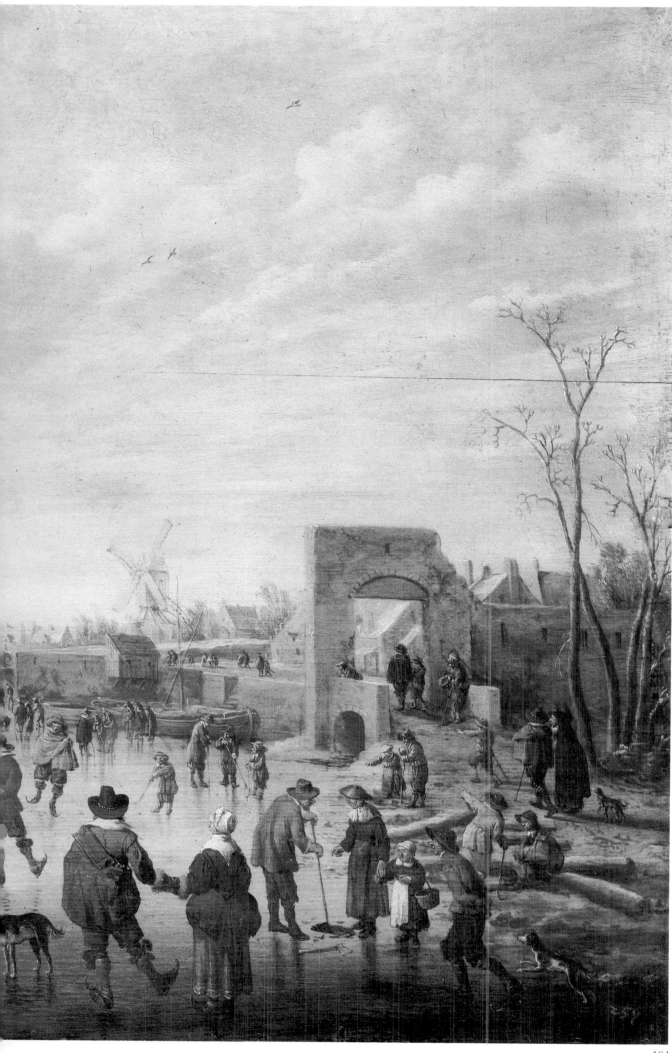

JOOST CORNELISZ DROOCHSLOOT

Biography: *see under* plate 142

← 184

Winter in a Dutch Town

Oil on panel, 20×29 ³/₈" (50.5×74.5 cm.)
Signed with monogram, bottom left corner: JDS f
The Hermitage, Leningrad. Inv. No. 700

PROVENANCE	REFERENCES
Before 1797 The Imperial Hermitage, St. Petersburg	* *Catalogues. The Hermitage* 1863–1916, No. 982; * *Catalogue. The Hermitage* 1958, 2, p. 195.

JAN VAN GOYEN

Born 1596 in Leyden, died 1656 in The Hague. Pupil of Coenraet van Schilperoort (1606), then of Isaak van Swanenburch and Jan de Man in Leyden, later of Willem Gerritsz in Hoorn. Returned to Leyden after 1610. Traveled to France (1615). On returning home studied under Esaias van de Velde. Member of the Leyden guild (from 1618), later a hoofdman (dean) of the Hague guild (1638–40). Voyaged along the rivers of Holland and Zeeland. Painted landscapes.

185

Landscape with an Oak

Oil on canvas, 34 ¹/₄×41 ³/₈" (87×105 cm.)
Signed and dated on wall of hut, right: V. Goyen 1634
The Hermitage, Leningrad. Inv. No. 806

PROVENANCE

Until 1920 Palace, Gatchina
1920 The Hermitage, Leningrad

REFERENCES

* *Catalogue. The Old Years* 1908, No. 455; * Shchavinsky 1916, pp. 75–76; * Shcherbachova 1924, p. 8; A. Pappe, "Oversicht der literatuur betreffende Nederlandsche kunst. Sovjet Russland," *Oud-Holland*, 1926, p. 200; H. Vollhard, *Die Grundtypen der Landschafts-* bilder des Jan van Goyen und ihre Entwicklung, Frankfurt on the Main, 1927, p. 174; N. Romanov, "*Landscape with Oaks* by Jan van Goyen," *Oud-Holland*, 1936, p. 189; * *Catalogue. The Hermitage* 1958, 2, p. 182; * *Fechner* 1963, pp. 30, 175; A. Dobrzycka, *Jan van Goyen*, Poznań, 1966, No. 70 (erroneously identified with No. 315 in Hofstede de Groot, VIII); H.-U. Beck, *Jan van Goyen*, vol. II, Amsterdam, 1973, No. 1132.

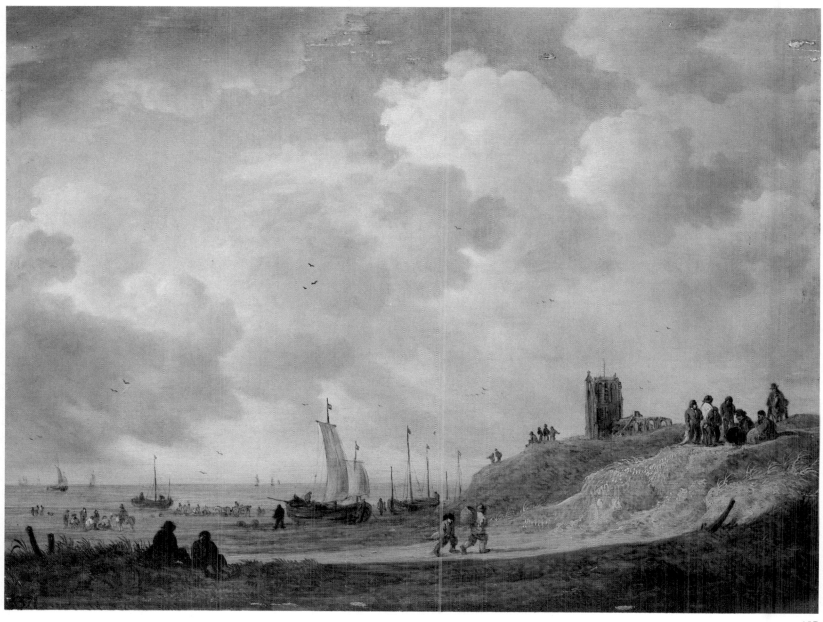

186, 187

The Shore at Egmond aan Zee

Oil on panel, 20 3/4×28" (53×71 cm.)
Signed with a monogram and dated, bottom, right of center :VG 1645
The Hermitage, Leningrad. Inv. No. 1127

PROVENANCE

Before 1797 The Imperial Hermitage,
St. Petersburg

REFERENCES

* *Catalogues. The Hermitage* 1863–1916, No. 1127; Hofstede de Groot. VIII, No. 101; H. Vollhard, *Die Grundtypen der Landschafts-* *bilder des Jan van Goyen und ihre Entwicklung,* Frankfurt on the Main, 1927, pp. 177–178; * *Catalogue. The Hermitage* 1958, 2, p. 183 (as *The Shore of Schewenningen*); A. Dobrzycka, *Jan van Goyen*, Poznań, 1966, No. 155; H.-U. Beck, *Jan van Goyen*, vol. II, Amsterdam, 1972, No. 954.

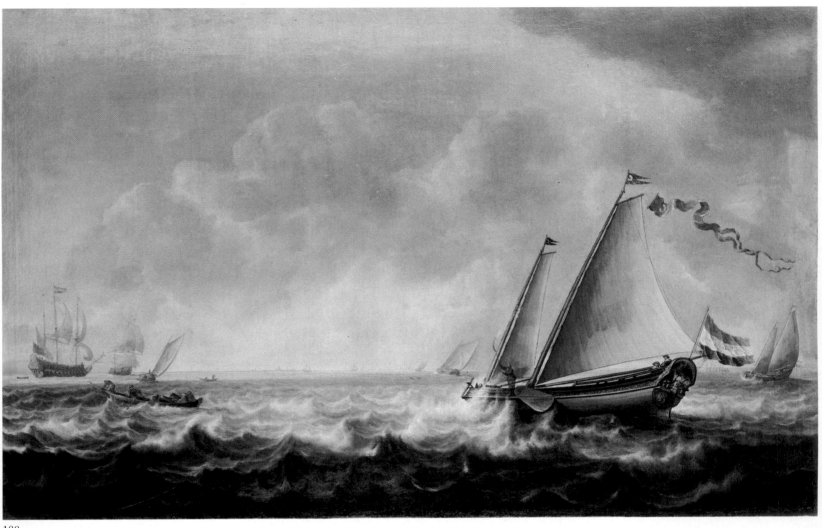

188

SIMON DE VLIEGER

Born 1601 in Rotterdam, died 1653 in Weesp. Pupil of Willem
van de Velde the Elder and, possibly, Jan Porcellis. Worked
in Rotterdam, Delft (1634–38), Amsterdam (until 1649),
and Weesp. Painted marines, landscapes, genre scenes,
and portraits.

188

Seascape with Sailboats

Oil on canvas, 35 ¹/₄×56 ³/₈" (89.8×143 cm.)
Signed and dated on flag of ship, right: S. de Vlieger A. 1634
Art Museum, Kharkov. Inv. No. 34

PROVENANCE	REFERENCES
1872 The A. Alfiorov Collection, Kharkov	*Catalogue. Kharkov* 1877, No. 229; *Catalogue.*
1877 Museum of Fine Arts of Kharkov University	*Kharkov* 1959, p. 42.
Art Museum, Kharkov	

JOHANNES PIETERSZ SCHOEFF

Born 1609 (place of birth unknown), died after 1660 in
The Hague (?). Matured as an artist under the influence
of Jan van Goyen. Worked in The Hague (1639–60).
Was a landscape painter.

189

Landscape with Two Oaks

Oil on panel, 12 5/8×17 3/4" (32×45 cm.)
Signed and dated on boards, right: J. Schoeff 1654
The Lunacharsky Art Museum, Krasnodar. Inv. No. 35

A variant of this landscape is in the University of Kansas Museum of Art (see
From the Collection of the University of Kansas Museum of Art, April 15–
June 13, 1971, The Museum of Fine Arts. Houston, No. 91).

REFERENCES

Provenance unknown.

* *Catalogue. Krasnodar* 1953, p. 12.

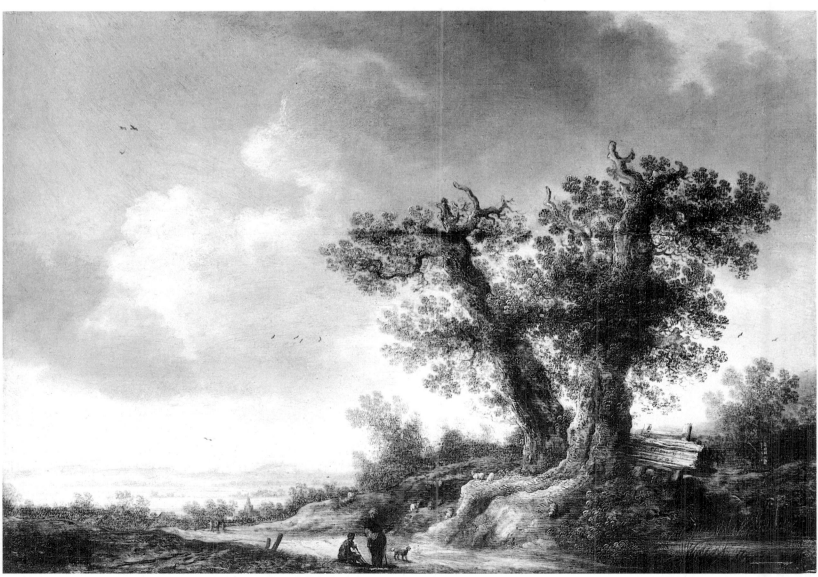

189

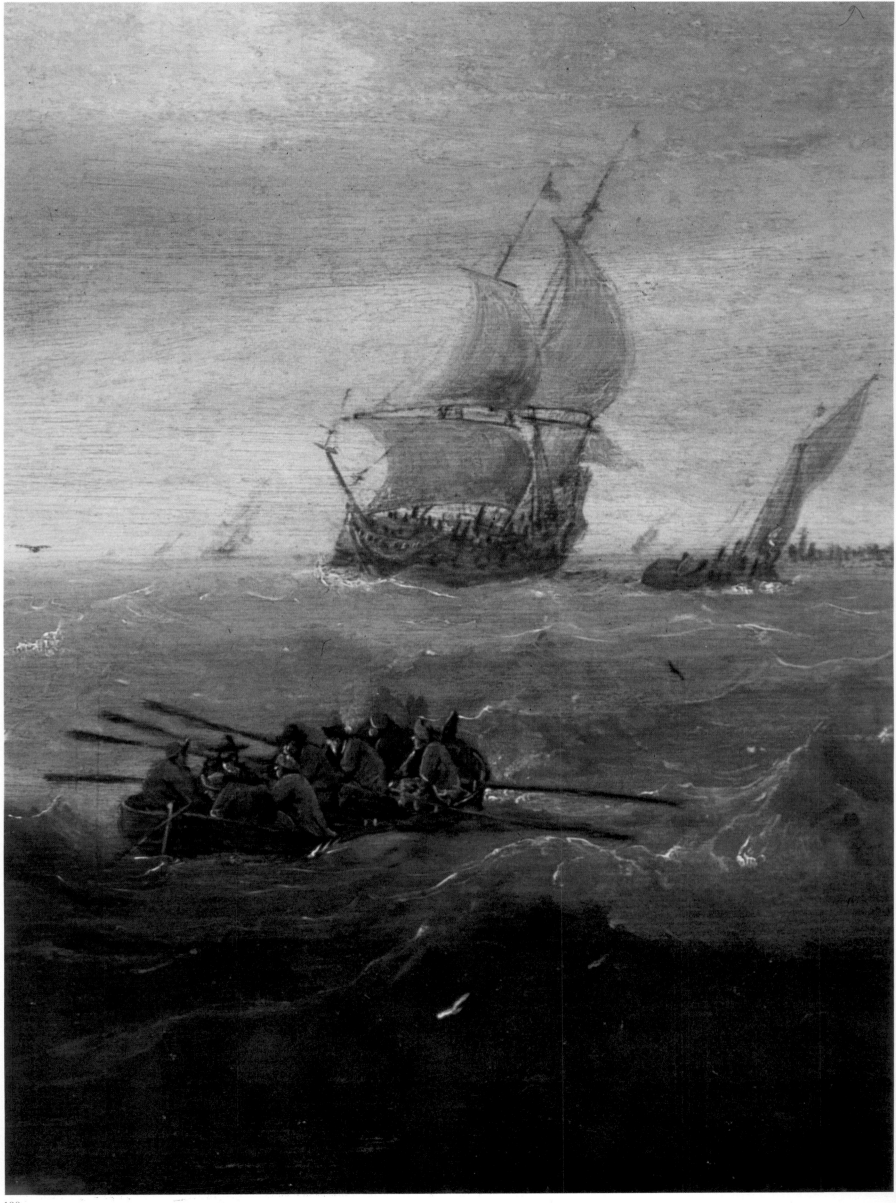

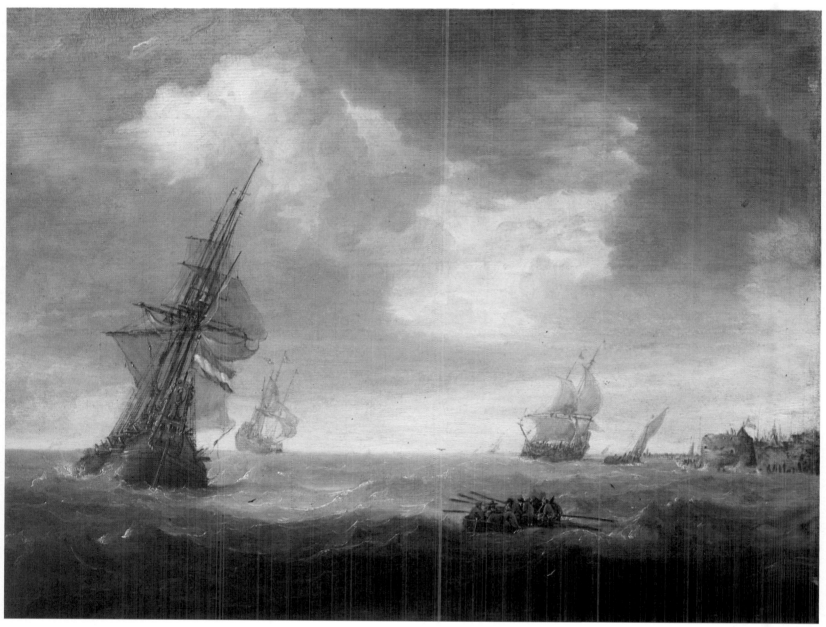

191

JAN PORCELLIS

Born 1584 in Ghent, died 1632 in Zoeterwoude (near Leyden).
Spent his youthful years in Rotterdam. Lived in Antwerp
(from 1615). Member of the painters' guild (from 1617).
Possibly worked in Ghent. Lived in Haarlem (1622), Amsterdam
(1624), and Zoeterwoude (1626). Was a marine painter.

190, 191

Ships at Sea on a Rough Day

Oil on canvas, 18 ¹/₂×26 ¹/₄" (47×67 cm.)
Signed with monogram on flag of ship, left: I P
The Hermitage, Leningrad. Inv. No. 1403

SALOMON VAN RUYSDAEL

Born in the early seventeenth century in Naarden, died 1670 in Haarlem. Was influenced by the art of Esaias van de Velde, Pieter Molijn, and Jan van Goyen. Worked in Haarlem. Painted landscapes and still lifes.

192

River View

Oil on panel, 14×19 ¹/₂" (35.8×49.6 cm.)
Signed and dated, bottom left: S. Ruysdael 1642
Museum of Western European and Oriental Art, Riga. Inv. No. 9

PROVENANCE	REFERENCES
1862 The V. Brederlo Collection, Riga	Neumann 1906, No. 160; W. Stechow, *Salomon van Ruysdael*, Berlin, 1938, No. 335; * *Catalogue. Riga* 1955, p. 71; * *Catalogue. Riga* 1973, p. 34.
1868 The Brederlo Picture Gallery, Riga	
1905 Museum of Western European and Oriental Art, Riga	

193

FRANS POST

Born around 1612 in Leyden, died 1680 in Haarlem. Worked
in Haarlem. Together with his brother Pieter Jansz Post, an
architect and battle painter, accompanied Prince Johannes
Moritz of Nassau on a voyage through Brazil (1637–49). Painted
landscapes, for the most part Brazilian views.

193

Brazilian Landscape with Sugarcane Plantation

Oil on panel, 18 1/2×24 3/4" (47×63 cm.)
Signed and dated, bottom center: Post f. 1659
The Hermitage, Leningrad. Inv. No. 3433

Depicted is a plantation unit—the owner's house with outbuildings, the
premises for processing sugarcane, and, in the background, a chapel.

PROVENANCE		REFERENCES
Until 1915	The P. Semionov-Tien-Shansky Collection, Petrograd	*Catalogue Semenov* 1906, No. 433; Semenov. *Etudes* 1906, p. CXLIV; * *Catalogue. The Hermitage* 1958, 2, p. 240; J. de Sousa-Leao, *Frans Post*, Amsterdam, 1973, No. 98.
1915	The Imperial Hermitage, Petrograd	

JACOBUS SIBRANDI MANCADAN

Born 1602 in Friesland, died 1680 in Leeuwarden.
Was burgomaster of Franeker (1637 to 1639) and Leeuwarden
(1645). After 1656 lived near Leeuwarden Painted landscapes.

194

Ruins of a Castle

Oil on panel, 15 3/8×20 1/2" (39.1×52.4 cm.)
Signed with monogram, bottom left: JM
Museum of Western European and Oriental Art, Riga. Inv. No. 15

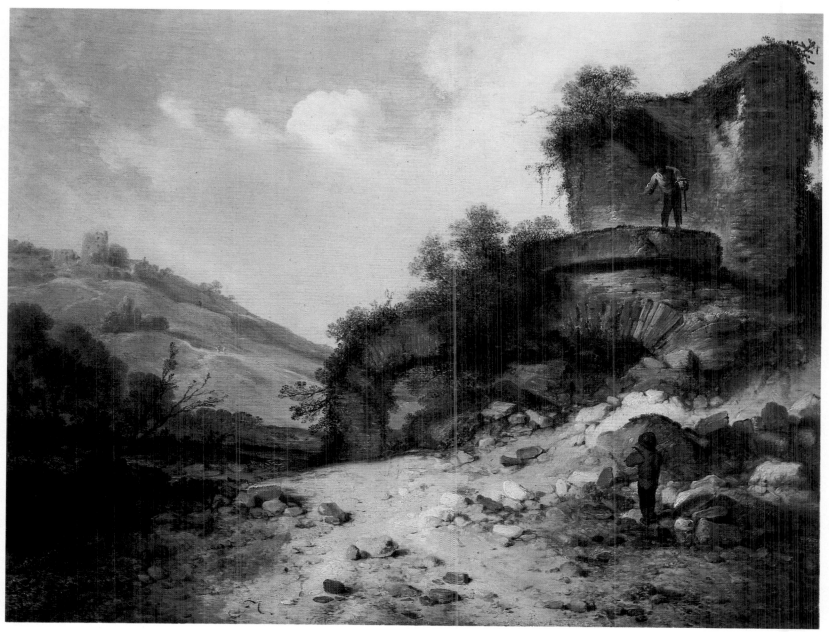

194

←

The antique ruins and the hills depicted prompted some scholars to assume that the artist had been to Italy and painted the landscape from impressions produced by the trip. The character of the vegetation, however, and the soft, tranquil light of the northern sky bespeak a Dutch, even, more specifically, a Friesland landscape.

JACOB ISAAKSZ VAN RUISDAEL

Born about 1628 in Haarlem, died 1682 in Amsterdam. Pupil of Salomon van Ruysdael (his uncle). Member of the Haarlem guild (from 1648). Worked in Amsterdam (from 1657). A great landscape painter, he also did engraving.

195

The Marsh

Oil on canvas, 28 1/2×39″ (72.5×99 cm.)
Signed, bottom left: JV Ruisdael
The Hermitage, Leningrad. Inv. No. 934

The picture was influenced by an engraving by Roelant Savery on the same subject.

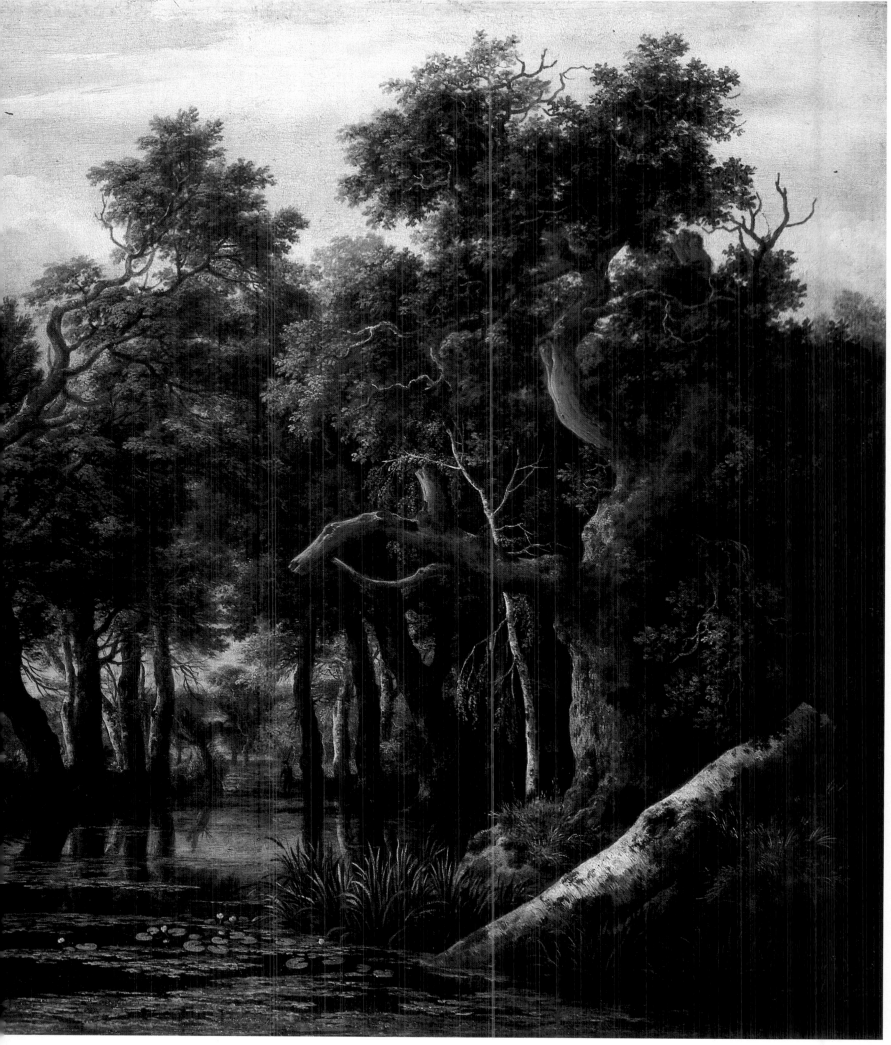

196

196

Peasant Houses in the Dunes

Oil on panel, 20 5/8×26 1/4" (52.5×67 cm.)
Signed and dated, bottom center: JV Ruisdael 1647
The Hermitage, Leningrad. Inv. No. 933

PROVENANCE

Until 1781 The Baudouin Collection, Paris
1781 The Imperial Hermitage,
 St. Petersburg

REFERENCES

* *Catalogues. The Hermitage* 1863–1916, No. 1148; Hofstede de Groot, IV, No. 896; J. Rosenberg, *Jacob van Ruisdael*, Berlin, 1928, No. 553/896, p. 14; * *Catalogue. The Hermitage* 1958, 2, p. 246; * Fechner 1958, p. 6; * Fechner 1963, pp. 93, 170.

197

The Seashore

Oil on canvas, 20 ³/₈×26 ³/₄″ (52×68 cm.)
Signed, bottom right: JV Ruisdael
The Hermitage, Leningrad. Inv. No. 5616

The figures were possibly painted by Adriaen van de Velde.

PROVENANCE		REFERENCES
Until 1919	Marble Palace, Petrograd	* Shcherbachova 1924, p. 23; J. Rosenberg, *Jacob van Ruisdael*, Berlin, 1928, No. 569; * *Catalogue. The Hermitage* 1958, 2, p. 250; * Fechner 1958, p. 23; * Fechner 1963, pp. 95, 171.
1919	The Hermitage, Petrograd	

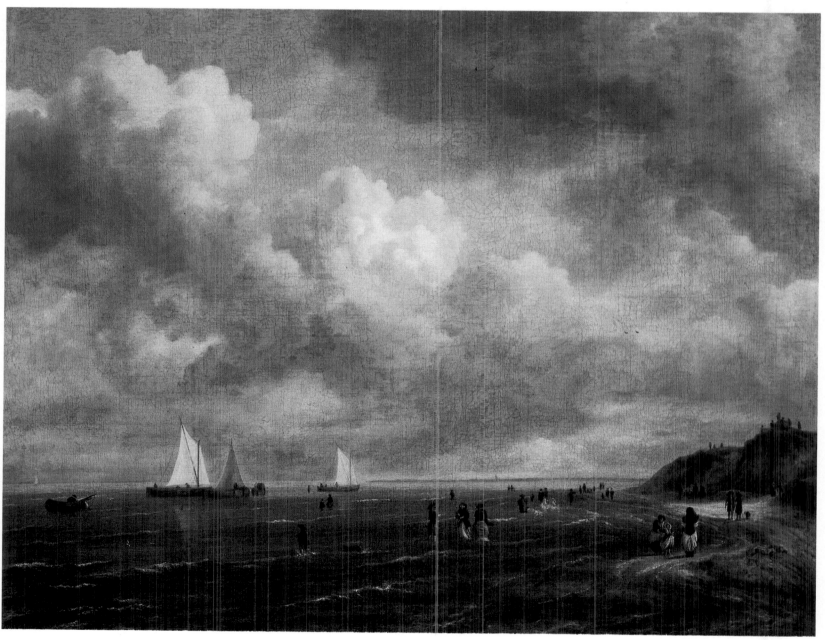

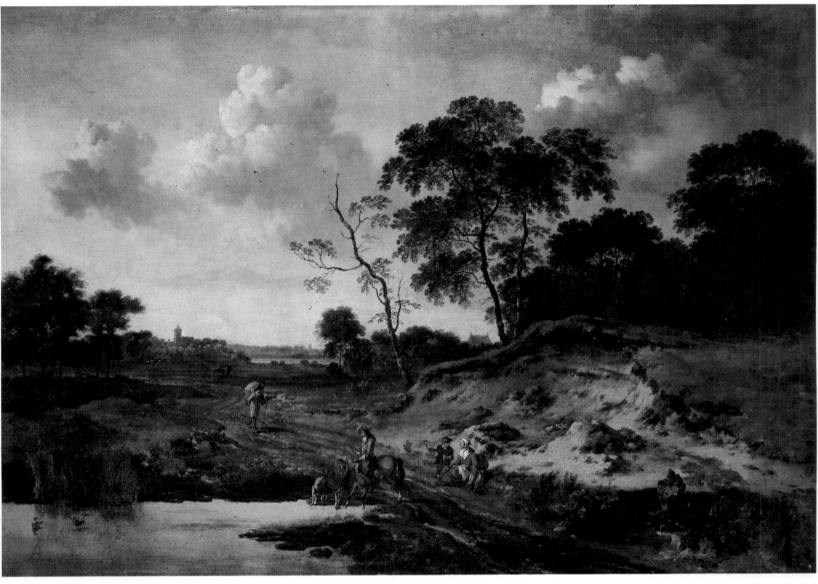

198

JAN WIJNANTS

Born between 1630 and 1632 in Haarlem, died 1684 in
Amsterdam. Was influenced by Jacob van Ruisdael. Worked
in Haarlem, Rotterdam, and Amsterdam (after 1659).
Was a landscape painter.

198

Landscape with a Sandy Slope

Oil on canvas, 42 ⁵/₈×60 ³/₈" (108.5×153.5 cm.)
Signed with monogram, bottom right: JW
The Hermitage, Leningrad. Inv. No. 826

The figures were painted by Johannes Lingelbach.

PROVENANCE

Until 1769 The Heinrich Brühl Collection,
 Dresden
1769 The Imperial Hermitage,
 St. Petersburg

REFERENCES

* *Catalogues. The Hermitage* 1863–1916, No.
1116; Hofstede de Groot, VIII, No. 434; * *Catalogue. The Hermitage* 1958, 2, p. 149.

JAN BAPTIST WEENIX

Born 1621 in Amsterdam, died 1663 in Deutekom. Pupil of
Abraham Bloemaert in Utrecht and Claes Cornelisz Moeyaert
in Amsterdam. Traveled to Italy, staying mostly in Rome (1642).
Painted landscapes, also still lifes and genre scenes.

199

The Wade

Oil on canvas, 39 3/8×51 7/8" (100×131.5 cm.)
Signed and dated on ruins, right: Gio Batta Weenix 1647 (date is barely visible)
The Hermitage, Leningrad. Inv. No. 3740

PROVENANCE		REFERENCES
Until 1922	Museum of the Academy of Arts, Petrograd	* *Catalogue. The Kushelev Gallery* 1886, No. 111; * Shcherbachova 1924, p. 14; * *Catalogue. The Hermitage* 1958, 2, p. 153, pl. 146; * Kuznetsov 1959, No. 37; * Fechner 1963, pp. 124, 172.
1922	The Hermitage, Petrograd	

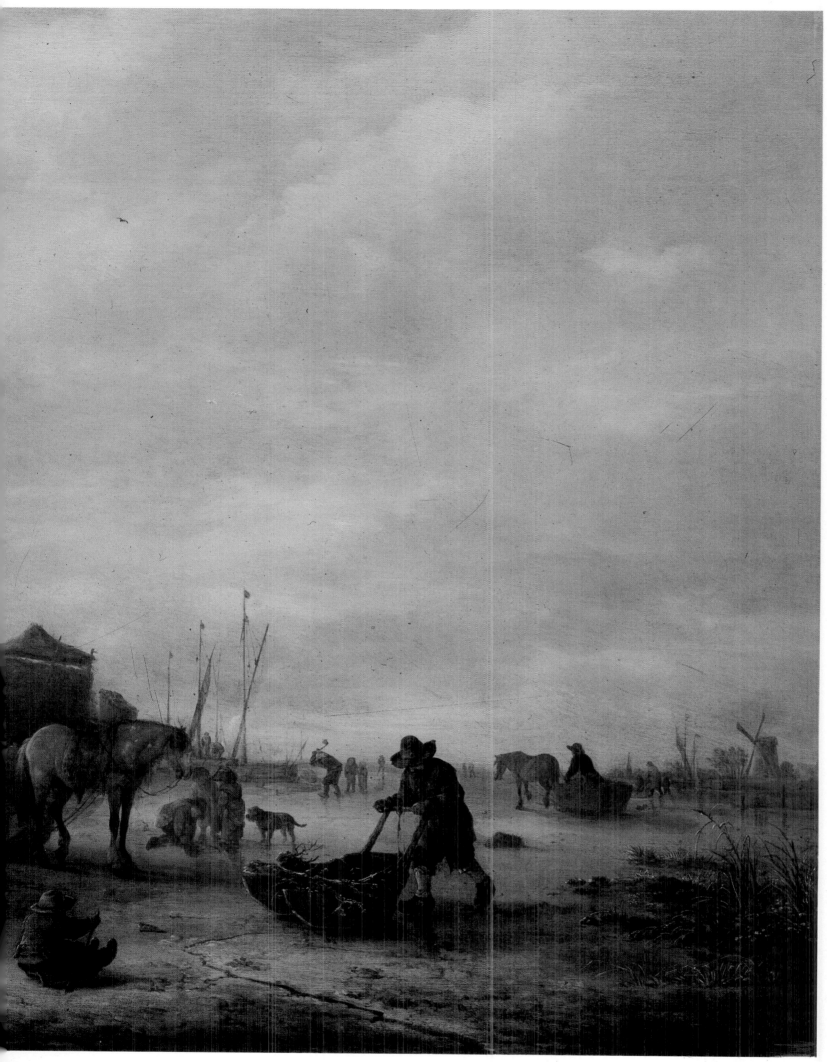

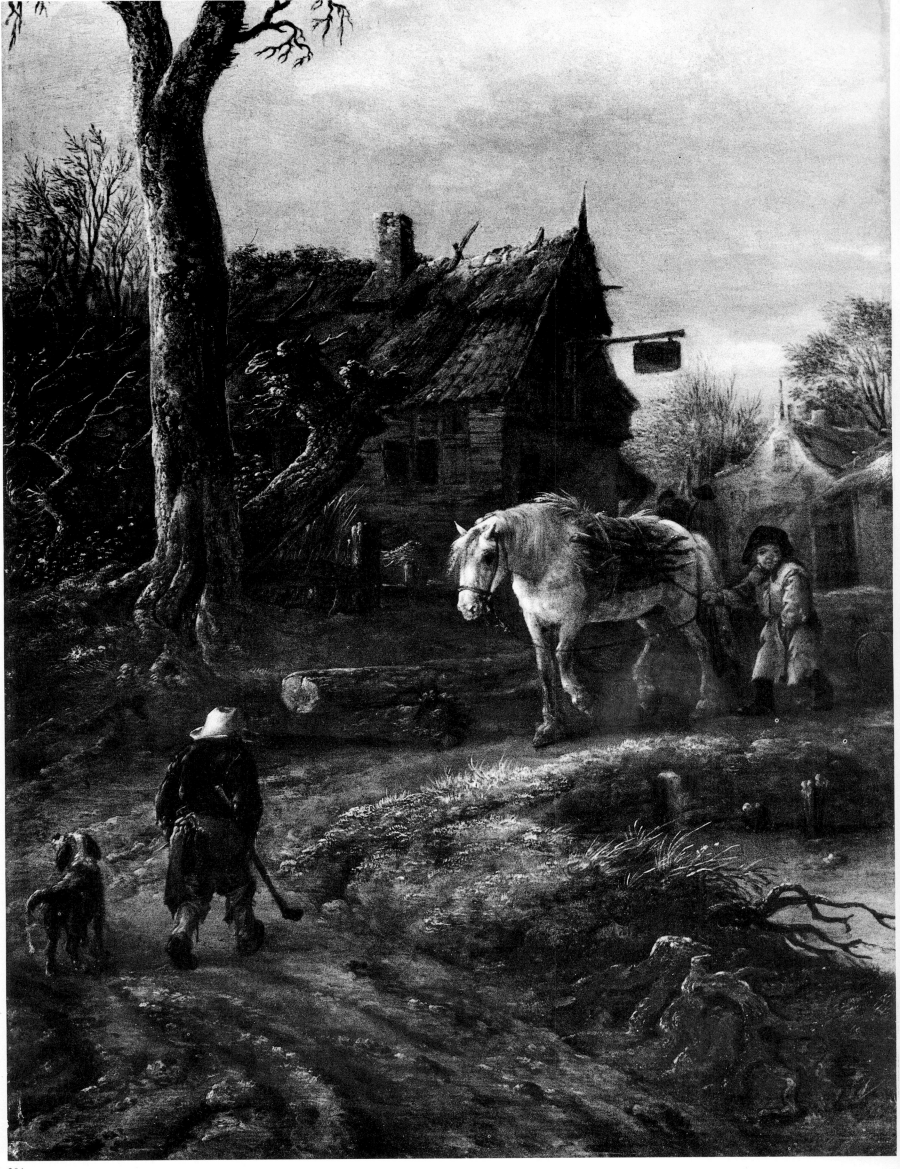

201

ISACK VAN OSTADE

Born 1621 in Haarlem, died there in 1649. Younger brother and pupil of Adriaen van Ostade. Worked in Haarlem. Painted genre scenes of peasant life and landscapes.

← 200, 201

Winter Scene

Oil on panel, 28 1/4×44 3/4" (71.5×113.5 cm.)
Signed, bottom right: Isack van Ostade
The Hermitage, Leningrad. Inv. No. 906

Painted around 1648.

PROVENANCE	REFERENCES
Until 1768 The Karl Cobenzl Collection, Brussels 1768 The Imperial Hermitage, St. Petersburg	* *Catalogues. The Hermitage* 1863–1916, No. 962; Hofstede de Groot, III, No. 85; * *Catalogue. The Hermitage* 1958, 2, p. 235; * Kuznetsov 1959, p. 8; * Kuznetsov 1960, No. 42; * Fechner 1963, pp. 74, 147.

ADRIAEN VAN DE VELDE

Biography: *see under* plate 167.

202 →

Landscape

Oil on canvas, 13 3/8×12 1/4" (34×31 cm.)
Signed and dated, bottom center: A v d Velde f. 1652
The Pushkin Museum of Fine Arts, Moscow. Inv. No. 3252

PROVENANCE	REFERENCES
1950 The Pushkin Museum of Fine Arts. Moscow (through the State Purchasing Commission)	* *Catalogue. The Pushkin Museum of Fine Arts* 1961, p. 34.

KLAES MOLENAER

Born around 1630 in Haarlem, died in that city in 1696. Worked in Haarlem. Painted lanscapes and genre scenes.

203 →

Fishing

Oil on panel, 14 1/8×12 7/8" (36×32.5 cm.)
Signed, bottom right: K. Molenaer
Art Museum, Kharkov. Inv. No. 18

PROVENANCE	REFERENCES
1872 The A. Alfiorov Collection, Kharkov 1877 Museum of Fine Arts of Kharkov University Art Museum, Kharkov	* *Catalogue. Kharkov* 1877, No. 230; * *Catalogue. Kharkov* 1959, p. 43.

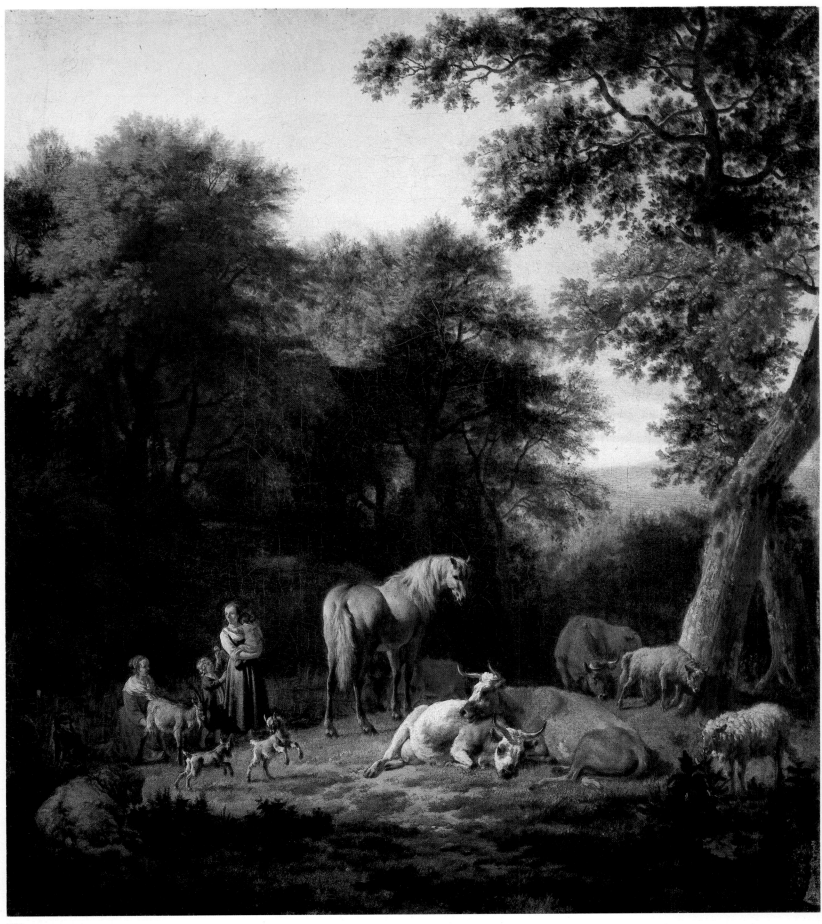

202

203

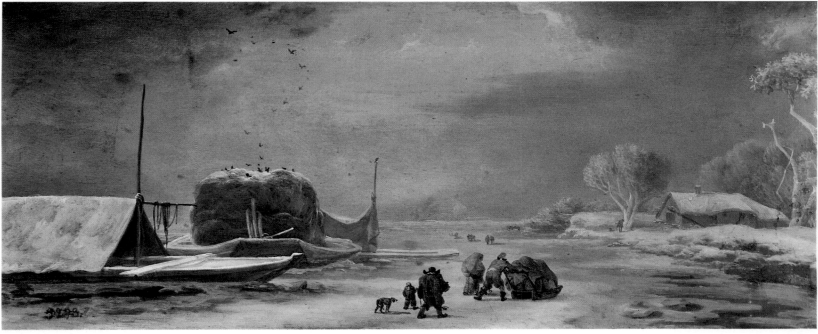

204

JAN ASSELYN

Born 1610 in Dieppe, died 1652 in Amsterdam. Pupil of Esaias
van de Velde. Lived in Rome (1638–43), then in France
(Lyons and Paris). Returned to Amsterdam not later than
July 1, 1647. Painted landscapes, cavalry battles, and animals.
Was also an etcher.

204

Winter

Oil on copper, 6 ×15 " (15×38 cm.)
Signed with monogram, bottom left: JA
The Hermitage, Leningrad. Inv. No. 1115

Companion piece to the picture *Horsemen Galloping toward the Gate of
a Castle* (*see* plate 205). The two were apparently intended to be installed in
wall panels.

PROVENANCE

1745 The De la Roque sale, Paris
(as a work by Jan Both)
Until 1920 Palace, Gatchina
1920 The Hermitage, Petrograd

REFERENCES

Hofstede de Groot, IX, No. 70; * *Catalogue.*
The Hermitage 1958, 2, p. 129; A. Ch. Stetland-
Stief, *Jan Asselijn*, Amsterdam, 1971, pp. 54–55,
No. 233.

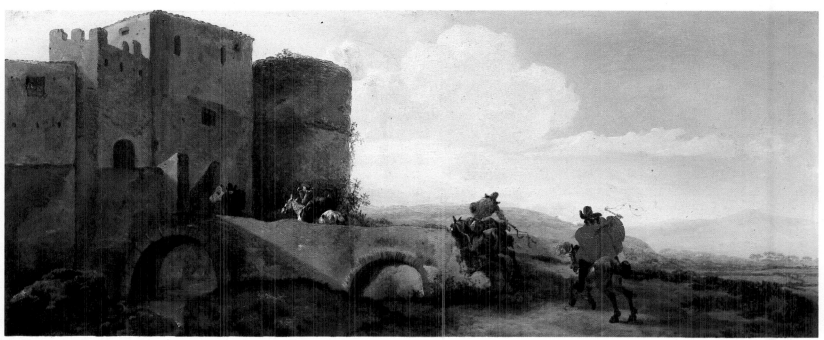

205

205

Horsemen Galloping toward the Gate of a Castle

Oil on copper, 6×15" (15×38 cm.)
The Hermitage, Leningrad. Inv. No. 1116

Companion picture to *Winter* (*see* plate 204).
Engraved in 1743 by Hippolyte Lebas as a Jan Both work; its title then was
The Flemish Messenger.

PROVENANCE	REFERENCES
See under No. 204	Hofstede de Groot, IX, No. 70 (as Jan Both); * *Catalogue. The Hermitage* 1958, 2, p. 129; A. Ch. Stetland-Stief. *Jan Asselijn*, Amsterdam, 1971, p. 54, No. 148.

EMANUEL DE WITTE

Born about 1618 in Alkmaar, died 1692 in Amsterdam.
Pupil to Evert van Aelst in Delft. Was influenced by
the art of Gerard Houckgeest, Hendrick van Vliet, and
Rembrandt. Worked in Alkmaar (entered the local
guild in 1636), Rotterdam (from 1639), Delft (from
1642), and Amsterdam. His oeuvre consists mostly of
church and domestic interiors, and also market scenes.
Portraits and mythological compositions are few and
far between.

206

Market in the Port

Oil on canvas, 24 ×29 1/2" (61×75 cm.)
The Pushkin Museum of Fine Arts, Moscow. Inv. No. 2803

Painted in the late 1660s. It depicts the new fish market near
the Haarlem Lock in Amsterdam.

PROVENANCE		REFERENCES
Until 1933	Art Gallery, Kursk	* Volskaya 1939, p. 43; * Kuznetsov
1933	Museum of Fine Arts, Moscow	1959, No. 56; * *Catalogue. The Pushkin Museum of Fine Arts* 1961, p. 41; * Vipper 1962, p. 250; I. Manke, *Emanuel de Witte*, Amsterdam, 1963, No. 15; *The Pushkin Museum of Fine Arts* 1966, No. 37.
1937	The Pushkin Museum of Fine Arts, Moscow	

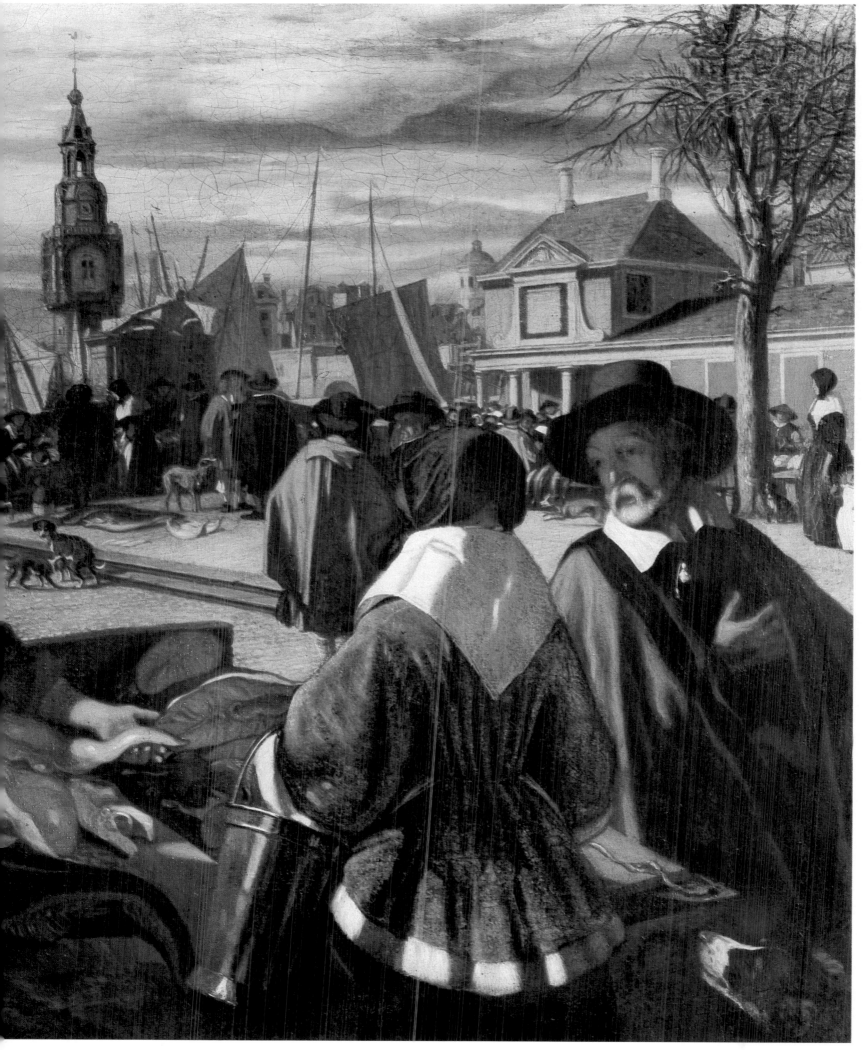

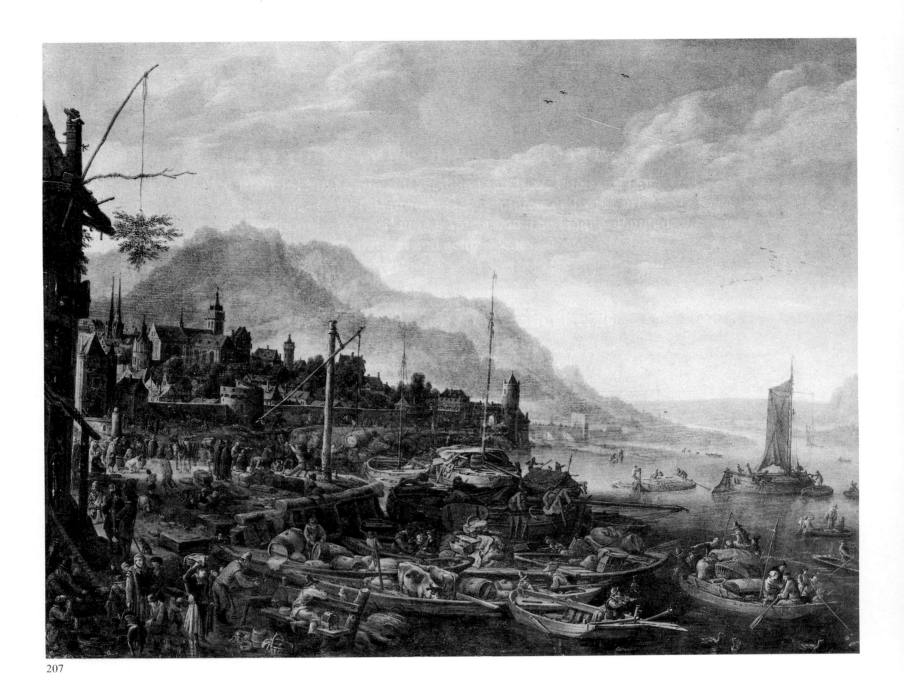

207

HERMAN SAFTLEVEN THE YOUNGER

Born around 1609 in Rotterdam, died 1685 in Utrecht. Pupil
of Herman Saftleven the Elder (his father). Was influenced by
the art of Bartholomeus Breenbergh, Roelant Savery,
Alexander Keirincx, and, especially, Jan Both. Lived and worked
in Utrecht (from 1632). Sailed along the Rhine and Mosel rivers.
Painted urban and river views. Was also an etcher.

207

View on the Rhine

Oil on canvas, 64 7/8×76 " (164.5×193 cm.)
Signed with monogram and dated, bottom left: HS 1647
The Hermitage, Leningrad. Inv. No. 978

PROVENANCE

Between 1763 The Imperial Hermitage,
and 1774 St. Petersburg

REFERENCES

* *Catalogues. The Hermitage* 1863–1916, No.
1155; * *Catalogue. The Hermitage* 1958, 2,
p. 267.

MICHIEL DE VRIES

Worked in the second half of the seventeenth century in
Haarlem, died before 1702. Achieved artistic maturity under
the influence of Roelof de Vries and Jan Wijnants.
Was a landscape painter

208

Riverside Manor

Oil on panel, 15 3/4×22" (40×56 cm.)
Remains of signature, bottom right: M. v. Vri..
Museum of Western European and Oriental Art, Kiev. Inv. No. 38

The picture was previously ascribed to Jan Baptist Wolfert.

PROVENANCE

	The Prince Borghese Collection, Rome
Until 1919	The B. and V. Khanenko Collection, Kiev
1919	Museum of Western European and Oriental Art, Kiev

REFERENCES

* *Catalogue. Khanenko* 1899, No. 309; *Collection Khanenko* 1911–13, pl. 82; * *Catalogue. Kiev* 1931, No. 411; * *Catalogue. Kiev* 1961, No. 210.

209

HENDRICK MOMMERS

Biography: *see under* plate 172.

209

Vegetable Market in Italy

Oil on canvas, 32×37 ¹/₄" (81.5×94.5 cm.)
Art Museum of the Estonian SSR, Tallinn. Inv. No. M-2571

The attribution is made by Irene Linnik (verbally). The picture
was previously ascribed to Pieter van Laer.

Provenance unknown.

REFERENCES
Catalogue. Tallinn 1953, p. 57 (as Pieter
van Laer).

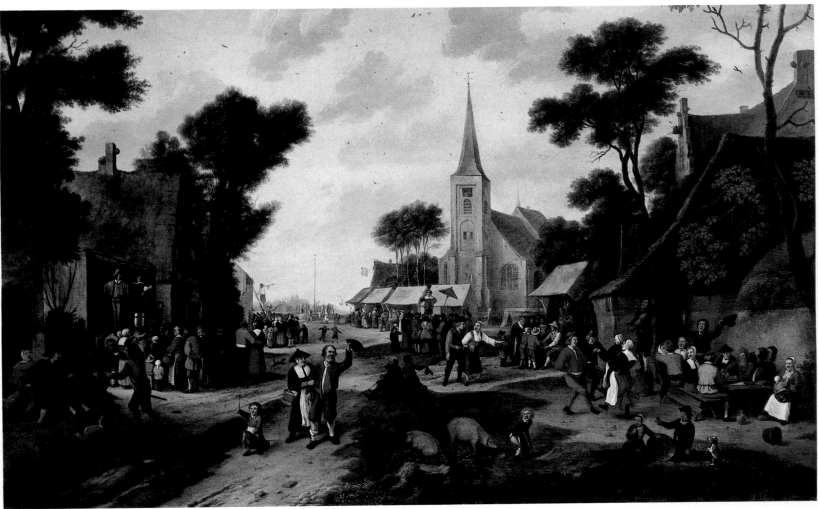

210

EGBERT VAN DER POEL

Born 1621 in Delft, died 1664 in Rotterdam. Worked in Delft
and Rotterdam (from 1655). Member of the Delft guild
(from 1650). Painted fairs, interiors of peasant cottages,
and landscapes.

210

The Fair

Oil on panel, 38 1/2×61 3/8" (98×156 cm.)
Remains of signature and date, right: E...el 1661
The Hermitage, Leningrad. Inv. No. 8478

No other works of this type are known in Van der Poel's creative legacy.
Prior to the discovery of the signature in 1957 the picture was ascribed to an
unknown Dutch artist of the seventeenth century.

PROVENANCE

1931 The Hermitage, Leningrad

REFERENCES

* Kuznetsov 1957, pp. 29–31; * *Catalogue. The
Hermitage* 1958, 2, p. 245.

SYBRAND VAN BEEST

Born around 1610 in the Hague, died 1674 in Amsterdam.
Pupil of Pieter van Ween (until 1629). Member of The Hague
guild (1640). One of the founders of Pictura, the painters' union
in The Hague of which he was hoofdman from 1659 to 1663.
Later moved to Amsterdam. Painted genre compositions and
market scenes.

211

The Market

Oil on panel, 15 3/4×21 5/8" (40×55 cm.)
Signed and dated, bottom right corner: S. Best 1649
The Hermitage, Leningrad. Inv. No. 3200

PROVENANCE

Until 1915 The P. Semionov-Tien-Shansky
 Collection, Petrograd
1915 The Imperial Hermitage, Petro-
 grad

REFERENCES

Catalogue Semenov 1906, No. 30 bis; * *Cata-
logue. The Hermitage* 1958, 2, p. 138.

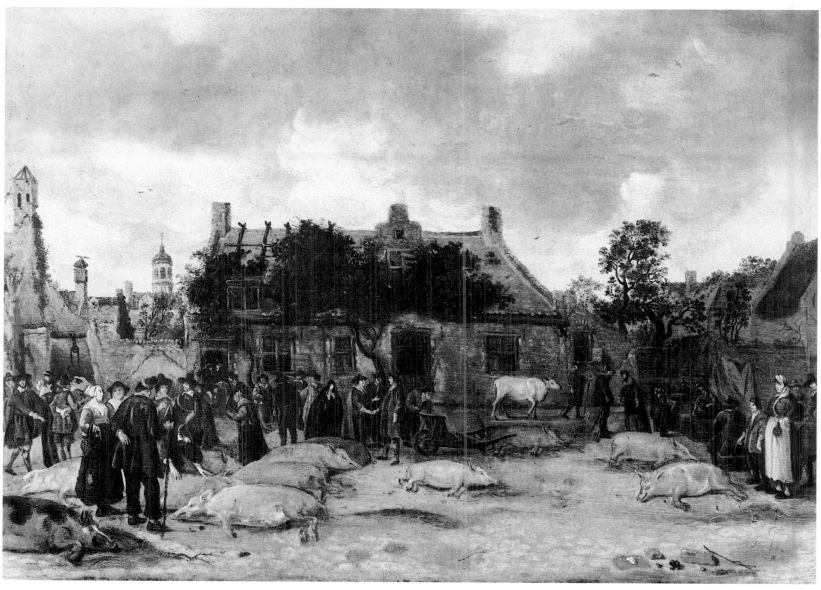

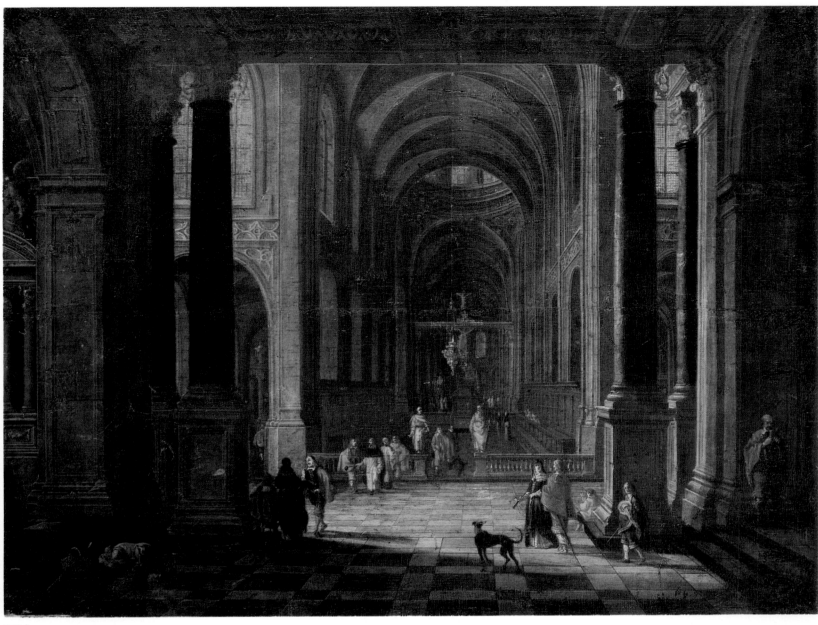

212

GERARD JORISZ HOUCKGEEST

Born about 1600 in The Hague, died 1661 in Bergen op Zoom.
Believed to have studied under Bartholomeus van Bassen.
Worked in The Hague (from 1625), Delft (from 1635),
Steenbergen (from 1652) and Bergen op Zoom (1653–55).
Painted architectural views, primarily church interiors.

212

Church Interior

Oil on panel, 12 ⅝×17 ¼" (32×44 cm.)
Signed with monogram and dated on base of column, left: GH 1648
The Hermitage, Leningrad. Inv. No. 2883

PROVENANCE	REFERENCES
Until 1915 The P. Semionov-Tien-Shansky Collection, Petrograd	* Semionov 1885–90, pp. 92–93; *Catalogue Semenov* 1906, No. 211; Semenov. *Etudes* 1906, p. LXIX;* *Catalogue. The Hermitage* 1958, 2, p. 187.
1915 The Imperial Hermitage, Petrograd	

PAULUS POTTER

Born 1625 in Enkhuizen, died 1654 in Amsterdam. Pupil of
Pieter Symonsz Potter (his father) and Jacob de Wet
in Haarlem. Member of the Delft guild (from 1646) and The
Hague guild (from 1649). Lived in Amsterdam. Almost all his
paintings are of animals in landscapes; he also made etchings.

213 →

The Farm

Oil on panel, 31 3/4×45 5/8" (81×115.5 cm.)
Signed and dated, bottom right corner: Paulus Potter 1649
The Hermitage, Leningrad. Inv. No. 820

Commissioned by the wife of the Stadtholder of the Netherlands, Amalia van
Solms, who then rejected it.

PROVENANCE	REFERENCES
The Mucard Collection, Amsterdam	* *Catalogues. The Hermitage* 1863–1916, No.
The Jacob van der Hoek Collection,	1051; Hofstede de Groot, IV, No. 114; J. Six,
Amsterdam	"Paul Potter," *Art flamand et hollandais*, 1907,
The De Wolff Collection, Amsterdam	VII, p. 3; L. Réau, "La galerie des tableaux de
1733 The Valerius de Reuver Collection	l'Ermitage à Saint-Petersbourg," *Gazette des*
1750 The collection of Duke Wilhelm VIII,	*Beaux-Arts*, II, 1912, pp. 481–487; W. von Bode,
Kassel	*Die Meister der holländischen und flämischen*
1806 Empress Josephine's collection, the	*Malerschulen*, Leipzig, 1956, p. 286; * *Cata-*
Malmaison Castle near Paris	*logue. The Hermitage* 1958, 2, p. 241; * Fechner
1815 The Imperial Hermitage, St. Petersburg	1963, pp. 74–75, 169, 170.

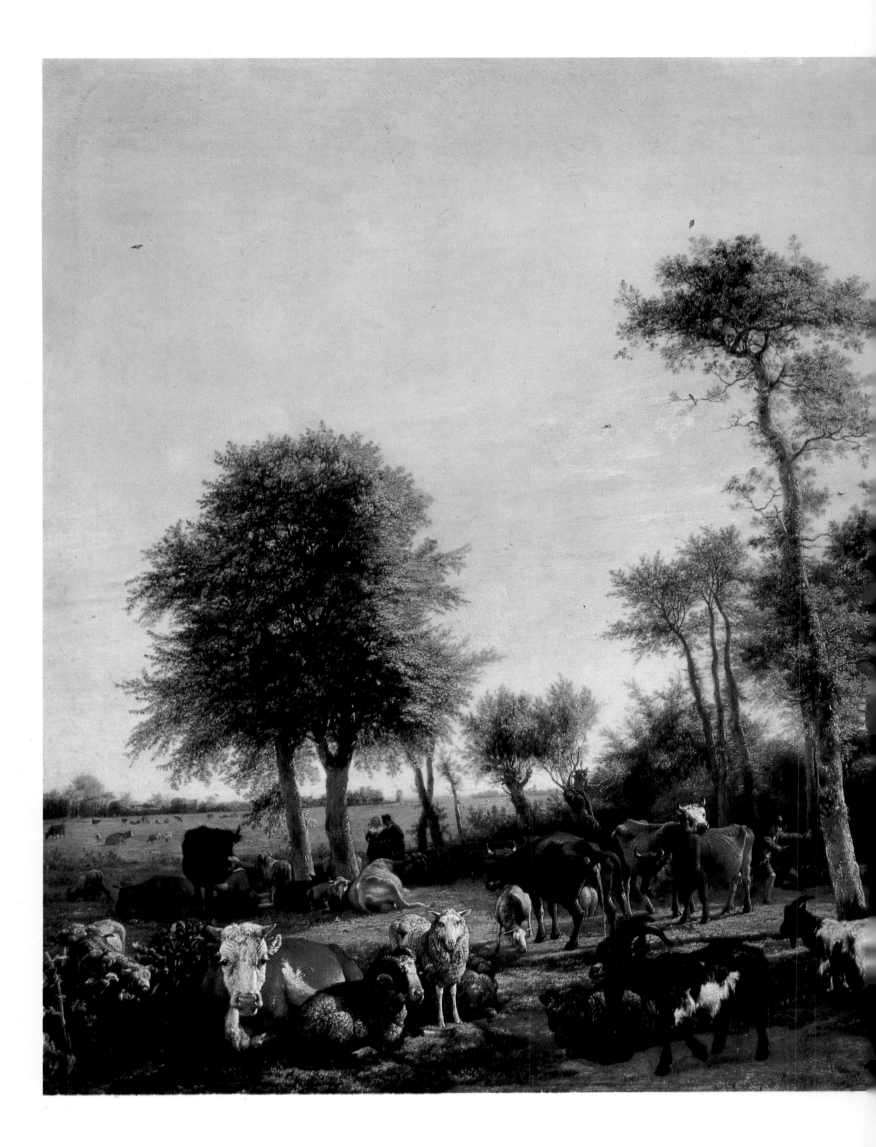

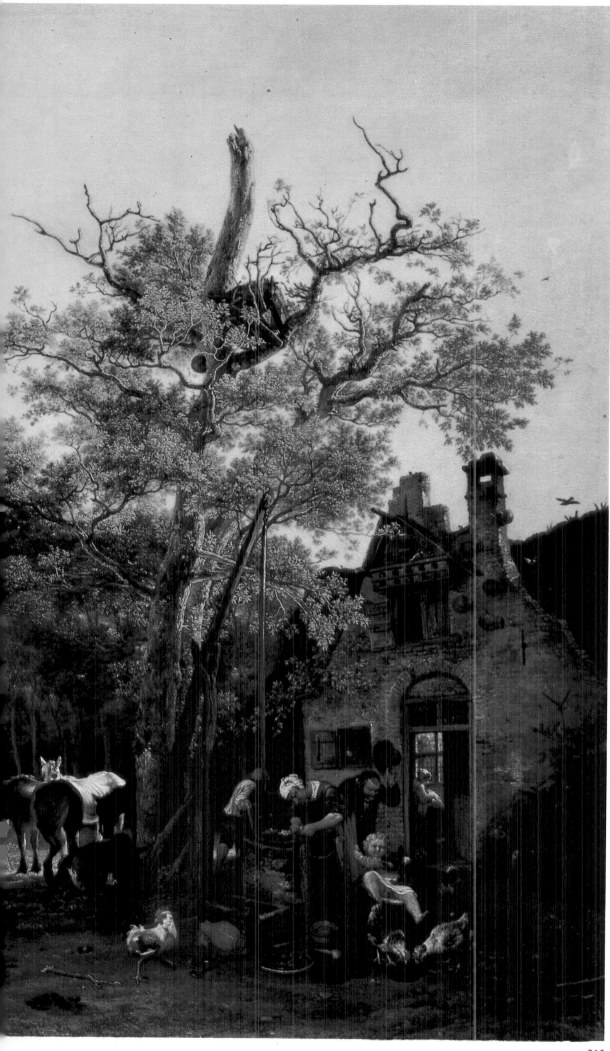

213

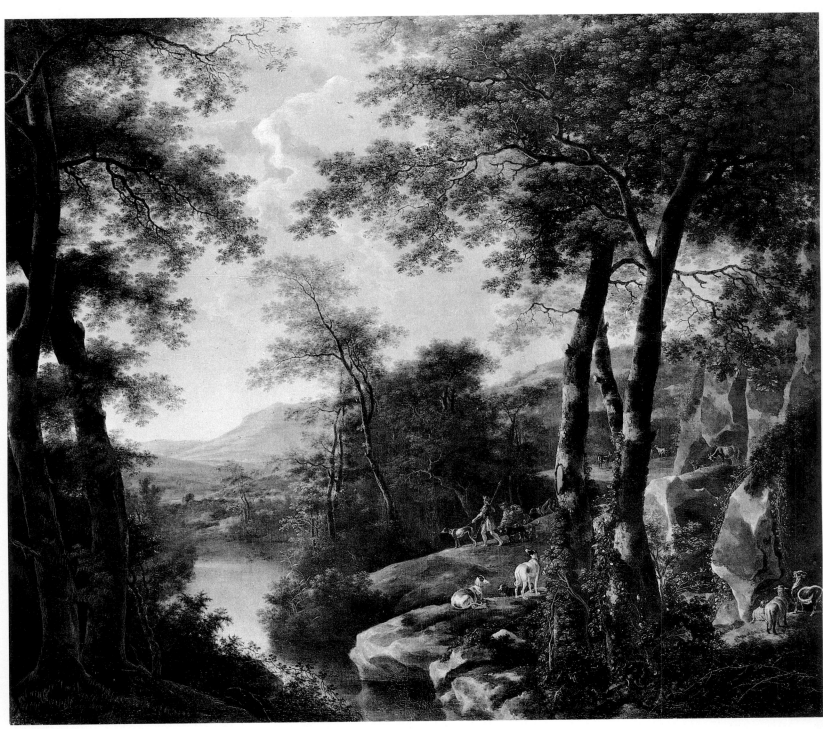

214

JAN BOTH

Born around 1618 in Utrecht, died there in 1652. Studied under
Dirck Joriaensz Both (his father) and Abraham Bloemaert in
Utrecht (1634). Traveled with his artist brother Andries Both
through France and Italy, lived for some time in Rome. Dean of
the painters' college in Utrecht (1649). Painted landscapes.

214

Italian Landscape

Oil on canvas, 60 5/8×68 1/2" (154×174 cm.)
Signed, bottom left: Both
The Hermitage, Leningrad. Inv. No. 3738

PROVENANCE		REFERENCES
Until 1922	Museum of the Academy of Arts, Petrograd	* *Catalogue. The Kushelev Gallery* 1886, No. 8; * Shcherbachova 1924, p. 12; * *Catalogue. The Hermitage* 1958, 2, p. 143; * Fechner 1963, pp. 120, 172.
1922	The Hermitage, Petrograd	

ADRIAEN VAN EEMONT

Born about 1627 in Dordrecht (?), died 1662 in Amsterdam.
Was influenced by the art of Jan Both and Philips Wouwerman.
Traveled in France and Italy together with Frédéric de
Moucheron (1654–56). Worked in Heusden and Amsterdam.
Painted landscapes and genre scenes.

215

Southern Landscape

Oil on canvas, 23 7/8×29 3/8" (60.5×74.5 cm.)
Signed, bottom center: AVE
Palace Museum, Pavlovsk. Inv. No. 101

Painted in the mid-1650s. Attributed to Adriaen van Eemont by
Yury Kuznetsov. It was earlier considered a work by Jan Asselyn, then
ascribed to an anonymous Dutch artist of Jan Both's circle.
The Hermitage picture has its closest stylistic analogue in *Mountainous
Landscape* (1654, Schlossmuseum, Gotha). The dog depicted in the
Hermitage piece and likewise present in *Huntsmen at the Fountain*
(Mauritshuis, The Hague) was borrowed by Van Eemont from Philips
Wouwerman's picture *Outdoor Dressage* (the Hermitage, Leningrad) or from
a preparatory drawing thereof.

PROVENANCE	REFERENCES
Late 18th century Palace, Pavlovsk	* *Art Treasures in Russia*, III, 1903, p. 146; * Kuznetsov 1970, pp. 97–101.

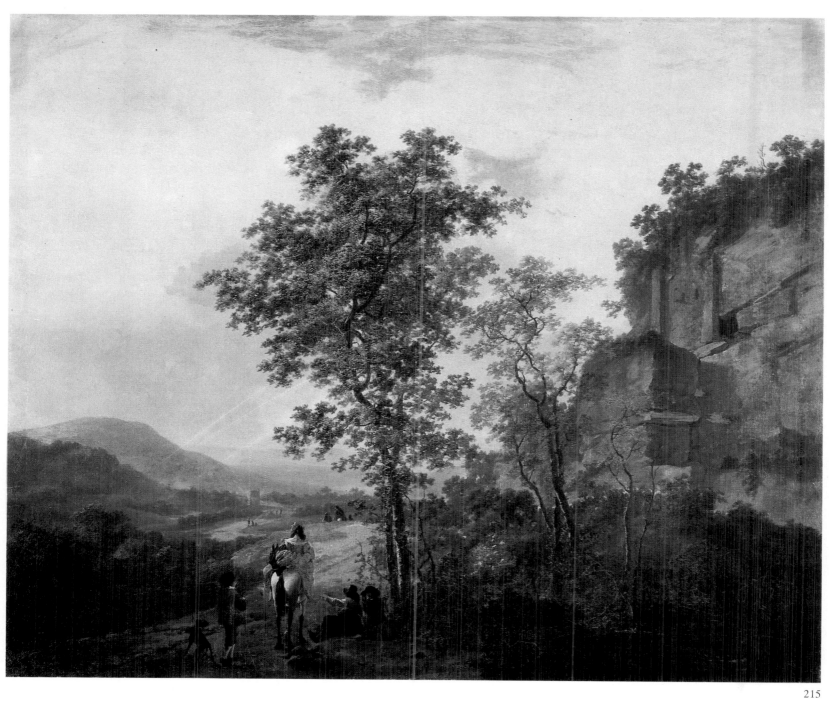

215

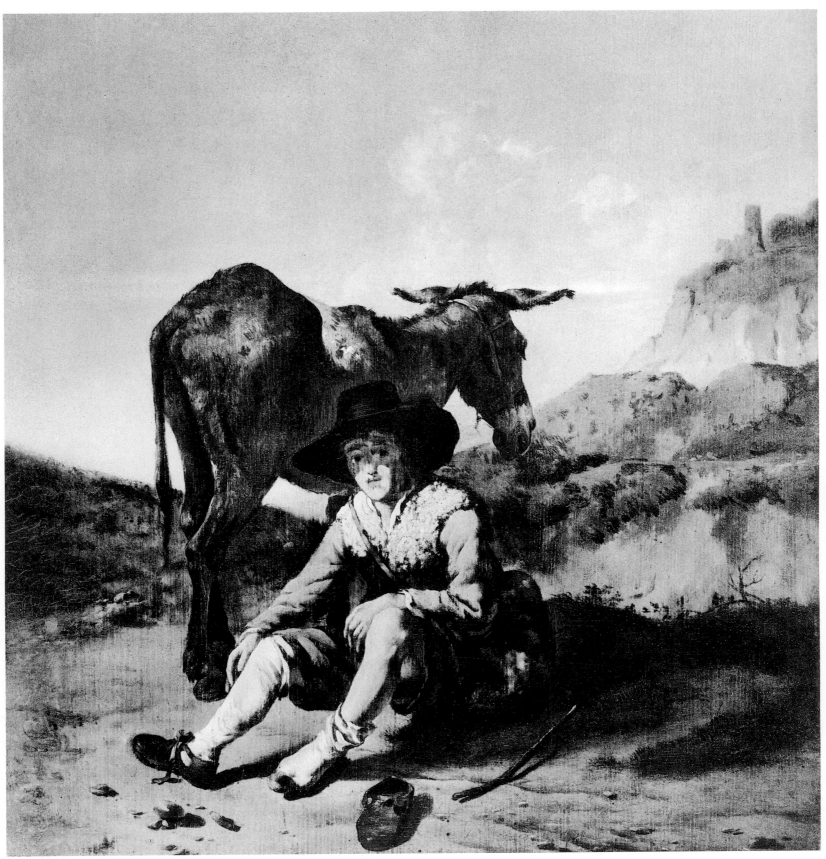

216

KAREL DUJARDIN

Born 1622 in Amsterdam, died 1678 in Venice. Studied under
Nicolaes Pietersz Berchem, was influenced by the art of Paulus
Potter. Visited Italy and France. Lived in The Hague (1656),
Amsterdam (1659). Moved to Italy in 1675. Painted landscapes
with animals, less frequently portraits and historical
compositions. Was also an etcher.

216

Shepherd with an Ass

Oil on panel, 10 ⁵/₈×9 ³/₄" (27×25 cm.)
Signed, bottom right: K. du Jardin
The Pushkin Museum of Fine Arts, Moscow. Inv. No. 433

	PROVENANCE	REFERENCES
Until 1924	The Rumiantsev Museum, Moscow	* *Catalogue. The Pushkin Museum of Fine Arts* 1961, p. 79.
1924	Museum of Fine Arts, Moscow	
1937	The Pushkin Museum of Fine Arts, Moscow	

AERNOUT (AERT) VAN DER NEER

Born 1603 or 1604 in Amsterdam (?), died in that city in 1677.
Was influenced by Rafel Camphuysen. Painted landscapes,
mostly moonlit, and winter scenes.

217 →

Mountainous Landscape

Oil on panel, 22 ³/₈×33" (57×84 cm.)
Signed with monogram and dated, bottom center: A.v.d.N. 1647
The Hermitage, Leningrad. Inv. No. 2104

In the Hermitage's first manuscript catalogue (1773) the picture was correctly
attributed to Aernout van der Neer. With the passage of time a layer of dirt
accumulated that blanketed the monogram and date. This, plus the fact that
the subject of the picture is uncharacteristic of the artist's oeuvre, led to the
loss of the author's identity. The picture was not even catalogued. In 1960 it
was subjected to cleaning, and the monogram and date were rediscovered.

	PROVENANCE		
Until 1797	The Imperial Hermitage, St. Petersburg	1817	The Crayton Collection, St. Petersburg
		1859	The Imperial Hermitage, St. Petersburg

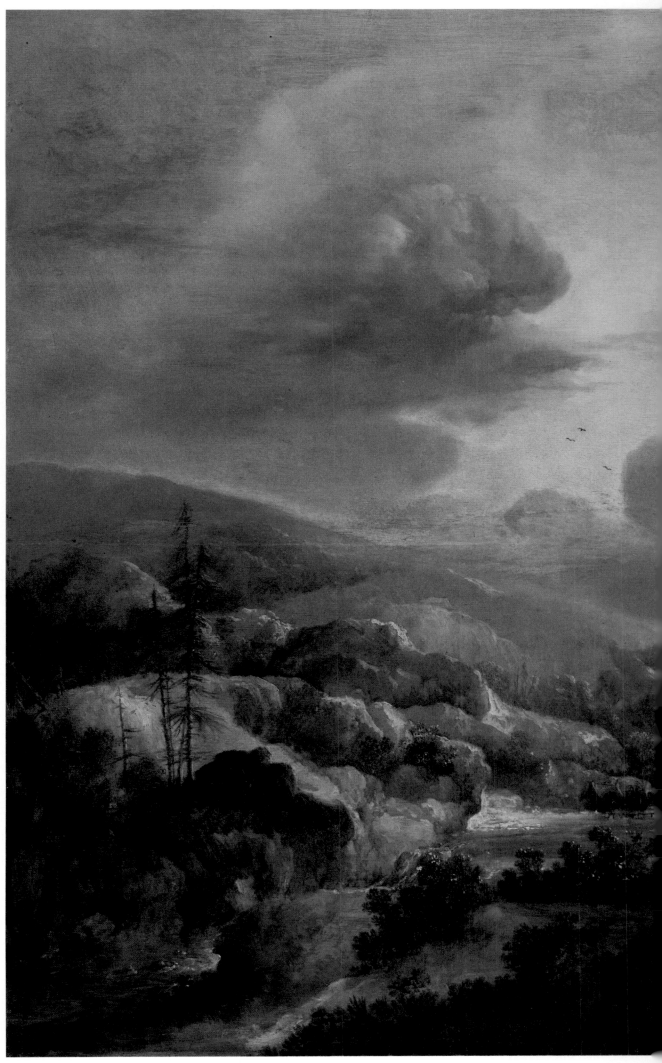

217

218

218

Landscape with a Windmill

Oil on panel, 27 ³/₈×36 ¹/₂" (69.5×92.5 cm.)
The Hermitage, Leningrad. Inv. No. 927

PROVENANCE

Before 1805	The Conradi Collection, Celle		The Duval Collection, St. Petersburg
	The Willer Collection, Leipzig	1805	The Imperial Hermitage, St. Petersburg

NICOLAES (CLAESZ) PIETERSZ BERCHEM

Born 1620 in Haarlem, died 1683 in Amsterdam. Studied under
Pieter Claesz (his father) in Haarlem, then under Nicolaes
Moeyaert in Amsterdam, Pieter de Grebber and Johannes Wils
in Haarlem. Worked in Haarlem and Amsterdam (1677–83).
Visited Italy (before 1642). Painted landscapes, depicting
animals in most of them, as well as historical and allegorical
compositions and portraits. Was also an engraver.

219

Italian Landscape with a Bridge

Oil on panel, 17 ¹/₂×24" (44.5×61 cm.)
Signed and dated, bottom right: Berchem f. 1656
The Hermitage, Leningrad. Inv. No. 1097

PROVENANCE

1754	The Lamperer Collection, Paris
Until 1772	Duc de Choiseul Collection. Paris
1772	The Imperial Hermitage, St. Petersburg

REFERENCES

* *Catalogues. The Hermitage* 1863–1916, No. 1081; * Shcherbachova 1924, p. 12; Hofstede de Groot, IX, No. 506; Ilse von Sick, *Nicolaes Berchem. Ein Vorläufer des Rokoko*, Berlin, 1926; * Kuznetsov. *Berchem* 1960, pp. 340–342.

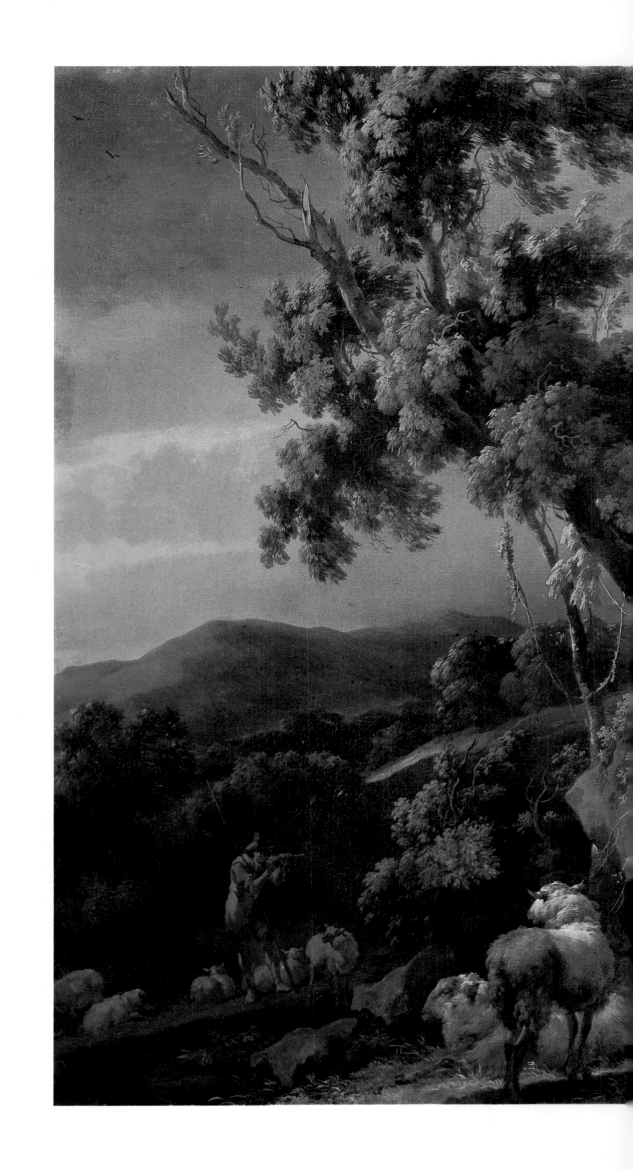

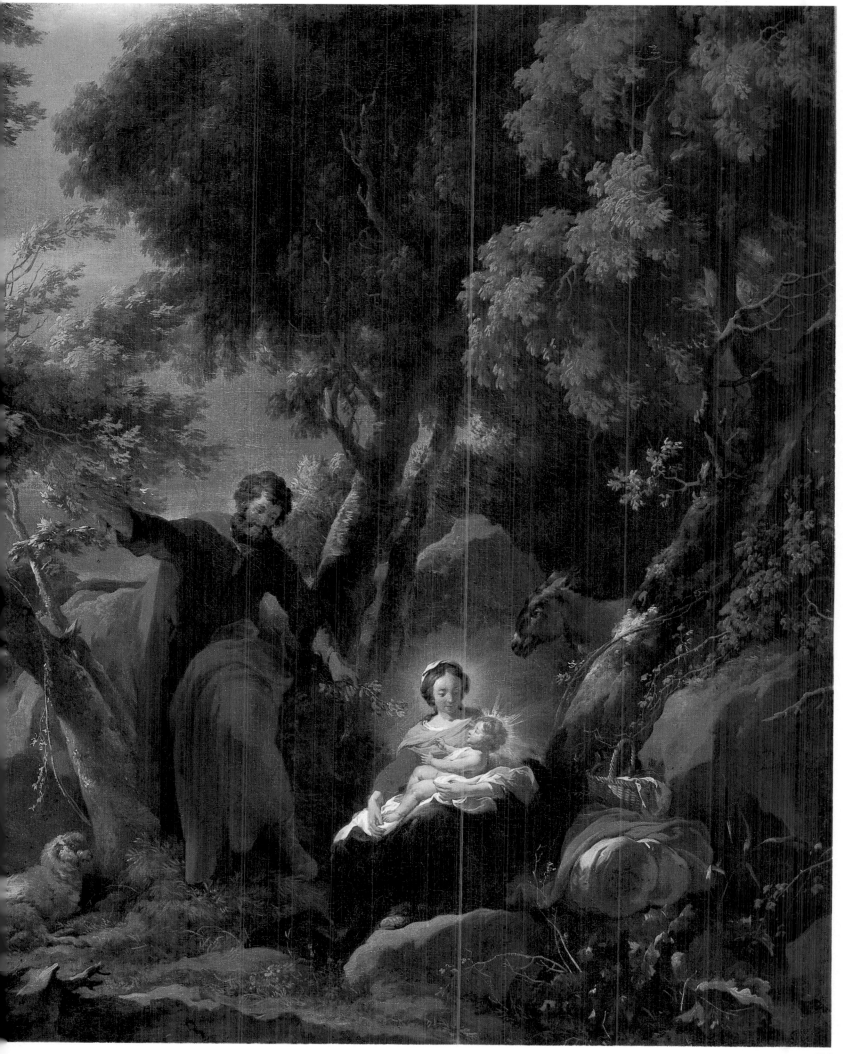

← 220

Rest on the Flight into Egypt

Oil on canvas, 39 ³/₈×55 ¹/₈" (100×140 cm.)
Signed, bottom right: Berch. f
The Pushkin Museum of Fine Arts, Moscow. Inv. No. 646

PROVENANCE		REFERENCES
Until 1781	The Baudouin Collection, Paris	*Catalogues. The Hermitage* 1863–1916, No.
Until 1924	The Hermitage, Petrograd	1071; * *Catalogue. The Pushkin Museum of*
1924	Museum of Fine Arts, Moscow	*Fine Arts* 1961, p. 17.
1937	The Pushkin Museum of Fine Arts, Moscow	

ADAM PYNACKER

Born 1622 in Pynacker (near Delft), died 1673 in Amsterdam.
Spent six years in Italy. Worked and lived in Delft (1649),
Schiedam (1658), then moved to Amsterdam (around 1660).
Was a landscape painter.

221

A Barge on the River at Sunset

Oil on canvas, 17 ¹/₄×14" (43.5×35.5 cm.)
Signed on rock, left: A. Pynacker
The Hermitage, Leningrad. Inv. No. 1093

In the Crozat Collection this canvas was considered a work by
Adriaen van de Velde. A copy or replica figured in the Bernonville sale
(Paris, 1881, No. 429).

PROVENANCE		REFERENCES
Until 1772	The Pierre Crozat collection, Paris	*Catalogues. The Hermitage* 1863–1916, No. 1166; Hofstede de Groot, IX, No. 29; * *Cata-*
1772	The Imperial Hermitage, St. Petersburg	*logue. The Hermitage* 1958, 2, p. 237; * Fechner 1963, pp. 121, 171–172.

222

CORNELIS DECKER

Born before 1625 in Haarlem, died in that city in 1678. Probably studied under Jacob Isaaksz van Ruisdael. Worked in Haarlem. Member of the Haarlem guild (from 1643). Painted landscapes and interiors of peasant houses, primarily weavers' workshops.

222

Landscape with a Peasant House

Oil on panel, 18 ³/₈×25″ (46.5×63.5 cm.)
Signed and dated over door, left: C. Decker 1650
The Hermitage, Leningrad. Inv. No. 944

PROVENANCE

Before 1797 The Imperial Hermitage,
 St. Petersburg

REFERENCES

* Catalogues. The Hermitage 1863–1916, No. 1150; * Catalogue. The Hermitage 1958, 2, p. 192.

MEINDERT HOBBEMA

Born 1638 in Amsterdam, died in that city in 1709. Pupil of
Jacob van Ruisdael (1656–57). Worked in Amsterdam.
Practically gave up painting in 1670. Most of his oeuvre consists
of forest landscapes.

223

The Forest

Oil on panel, 13 3/8×16 1/2" (34×42 cm.)
The Hermitage, Leningrad. Inv. No. 1014

PROVENANCE

Until 1912 The P. Stroganov Collection.
St. Petersburg
1912 The Imperial Hermitage,
St. Petersburg

REFERENCES

* *Catalogues The Hermitage* 1863–1916, No.
1971; * *Catalogue. The Hermitage* 1958, 2, p.
181; * Fechner 1963, pp. 97, 171.

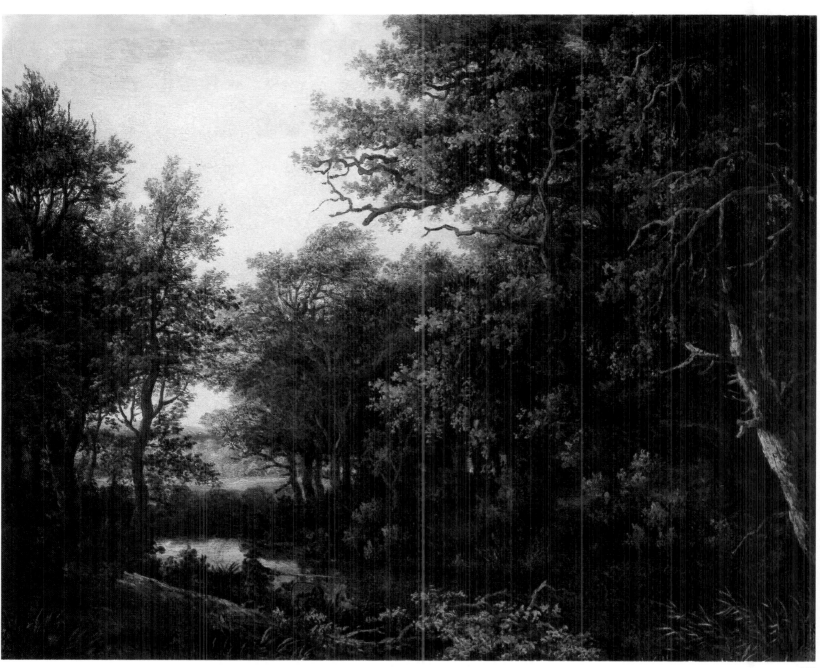

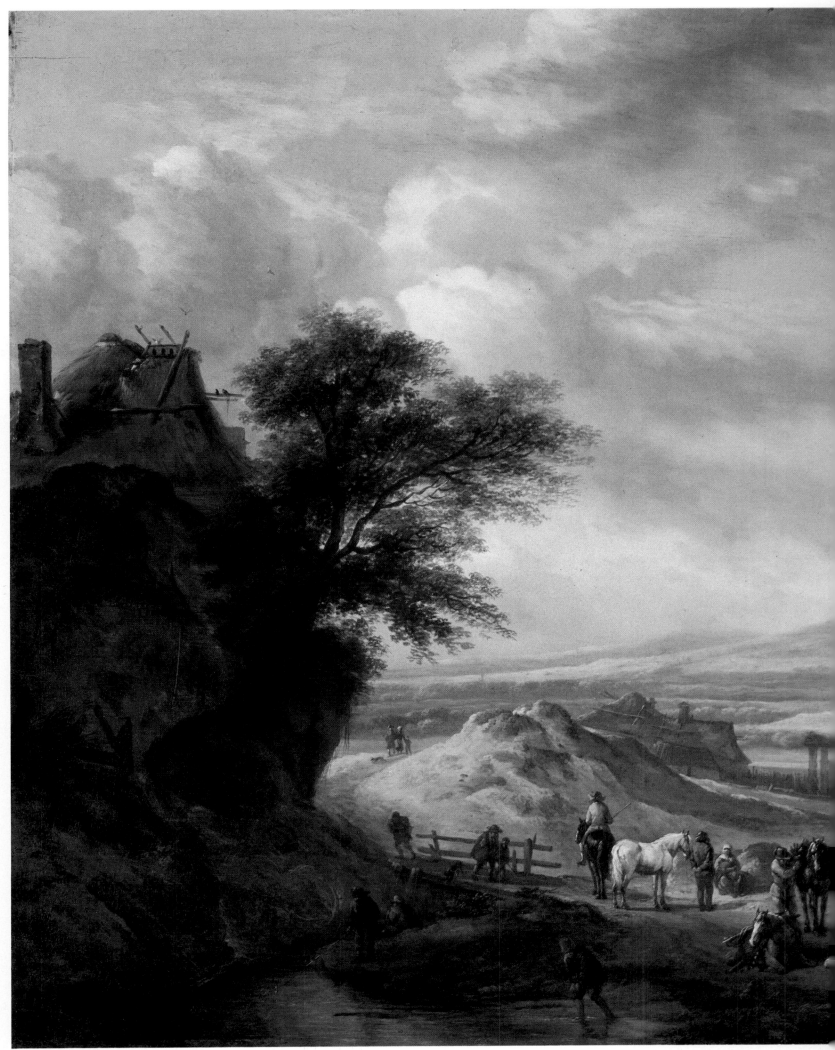

PHILIPS WOUWERMAN

Born 1619 in Haarlem, died in that city in 1668.
Studied under Frans Hals (his uncle) and Pieter
Cornelisz Verbeeck (?), but matured as an artist
mainly under the influence of Pieter van Laer. Lived
for some time in Hamburg where he worked in the
workshop of Evert Decker. Member of the Haarlem
guild (1640). Painted landscapes, marines, scenes of
the hunt and of military life, as well as the staffage in
the pictures of Jacob Isaaksz van Ruisdael
and Cornelis Decker.

224

Landscape with Resting Riders

Oil on panel, 23 ⁵/₈×28 ¹/₄" (60×72 cm.)
Signed with monogram, bottom right: PHLS W
Art Museum, Kuibyshev. Inv. No. 686

PROVENANCE

Until 1752 The Julienne Collection, 1942 Art Museum, Kuibyshev (ac-
Paris quired from Avedova)

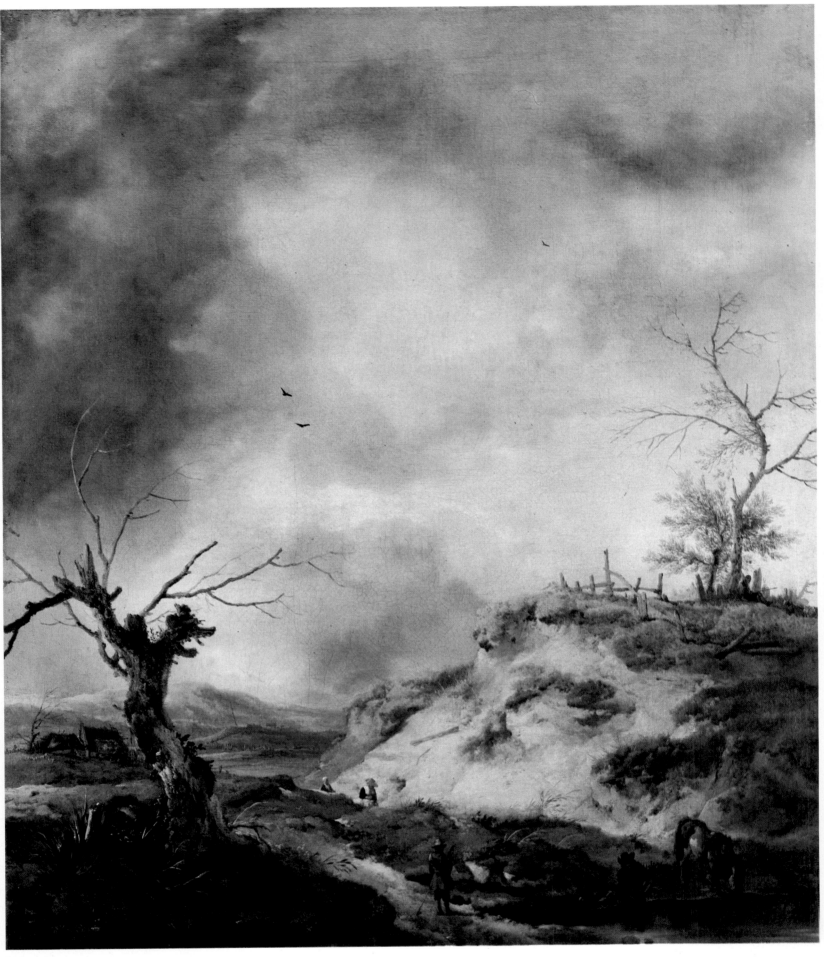

225

225

The Outskirts of Haarlem

Oil on canvas, 30×26 1/4" (76×67 cm.)
Signed with monogram, bottom left corner: PHLS W
The Hermitage, Leningrad. Inv. No. 853

This is a companion picture to *The Outskirts of Haarlem* also in the Hermitage
(inv. No. 854).

PROVENANCE		REFERENCES
Until 1769	The Heinrich Brühl Collection, Dresden	* *Catalogues. The Hermitage* 1863–1916, No. 1017; Hofstede de Groot, II, No. 1083; * *Catalogue. The Hermitage* 1958, 2, p. 165; * Fechner 1963, p. 76, pl. 51.
1769	The Imperial Hermitage, St. Petersburg	

DIRCK VAN DELEN

Born 1605 in Heusden, died 1671 in Arnemuiden. Probably
studied under Hendrick Aertsz. Member of the Middelburg guild
(from 1639). Lived and worked in Arnemuiden, where he was
the burgomaster. Painted architectural views.

226 →

The Palace Entrance

Oil on panel, 22 3/8×25 5/8" (57×65 cm.)
Signed with monogram and dated, bottom: D.v.D.Fc. 1667
The Hermitage, Leningrad. Inv. No. 973

PROVENANCE		REFERENCES
Between 1763 and 1774	The Imperial Hermitage, St. Petersburg	* *Catalogues. The Hermitage* 1863–1916, No. 973; * *Catalogue. The Hermitage* 1958, 2, p. 192.

EMANUEL DE WITTE

Biography: *see under* plate 206.

227 →

The Palace Square in an Italian City

Oil on canvas, 26 1/4×26 1/4" (66.5×66.5 cm.)
Signed and dated on bottom step, right: E. de Witte f. 1664
The Hermitage, Leningrad. Inv. No. 2805

PROVENANCE		REFERENCES
Until 1915	The P. Semionov-Tien-Shansky Collection, Petrograd	*Catalogue Semenov* 1906, No. 600; Semenov. *Etudes* 1906, p. CXXXVII; * *Catalogue. The Hermitage* 1958, 2, p. 162; Ilse Manke, *Emanuel de Witte*, Amsterdam, 1963, No. 45.
1915	The Imperial Hermitage, Petrograd	

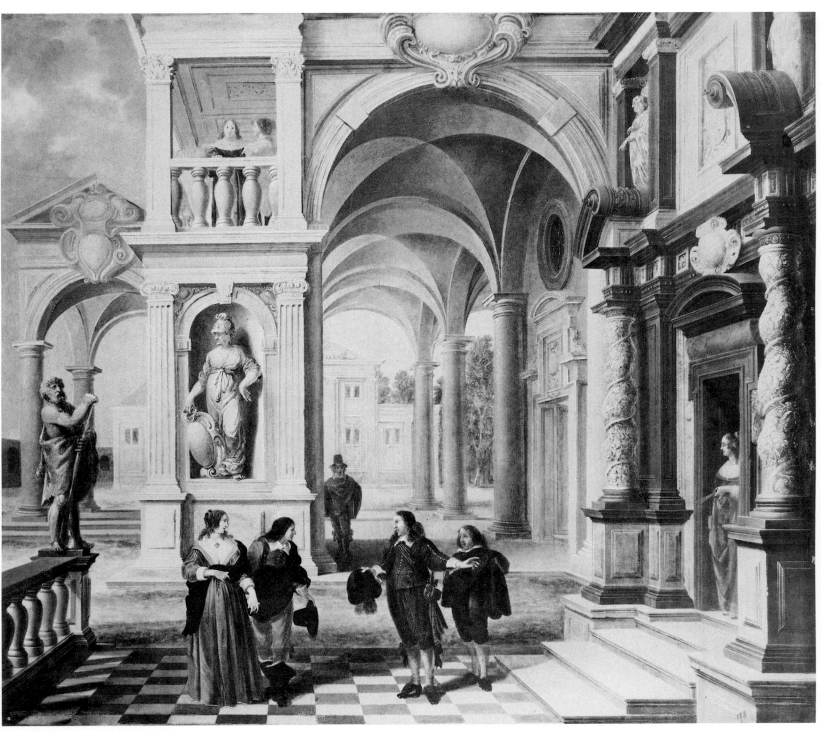

226

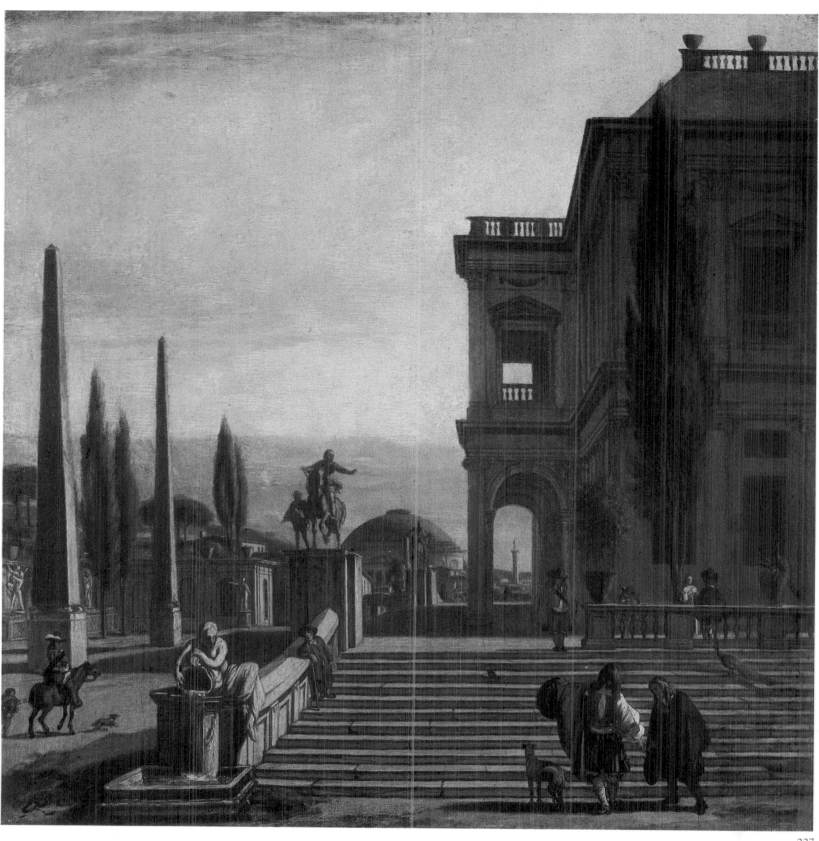

227

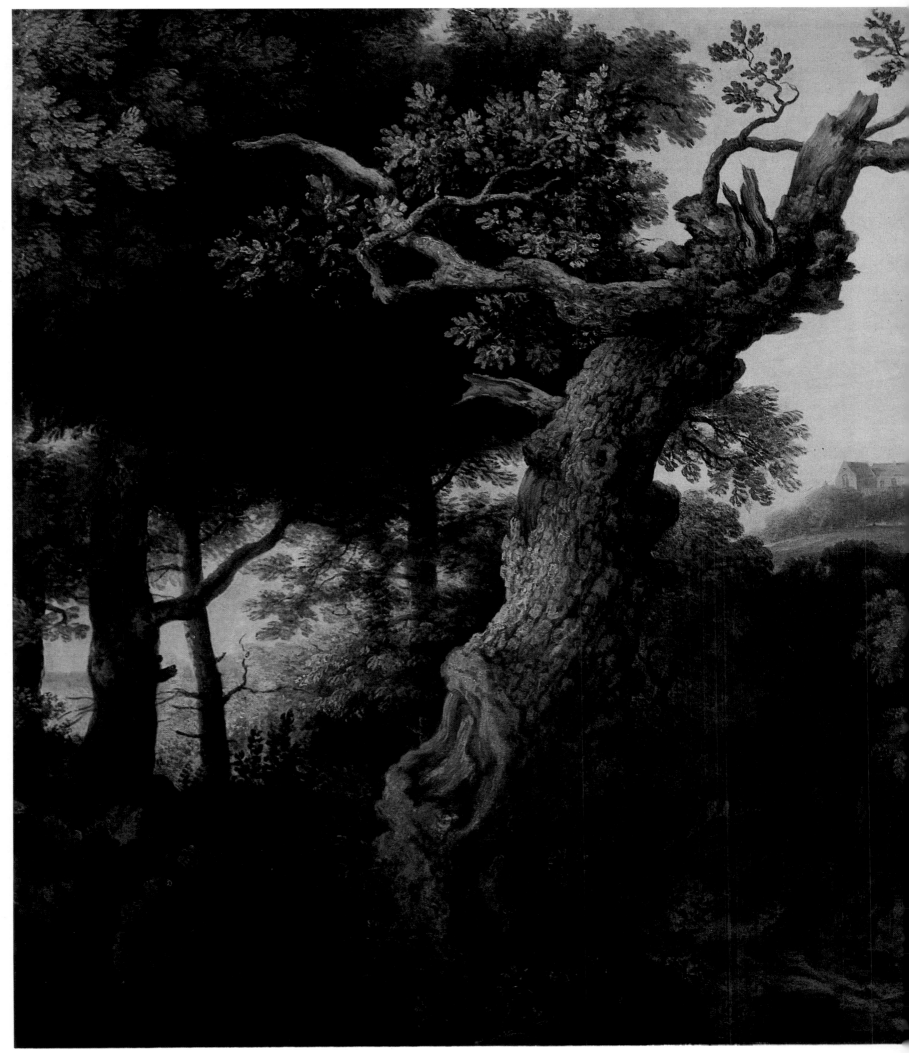

229

ALLAERT PIETERSZ VAN EVERDINGEN

Born 1621 in Alkmaar, died 1675 in Amsterdam. Pupil of Roelant Savery in Utrecht and Pieter Molijn in Haarlem. Traveled to Sweden and, possibly, Norway (early 1640s). Member of the Haarlem guild (from 1645). Worked in Amsterdam (from 1651). Was a landscape painter and etcher.

229

Scandinavian Landscape with a Dead Tree

Oil on canvas, 33 1/4×44 7/8" (84.5×114 cm.)
Art Gallery of Armenia, Yerevan. Inv. No. 290/400

The attribution is due to H. Gerson (verbally). The picture was earlier ascribed to Jan Wijnants.

PROVENANCE

1925 Art Gallery of Armenia, Yerevan (from the State Museum Reserve, Leningrad)

REFERENCES

* *Catalogue. The Hermitage* 1964, p. 10 (as Jan Wijnants); * *Reports of the Hermitage*, 27, 1966, p. 12.

CLAES JANSZ VAN DER WILLIGEN

Born around 1630 in Rotterdam, died there in 1676.
Was a landscape painter.

232

Landscape

Oil on panel, 18 3/8×24 3/8" (46.6×62 cm.)
Signed and dated, bottom left: C. v. Willigen 64
Museum of Western European and Oriental Art, Odessa.
Inv. No. 344

PROVENANCE		REFERENCES
Until 1920	State Museum Reserve, Petrograd	* *Catalogue. Odessa* 1973, p. 26.
1920	The Hermitage, Petrograd	
1956	Museum of Western European and Oriental Art, Odessa	

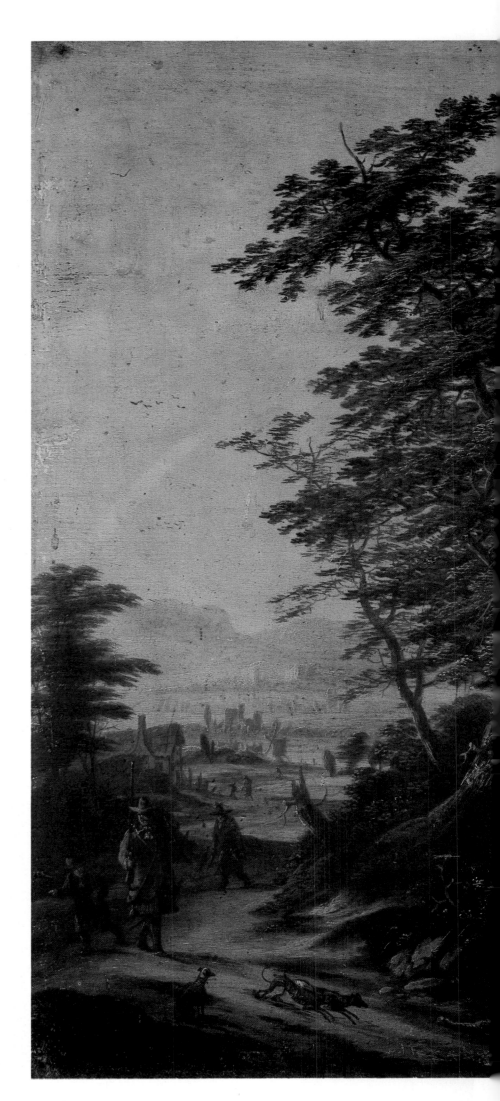

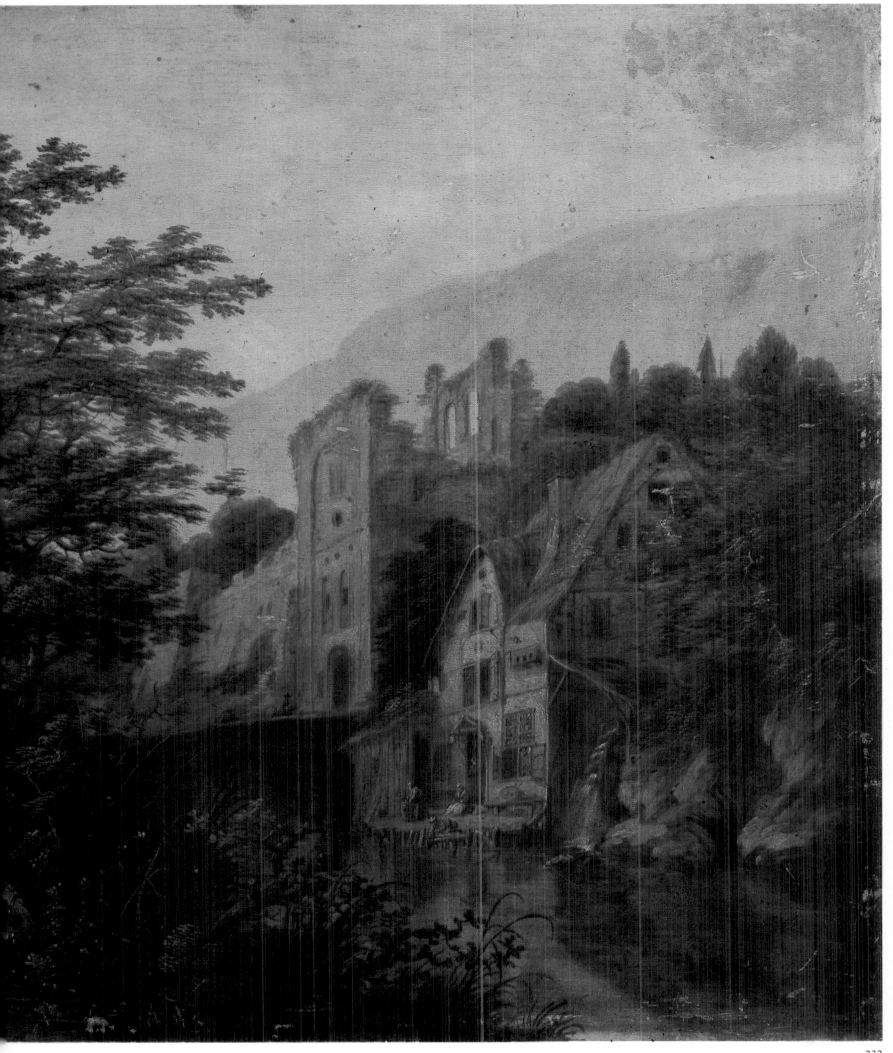

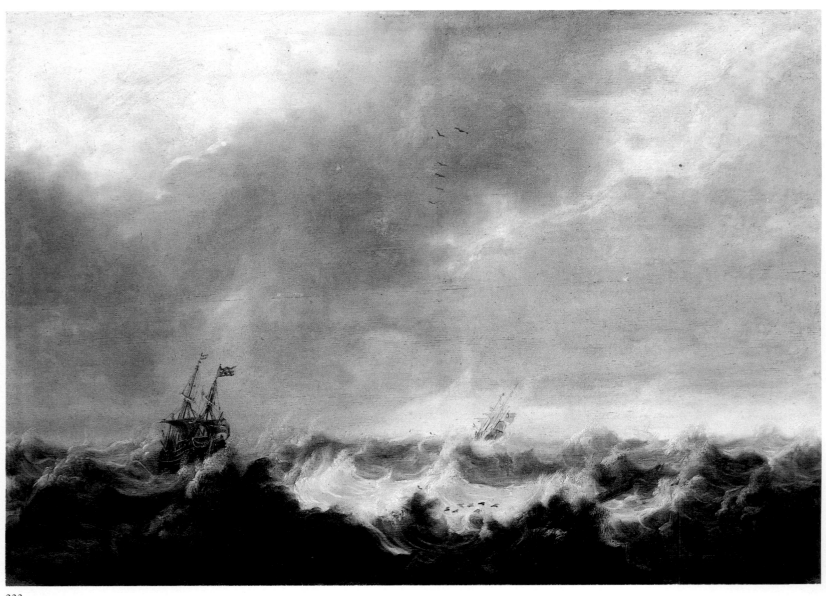

233

PIETER VAN DER CROOS

Born between 1609 and 1611, probably in Alkmaar, died on the
island of Tobago in 1677 or thereabouts. Worked in The Hague
(from 1644), Alkmaar (member of the Alkmaar guild from 1651),
and Amsterdam (from 1661). Painted landscapes and marines.

233

Storm at Sea

Oil on panel, 18 ³/₈×26" (46.5×66 cm.)
Signed on log, right: P. Croos
Art Gallery, Lvov. Inv. No. 56

This is one of the artist's few known works. Because the poorly preserved
signature had been incorrectly read the picture was formerly ascribed to
Jan Porcellis.

Provenance unknown.

REFERENCES

* *Catalogue. Lvov* 1955, p. 98 (as Jan Porcellis).

PHILIPS DE KONINCK

Biography: *see under* plate 85

234

View in Gelderland

Oil on canvas, 51 ⁵/₈×63 ³/₈" (131×161 cm.)
The Pushkin Museum of Fine Arts, Moscow. Inv No. 489

The attribution is made by S. M. Rosenthal. The canvas was earlier
considered a Rembrandt.

PROVENANCE		REFERENCES
Until 1918	The K. Khreptovich-Butenev Collection, Moscow	* Rosenthal 1930, pp. 23–24; H. Gerson, *Philips Koninck*, Berlin, 1936, p. 108; * *Catalogue.*
1918	The Rumiantsev Museum, Moscow	*Rembrandt* 1956, p. 79; * Kuznetsov 1959, No. 33; * *Catalogue. The Pushkin Museum of Fine*
1924	Museum of Fine Arts, Moscow	*Arts* 1961, p. 98; * *Catalogue. The Hermitage*
1937	The Pushkin Museum of Fine Arts, Moscow	1964, p. 23; * Kuznetsov 1967, No. 51.

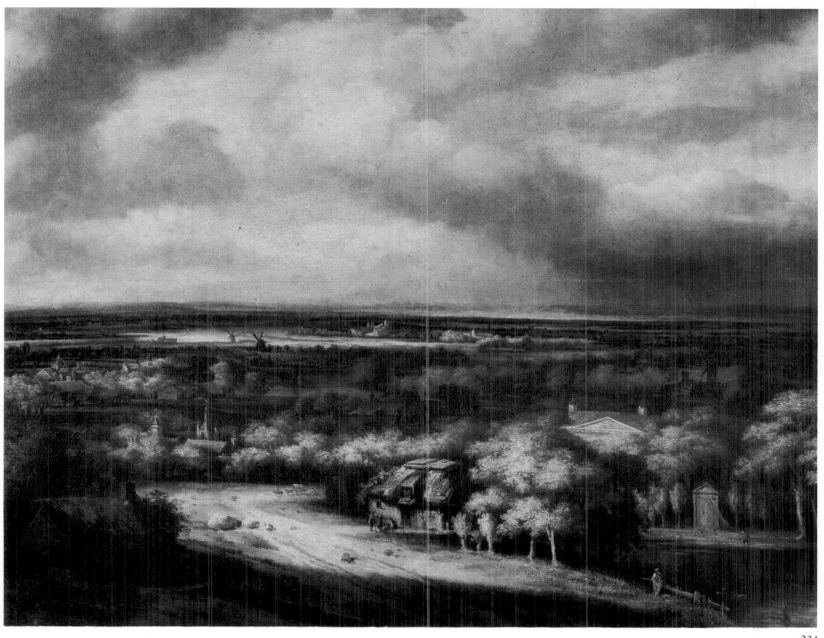

JAN HACKAERT

Born 1629 in Amsterdam, died in that city about 1699.
Was influenced by Jan Both. Worked in Amsterdam. Traveled
in Switzerland and Italy (1653–56). Painted landscapes.
The figures were attributed to Adriaen van de Velde, Johannes
Lingelbach, and Nicolaes Pietersz Berchem.
Was also an engraver.

235

Deer Hunt

Oil on canvas, 47 3/8×39 7/8" (120.5×101.5 cm.)
The Hermitage, Leningrad. Inv. No. 831

PROVENANCE

October 12, 1768 The Fiseau Collection, Amsterdam

February 12, 1770 Auction sale in Amsterdam (sold to Yver for 400 florins)

Until 1832 The Sapega Collection, Grodno

1832 The Imperial Hermitage, St. Petersburg

REFERENCES

* *Catalogues. The Hermitage* 1863–1916, No. 1161; Hofstede de Groot, IX, No. 19; * *Catalogue. The Hermitage* 1958, 2, p. 169; * Fechner 1963, pp. 122, 172.

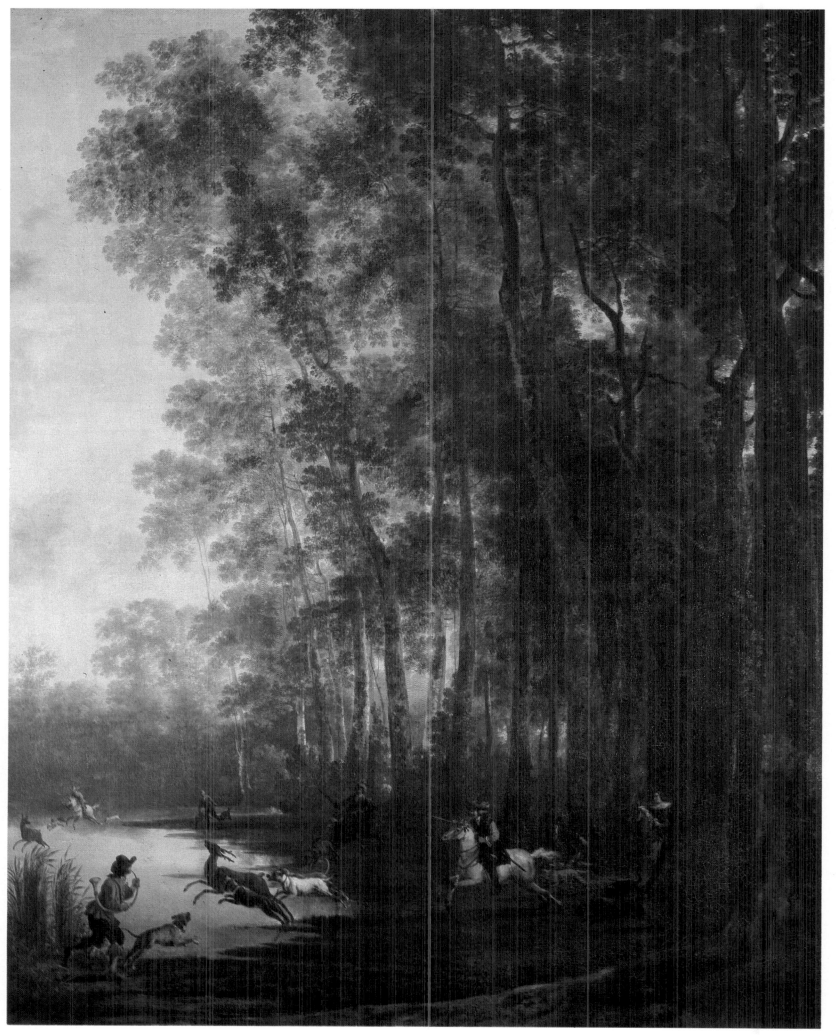

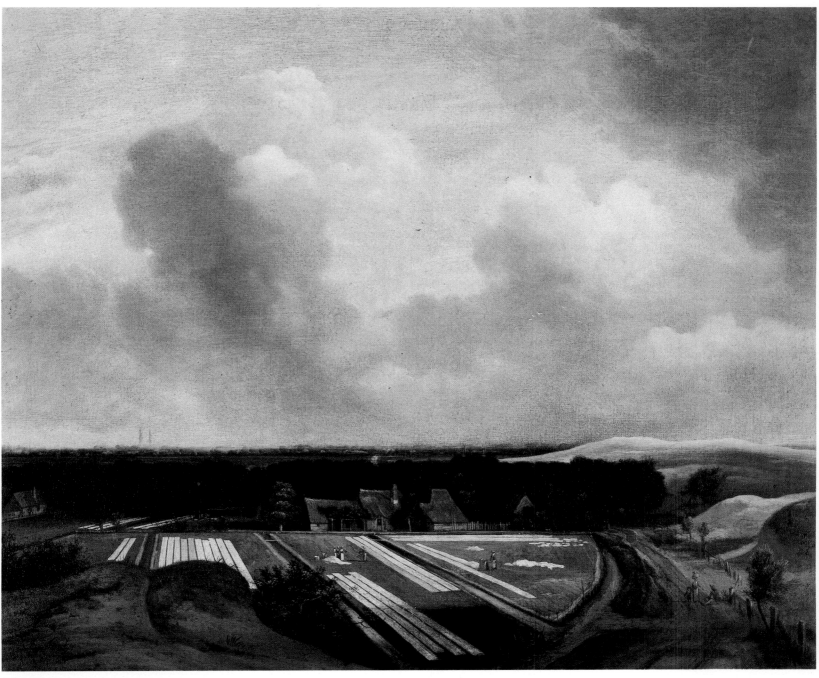

236

JAN VAN KESSEL THE YOUNGER

Born 1641 in Amsterdam, died there in 1680. Is believed to have studied under Jacob van Ruisdael. Was a friend of Meindert Hobbema. Painted landscapes.

236

Bleaching Linen

Oil on canvas, 21 5/8×26 1/4" (55×67 cm.)
Signed, bottom left: J. van Kessel
The Pushkin Museum of Fine Arts, Moscow. Inv. No. 491

PROVENANCE

1915 The K. Khreptovich-Butenev Collection, Moscow
The Rumiantsev Museum, Moscow
1924 Museum of Fine Arts, Moscow
1937 The Pushkin Museum of Fine Arts, Moscow

REFERENCES

* *Catalogue. Private Collections* 1915, No. 156;
* Shchavinsky 1915, p. 113; * *Catalogue. The Pushkin Museum of Fine Arts* 1961, p. 96.

SALOMON ROMBOUTS

Born about 1650, died before 1702. Pupil of Gillis Rombouts
(his father). Worked in Haarlem. Lived in Italy about ten years
(in 1690 in Florence). Painted landscapes.

237

Landscape with a Hut

Oil on panel, 22 5/8×30 1/2" (57.7×77.8 cm.)
Art Gallery, Lvov. Inv. No. 84

Provenance unknown.

REFERENCES
* *Catalogue. Lvov* 1955, p. 98.

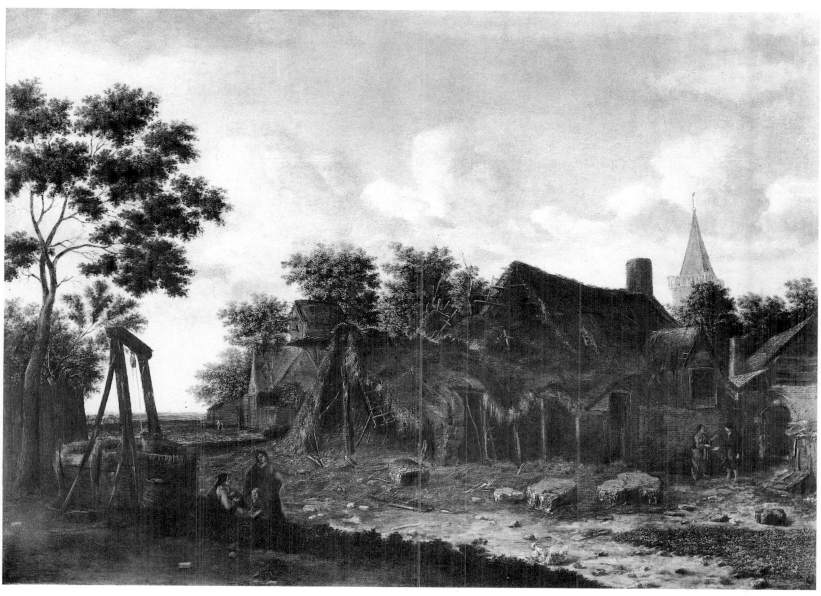

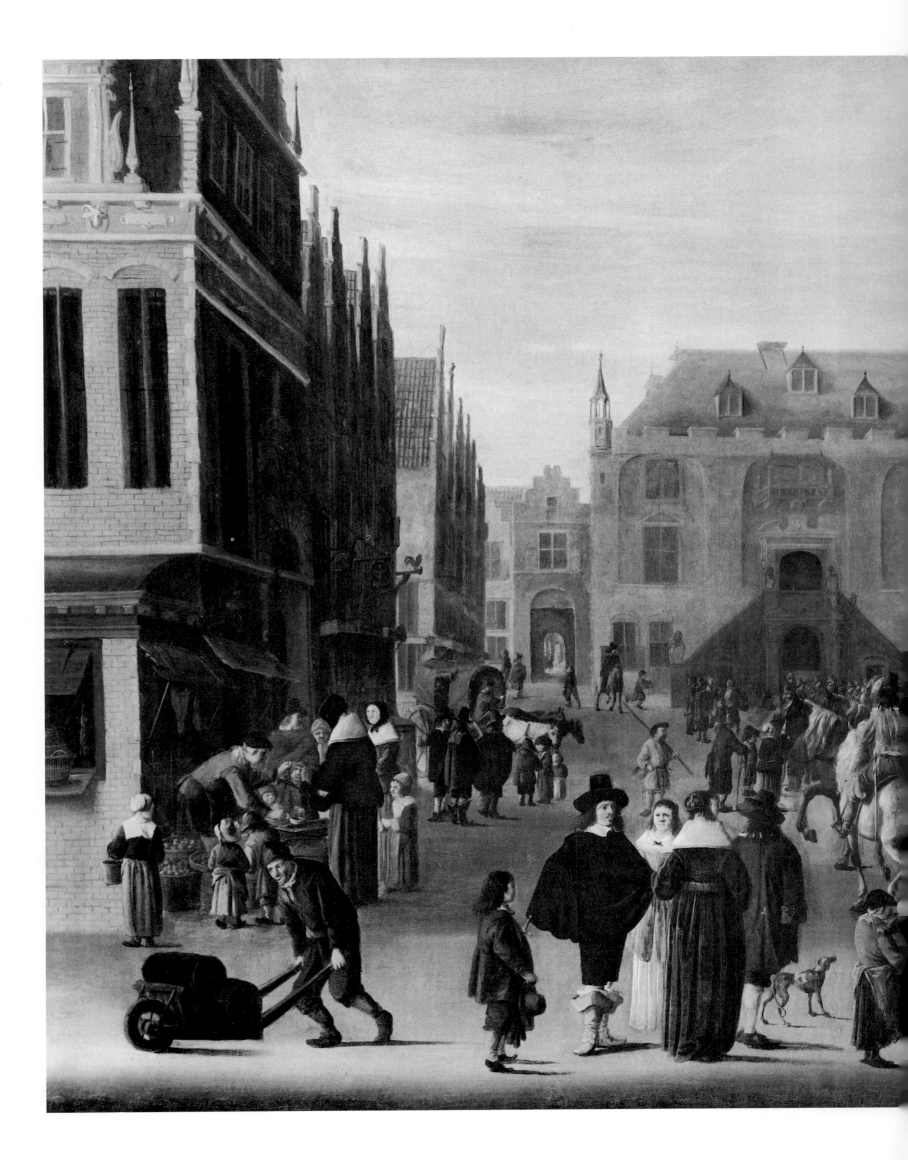

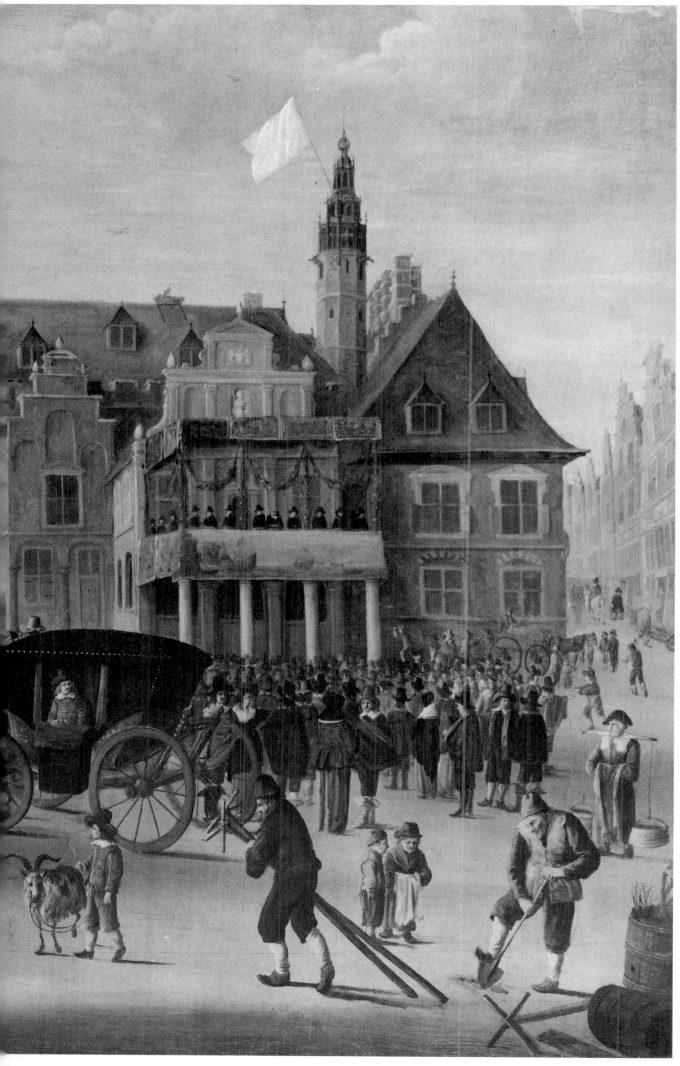

238

CORNELIS BEELT

Born about 1660. Worked in Haarlem. Died before 1702.
Painted townscapes, markets, artisans' workshops.

← 238

Announcing the Treaty of Breda
in the Grote Markt, Haarlem

Oil on canvas, 39 3/4×58 5/8" (101×149 cm.)
The Hermitage, Leningrad. Inv. No. 2515

The Treaty of Breda of July 31, 1667, closed the second Anglo-Dutch war.
A variant of the canvas is in the Rijksmuseum in Amsterdam. There is a
picture in the Max Michaelis Collection in Capetown which is ascribed to
Salomon Rombouts and which depicts the same event. Its composition is
analogous to that of the Hermitage canvas.

PROVENANCE		REFERENCES
Late 18th century	The Imperial Hermitage, St. Petersburg	* *Catalogue. The Hermitage* 1958, 2, p. 135.
Until 1926	Palace Museum, Gatchina	
1926	The Hermitage, Leningrad	

JOHANNES LINGELBACH

Born 1622 in Frankfurt on the Main, died 1674 in Amsterdam.
Worked in Amsterdam. Visited France and Italy.
Painted genre scenes.

239

Reapers at Rest

Oil on canvas, 17 3/4×21 5/8" (45×55 cm.)
Signed over fence, left: J. Lingelbach
The Radishchev Art Museum, Saratov. Inv. No. 967

PROVENANCE		REFERENCES
1968	The Radishchev Art Museum, Saratov (through the State Purchasing Commission)	* *Catalogue. Saratov* 1969, p. 9.

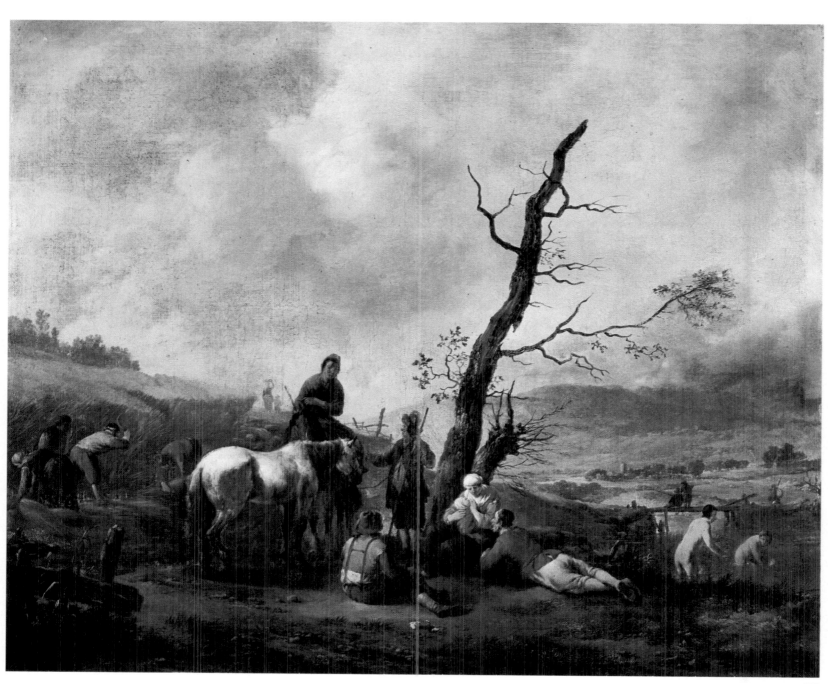

239

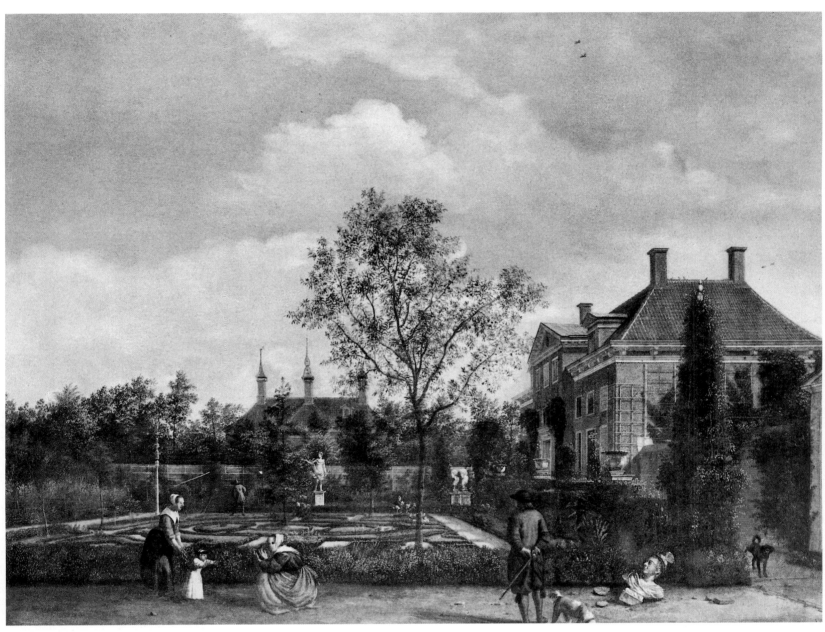

240

JAN VAN DER HEYDEN

Born 1637 in Gorkum, died 1712 in Amsterdam. Traveled in
Germany and the Southern Netherlands. Lived in Amsterdam
(from 1650). Painted townscapes and still lifes.
Was also an engraver.

240

The Vechtvliet Country House

Oil on panel, 18 1/8×23 1/4" (46×59 cm.)
Signed, bottom left: V. Heyden
The Pushkin Museum of Fine Arts, Moscow. Inv. No. 300

Vechtvliet, one of the most beautiful structures on the banks of the river
Vecht between Utrecht and Amsterdam, was often portrayed by Dutch
artists. In the Hermitage piece it is presented as viewed from the garden.

PROVENANCE

1912 The Rumiantsev Museum, Moscow
1924 Museum of Fine Arts, Moscow
1937 The Pushkin Museum of Fine Arts,
 Moscow

REFERENCES

*Catalogue. The Public and Rumiantsev Mu-
seums* 1912, p. 109, No. 1; Hofstede de Groot,
VIII, No. 260; * Kuznetsov 1959, No. 88; * *Cat-
alogue. The Pushkin Museum of Fine Arts* 1961,
p. 51; Wagner 1971, No. 148.

242

Falconry

Oil on canvas, 21 1/4×24 3/4" (54×63 cm.)
Signed, bottom right: Gerrit Berck Heyde
The Pushkin Museum of Fine Arts, Moscow. Inv. No. 305

PROVENANCE		REFERENCES
Until 1924	The Rumiantsev Museum, Moscow	*Catalogue. The Public and Rumiantsev Museums* 1912, p. 111, No. 15; * *Catalogue. The Pushkin Museum of Fine Arts* 1961, p. 16.
1924	Museum of Modern Western Art, Moscow	
1937	The Pushkin Museum of Fine Arts, Moscow	

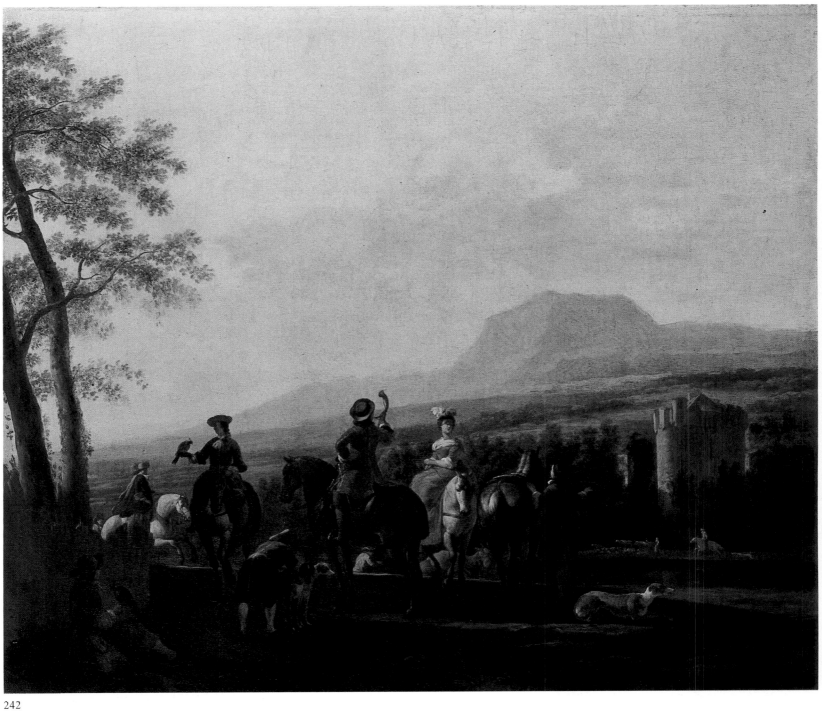

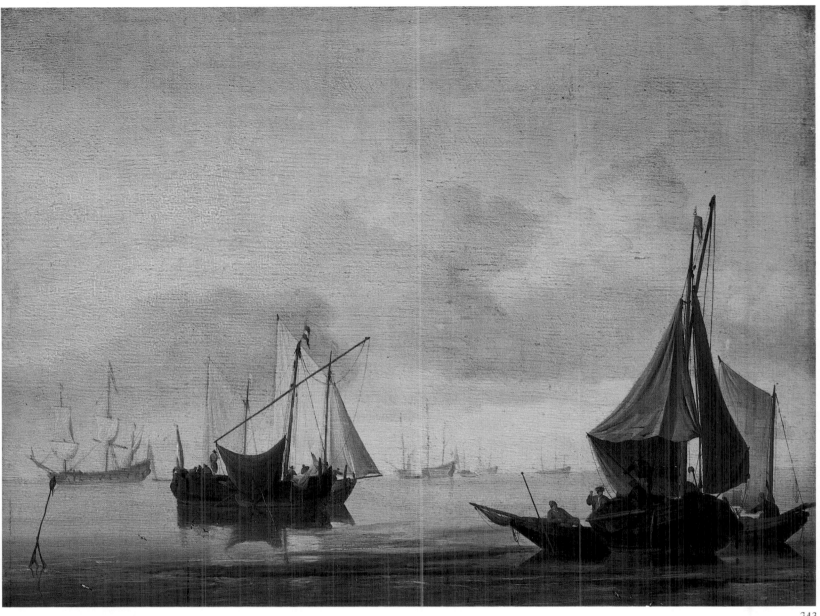

243

WILLEM VAN DE VELDE THE YOUNGER

Born 1633 in Leyden, died 1707 in London. Pupil of Willem van
de Velde the Elder (his father) and Simon de Vlieger. Worked
in Amsterdam, then moved with his father to London (1673)
where he fulfilled commissions for the royal court.
Was a marine painter.

243

Tranquil Sea with Fishing Boats

Oil on panel, 9 3/8×12 7/8" (24.2×32.5 cm.)
Signed with monogram, bottom right corner: WvV
The Hermitage, Leningrad. Inv. No. 1020

<table>
<tr><td colspan="2">PROVENANCE</td><td>REFERENCES</td></tr>
<tr><td>Until April 19,
1772</td><td>Duc de Choiseul Collection,
Paris</td><td>* Catalogues. The Hermitage 1863–1916, No.
1186; Hofstede de Groot, VII, No. 222; * Cata-</td></tr>
<tr><td>Until 1781</td><td>The Baudouin Collection,
Paris</td><td>logue. The Hermitage 1958, 2, p. 150; * Fechner
1963. p. 146.</td></tr>
<tr><td>1781</td><td>The Imperial Hermitage,
St. Petersburg</td><td></td></tr>
</table>

LUDOLF BACKHUYZEN

Born 1631 in Emden, died 1708 in Amsterdam. Pupil
of Allaert van Everdingen and Hendrick Jacobsz
Dubbels. Besides seascapes he painted some portraits.
Was also an engraver and calligrapher.

244

Shipwreck on the Rocks

Oil on canvas, 20 5/8×26 3/4" (52.5×68 cm.)
The Hermitage, Leningrad. Inv. No. 1038

PROVENANCE		REFERENCES
Until 1764	The Johann Ernest Gotz-kowsky Collection, Berlin	*Catalogues. The Hermitage* 1863–1916, No. 118; Hofstede de Groot, VII, No.
1764	The Imperial Hermitage, St. Petersburg	259; *Catalogue. The Hermitage* 1958, 2, p. 130; *Fechner 1963, pp. 146, 173.

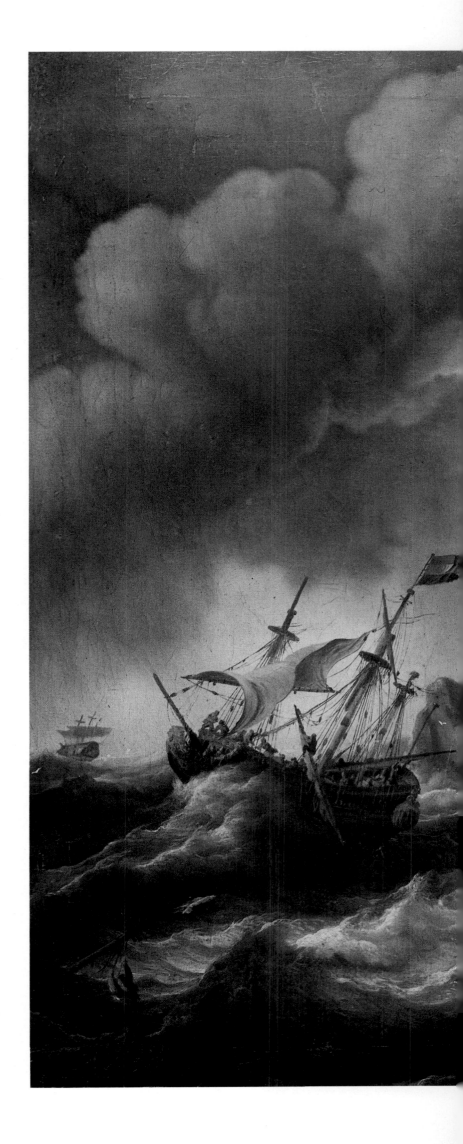

245

MATTHIAS WITHOOS

Born 1621 or 1627 in Amersfoort, died 1703 in Hoorn. Pupil of
Jacob van Campen. Spent some time in Italy, working in Rome.
After the capture of Amersfoort by French troops, he moved to
Hoorn (1672). Painted landscapes, still lifes, and portraits.

245

The Park

Oil on canvas, 31 3/4×31 3/4" (81×81 cm.)
Signed on pedestal, top right: M. Withoos
The Hermitage Pavilion, Petrodvorets. Inv. No. 1622

PROVENANCE		REFERENCES
Until 1809	The Imperial Hermitage, St. Petersburg	* Znamenov, Tenikhina 1973, p. 53, No. 22.
1809	The Hermitage Pavilion, Peterhof (now Petrodvorets)	

BALTHASAR VAN DER AST

Born 1593/94 in Middelburg, died 1657 in Delft. Probably
studied under Ambrosius Bosschaert the Elder (his father-in-law).
Worked in Utrecht. Member of the Utrecht guild (from 1619)
and Delft guild (from 1632). Painted still lifes.

246, 247 →

Still Life with Fruit

Oil on panel, 29 1/2×40 7/8" (75×104 cm.)
Signed on edge of tabletop, left: B. van der Ast
The Hermitage, Leningrad. Inv. No. 8472

PROVENANCE		REFERENCES
1937	The Hermitage, Leningrad	* Catalogue. The Hermitage 1958, 2, p. 129.

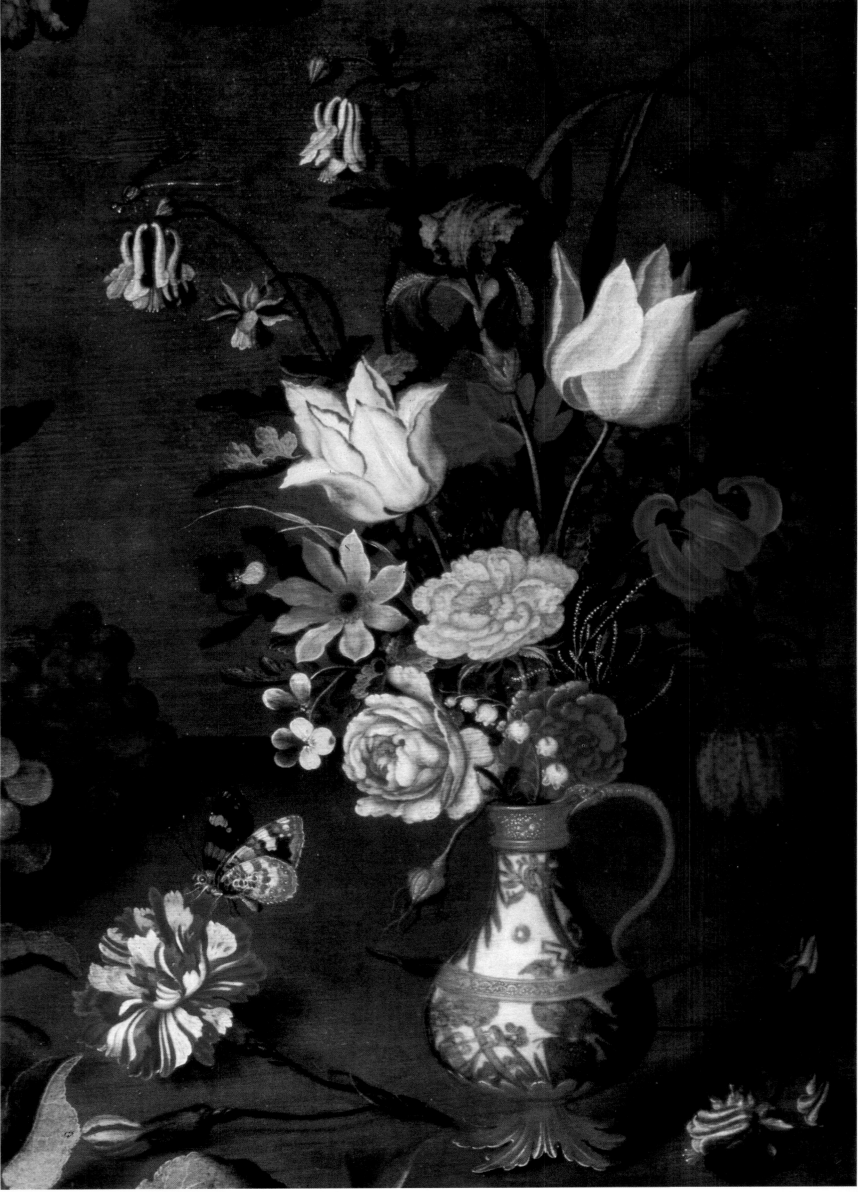

FERDINAND BOL

Biography: *see under* plate 58.

248 →

Dead Game

Oil on canvas, 39×32 5/8" (99×83 cm.)
At bottom right, under the false signature, Rembrandt f. 1645, is the
authentic signature: F. Bol fecit 1646
The Hermitage, Leningrad. Inv. No. 1445

PROVENANCE		REFERENCES
Until 1772	The Pierre Crozat Collection, Paris	* Shcherbachova 1945, p. 60, No. 13; * *Catalogue. Rembrandt* 1956, p. 69; *Catalogue. The Hermitage* 1958, 2, p. 141; * Kuznetsov 1966, No. 37; * *Catalogue. Rembranat* 1969, No. 34.
1772	The Imperial Hermitage, St. Petersburg; transferred to the Gatchina Palace	
Until 1920	Palace, Gatchina	
1920	The Hermitage, Petrograd	

MATHEUS BLOEM

Active in Amsterdam between 1642 and 1659. Painted still lifes
with trophies of the hunt, also depicted poultry yards.

249 →

Trophies of the Hunt

Oil on canvas, 86 5/8×74 1/4" (219.5×188.5 cm.)
The Hermitage, Leningrad. Inv. No. 1110

PROVENANCE		REFERENCES
Before 1797	The Imperial Hermitage, St. Petersburg	* *Catalogues. The Hermitage* 1863–1916, No. 1336; * Shcherbachova 1945, p. 59, No. 12; * *Catalogue. The Hermitage* 1958, 2, p. 138.

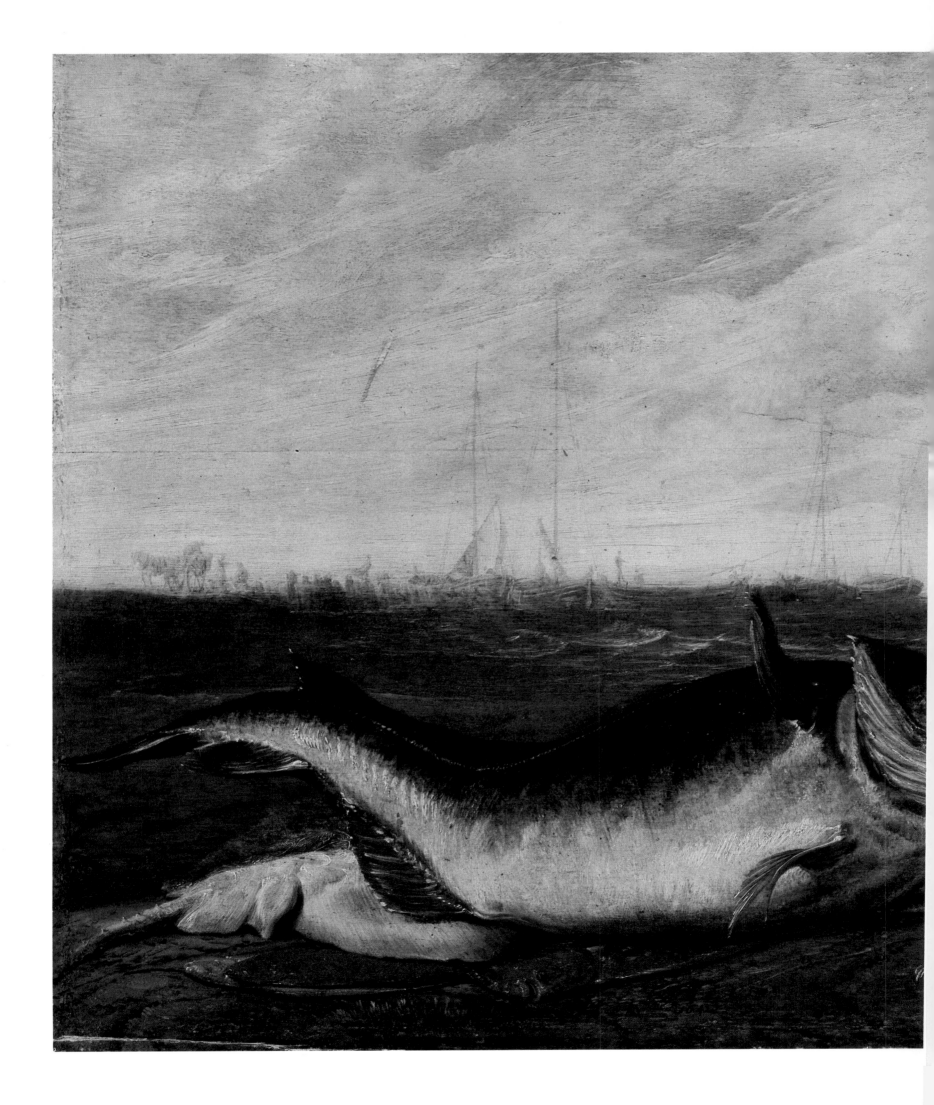

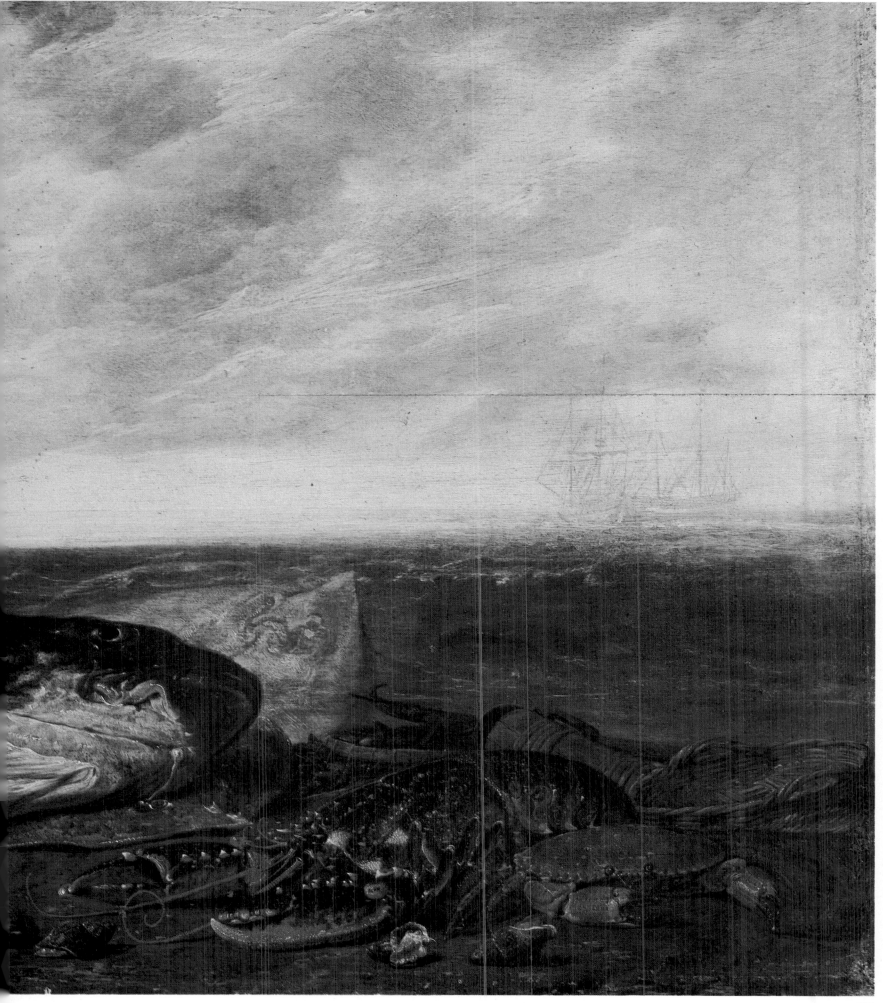

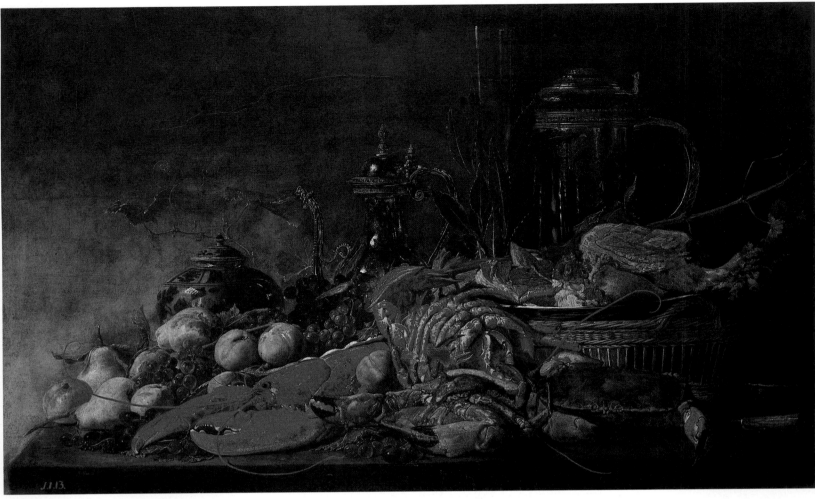

252

Fruit and Lobster on a Table

Oil on panel, 27 1/2×46 3/8" (70×118 cm.)
Signed with monogram and dated on edge of tabletop, left: FRHLS 1640
The Hermitage, Leningrad. Inv. No. 3775

Because the monogram was previously incorrectly deciphered, this picture,
like others similarly signed, was considered a work by Frans Hals the
Younger. The mistake was corrected by A. Bredius in 1917.

PROVENANCE		REFERENCES
Until 1915	The P. Semionov-Tien-Shansky Collection, Petrograd	* Semionov 1885–90. p. 271; Semenov, *Etudes* 1906, p. XLV; *Catalogue Semenov* 1906, No. 190; A. Bredius, "De schilder François Ryck-hals," *Oud-Holland*, 1917, pp. 1–11; * Fechner. *Ryckhals* 1961, pp. 237–238; Kuznetsov 1966, No. 32.
1915	The Imperial Hermitage, Petro-grad	

PIETER CLAESZ

Born 1596 or 1597 in Burgsteinfurt, died 1661 in Haarlem.
Worked in Haarlem. Painted still lifes.

253

Still Life

Oil on panel, 15 ³/₄×21 ¹/₄″ (40×54 cm.)
Signed with monogram on blade of knife: PC
Museum of Fine Arts, Voronezh. Inv. No. 461

PROVENANCE

Until 1933 University, Voronezh
1933 Museum of Fine Arts, Voronezh

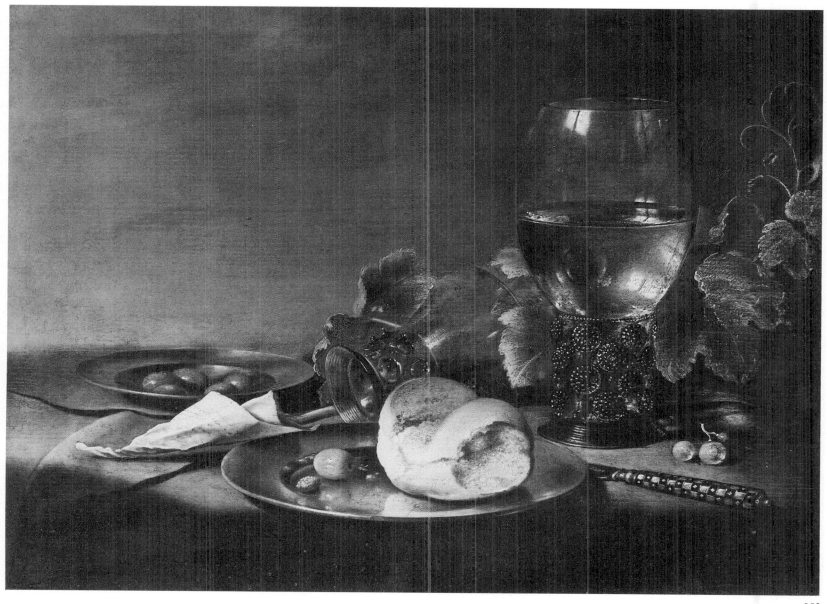

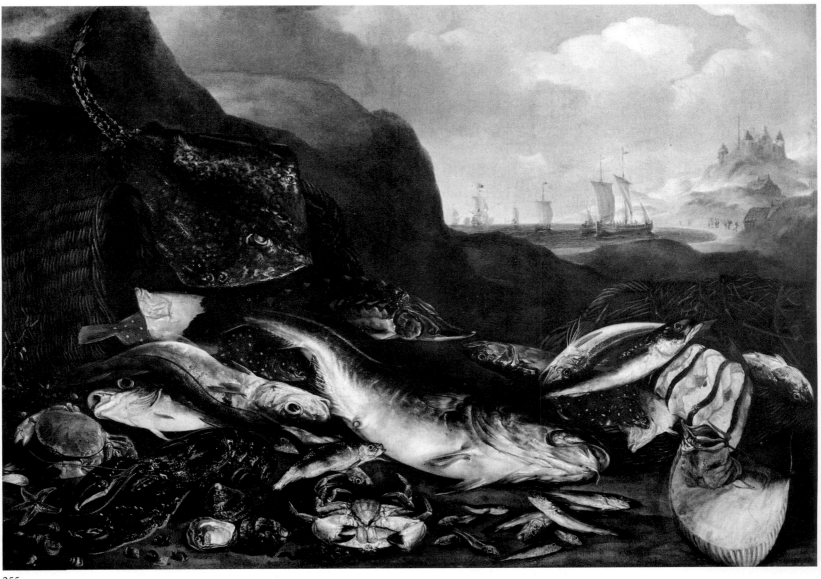

255

ABRAHAM VAN BEYEREN

Born 1621 in The Hague, died 1690 in Overschie. Probably
studied under Pieter de Putter. Member of The Hague guild
(from 1640). Worked in Delft (from 1657), The Hague
(1663–68), Amsterdam (1669–74), Alkmaar (1674–78), and
Overschie (from 1678). Painted fish, breakfasts, flowers,
and occasionally seascapes.

255, 256

Fish on the Seashore

Oil on canvas, 46 7/8×65 5/8" (119×167 cm.)
Signed, bottom left corner: A. Beveren
The Hermitage, Leningrad. Inv. No. 5201

PROVENANCE		REFERENCES
Until 1920	State Museum Reserve, Petrograd	* Shcherbachova 1945, pp. 42–43, No. 9; * *Catalogue. The Hermitage* 1958, 2, p. 134; * Kuznetsov 1959, No. 57.
1920	The Hermitage, Petrograd	

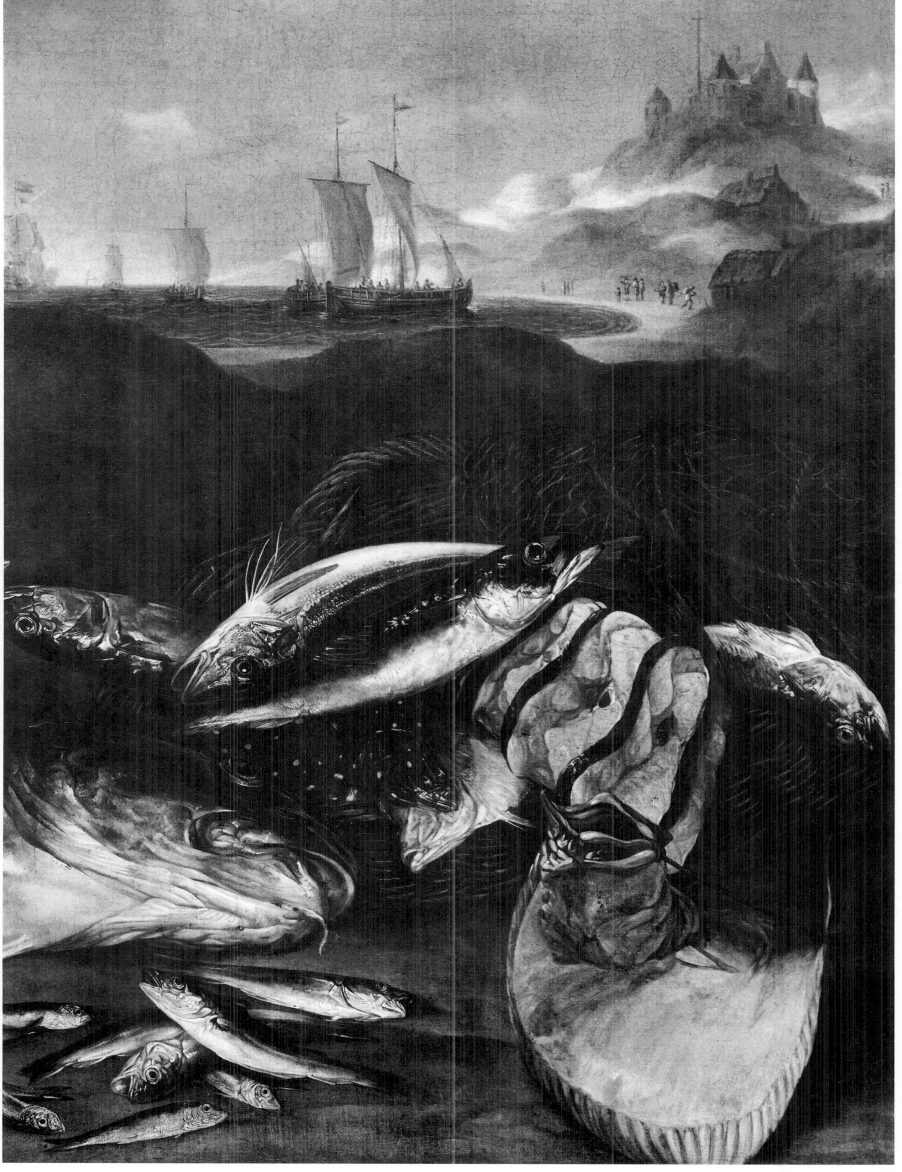

257

Still Life with Watch

Oil on panel, 17×21 5/8" (43×55 cm.)
Signed with monogram on edge of tabletop, left: ABf
The Hermitage, Leningrad. Inv. No. 980

PROVENANCE

Before 1859 The Imperial Hermitage,
St. Petersburg

REFERENCES

* Shcherbachova 1945, pp. 43–44, No.
6; * *Catalogue. The Hermitage* 1958, 2,
p. 134; * Kuznetsov 1966, No. 43.

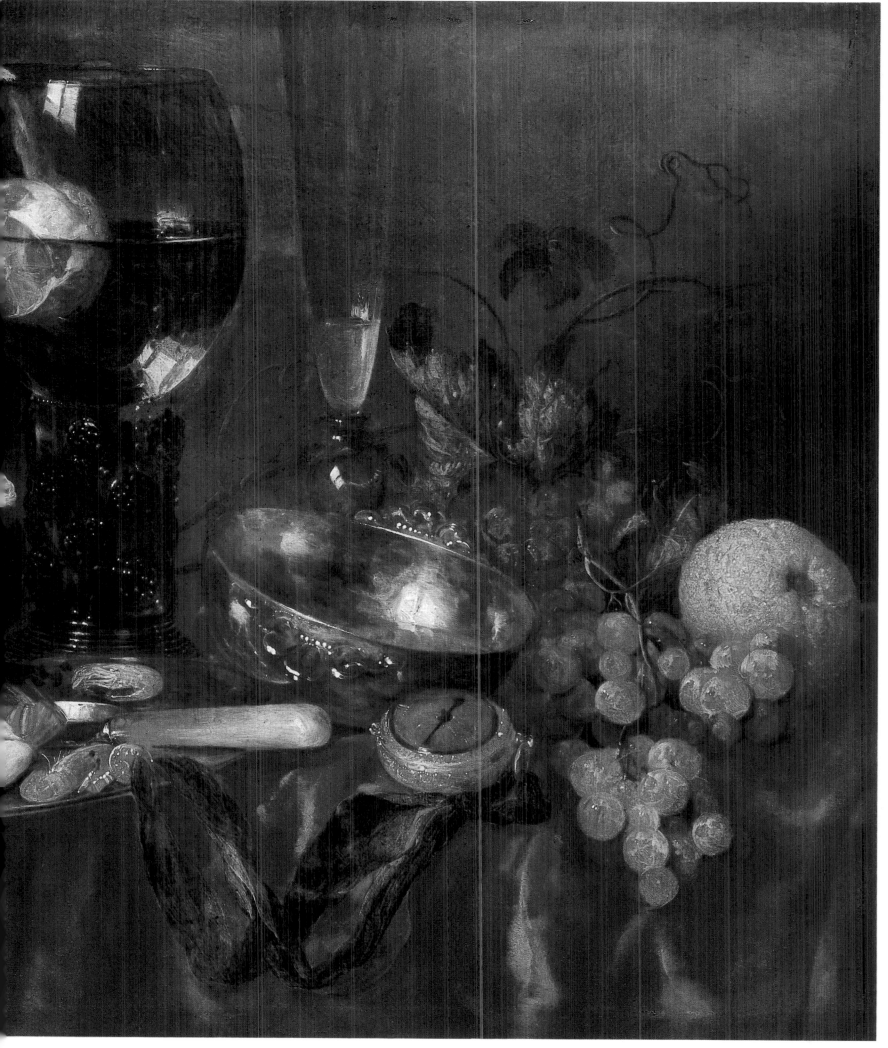

PHILIPS ANGEL

Born 1616 in Middelburg, died in that city after 1683. Worked
in Haarlem. Member of the Haarlem guild (from 1639) and
Middelburg guild. Painted still lifes and interiors.

259

Kitchen

Oil on panel, 10×16 ¹/₂" (25.5×42 cm.)
Signed and dated on cowl of stove, right: P.An. 1659
The Hermitage, Leningrad. Inv. No. 825

PROVENANCE

Late 18th century The Imperial Hermitage,
Petersburg

REFERENCES

* *Catalogues. The Hermitage* 1863–1916, No.
979; L. J. Bol, "Philips Angel van Middelburg
en Philips Angel van Leyden," *Oud-Holland*,
1949, p. 14, No. 3; * *Catalogue. The Hermitage*
1958, 2, pp. 127–128.

260

FLORIS GERRITSZ VAN SCHOOTEN

Born about 1590, died after 1655. Was a follower of Pieter
Aertsen and Joachim Beuckelaer. Worked in Haarlem. Painted
still lifes, sometimes with human figures.

260

Still Life

Oil on panel, 17 3/4×33" (45×84 cm.)
Signed with monogram on edge of tabletop: F.v.S.
Picture Gallery, Kalinin. Inv. No. 371

Provenance unknown.

261

PIETER VAN DEN BOS

Born 1613 in Amsterdam, died in that city (?) after 1660.
Probably studied under Gerrit Dou in Leyden.
Painted genre scenes and still lifes.

261

Kitchenware

Oil on panel, 9 3/8×9″ (24×23 cm.)
Palace Museum, Pavlovsk. Inv. No. 876

The attribution of the picture was made by Irene Linnik on the basis of
its comparison with the works of Pieter van den Bos housed in the National
Gallery, London (cat. No. 2551), and in the former Kaiser-Friedrich Museum,
Berlin (cat. 1931, No. 1011). The composition betrays the strong influence of
Gerrit Dou's art.

PROVENANCE		REFERENCES
Until 1920	The Yusupov Collection, St. Petersburg/Petrograd	* *Catalogue. The Yusupov Gallery* 1920, No. 321; * Kuznetsov 1966, No. 38; * Linnik 1974, pp. 10–11.
1920	The Hermitage, Petrograd	
1933	Palace Museum, Pavlovsk	

→

WILLEM KALF

Born 1619 in Rotterdam, died 1693 in Amsterdam. Pupil of
Hendrick Gerritsz Pot. Lived and worked in Paris (1640–45),
Hoorn (from 1651), and Amsterdam. Was influenced by his
predecessors Frans Ryckhals and Jan Jansz Treck, but the
decisive role in the evolution of his artistic perception was
played by Rembrandt. Painted still lifes and kitchen interiors.

262

262

Kitchen Nook

Oil on copper, 6 ³/₄×5 ³/₈" (17×13.5 cm.)
The Hermitage, Leningrad. Inv. No. 945

Painted between 1640 and 1645. Companion picture to *Peasant Yard*
(*see* plate 263).

PROVENANCE

Until 1772 The Pierre Crozat Collection,
 Paris
1772 The Imperial Hermitage,
 St. Petersburg

REFERENCES

* *Catalogues. The Hermitage* 1863–1916, No.
1371; * Shcherbachova 1945, p. 53, No. 23;
* *Catalogue. The Hermitage* 1958, 2, p. 198.

263

263

Peasant Yard

Oil on copper, 6 ³/₄×5 ³/₈″ (17×13.5 cm.)
Signed on threshold: Kalf
The Hermitage, Leningrad. Inv. No. 946

Painted between 1640 and 1645. Companion picture to *Kitchen Nook*
(*see* plate 262).

PROVENANCE

Until 1772 The Pierre Crozat Collection,
Paris
1772 The Imperial Hermitage,
St. Petersburg

REFERENCES

* *Catalogues. The Hermitage* 1863–1916, No.
1370; * Shcherbachova 1945, p. 53, No. 22;
* *Catalogue. The Hermitage* 1958, 2, p. 198;
* Kuznetsov 1966, No. 40.

JAN DAVIDSZ DE HEEM

Born 1606 in Utrecht, died 1683 or 1684 in Antwerp. Pupil of
David de Heem (his father), Balthasar van der Ast, and David
Bailly in Leyden. Worked in Leyden (1626–32), Utrecht
(1632–35; 1667–72), and Antwerp (1636–67 and after 1672).
Painted still lifes.

265

Fruit and a Vase of Flowers

Oil on canvas, 37 ³/₈×49″ (95×124.5 cm.)
Signed and dated, bottom left corner: J.D.d. Heem f. A° 1665
The Hermitage, Leningrad. Inv. No. 1107

PROVENANCE	REFERENCES
Before 1797 The Imperial Hermitage, St. Petersburg	* *Catalogues. The Hermitage* 1863–1916, No. 1353; * Shcherbachova 1945, p. 37, No. 46; * *Catalogue. The Hermitage* 1958, 2, p. 179; * Kuznetsov 1966, No. 33.

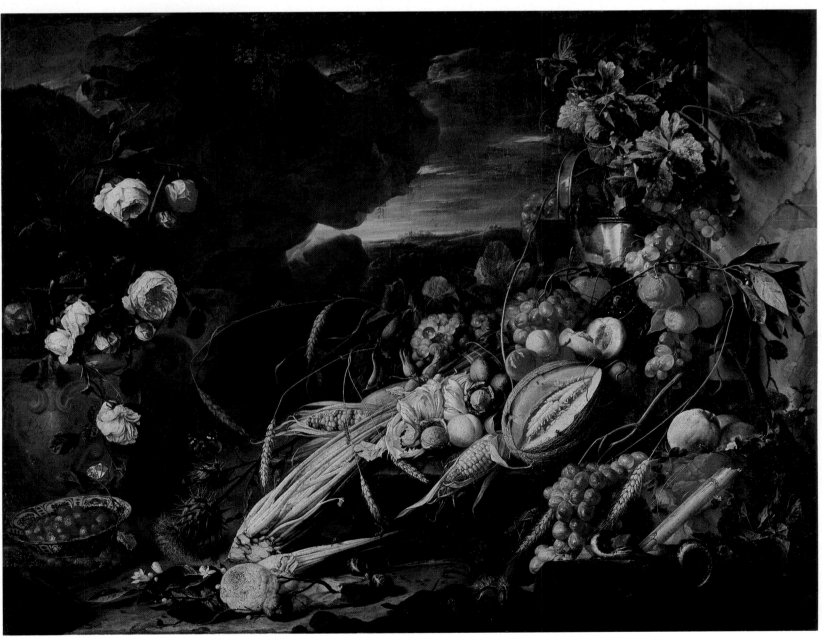

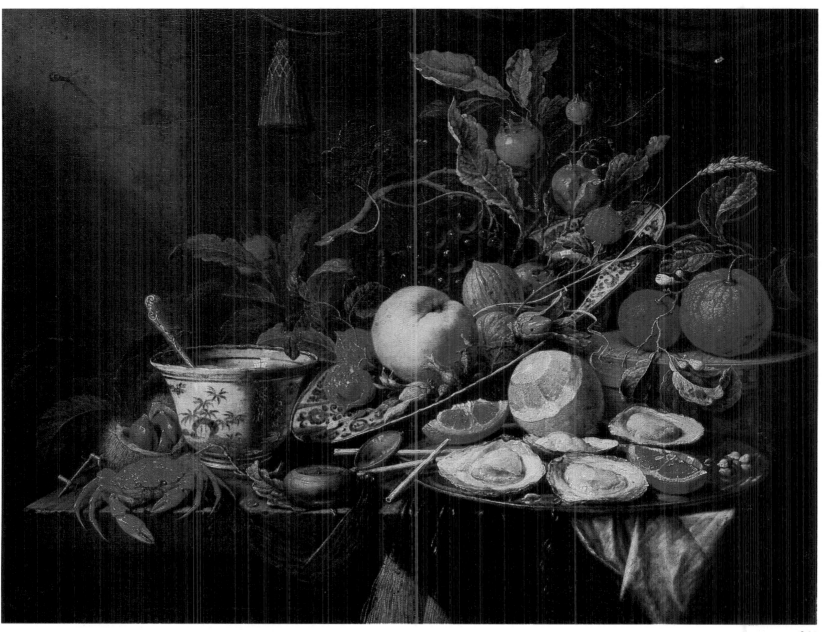

NICOLAES VAN GELDER

Born about 1636 in Leyden, died 1676 in Amsterdam.
Worked in Leyden, Sweden (1661), and Amsterdam.
Painted still lifes.

266

Still Life

Oil on canvas, 22 ³/₈×29 ¹/₂" (57×75 cm.)
Signed with monogram, bottom left corner: NG
The Pushkin Museum of Fine Arts, Moscow. Inv. No. 585

PROVENANCE		REFERENCES
Until 1924	The Dmitry Shchukin Collection, Moscow	* *Catalogue. The Pushkin Museum of Fine Arts* 1961, p. 52.
1924	Museum of Fine Arts, Moscow	
1937	The Pushkin Museum of Fine Arts, Moscow	

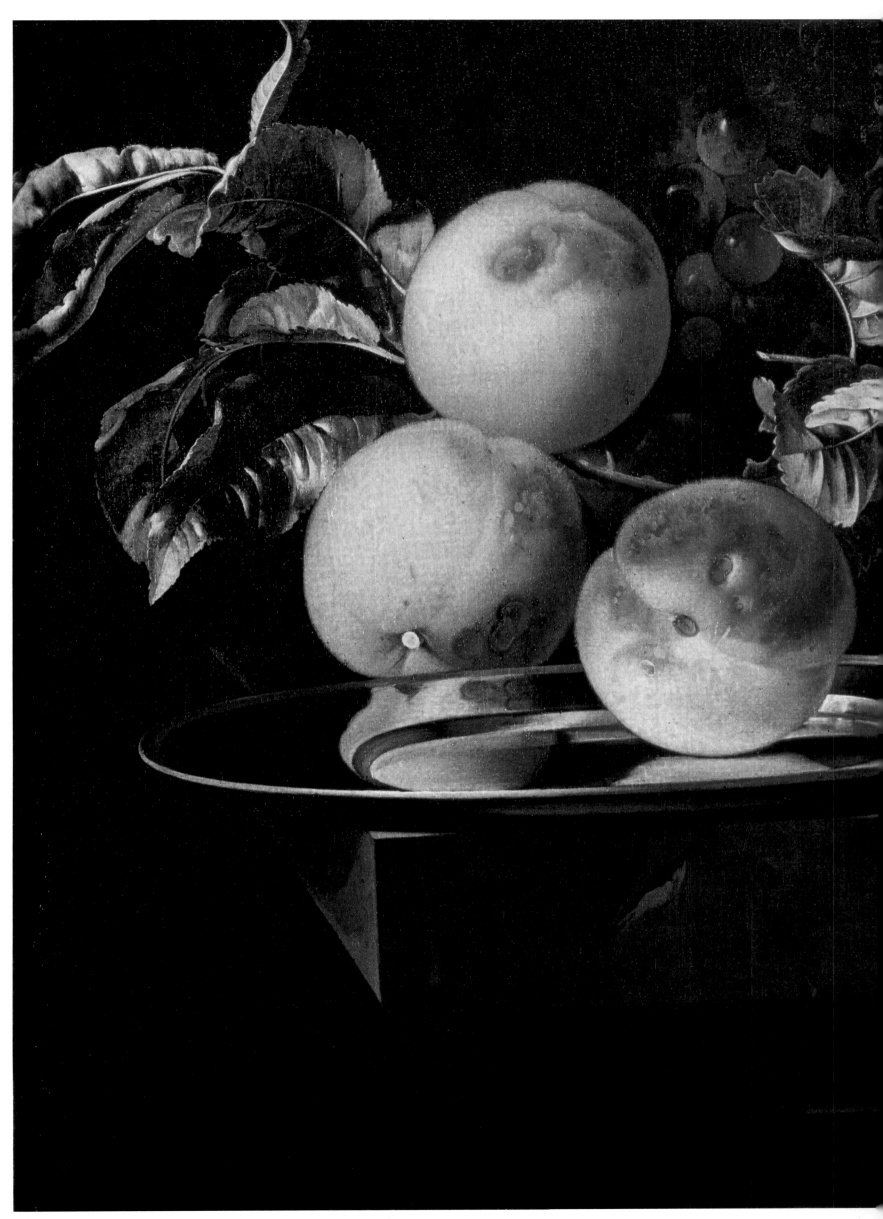

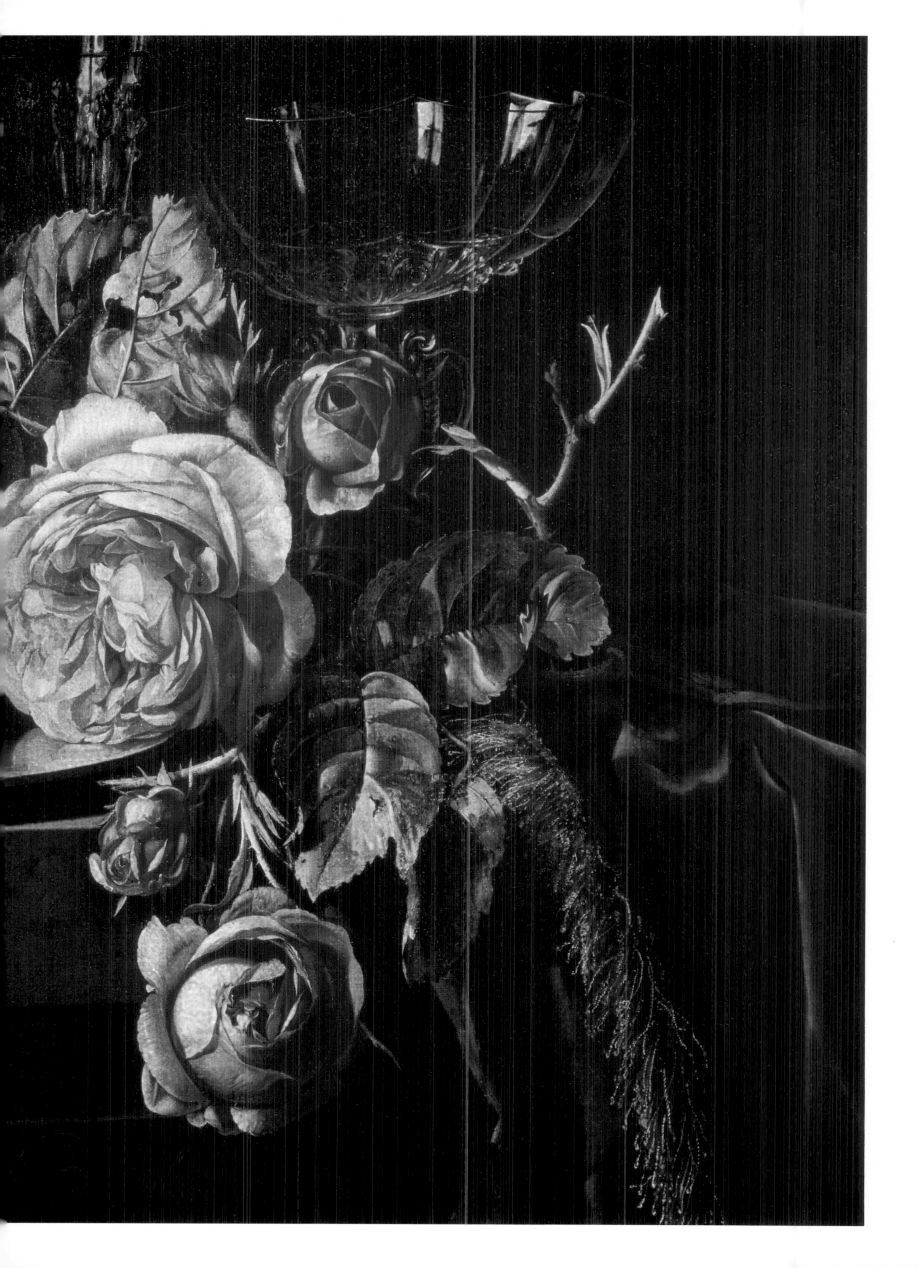

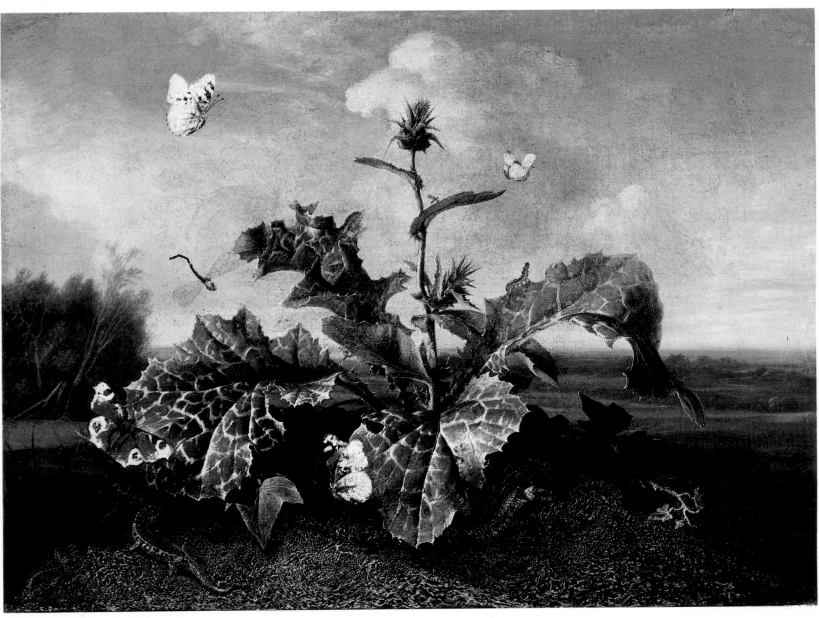

271

OTTO MARSEUS VAN SCHRIECK

Born 1619 in Nijmegen, died 1678 in Amsterdam. Visited Italy,
France, and England. Worked mainly in Amsterdam.
Painted plants, reptiles, and insects.

271

Burdock Bush

Oil on panel, 15 3/4×21 7/8" (40×55.7 cm.)
Remains of signature, bottom right: Otto Mars...
The Radishchev Art Museum, Saratov. Inv. No. 59

PROVENANCE

The Musin-Pushkin Collection
1922 The Radishchev Art Museum, Saratov
(through the State Museum Reserve)

REFERENCES

* *Catalogue. Saratov* 1969, p. 12.

MELCHIOR DE HONDECOETER

Born 1636 in Utrecht, died 1695 in Amsterdam. Pupil of Gysbert
Gillisz de Hondecoeter (his father) and Jan Baptist Weenix.
Lived and worked in The Hague (1659–63), later in Amsterdam.
Painted birds and trophies of the hunt.

272

Poultry

Oil on canvas, 44 ¹/₈×49 ¹/₈" (112×125 cm.)
The Hermitage, Leningrad. Inv. No. 1031

PROVENANCE

Before 1797 The Imperial Hermitage,
St. Petersburg

REFERENCES

* *Catalogues. The Hermitage* 1863–1916, No.
1341; * *Catalogue. The Hermitage* 1958, 2, p. 185.

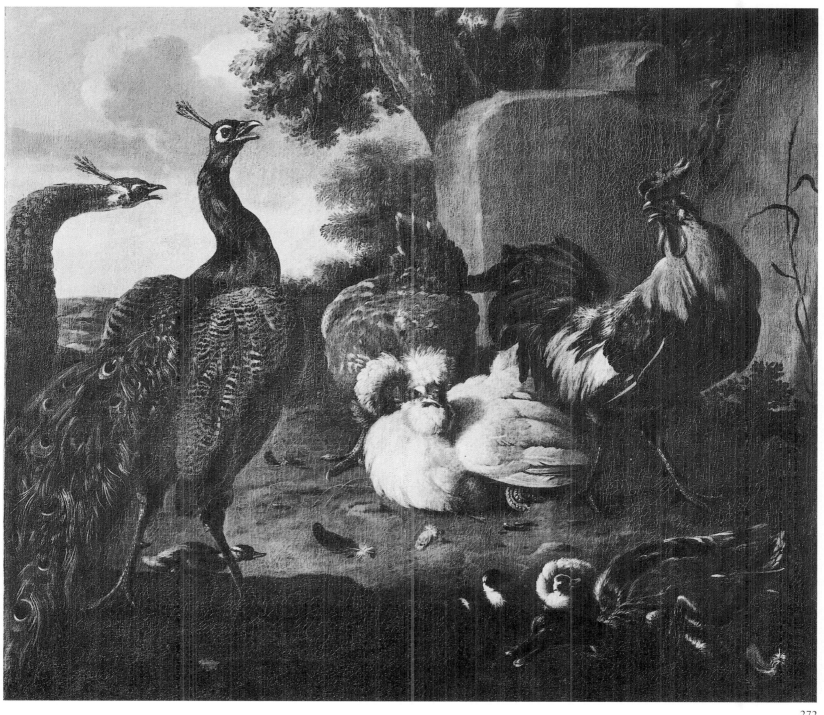

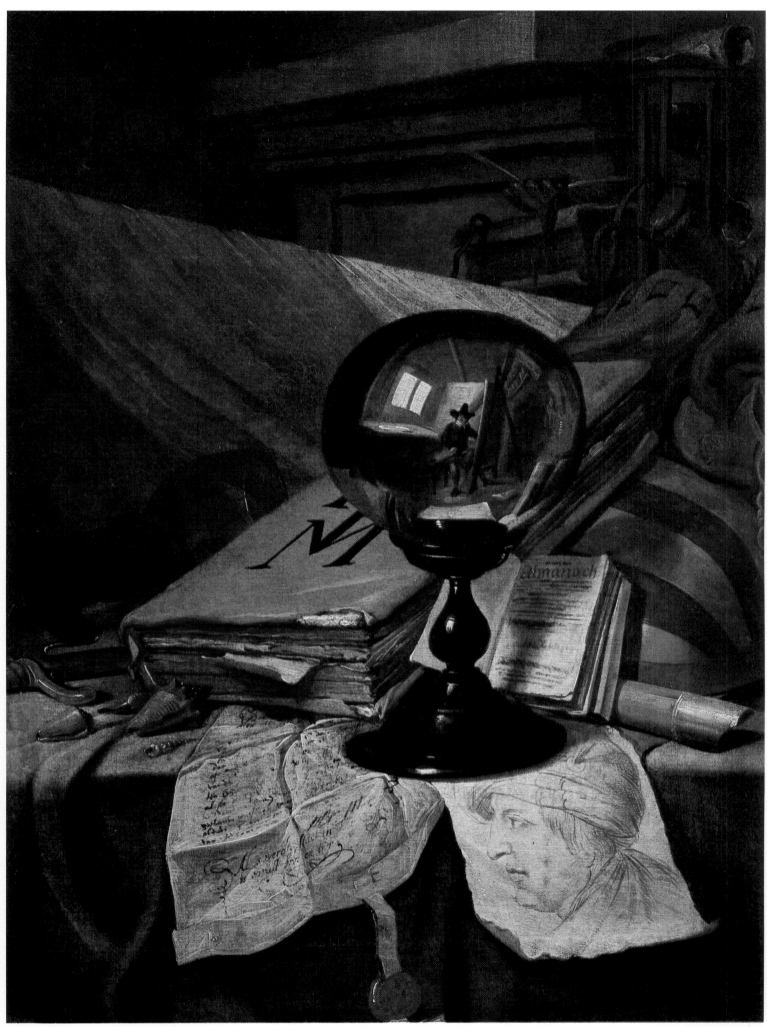

VINCENT LAURENSZ VAN DER VINNE

Born 1629 in Haarlem, died in that city in 1702. Pupil of Frans Hals. Traveled in Germany, Switzerland, and France (1652–55). Worked in Haarlem. Painted portraits, genre scenes, landscapes, and still lifes.

273

Still Life with a Glass Ball

Oil on canvas, 25 1/4×19 1/4" (64×49 cm.)
The Pushkin Museum of Fine Arts, Moscow. Inv. No. 2005

Attributed to Van der Vinne by Yury Kuznetsov. The picture was formerly ascribed to an unknown Dutch artist of the seventeenth century. It belongs to the "scholarly" type of still life which is characterized by the presence of *Vanitas* elements (musical instruments, old books).

	PROVENANCE	REFERENCES
Until 1926	The Dmitry Shchukin Collection, Moscow	* *Catalogue. The Pushkin Museum of Fine Arts* 1961, p. 58; * Kuznetsov 1966, pp. 20, 189, No. 53.
1926	Museum of Fine Arts, Moscow	
1937	The Pushkin Museum of Fine Arts, Moscow	

JAN WEENIX

Born 1640 in Amsterdam, died in that city in 1719. Pupil of Jan Baptist Weenix (his father). Worked in Utrecht (1664–68), Amsterdam, Germany (1702–14). Besides numerous paintings of dead game, he painted a number of portraits and landscapes.

274 →

Trophies of the Hunt

Oil on canvas, 39 3/8×32 1/4" (100×82 cm.)
The Hermitage, Leningrad. Inv. No. 2785

	PROVENANCE	REFERENCES
Until 1915	The P. Semionov-Tien-Shansky Collection, Petrograd	*Catalogue Semenov* 1906, No. 586; * *Catalogue. The Hermitage* 1958, 2, p. 153.
1915	The Imperial Hermitage, Petrograd	

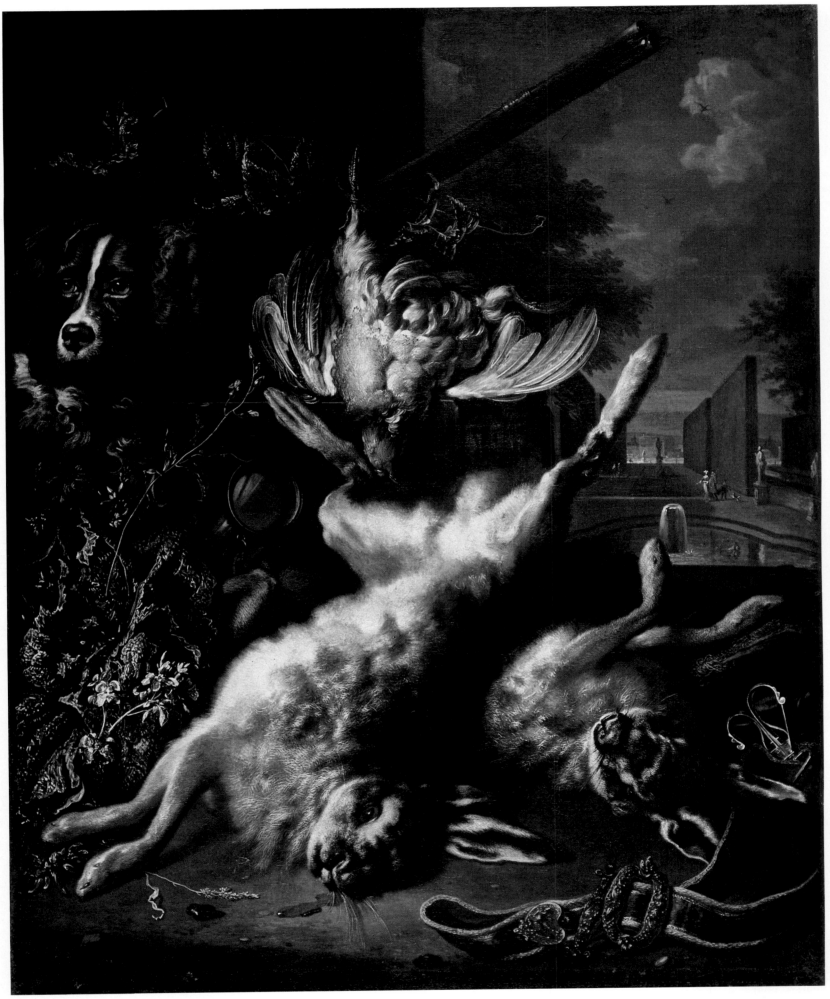

18th to 20th Century

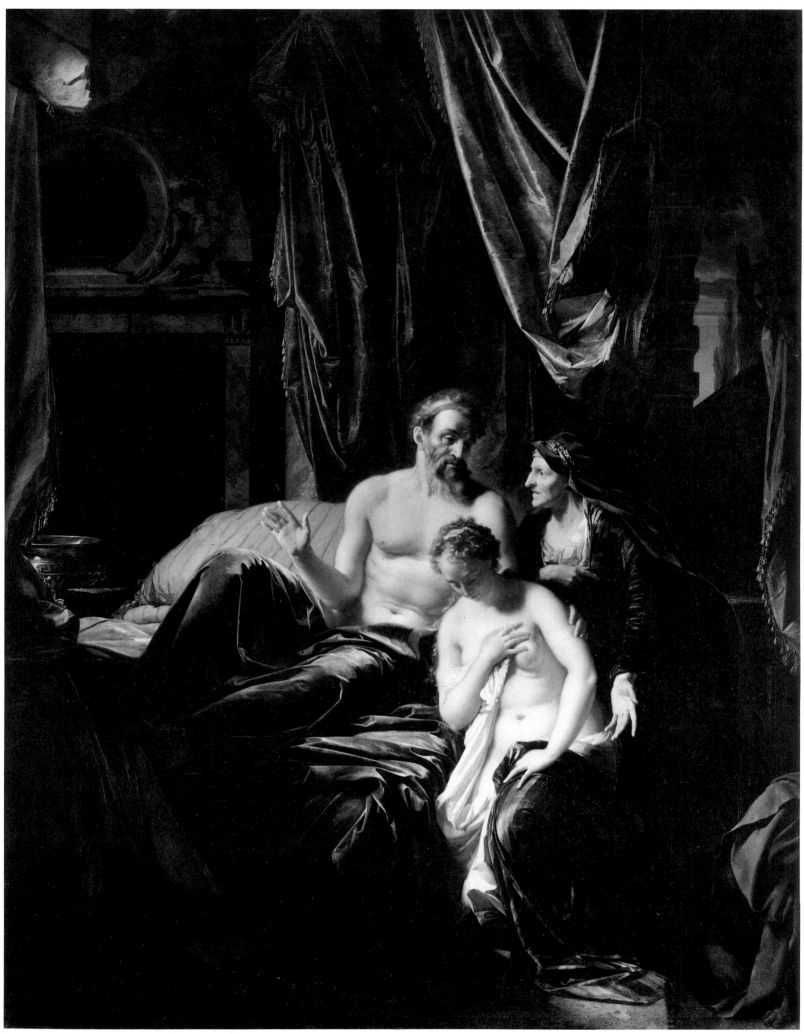

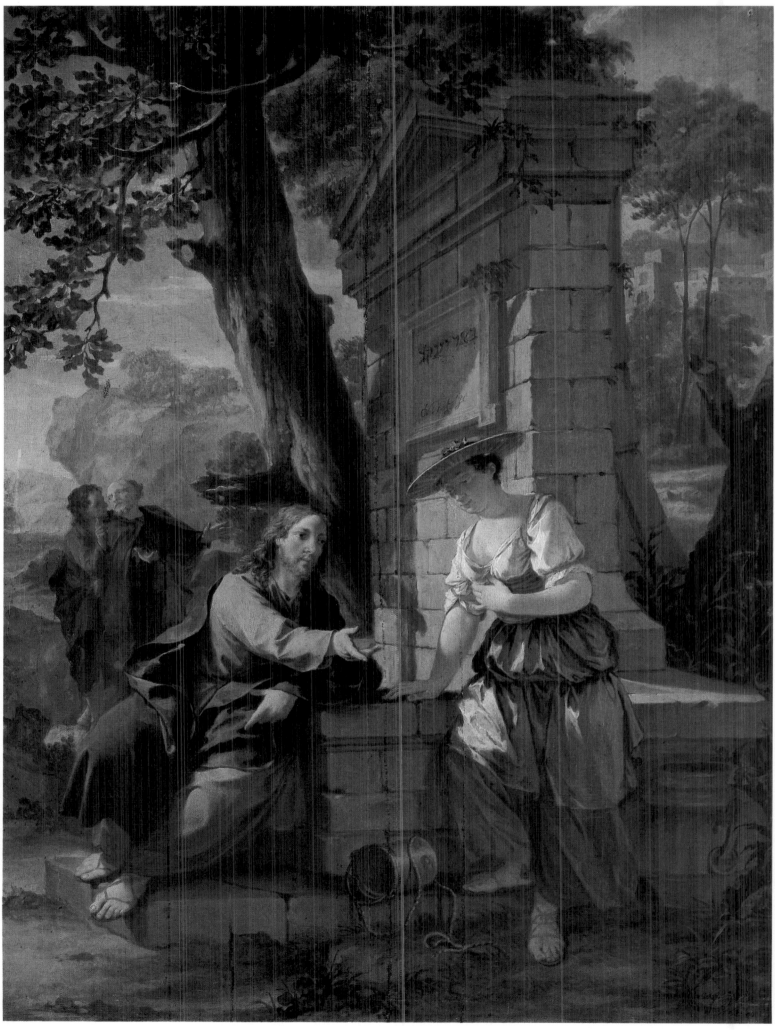

NICOLAES VERKOLJE

Born 1673 in Delft, died 1746 in Amsterdam. Pupil of Jan
Verkolje (his father). Worked in Delft and Amsterdam
(from 1700). Painted portraits, historical compositions, genre
scenes, and decorative panels.

← 277

Christ and the Woman of Samaria

Oil on panel, 20 ³/₈×15 ³/₄" (52×40 cm.)
Signed on stone slab of well: N. Verkolje
The Hermitage, Leningrad. Inv. No. 6792

The subject is taken from the Bible (St. John, IV: 7–27).
A companion picture—*Christ with Martha and Mary*—is also in the
Hermitage (inv. No. 7100).

PROVENANCE	REFERENCES
Until 1931 The Catherine Palace Museum	* *Catalogue. The Hermitage* 1958, 2, p. 155.
Tsarskoye Selo/Detskoye Selo	
1931 The Hermitage, Leningrad	

JACOB DE WIT

Born 1695 in Amsterdam, died in that city in 1754. Pupil of
Albert van Spiers and Jacob van Hal. Worked in Amsterdam and
Antwerp (1708–17). Painted historical compositions, allegories,
portraits, and decorative panels. Was also an etcher. Published
a treatise on human proportion (*Teekenboek der Proportien van
het menschelijk ligchnaam*, 1747).

278

Cupids

Oil on canvas, 46 ¹/₈×46 ¹/₈" (117×117 cm.)
Signed and dated on bottom of basket: JD Wit 1737
The Hermitage, Leningrad. Inv. No. 8712

This is a ceiling painting.

PROVENANCE	REFERENCES
1938 The Hermitage, Leningrad (through the	* *Catalogue. The Hermitage* 1958, 2, p. 161.
State Purchasing Commission)	

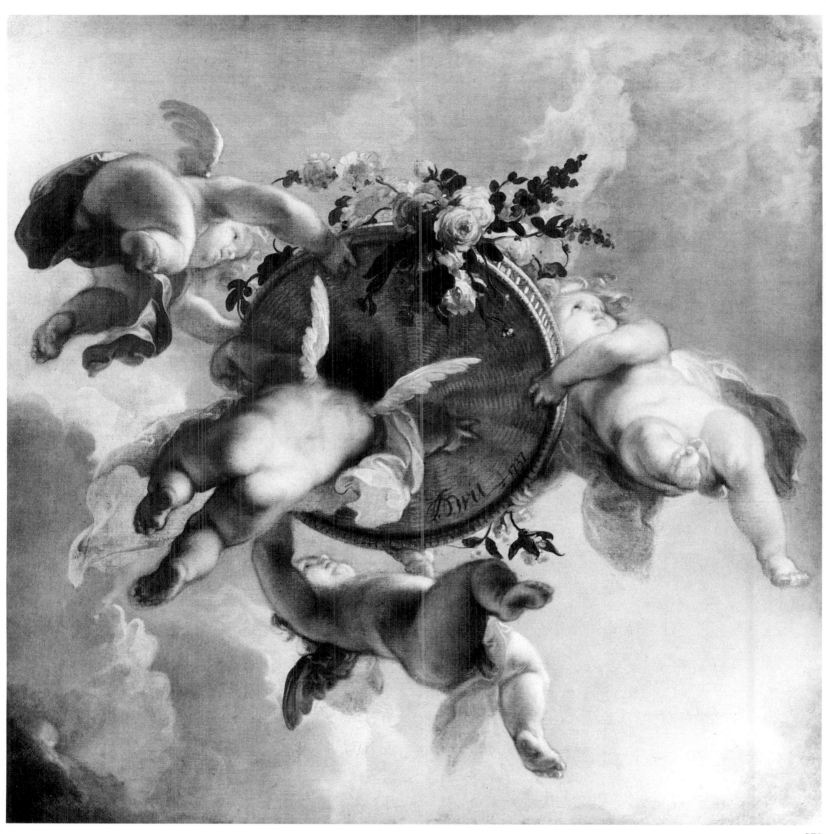

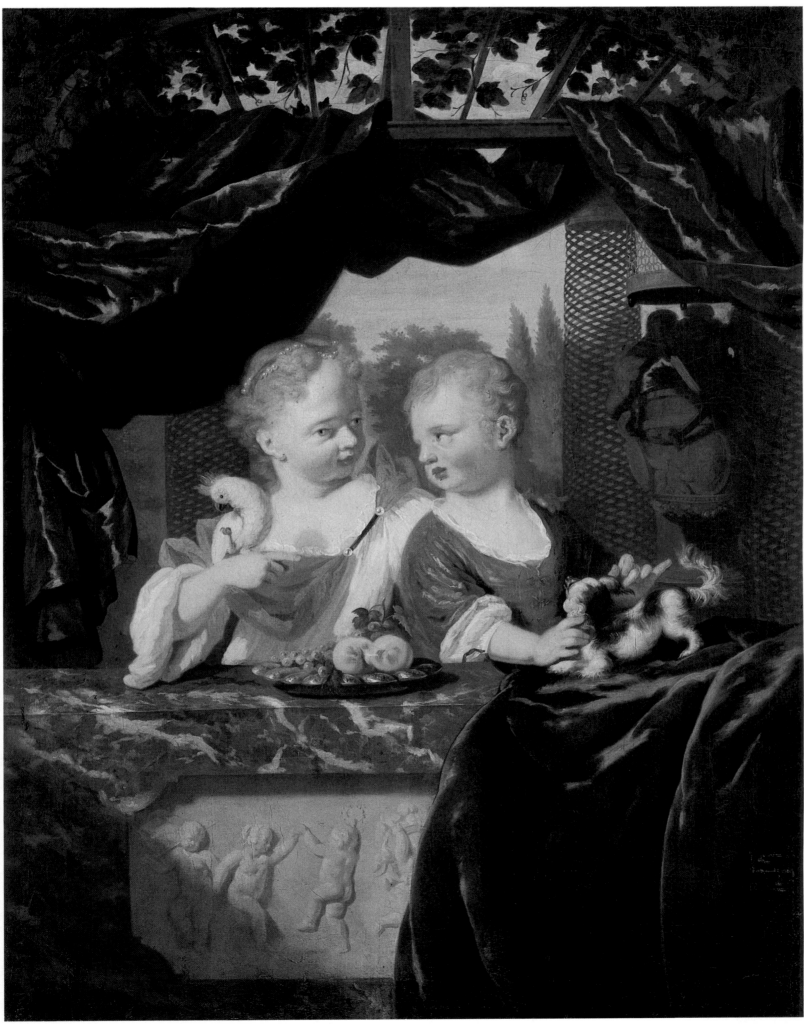

279

PHILIP VAN DYCK

Born 1680 in Amsterdam, died 1753 in The Hague. Worked in Middelburg and The Hague, likewise in Kassel at the court of the Elector of Hesse. Painted genre compositions and portraits.

279

Boy with a Dog and Girl with a Bird

Oil on canvas, 16 3/4×13 3/8" (42.5×34 cm.)
The Hermitage, Leningrad. Inv. No. 1421

PROVENANCE

Before 1859 The Imperial Hermitage, St. Petersburg

REFERENCES

* *Catalogue. The Hermitage* 1958, 2, p. 191.

CORNELIS TROOST

Born 1697 in Amsterdam, died there in 1750. Pupil of Arnold Boonen. Worked in Amsterdam. Painted portraits, genre scenes, historical compositions and scenes from stage plays. Was also a draughtsman, etcher, and engraver.

280

Coffeehouse Hall

Oil on canvas, 25 5/8×39 3/8" (65×100 cm.)
The Hermitage, Leningrad. Inv. No. 5622

PROVENANCE

March 29, 1757 The Pieter Testas II sale in Amsterdam (No. 13); sold to Adrianus van Eyk for 220 florins

June 12, 1790 Sale in Amsterdam (No. 113); sold to van der Schley for 220 florins

August 14, 1793 Sale in Amsterdam (No. 129); sold for 125 florins

June 10, 1801 The H. ten Kate sale in Amsterdam (No. 162); sold to Rynders for 21 florins

May 5, 1802 Sale in Amsterdam (No. 207); sold to C. S. Roos for 24.10 florins

August 6, 1810 Sale in Amsterdam (No. 100); sold to Du Pré for 8.10 florins

1902 The Yusupov Collection, St. Petersburg/Petrograd

1925 The Hermitage, Leningrad

REFERENCES

* *Catalogue. The Old Years* 1908, No. 448; * *Catalogue. The Yusupov Gallery* 1920, No. 288; * *Catalogue. The Hermitage* 1958, 2, p. 283; * Kuznetsov 1959, No. 90; J. W. Niemeijer, *Cornelis Troost*, Assen, 1973, No. 615.

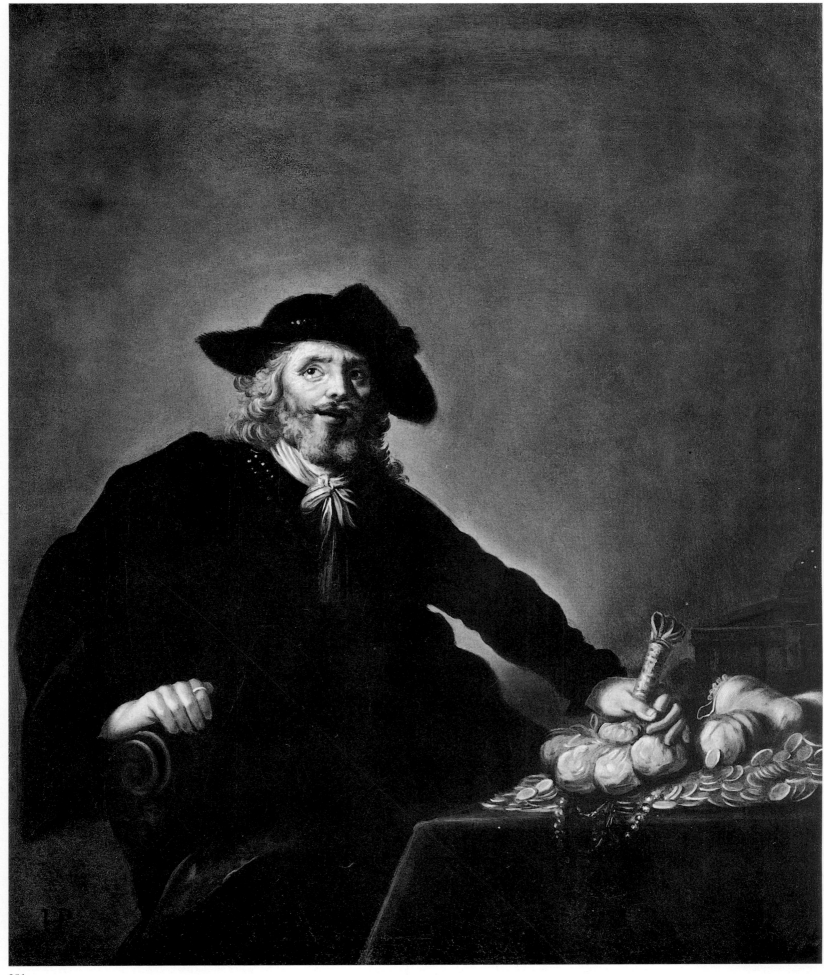

HENDRICK POTHOVEN

Born 1728 in Amsterdam, died 1793 in The Hague. Pupil of
Philip van Dyck. Worked in Amsterdam and The Hague
(after 1764). Painted portraits, genre scenes, and townscapes.

281

The Money Changer

Oil on canvas, 12 ⁵/₈×12 ⁵/₈" (32×32 cm.)
Signed with monogram, bottom left corner: HP
The Radishchev Art Museum, Saratov. Inv. No. 34

Formerly the canvas was ascribed to Hendrick Gerritsz Pot and Horatius
Paulyn (?). A replica is in the Uffizi Gallery in Florence (as a work by
Hendrick Pot), and there are also two copies: one is in the History and Art
Museum of Serpukhov (as a work by an unknown artist), the other figured in
the Lempertz sale of November 14–17, 1956, in Cologne (as a work by
Hendrick Pot).

	PROVENANCE	REFERENCES
Until 1920	Department of Fine Arts, Saratov	* *Catalogue. Saratov* 1969, p. 11.
1920	The Radishchev Art Museum, Saratov	

→

ADRIAEN CORNELISZ VAN DER SALM

Born around 1665 in Delftshaven, died there in 1720. Worked
(as a schoolteacher) in Delftshaven and Schenderloo. Member
of the Delft guild (from 1706). Painted seascapes, ships, and
harbor scenes.

282

282, 283

The Harbor of Archangel

Grisaille on panel, 24 ⁵/₈×42 ¹/₈″ (62.5×107 cm.)
Signed on piece of paper floating in the water, bottom right:
A.v d. Salm Fecit
Monplaisir Palace, Petrodvorets. Inv. No. 567

Executed after 1714. Companion picture to *The Harbor of Amsterdam*, also in Monplaisir Palace. The supposition that the harbor portrayed is that of Archangel was voiced by Hofstede de Groot. It was confirmed by the Guardian of the palace museums and parks of Petrodvorets, V. Znamenov, who established that Salm had based his canvas on an engraving by C. de Bruyn depicting Archangel in 1714. It is, therefore, safe to assume that the two companion pictures of Amsterdam and Archangel were specially commissioned from Salm by Peter the Great.

Because of the singular technique employed in the works of this artist, they are known as "drawn pictures." However, it is possible that he used oils, too—there was an oil in the P. Miakin Collection in St. Petersburg signed *A. S.* that was considered to have been painted by Salm (* *Catalogue of the Miakin Collection*, St. Petersburg, 1907, p. 31).

PROVENANCE

Acquired by Peter the Great

REFERENCES

* Koskull 1914, pp. 21–22, notes 50, 51; B. von Koskull, "Die Anfänge der ehemals Kaiserlich-russischen Gemäldesammlungen. Ein Beitrag zur holländischen Seemalerei des 18. Jahrhunderts," *Oud-Holland*, 1937, p. 80; J. B. Overeen, "De schilders A. en R. van der Salm," *Rotterdams Jaarboekje*, 1958, p. 21, No. 4; * Friedman 1973, p. 219.

JAN TEN KOMPE

Born 1713 in Amsterdam, died there in 1761.
Worked in Amsterdam. Painted townscapes.

284

A House by the Canal on the Outskirts of Amsterdam

Oil on panel, 15×19 ¹/₄" (38×49 cm.)
The Hermitage, Leningrad. Inv. No. 1084

A companion picture—*Bridge over a River on the Outskirts of Amsterdam*—is also in the Hermitage (inv. No. 1085).

PROVENANCE	REFERENCES
1815 The Imperial Hermitage, St. Petersburg	* *Catalogues. The Hermitage 1863–1916,* No. 1268; * *Catalogue. The Hermitage 1958,* 2, p. 208.

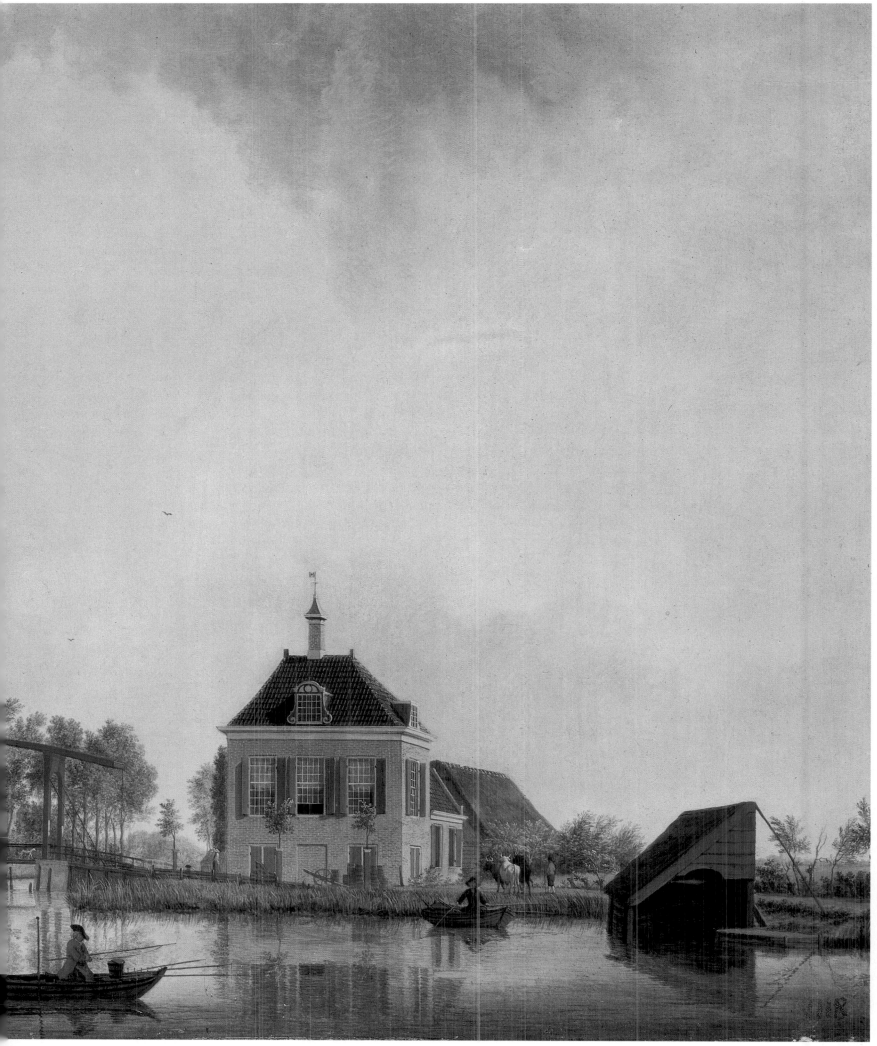

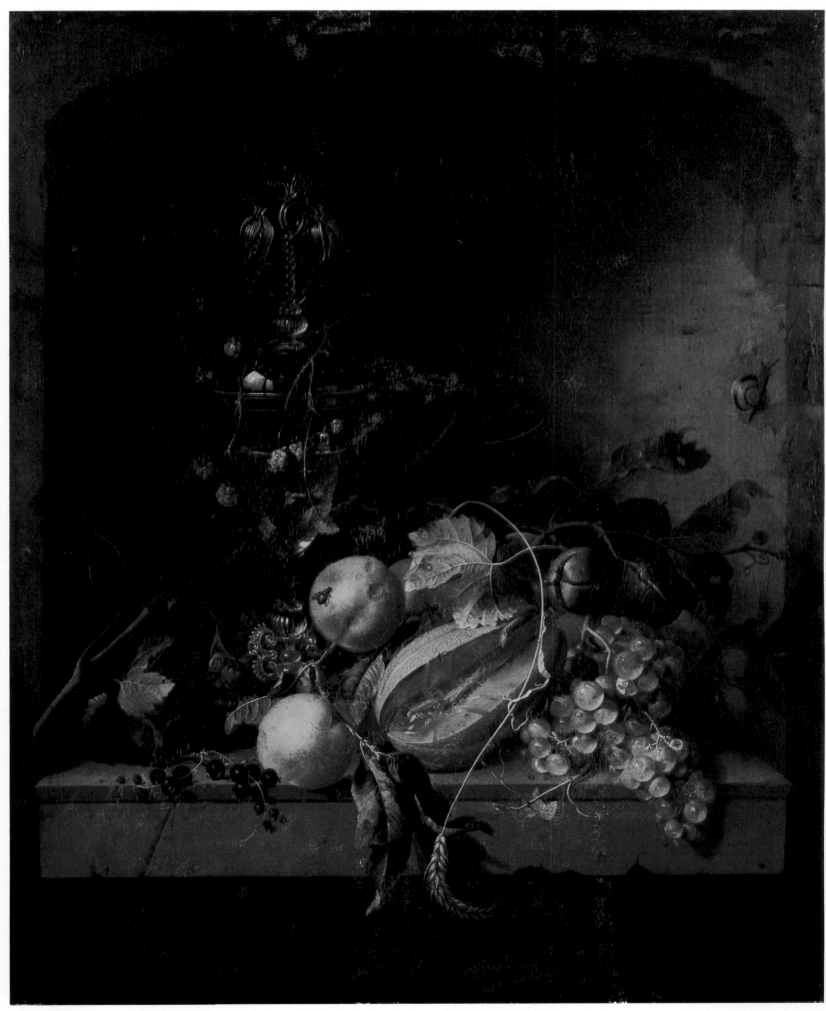

285

JACOB VAN WALSCAPELLE

Born 1644 in Dordrecht, died 1727 in Amsterdam. Possibly
studied under Cornelis Kick. Worked in Dordrecht and
Amsterdam (from 1667). Painted still lifes.

285

Still Life

Oil on canvas, 29 1/8×23 5/8" (74×60 cm.)
The Pushkin Museum of Fine Arts, Moscow. Inv. No. 590

PROVENANCE		REFERENCES
Until 1924	The Dmitry Shchukin Collection, Moscow	* *Catalogue. The Pushkin Museum of Fine Arts* 1961, p. 31.
1924	Museum of Modern Western Art, Moscow	
1937	The Pushkin Museum of Fine Arts, Moscow	

JAN VAN HUYSUM

Born 1682 in Amsterdam, died in that city in 1749. Pupil of
Justus van Huysum (his father). Painted flowers, fruit
and landscapes

286 →

Flowers

Oil on canvas (transferred from a panel), 31 1/8×23 5/8" (79×60 cm.)
Signed and dated on edge of tabletop, right: Jan van Huysum fecit 1722
The Hermitage, Leningrad. Inv. No. 1051

The picture was engraved by Richard Earlom. It is a companion piece to
Flowers and Fruit (*see* plate 287).

PROVENANCE		REFERENCES
Until 1779	The Walpole Collection, Houghton Hall, England	* *Catalogues. The Hermitage* 1863–1916, No. 1379; * Shcherbachova 1945, p. 57, No. 50; * *Catalogue. The Hermitage* 1958, 2, p. 175.
1779	The Imperial Hermitage, St. Petersburg	

287 →

Flowers and Fruit

Oil on panel, 31 1/2×23 7/8" (80×60.5 cm.)
Signed and dated on edge of tabletop, left: Jan van Huysum fecit 1723
The Hermitage, Leningrad. Inv. No. 1049

This is a companion picture to *Flowers* (*see* plate 286).

PROVENANCE	REFERENCES
See under plate 286.	* *Catalogues. The Hermitage* 1863–1916, No. 1378; * Shcherbachova 1945, p. 57, No. 51; * *Catalogue. The Hermitage* 1958, 2, p. 174; * Kuznetsov 1966, No. 51.

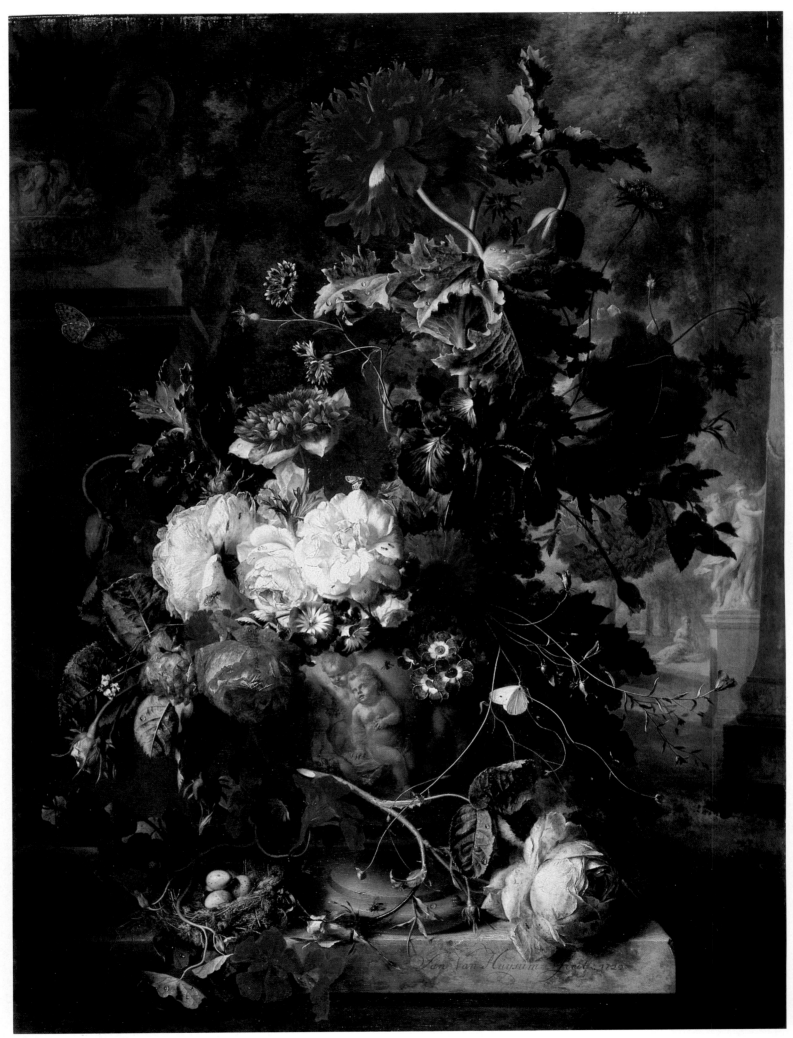

286

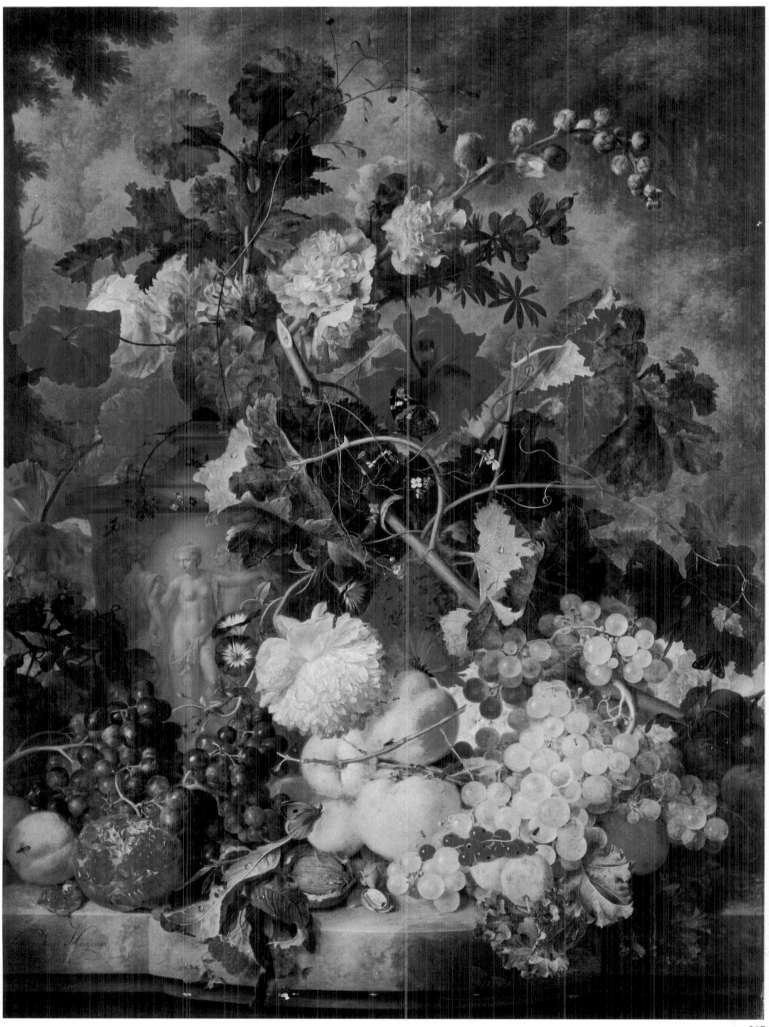

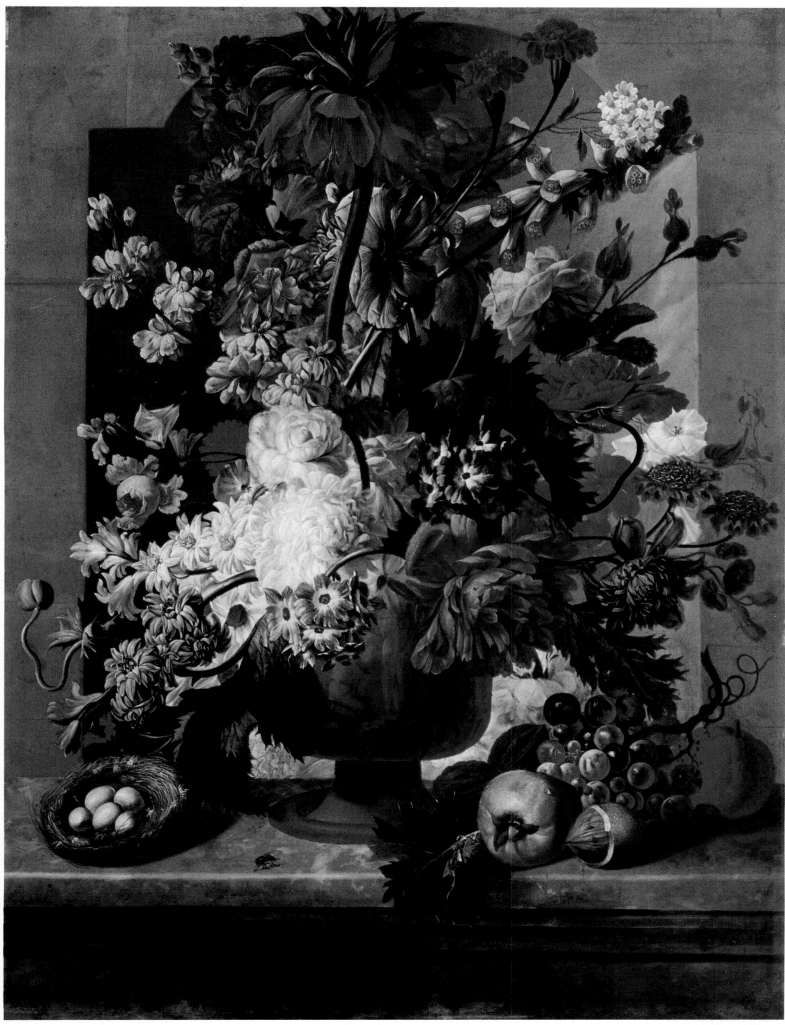

288

PAULUS THEODORUS VAN BRUSSEL

Born 1754 in Zuid Polsbroek near Schoonhoven, died 1791
in Amsterdam. Trained at decorative wallpaper factories in
Haarlem. Painted flowers and fruit, also interiors.

288

Flowers and Fruit

Oil on panel, 27 1/2×21 1/4" (70×54 cm.)
Signed, bottom center: V. Brussel f.
The Pushkin Museum of Fine Arts, Moscow. Inv. No. 1668

PROVENANCE		REFERENCES
Until 1924	The Hermitage, Petrograd	* *Catalogue. The Pushkin Museum of Fine Arts* 1961, p. 27.
1924	Museum of Modern Western Art, Moscow	
1937	The Pushkin Museum of Fine Arts, Moscow	

PETRUS VAN SCHENDEL

Born 1806 in Terheyde near Breda, died 1870 in Brussels.
Studied at the Antwerp Academy. Worked in Rotterdam
(1832–36), The Hague and Amsterdam (1838–44), and
Brussels. Painted biblical and genre scenes, and also portraits.

289 →

Family Scene

Oil on panel, 21 5/8×17 1/4" (55×44 cm.)
Signed and dated on flagstone, right: P. van Schendel 1845
The Hermitage, Leningrad. Inv. No. 3958

PROVENANCE		REFERENCES
Until 1922	Museum of the Academy of Arts, Petrograd	* *Catalogue. The Kushelev Gallery* 1886, No. 322; * *Catalogue. The Hermitage* 1958, 2, p. 299.
1922	The Hermitage, Petrograd	

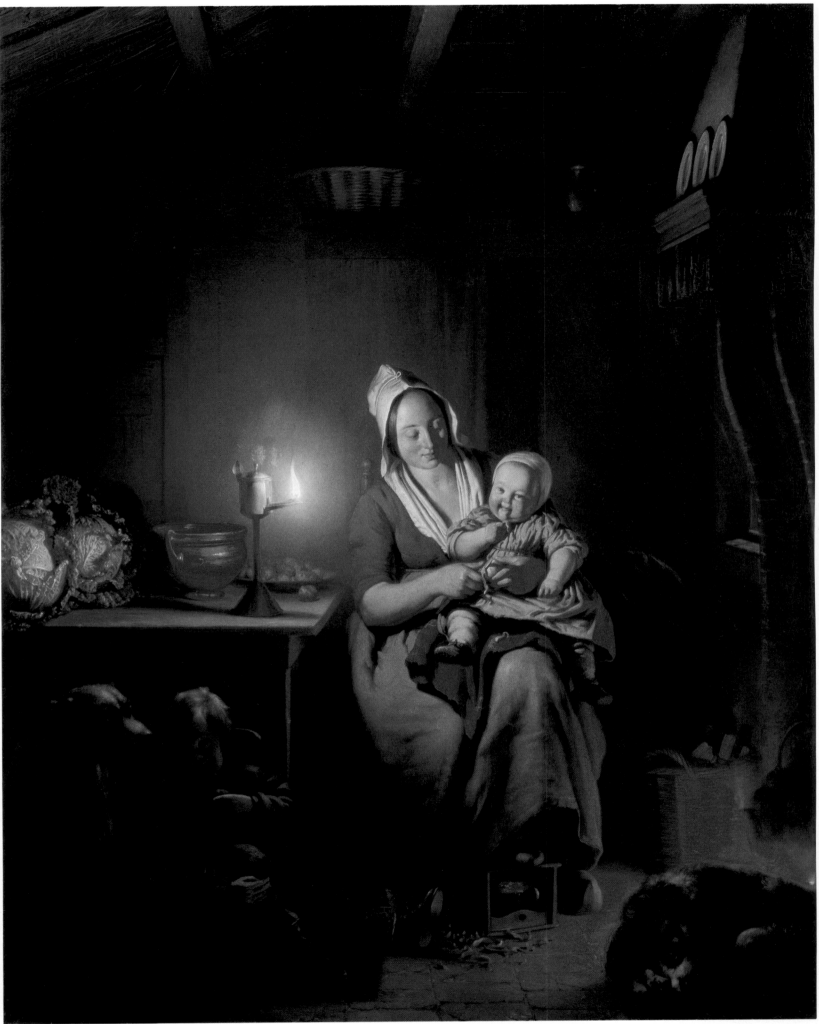

289

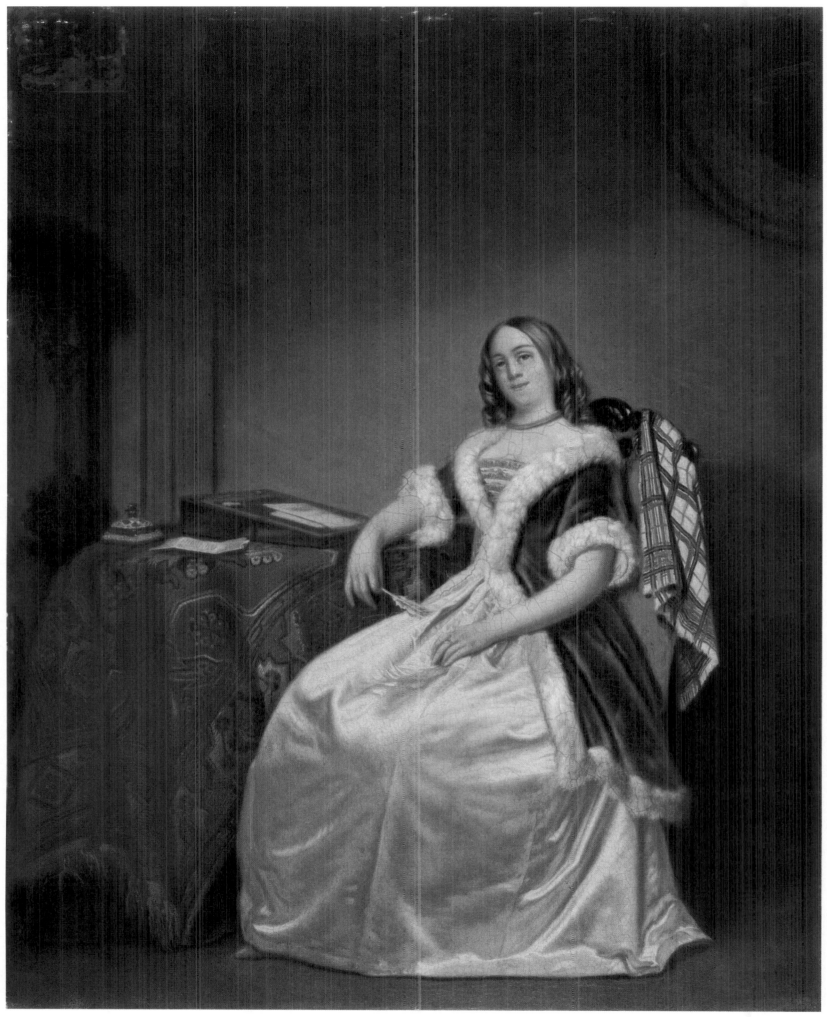

JAN LODEWIJK JONXIS

Born 1789 in Utrecht, died there in 1867. Pupil of Louis François Gérard van der Puyl. Visited Paris (1828). Painted genre scenes and portraits.

← 290

Lady at a Table

Oil on panel, 18 1/8×14 3/4" (46×37.5 cm.)
Signed, bottom left: ILJonxis
Art Museum of the Tatar ASSR, Kazan. Inv. No. 961

Provenance unknown.

NICOLAAS PIENEMAN

Born 1809 in Amersfoort, died 1860 in Amsterdam. Pupil of Jan Willem Pieneman (his father). Traveled to England, France, Germany, and Belgium. Worked in Amsterdam. Painted historical compositions, genre scenes, and portraits.

291

Jacoba of Bavaria

Oil on canvas, 31 7/8×26 1/4" (81.4×66.5 cm.)
Signed, bottom right: N. Pieneman f.
Museum of Western European and Oriental Art, Riga. Inv. No. 87

Jacoba of Bavaria (or of Holland, 1401–1436) was heiress to Willem VI, Count of Holland, Zeeland, and Hainaut. After her secret marriage to Francis of Borselen, a Zeeland nobleman, she was removed from power in 1433. Her romantic life story invariably caught the imagination of artists and poets. Pieneman might have been inspired by Jan de Marre's drama *Jacoba van Beyeren, Countess of Holland and Zeeland* (1736). The play enjoyed tremendous popularity, never leaving the stage till the early nineteenth century.

PROVENANCE	REFERENCES
1862 The V. Brederlo Collection, Riga	Neumann 1906, No. 136; *Catalogue, Riga*
1868 The Brederlo Picture Gallery, Riga	1955, p. 67.
1905 Museum of Western European and Oriental Art, Riga	

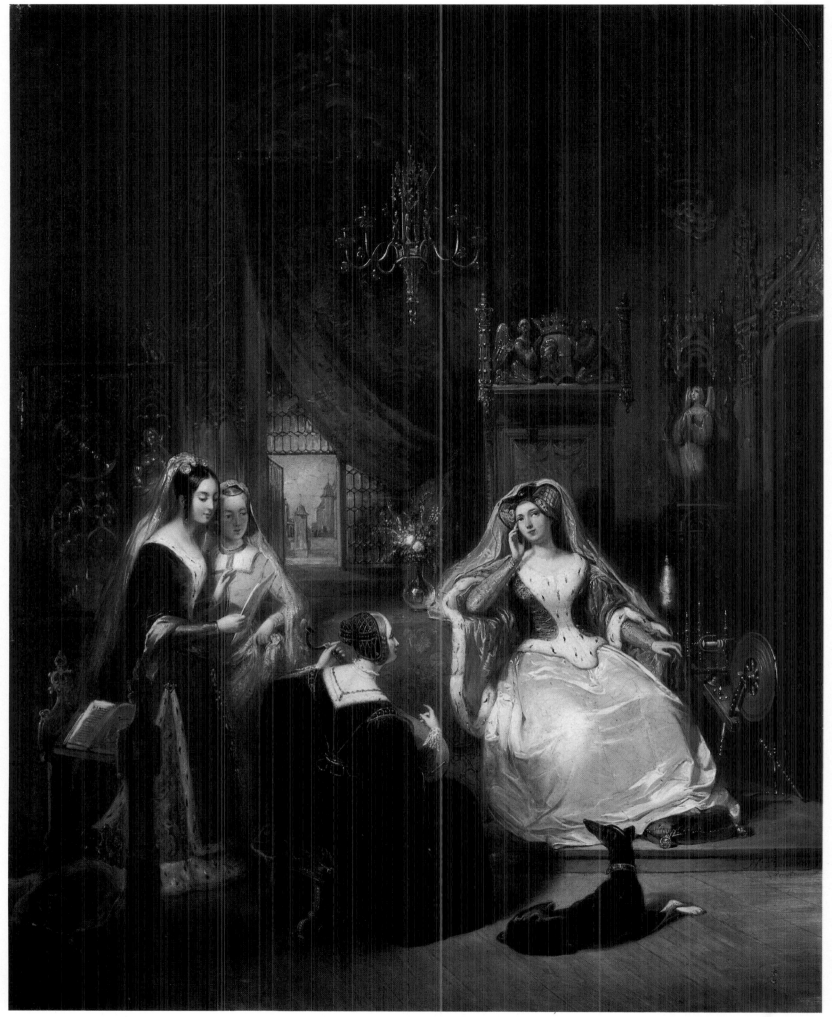

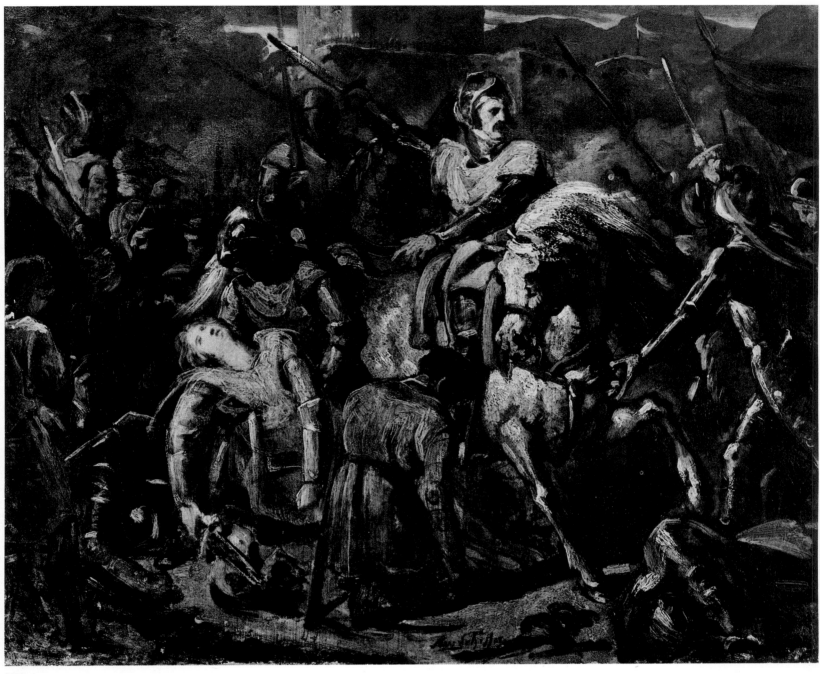

292

ARY SCHEFFER

Born 1795 in Dordrecht, died 1858 in Argenteuil near Paris.
Pupil of Johann Bernard Scheffer (his father) in Dordrecht and
Pierre Narcisse Guérin in Paris. Worked in Paris (from 1812)
and England (1857–58). Painted historical and biblical
compositions, also portraits.

292

The Death of Gaston de Foix

Oil on canvas, 15×18 ¹/8" (38×46 cm.)
Signed, bottom center: Ary Scheffer
The Hermitage, Leningrad. Inv. No. 3991

←

The picture is actually a study for the large canvas *The Death of Gaston de Foix in the Battle of Ravenna on April 11, 1512*, exhibited at the Salon of 1824 in Paris and now housed in the Versailles Museum. Gaston de Foix (1488–1512), the Duke of Nemours, nephew to Louis XII, commanded the French troops and gained the battle of Ravenna against the Spaniards, but was slain when pursuing the fugitives.

PROVENANCE	REFERENCES
1862 The N. Kushelev-Bezborodko Collection, St. Petersburg The Kushelev Gallery, St. Petersburg 1922 Museum of Academy of Arts, Petrograd The Hermitage, Petrograd	* *Catalogue. The Kushelev Gallery* 1886, No. 362; * *Catalogue. The Hermitage* 1958, 1, p. 456; * Berezina 1972, pp. 108–111.

HUBERTUS VAN HOVE

Born 1814 in The Hague, died 1864 in Antwerp. Pupil of Bartholomeus Johannes van Hove (his father) and Hendricus van de Sande Bakhuyzen. Worked in The Hague and Antwerp (from 1854). Painted interior genre scenes and landscapes.

293 →

The Castle

Oil on panel, 24×18 1/2" (61×47 cm.)
Signed and dated, bottom left: H. van Hove 1838
Art Museum, Kharkov. Inv. No. 43

	REFERENCES
Provenance unknown.	* *Catalogue. Kharkov* 1959, p. 47.

294 →

The Lacemaker

Oil on panel, 10 7/8×7 3/4" (27.5×20 cm.)
Signed, bottom right: HVHove BZ
Art Museum, Sevastopol. Inv. No. 249

The picture betrays the artist's wholehearted admiration for the seventeenth-century national school of painting, particularly for Pieter de Hooch.

Provenance unknown.

293

294

HERMAN FREDERICK CAREL TEN KATE

Born 1822 in The Hague, died in that city in 1891. Pupil of
Cornelis Kruseman. Traveled to Belgium, Germany, Italy, and
France (1840–41), where he met Jean-Louis Ernest Meissonier.
Studied at The Hague Academy of Arts (1841–42). Was director
of the Amsterdam Academy of Arts (1860s), then worked in
The Hague. Painted genre scenes, mostly of army life.

295

Signing Up Volunteers

Oil on canvas, 33 5/8×50 5/8" (85.5×128.5 cm.)
Signed and dated, bottom left: Herman ten Kate f. 1856
The Hermitage, Leningrad. Inv. No. 8304

PROVENANCE	REFERENCES
1937 The Hermitage, Leningrad (through the State Purchasing Commission)	* *Catalogue. The Hermitage* 1958, 2, p. 296.

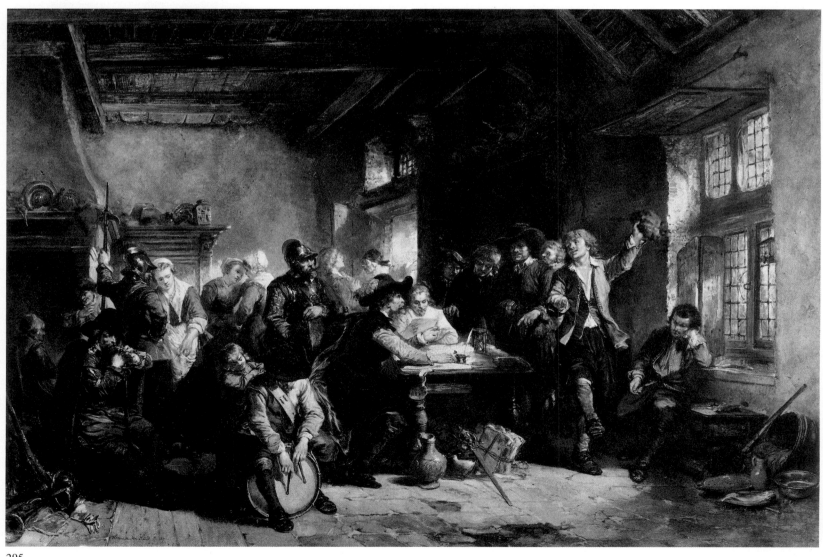

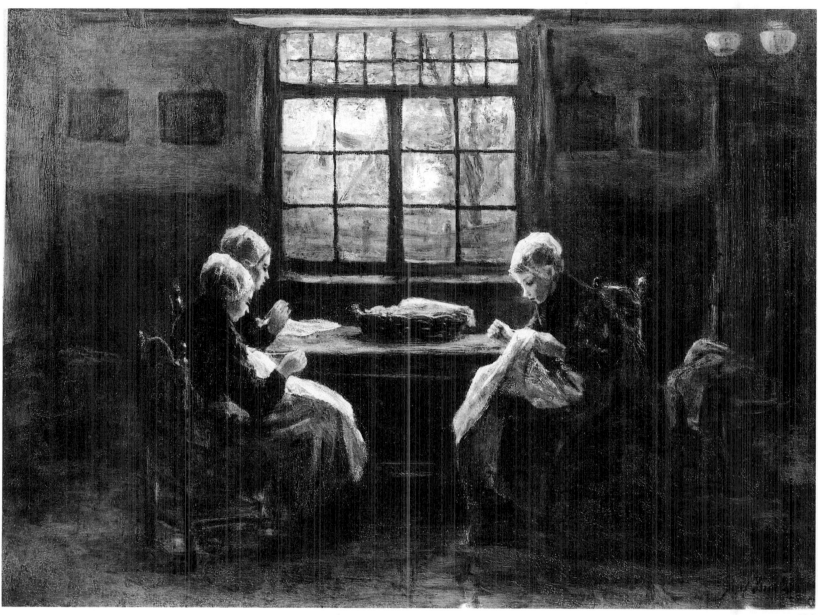

296

JOZEF ISRAELS

Born 1824 in Groningen, died 1911 in The Hague. Studied in
Amsterdam and Paris. Lived in The Hague (from 1871).
Painted genre compositions.

296

Seamstresses

Oil on canvas, 23 1/4×30 3/4" (59×78 cm.)
Signed, bottom right corner: Joseph Israels
The Pushkin Museum of Fine Arts, Moscow. Inv. No. 3510

PROVENANCE

Until 1948 Museum of Modern Western Art,
Moscow
1948 The Pushkin Museum of Fine
Arts, Moscow

REFERENCES

* *Catalogue. The Pushkin Museum of Fine Arts*
1961, p. 85.

DAVID JOSEPH BLES

Born 1821 in The Hague, died in that city in 1899. Pupil of
Cornelis Kruseman (1841–42). Consulted with Joseph Nicolas
Robert-Fleury in Paris. Painted portraits and genre scenes.

297

Auction at an Artist's Studio

Oil on panel, 16 1/8×15″ (41×38 cm.)
Signed and dated on wall, top right: David Bles 51. s'Hage
Art Museum, Ulyanovsk. Inv. No. 115

The plot of the picture has its analogues in the works of seventeenth-century
Dutch painters that are thematically united into a series known as "The
Devil-may-care Tribe" or "The Topsy-turvy World." The theme was popular
in Western European art throughout the nineteenth century and is also
touched upon in the oeuvre of the Russian artist Pavel Fedotov (for example,
in *The Artist Who Married a Dowryless Wife and Pinned All His
Hopes on His Talent*).

REFERENCES

Provenance unknown. * *Catalogue. Ulyanovsk* 1957, p. 91.

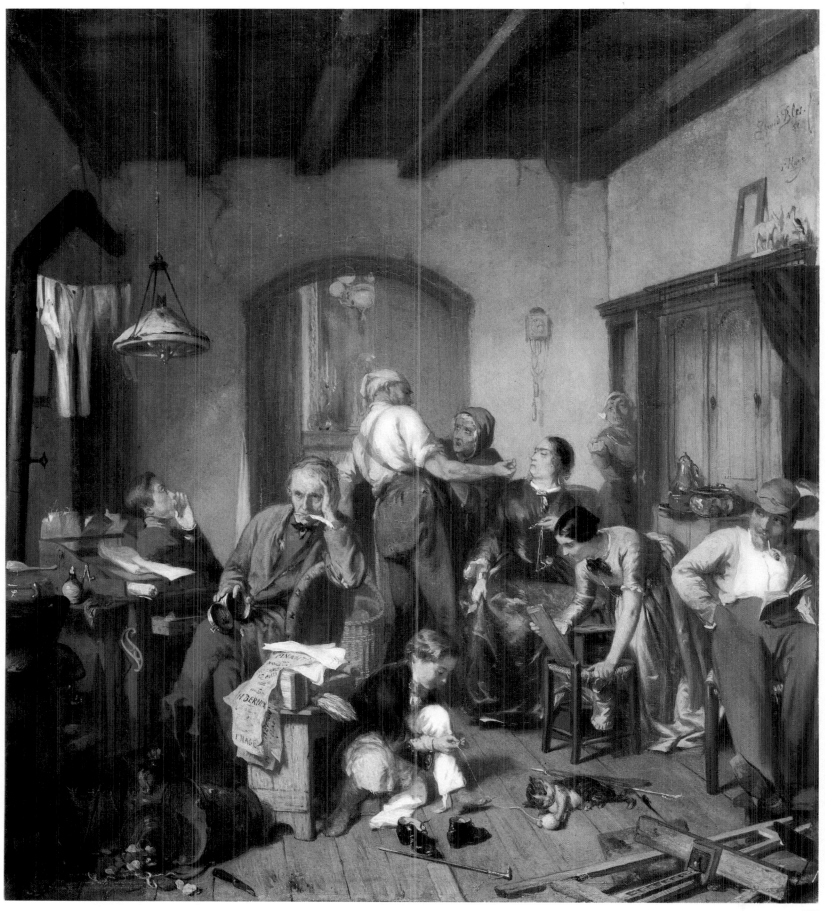

297

WOUTERUS VERSCHUUR

Born 1812 in Amsterdam, died 1874 in Verdun. Pupil of Pieter
Gerardus van Os and Cornelis Steffelaar. Worked in The
Hague, Doorn (1842), Amsterdam (1846–56), Haarlem
(1859–68), again in Amsterdam (1873–74). Traveled in Belgium
and to Hanover. Member of the Royal Academy in Amsterdam
(from 1873). Painted animals. Was also a lithographer.

298

Horses in a Stable

Oil on panel, 18 3/4×25 1/4" (48×64 cm.)
Signed, bottom right: W. Verschuur
The Hermitage, Leningrad. Inv. No. 4960

PROVENANCE	REFERENCES
Until 1931 Museum of the Academy of Arts, Leningrad	* *Catalogue. The Hermitage* 1958, 2, p. 291.
1931 The Hermitage, Leningrad	

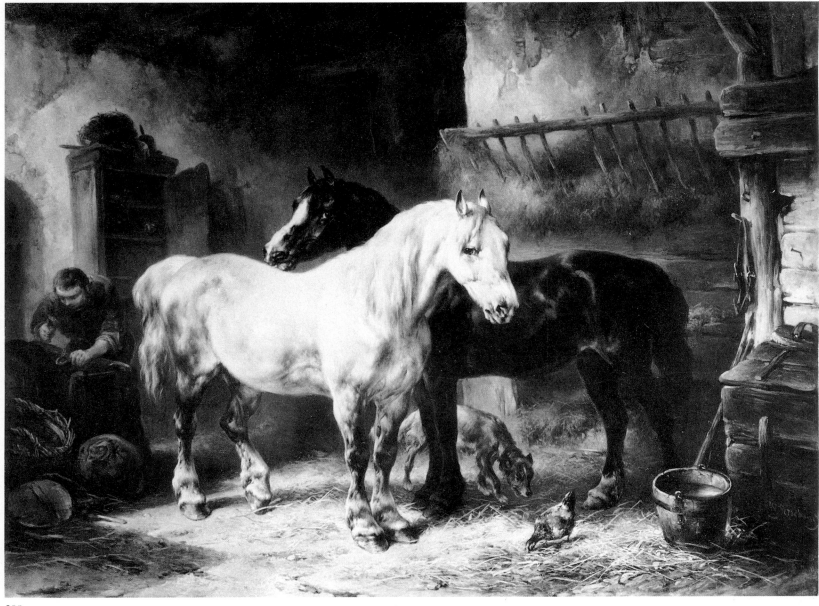

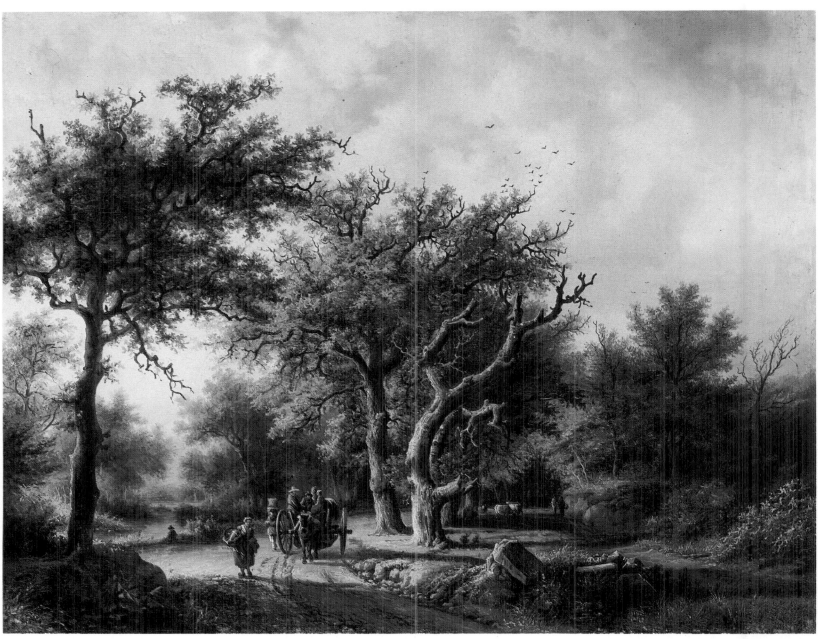

299

BAREND CORNELIS KOEKKOEK

Born 1803 in Middelburg, died 1862 in Kleve. Pupil of Johannes
Hermanus Koekkoek (his father). Worked in Beek near
Nijmegen, and Kleve (from 1836). Traveled in Germany
and Belgium. Was a landscape painter.

299

Landscape

Oil on panel, 14 ¹/₈×18 ⁵/₈" (36.2×47.4 cm.)
Signed and dated, botom right: B. C. Koekkoek F. 1856
The Radishchev Art Museum, Saratov. Inv. No. 38

PROVENANCE

1886 The Radishchev Art Museum, Saratov
(presented by S. Tretyakov)

REFERENCES

* *Catalogue. Saratov* 1969, p. 9.

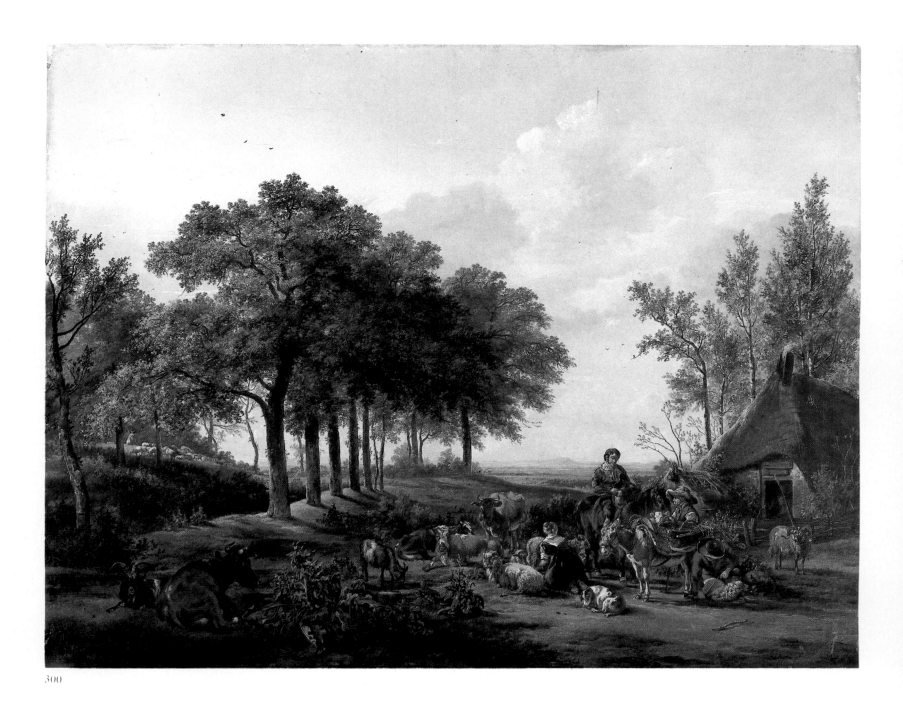

300

PIETER GERARDUS VAN OS

Born 1776 in The Hague, died in that city in 1839. Studied under
Jan van Os (his father) and at the Academy of Drawing in The
Hague. Worked in Amsterdam (from 1796), Gravenland
(1810–12, 1814–19), Naarden (1813), Hilversum (1823–30), and
The Hague (after 1830). Painted ladscapes and battle scenes.

300

The Farm

Oil on panel, 26 1/2×34 5/8" (67.5×88 cm.)
Signed and dated, bottom right: P. G. van Os f. 1813
Art Museum, Kharkov. Inv. No. 58

PROVENANCE

1872 The A. Alfiorov Collection, Kharkov
1877 Museum of Fine Arts of Kharkov
University
Art Museum, Kharkov

REFERENCES

* Catalogue. Kharkov 1877, No. 188 * Cata-
logue. Kharkov 1959, p. 47.

301

Landscape with a Herd

Oil on panel, 10 ¹/₄×13 ³/₈" (26×34 cm.)
Signed and dated, bottom right: P. G. van Os. 1833
Museum of Western European and Oriental Art, Riga. Inv. No. 120

PROVENANCE

1862 The V. Brederlo Collection, Riga
1868 The Brederlo Picture Gallery, Riga
1905 Museum of Western European and
 Oriental Art, Riga

REFERENCES

Neumann 1906, No. 133; * *Catalogue. Riga*
1955, P. 65.

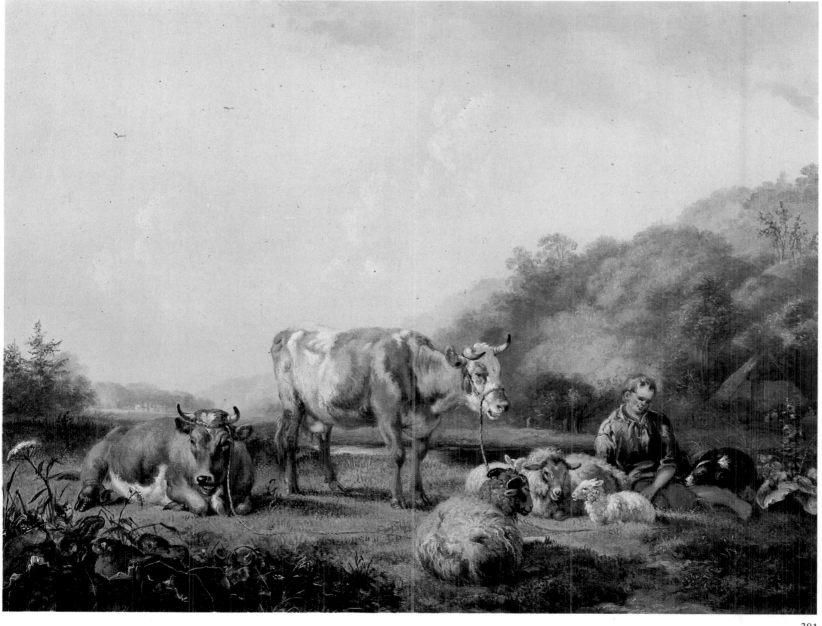

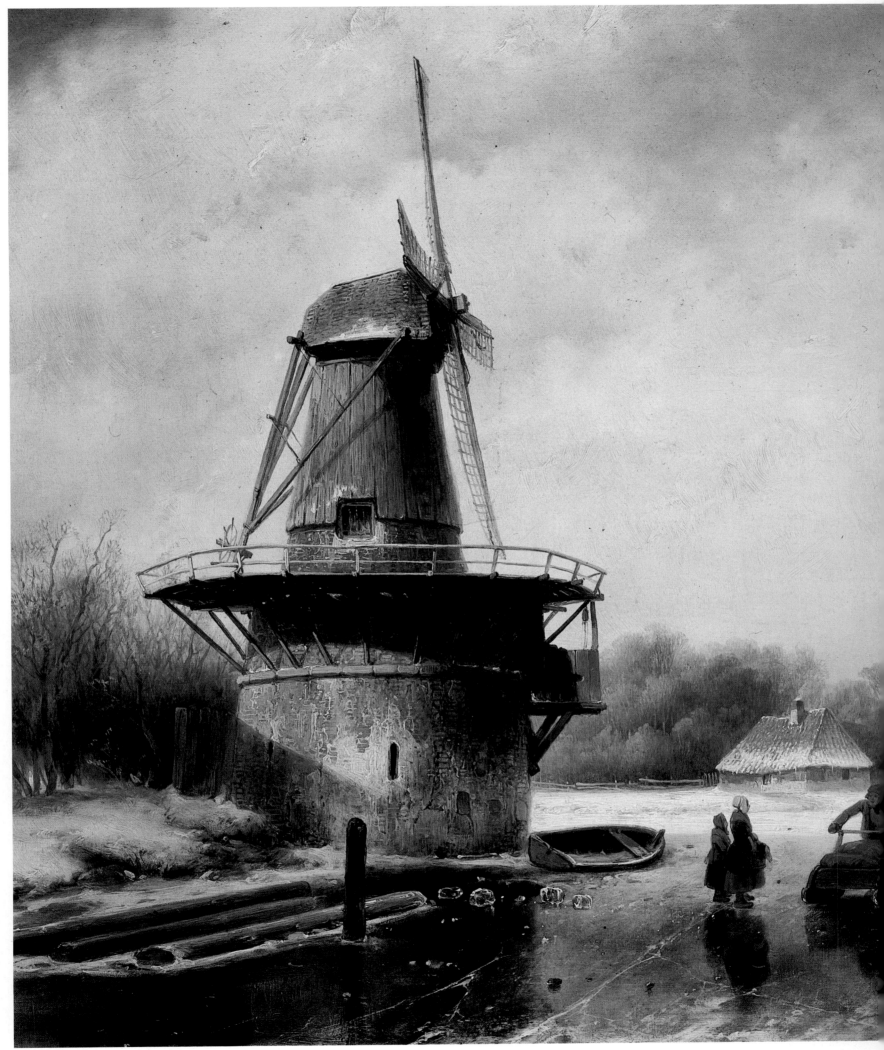

302

ANDREAS SCHELFHOUT

Born 1787 in The Hague, died there in 1870. Pupil of Johannes Hendricus Breckenheimer. Worked in The Hague. Was a landscape painter.

302

Winter Landscape

Oil on panel, 14×17 1/4" (34.5×44 cm.)
Signed, bottom right: A. Schelfhout
Museum of Western European and Oriental Art, Riga.
Inv. No. 212

PROVENANCE	REFERENCES
1862 The V. Brederlo Collection, Riga	Neumann 1906, No. 163; * *Catalogue.* *Riga* 1955, p. 92.
1868 The Brederlo Picture Gallery, Riga	
1905 Museum of Western European and Oriental Art, Riga	

303

The Marsh

Oil on canvas, 5 ¹/₂×7 ¹/₂" (14×19 cm.)
Signed and dated, bottom right: A.S. 53
The Radishchev Art Museum, Saratov. Inv. No. 855

PROVENANCE		REFERENCES
Until 1885	The A. Bogoliubov Collection, Saratov	* *Catalogue. Saratov* 1969, p. 12.
1885	The Radishchev Art Museum, Saratov	

303

304

JAN VAN RAVENSWAAY

Born 1789 in Hilversum, died in that city in 1869. Pupil of
Jordanus Hoorn and Pieter Gerardus van Os. Traveled to
Belgium, Germany, and Switzerland. Painted landscapes
and animals

304

Landscape with a Herd

Oil on panel, 10 ¹/₄×14" (26×34.5 cm.)
Signed, bottom left corner: J. V. Ravenswaay fecit
Museum of Western European and Oriental Art, Riga. Inv. No. 141

PROVENANCE		REFERENCES
Until 1862	The V. Brederlo Collection, Riga	Neumann 1906, No. 147; *Catalogue. Riga*
1868	The Brederlc Picture Gallery, Riga	1955, p. 70.
1905	Museum of Western European and Oriental Art, Riga	

305

WILLEM ROELOFS

Born 1822 in Amsterdam, died 1897 in Antwerp. Pupil of
Abraham Hendrik Winter in Utrecht and Hendricus van de
Sande Bakhuyzen (from 1840). Traveled along the Rhine (1841).
Worked in Barbizon for a while (1851). Was one of the founding
members of the Studio Pulchri in The Hague (1847) and the
Society of Watercolorists (1855). Painted landscapes.

305

Landscape with a Lake

Oil on canvas, 29 1/2×39 3/8" (75×100 cm.)
Signed and dated, bottom right: W. Roelofs. f. 1854
The Hermitage, Leningrad. Inv. No. 3949

PROVENANCE

Until 1922 Museum of the Academy of Arts,
 Petrograd
1922 The Hermitage, Petrograd

REFERENCES

* Catalogue. The Kushelev Gallery 1886, No.
306; * Catalogue. The Hermitage 1958, 2, p. 298.

REMIGIUS ADRIANUS VAN HAANEN

Born 1812 in Oosterhout, died 1894 in Auszee. Pupil of Casparis van Haanen (his father) and Jan van Revenswaay. Traveled to Germany (1834–35), Vienna (from 1836), and St. Petersburg (between 1850 and 1854). Painted landscapes and urban views.

306

The Gathering Storm

Oil on panel, 9 ³/₈×19 ¹/₄″ (24×49 cm.)
Signed and dated bottom right: RvHaanen f 74
Art Museum, Ulyanovsk. Inv. No. 136

This is a companion piece to the picture *Landscape*, also in the Ulyanovsk Art Museum (inv. No. 503). In Vienna the artist was known as Remy van Haanen and thus signed his works.

PROVENANCE	REFERENCES
Until 1918 The E. Percy-French Collection, Simbirsk | * *Catalogue. Ulyanovsk* 1957, p. 92.
1918 Art Museum, Simbirsk (now Ulyanovsk) |

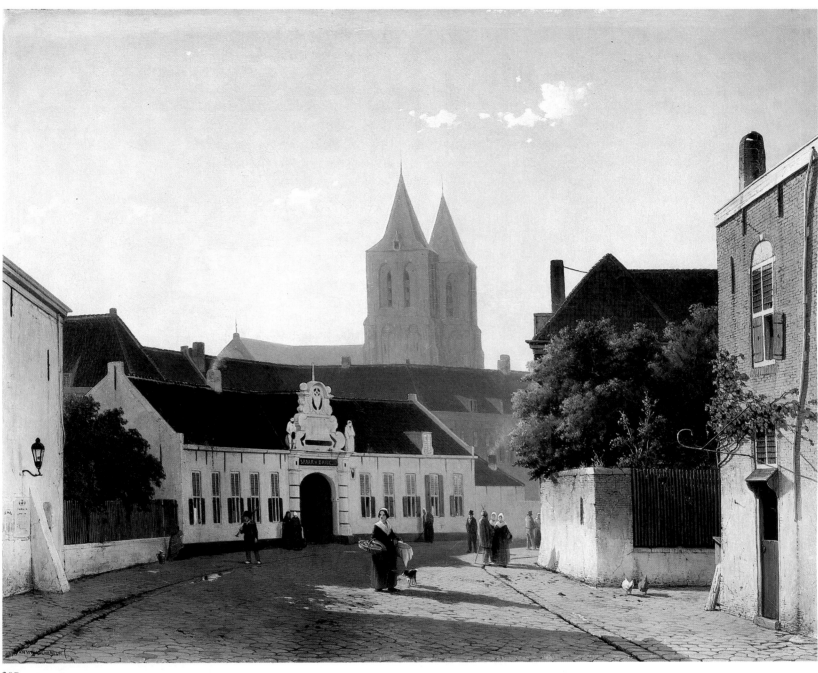

307

JAN WEISSENBRUCH

Born 1822 in The Hague, died in that city in 1880. Studied under
Salomon Leonardus Verveer and at the Academy of Drawing in
The Hague (1839–47). Worked mostly in The Hague. Painted
townscapes, genre scenes, and portraits. Was also
a watercolorist, etcher, and lithographer.

307

Street in a Dutch Town

Oil on canvas, 30×37 ³/₄" (76×96 cm.)
Signed, bottom left corner: Jan Weissenbruch
The Hermitage, Leningrad. Inv. No. 3824

<table>
<tr><td>PROVENANCE</td><td>REFERENCES</td></tr>
<tr><td>Until 1921 Museum of the Academy of Arts,
Petrograd</td><td>* Catalogue. The Kushelev Gallery 1886, No.
144; * Catalogue. The Hermitage 1958, 2, p. 290.</td></tr>
<tr><td>1921 The Hermitage, Petrograd</td><td></td></tr>
</table>

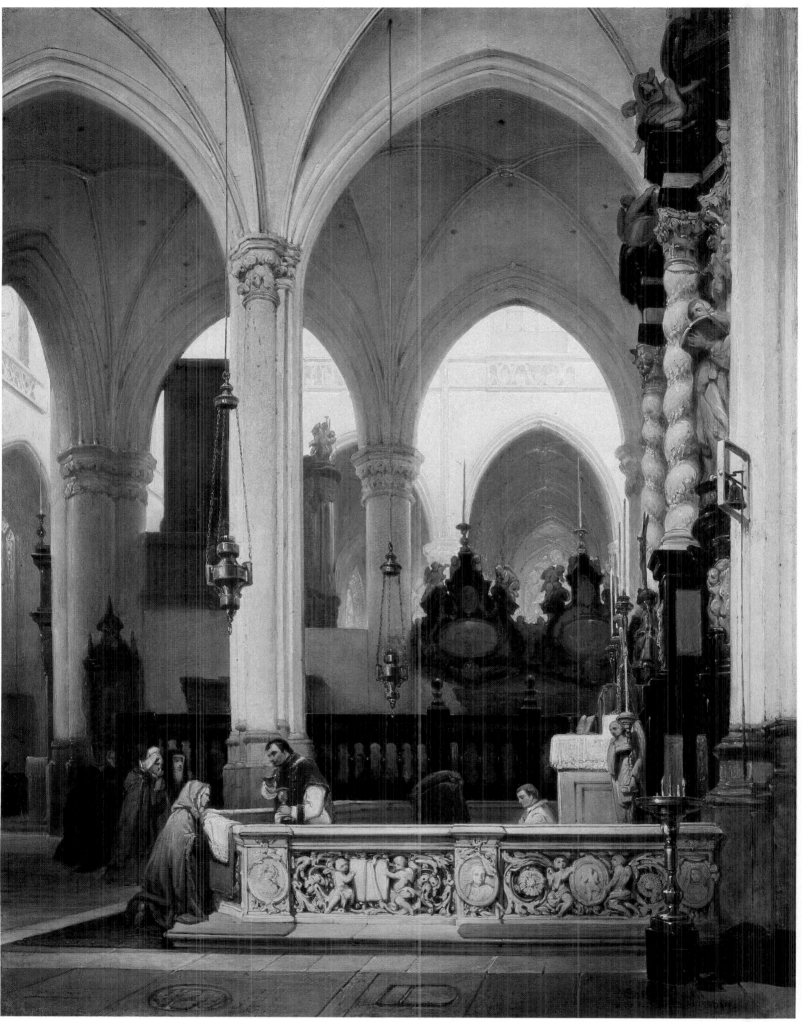

JOHANNES BOSBOOM

Born 1817 in The Hague, died there in 1891. Studied under Bartholomeus Johannes van Hove and at the Academy of Drawing in The Hague (1831–35 and 1839–40). Traveled in Germany, France, and Belgium (in the 1830s). Painted interior views of churches. Was also a draughtsman, etcher, and lithographer.

← 308

Interior View of the St. Jacobs Kerk in Antwerp

Oil on panel, 29 1/2×23 5/8" (75×60 cm.)
Signed, bottom right: J. Bosboom St. Jacobs Kerk Antverpen
The Hermitage, Leningrad. Inv. No. 3812

In the foreground, the tomb of Rubens.

PROVENANCE	REFERENCES
Until 1922 Museum of the Academy of Arts, Petrograd	* *Catalogue. The Kushelev Gallery* 1886, No. 128; * *Catalogue. The Hermitage* 1958, 2, p. 290.
1922 The Hermitage, Petrograd	

CAREL JACOBUS BEHR

Born 1842 in The Hague, died in that city in 1895. Pupil of Bartholomeus Johannes van Hove. Worked in The Hague. Painted architectural landscapes, mostly views of Dutch cities.

309

View of Leyden

Oil on panel, 17×20" (43×51 cm.)
Signed on boat, right: C. J. Behr
The Hermitage, Leningrad. Inv. No. 8292

PROVENANCE	REFERENCES
1937 The Hermitage, Leningrad (through the State Purchasing Commission)	* *Catalogue. The Hermitage* 1958, 2, p. 289.

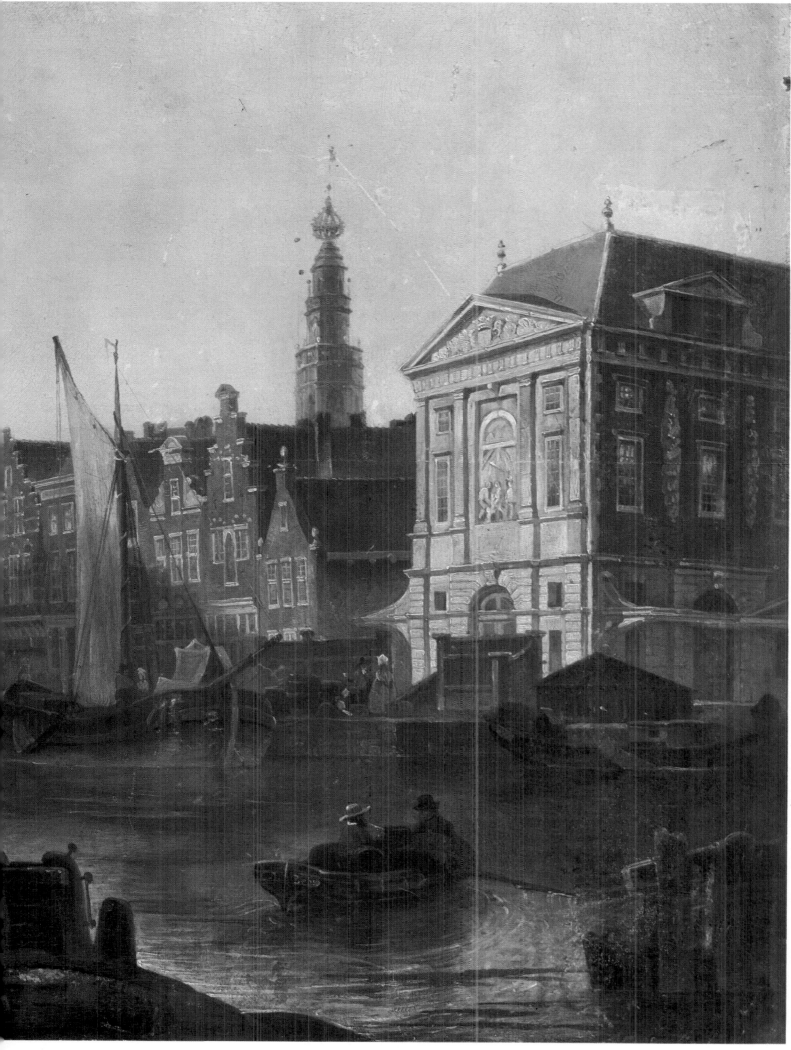

310

JOHANN BARTHOLD JONGKIND

Born 1819 in Latrop near Rotterdam, died 1891 in
Côte-Saint-André (France). Pupil of Andreas Schelfhout.
Worked in Paris, Picardy, and Normandy, with occasional trips
to Holland. Was a landscape painter, watercolorist, etcher,
and lithographer.

310

Canal Embankment

Oil on canvas, 16 ¹/₈×25 ⁵/₈" (41×65 cm.)
Signed and dated, bottom right: Jongkind 1869
The Pushkin Museum of Fine Arts, Moscow. Inv. No. 3440

PROVENANCE

The M. Riabushinsky Collection,
Moscow
Until 1925 The Tretyakov Gallery, Moscow
1925–37 Museum of Modern Western Art,
Moscow
1937 The Pushkin Museum of Fine
Arts, Moscow

REFERENCES

* *Catalogue. Museum of Modern Art* 1928, No.
196; * *Catalogue. The Pushkin Museum of Fine
Arts* 1961, p. 85.

JACOB HENDRIKUS MARIS

Born 1837 in The Hague, died 1899 in Carlsbad. Brother to the
painters Matthias and Willem Maris. Studied under Johan
Anthonie Balthasar Stroebel and Hubertus van Hove and at the
Antwerp Academy (1853). Traveled along the Rhine together
with his brother Matthias (1860). Lived in Paris where his art
was strongly influenced by the Barbizon school, Camille Corot,
and Johan Barthold Jongkind (1865–71). Painted genre scenes
and landscapes. Was also a watercolorist, etcher,
and lithographer.

311

Landscape with Windmills

Oil on canvas, 18 1/8×28 3/4" (46×73 cm.)
Signed, bottom right: J. Maris
The Hermitage, Leningrad. Inv. No. 6739

PROVENANCE		REFERENCES
Until 1931	Museum of the Academy of Arts, Leningrad	* *Catalogue. The Hermitage* 1958, 2, p. 297.
1931	The Hermitage, Leningrad	

311

HENDRICK WILLEM MESDAG

Born 1831 in Groningen, died 1915 in The Hague. Pupil of
C. B. Buys, Johannes Henderikus Egenberger, and Willem
Roelofs. Worked in The Hague and Brussels (1867–69). Painted
portraits, landscapes, and urban views.

312

Fishing Fleet

Oil on panel, 43 5/8×28 1/2" (110.5×72.5 cm.)
Signed, bottom right: H W Mesdag
Museum of Western European and Oriental Art, Kiev. Inv. No. 66

PROVENANCE

1933–36 Museum of Western European and
Oriental Art, Kiev (from the Kiev
Art Gallery)

REFERENCES

Catalogue. Kiev 1941, No. 47; * *Catalogue.
Kiev* 1961, No. 123.

VINCENT VAN GOGH

Born 1853 in Groot-Zundert (North Brabant),
died 1890 in Auvers-sur-Oise (France). Began painting
systematically in 1880. Took lessons in painting from
Anton Mauve. Worked in Belgium and Holland
(until 1886), then in France: Paris (1886–88),
Arles (1888–89), Saint-Rémy (1889–90), and
Auvers-sur-Oise (1890). Painted landscapes, portraits,
still lifes, and genre scenes.

313

Seascape at Saintes-Maries

Oil on canvas, 17 1/4×20 3/4" (44×53 cm.)
Signed, bottom right corner: Vincent
The Pushkin Museum of Fine Arts, Moscow. Inv. No. 3438

Executed in June, 1888. The picture is mentioned by Van Gogh in
a letter to his brother, Théo, dated June 22, 1888 (No. 499) and
sketched in a letter to Emile Bernard (B.6). The composition is
also recorded in drawings housed in the Kupferstichkabinett und
Sammlung der Zeichnungen, Berlin (Faille, 1430), the Solomon
R. Guggenheim Museum, New York (Faille, 1430a), and the
Musée d'Art Moderne, Brussels (Faille, 1430b).

PROVENANCE	REFERENCES
1908 The Ivan Morozov Collection, Moscow	* *Catalogue. Museum of Modern Western Art* 1928, No. 96; Scherjon, Gruyter 1937, No. 37; * *Catalogue. The Pushkin Museum of Fine Arts* 1961, p. 53; Faille, 417; *French Painting* 1979, No. 185.
1910 The Tretyakov Gallery, Moscow	
1925 Museum of Modern Western Art, Moscow	
1948 The Pushkin Museum of Fine Arts, Moscow	

314

314

Portrait of Doctor Félix Rey

Oil on canvas, 25 1/4×20 3/4" (64×53 cm.)
Signed and dated, bottom right: Vincent Arles 89
The Pushkin Museum of Fine Arts, Moscow. Inv. No. 3272

Painted in January, 1889, in Arles. Félix Rey was Van Gogh's physician in
Arles. In a letter to his brother of January 7, 1889 (No. 568), the artist wrote:
"I'm thinking of doing a portrait of Mr. Rey..." Ten days later (January 17,
No. 571) he reported: "...have done three studies and also a portrait of
Mr. Rey which I presented to him for a keepsake."

PROVENANCE		REFERENCES
1889–1900	In the possession of Dr. Rey, Arles	* *Catalogue. The Shchukin Collection* 1913, No.
1900	The Ch. Camoin Collection, Paris	33; * Tugendhold 1914, p. 39; * *Catalogue. Mu-*
	The A. Vollard Collection, Paris	*seum of Modern Western Art* 1928, No. 80;
	The P. Cassirer Collection, Berlin	Scherjcn, Gruyter 1937, No. 144; * *Catalogue.*
	The E. Druet Collection, Paris	*The Pushkin Museum of Fine Arts* 1961, p. 53;
1908	The Sergei Shchukin Collection, Moscow	Faille, 500; *French Painting* 1979, No. 188.
1918	Museum of Modern Western Art, Moscow	
1948	The Pushkin Museum of Fine Arts, Moscow	

315

The Red Vineyard—Montmajour

Oil on canvas, 29 1/2×36 5/8" (75×93 cm.)
The Pushkin Museum of Fine Arts, Moscow. Inv. No. 3372

Executed in Arles in November, 1888. Walking with Gauguin in
Montmajour, Van Gogh was struck by the sight of a vineyard in the dusk. In
a letter to his brother (No. 559) he wrote: "Oh, why weren't you with us on
Sunday? We saw a completely red vineyard, red as red wine. From afar it
seemed yellow, over it was a green sky, all around was ground purple after
a shower, and here and there on that ground yellow reflexes of the setting
sun." The picture itself is mentioned in letters to his brother mailed
approximately between October 29 and November 12, 1888 (Nos. 559, 561),
in the following year on May 2 (No. 589) and November 16 (No. 614), and
also in a letter to O. Maousse dated November 20, 1889, wherein Van Gogh
agrees to dispatch six of his pictures, including *The Red
Vineyard—Montmajour*, to an exhibition of "The Twenty" in Brussels. Théo
van Gogh praised the picture, and the Belgian painter Anna Boch bought it
when the Brussels exhibition closed. It has recently been suggested
(by T. Faider-Thomas) that the picture sold in February 1890 for 400 francs
was not *The Red Vineyard*, but very probably a sunflower still life.
Also known is the fact that Anna Boch (and this is confirmed in a letter of
June 29, 1891, from O. Maousse to Théo's widow) purchased a Van Gogh
picture for 350 francs from the art dealer Tangly in Paris in the May of that
year. It is, however, the publication of Théo van Rysselberghe's letter to

315

Eugene Boch (February, 1907) that puts everything into its proper perspective. The letter states flatly that Anna Boch had two Van Gogh canvases in her collection: "Your sister came to see me recently. You know, she sold both her Van Goghs for ten thousand..." (*see* Anna Boch und Eugene Boch, *Werke aus den Anfängen der modernen Kunst. Moderne Galerie, Saarbrücken*, 1971, p. 10).

PROVENANCE		REFERENCES
1891	The J. Tanguy Collection, Paris	* *Catalogue. Museum of Modern Western Art* 1928, No. 82; Scherjon, Gruyter 1937, No. 119; * *Catalogue. The Pushkin Museum of Fine Arts* 1961, P. 53; T. Faider-Thomas, *Miscellanea Josef Duverger*, 1968, pp. 402–410; Faille, 495; *French Painting* 1979, No. 187.
1891–1906	The Anna Boch Collection, Brussels	
1907	The Prince de Wagram Collection, Paris	
	The E. Druet Collection, Paris	
1909	The Ivan Morozov Collection, Moscow	
1918	Museum of Modern Western Art, Moscow	
1948	The Pushkin Museum of Fine Arts, Moscow	

316

Cottages with Thatched Roofs

Oil on canvas, 23 5/8×28 3/4" (60×73 cm.)
The Hermitage, Leningrad. Inv. No. 9117

Painted in May, 1890, in Auvers, this is one of the first pictures of the artist's
final period. Van Gogh informs his brother about it immediately after
arriving in Auvers (No. 636, about May 21): "I am now painting a study—old
houses with thatched roofs, wheatfields and blossoming peas in the
foreground and hills in the distance." In July 1890 he repeats the motif in
a watercolor (F. 1640 recto, Rijksmuseum Vincent van Gogh, Amsterdam).
A comparison of the watercolor with the painting reveals a markedly more
expressionistic approach in Van Gogh's artistic perception of reality.

←

REFERENCES

Hôtei Drouot. Catalogue des tableaux modernes 1908, May, Paris, No. 26; * *Catalogue. Museum of Modern Western Art* 1928, No. 84; * *Catalogue. The Hermitage* 1958, 2, p. 291; *The Hermitage, Leningrad: French 19th Century Masters*, Prague–Leningrad, 1970, No. 69; Faille, 750; *French Painting* 1975, No. 51.

317

The Lilac Bush

Oil on canvas, 28 3/4×36 1/4" (73×92 cm.)
Signed, bottom left corner: Vincent
The Hermitage, Leningrad. Inv. No. 6511

Painted in May, 1889, in Saint-Rémy. Some art historians believe the picture to have been painted in August, 1888 (the Arles period). The assertion is grounded on the fact that the painterly manner of this canvas resembles that of Van Gogh's Impressionist period, and on the artist's letter to Théo dated August 14 or 15, 1888 (No. 524), in which he refers to a large landscape with bushes. The iconographic details of the landscape, however—the low brick fence, the purple irises bordering the pathway, and the lilac bush—all point to his Saint-Rémy retreat where he underwent treatment from May, 1889, to May, 1890.

In a letter to his brother dated May 9 (No. 591), i.e. the day after his arrival in Saint-Rémy, Van Gogh wrote: "I have going two new subjects which I discovered right here in the garden—purple irises and a lilac bush." *The Irises* is now in a private collection in New York (Faille, 608), the *Lilac Bush* is in the Hermitage.

The Leningrad picture is, therefore, a brilliant example of the harmony and freshness that characterized the artist's perception of nature even during this difficult period of his life.

REFERENCES

* *Catalogue. The Shchukin Collection* 1913, No. 36; * *Tugendhold* 1914, p. 39; * *Catalogue. Museum of Modern Western Art* 1928, No 77; Scherjon, Gruyter 1937, No. 71; * *Catalogue. The Hermitage* 1958, 2, p. 291; * *Asayevich* 1964, p. 109; *The Hermitage, Leningrad: French 19th Century Masters*, Prague–Leningrad, 1970, No. 67; Faille, 579; *French Painting* 1975, No. 52.

318

The Prison Courtyard

Oil on canvas, 31 1/2×25 1/4" (80×64 cm.)
The Pushkin Museum of Fine Arts, Moscow. Inv. No. 3373

Painted in February, 1890, in Saint-Rémy. Van Gogh wrote to his brother on January 10 (No. 623): "I want to do Daumier's *Drinkers* and Regamé's *Penal Prison* in oils. Please see if you can find the two woodcuts for me." A month later, February 11 (No. 626), he has this to say on the subject: "Have tried to copy Daumier's *Drinkers* and Doré's *Penal Prison*: it's a very difficult job." Our picture is indeed a copy, though not from Regamé, but from a Doré woodcut (*Newgate—The Exercise Yard*, from *London: A Pilgrimage by Gustave Doré and Blanchard Jerrold*, London, 1872). It and *The Red Vineyard* (*see* plate 315) were selected for purchase by Ivan Morozov and Valentin Serov when they visited the exhibition in the Hotel Drouot together.




PROVENANCE

The Jo Van Gogh-Bönger Collection, Amsterdam
1906 The E. Druet Collection, Paris
1909 The Prince de Wagram Collection, Paris
The E. Druet Collection, Paris
The Ivan Morozov Collection, Moscow
1918 Museum of Modern Western Art, Moscow
1948 The Pushkin Museum of Fine Arts, Moscow




REFERENCES

* *Catalogue. Museum of Modern Western Art* 1928, No. 83; Scherjon, Gruyter 1937, No. 96; J. Navotny, *Festschrift Kurt Badt*, Berlin, 1961, p. 215; * *Catalogue. The Pushkin Museum of Fine Arts* 1961, p. 53; Faille, 669; *French Painting* 1979, No. 189.




KEES VAN DONGEN

Born 1877 in Delftshaven near Rotterdam, died 1968 in Monaco. Studied at the Academy of Fine Arts in Rotterdam under professors Jan Straning and Johannes Gerardus Heyberg. Was in Spain, Morocco, Egypt, and other countries. Worked in Paris and Monaco. Painted portraits and figure compositions, less frequently landscapes and still lifes.

319

The Red Danseuse

Oil on canvas, 39×31 ¹/₂" (99×80 cm.)
Signed, bottom left corner: van Dongen
The Hermitage, Leningrad. Inv. No. 9129

Painted around 1907, in the period when the artist lived and worked with Pablo Picasso in the Bateau-Lavoir. The influence of Picasso's works (of his *Les Demoiselles d'Avignon* period) is evident here in the sharp, almost triangular profile of the woman. But the vivid, almost "venomous" colors of the picture reflect the searchings of Van Dongen himself, who, Fauvist that he was, used artificial illumination to heighten the sonority of his colors.

	PROVENANCE	REFERENCES
1909	The N. Riabushinsky Collection, Moscow	* *Catalogue. The Golden Fleece* 1909, No. 34; * Ternovets 1922, pp. 21–29; * *Catalogue. Museum of Modern Western Art* 1928, No. 180; * *Catalogue. The Hermitage* 1958, 1, p. 385; *Van Dongen: Paris, Musée National d'Art Moderne; Rotterdam, Museum Boymans–van Beuningen*, 1967–68, No. 164; *The Hermitage, Leningrad: French 20th Century Masters*, Prague–Leningrad, 1970, No. 45; *French Painting* 1975, No. 207.
Until 1918	The M. Mazurin Collection, Moscow	
1918	The Sixth Proletarian Museum, Moscow	
1920	Museum of Modern Western Art, Moscow (through the State Museum Reserve)	
1948	The Hermitage, Leningrad	

320

Lady in a Black Hat

Oil on canvas, 39 3/8×31 3/4" (100×81 cm.)
Signed, bottom right: van Dongen
The Hermitage, Leningrad. Inv. No. 6572

This is very likely a portrait of a music-hall actress. It may have been exhibited at the Salon d'Automne of 1909 (cat. No. 430).

PROVENANCE

	The Kahnweiler Gallery, Paris
Until 1918	The Sergei Shchukin Collection, Moscow
1918	Museum of Modern Western Art, Moscow
1931	The Hermitage, Leningrad

REFERENCES

Catalogue. The Shchukin Collection 1913, No. 56; * *Catalogue. Museum of Modern Western Art* 1928, No. 178; * *Catalogue. The Hermitage* 1956, p. 26; * *Catalogue. The Hermitage* 1958, 1, p. 385; *Van Dongen: Paris, Musée National d'Art Moderne; Rotterdam, Museum Boymans–van Beuningen*, 1967–68, No. 62a; *The Hermitage, Leningrad: French 20th Century Masters*, Prague–Leningrad, 1970, No. 46; *French Painting* 1975, No. 208.

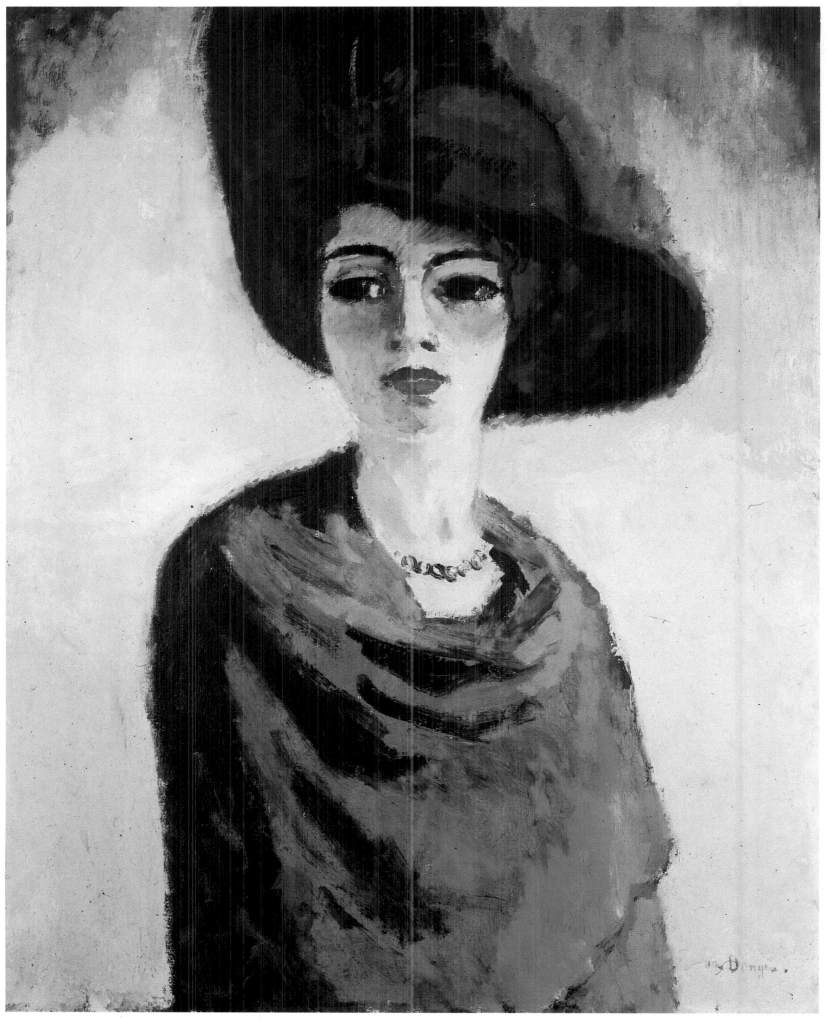

321

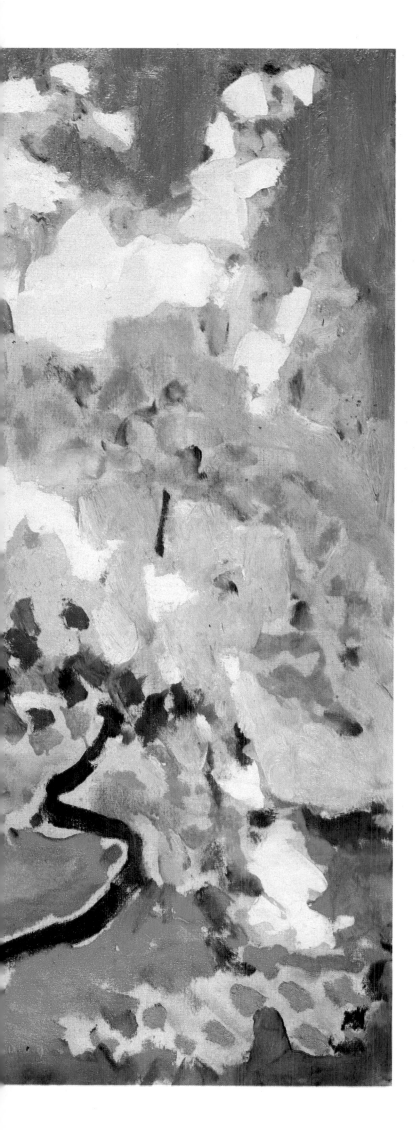

321

Spring

Oil on canvas, 31 1/2×39" (80×99 cm.)
Signed, bottom right: van Dongen
The Hermitage, Leningrad. Inv. No. 9130

Painted around 1907.

PROVENANCE		REFERENCES
1908	The Bernheim-Jeune Gallery, Paris	*Catalogue. The Shchukin Collection* 1913, No. 57; * *Catalogue. Museum of*
Until 1918	The Sergei Shchukin Collection, Moscow	*Modern Western Art* 1928, No. 177; * *Catalogue. The Hermitage* 1958, 1, p.
Until 1948	Museum of Modern Western Art, Moscow	385; *French Painting* 1975, No. 206.
1948	The Hermitage, Leningrad	

322 →

Spanish Woman

Oil on canvas, 18 1/8×15 3/8" (46×39 cm.)
Signed, top right corner: van Dongen
The Pushkin Museum of Fine Arts, Moscow. Inv. No. 3972

Possibly painted during a trip to Spain in 1911.

PROVENANCE		REFERENCES
Until 1966	The G. Kostaki Collection, Moscow	"La Chronique des arts," *Gazette des Beaux-Arts*, 72, 1968, No. 465, p. 127;
1966	The Pushkin Museum of Fine Arts, Moscow	*French Painting* 1979, No. 254.

322

Abbreviations

Index

ABBREVIATIONS

Agafonova 1940 — K. Agafonova, "On the History of the Composition of *Danaë* and *The Prodigal Son*," *Papers of the Hermitage*, 1, 1940 [К. Агафонова, «К истории композиции *Данаи* и *Блудного сына*», *Труды Государственного Эрмитажа*, 1, 1940]

Art in Southern Russia 1913 — *Art in Southern Russia*, 1913, January–December [*Искусство в южной России*, 1913, январь–декабрь]

Art Museum, Riazan 1927 — *Art Museum, Riazan. Picture Gallery*, Riazan, 1927 [*Рязанский Государственный художественный музей. Картинная галерея*, Рязань, 1927]

Art Treasures in Russia — *Художественные сокровища России*

Asayevich 1964 — K. Asayevich, "*The Lilac Bush* by Van Gogh," in: *The Hermitage*, Leningrad, 1964 [К. Асаевич, «*Куст* Ван Гога», в кн.: *Эрмитаж*, Ленинград, 1964]

B. — A. Bartsch, *Catalogue raisonné de toutes les estampes qui forment l'œuvre de Rembrandt et ceux de ses principaux imitateurs*, 2 vols., Vienna, 1797

Bauch 1933 — K. Bauch, *Die Kunst des jungen Rembrandt*, Heidelberg, 1933

Bauch 1960 — K. Bauch, *Der frühe Rembrandt und seine Zeit: Studien zur geschichtlichen Bedeutung seines Frühstils*, Berlin, 1960

Bauch 1966 — K. Bauch, *Rembrandt: Gemälde*, Berlin, 1966

Benesch 1935 — O. Benesch, *Rembrandt: Werk und Forschung*, Vienna, 1935

Benesch — O. Benesch, *The Drawings of Rembrandt*, 7 vols., London, 1954–57

Benois 1913 — N. Benois, *A History of Landscape Painting*, vol. 2, St. Petersburg, 1913 [Н. Бенуа, *История пейзажной живописи*, т. 2, Санкт-Петербург, 1913]

Berezina 1972 — V. Berezina, *The Hermitage. Nineteenth-century French Painting from David to Fantin-Latour*, Leningrad, 1972 [В. Н. Березина, *Государственный Эрмитаж. Французская живопись XIX века от Давида до Фантен-Латура*, Ленинград, 1972]

Bloch 1921 — V. Bloch, "Netherlandish Masters in Moscow Collections," *Art Collectors' Journal*, 1921, No. 8/9 [В.С.Блох,«Нидерландские мастера в московских собраниях», *Среди коллекционеров*, 1921, № 8/9]

Bloch 1922 — V. Bloch, "New Acquisitions of the Rumiantsev Museum. Seventeenth-century Dutch and Flemish Artists," *Art Collectors' Journal*, 1922, No. 9 [В. Блох, «Новые поступления Румянцевского музея. Голландские и фламандские мастера XVII века», *Среди коллекционеров*, 1922, № 9]

Bode 1873 — W. Bode, *Die Gemäldegalerie in der Kaiserlichen Eremitage. Meisterwerke der holländischen Schule*, St. Petersburg, 1873

Bode 1883 — W. Bode, *Studien zur Geschichte der holländischen Malerei*, Braunschweig, 1883

Bode, Hofstede de Groot 1897–1906 — W. Bode, C. Hofstede de Groot, *Rembrandt. Beschreibendes Verzeichnis seiner Gemälde*, Paris, 1897–1906

Bredius 1935 — A. Bredius, *Rembrandt: schilderijen*, Utrecht, 1935

Bredius 1969 — A. Bredius, *Rembrandt: The Complete Edition of the Paintings* (revised by H. Gerson), London, 1969

Caravaggio and His Followers 1975 — *Caravaggio and His Followers* (introductory article and notes by S. Vsevolozhskaya and I. Linnik), Leningrad, 1975

Catalogue. Academy of Arts 1874 — A. Somov, *Picture Gallery of the Academy of Arts. Catalogue of Western European Paintings*, St. Petersburg, 1874 [А. Сомов, *Картинная галерея Императорской Академии художеств. Каталог произведений иностранной живописи*, Санкт-Петербург, 1874]

Catalogue. Caravaggio and His Followers 1973 — *Caravaggio and His Followers. Exhibition Catalogue*, Leningrad, 1973 [*Караваджо и караваджисты. Каталог выставки картин из музеев СССР*, Ленинград, 1973]

Catalogue. H. Brokard Collection 1903 — *Catalogue of the H. Brokard Collection*, Moscow, 1903 [*Каталог картин Г. А. Брокара*, Москва, 1903]

Catalogue. Irkutsk 1957 — *Art Museum, Irkutsk. Western European Art. Catalogue*, Irkutsk, 1957 [*Иркутский областной художественный музей. Западноевропейское искусство. Каталог*, Иркутск, 1957]

Catalogue. Kalinin 1940 — *Picture Gallery, Kalinin. Exhibition of Sixteenth- to Nineteenth-century Western European Painting. Catalogue*, Kalinin, 1940 [*Калининская областная картинная галерея. Выставка западноевропейской живописи XVI–XIX веков. Каталог*, Калинин, 1940]

Catalogue.
Kaluga 1959

Art Museum, Kaluga. Catalogue, Leningrad, 1959 [Калужский областной художественный музей. Каталог, Ленинград, 1959]

Catalogue.
Kazan 1927

Central Museum of the Tatar ASSR. Catalogue of Paintings, Kazan, 1927 [Центральный музей Татарской АССР. Каталог художественного отдела (живопись), Казань, 1927]

Catalogue.
Kazan 1934

Realist Art of the Seventeenth-century Dutch Bourgeoisie. Exhibition of Works from the Central Museum of the Tatar ASSR in the House of Scientists. Catalogue, Kazan, 1934 [Реалистическое искусство голландской торговой буржуазии XVII века. Выставка Центрального музея Татарской АССР в Доме ученых. Каталог, Казань, 1934]

Catalogue.
Kazan 1958

Art Museum of the Tatar ASSR. Exhibition of Western European Art. Catalogue, Kazan, 1958 [Государственный музей Татарской АССР. Выставка произведений западноевропейского искусства. Каталог, Казань, 1958]

Catalogue.
Khanenko 1899

B. and V. Khanenko, Collection of Paintings by Italian, Spanish, Flemish and Other Artists, Kiev, 1899 [Б. И. и В. Н. Ханенко, Собрание картин итальянской, испанской, фламандской и других школ, Киев, 1899]

Catalogue.
Kharkov 1877

Catalogue of Paintings Housed in the Museum of Fine Arts of Kharkov University, Kharkov, 1877 [Указатель произведений, хранящихся в музее изящных искусств при императорском Харьковском Университете, Харьков, 1877]

Catalogue.
Kharkov 1959

Art Museum, Kharkov. Department of Western European Art. Catalogue and Guide, Kharkov, 1959 [Харьковский государственный музей изобразительных искусств. Путеводитель и каталог Отдела западноевропейской живописи, Харьков, 1959]

Catalogue.
Kiev 1931

Art Museum of the Ukrainian SSR Academy of Sciences, Kiev. Catalogue, Kiev, 1931 [Музей мистецтв Всеукраїнської академії наук. Каталог картин, Київ, 1931]

Catalogue.
Kiev 1941

Museum of Western European and Oriental Art, Kiev. Western European Landscapes. Exhibition Catalogue, Kiev, 1941 [Державний музей західного та східного мистецтва у Києві. Каталог виставки західно-європейського пейзажу, XVII–XIX ст., Київ, 1941]

Catalogue.
Kiev 1961

Museum of Western European and Oriental Art, Kiev. Catalogue of Western European Paintings and Sculptures, Moscow, 1961 [Киевский государственный музей западного и восточного искусства. Каталог западноевропейской живописи и скульптуры, Москва, 1961]

Catalogue.
Krasnodar 1953

The Lunacharsky Art Museum, Krasnodar. Catalogue, Krasnodar, 1953 [Краевой художественный музей имени А. В. Луначарского. Каталог, Краснодар, 1953]

Catalogue.
Lvov 1955

Art Gallery, Lvov. Catalogue, Kiev, 1955 [Львівська державна картинна галерея. Каталог художніх творів, Київ, 1955]

Catalogue.
Moscow 1862

Public Museum, Moscow. Catalogue, Moscow 1862 [Каталог картин Московского Публичного музеума, Москва, 1862]

Catalogue.
Museum of
Modern
Western
Art 1928

Museum of Modern Western Art, Moscow. Catalogue, Moscow, 1928 [Каталог Государственного музея нового западного искусства, Москва, 1928]

Catalogue.
Odessa 1973

Museum of Western European and Oriental Art, Odessa. Catalogue, Kiev, 1973 [Одесский музей западного и восточного искусства. Каталог, Киев, 1973]

Catalogue.
Private
Collections
1915

Exhibition of Old Master Paintings from Moscow Private Collections. Catalogue, Moscow, 1915 [Выставка старых западных мастеров из московских частных собраний. Каталог, Москва, 1915]

Catalogue.
Rembrandt 1956

Exhibition of Paintings by Rembrandt and His Followers. Catalogue, Moscow, 1956 [Выставка произведений Рембрандта и его школы в связи с 350-летием со дня рождения. Каталог, Москва, 1956]

Catalogue.
Rembrandt 1969

Rembrandt. His Precursors and Followers. Exhibition Catalogue, Leningrad, 1969 [Рембрандт, его предшественники и последователи. Каталог выставки, Ленинград, 1969]

Catalogue.
Riazan 1957

Art Museum, Riazan. Catalogue, Riazan, 1957 [Рязанский областной художественный музей. Каталог, Рязань, 1957]

Catalogue.
Riga 1955

Art Museum, Riga. Catalogue of Paintings, Riga, 1955 [Государственный музей изобразительных искусств. Каталог живописи, Рига, 1955]

Catalogue.
Riga 1973

Art Museum of the Latvian SSR. Catalogue of Netherlandish, Dutch and Flemish Paintings, Riga, 1973 [Музей изобрази-

**Catalogue.
Saratov 1969** — *The Radishchev Art Museum, Saratov. Catalogue of Western European Paintings,* Saratov, 1969 [*Саратовский Государственный художественный музей имени А. Н. Радищева. Западноевропейская живопись. Каталог,* Саратов, 1969]

**Catalogue
Semenov 1906** — *Catalogue de la Collection Semenov,* St. Petersburg, 1906

**Catalogue.
Tallinn 1953** — *Lääne-Euroopa rahvaste realistlik kunst. Kataloog,* Tallinn, 1953

**Catalogue.
Tallinn 1970** — *Tallinna Riiklik Kunstimuuseum. XVII sajandi hollandi ja flaami kunsti kogu kataloog,* Tallinn, 1970

**Catalogue.
The Golden
Fleece 1909** — *The Golden Fleece: Exhibition Catalogue,* Moscow, 1909 [*Каталог выставки «Золотое Руно»,* Москва, 1909]

**Catalogues.
The Hermitage
1863–1916** — *The Imperial Hermitage. Catalogues of the Picture Gallery,* St. Petersburg–Petrograd, 1863–1916 [*Императорский Эрмитаж. Каталоги картинной галереи,* Санкт-Петербург–Петроград, 1863–1916]

**Catalogue.
The Hermitage
1956** — *The Hermitage. Exhibition of French Art: 12th–20th Centuries. Catalogue,* Moscow, 1956 [*Государственный Эрмитаж. Выставка французского искусства XII–XX веков. Каталог,* Москва, 1956]

**Catalogue.
The Hermitage
1958** — *The Hermitage, Department of Western European Art. Catalogue of Paintings,* 2 vols., Leningrad–Moscow, 1958 [*Государственный Эрмитаж. Отдел западноевропейского искусства. Каталог живописи,* т. 1, 2, Ленинград–Москва, 1958]

**Catalogue.
The Hermitage
1964** — *Western European Painting in Soviet Museums. Exhibition Catalogue,* Leningrad, 1964 [*Западноевропейская живопись из музеев СССР (выставка к 200-летию Государственного Эрмитажа). Каталог,* Ленинград, 1964]

**Catalogue.
The Kushelev
Gallery 1886** — *Picture Gallery of the Imperial Academy of Arts. Catalogue of the Count Kushelev-Bezborodko Gallery,* St. Petersburg, 1886 [*Картинная галерея императорской Академии художеств. Каталог галереи графа Н. А. Кушелева-Безбородко,* Санкт-Петербург, 1886]

**Catalogue.
The Old Years
1908** — *The Old Years: Exhibition Catalogue,* St. Petersburg, 1908 [*Старые годы. Каталог выставки,* Санкт-Петербург, 1908]

**Catalogue.
The Public and
Rumiantsev
Museums 1912** — *The Imperial Moscow Public and Rumiantsev Museums. Catalogue of the Picture Gallery,* Moscow, 1912 [*Императорский Московский Публичный и Румянцевский музей. Каталог картинной галереи,* Москва, 1912]

**Catalogue.
The Pushkin
Museum of Fine
Arts 1961** — *The Pushkin Museum of Fine Arts, Moscow. Catalogue of the Picture Gallery,* Moscow, 1961 [*Государственный музей изобразительных искусств имени А. С. Пушкина. Каталог картинной галереи,* Москва, 1961]

**Catalogue.
The Rumiantsev
Museum 1915** — *The Rumiantsev Museum. Catalogue of the Picture Gallery,* Moscow, 1915 [*Каталог картинной галереи Румянцевского музея,* Москва, 1915]

**Catalogue.
The Shchukin
Collection 1913** — *Catalogue of the Shchukin Collection,* Moscow, 1913 [*Каталог картин собрания С. И. Щукина,* Москва, 1913]

**Catalogue.
The Yusupov
Gallery 1920** — *State Museum Reserve. Catalogue of Art Works in the Former Yusupov Gallery,* Petrograd, 1920 [*Государственный музейный фонд. Каталог художественных произведений бывшей Юсуповской галереи,* Петроград, 1920]

**Catalogue.
Ulyanovsk 1957** — *Art Museum, Ulyanovsk. Catalogue of Russian, Soviet and Western European Paintings,* Ulyanovsk, 1957 [*Ульяновский областной художественный музей. Русская, советская и западноевропейская живопись. Каталог,* Ульяновск, 1957]

Chechulin 1912 — N. Chechulin, "What Is the Real Subject of Rembrandt's Painting Known as *Danaë*," *The Old Years,* 1912, June [Н. Чечулин, «Что изображено на картине Рембрандта, известной под именем *Данаи*», *Старые годы,* 1912, июнь]

Chlenov 1958 — A. Chlenov, "On *David and Uriah* by Rembrandt," *Art,* 1958, No. 10 [А. Членов, «К вопросу о сюжете картины Рембрандта *Давид и Урия*», *Искусство,* 1958, № 10]

Chlenov 1960 — A. Chlenov, "Who Is the Main Character in the Hermitage Painting of Rembrandt?," *Art,* 1960, No. 6 [А. Членов, «Кто героиня эрмитажной картины Рембрандта?», *Искусство,* 1960, № 6]

**Collection
Khanenko
1911–13** — *Collection Khanenko. Tableaux des écoles néerlandaise . . . ,* Kiev, 1911–13

Conradi 1917 — V. Conradi, *Among the Hermitage Pictures,* Petrograd, 1917 [В. Конради, *Среди картин Эрмитажа,* Петроград, 1917]

At the top left, continued from previous page:

тельного искусства Латвийской ССР. Живопись Нидерландов, Голландии, Фландрии, Рига, 1973]

Dulsky 1923 — P. Dulsky, "Western European Painters in the Kazan Museum," in: *Twenty-five Years of the Kazan Museum*, Kazan, 1923 [П. Дульский, «Иностранные живописцы в Казанском музее», в кн.: *Казанский музей за 25 лет*, Казань, 1923]

Fabrikant 1927 — M. Fabrikant, "An Early Self-portrait by Michiel van Musscher," *Publications of the Society for the Study of Russian Country Estates*, 1927 [М. И. Фабрикант, «Ранний автопортрет Ван-Мюсхера», *Сборник Общества изучения русской усадьбы*, 1927]

Faille — J. B. de la Faille, *The Works of Vincent van Gogh: His Paintings and Drawings* (revised, augmented and annotated edition of de la Faille 1928), Amsterdam, 1970

Fechner 1949 — E. Fechner, *Netherlandish Painting of the 16th Century*, Leningrad, 1949 [Е. Фехнер, *Нидерландская живопись XVI века*, Ленинград, 1949]

Fechner 1955 — E. Fechner, *"Granida and Daifilo* by Caspar Casteleyns," *Reports of the Hermitage*, 7, 1955 [Е. Фехнер, «Картина Каспара Кастелейнса *Гранида и Дайфило*», *Сообщения Государственного Эрмитажа*, 7, 1955]

Fechner 1958 — E. Fechner, *Paintings by Jacob van Ruisdael in the Hermitage*, Leningrad, 1958 [Е. Фехнер, *Якоб ван Рейсдаль и его картины в Государственном Эрмитаже*, Ленинград, 1958]

Fechner 1960 — E. Fechner, *"Portrait of a Man* by Frans Hals," *Reports of the Hermitage*, 19, 1960 [Е. Фехнер, «Мужской портрет работы Франса Гальса», *Сообщения Государственного Эрмитажа*, 19, 1960]

Fechner 1961 — E. Fechner, *"Moses Strikes Water from the Rock* by Reyer van Blomendael," *Reports of the Hermitage*, 21, 1961 [Е. Фехнер, «Картина Рейнера ван Бломендаля *Моисей, источающий воду из скалы*», *Сообщения Государственного Эрмитажа*, 21, 1961]

Fechner. Ryckhals 1961 — E. Fechner, "Paintings by Ryckhals," *Papers of the Hermitage*, 6, 1961 [Е. Фехнер, «Картины Рейкгальса», *Труды Государственного Эрмитажа*, 6, 1961]

Fechner 1963 — E. Fechner, *Seventeenth-century Dutch Landscapes in the Hermitage*, Leningrad, 1963 [Е. Фехнер, *Голландская пейзажная живопись XVII века в Эрмитаже*, Ленинград, 1963]

Fechner 1965 — E. Fechner, *Rembrandt Paintings in Soviet Museums*, Leningrad–Moscow, 1965 [Е. Фехнер, *Рембрандт. Произведения живописи в музеях СССР*, Ленинград–Москва, 1965]

French Painting 1975 — *French Painting: Second Half of the 19th to Early 20th Century. The Hermitage Museum, Leningrad*, Leningrad, 1975

French Painting 1979 — *French Painting from the Pushkin Museum of Fine Arts, Moscow: 17th to 20th century*, Leningrad, 1979

Friedländer — M. J. Friedländer, *Die altniederländische Malerei*, 14 vols., Berlin, 1924–37

Friedman 1973 — M. Friedman, "From the Art Collection of Peter the Great," *The Neva*, 1973, No. 6 [М. Фридман, «Из Петровской коллекции», *Нева*, 1973, № 6]

Gerson 1968 — H. Gerson, *Rembrandt Paintings*, Amsterdam, 1968

Haak 1968 — B. Haak, *Rembrandt: zijn leven, zijn werk, zijn tijd*, Amsterdam, 1968

Hamann 1948 — R. Hamann, *Rembrandt*, Berlin, 1948

Hoet 1752 — G. Hoet, *Catalogus of Naamlijst van schilderijen, met derselven prijzen . . .*, 2 vols., The Hague, 1752

Hofstede de Groot — C. Hofstede de Groot, *Beschreibendes und kritisches Verzeichnis der Werke der hervorragendsten holländischen Maler des XVII. Jahrhunderts*, 10 vols., Esslingen–Paris, 1907–28

Hoogewerff — G. J. Hoogewerff, *De Noord-Nederlandsche Schilderkunst*, The Hague, part II, 1937; part III, 1939; part IV, 1941–42

In Memory of Semionov 1915 — *In Memory of Piotr Semionov-Tien-Shansky. Catalogue*, Petrograd, 1915 [*Памяти Петра Петровича Семенова-Тян-Шанского. Каталог* (составил бар. Н. Н. Врангель), Петроград, 1915]

Kaluga Museum 1929 — *Art Department of the Kaluga Museum*, Kaluga, 1929 [*Художественный отдел Калужского областного музея*, Калуга, 1929]

Karel van Mander 1940 — Karel van Mander, *A Book of Artists*, Moscow–Leningrad, 1940 [Карель ван Маннер, *Книга о художниках*, Москва–Ленинград, 1940]

Kharinova 1923 — E. Kharinova, "Dutch and Flemish Painting in the Pavlovsk Palace Museum," in: *The Town*, Petrograd, 1923 [Е. Харинова, «Голландская и фламандская живопись Павловского дворца-музея», в сб.: *Город*, Петроград, 1923]

Knuttel 1956 — G. Knuttel, *Rembrandt. De meester en zijn werk*, Amsterdam, 1956

Koskull 1914 G. Koskull, "Adam Silo and Some of the Netherlandish Painters of Seascapes of the Petrine Epoch," *The Old Years*, 1914, June [Г. Коскуль, «Адам Сило и некоторые нидерландские маринисты времени Петра Великого», *Старые годы*, 1914, июнь]

Kuznetsov 1948 Yu. Kuznetsov, *Village Musicians*, Leningrad, 1948 [Ю. Кузнецов, «*Деревенские музыканты*», Ленинград, 1948]

Kuznetsov 1955 Yu. Kuznetsov, "A Newly Attributed Painting by Cornelis Bega," *Reports of the Hermitage*, 8, 1955 [Ю. И. Кузнецов, «Вновь определенная картина Корнелиса Бега», *Сообщения Государственного Эрмитажа*, 8, 1955]

Kuznetsov 1956 Yu. Kuznetsov, "A Newly Attributed Painting by Pieter de Bloot," *Reports of the Hermitage*, 9, 1956 [Ю. И. Кузнецов, «Вновь определенная картина Питера де Блоота», *Сообщения Государственного Эрмитажа*, 9, 1956]

Kuznetsov 1957 Yu. Kuznetsov, "An Unknown Type of Painting by Egbert van der Poel," *Reports of the Hermitage*, 11, 1957 [Ю. И. Кузнецов, «Неизвестный тип картины у Эгберта ван дер Пуля», *Сообщения Государственного Эрмитажа*, 11, 1957]

Kuznetsov 1958 Yu. Kuznetsov, "A New Painting by Jan van Scorel," *Art*, 1958, No. 9 [Ю. И. Кузнецов, «Новое произведение Яна ван Скореля», *Искусство*, 1958, № 9]

Kuznetsov. Jan Steen 1958 Yu. Kuznetsov, "Jan Steen in the Hermitage," *Annual of the History of Art Institute*, Moscow, 1958 [Ю. И. Кузнецов, «Картины Яна Стена в Государственном Эрмитаже», *Ежегодник института истории искусств*, Москва, 1958]

Kuznetsov 1959 Yu. Kuznetsov, *Seventeenth-century Dutch Painting in Soviet Museums*, Moscow, 1959 [Ю. И. Кузнецов, *Голландская живопись XVII века в музеях СССР*, Москва, 1959]

Kuznetsov. Van Scorel 1959 Yu. Kuznetsov, "A Newly Attributed Painting by Jan van Scorel," *Reports of the Hermitage*, 16, 1959 [Ю. И. Кузнецов, «Вновь открытые произведения Яна фан Скореля», *Сообщения Государственного Эрмитажа*, 16, 1959]

Kuznetsov 1960 Yu. Kuznetsov, *Adriaen van Ostade. Exhibition Catalogue*, Leningrad, 1960 [Ю. И. Кузнецов, *Адриан фан Остаде. Выставка произведений художника к 350-летию со дня рождения. Каталог-путеводитель*, Ленинград, 1960]

Kuznetsov. Berchem 1960 Yu. Kuznetsov, *Claesz Berchem Paintings in the Hermitage*, Moscow, 1960 [Ю. И. Кузнецов, *Клас Берхем и его произведения в Эрмитаже. Из истории русского и западноевропейского искусства*, Москва, 1960]

Kuznetsov 1961 Yu. Kuznetsov, "The *Parable of the Laborers in the Vineyard*" by Rembrandt," *Papers of the Hermitage*, 6, 1961 [Ю. И. Кузнецов, «Картина Рембрандта *Притча о работниках на винограднике*», *Труды Эрмитажа*, 6, 1961]

Kuznetsov. Jan Steen 1964 Yu. Kuznetsov, *Jan Steen*, 1964 [Ю. И. Кузнецов, *Ян Стен*, 1964]

Kuznetsov 1966 Yu. Kuznetsov, *Western European Still Lifes*, Leningrad–Moscow, 1966 [Ю. И. Кузнецов, *Западноевропейский натюрморт*, Ленинград–Москва, 1966]

Kuznetsov. Danaë 1966 Yu. Kuznetsov, "New Information on *Danaë* by Rembrandt," *Reports of the Hermitage*, 27, 1966 [Ю. И. Кузнецов, «Новое о картине Рембрандта *Даная*», *Сообщения Государственного Эрмитажа*, 27, 1966]

Kuznetsov 1967 Yu. Kuznetsov, *Western European Painting in Soviet Museums*, Leningrad, 1967 [Ю. И. Кузнецов, *Западноевропейская живопись в музеях СССР*, Ленинград, 1967]

Kuznetsov 1970 Yu. Kuznetsov, "New Information on Adriaen van Eemont," in: *Western European Art*, Leningrad, 1970 [Ю. И. Кузнецов, «Новое об Адриане фан Эмонте», в кн.: *Западноевропейское искусство. Сборник статей*, Ленинград, 1970]

Kuznetsov. Danaë 1970 Yu. Kuznetsov, *The Enigmas of Danaë. On the History of Rembrandt's Painting*, Leningrad, 1970 [Ю. И. Кузнецов, *Загадки «Данаи». К истории создания картины Рембрандта*, Ленинград, 1970]

Kuznetsov 1972 Yu. Kuznetsov, *The Hermitage: Painting*, Leningrad, 1972 [Ю. И. Кузнецов, *Государственный Эрмитаж. Живопись*, Ленинград, 1972]

Levinson-Lessing 1964 V. Levinson-Lessing, *The Hermitage, Leningrad: Dutch and Flemish Masters*, London, 1964

Linnik 1956 I. Linnik, "On the Subject of a Hermitage Rembrandt," *Art*, 1956, No. 7 [И. В. Линник, «К вопросу о сюжете картины Рембрандта из собрания Эрмитажа», *Искусство*, 1956, №7]

Linnik 1959 I. Linnik, "Newly Attributed Paintings by Frans Hals," *Art*, 1959, No. 10

	[И. В. Линник, «Вновь опознанные картины Франса Хальса», *Искусство*, 1959, № 10]
Linnik 1960	I. Linnik, "Newly Attributed Paintings by Frans Hals," *Reports of the Hermitage*, 17, 1960 [И. В. Линник, «Вновь найденные картины Франса Хальса», *Сообщения Государственного Эрмитажа*, 17, 1960]
Linnik 1961	I. Linnik, "New Data on the Works of Rembrandt's Pupils Done for the Amsterdam Town Hall," *Papers of the Hermitage*, 4, 1961 [И. В. Линник, «Новые материалы о работах учеников Рембрандта для Амстердамской ратуши», *Труды Государственного Эрмитажа*, 4, 1961]
Linnik 1963	I. Linnik, *The Garden of Love by Karel van Mander*," *Reports of the Hermitage*, 24, 1963 [И. В. Линник, «Сад любви Карела Мандера», *Сообщения Государственного Эрмитажа*, 24, 1963]
Linnik 1971	I. Linnik, "Newly Attributed Paintings by the Netherlandish Followers of Caravaggio," *Art*, 1971, No. 6 [И. В. Линник, «Вновь опознанные картины нидерландских караваджистов», *Искусство*, 1971, № 6]
Linnik 1972	I. Linnik, "Newly Attributed Paintings by Claes Moyaert," *Reports of the Hermitage*, 35, 1972 [И. В. Линник, «Вновь опознанные картины Класа Муйарта», *Сообщения Государственного Эрмитажа*, 35, 1972]
Linnik 1973	I. Linnik, "Newly Attributed Paintings by the Dutch Followers of Caravaggio," *Reports of the Hermitage*, 37, 1973 [И. В. Линник, «Вновь определенные картины голландских караваджистов в Эрмитаже», *Сообщения Государственного Эрмитажа*, 37, 1973]
Linnik 1974	I. Linnik, "Newly Attributed Paintings by Pieter and Paulus van den Bos," *Reports of the Hermitage*, 39, 1974 [И. В. Линник, «Вновь опознанные картины Питера и Паулиса фан Ден Босов», *Сообщения Государственного Эрмитажа*, 39, 1974]
Loewinson-Lessing 1956	V. Loewinson-Lessing, I. Linnik, *Rembrandt van Rijn*, Moscow, 1956 [В. Ф. Левинсон-Лессинг, И. В. Линник, *Рембрандт ван Рейн*, Москва, 1956]
Loewinson-Lessing 1957	V. Loewinson-Lessing, "On the History of *David's Farewell to Jonathan* by Rembrandt", *Reports of the Hermitage*, 11, 1957 [В. Ф. Левинсон-Лессинг, «К истории картины Рембрандта *Давид и Ионафан*», *Сообщения Государственного Эрмитажа*, 11, 1957]
Nemilova 1974	I. Nemilova, "*Rinaldo and Armida* by Barend Graat," *Reports of the Hermitage*, 38, 1974 [И. Немилова, «Картина Барента Граата *Ринальдо и Армида*», *Сообщения Государственного Эрмитажа*, 38, 1974]
Neumann 1906 (1908)	W. Neumann, *Beschreibendes Verzeichnis der Gemälde der vereinigten Sammlungen der Stadt Riga...*, 1906 (1908)
Neustroyev 1898	A. Neustroyev, *The Picture Gallery of the Imperial Hermitage*, St. Petersburg, 1898 [А. А. Неустроев, *Картинная галерея Императорского Эрмитажа*, Санкт-Петербург, 1898]
Nikulin 1963	N. Nikulin, "The Reconstruction of the Altarpiece *Calvary* by Maerten van Heemskerk," *Reports of the Hermitage*, 24, 1963 [Н. Никулин, «Реконструкция алтаря *Распятие* Мартина ван Хемскерка», *Сообщения Государственного Эрмитажа*, 24, 1963]
Nikulin 1964	N. Nikulin, "On a Self-portrait by Lucas van Leyden," *Reports of the Hermitage*, 25, 1964 [Н. Никулин, «Об одном автопортрете Луки Лейденского», *Сообщения Государственного Эрмитажа*, 25, 1964]
Nikulin 1965	N. Nikulin, "On the History of the triptych *The Healing of the Blind Man of Jericho* by Lucas van Leyden," *Reports of the Hermitage*, 26, 1965 [Н. Никулин, «К истории триптиха Луки Лейденского *Исцеление Иерихонского слепца*», *Сообщения Государственного Эрмитажа*, 26, 1965]
Nikulin 1972	N. Nikulin, *Netherlandish Painting of the 15th and 16th Centuries in the Hermitage*, Leningrad, 1972 [Н. Никулин, *Нидерландская живопись XV–XVI веков в Эрмитаже*, Ленинград, 1972]
Plietzsch 1960	E. Plietzsch, *Holländische und flämische Maler des XVII. Jh.*, Leipzig, 1960
P. V. *The Old Years* 1910	P. V., "*Ahasuerus, Haman and Esther* in the Rumiantsev Museum, Moscow," *The Old Years*, 1910, February [П. В., «Агасфер и Аман у Эсфири. Румянцевский музей. Москва», *Старые годы*, 1910, февраль]
Rembrandt 1981	*Rembrandt Paintings in Soviet Museums*, Leningrad, 1981
Reports of the Hermitage	*Сообщения Государственного Эрмитажа*

Romanov 1926 N. Romanov, *Paintings by Netherlandish Artists in the Museum of Fine Arts (Jan Mostaert)*, 5, 1926 [Н. И. Романов, *Нидерландские картины в Музее изящных искусств (Ян Мостарт)*, 5, 1926]

Rosenberg 1948 J. Rosenberg, *Rembrandt*, 2 vols., Cambridge (Mass.), 1948

Rosenthal 1930 Sh. Rosenthal, "Landscapes by Philips de Koninck," *Bulletin of the Museum of Fine Arts*, Moscow, 1930 [Ш. Розенталь, «Пейзажи Филипса Конинка», *Бюллетень Музея изящных искусств*, Москва, 1930]

Rotenberg 1956 E. Rotenberg, *Rembrandt Harmensz van Rijn*, Moscow, 1956 [Е. Ротенберг, *Рембрандт Гарменс ван Рейн*, Москва, 1956]

Scherjon, Gruyter 1937 W. Scherjon, W. J. de Gruyter, *Vincent van Gogh's Great Period: Arles, St. Rémy and Auvers-sur-Oise*, 2 vols., Amsterdam, 1937

Schmidt 1916 D. Schmidt, "Zurov's Gift to the Hermitage," *The Old Years*, 1916, March [Д. А. Шмидт, «Дар Зурова Императорскому Эрмитажу», *Старые годы*, 1916, март]

Schmidt 1922 D. Schmidt, "Haarlem Painters Jan and Salomon de Bray," *Annual of the Institute of Art History*, 1922 [Д. Шмидт, «Гарлемские живописцы Ян и Саломон де Брей», *Ежегодник Института истории искусств*, 1922]

Semenov. Etudes 1906 P. Semenov, *Etudes sur les peintres des écoles hollandaise, flamande et néerlandaise qu'on trouve dans la Collection Semenov et les autres collections publiques et privées de St. Pétersbourg*, St. Petersburg, 1906

Semionov 1885–90 P. Semionov, *Essays on the History of Netherlandish Painting Based on the Pictures Kept in Museums and Private Collections in St. Petersburg*, 2 vols., St. Petersburg, 1885–90 [П. П. Семенов, *Этюды по истории нидерландской живописи на основании ее образцов, находящихся в публичных и частных собраниях Петербурга*, т. 1, 2, Санкт-Петербург, 1885–90]

Senenko 1960 M. Senenko, "New Acquisitions of the Department of Western European Art in the Pushkin Museum of Fine Arts, Moscow," *Reports of the Pushkin Museum of Fine Arts*, 1960 [М. Сененко, «Новые приобретения отдела западноевропейского искусства Государственного музея изобразительных искусств имени А. С. Пушкина», *Сообщения Государственного музея изобразительных искусств имени А. С. Пушкина*, 1960]

Shchavinsky 1909 V. Shchavinky, "A History of Dutch Painting Based on the Pictures from the Semionov-Tien-Shansky Collection," *The Old Years*, 1909, May [В. А. Щавинский, «История голландской живописи по коллекции Петра Петровича Семенова-Тян-Шанского», *Старые годы*, 1909, май]

Shchavinsky 1915 V. Shchavinsky, "Netherlandish Painters in Moscow Private Collections," *The Old Years*, 1915, July–August [В. Щавинский, «Нидерландские мастера в московских частных собраниях», *Старые годы*, 1915, июль–август]

Shchavinsky 1916 V. Shchavinsky, "Paintings by Dutch Artists in the Gatchina Palace," *The Old Years*, 1916, July–September [В. Щавинский, «Картины голландских мастеров в Гатчинском дворце», *Старые годы*, 1916, июль–сентябрь]

Shcherbachova 1924 M. Shcherbachova, "On the New Arrangement of Pictures by Dutch Artists in the Hermitage," *Art Collectors' Journal*, 1924, Nos. 9–12 [М. И. Щербачева, «К новой развеске голландцев в Эрмитаже», *Среди коллекционеров*, 1924, № 9–12]

Shcherbachova 1940 M. Shcherbachova, "Paintings by Pieter Lastman in the Hermitage," *Papers of the Department of Western European Art*, vol. 1, Leningrad, 1940 [М. И. Щербачева, «Картины Питера Ластмана в Эрмитаже», *Труды отдела западноевропейского искусства*, т. 1, Ленинград, 1940]

Shcherbachova 1945 M. Shcherbachova, *Still Lifes in Dutch Painting*, Leningrad, 1945 [М. И. Щербачева, *Натюрморт в голландской живописи*, Ленинград, 1945]

Shcherbachova 1956 M. Shcherbachova, "New Paintings by Honthorst in the Hermitage," *Papers of the Hermitage*, 1, 1956 [М. И. Щербачева, «Новые картины Гонтгорста в собрании Эрмитажа», *Труды Государственного Эрмитажа*, 1, 1956]

Somov 1888 A. Somov, "New Paintings by Rembrandt and Elsheimer in the Imperial Hermitage, St. Petersburg," in: *Art and Design*, 1888 [А. Сомов, «Новые Рембрандт и Эльцхеймер в Императорском Эрмитаже», в сб.: *Искусство и художественная промышленность*, 1888]

Somov 1899 A. Somov, "Dutch Genre Painting in the 17th Century: Jan Steen," in: *Art and Design*, 1899 [А. Сомов, «Голландский жанр в XVII веке: Ян Стен», в сб.: *Искусство и художественная промышленность*, 1899]

Ternovetz 1922 B. Ternovetz, "New Acquisitions of the Second Museum of Modern Art in Moscow," *Art Collectors' Journal*, 1922, Nos. 5/6 [Б. Н. Терновец, «Новые поступления во 2-й Музей Новой западной живописи в Москве», *Среди коллекционеров*, 1922, № 5/6]

Terwesten 1770 P. Terwesten, *Catalogus of Naamlijst van schilderijen, met derselven prijzen . . .*, The Hague, 1770

The Old Years *Старые годы*

The Pushkin Museum of Fine Arts 1966 *The Pushkin Museum of Fine Arts in Moscow. Western European Painting and Sculpture*, Moscow, 1966 [*Государственный музей изобразительных искусств имени А. С. Пушкина. Западноевропейская живопись и скульптура*, Москва, 1966]

Thieme-Becker *Allgemeines Lexikon der bildenden Künstler von der Antike bis zur Gegenwart . . . herausgegeben von Dr. Ulrich Thieme und Dr. Felix Becker*, 37 vols., Leipzig, 1907–50

Trubnikov 1912 A. Trubnikov, "Paintings in the Pavlovsk Palace," *The Old Years*, 1912, October [А. А. Трубников, «Картины Павловского дворца», *Старые годы*, 1912, октябрь]

Tugendhold 1914 Ya. Tugendhold, "Shchukin's Collection of French Paintings," *Apollon*, 1914, Nos. 1–2 [Я. Тугендхольд, «Французское собрание С. И. Щукина», *Аполлон*, 1914, № 1–2]

Valentiner 1909 W. R. Valentiner, *Rembrandt: Des Meisters Gemälde* (*Klassiker der Kunst*), Stuttgart–Leipzig, 1909

Vasilchikov 1883 A. Vasilchikov, "New Acquisitions of the Hermitage," *Bulletin of Fine Arts*, 1, 1883 [А. Васильчиков, «Новые приобретения Императорского Эрмитажа», *Вестник изящных искусств*, 1, 1883]

Vipper 1957 B. Vipper, *The Advent of Realism in Seventeenth-century Dutch Painting*, Moscow, 1957 [Б. Р. Виппер, *Становление реализма в голландской живописи XVII века*, Москва, 1957]

Vipper 1960 B. Vipper, "Evolution in the Art of Gabriel Metsu," in: *A History of Russian and Western European Art*, Moscow, 1960 [Б. Р. Виппер, «О творческой эволюции Габриэля Метсю», в кн.: *Из истории русского и западноевропейского искусства*, Москва, 1960]

Vipper 1962 B. Vipper, *Dutch Painting at Its Height*, Moscow, 1962 [Б. Р. Виппер, *Очерки голландской живописи эпохи расцвета*, Москва, 1962]

Volskaya 1939 V. Volskaya, "Genre Paintings by Emanuel de Witte in the Pushkin Museum of Fine Arts," *Papers of the Pushkin Museum of Fine Arts*, Moscow, 1939 [В. Н. Вольская, «Жанровая композиция Э. де Витте в Государственном музее изобразительных искусств имени А. С. Пушкина», *Труды Государственного музея изобразительных искусств имени А. С. Пушкина*, Москва, 1939]

Volskaya 1956 V. Volskaya, "Rembrandt and His Contemporaries," *Art*, 1956, No. 7 [В. Н. Вольская, «Рембрандт среди своих современников», *Искусство*, 1956, № 7]

Volskaya 1966 V. Volskaya, "Rembrandt and the Baroque," in: *Classic Art in the West*, Moscow, 1966 [В. Н. Вольская, «Рембрандт и барокко», в сб.: *Классическое искусство за рубежом*, Москва, 1966]

Waagen 1870 G. F. Waagen, *Die Gemäldesammlung in der Kaiserlichen Eremitage zu St. Petersburg . . .*, St. Petersburg, 1870

Wagner 1971 H. Wagner, *Jan van der Heyden*, Amsterdam–Haarlem, 1971

Weisbach 1926 W. Weisbach, *Rembrandt*, Berlin–Leipzig, 1926

Wrangel 1908 N. Wrangel, "Genre and Portrait Paintings by Seventeenth- and Eighteenth-century Netherlandish Artists," *The Old Years*, 1908, November–December [Н. Врангель, «Бытовая живопись и портреты нидерландских художников XVII и XVIII веков», *Старые годы*, 1908, ноябрь–декабрь]

Wurzbach 1906–11 A. von Wurzbach, *Niederländisches Künstler-Lexikon*, Vienna–Leipzig, 1906–11

Yegorova 1966 K. Yegorova, "Portraits in the Work of Rembrandt of the 1650s," in: *Classic Art in the West*, Moscow, 1966 [К. С. Егорова, «Портреты в творчестве Рембрандта 1650-х годов», в сб.: *Классическое искусство за рубежом*, Москва, 1966]

Znamenov, Tenikhina 1973 V. Znamenov, V. Tenikhina, *The Hermitage Pavilion in the Lower Park of Petrodvorets*, Leningrad, 1973 [В. В. Знаменов, В. М. Тенихина, «Эрмитаж» в Нижнем парке Петродворца, Ленинград, 1973]

521

INDEX OF ARTISTS

Numbers refer to plates

Aelst, Willem van 269–270
Aertsen, Pieter 19, 20
Aldewerelt, Herman van 65
Angel, Philips 259
Asselyn, Jan 204, 205
Ast, Balthasar van der 246–247
Avercamp, Hendrick 177

Baburen, Theodor (Dirck) van 60
Backer, Jacob Adriaensz 134
Backhuyzen, Ludolf 244
Beelt, Cornelis 238
Beest, Sybrand van 211
Bega, Cornelis Pietersz 92
Behr, Carel Jacobus 309
Berchem, Nicolaes (Claesz)
 Pietersz 219, 220
Berckheyde, Gerrit Adriaensz 242
Berckheyde, Job Adriansz 78
Beyeren, Abraham van 255–256, 257
Bie, Pieter van 139
Bijlert, Jan van 79
Bles, David Joseph 297
Blijhooft, Zacharias 56
Bloem, Matheus 249
Bloemaert, Abraham 66, 128–129,
 130
Bloemaert, Hendrick 31
Blomendael, Reyer van 168
Bloot, Pieter de 141
Bol, Ferdinand 58, 165, 248
Bos, Paulus van den 258
Bos, Pieter van den 261
Bosboom, Johannes 308
Bosch, Hieronymus (School of) 2
Both, Jan 214
Boursse, Esaias 94
Bramer, Leonard 131, 132
Bray, Jan de 46, 169
Bray, Salomon de 158
Brekelenkam, Quiringh Gerritsz van 93
Bronckhorst, Jan Gerritsz van 110
Brussel, Paulus Theodorus van 288

Casteleyns, Casper 174
Claesz, Pieter 253, 254
Codde, Pieter 156
Covijn, Israel 113
Croos, Pieter van der 233
Cuyp, Aelbert 230–231
Cuyp, Benjamin Gerritsz 151
Cuyp, Jacob Gerritsz 67, 68

Decker, Cornelis 222
Delen, Dirck van 226

Donck, G. 157
Dongen, Kees van 319, 320, 321, 322
Dou, Gerrit 114, 115
Droochsloot, Joost Cornelisz 142, 184
Duck, Jacob 73
Dujardin, Karel 216
Dusart, Cornelis 99
Dyck, Abraham van 152
Dyck, Philip van 279

Eemont, Adriaen van 215
Engelbrechtsen, Cornelis (?) 5
Everdingen, Allaert Pietersz van 229

Fabritius, Barent 166
Flinck, Govaert Tennisz 35

Geel, Joost van 111
Geertgen tot Sint Jans (?) 3
Gelder, Aert (Arent) de 59, 170
Gelder, Nicolaes van 266
Gogh, Vincent van 313, 314, 315, 316,
 317, 318
Goltzius, Hendrick 26, 27
Goyen, Jan van 185, 186–187
Graat, Barend 175
Grebber, Pieter Fransz de 143

Haanen, Remigius Adrianus 306
Haarlem, Cornelis Cornelisz van 28
Hackaert, Jan 235
Hals, Dirck 61
Hals, Frans 37, 125, 126
Hanneman, Adriaen 42
Heda, Willem Claesz 250
Heem, Jan Davidsz de 265
Heemskerk, Maerten van 12–14
Heerschop, Hendrick 49
Helst, Bartholomeus van der 38–39
Heyden, Jan van der 240, 241
Hobbema, Meindert 223
Hoef, Abraham van 75
Hondecoeter, Melchior de 272
Hondius (de Hondt), Abraham 173
Honthorst, Gerrit van 63, 64, 120
Hooch, Pieter de 80, 81
Houckgeest, Gerard Jorisz 212
Hove, Hubertus van 293, 294
Huysum, Jan van 286, 287

Israels, Jozef 296

Jacobsz, Dirck 16–17, 18
Jongh, Ludolf (Louven) de 98
Jongkind, Johann Barthold 310
Jonxis, Jan Lodewijk 290

Kalf, Willem 262, 263, 264
Kate, Herman Frederick Carel ten 295
Keirincx, Alexander 182–183
Kessel the Younger, Jan van 236
Keyser, Thomas de 32, 127
Knupfer, Nicolaus 163–164
Koedyck, Isaac 97
Koekkoek, Barend Cornelis 299
Kompe, Jan ten 284
Koninck, Philips de 85, 234
Koninck, Salomon 153

Lastman, Pieter 119
Leyden, Lucas van 6–9
Lingelbach, Johannes 239
Loo, Jacob van 112
Luttichuijs, Isaack 47

Maes, Nicolaes 54, 55
Mancadan, Jacobus Sibrandi 194
Mander, Karel van 21–22, 23–24
Marienhof, Jan Aertsen (?) 77
Maris, Jacob Hendrikus 311
Martszen the Younger, Jan 74
Merck, Jacob Fransz van der 33
Mesdag, Hendrick Willem 312
Metsu, Gabriel 107, 108–109
Mieris the Elder, Frans van 104–105
Mieris, Willem van 117
Moeyaert, Nicolaes (Claes) 133
Molenaer, Jan Miense 71, 140
Molenaer, Klaes 203
Mommers, Hendrick 172, 209
Moreelse, Paulus 29
Mostaert, Jan 4
Musscher, Michiel van 57
Mytens, Jan 161

Nason, Pieter 41
Neck, Jan van 176
Neer, Aernout (Aert) van der 217, 218
Neer, Eglon Hendrick van der 116
Nellius, Martinus 267
Noort, Pieter Pietersz van 91
North Netherlandish Artist of the late
 15th century 1

Ochtervelt, Jacob 106
Oostsanen, Jacob van 15
Os, Pieter Gerardus van 300, 301
Ostade, Adriaen van 86, 87, 88–90
Ostade, Isack van 200–201

Palamedesz, Anthonie 43, 70
Pickenoy, Nicolaes Eliasz 36

Pieneman, Nicolaas 291
Poel, Egbert van der 210
Poelenburgh, Cornelis van 160
Porcellis, Jan 190–191
Post, Frans 193
Pothoven, Hendrick 281
Potter, Paulus 213
Pynas, Jan 121
Pynacker, Adam 221

Quast, Pieter 72

Ravenswaay, Jan van 304
Rembrandt 50,51,144–145,146,147,
 148–149, 150
Ringh, Pieter de 268
Roelofs, Willem 305
Rombouts, Salomon 237
Rosendael, Nicolaes 171
Ruisdael, Jacob Isaaksz 195, 196, 197
Ruysdael, Salomon van 192
Ryckhals, Frans 251, 252

Saftleven, Cornelis 162
Saftleven the Younger, Herman 207
Salm, Adriaen Cornelisz van der
 282–283

Scheffer, Ary 292
Schelfhout, Andreas 302, 303
Schendel, Petrus van 289
Schoeff, Johannes Pietersz 189
Schooten, Floris Gerritsz van 260
Schrieck, Otto Marseus van 271
Scorel, Jan van 10, 11
Slabbaert, Karel 40
Slingelandt, Pieter Cornelisz van 82
Steen, Jan 103
Stomer, Mathias 135–136,137,138
Streeck, Juriaen van 95
Sweerts, Michiel 44–45, 96

Tempel, Abraham van den 53
Ter Borch, Gerard 52, 100, 101–102
Terbrugghen, Hendrick 62, 122–123
Troost, Cornelis 280

Velde, Adriaen van de 167, 202
Velde, Jan van de 178, 179
Velde the Younger, Willem van de 243
Velsen, Jacob van 69
Venne, Adriaen Pietersz van de 84,124
Verdoel, Adriaen 154
Verdoel the Younger, Adriaen 48
Verkolje, Nicolaes 277

Verschuur, Wouterus 298
Verspronck, Jan 34
Vinne, Vincent Laurensz van der 273
Vlieger, Simon de 188
Vliet, Hendrick Cornelisz van 228
Voort, Cornelis van der 30
Vrel, Jacobus 83
Vries, Michiel de 208
Vucht, Jan van der 181

Wabbe, Jakob 118
Walscapelle, Jacob van 285
Weenix, Jan 274
Weenix, Jan Baptist 199
Weissenbruch, Jan 307
Werff, Adriaen van der 275, 276
Wet, Gerrit de 159
Wet, Jacob Willemsz de 155
Wijk, Thomas 76
Wijnants, Jan 198
Willaerts, Adam 180
Willigen, Claes Jansz van der 232
Wit, Jacob de 278
Withoos, Matthias 245
Witte, Emanuel de 206, 227
Wouwerman, Philips 224, 225
Wtewael (Utewael), Joachim Antonisz 25

ГОЛЛАНДСКАЯ ЖИВОПИСЬ
В музеях Советского Союза
Альбом (на английском языке)

ИЗДАТЕЛЬСТВО «АВРОРА» ЛЕНИНГРАД 1982
Изд. № 3328
Printed and bound in Yugoslavia